Art, Crafts, and Architecture in Early Illinois

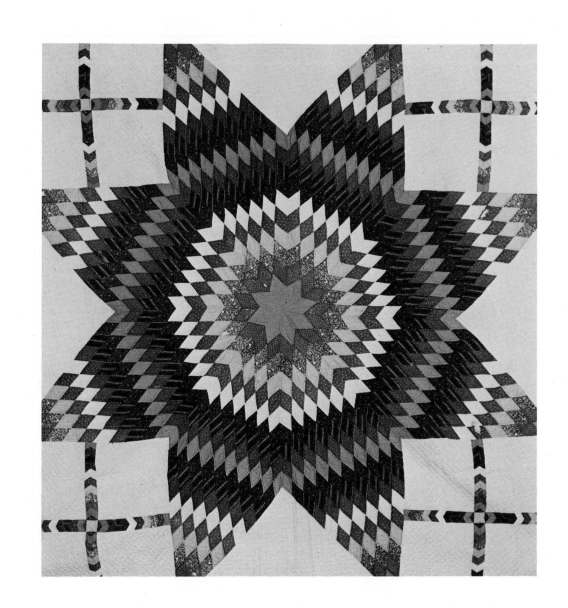

Art, Crafts, and Architecture in Early Illinois

BETTY I. MADDEN

Published in cooperation with the Illinois State Museum

UNIVERSITY OF ILLINOIS PRESS *Urbana Chicago London*

Publication of this volume has
been aided by a grant from the
Illinois Bicentennial Commission

Drawings have been made by the
author except where otherwise noted

Library of Congress Cataloging in Publication Data

Madden, Betty I. 1915-
 Art, crafts, and achitecture in early Illinois.

 1. Art — Illinois — History. 2. Architecture —
Illinois — History. 3. Illinois — Industries — History.
I. Illinois. State Museum, Springfield. II. Title.
N6530.I4M32 709′.773 73-22468
ISBN 0-252-00391-8

Dedicated to the pioneers
who recorded Illinois history
with their creative hands

Contents

	Preface	*page* xi
	Acknowledgments	xiii
1	Art before Written History	3
2	Map Makers and Fort Builders	15
3	The French Settlers	23
4	Pioneer Hunters and Spinners	37
5	Art in the Wilderness	45
6	Early Frontier Craftsmen	57
7	Early Encounters with the Prairies	65
8	Patriots and Portraits	81
9	Yankee Influence	91
10	Painters of the Indian	113
11	Melting Pot Culture	125
12	Greek Temples and Gothic Spires	137
13	The Plight of the Artist	159
14	Signs of a Vanished Frontier	169
15	Jug Towns	181
16	Nauvoo, the Utopia	195
17	Discovering the Landscape	211
18	Swedes on the Prairies	231
19	End of an Era	243
	Appendix: Additional Artists Known to Have Been in Illinois	263
	Notes and Sources	269
	Index of Names	281
	General Index	289

Color Illustrations

Pierre Menard house, Kaskaskia — *page* 35

Church of the Holy Family, Cahokia — 36

"The Legend of the Piasa Bird" — 53

Effigy pipe from Rutherford Mound, Hardin County — 53

Middle Woodland figurine from Knight Mound, Calhoun County — 53

Portrait of Chief Black Hawk by Samuel Gardiner Drake — 54

"Kee-mo-rá-nia" by George Catlin — 54

Wagner family portrait by Sheldon Peck — 87

"Park House, Albion, Edwards County, Illinois" by George Flower — 87

Carved and painted eagle from Galena — 88

Stenciled hanging from Belvidere, Boone County — 88

Appliqué counterpane by Helen Gilcrest — 88

Kitchen of the Rutledge Tavern, New Salem — 105

Clayville Tavern, near Pleasant Plains — 106

Frank B. Thompson house, Albion — 139

First National Bank of Old Shawneetown — 139

Jacquard coverlets by George Gauss and John Philip Seewald — 140

Double-woven coverlet by Mrs. William N. Bock — 140

Pieced and appliquéd quilt by Ann Koenig Koch — 140

Senate chamber of Old State Capitol, Springfield — 157

Tuscan villa, Galena — 157

"The Knitting Lesson" by Junius R. Sloan — 158

Portrait of Mary "Polly" Greene Watkins — 158

Portrait of Anna P. Sill by George J. Robertson — 158

Galena redware pottery and White Hall stoneware jug — 191

"Galena Harbor, 1852" by Bayard Taylor — 192

"View of Galena" by John Caspar Wild — 192

"Old Man Grey" by John Williams O'Brien — 209

"View of Alton, Illinois" attributed to J. B. Blair — 209

"Olof in His Union Suit" and "Butcher Boys on a Bender" by Olof Krans — 210

Bishop Hill church apartment interior — 210

Preface

It has long been recognized that a knowledge of history is necessary to the proper interpretation of man's arts; yet the general historian, whose writings are largely the result of studying existing manuscripts and printed materials, has been slow to accept the fact that he, in turn, can learn a good deal more about history and can interpret it more broadly through the study of man's artifacts. The historian is likely to forget his dependence upon the artist or craftsman and that every volume in a library, every tool, painting, sculpture, and piece of furniture in a historical museum is a product of man's inventive mind and creative hands. Without the artist's pictures, little would be known of the appearance of George Washington, the historic Indian, the uncivilized prairie, or the colonial buildings in New York and Philadelphia. We would have considerably less information about early battles, treaties, or even the everyday life and customs of the American settler. Before the invention of the camera, the artist recorded the only visual images for posterity through his drawings, paintings, engravings, and sculpture.

Today, without written documents, we can learn much about man's past through the study of his artifacts, investigation of the regions in which they have been found, and determination of their approximate ages. Although the earliest written records of the Illinois region reach back only about 300 years, scientists have come to recognize that man has actually hunted or lived in the Illinois area for perhaps 35,000 years. An ancient spearpoint, a fishhook, a pot, or an ornament can become a historic record in itself. After thousands of such artifacts are scientifically collected, analyzed, compared, and recorded, the anthropologist is able to hypothesize a cultural history for the prehistoric past.

Only since about 1920 have historians studied the arts, crafts, and architecture of historic America; previous to that time such American products were considered by art critics to be inferior reflections of European influences. Art museums concentrated on arts and artifacts from foreign lands. Native art pieces were often relegated to basements or were discarded. Today the attitude is changing. Arts and crafts of European masters are still highly prized, but scholars recognize that American products are valuable for their unique attributes and that they should not be judged by European standards. They should instead be viewed as representations of the newer and unique American way of life.

With a few exceptions, the study of American artifacts as reflections of the cultural history of a people is largely confined to the areas east of the Appalachians. The architecture of the Midwest has been studied, but the contributions of the region's craftsmen and artists have been greatly neglected by historians. Because Illinois history has involved outstanding national figures and a great spirit of democracy, the study of politics still remains the main passion of Illinois historians. No book has dealt comprehensively with the cultural history of the Midwest.

Although this book concerns art, architecture, and crafts, it does not attempt to make aesthetic judgments. What it does attempt to do is to pose such questions as "What did man in Illinois create with his mind and hands?," "How?," and, of even greater importance, "Why?" The answers to such questions are basic to an appreciation of and a sound judgment about the history of the region.

Pictures of artifacts inspired by the region have been selected for this volume to reveal how man, his arts, and his environment have been interdependent throughout history. The story reveals the influence which settlers and artist travelers have had upon Illinois culture. Most artists of the early Midwest were men on the move, impelled either by curiosity or by the necessity of earning a living to travel or migrate. Although

the works of such men are often the only existing illustrations of this country's earlier period, the artists themselves have seldom been named in the historians' credit lines, and their lives have infrequently been studied.

This volume deals largely with the years before 1860 — the Golden Era of the handcraftsman. Great changes occurred after that date, creating quite another story. There has been an attempt to go beyond amply recorded political history, well-known personalities, and events in order to focus on the geographical and folk history of Illinois. Hopefully, the activities of hundreds of unsung individuals who made the true "history" of the state will be brought to light.

This is not intended to be a definitive work. Instead, it is a pioneering effort, presented with the hope that it will be a springboard for additional studies in a long-neglected, little-understood, but fascinating aspect of Illinois history. If certain regions or towns appear to be overemphasized to the exclusion of others of equal significance, it is because the author has provided only typical examples that illustrate general settlement patterns, trends, and cultural advances; if certain subjects seem overemphasized, it is because little research has been accomplished in others. There remains much to be done, yet there comes a time when a researcher must stop and record what has been found before it is lost. May you find this recording an enjoyable and inspirational experience.

Betty Madden
Springfield
January 1, 1974

Acknowledgments

My inspiration for research into the field of Illinois culture began at a forum and exhibition, "Arts and Crafts of the Northwest Territory," sponsored by the Henry Ford Museum at Dearborn, Michigan, in October 1964. The following October a first exhibition of "Old Illinois Arts and Crafts" was held at the Illinois State Museum of Natural History and Art in Springfield; and, after continuing research, it was decided that the considerable accumulated information should be assembled in book form.

It is with gratitude that I acknowledge the continuous confidence and support of both Milton Thompson, director of the Illinois State Museum, and George Irwin, former chairman of the Illinois Arts Council. The institutions which they represent provided funds required for the preliminary research; the Illinois Bicentennial Commission provided funds for color reproductions in the book. The time necessary for much of the project was generously allowed by the Illinois State Museum. I would like also to express sincere appreciation to individuals in the various state departments that have contributed time, research material, and encouragement. I particularly extend thanks to these members of the Illinois State Historical Library staff: William Alderfer, state historian; Lowell Anderson, historic sites curator; James Hickey, historian and curator of the Lincoln collections; Mildred Schulz, head librarian; and Albert Von Behren, photographer; to the late John Schulte of the Illinois State Department of Conservation; Robert Sherman, curator of Clayville Stagecoach Stop, Sangamon State University; and to Wayne Temple, acting administrator of the Illinois State Archives.

Frank Williams, assistant director of the University of Illinois Press, has extended wise counsel, patience, and understanding throughout the transformation of this work into book form.

The staffs of city libraries, county historical societies, and museums throughout Illinois have been most generous in extending their services. I am sincerely grateful to the many owners of private collections of Illinois artifacts who have opened their doors to me and to all who have so graciously donated knowledge and time.

I personally wish to acknowledge those who have generously reviewed parts of the manuscript: George Bassett, curator of the Edwards County Museum, Albion; Natalia Belting, Department of History, University of Illinois; Emily Blasingham, former curator of anthropology, Illinois State Museum; Herman Eifert, curator of education, Illinois State Museum; Margaret Flint, former assistant state historian, Illinois State Historical Library; Richard Hagen, former chief historian, Illinois State Department of Conservation, Division of Parks and Memorials; T. Edgar Lyon, historian, Nauvoo Restoration Incorporated, Salt Lake City; Bruce McMillan, assistant director, Illinois State Museum; Ronald Nelson, historian, Illinois State Department of Conservation, Division of Parks and Memorials; Richard Phillips, historian, photographer, and editor of *Iliniwek*, East Peoria.

I also extend my cordial thanks to those at the Illinois State Museum who have contributed to the completion of the manuscript: Helen Banaitis, secretary to the director; Bernice Fernandes, art department secretary; Charles Hodge, former chief photographer; Violet Jones, secretary to the assistant director; Orvetta Robinson, librarian; Marlin Roos, photographer; summer research assistants Constance Kanatzer, Beverly Hoffman, Donna McCracken, and Ann Zelle.

And there are many others; those who through the years have studied the pattern of a building, who have paused on a country road to wonder about a deserted farmhouse, who have delighted in a favorite bit of old pottery, and who have brought these to my attention, have inadvertently contributed to this manuscript. To all these people and to those hundreds of others whose knowledge, encouragement, and support have made this book possible the author is deeply indebted.

Art, Crafts, and Architecture in Early Illinois

1 Art before Written History

"Flying Dragon,"
William Dennis's 1825 pen-and-ink drawing
of his conception of the Piasa Bird
on a cliff above present-day Alton.
The inscription reads:
 William Dennis that's his Name
 And with his pen he drew the same
 One Thousand and Eigh[t] 800 and 25
 In Aprile about the third
 and with his pen he drew the bird
ILLINOIS STATE HISTORICAL LIBRARY

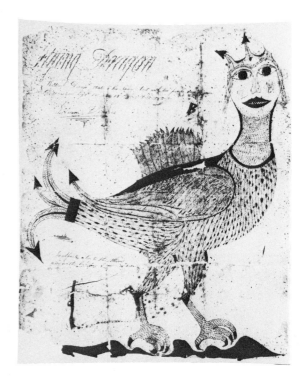

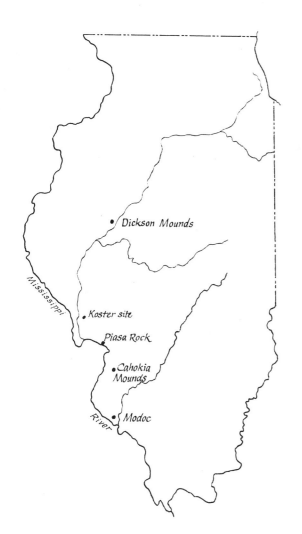

The first known Europeans to explore the middle Mississippi River region were seven daring French Canadians who in 1673 were looking for a westward route to the Far East. The leader of the expedition was Louis Jolliet, an experienced woodsman and map maker of Canada; the chaplain was Father Jacques Marquette, a Jesuit priest.

In his journal of the expedition (presumably edited by his superior, Father Dablon of Quebec) Father Marquette described a pictograph on the rocky bluffs above present-day Alton, Illinois. Of the drawing, which has long since disappeared, he said:

While Skirting some rocks, which by Their height and length inspired awe, We saw upon one of them two painted monsters which at first made Us afraid, and upon Which the boldest savages dare not Long rest their eyes. They are as large As a calf; they have Horns on their heads Like those of a deer, a horrible look, red eyes, a beard Like a tiger's, a face somewhat like a man's, a body Covered with scales, and so Long A tail that it winds all around the Body, passing above the head and going back between the legs, ending in a Fish's tail. Green, red, and black are the three Colors composing the Picture. Moreover, these 2 monsters are so well painted that we cannot believe that any savage is their author; for good painters in france would find it difficult to paint so well, — and, besides, they are so high up on the rock that it is difficult to reach that place Conveniently to paint them. Here is approximately The shape of these monsters, As we have faithfully Copied It.[1]

The pictograph was not to be forgotten, however. It was seen later by La Salle, by succeeding French explorers, and by the missionaries of the late 1600s. For a period of about a hundred years there were no reports of the pictograph; then in the early 1800s a rash of new sightings was reported. The earliest known artist's sketch is a naive pen-and-ink drawing inscribed with a poem naming the artist as William Dennis and the year as 1825. The sketch is titled "Flying Dragon" — the name given to the pictograph by early settlers.

3

It is obvious from the drawing that Dennis was unfamiliar with Marquette's description of the creature. In 1836 John Russell, a former Alton Seminary professor from Bluffdale, Illinois, wrote a magazine article about "The Bird That Devours Men," calling the monster for the first time the "Piasa Bird" — the name by which it is known today. The article related a fanciful legend which persists to this day.

According to Russell's story, a great, fearsome bird once lived high among the cliffs, preying upon unwary Indians, sometimes even bearing their bodies off to its lair. For years brave warriors attempted to destroy it, but the bird continued its destruction of nearby villages. At last an Indian chief named Ouatogá prayed to the Great Spirit for deliverance from this scourge. Told in a dream to select twenty warriors, arm them with bows and poisoned arrows, and hide them among the rocks, Ouatogá did so, placing himself in open view atop the bluff with his feet planted firmly upon the earth and his manly form drawn to its full height. When Ouatogá began to chant the death song of the warrior, the Piasa spread its strong wings, lifted itself into the air, and — swift as a thunderbolt — darted toward the chief. Just as it reached its intended victim, the warriors each sent a poisoned arrow into its body. Uttering a wild scream that resounded across the river, the Piasa fell into the Mississippi and drowned. According to the legend, Ouatogá had been kept safe and untouched by the Master of Life, who, in admiration of his courageous deed, had held over him an invisible shield. It was in commemoration of this event that the image of the Piasa was said to have been engraved and painted on the face of the bluff.[2]

Later versions of this legend, descriptions of

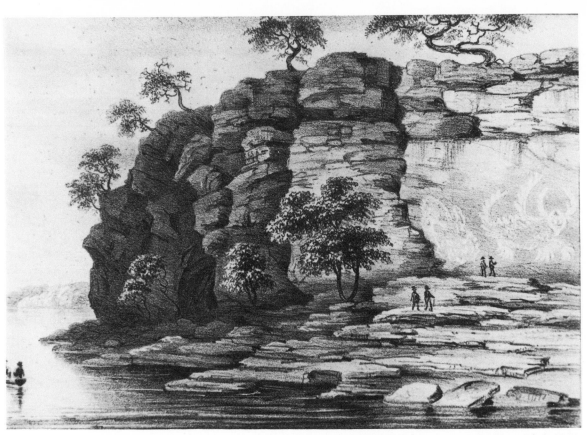

John Caspar Wild's lithograph of the Piasa Bird, 1841.

the pictograph, and depictions of it differ from Russell's, and he later admitted that his legend was "somewhat illustrated."[3]

In 1841 John Caspar Wild, a Swiss landscape artist who had been working in the East, published a portfolio, *The Valley of the Mississippi Illustrated in a Series of Views* (St. Louis), which included a lithograph of the mysterious creature on the cliff. Wild described it as a "hybridous animal with the head of a fox." Three years later an Alton resident published over the signature "L" a version of the legend of the Piasa which he

said originated among Potawatomi rather than Illini Indians. According to this legend the heroes were twins named Peasayah and Onecaw. The author said that some believed the figure to be a giant bird, but he thought it resembled a "hippopotamus with branching horns." The portrait was indistinct and its form a matter of some conjecture. The author of the article wrote, "This portrait has become faded, by exposure to the elements, and its outlines are but faintly perceived, unless closely examined."[4]

In 1846-47 Henry Lewis, a scene painter of St.

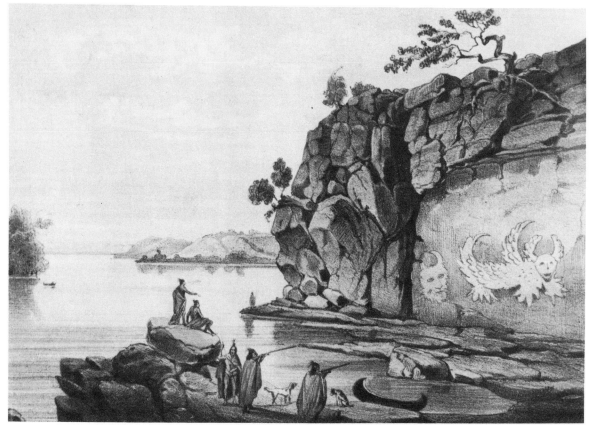

Lithograph from an 1846-47 drawing of the Piasa Bird by Henry Lewis.

CITY ART MUSEUM OF ST. LOUIS

Louis, sketched the Piasa Bird in preparation for his great painted panorama of the Mississippi River. Ten years later in Germany he published *Das Illustrirte Mississippithal* (Düsseldorf, 1854), an account of the wonders of the Mississippi containing a lithograph of the Piasa Bird — a strange feathered creature with horns, wings, and three feet — and also a portion of another figure either weathered away or destroyed when the bluff was quarried in mid-century.

In March of 1847 Rudolf Friederich Kurz, another visiting Swiss artist, described the pictograph as an "age-old, half-disintegrating hieroglyphic drawing of a colossal eagle, which is said to have played in early days a role similar to that of our dragon, and is reputed to have had, also, his St. George and his secret nook in a fen."[5] In October of that year John Russell refuted his former version of the legend, publishing another which told of "a gigantic bird, which is supposed to represent the condor." Russell added that the pictograph had been "obscured by time." The hero of this new legend was Alpeora, who stood alone when the bird "alighted within range of his arrow.... A gigantic figure with folded wings, which were ample enough to cover his entire lodge, sat before him. His claws and bills were enormous. His eyes glanced out fire." With four arrows Alpeora dispatched the bird and then drew the figure on the cliff "quite out of common reach, so that his exploit might appear to his countrymen, and to all after times, the more wonderful."[6] The following year Russell's original version was reprinted in the July 14 issue of the *Evangelical Magazine and Gospel Advocate* in Utica, New York, and soon all these versions of the legend became equally well known.

Various reports indicate that the entire rock upon which the pictograph appeared has been quarried away for making lime. Speculation about the Piasa and its legend continues nonetheless. One oil painting of around 1850 apparently remains unique: its anonymous artist depicted the legend rather than the pictograph. Below a high cliff near the edge of a river two Indians, perhaps meant to be Peasayah and Onecaw, are shown in battle with a giant condor. Such a romantic, imaginative concept was more typical of the European artist who, in contrast with the average American, regarded the Indian as a "noble savage" (see p. 53).

Another description of the Piasa was given in 1883 by the son of John Russell, Spencer G. Russell, who claimed to have seen the Piasa painting in 1849:

The bird or beast . . . had the head of a bear . . . the mouth was open, plainly showing large disproportioned teeth. On its head were the unmistakable horns of an elk.... The body was that of a fish . . . it also disclosed distinctly the marks of scales, resembling those of a fish. The wings were expanded to the right and left of the face, as if in the act

of taking flight, extending probably from sixteen to eighteen feet from point to point. The tail was wrapped three times around the body, twice back of the wings, once forward, terminating in the shape of a spear head. The most prominent features were the wings and head, the latter being covered by a long beard or mane. There was also one other remarkable fact, which has been noticed by all who were familiar with this picture, that at times it could be seen more distinctly than at others. When the atmosphere was damper than usual, the colors came out plainer; hence it may be inferred that as Marquette passed in June (one of our dryest months) the wings were not visible.[7]

Following this new description, local artists depicted a strange dragon-like creature with a bearded head and a long tail wrapped around the body three times. A similar, later version of this type is in the Hayner Public Library at Alton. Although it is inscribed "S. A. Dennis, 12/6/00," the year has been established as 1900 rather than 1800, because the lettering is obviously in an early twentieth-century style.

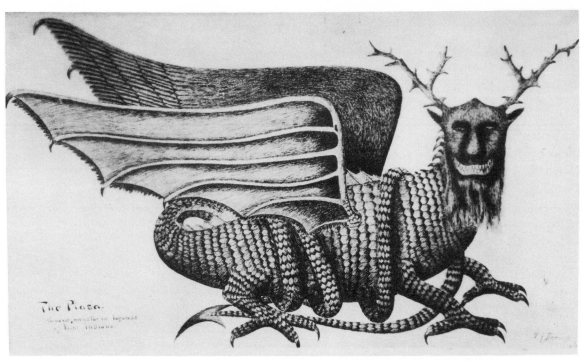

"The Piasa: Famous monster in legends of Illini Indians."
A pen-and-ink drawing by "S. A. Dennis, 12/6/00"
corresponding to the 1883 description by Spencer G. Russell.
HAYNER PUBLIC LIBRARY, ALTON

Today's popular concept of the Piasa Bird, based on Marquette's description without the wings. An anonymous pen-and-ink drawing.
ILLINOIS STATE MUSEUM PHOTOGRAPH

The most commonly accepted version of the pictograph, showing a creature like that described by Marquette except for the wings, first appeared as a wood engraving in William McAdams's *Records of the Ancient Races in the Mississippi Valley* (St. Louis, 1887). According to the author, some of the old citizens of Alton, including the Honorable Samuel Blackmaster and Henry G. McPike, then mayor of the city, collaborated on the sketch, which shows the tail passing over the head and back through the legs. This sketch has been reproduced many times and has even been painted on a cliff along the Great River Road above Alton.

Although there is no way of determining exactly what the original pictograph looked like, it was undoubtedly far simpler than most depictions indicate. Henry Rowe Schoolcraft, a topographical artist, ethnologist, and writer from New York, visited the area in 1811 and observed that the Piasa resembled both the Thunder Bird of the Dakota Sioux and the medicine animal of the Winnebagos, both of which had a serrated back, human head, horns, and long, winding tail.[8] Wayne Temple has suggested that Father Mar-

Art, Crafts, and Architecture in Early Illinois

quette may have been reminded of "La Grande Goule," a dragon-like creature that appeared in seventeenth-century Roman Catholic celebrations, and that he may have indulged in some romantic exaggeration when describing the Piasa Bird.[9]

Anthropologists point out similarities between the description and prehistoric representations of the winged, horned serpents found on pottery at Moundville, Alabama.[10] About 1950 Gregory Perino of Belleville found a fragment of a clay pot in a prehistoric Illinois Indian burial mound bearing a cord-impressed design of a strange, long-tailed creature. Although hornless, this creature had arrow-shaped marks on its body which might originally have been intended to represent

Prehistoric pottery fragment possibly representing the Piasa Bird.
IN *The Living Museum*

wings. Whether this is an early version of the Piasa Bird or simply an ancient potter's depiction of a wildcat is impossible to determine.[11] Other mysterious pictographs left by prehistoric Indians are still visible on rocks and cave walls in Illinois, but none with so dramatic a legend as that of the Piasa Bird.

The Winnebago medicine animal as drawn for Henry Rowe Schoolcraft by Little Hill, an early nineteenth-century Winnebago chief and medicine man.
IN MC ADAMS

As Jolliet and Marquette proceeded down the Mississippi — as far as the Arkansas River — they undoubtedly were unaware of artifacts which were thousands of years older than the Piasa Bird. Near the shores of the Mississippi and the Illinois lay buried the accumulated sherds, flints, and tools of Indians who had inhabited the area in prehistoric times. The explorers continued past the strange mounds which mushroomed from the flat river plain between East St. Louis and Collinsville, not realizing that these were the man-made remnants of the largest prehistoric Indian village north of the Rio Grande.

During the days of French and American settlement, travelers and settlers alike were impelled by curiosity to probe the mystery of these mounds. Not until the late 1800s, though, was much excavation done. In 1876, long before any university had an organized archaeological research center, John Francis Snyder, a physician from Virginia, Illinois, began the first digging. He recorded artifacts found in some of these prehistoric burial sites, since destroyed by plow and bulldozer. The information he gathered, together with later findings and scientific research, is enabling archaeologists to partially interpret the culture of the prehistoric Indian.

It is generally agreed that the ancestors of these early people were primitive hunters who came to America from Asia 25,000 to 50,000 years ago during a long glacial period when a lowering sea level created a land bridge between Siberia and Alaska. These people hunted such great land beasts as the mammoth and the mastodon, carrying little with them except hides for warmth and shelter and a few wooden or stone tools. As the large animals gradually moved southward along waterways created by the melting of the glaciers, these hunters — the Paleo-Indians — penetrated far within and beyond the present boundaries of the United States.

In 1926 at Folsom, New Mexico, a uniquely chipped flint spearpoint belonging to one of these Paleo-Indians was found in place among the bones of a prehistoric bison. Similarly designed

Prehistoric pictographs as seen by William McAdams near Alton in the late 1800s.
IN MC ADAMS

points were later found with stone tools at camp-sites discovered in other sections of North America, and several hundred such points have been found in Illinois.

Up to the present time no skeletal remains have been found which might furnish a clue to the appearance of the Paleo-Indian; an examination of his tools, however, has allowed us to deduce some information about his way of life. Stone chipping was an exacting art, so he must have been a skillful workman. A unique extra-long chip down the center of each side of the spearpoint ingeniously provided means for attaching it to a stem. So the Paleo-Indian must have been an intelligent craftsman.

Early Archaic Indian point.

Paleo-Indian Clovis point.

About 8,000 B.C. the glacial ice began to recede, and as the climate warmed the animal population stabilized. Animals became a reliable food source, and the prehistoric Indian became less nomadic. He may have lived during cold months in the natural caves and shelters along the river banks, where he was protected from the elements and could build fires. During the hunting seasons he roamed through the woodlands for game or fished from the ponds and rivers, while women dug freshwater mussels from the streams or, when the ice was gone, gathered wild berries, nuts, and seeds.

New occupations required new tools. For the hunting of smaller animals this Archaic Indian chipped projectile points smaller and differently shaped. He ground out artfully shaped and finely

Finely polished stone plummets.

balanced stone weights and fashioned abraders to grind out stone mortars, pestles, and choppers for pulverizing nuts, roots, and seeds. He fashioned stone axes to cut wood, and from pieces of flint he made scrapers for cleaning skins. From the bones of small animals he made needles, fishhooks, and awls; from shells, ornaments and beads.

Many tools and ornaments of the Archaic Indian were found during archaeological excava-

Archaic Indian ax.

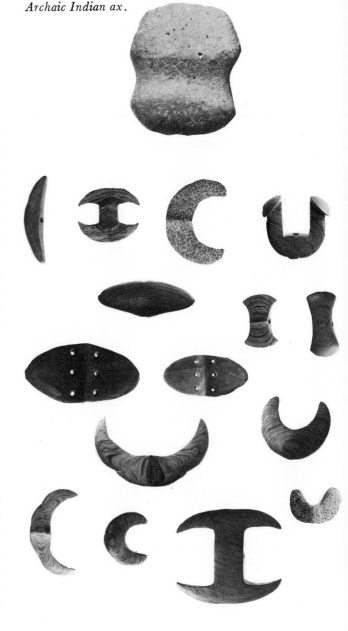

Weights for spear-throwing stick (atlatl) *(restored). Ferry site, Hardin County.*

Art, Crafts, and Architecture in Early Illinois

tion at a prehistoric Indian campsite under an overhanging bluff of the Mississippi River near Modoc, Illinois. The accumulated tools of succeeding prehistoric Indians indicate that this shelter was a favorite spot for at least seasonal occupancy from about 8000 to 2000 B.C. More recently, a series of Late Archaic sites found in the Wabash valley demonstrate the seasonal use given defined areas.

About 3,000 years ago, man in Illinois increased his use of the roots, berries, nuts, and fruits native to the area. He began to cultivate certain native plants along with those grown in other regions of North America. The change in economic pattern from hunting and gathering to a more sedentary existence marks the beginning of what is called the Woodland tradition.

New economic pursuits again required additional tools — hoes to cut the soil and baskets

Early Woodland Indian storage vessels.

made of reeds or rushes for storing the harvest. About 700 B.C. women began to fashion coils of clay reinforced with grit into storage vessels. These were air-dried and then baked in open fires. Using new-found skills, the women decorated some of the pots. Some groups made round-bottom vessels which were decorated with the pressed marks of bark-fiber cords and designs punched or incised with pieces of wood, bone, or shell; others fashioned flat-bottom pots impressed with fabrics woven from bast fibers or cedar rootlets.

Culminating about 500 B.C., the Woodland culture flourished throughout the entire eastern half of the United States. There developed during this age several great population centers, one of which — in Illinois — existed from about 500 B.C. to A.D. 300, contemporary with the Roman Empire across the sea.

Middle Woodland Indians lived mainly above the floodplains and on or near the adjacent bluffs of the Mississippi, Illinois, and lower Wabash rivers or their major tributaries. Here an extremely fertile soil provided an abundance of wood for fire and shelter. The area was rich in wildfowl, native game, and natural plant resources. The Middle Woodland houses, some as large as forty feet across, were oval or round. Built of posts tied together with sticks and covered with mud and bark, skins, or mats, these dwellings probably had thatch roofs.

Like the Americans of today who admire mahogany imported from South America, ivory from Africa, and silks from the Orient, these prehistoric Indians admired strange and exotic materials. They obtained large marine shells from the Atlantic and Gulf coasts, mica from North Carolina, copper from the Lake Superior region,

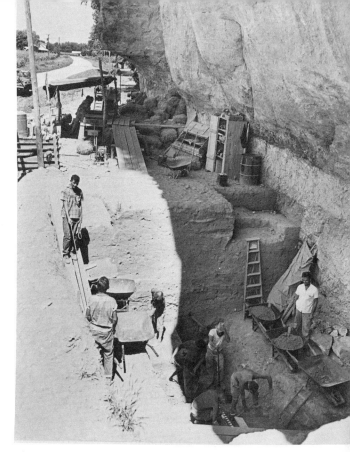

Final stages of the excavation at Modoc Rock Shelter, Randolph County.

grizzly bear teeth from the Rocky Mountains, obsidian from Wyoming, and meteoric iron from Kansas. With these prized materials — plus such native materials as clay, bark, river pearls, and shells — the Middle Woodland artisans fashioned ornaments, vessels, clothing, and ceremonial objects artistically unsurpassed in the area to that date. Highly trained and important artisans learned to work bits of iron into globular shapes for beads; they pounded copper into ceremonial adzes, axe blades, finger rings, bracelets, and earspools. They used flattened metal sheets for head-

Forming a pot with coils of clay.

*Earspool found in
Calhoun County.*

METHODS OF DECORATION
AND THE TOOLS EMPLOYED.

*Cord-wrapped paddle
impression.*

Cord impression.

*Necklaces made of
ground discs of shell.*

*Cord-wrapped
stick impression.*

*Inscribed line
made with an antler
or sharp stick.*

modern animal sculptures (see p. 53). Even more significant to modern cultural historians are the small clay figurines, which provide substantial evidence of the physical appearance of the prehistoric Indian, his hair styles, costumes, ornamentation, and some of his customs (see p. 53).

The Middle Woodland burials often contained

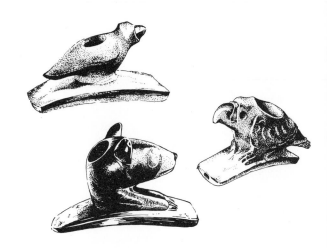

*Bear, cardinal, and hawk effigies
carved in stone for pipe bowls.*
ILLINOIS STATE MUSEUM

Probably the finest Middle Woodland products were stone or clay pipes. These were decorated with detailed effigies of creatures such as the raven, falcon, frog, beaver, bear, or fish. These simple pieces were so sensitively designed that they compare favorably with some of the finest

dresses and breastplates with repoussé designs. They patiently drilled holes into thousands of river pearls and into bits of shell for necklaces and ornaments for the garments of leaders and important individuals. They wove bast-fiber cloth and decorated it with red, orange, and black designs, or they applied resists to produce bold batik-like patterns.

At the height of the Woodland period both utilitarian and ceremonial pottery was made. Utilitarian wares (always functional) were usually undecorated or were simply cord-marked. Ceremonial grave vessels for important individuals, equally well made, were skillfully decorated with zones of punctations, incising, trailing, and various stamped designs.

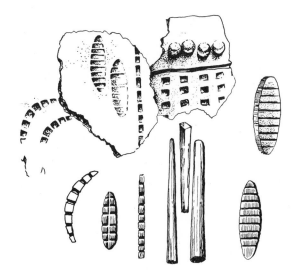

Designs made with stamps and punches.

grave goods. Apparently bodies which were provided with few or no grave goods had little status or rank. Artisans were buried with specialized tools. Individuals of high status were buried with various utilitarian objects and also with abundant ceremonial or status goods: pottery vessels, clay and stone pipes, freshwater mussel pearls, grizzly bear teeth, copper earspools, and sometimes even human attendants. Important individuals were buried in large log tombs constructed in pits or on the surface of the ground. Such

Art, Crafts, and Architecture in Early Illinois

Woman and child.

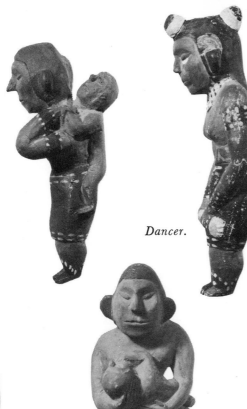

Dancer.

*Replicas of Middle Woodland
figurines found in the Knight Mound,
Calhoun County.*
ILLINOIS STATE MUSEUM, MADE AFTER
THE ORIGINALS IN THE MILWAUKEE PUBLIC MUSEUM

Seated woman.

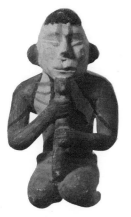

Warrior.

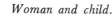
Woman and child.

Middle Woodland ceremonial pottery made in Illinois.
ILLINOIS STATE MUSEUM

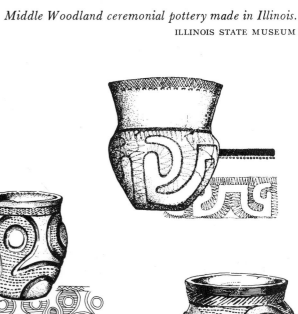

graves were often lined with bark or with reed mats, and their exteriors were protected with a similar material. The entire grave was covered with logs or large stone slabs, then topped with many basketloads of dirt. Individuals apparently of lower rank were often buried without status objects in shallow pits near and at the edges of such mounds.

For unknown reasons, the nature of the Middle Woodland culture had changed by A.D. 700. This may have been due to a climatic change that affected the growing of crops or may have been the result of an expansion into new frontiers. For whatever reason, the larger Middle Woodland settlements began to dwindle, and small villages appeared in areas formerly unused by the Middle Woodland people. During this period there was a decline in the production and acquisition of status goods. By A.D. 800 or 900 the culture had changed sufficiently to be considered a new phase, which anthropologists have named Late Woodland.

*One of a number of matched
ceremonial spearpoints found
in a cache in Tazewell County.*
ILLINOIS STATE MUSEUM

Coincidental with the Late Woodland period was a culture which entered the fertile Mississippi River area about thirty miles south of present-day Alton. By about A.D. 1000 the influences of this culture were spreading along the Illinois and Ohio rivers. A village of this Middle Mississippian culture might eventually cover several acres and typically be composed of many buildings, one or more flat-topped mounds, and at least one plaza area, with the entire village site protected by a wooden stockade.

The greatest center of population of this new culture was at Cahokia. By A.D. 1200 a great metropolis had developed with over eighty mounds and a population of thousands. Large flat-topped mounds served as foundations for ceremonial temples or for the dwellings of priests and other important individuals. Graded ramps pro-

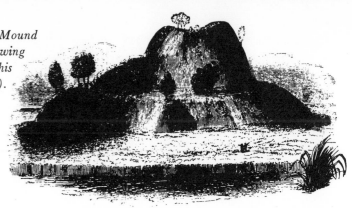

An engraving of Monk's Mound made from an 1834-35 drawing by G. W. Featherstonhaugh for his Excursion through the Slave States *(1844).*

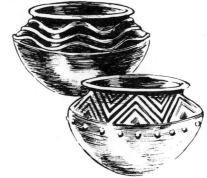

Polished pots with trailing and incised lines.

vided access from the broad plazas. Oval mounds marked the burials of important individuals. One of these mounds has been found to contain over 120 burials of some individuals apparently of high status and many others presumed to have been attendants, together with numerous sacrificial offerings. About the broad plazas at Cahokia

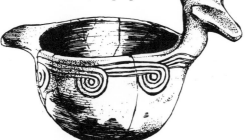

RECONSTRUCTED POTTERY FOUND AT CAHOKIA.
AFTER PHOTOGRAPHS IN GRIMM

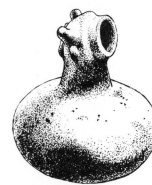

Water bottle.

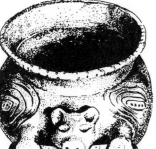

Mississippian effigy bowls found in Madison County.
ILLINOIS STATE MUSEUM

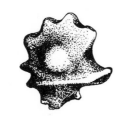

Fragment.

were dwellings of ordinary individuals built of wooden posts with roofs of thatch. At least one tall stockade surrounded some of the plazas, mounds, and dwellings. Within the village complex there were "woodhenges," large circles of widely and evenly spaced posts. By sighting over a center post and observing the position of the

Art, Crafts, and Architecture in Early Illinois

sun in relation to the posts in the circle, these prehistoric people had a solar calendar with which they could schedule their ceremonial rites.

Of all the mounds that still remain in Illinois, Monk's Mound at Cahokia is the most amazing. Its name refers to a group of Trappist monks who in the early 1800s farmed its first terrace while living on a mound to the west. It is the largest man-made earthwork in the western hemisphere. Flattened out halfway to the top as a broad terrace at one end, it rises at the other to a full height of over 100 feet. Covering an area of sixteen acres, it is more expansive than the largest pyramid of Egypt. Henry Marie Brackenridge, traveling in the area in 1811, claimed to have seen over 150 other mounds of various sizes within a ten-mile radius of the Cahokia village and a number of mounds across the river at the present site of St. Louis — then called Mound City. These mounds are a prodigious accomplishment, each

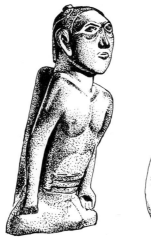
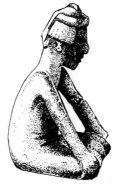

Human effigies of the Mississippian Indians.
ILLINOIS STATE MUSEUM

tive-painted geometric patterns. Some were covered with a red ocher wash, while others had effigies of animals, birds, or reptiles molded into them or incised on their surfaces.

Incised beanpot.

one of which represents hundreds of thousands of basketloads of earth carried by people over many years. Such large and organized concentrations of people required extensive means for their subsistence, and they evidently raised corn, beans, and squash, hunted small game with the bow and arrow, and obtained fish and shellfish in abundance. The Middle Mississippians fashioned water bottles, bean pots, and plates to hold and cook such foods. Some ceremonial vessels were embellished with broad-trailed, incised, or nega-

A swastika painted on a bottle. Found in Massac County.

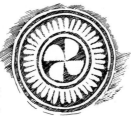

A cross within a circle for a shell pendant.

DESIGNS COMMON
TO FOREIGN CIVILIZATIONS.

An inscribed shell pendant with a spider design that somewhat resembles a scarab of ancient Egypt. Note the swastika. Found in St. Clair County.

Being fond of personal adornment, these people cut, carved, and engraved pendants, many of which were made from large conch shells from Florida. In a few areas small effigy pendants were made from fluorite — a beautifully colored mineral found in abundance in southernmost Illinois. Flat disc and oval beads made from shells, stones, and minerals were ground to the desired shape, polished, then drilled for necklaces, bracelets, armlets, or decorations on clothing.

Copper plate from a mound near Peoria.

Copper plate found in Union County.

Many Mississippian artifacts exhibit strikingly foreign characteristics. Especially those articles for ceremonial use have designs and symbols upon them which closely resemble those on pieces from pre-Columbian Mexico. There are pierced shell pendants and painted vases decorated with a cross within a circle, a weeping eye, or a swastika — designs common in Mexican cultures. There are ornaments resembling strange, long-nosed masks; others are incised with exotic dancing figures strikingly similar to those of prehistoric Yucatán and the central valley of Mexico. Although to-

Copper earspool found in Jackson County.

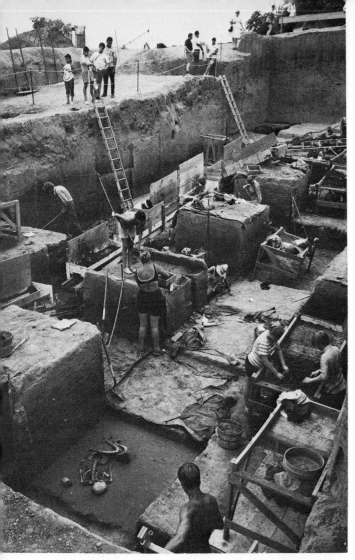

The Koster site in 1972 when the main excavation had reached a depth of thirty-four feet in some areas and fifteen prehistoric cultures had been exposed.

FOUNDATION FOR ILLINOIS ARCHEOLOGY

day's anthropologists admit to such similarities between many Mississippian motifs and those of the Mexican Indian, they have as yet been unable to prove any relationships.

From about A.D. 1000, the cultural influence of the Cahokia area spread northward, particularly up the Illinois River. One of the earliest settlements and burial areas was near present-day Lewistown, a short distance from the junction of the Spoon and Illinois rivers. The Dickson Mounds Museum on the site displays an actual excavation — the largest known prehistoric cemetery of well-preserved exposed burials and grave offerings. Over 200 skeletons are at present exposed in their burial positions in the cemetery area of this crescent mound.

Development of the Middle Mississippian settlements in Illinois was stimulated by influences from other areas besides Cahokia. By A.D. 1400 the inhabitants of the upper Illinois River valley had a culture basically Mississippian but mixed with characteristics of cultures to the north. At the same time, Mississippian settlements elsewhere in the state had greatly diminished or completely vanished. A few descendants of the prehistoric Indian may have been observed by the first European explorers in Illinois, but it is not known what happened to the rest of the population. It is

unlikely that examples of every art form produced by the various midwestern prehistoric cultures have been found or that they ever will be. Fabrics, quill work, wood carving, and embellishments of animal hair, feathers, and skin decompose except when they are kept constantly dry or constantly wet. What has been found, though, is of great interest to archaeologists, who constantly labor to keep ahead of plow and bulldozer in order to gain additional knowledge of the prehistoric past before it is lost forever.

New discoveries have a way of upsetting previous assumptions about prehistoric man. At the Koster site, located about five miles south of Eldred in Greene County, scientists and students under Dr. Stuart Struever of Northwestern University have recently uncovered the ruins of at least fifteen Indian communities, one over the other, dating to at least 6000 B.C. Evidence of dwellings dating to 4000 B.C. indicates that man lived in permanent settlements even before he tilled the soil. Further probes beneath the 10,000-year-old glacial sediment underlying the site may yield evidence of even earlier occupations.

On a ridge east of Galena.

Near Aurora.

In Rockford.

MYSTERIOUS EFFIGY MOUNDS AS SEEN BY EARLY SETTLERS IN NORTHERN ILLINOIS.

AFTER SNYDER

Art, Crafts, and Architecture in Early Illinois

2 Map Makers and Fort Builders

The geographical features of the Illinois country first became known to the world of the white man by means of symbolic lines drawn on paper. These lines, the earliest known maps of the region, were rough drawings made by French explorers. Although crude and inaccurate work sketches, they are priceless historical records of the first Europeans' gropings into the wilderness of the Illinois Indian. Charts had undoubtedly been made by explorers as early as the time of ancient Egypt, but it was the later Greeks who developed map making into the art and science of cartography. As their commerce expanded upon the high seas, the Greek traders ventured into unknown regions, charting and recording their courses as they went. They are credited with having devised for this purpose the oldest scientific instrument in the world, the astrolabe, with which time and latitude could be determined from the positions of the sun and stars. They also recorded the directions of wind and water currents, the depths of waters, the weather conditions, the appearance of lands and natives they discovered. Their charts and written logs guided them home and served as reports for sponsors of the expeditions.

Maps were especially valuable: by means of drawn symbols the sponsors could visualize the geographical features of newly discovered lands far more easily and quickly than by any amount of written or oral description. They were so precious that it became the custom for the explorer, or other men at his direction, to make copies. In the event the original map was lost, others would still be available.

As European exploration increased, the outlines of new continents, inland rivers, lakes, and streams, and the signs of new settlements were recorded. The crude work sketches of the explorers were sent to Europe, where they were copied by more expert cartographers; features of newly discovered regions were added to previous maps, producing new maps which illustrated the broadening world. Nearly all early maps were tediously produced by hand, first on papyrus rolls, then on vellum, and finally on paper. Some were beautifully embellished with ornate lettering, ships in full sail, decorative symbols, mythical or human figures. Such maps were ornamental works of art, the jealously guarded treasures of kings. Although the art of wood-block printing had been known in China before the second century, and the more elaborate art of line engraving on copper had been discovered about 1425, paper was scarce in Europe, and maps were not printed until almost 1500.

During the fifteenth and sixteenth centuries, the known eastern routes to the riches of the Far East were cut off by the Turks, with the result that the European explorer required new routes which would take him to the East by going westward. A new obstacle was discovered — the great land mass of America. The European explorer sailed its shores in search of a passageway; and, because maps were always made during such explorations, most of the eastern, western, and southern borders of the continent were charted by the end of the sixteenth century. First to travel inland were the Spaniards, who explored and mapped a vast arc from the Carolinas and Florida westward to California and southward into Mexico. Spain thereby became the only country to be successful in finding gold by going west.

In 1608 an enterprising group of Frenchmen chose Quebec for a settlement, a most fortunate site on the St. Lawrence River. From this point westward they could follow a system of waterways into the heart of the North American continent, then southward to the Gulf of Mexico. Explorations began with small groups of hopeful and courageous men boating westward through the Great Lakes to the tip of Lake Superior. Fortunately, the Indians in the area were friendly and informed the French explorers of a great in-

land river called the Mississippi. This exciting information caused a young geographer named Louis Jolliet to be appointed by Jean Talon, intendant of Canada, to explore the river in order to discover whether this might not be at last a westward route through the American continent.

Jolliet was probably the most expert map maker in New France in a day when the most skilled cartographers still lived and taught back in Europe. Born in 1645, Jolliet had studied in the College of the Jesuits at Quebec, where he probably learned the rudiments of map making before becoming a cleric and music teacher. Dissatisfied with his role in the church, he obtained a release from his vows in 1667. With the financial support of Bishop Laval he went to France that fall, where he purchased trade goods, pistols, beads, and hatchets, presumably to assist him in following his brother Adrian in a career as an explorer and voyageur in Canada. He may also have purchased a more modern type of astrolabe, fitted with new accessories such as a magnetic compass, devices for simple surveying, and lines and tables of use to the astronomer. As a friend of Bishop Laval, he may also have been allowed to visit the workshops of such eminent French cartographers as Pierre Duval or Nicolas Sanson to study briefly new techniques of instrumental observation and survey which could certainly have been of value to him as an explorer.

In Quebec, meanwhile, the fur trade was flourishing and trappers were venturing farther and farther inland after beaver and otter. Jolliet returned to Canada, where he joined his brother in the fast-growing fur trade. Traveling westward along the rivers and lakes, seeking pelts and making maps, he became an expert woodsman; consequently, at the age of twenty-eight, Jolliet — an educated man with a most fortunate combination of talents — was chosen to lead the expedition to find the great river described by the Indians.

In 1673 Jolliet's party, which included Father Jacques Marquette and five engagés, journeyed in two canoes via Lake Michigan to Green Bay, where they entered the Fox River and then portaged to the Wisconsin River, which flowed into the Mississippi. With only a few instruments, including the astrolabe, Jolliet began his charting of the river. The party's first encounter with human beings was their meeting with remnants of the Peoria tribe of the Iliniwek, or Illinois Confederation of Indians, living in what is now the state of Iowa. From these Indians — displaced by the savage Iroquois — Jolliet heard of the great creature painted on the rocky cliff downriver and of the waters and land farther to the south and east. The explorers went on to chart over a thousand miles of the Mississippi River. At the mouth of the Arkansas Jolliet learned from the local Indians that he was not far from the mouth of the Mississippi. Greatly disappointed to learn that the route he had hoped might lead to the Pacific and the Far East led instead to the already explored Gulf of Mexico, he turned back. Paddling upstream against the strong Mississippi current, the weary explorers eventually reached the Illinois River. They followed this shortcut through the land of the Iliniwek, northeastward to the Des Plaines, across the portage to the Chicago River, and on to Lake Michigan.

Marquette was ill, and in September of 1673, when the travelers finally reached St. Francis Xavier Mission on Green Bay, he remained for the winter to complete his journal and his crude map of the explored region. Jolliet proceeded onward to Sault Ste. Marie, where he stayed during the winter, making careful copies of his own maps and journal. In the spring, leaving the copies at the mission and taking the originals with him, he resumed his journey toward Quebec. On the rapids of the Ottawa River, which was the last leg of the journey, a tragic accident occurred: attempting to negotiate the seething waters, Jolliet overturned his canoe. His Indian boy companion was drowned, the fur pelts (with which he had planned to repay his debts), his maps, notes, sketches, and journals were all lost. Jolliet's nearly lifeless body was found on a rock by two fishermen.

Back in Quebec and badly in debt, Jolliet had a single consoling thought — that the copies of his lost maps and journals were safe at the Sault — but was denied even this comfort when he learned that after his departure a fire had completely destroyed the mission. Nothing at all had been saved. He could only try to reconstruct the maps from memory.

Jolliet suffered more discouragements in the several years to come, but he continued doggedly to make maps of his new voyages to Hudson Bay, Newfoundland, and Labrador. In 1696 the king of France awarded Jolliet both a commission as Royal Hydrographer, the King's Map Maker of Quebec, and a position as teacher of pilots and map makers in Canada. This also lasted but a short time; three years later Jolliet embarked with his family for his summer home and simply vanished, never again to be heard from.

For many years it was believed that all of Jolliet's maps of 1673-74 had been lost. Then, in the 1880s, a map signed "Louis Joliet" and bearing the date 1674 was discovered in Paris. Believed at first to be a map made by Jolliet from memory,

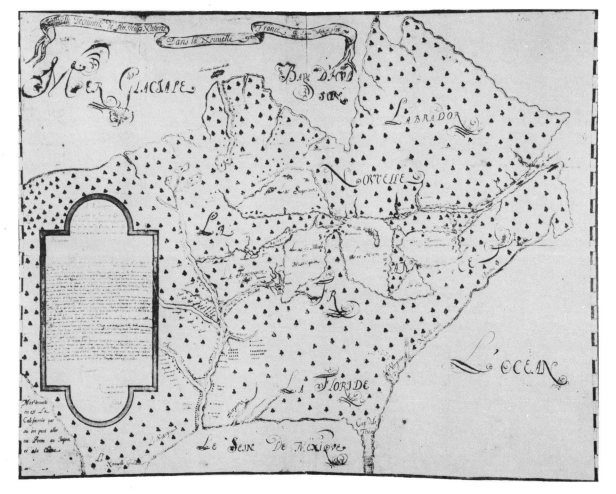

in Paris in the Bibliothèque du Service Hydrographique de la Marine by Wayne Temple.[1] This fortunate discovery is apparently an authentic map made by the explorer. In addition to carrying the proper name and date, it is the work of a more expert draftsman and cartographer.

The early explorers of America were usually followed by military men who made additional maps, laid claim to the explored region for their country, and built forts for its defense. Robert Cavelier, Sieur de La Salle, was such a man. He had already built Fort Frontenac on Lake Ontario (1673) and Fort Miami on Lake Michigan at Green Bay (1678) when he erected Fort Crèvecoeur in 1680. This fort, situated on a low hill between two ravines on the Illinois River near the present site of Peoria, was of relatively simple construction: a high double palisade of logs enclosing two cabins, a forge, a few tents, and a dwelling for the priests. The logs for the buildings undoubtedly were set upright in the ground in the characteristic style of the French, and a low, outside fortification of interlaced spiked timbers probably surrounded the fort. Since it was shortly destroyed by La Salle's own men, no test of its strength was ever made.

In 1682 La Salle and his faithful lieutenant, Henri de Tonti, explored and mapped the Mississippi River from its source to the Gulf, claiming the vast land drained by its tributaries for France and naming the area Louisiana. Then La Salle returned to build Fort St. Louis (1682-83), the second of his forts in the Illinois country. Erected on top of a 125-foot rocky eminence above the Illinois River near present-day Utica,

it was later declared by the scholar Jean Delanglez, S.J., to be a crude and inaccurate copy made by an anonymous person who knew far less about the features of Georgian Bay and the Great Lakes than the explorer. Furthermore, the penmanship on the map was superior to that of Jolliet, and the signature aroused suspicion because Jolliet always signed his manuscripts with two *l*'s.

The only remaining map made by a member

of the original expedition was apparently the work sketch of the unskilled map maker Father Marquette. This map shows little accuracy or drawing ability, but because of its references to the locations of contemporary Indian tribes, it remains of interest to both the historian and the anthropologist.

It was generally believed that the story of the maps had ended; but in 1955 a map dated 1674 and bearing the signature "Jolliet" was discovered

this fort was accessible only from a wide plateau behind and was protected on that side by a parapet covered with earth and crowned with wooden spikes. Although it remained the main seat of government for the Illinois country until 1690, little is known of its general construction. It is known that the fort was the center for a flourishing fur trade, and that a village of 3,000 Kaskaskia Indians was situated at the base of the cliff.

La Salle — though a loyal French subject eager to obtain new territory for his king — was not a popular leader. In 1687, on a mission to establish a colony at the mouth of the Mississippi, he was murdered by members of his own party. His map of the expedition has long since disappeared, but the expedition's engineer, a man named Minet, fortunately made a copy of it after

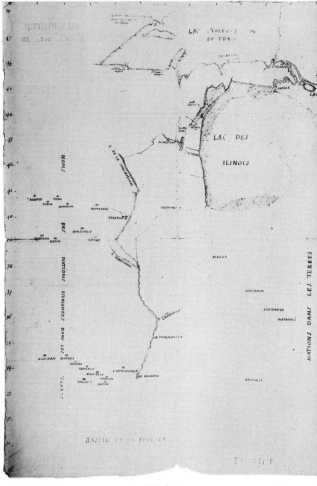

The Marquette map of 1673-74.

La Salle's murder. He added features from still another French map of the known areas of the Gulf and of Florida, thereby assuring the king of France a broad view of the extent of his new possessions on the North American continent. Later Frenchmen made additional maps containing the area which is now Illinois, basing them on La Salle's map and on letters written by La Salle and Henri de Tonti. By the early 1700s French maps which included the Illinois country were more abundant and were increasingly accurate and artistic.

It is believed that the first drawings of Illinois Indians were made about 1700 by Charles Bécard de Granville, a French official in Canada whose manuscript about the Indians and the natural wonders of Canada and northeastern America contained over seventy-nine illustrations. One of these — a tattooed, pipe-smoking Illinois Indian chief — was undoubtedly drawn from life. De Granville's manuscript was published in an edition of 110 copies in Paris in 1930 under the title *Les Raretés des Indes, Codex Canadiensis.*

For a recording of the arts and crafts of the early historic Indian in Illinois, artists and historians rely not on drawings, but on the writings of Frenchmen who observed the ways of the natives. Louis Hennepin, a Belgian Recollect friar who accompanied La Salle and who was also an explorer of the upper Mississippi River, described the lodges of the Kaskaskia village near Starved Rock as being "made like long arbors and covered with double mats of flat flags, so well sewed, that they are never penetrated by wind, snow, or rain." Each lodge, he said, was large enough to accommodate five or six families.[2] Hennepin wrote two books relating La Salle's

De Granville's Illinois Indian, from the original in the New York Public Library.

deeds and describing Louisiana. One was published in the late seventeenth century, the other in 1704, and both contained fanciful engravings of romantic landscapes with palm trees, exotic birds, and buffalo.

The so-called De Gannes Memoir,[3] believed to have been written by Sieur Deliette, Tonti's nephew, contains a vivid description of the Illi-

Art, Crafts, and Architecture in Early Illinois

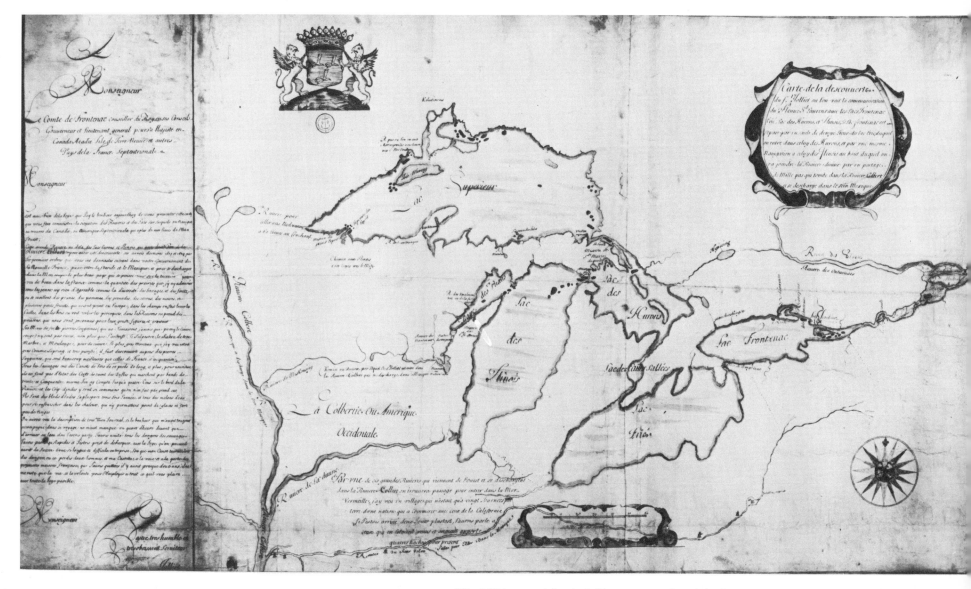

The 1674 map of Louis Jolliet, apparently original.

WAYNE TEMPLE AND THE BIBLIOTHÈQUE DU SERVICE HYDROGRAPHIQUE DE LA MARINE, PARIS

nois country. The writer described the quantities of turkeys, buzzards, swans, ducks, cranes, teals, and parakeets; he wrote of the abundance of deer and buffalo, of the grass, taller in places than a man, and of the virgin forests of walnut, ash,

Map Makers and Fort Builders

19

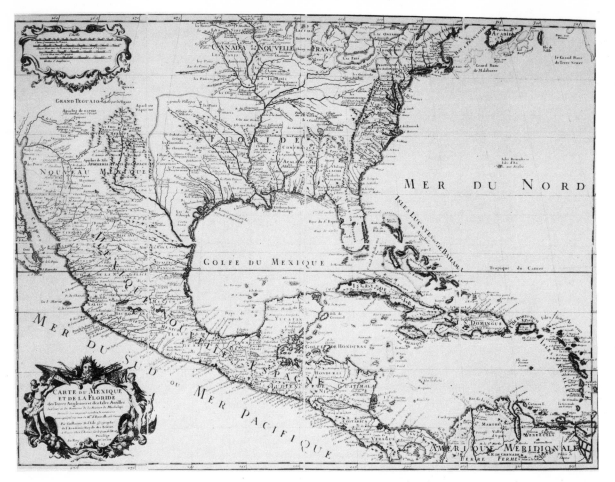

A memoir concerning the death of a chief related that a tree trunk, perhaps forty or fifty feet long, was peeled of its bark and decorated with shades of black and red paint. After pictures of the chief and of the prisoners he had taken were fastened to the stake, it was erected beside the tomb and various articles were placed inside to procure passage for the chief across the great river into the delights of the afterworld.[4]

Early Illinois history and knowledge of the Indian's arts were expanded with the writings, sketches, and maps of French explorers. Missionaries, military men, engineers, government agents, and artist travelers also recorded their experiences; map making continued, features being added to newer maps as more settlements were established and villages grew during the remainder of the French occupation.

During the English occupation, a highly detailed map of Illinois was produced by Thomas Hutchins, an American surveyor and engineer who had served in the British army at various frontier posts in the West. At the outbreak of the Revolution Hutchins was in England, and he resigned his commission rather than fight against his countrymen. There in 1778 he published two very fine maps of the Illinois region, one showing the area of the French and Indian settle-

whitewood, maple, and cottonwood. He gave a detailed account of the Indians, their customs and crafts.

The Indians wore clothing made entirely of animal skins, sometimes colorfully decorated with designs made with dyed porcupine quills. Buffalo hair was woven into garters and sacks for carrying fur pelts. At the beginning of summer, the Indian braves would go on a buffalo hunt, and women from each cabin would set out in pirogues for the marshes, where they cut reeds which were

made into mats and coverings for their shelters. The reeds were separated, laid out to dry, then woven together with bands of twine made from white wood at intervals of about six inches. On a framework of bent branches these mats were laid to overlap, creating an excellent waterproof, portable covering for a dwelling. Reeds were dyed red, yellow, or black and made into mats for holding good-luck charms. These charms, called manitous, were simply the skins of certain animals and birds.

Art, Crafts, and Architecture in Early Illinois

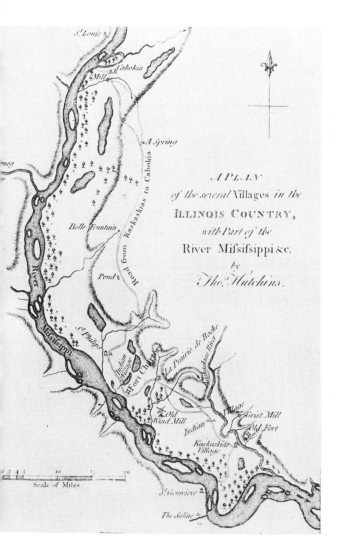

"*A Plan of the several Villages in the Illinois Country, with Part of the River Mississippi & c. by Thos. Hutchins,*" *1771. Made during the period of British occupation, this map shows the area below present-day St. Louis. It was published as an engraving in Hutchins's* Topographical Description of Virginia, Pennsylvania, Maryland and North Carolina, Comprehending the Rivers Ohio, Kenhawa, Sioto, Cherokee, Wabash, Illinois, Mississippi, & c. . . . *(London, 1778).*

UNIVERSITY OF CHICAGO LIBRARY

"*Map of the Country of the Illinois.*" *An engraving by P. A. Tardieu after a 1796 field sketch by General George H. V. Collot. Published in Collot's 1826 English edition of* A Journey in North America.

ILLINOIS HISTORICAL SURVEY

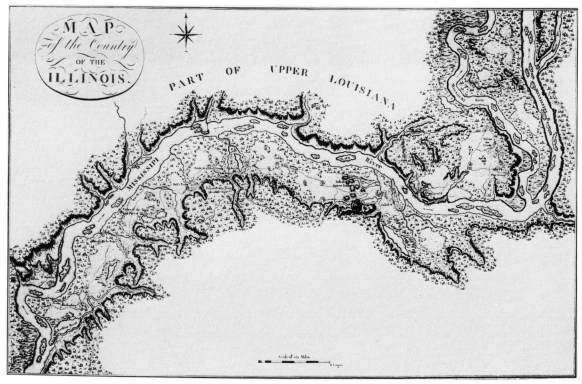

ments along the Mississippi River. In 1796, after the beginning of American occupation, an even more informative map was made by General George Henri Victor Collot, a French artist explorer and former soldier in the American Revolution. Collot was sent by the minister of France to obtain details of the political, commercial, and military state of the western part of

the continent, but his sketches were not published until 1826, after his death. A comparison of these maps with those of Marquette and Jolliet gives a striking indication of the many changes in the landscape of Illinois during the hundred-year interim. Also to be noted are the great advances that had been made in map making during that same period. Hutchins and Collot were capable of making comprehensive field maps and so enabled engravers to produce some of the most accurate, detailed, and beautiful maps of the Illinois country during this little-known period of Illinois history.

The purchase of the Louisiana Province from France by the United States in 1803 meant that army engineers and topographers would be sent to explore and map the far West. Meriwether Lewis, William Clark, and Colonel Zebulon Pike were among the first such American explorers. Since the headquarters of the Ninth Military Department was then located at Bellefontaine (now a part of Waterloo) in the Illinois country, it was to this point that explorers usually returned to write their reports and finish their maps. In 1816 Stephen H. Long, assigned by the U.S. Corps of Engineers to continue explorations and map making of the West, traveled by stagecoach, skiff, and keelboat to reach St. Louis. He moved up the Illinois River as far as Peoria Lake and later went to Chicago and Fort Wayne. On each of these trips he recorded the position and probable extent of islands, the width and windings of rivers, the proximity or remoteness of river bluffs, and whatever other information would be required for accurate written and pictorial reports of the explored regions.

The following year Long explored the upper Mississippi and 700 miles of the Arkansas River, proceeding to the Hot Springs of the Ouachita (Washita) River, then returning to Bellefontaine to spend the winter preparing his final maps and his memoirs. In later years Long explored the Rocky Mountains and the Hudson Bay area. He worked on improvements in transportation on the western rivers and the National Road leading from Baltimore, Maryland, to Vandalia, Illinois. He located forts, reactivated Fort Massac on the Ohio River, and in addition surveyed and superintended the building of ships, railroads, and U.S. hospitals. In 1860 Long was appointed head of the Topographic Bureau in Washington. He retired only a year later, having traveled 20,000 miles in his explorations. His maps and geographical descriptions of the country were published in two octavo volumes. When at last he settled down with his wife and three children, he chose for his home a site about thirty-five miles north of his old army headquarters at Bellefontaine — a place called Alton.[5]

The progression of Illinois maps from those crude and often inaccurate sketches of the early explorer to the highly detailed highway and topographic maps of today makes a fascinating study. Research into this development began in 1942 with the publication of a portfolio of old and rare maps which included the Illinois country.[6] These were the products of early French, English, and American map makers. The plates, which are reproduced from maps found in widely scattered libraries and archives in both North America and Europe, include work by Marquette, "Joliet," La Salle, Hutchins, Collot, Lewis and Clark, Pike, and Long. Intended originally to aid anthropologists in their study of historic Indian tribes, they have proved of great significance to the historian and the student of art history as well. Such works are invaluable aids to the reconstruction and interpretation of history; studied intimately, they reveal the gradual progress of skill and knowledge in the ancient art and science of map making.

3 The French Settlers

Historic events took place in 1699 on either side of a thousand-mile wilderness in North America. Near the eastern seaboard a town called Williamsburg became the capital of the English colony Virginia. At the same time, deep in the heart of the continent, a settlement was being established by the French at Cahokia in the Illinois country. Here, near a village of Tamaroa Indians, a mission was built by priests and friars from a seminary in Quebec, aided by two blacksmiths and twelve laborers from Montreal. Soon they were joined by fur traders and settlers. The two settlements — Williamsburg and Cahokia — exist to this day, the latter being the oldest permanent settlement on the Mississippi River.

The site chosen for the Cahokia mission lay near the northern end of the same Mississippi River bottomland where prehistoric Indians had lived for over 6,000 years. Here the most fertile soil of the entire Mississippi River valley — perhaps of all America — stretched for a distance of about ninety miles. Like the land along the Nile, it was ideal for growing fruits, vegetables, and especially grain. Nearby, luxuriant forests abounded with wild birds and fur-bearing animals; the river provided a variety of fish and waterfowl; and on the prairies the buffalo roamed. For French military strategists and fur traders the location could not have been better. It lay at a vital crossroads of the continent; a little to the north was the mouth of the Missouri, beckoning toward vast unexplored regions to the west; about thirty miles farther north lay the mouth of the Illinois, the shortest route northeastward into Lake Michigan and Canada. From Cahokia south to the junction of the Ohio the French had a waterway extending to present-day Pittsburgh; going down the Mississippi, they could reach the Gulf of Mexico. No white settlement yet existed on the lower Mississippi River; Old Biloxi (now Ocean Springs) was founded that same year by the French, but it lay east of the river's mouth, on the Gulf of Mexico.

By 1703 a second settlement, Kaskaskia, was established by missionaries in the Illinois country near the southern end of the bottomlands. The mission, built by the Jesuit Father Gabriel Marest, mainly served the Kaskaskia Indians who had formerly lived near La Salle's Fort St. Louis on the Illinois River and later on the western side of the Mississippi opposite the mission at Cahokia. Not long after it was built, settlers from Quebec arrived to join the fur traders and their families. The earliest homes were undoubtedly quite simple and roofed with thatch, but the one

23

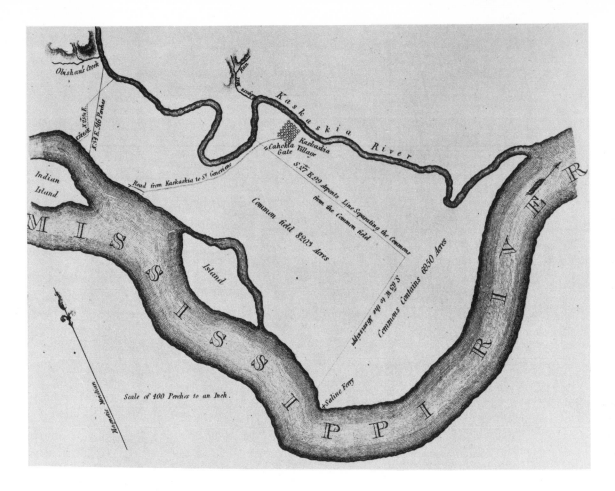

Fort de Chartres between the villages of Cahokia and Kaskaskia. Descriptions of this wooden fort differ; according to a contemporary Frenchman it was square and built of piles with two bastions or diamond-shaped projections at the corners providing points for protecting all four sides. Inside the palisade, the commandant's quarters, barracks, a blacksmith shop, and a storehouse were all built of hewn timbers and whipsawed plank. Compared to some French fort buildings in Michigan and Minnesota — little better than bark-covered huts — such wilderness quarters were luxurious.[2]

In the shadow of this fort (which was soon to be destroyed by floods) there grew a third settlement around a church dedicated to Saint Anne. This village existed only into English times, but a fourth settlement, the town of Prairie du Rocher (1722), survives today. Edmund Flagg, in a journal written in 1836-37, described the wild luxuriance of the region of Prairie du Rocher: "endless thickets" of wild plum, blackberry, and grapevine; a "boundless profusion" of ruby crab-apple, golden persimmon, black and white mulberry, wild cherry, papaw, peach, pear, and quince; an abundance of pecan, hickory, and black walnut. Under the beetling crags of the bluffs, a vast common field rustling with maize stretched toward the Mississippi, and at the river's edge grew great cottonwood and sycamore trees.[3]

St. Philippe was the fifth settlement to come

impressive structure at Kaskaskia in 1711 was the large church, described by a contemporary French soldier named Penicaut as having three chapels, a belfrey, and a bell.[1]

Because bloody wars had broken out between the Iliniwek and the hostile tribes that had invaded the area, the old travel route of the explorers, missionaries, and first settlers by way of the Chicago, Des Plaines, and Illinois rivers had been abandoned as too dangerous, and the Guardian Angel Mission, established at the site of

Chicago as early as 1696, had been closed by 1700. As a result of these troubles, the only remaining convenient entrance to the Illinois country was through the mouth of the Mississippi. Here new French settlements had started to grow: Natchez (Fort Rosalie) in 1716 and New Orleans in 1718, which France, the West Indies, and Canada used as the main post for their commerce with the French villages in the Illinois country.

In 1721 the French government completed

Art, Crafts, and Architecture in Early Illinois

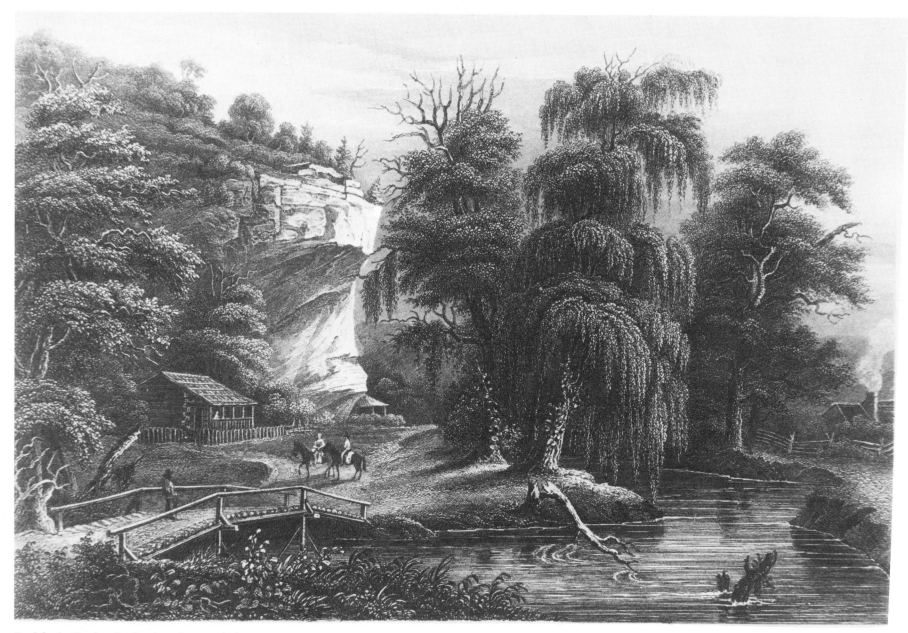

Prairie du Rocher in the American period.
An engraving published by Herman J. Meyer, New York, ca. 1843.

The French Settlers

into being at about this time. Situated not far from Fort de Chartres, the spot was picked for the housing of more than 200 miners, craftsmen, and laborers brought to Illinois by Phillipe Renault, who had been granted a lead-mining monopoly in the region.

By 1721 Kaskaskia was the largest village in the area, with eighty houses and four mills, and by the following year the population of the Illinois country was over 700. The early houses had typically French wall construction, much like the houses of old Normandy and Canada, which differed in structure and appearance from common log structures of later American pioneers in the region.[4] The French, instead of stacking logs horizontally as the Americans did, constructed walls of heavy upright logs often hewn on two or four sides, filling the spaces between with a mixture of clay and grass or clay and rubble. In some buildings cedar or mulberry posts were simply set with two or three feet of their ends buried in the ground (*poteaux en terre*). The ends of the logs rotted and disintegrated in time, so such constructions rarely lasted long.[5]

The arrival of more skilled artisans in the Illinois country meant new types of structures. Lime kilns were erected for reducing some of the abundant limestone from the local cliffs to lime for making mortar, thus making possible solid stone foundations, chimneys, and even walls. Hewn timbers, set upright and up to a foot apart on a solid stone foundation (*poteaux sur sole*), kept the wooden frame above the soil and thus created a more permanent type of construction. Such old French buildings still exist in both Illinois and Missouri.

The first stone house in Illinois was built by Phillipe Renault at St. Philippe about 1722.[6] Ac-

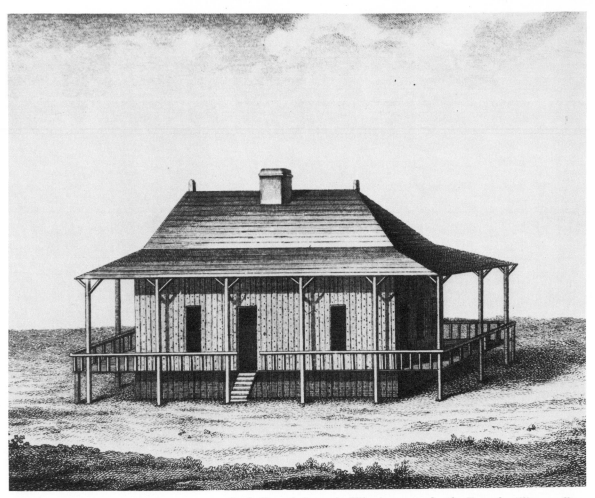

Early French home in Illinois as seen by the French military officer George Henri Victor Collot in 1796.
IN COLLOT

cording to contracts and bills of sale still existing from the 1730s, a number of stone structures were later built in Kaskaskia; by 1766 there were forty-three.[7]

A visitor to the French villages in Illinois would have found them haphazard in appearance. None of the narrow streets had been surveyed.

The houses lay clustered near the parish church, each with its fruit and vegetable garden and outbuildings and each surrounded by a high picket fence. With the exception of a single three-story stone structure at Kaskaskia and a two-story house nearby, the dwellings were one and a half stories high with up to four rooms. Dormer win-

Art, Crafts, and Architecture in Early Illinois

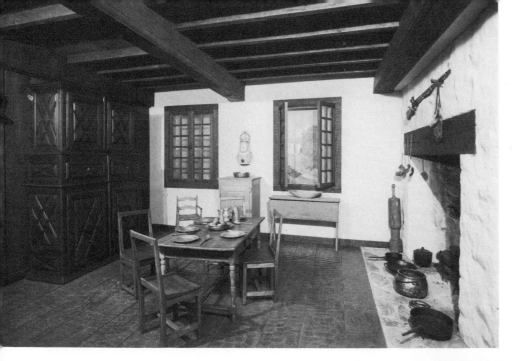

After Collot's death in 1805, an engraving of this sketch was made by Pierre Alexandre Tardieu and published in Collot's journal, *A Journey in North America* (Paris, 1826). This type of porch, which appeared in America only in the Mississippi valley, is said to have originated in the West Indies.[8]

The rooms of these dwellings were furnished simply yet comfortably. Although most of the

Typical rooms of a French house in Illinois as re-created by the Chicago Historical Society. The plastered walls and the furniture illustrate the desire to bring France to the frontier. Note the massive buffet à deux-corps, *the typically low table and chairs, the small chest, the water font, the bed steps, the* prie-dieu *(praying desk), the* crucifix, *the* coffre de mariage *(dowry chest) — all original pieces made in the New World during the eighteenth century. The bed is typical of the period 1673-1765.*

dows in the roof frequently provided light and air for upper rooms. The walls were plastered or whitewashed inside and out, and the ceilings were left with beams and attic flooring exposed. Roofs were of thatch, bark, or shingles. Better structures used imported glass and wooden shutters in their casement windows, and it appears that hardware and nails were used from early days. Perhaps the most outstanding characteristic of many French homes in the Mississippi valley was the porch or *galerie* extending across the front and back, along three sides, or sometimes around the entire house. Rooms were laid out end to end, their doors opening out upon these porches. An unusually elaborate style of roof framing allowed the steeply pitched hip or gable roof to flare out, forming pavilions over the *galeries*. A typical Illinois *poteaux en terre* house, topped by a hipped roof with pavilions on all sides, was sketched by George Henri Victor Collot in 1796.

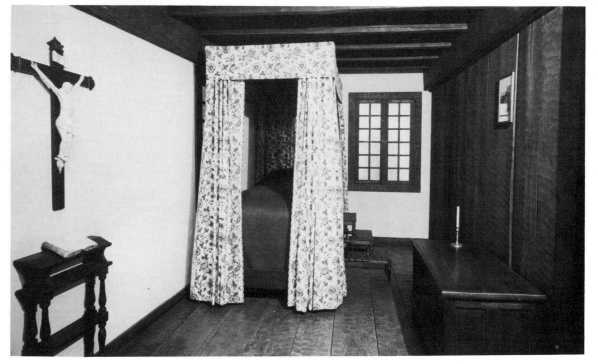

furniture and utensils were brought from Canada or imported from France, some of the heavier articles were made from the native woods of Illinois. Inventories were carefully made upon the death of each inhabitant, listing such possessions as beds, featherbeds and pillows, linen or calico curtains, counterpanes, and wool or buffalo-hide blankets. Large cupboards or armoires held clothing or linen tablecloths and napkins. Tables — one at Kaskaskia was large enough to seat twelve persons — were laid with pewter or brightly colored French crockery and earthenware plates, pewter or iron forks and spoons, and infrequently with goblets of crystal, silver, or gold. When not in use, fine dishes were displayed on shelves over the chests. Cooking utensils, lanterns, and oil lamps were copper or iron. There were glass wine bottles, candlesticks, snuffboxes, scissors, spectacles, and even dice boxes, among other items.

Pioneers in America needed salt for food and lead for ammunition; the French at Kaskaskia obtained both on the west side of the Mississippi River. Perhaps as early as 1723 Frenchmen from Illinois found it convenient to stay close to the saline springs and lead mines across the Mississippi and so settled what is now the town of Ste. Genevieve.

The Illinois villagers were engaged in supplying grain to the French of Lower Louisiana and trading for furs with the Indians, while the English, covetous of the western fur trade, were moving progressively westward into the valley of the Ohio. Open hostilities broke out between the French and English in the East. France built two forts in the Illinois country: Fort Massac along the Ohio River (1757) and Fort de Chartres (1752-56), a stone structure replacing the wooden one damaged earlier by floods.

The new Fort de Chartres was one of the finest and most expensive ever built on the continent of North America. Erected according to the plan

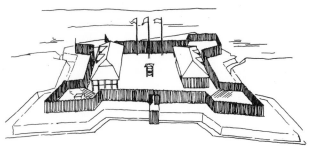

Archaeologist's conception of Fort Massac in 1757.
ILLINOIS DEPARTMENT OF CONSERVATION

The reconstructed main gate of Fort de Chartres.
PHOTOGRAPH BY THE ILLINOIS
DEPARTMENT OF CONSERVATION

of French army engineer François Saucier and costing over a million dollars, this construction was of limestone cut, squared, and numbered at the nearby river bluffs. Its walls were 18 feet high, more than 2 feet thick, and nearly 2,000 feet long, enclosing an area of about four acres. The fort was shaped like a polygon with four bastions at the corners, each with forty-eight loopholes for muskets, two portholes for cannons, embrasures, and a sentry box. An arched main gateway fronted on the prairie to the north, and it is believed that another faced the river. Inside, a raised platform ran beneath the loopholes.

Art, Crafts, and Architecture in Early Illinois

Within the walls stood a storehouse 90 feet long, 30 feet wide, and two stories high, as well as a guardhouse with two rooms above for a chapel and missionary quarters, the commandant's quarters (84 by 32 feet) with iron gates and a stone porch, a coachhouse, a round dovecote, and a bakehouse. There were two long rows of barracks, each 128 feet long, and a large building containing prison cells with iron doors and barred windows. A powder magazine with an arched roof was 35 by 38 feet and 13 feet tall. A large well, walled with expertly dressed rock, completed the community of functional constructions.

Neither this fine stronghold nor the well-built structures in the five villages could have been constructed without the services of expert artisans: stonemasons, carpenters, roofers, sawyers, and joiners. Nor would there have been such hardware as locks, keys, and hinges, which required the services of blacksmiths and locksmiths. The presence of all such artisans, as well as gun-

The original powder magazine at Fort de Chartres.
PHOTOGRAPH BY THE ILLINOIS DEPARTMENT OF CONSERVATION

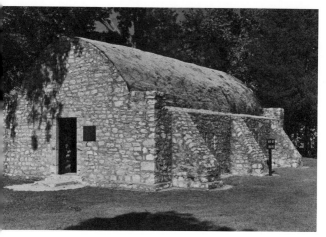

smiths, turners, and toolmakers, is documented in carefully kept government records. The names and occupations of the inhabitants, their landholdings, and even their household articles were matters of concern to the French government. Many of these records are still to be found in archives in this country and in Canada.

About 1915 some 3,000 French manuscripts — kept at Kaskaskia until a devastating flood wiped out the old town — were discovered on top of an old bookcase in the courthouse at Chester. These were private, public, and commercial papers involving the lives of the inhabitants from 1719 to 1780.[9] In 1939 Natalia Belting of the University of Illinois made microfilms of most of the manuscripts in the collection and wrote *Kaskaskia under the French Regime,* which explores an almost forgotten century of Illinois history. Before 1915 the lives of the inhabitants

"Festivities of the Early French in Illinois."
A wood engraving by Lockwood Sanford
after a sketch by Sophia Gengembre.
IN HOWE

had been described only by historians of the early 1800s who arrived in Illinois after British and early American occupations had reduced the French population in size and wealth.

A rare engraving shows the Kaskaskia population as consisting entirely of clergy, simple happy peasants, and a few slaves. The golden age of the French frontier had long been over when Governor Thomas Ford wrote in 1854: "No genuine Frenchman, in those days, ever wore a hat, cap, or coat. The heads of both men and women were covered with Madras cotton handkerchiefs, which were tied around, in the fashion of nightcaps. For an upper covering of the body the men wore a blanket garment, called a 'capot' (pronounced

cappo) with a cap to it at the back of the neck, to be drawn over the head for a protection in cold weather, or in warm weather to be thrown back upon the shoulders in the fashion of a cape."[10] Such descriptions may have suited the everyday appearance of the inhabitants of the smaller villages, but inventories of clothing at both Kaskaskia and Fort de Chartres indicate that many Illinois citizens of the mid-1700s could have appeared quite in style in the streets of middle-class Paris. Because the king discouraged industries in his colonies that competed with those of the homeland, materials for clothing, as well as most household accessories, were imported from France. The settlers were highly dependent people with no spinning wheels, looms, or crude home-woven materials among their possessions. Merchants imported material which was in turn cut and made into clothing by the local tailor, housewife, or slave, or made to order in New Orleans. Eighteenth-century inventories of the

more affluent citizens of Kaskaskia list taffeta and silk dresses; dress coats trimmed with wide gold ribbon, silver or gold lace, and silver buttons; beaver or gold-embroidered hats trimmed with feathers; fine muslin or linen shirts and chemises; and slippers with gold buckles. Infants wore caps of gauze. Wigs made by a local wigmaker completed the fine apparel.

The ordinary inhabitant, on the other hand, was outfitted like the country folk in Canada or Normandy. Various researchers have provided a general description of their appearance based on knowledge of peasant costumes of France and the colonies. Fringed leather shirts were apparently worn by voyageurs and trappers in the woods, while male residents of the villages were, as mentioned by Governor Ford, distinguished by the *capot* — a knee-length hooded jacket caught about the waist by a sash of red or checkered woolen material. Under this jacket the villager wore a shirt of cotton or wool and knee-length

breeches, often with a sash. Long wool stockings were held up by garters. Like the peasants of France, the inhabitants of both Canada and Illinois probably wore carved wooden slippers for protection in damp weather, but more common were the homemade *bottes sauvages* (shoes of the savages) made of tanned hides with a soft sole and a top reaching to the knee. The typically Canadian *tuque* (a close-fitting knitted stocking cap) was decorated with a tassel or a ribbon that encircled the *tuque* and hung down on one side. The color of the *tuque* varied according to the region: in Quebec it was red; in the Three Rivers district, white; and at Montreal and Fort de Chartres, blue. In place of a *tuque*, a kerchief might be wound about the head.

The women wore sleeveless blue or scarlet bodices over a short- or long-sleeved plain or flowered blouse. Ankle-length gathered skirts of scarlet dimity, drugget, or printed calico might be tucked up out of the way while in the fields,

Art, Crafts, and Architecture in Early Illinois

revealing a red-and-white striped cotton or flowered calico petticoat. In Illinois the typical overskirt might have been occasionally replaced by a shorter, Indian-style skirt. The women went barefoot or wore either leather moccasins or wooden shoes. Tall, broad-brimmed hats of braided straw were worn by both men and women in the fields; kerchiefs of many colors made of cotton, muslin, or even silk were commonly worn around the head or neck; starched white bonnets were worn to church or to festivities. Jewelry was rare, except for silver wedding rings and crosses.

The citizens enjoyed numerous festivals, dancing, singing, and playing cards. Nearly every home had a violin: "The old fiddle, fashioned by the dextrous hand of the *grand-père*, out of a length of *plaine* (hard maple) free of knots and a plank of fir, in the course of long winter nights spent at the corner of the fireplace, often revealed itself a choice instrument under the deft touch of the village fiddler. . . . The fiddlestick was formed very simply of a lock of horse-hair from *la Grise* (the gray mare), drawn taut on a bow of supple wood. . . ."[11]

It appears, then, that the Illinois French of the mid-1700s lived in a carefree manner compared to the American pioneers who followed them. The French had suffered initial hardships, but commerce in grain and furs had brought them a prosperity that enabled them to make their homes and surroundings adequate and very comfortable. They built cowsheds, barns, stables, dovecotes, windmills, and horse mills. Cattle, horses, pigs, and sheep grazed in the fields. Fur trade with the Indians spread, however, and Frenchmen began to meet Englishmen in the vast territory between their settlements. A

period of open hostility ended in 1763 with the defeat of the French, and that year the Treaty of Paris declared the territory east of the Mississippi (with the exception of New Orleans, which had been ceded to Spain) to be a possession of England. Indian uprisings and a reluctance to live under the British flag caused many of the wealthier Illinois inhabitants to move with their possessions into Spanish territory, settling in the new village of St. Louis (1764), in Ste. Genevieve, Prairie à Catalan (Carondelet), and New Orleans.

Meanwhile the Jesuits, having fallen into disfavor, were banished from the Illinois country. The property of the mission at Kaskaskia was sold at public auction in November 1763. This included a house covered with boards and divided into different rooms and apartments, a garret, and a cellar; and another apartment building of posts covered with boards. There were also Negro cabins, cowsheds, a barn, a stable, a horse mill, and a dovecote.

A view of Kaskaskia as it appeared sometime after 1772.
IN SCHLARMAN

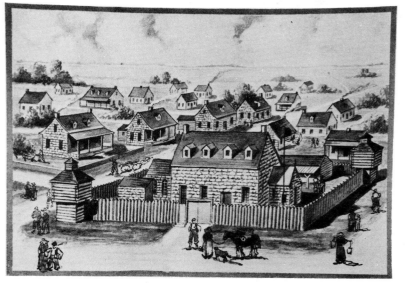

Not until 1765 did the British actually take possession of the Illinois country at Fort de Chartres. The once-impressive fort was already falling into ruin from neglect and a succession of destructive floods. In 1772 it was finally destroyed, and the garrison moved to Kaskaskia. There the British took over the large stone house of the former Jesuits, added stockades fifteen feet high with blockhouses at the corners, and named the remodeled structure Fort Gage. In 1778, after thirteen years of British occupation, the region became Illinois County of the Commonwealth of Virginia when George Rogers Clark and his American soldiers captured Kaskaskia. Without any authorized civil government, order gradually declined. As confusion mounted, the French towns dwindled further.

By the early 1800s most of the remaining French inhabitants were living in reduced circumstances, although they retained their pride. Governor Ford wrote: "Notwithstanding this people had been so long separated by an im-

mense wilderness from civilized society, they still retained all the suavity and politeness of their race. And it is a remarkable fact, that the roughest hunter and boatman amongst them could at any time appear in a ballroom or other polite and gay assembly, with the carriage and behavior of a well-bred gentleman."[12]

Today the old French towns of the Illinois country have vanished or have been so altered by modern civilization that it is difficult to see in them what they must once have been. Surprisingly little remains of this romantic and little-known period in Illinois. Excavations made at Fort Massac in 1940 uncovered building foundations and a few relics. There is a little more evidence of French settlement along the sixty-mile stretch of bottomland and its neighboring bluffs south of East St. Louis: the towns of Cahokia and Prairie du Rocher, the remains of Fort de Chartres, and a few scattered French structures.

Today Cahokia is a modern city of 16,000 containing two carefully restored French structures of the 1700s. The first St. Clair County courthouse, once a private French home, and the old French Church of the Holy Family are constructed of hewn logs set vertically in the French manner. The four-room courthouse, built with a surrounding *galerie*, has had an eventful history. Although the exact date of its erection is not known, scholars agree that it was once the home of Jean Roy *dit* Lapancé, who came from Canada sometime before 1752. Later the house was acquired by a Cahokian, François Saucier (not the builder of Fort de Chartres), who married into the Lapancé family. In 1793 the building was purchased for use as a courthouse and prison for the large area of St. Clair County in the

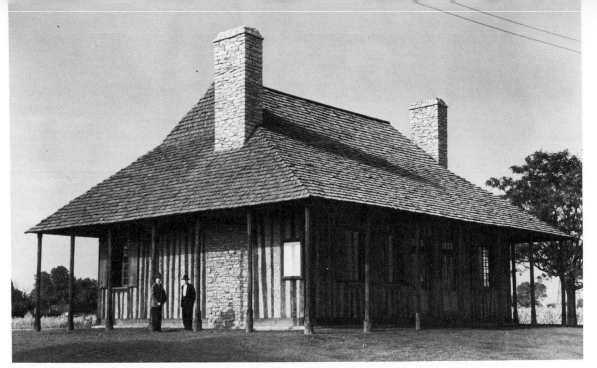

The Cahokia courthouse, a state memorial, was once a French home built around 1752.
PHOTOGRAPH BY THE ILLINOIS DEPARTMENT OF CONSERVATION

Northwest Territory. It served in that capacity, surrounded by a stockade of 600 mulberry pickets 7½ feet long, until the county seat was moved to Belleville in 1814. The building was then used for various purposes. For a time it was even a saloon. In 1904 it was dismantled and moved to St. Louis for the Louisiana Purchase Exposition as a quaint relic of old French days, and after the exposition one-fourth of the original structure was set up in Jackson Park in Chicago. Many years later the state of Illinois purchased the remaining section for restoration of the building on its original site at Cahokia. Preparations were thorough: old photographs and documents were consulted, and an archaeologist was hired. During the scientific excavation not only the original foundation was located, but also many bits of ironwork and relics that helped in reconstruct-

ing the story of the culture of the period. Preliminary groundwork was completed; the building was carefully rebuilt using what remained of the old structure, and faithful reproductions were made of the old ironwork found in the excavation. The building stands now as the oldest courthouse west of the Appalachian Mountains and is a fine example of the remarkable building methods of the French in the eighteenth-century Illinois wilderness.

The Church of the Holy Family at Cahokia, dedicated in 1799 and probably the oldest remaining church building west of the Alleghenies, is in general character quite similar to the old churches of Normandy and Canada (see p. 36). Built of massive vertical hewn timbers of walnut cut from the village commons, mounted on a stone foundation, and filled between the timbers

Art, Crafts, and Architecture in Early Illinois

with lime and rubble, it includes parts of other old buildings ruined by the English and American troops during their occupations. Local carpenters, a joiner, and a master blacksmith pooled their talents in its original construction. The walls, made to slant inward, were braced at the corners to support the hewn oak trusses and cross-ties of the roof construction. The floors were of split logs called puncheons. The simple exterior was finished with side windows protected by shutters, roof shingles hung with pegs, a wide round-headed door, a round window in the gable, and a steeple with a belfry. Thirty-four years after its dedication small side wings and weatherboarding were added to the church — one for a sacristy and one for an organ and choir — and in 1840 a lean-to was added to the rear. By 1949 additional restorations and removal of the weatherboarding had exposed the fine basic construction once again. During the occasional services since then, the parishioners have sat in the simple rustic interior under great beams hung with the flags of the four nations which have claimed the Illinois country — Spain, France, England, and the United States (see p. 36). On April 25, 1971, the church was dedicated as a National Historic Landmark.

Prairie du Rocher, continuously occupied since 1722, lies south of Cahokia, along the old French

The Creole House
in Prairie du Rocher, built ca. 1800.

bottomlands near the base of the river bluff. Here a few descendants of the French still live, celebrating some of the festivals of bygone days. The Creole House on the main street, built sometime after 1755, was added to the National Register of Historic Places in 1973. Although its hewn log exterior is now covered with modern weatherboarding, and various occupants have made additions and alterations, this house is still recognizably French.

A short distance west of the old French town are the remains and restored portions of the stone Fort de Chartres, once proclaimed by a British officer to be the finest fortress on the North

The Sweet Tavern in Kaskaskia as it looked about 1800.

American continent. Built to accommodate 400 men, this masterpiece of stone was unfortunately situated on a spot where it was undermined by the floodwaters of the Mississippi River. During the period of occupation by the French and later by the English, all buildings except the powder

magazine were destroyed. After the site of the fort was acquired by the state of Illinois in 1915, the remaining foundations of buildings were capped or else rebuilt, the great stone gateway and the combined chapel and guardhouse were restored, and two new buildings were erected on old foundations to serve as a museum and custodian's quarters. It is said that the three chalices, the monstrance, and the tabernacle of inlaid wood in the Church of St. Joseph

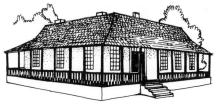

Vanished house
of General John Edgar in Kaskaskia.

in Prairie du Rocher are relics of the Church of Ste. Anne of Fort de Chartres.[13]

Perhaps Ste. Genevieve, Missouri, best retains the charming atmosphere of the old French Mississippi towns. Here one can spend a delightful day walking through the cemetery and along old streets, visiting the shops and such fine old French houses as Bolduc House, which was built between 1785 and 1790 and is very similar in construction to the old Cahokia courthouse.

Kaskaskia, the most important of the French settlements in the Illinois country, has vanished. Although it became the first capital of the state of Illinois (1818), it was — like Fort de Chartres and the towns of Ste. Anne and St. Philippe — doomed to extinction. The floods of the 1800s gradually washed away some of its buildings, forcing the inhabitants to move to higher ground. Then, in 1881 a raging Mississippi River broke

through the strip of land which separated it from the lower Kaskaskia River. The new stream flowed directly over the town, and from that time Kaskaskia has lain at the bottom of the Mississippi River. For some time afterward those rowing over the area could look down into the waters and see remnants of old stone chimneys and foundations — all that remained of the main town.

The old Kaskaskia commons now lie south of the town of Ste. Genevieve on what is known as Kaskaskia Island — the only area of Illinois that lies west of the Mississippi. Here, in a later village also called Kaskaskia, is the Church of the Immaculate Conception, which contains a beautiful walnut altar carved in 1737 for the church of the original village. Nearby, a memorial building erected by the state of Illinois holds a great bronze bell cast at La Rochelle, France, in 1741, the gift of Louis XV to his subjects in the Illinois country. It is known as the "Liberty Bell of the West" because it was rung in triumph in 1778 when George Rogers Clark delivered the French from British domination.

One house of considerable distinction escaped the devastation of old Kaskaskia. Built high on the side of the bluff on the east side of the Kaskaskia River, this house — a mansion in its day — was constructed in 1802 for Pierre Menard (see p. 35). A Canadian, Menard had grown wealthy trading fur in Vincennes and had this home built to resemble French plantation houses near New Orleans. The main living quarters were located above a brick ground story used for servants' quarters and storerooms. A flight

Original fireplace in the home of Pierre Menard.
PHOTOGRAPH BY
RICHARD PHILLIPS

of steps led up to the *galerie,* which extended the length of the second floor. The separate kitchen at the rear was connected to the house by a flagstone-floored open porch. Behind the main buildings stood various structures for the field hands.

This unusual old house was once famous throughout the Midwest for its parties and lavish furnishings. Menard was highly respected by the French, the Indians, and the Americans alike. He served as a commander of the militia; he was a judge and presiding officer of Illinois Territory; and in 1818 he became the first lieutenant governor of the new state of Illinois.

On the slopes of Garrison Hill behind Menard's home are the grass-covered foundations of Fort Kaskaskia. Built by the French during the French and Indian War, the fort stood until 1766, when it was destroyed by the townspeople to prevent its falling into the hands of the British. Nearby is a cemetery where the graves of many of the old Kaskaskia citizens have been transferred to take them out of the reach of the river floods, and the state has erected a monument in the cemetery dedicated to the French settlers.

At the crest of the hill is a shelter and a vantage point from which one can see the river flowing over the site of old Kaskaskia. Two plaques indicate that on this spot once stood a busy and prosperous town of fun-loving, lighthearted people, a town which was for 120 years the most important in all Illinois.

Art, Crafts, and Architecture in Early Illinois

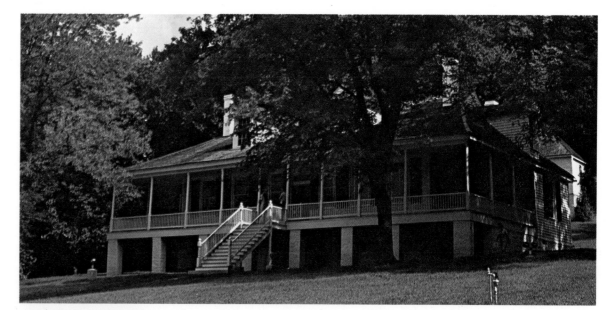

The Kaskaskia plantation-style home of Pierre Menard, built in 1802, is one of the finest remnants of French Colonial architecture on the Mississippi River. Today it is a state memorial. The restored kitchen is pictured below.

PHOTOGRAPHS BY RICHARD PHILLIPS

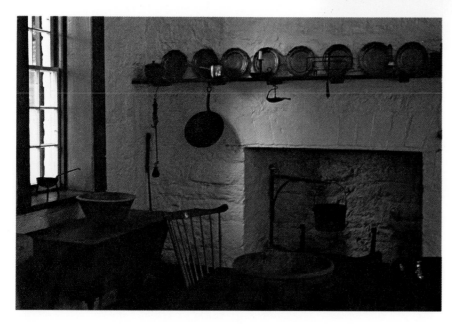

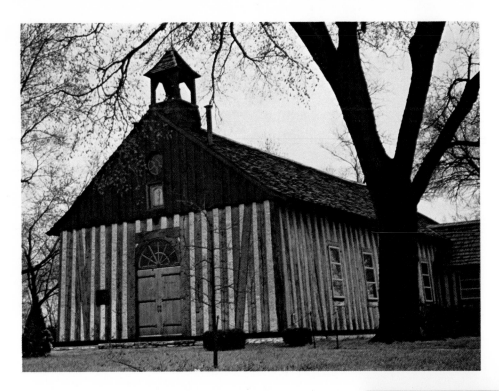

The Church of the Holy Family in Cahokia, built in 1799.
Note the slanting side walls
and the typically French poteau sur sole construction.
The wing is a later addition.
A view of the church interior (right) shows the elaborate
roof construction and the flags of the four nations
which have claimed the Illinois country (see pp. 32-33).
In 1971 the building was dedicated as a national monument.
PHOTOGRAPHS BY RICHARD PHILLIPS

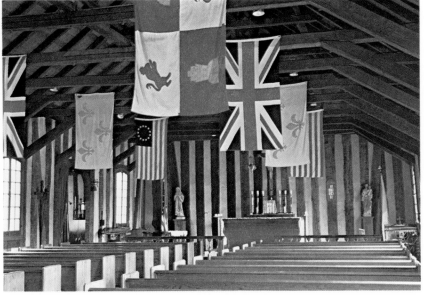

Art, Crafts, and Architecture in Early Illinois

4 Pioneer Hunters and Spinners

Both the Indian and French cultures in the Illinois country were launched by pioneers — men who for various reasons had left more familiar surroundings to settle in a wilderness. The culture next to develop in the area — the American — was also launched by pioneers.

Historians often divide the American pioneers into three general types according to the order of their arrival on a frontier. The first type was the migratory hunter and woodsman, a rough, tough, proudly independent "squatter" who would build for his family a crude cabin, clear a little land for the necessary crops, and spend most of his time hunting and fishing, only to move — when civilization finally caught up with him and food animals became scarce — to a farther wilderness. The second type of pioneer was primarily the poor but diligent farmer who might also be a lawyer, minister, or simple craftsman; he sought a land of opportunity without class distinctions — a land where soil was good, where his services might be needed, and where he might settle down to raise his family and eventually prosper. The third type, and the most affluent of the pioneers, was the enterprising fortune seeker who bought and sold land, laid out towns and roads, established churches and schools, and otherwise encouraged development by increasing the efficiency of industry and commerce.

Such a classification by order of arrival must not be taken too literally, since hunters were in fact apt to settle down and become farmers, or farmers might become town builders. In some instances all three types of pioneers might have lived in relative proximity. Nevertheless, each played a distinct role in transforming the western wilderness into a civilized land, and each was admirably suited for his particular role by both background and temperament.

The hunter was apt to have had ancestors who had been weavers and spinners in Scotland or Ireland. Emigrating to America to escape British oppression, these pioneers had little in common with the English colonists in the towns of the East. With little aptitude for farming, most of them, seeking the freedom of the frontier, became hunters. Some settled in Maryland, but the majority found William Penn's colony of Pennsylvania to be the most hospitable for foreigners. It was there, on the eastern plateau of the Appalachian Mountains near the settlements of Germans from the Palatinate, that the majority of the Scotch-Irish first settled.

From their Pennsylvania German neighbors these Scotch-Irish obtained two valuable aids for

life in the wilderness: the Pennsylvania rifle —
later called the Kentucky rifle — developed by
the Germans to fill their need for a more accu-
rate hunting weapon; and the know-how to build
log cabins. Since the only material this structure
required was the wood of the forest, and since
it could be built by ordinary woodsmen with a
bare minimum of simple tools, the log cabin was
an ideal dwelling for life in a forest wilderness.
This type of shelter had not been built in the
early English colonies nor in the colonies of
the French. It first appeared in America in the
Swedish colony of Delaware and was later
adopted by the Germans on the frontier of
Pennsylvania.

For a long time the Appalachians were a bar-
rier to further expansion into the Midwest, and
only a few of the hardier hunters and fur traders
had struggled into western Pennsylvania and
Ohio by 1769. By this time almost one-sixth of
the American population was Scotch-Irish. Along
with a few Pennsylvania Germans, many were
moving southward into Virginia, North Carolina,
and eastern Tennessee, where they settled with
migrating Virginians in groups around forts for
protection against the Indians.

In 1775 Daniel Boone blazed a trail through
the great mountain barrier at Cumberland Gap
into the area that is now western Tennessee and
Kentucky. Three years later, during the War of
Independence, 350 freedom-loving backwoods-
men from Virginia and Kentucky, under the
leadership of George Rogers Clark, wrested Kas-
kaskia in the Illinois country from the British.
With the capture of Vincennes the following year,
the Northwest Territory was finally opened for
American settlement, and the westward trek of
thousands of American pioneers began. By horse-

*Routes to the West
about 1800.*

back, cart, and wagon they trudged over the
mountains at Cumberland Gap into Kentucky.
Soon another trail was opened in Pennsylvania,
providing a water route down the Ohio River
for pioneers to travel by keelboat, flatboat, or
ark to Ohio, Kentucky, and Indiana. Some of
Clark's soldiers, remembering the wonderfully
fertile bottomlands they had seen along the
Mississippi River in Illinois, made plans to return
there with their families and friends.

Toward the end of the Revolution, many
American families settled in Kaskaskia, some of
them undoubtedly occupying the abandoned
homes of the French. Before 1778 other settlers
had received bounties of land from the govern-
ment. As early as 1781 new settlements had been

made at Prairie du Pont (now including Dupo)
and at Bellefontaine (now a part of Waterloo)
between the old French villages of Cahokia and
Kaskaskia. Four miles south of Bellefontaine,
New Design, the largest of the early settlements,
came into being in 1782; horse mills, a sawmill,
and blacksmith shops were established. By 1790
there were seventeen families at Piggott's Fort
(or the fort of the Grand Ruisseau) west of
present-day Columbia. Eastward other small set-
tlements grew — Turkey Hill (south of present
Shiloh) and Horse Prairie (at and near present
Fayetteville); and the rich 100-mile-long area
where the prehistoric Indian and the French pio-
neer had lived over a span of about 6,000 years
became known as the American Bottom — the
far western edge of the American frontier.

By 1800 there were perhaps a thousand Ameri-
can pioneers in the region. A few of them were
polished gentlefolk, enterprising and talented, but
the majority were poor and uneducated due
to their separation from eastern culture by sev-
eral generations of rough living in various wilder-
nesses. Their more genteel French neighbors must
certainly have seen these settlers as an uncouth
lot. In spite of their lack of material wealth
and refinement, however, the American pioneer
hunters had arrived with several advantages over
the French. Living in a wilderness had made
them sturdy and resourceful. They had learned
how to obtain for themselves nearly all the ne-
cessities of life and how to live with a minimum
of comforts. Each man was his own builder,
furniture maker, tanner, farmer, hunter, and
butcher. Each woman knew how to preserve
foods and was able to manufacture clothing, bed-
ding, soap, and dyes from raw materials produced
on the family farm. The bounteous natural re-

Art, Crafts, and Architecture in Early Illinois

sources of southern Illinois provided almost all other necessities: abundant fresh water; wood for fuel, cabins, furniture, and utensils; a plentiful supply of honey, wildfowl, and game for food; salines for salt; and — across the river — lead for ammunition. Small wonder that the land of Illinois was often referred to by the American pioneers as Goshen, the Promised Land.

As they had done in the woodlands of the East, these pioneers would first pick a desirable spot near a river or stream and immediately clear an area in the forest for planting at least a crop of corn to tide them over the first winter. In the meantime they lived under the canvas of their wagon beds, in tents, or in "half-faced" camps — three log walls with a roof and one side left open to a pile of logs used for heating and cooking. An even more temporary shelter might be built into a bank. Once a supply of food had been assured for the winter ahead, the settler could at last start his log cabin.

Unlike his French neighbors, the American pioneer built his cabin with logs laid horizontally and stacked alternately by pairs so as to form a kind of rectangular pen about 16 feet wide and 18 feet long. Since the work involved in erecting

A typical early pioneer's log cabin, with its stick chimney and clapboard roof. It has the luxury of a wooden door, but no glass in the window.

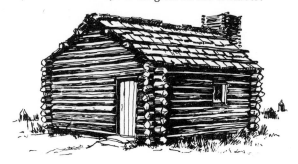

such a cabin was too heavy for the woodsman and his family alone, it was customary for the neighbors to gather for a house raising — an occasion for combining backwoods frolic with work.

After seventy or eighty logs of approximately the same diameter were cut to proper lengths and hauled to the site of the cabin, both men and women rolled the logs up inclined poles to the top of the walls. Several more expert woodsmen cut corner notches which interlocked the logs.

Saddle-notched logs.

When the walls were seven or eight feet high, a door, a hole for the fireplace, and perhaps even a window or two were cut out.

In order to construct a roof and form gables, the two ends of the pen were raised with gradually shortened logs. These in turn were connected together by long wooden poles. Wide, overlapping, hand-split boards about four feet long were then laid on these ribs to form the roof covering. Occasionally longer boards were made to project beyond the eaves to form the roof of a porch. Finally, all of the boards were weighted down and made secure by long poles laid the length of the roof.

For a fireplace, a smaller type of pen was built on the outside of the cabin. Raised to mantel height with small logs, the pen was built up with sticks, becoming smaller by degrees and eventually rising straight up as the chimney. Sometimes the fireplace was lined with stones; more often both fireplace and chimney were simply

sealed with mud clay. The final step was a weatherproofing procedure called chinking and daubing — filling the spaces between the logs and sticks with small wedges of wood and daubing them over with mud.

Such was the usual cabin which the hunter and his family erected in perhaps as short a time as two or three days. The logs were often left unseasoned and unpeeled. The floor was the bare earth; the windows were covered with oiled paper; and the door was hung with a blanket or skin. No nail, no hinge, nothing of iron was used in its construction. An entire winter might be spent with no chimney other than a hole in the roof. Crude and uncomfortable it doubtless was, but many such a cabin in Illinois was called "home." These cabins sheltered an average of six persons, as well as an occasional traveler invited to stay the night.

A more ambitious pioneer, on the other hand, might erect a more comfortable cabin — one with a puncheon floor and perhaps a second-floor loft under the roof with a floor of rived boards laid on log joists. Such a cabin usually had shutters at the windows and a wooden door made of split boards shaved with a drawing knife, fastened together with wooden pegs, and hung with wooden hinges. An inside latch for such a door was a long bar which dropped down into a

"The latch-string is out."

wooden hook on the door frame. By means of a strip of buckskin fastened to the bar and then drawn up to pass through a hole in the door, the bar could be lifted from the outside. From this arose the custom of welcoming a neighbor by saying, "The latch-string is out." To lock the door one simply pulled the cord inside.

The Reverend Braxton Parrish, a pioneer preacher of Franklin County, related his experiences upon reaching the frontier:

When I arrived here I had but 18¾ cents in money. It troubled me to know how to dispose of it to my best advantage, more than any money has ever troubled me since. We settled about six miles east of where Benton now is, in the winter of 1821-2; went right into the woods and cut logs and hauled them upon what was then called a "lizard," a kind of dray made out of the forms of a tree. After getting the logs dragged up, the next thing was to get them put up. We invited in the whole neighborhood, far and near, and got the services of six women and four men. The men kept up the corners and the women lifted the logs up to them, and we did an admirable job. We put the walls cabin fashion, weighted down the clapboard roof with poles, cut openings for door and fireplace, all in one day.

The next day we moved into it, on the frozen earth among the chips and snow. Soon raised a wooden chimney daubed with mud, as high as the mantel-piece. We split trees and made puncheons for a floor, laid it down and then we felt pretty

A puncheon seat.

comfortable. My wife says: "Now I can spin on this floor," and by the light of the fireplace, I took the cards and she the wheel and we soon had three cuts of cotton yarn spun. We then had prayer, and in that rude structure, erected in the woods, surrounded by the howling wolves and panthers, we went to bed, slept soundly and were supremely happy, such happiness as comes to but few of us in a lifetime.

After this we built the chimney out with sticks and mud, and daubed the cracks of the cabin. My

An early pioneer bed.

wife carrying me all the mixed mud for that purpose. While we were working it, it snowed so hard that I could hardly see her to the clay hole. I wanted to quit, but she said no, and we finished it that night. We made a door shutter out of clapboards, fastening them on with wood pins, as nails were not to be had nearer than sixty miles. We made a table out of slabs split from a walnut tree. Our bedstead was nothing more than a platform made on forked sticks, and all our furniture and utensils were of a like rude character, such as we could make ourselves with the aid of an auger and an axe.[1]

Many an early settler in Illinois might have told a similar story. Because of the problems of travel over rough and hazardous trails to the west, the average pioneer had been able to bring only the bare essentials: a gun, a few tools, iron

kitchen utensils, clothing and blankets, a spinning wheel, and perhaps a loom. In addition, he brought seeds for crops to produce both food and the raw materials for the family's clothing. Garments of dressed deerskin and hats of the skin of the prairie wolf or fox were ideal for traveling in the forest underbrush, but they were extremely uncomfortable when wet or in hot weather. Consequently cotton was brought by the southerners to Illinois and was grown as far north as Springfield and Beardstown into the 1830s. According to former governor John Reynolds:

Cotton, at as early a day as 1800, and for many years after, was cultivated to a considerable extent in Illinois. . . . My father had resided in Tennessee previous to his emigration to Illinois . . . and we were tolerably well acquainted with the culture of cotton in that State. . . .

At that early day . . . the disadvantage in the article of cotton was labor in picking the seeds from it so as to prepare the cotton for the spinning wheels. There were then no improved spinning jennies invented, and the old fashioned wheels were the only means of preparing the threads for the looms. . . . much amusement and innocent mirth were enjoyed at the "cotton pickings" as these parties were called. The whole neighborhood would be brushed up to perfect neatness, and made still more attractive by the large fire in the wooden chimney, with rocks under the fore sticks in place of andirons. A large pile of cotton was spread out to dry, so it could be picked the easier. Generally, two sprightly young ladies were elected to divide the heap of cotton, and then the hands began to pick it; so that a contest for victory would excite the two contending parties, by which the more cotton would be picked, and with additional merriment. The last, indeed, was the main object of the young folks. The lady leaders chose their sides to pick alternately,

Art, Crafts, and Architecture in Early Illinois

and then a general tornado of excitement began — picking, talking, and hiding the cotton, and all sorts of frolicking in the sphere of a backwoods cotton picking. A perfect equality and the best good feeling pervaded the whole company, and each one enjoyed as much innocent merriment as is generally allotted to man.[2]

Early in the century most pioneers were also raising sheep and growing flax. Such a choice of

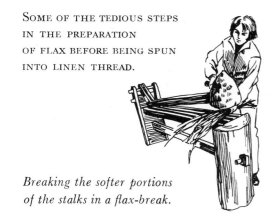

SOME OF THE TEDIOUS STEPS IN THE PREPARATION OF FLAX BEFORE BEING SPUN INTO LINEN THREAD.

Breaking the softer portions of the stalks in a flax-break.

raw materials meant a woman might weave textiles of various assortments of threads or yarns. Linsey-woolsey, a favorite, was a combination of linen thread to provide strength and wool yarn to provide warmth. Preparation of all raw materials for weaving was tedious and time-consuming. Before they could be spun into thread, cotton and wool had to be cleaned, then mixed and fluffed between two carding paddles. Preparation of flax was even more involved, requiring several lengthy processes before it could be spun. Only certain flax fibers were suitable for weaving, and these had to be separated from the unwanted inner stem portions. The first step was accomplished either by laying the flax stalks in a run-

ning stream for a time or by exposing them to the weather. Either process allowed the softer, unwanted portions of the flax to "ret" (rot). They could then be broken by chopping in a flax-break, loosened from the tougher outer fibers by beating with a swingling knife, and then stripped off through graduated sizes of combs called

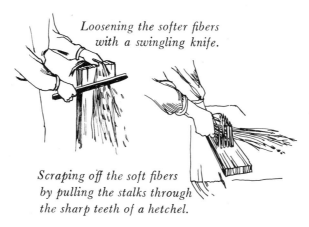

Loosening the softer fibers with a swingling knife.

Scraping off the soft fibers by pulling the stalks through the sharp teeth of a hetchel.

hetchels. Such initial preparations for making the family clothing and blankets were usually begun in early fall. Even the boys carded wool and pulled, broke, and hetched flax so that there would be a good supply of raw material for the spinner and weaver.

During the winter months the whir of spinning wheels and the stroke of the loom could be heard in nearly every cabin on the frontier. The spinning process for wool, cotton, and flax alike worked to accomplish the identical result: after the spinner pulled and smoothed the fiber into an even thickness, the wheel simply twisted it into a strong thread or yarn and wound it on a spindle. Finally, when a certain amount of yarn had been spun, it was taken from the spindle and wound on a reel until there was enough for a hank.

The "little wheel" used for spinning flax.

Homemade distaff used on a flax wheel in Franklin County for holding the flax while spinning. Because spinning was woman's work, there arose the expression "from the distaff side of the family."
ROSA MC LAIN COLLECTION

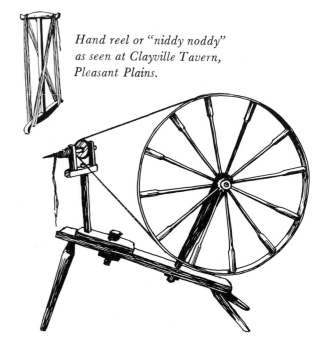

Hand reel or "niddy noddy" as seen at Clayville Tavern, Pleasant Plains.

The "big wheel" used for the spinning of wool or cotton.

Since linen thread was hard to dye, it was usually left natural or else bleached in the sun. Most of the spun wools and cottons were dyed various colors. The frontier housewife concocted her own dyes, using the native barks, shrubs, fruits, and herbs of the woods, experimenting with various fixing agents or mordants to make the resulting colors more permanent. This was one of the few ways in which she might provide color and pattern in her home and in her family's clothing. The boiled inner bark of the white walnut or butternut tree produced a fine yellow-brown dye that was especially popular for everyday clothing. Adding a little copperas and a few "shumaker berries" (sumac) produced a black dye. Dark brown might be produced with hickory nut or black walnut hulls; yellow and gold with yellow hickory bark, onion skins, black-eyed Susans, or goldenrod. The most popular color of all may have been the blue obtained from the indigo plant. Although one species of this plant grew wild in southern Illinois, many pioneer women raised their own indigo in a patch near the house. According to Cass County historian William Henry Perrin: "A kettle of blue dye covered with an old barrel head or plank, was always a conspicuous object by the fireplace on cold winter nights. . . . Some of the best men of our country wooed and won their brides seated on a kettle of 'blue dye' by the blazing fire of the backwoodman's rude cabin."[3]

Some of the dyed yarn was used for making knitted socks, mittens, and caps, but most was reserved for the loom to be woven into blankets and material for clothing. Two kinds of looms were used by the pioneer: the most primitive, called a side loom, was constructed of two pieces of scantling which ran obliquely from the floor to the wall; the other was the large barn-frame loom, which somewhat resembled the framework of a timber house with the working parts attached and suspended within.[4] Although it was bulky and occupied a large portion of one corner of the cabin, the average two-harness home loom was quite simple in construction, and the colored patterns that could be woven on it were limited to simple stripes, plaids, or checks. Wide articles, such as sheets and blankets, were made by sewing together two separately woven strips. With the slightly more complicated four-harness loom it was possible to weave such an article in one piece, although it did involve a far more difficult process than the average housewife knew or cared to learn.

Women's garments were often ornamented with woven stripes and crossbars of bright color. Dresses themselves were of relatively simple construction. An everyday frock was made "rainy-day length" with straight sides and attached sleeves. When completed, it simply slipped over the head and fastened tightly at the throat with a drawstring, over which a neckerchief might be added. Another drawstring gathered the dress in around the waist. The opening down the front might be fastened with buttons made of cow horn. A large knitted or woven wool scarf provided additional warmth in cold weather. The men ordinarily wore only a few articles of clothing in the summer: a hat made of plaited rye, oat, or wheat straw, a cotton shirt or one of flax or tow linen, and "jeans" — so-called from the name of the material from which they were cut, a cotton with a twill weave. According to Governor Reynolds, the favorite type of hunting shirt was made of blue linsey, belted and occasionally trimmed with red or other gaily colored fringe.

In cold weather, near the French villages, a white wool blanket-coat with a cape that could be turned over the head was a favored outer garment, worn over a shirt and pantaloons of deerskin or linsey. Homemade wool hats were far more common than fur hats. Garments of wool, even when worn out, were carefully saved, and the good portions were cut into squares to be sewn into comforters; the scraps were cut into strips for making braided or woven rugs.

In the summer nearly everyone on the frontier either went barefoot or wore deerskin moccasins. In the winter coarse shoes called shoe-packs were worn. Made laboriously at home, such shoes were considered so valuable that "young ladies sometimes walked barefoot to church, putting on their stockings and shoes as they neared the House of God."[5] It took about a year to make a good pair of shoes. The cowhide or hogskin was first soaked in a solution of water and ashes to loosen hair and flesh so they could be easily scraped off. Then the hide was cured in a tannic acid solution, produced by soaking ground oak bark in water. After soaking for a considerable length of time, the hide had to be tediously worked. When supple, it was ready to be fashioned into shoes over hand-carved wooden lasts.

The resulting product was often very crude. Knowing little of tanning or shoemaking, one Sangamon County pioneer made the lye solution too weak, with the result that little more than half the hair was removed. He then failed to leave the hide in the tanbark solution for a long enough time. Finally, when forming the shoes, he turned the upper leather outward beyond the last instead of under it, and sewed the edge with a straight awl through the lower sole. This, says the account, made a walkway around the shoe

"that a mouse could have traveled on."[6] The resulting product, its upper part half covered with hair and without any blacking, certainly must have been an odd-looking footpiece.

During the long winter months, besides making shoes, the men and boys fashioned tools and utensils for the family's use. Because early pioneers could neither afford nor obtain such luxuries as pewter plates, tin cups, or metal spoons from the East, and because few pottery containers would have arrived on the frontier intact, the frontiersman fashioned most of his utensils and tools from the abundant woods of the forest. Large trees cut into lengths and hollowed out, first by burning, then by scraping, became con-

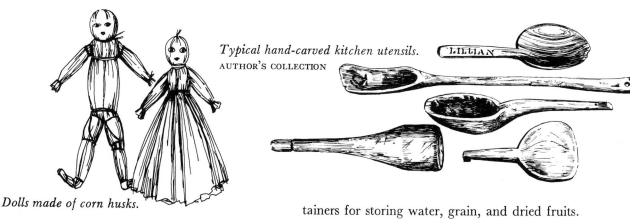

Typical hand-carved kitchen utensils.
AUTHOR'S COLLECTION

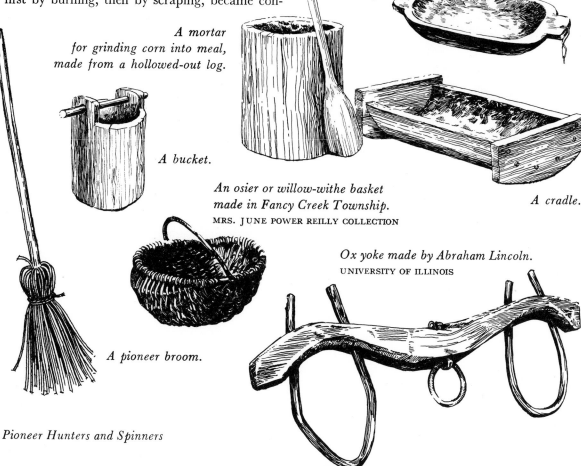

Dolls made of corn husks.

A wooden dish made by burning out the bowl and carving out the charred surface.

A mortar for grinding corn into meal, made from a hollowed-out log.

A bucket.

An osier or willow-withe basket made in Fancy Creek Township.
MRS. JUNE POWER REILLY COLLECTION

A cradle.

A pioneer broom.

Ox yoke made by Abraham Lincoln.
UNIVERSITY OF ILLINOIS

tainers for storing water, grain, and dried fruits. Sometimes they were made into mortars for grinding corn into meal, or they were fashioned into crude cradles for infants or into dugouts like those of the Indians for transportation on the rivers. Smaller trees, cut to shorter lengths, became pails for holding honey or milk or were made into bowls of various sizes. The smaller bowls for cornmeal mush were called noggins; the shallow dish-shaped bowls were called trenchers. Less apt to split or to splinter, burls provided an ideal material for such utensils. The pioneers carved ladles and spoons of various sizes; they also carved ox yokes and crude wooden ploughs. They fashioned wooden carts with wheels cut from sections of tree stumps and built sleds with solid wooden runners. Brooms were made from young hickory trees by picking off the bark and splitting one end into strips; osier baskets were woven from the withes of willows found along the river and creeks; cut gourds were used for cups, baskets, dippers, and soap dishes. Filled with lard and provided with a strip of cloth for a wick, a hollowed-out sweet potato became a lamp. Like the Indians before them, the pioneers twisted native hemp into rope or coarse thread and bound husks of corn to form dolls for their children. Plaited and sewed together, corn husks also became hats or horse collars.

Pioneer Hunters and Spinners

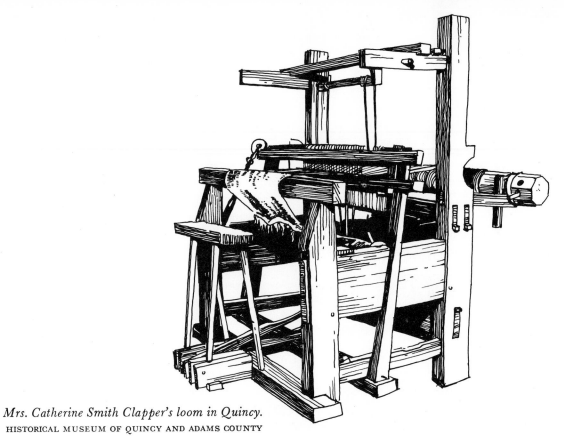

Mrs. Catherine Smith Clapper's loom in Quincy.
HISTORICAL MUSEUM OF QUINCY AND ADAMS COUNTY

But all was not work for the early pioneer. Many early accounts tell of fiddles on the frontier and jolly country dances and songfests. Because pioneers from the South were usually friendly and hospitable, they were fond of a rollicking good time with friends. They also enjoyed simply sitting after a meal and swapping yarns. While seated around the fire on such occasions, southerners (both men and women) would bring out homemade corn-cob pipes for a friendly smoke.[7]

Such were the activities of the first Americans in Illinois — Americans who widened the buffalo and Indian trails and blazed new ones; Americans who broke the land, fought the Indians, and prepared the way for later pioneers. However poor and uneducated most of these earliest pioneers may have been, they were also proudly independent, self-sufficient, patriotic, and courageous. When they moved farther north and west to blaze more trails and open new frontiers, they always left some of their people behind, a few of whom would play vital roles in the development of Illinois.

5 Art in the Wilderness

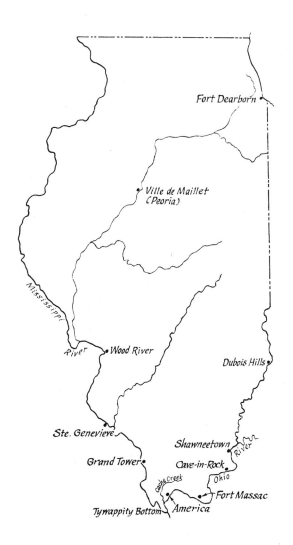

By 1804, despite a continuing trickle of pioneers into the area, the northernmost American settlement in Illinois was Wood River (Upper Alton). Except for two French villages — Ville de Maillet (Peoria) on the Illinois River and Dubois Hills on the western side of the Wabash opposite Vincennes, Indiana — north of this point was complete wilderness inhabited only by Indians and fur traders. Wood River became a convenient base from which government expeditions could proceed westward on the Missouri River. Here, during the winter of 1803-04, Meriwether Lewis and William Clark built a fifty-five-foot keelboat and forty-foot pirogues for their journey to the west coast and back.

The great Northwest Territory had been divided into Ohio and Indiana territories, and in 1803 a vast new region had been added to the young republic, purchased from Spain by that great advocate of westward expansion Thomas Jefferson. While the pioneers in the Midwest were building their cabins, the national government was busy providing forts for their protection and directing the exploration and mapping of the newly acquired lands beyond the Mississippi.

In the far north at Chicago, a militarily strategic site at the base of Lake Michigan, Captain John Whistler was getting ready to build

Fort Dearborn. Chicago had long been a favorite spot for French missionaries and traders. The first known settler at Chicago, the fur trader Jean Baptiste Point du Sable, had arrived about 1779 and had lived on the north bank of the Chicago River until 1800, when he sold his farm and moved away. Mystery still surrounds much of the life of this man, but existing records indicate that he was a well-educated Negro or mulatto, a prosperous fur trader, miller, farmer, and a craftsman as well. His possessions — sold at the time he left Chicago — included a 40-by-20-foot house, a dairy, bakehouse, poultry house, stable, barn, horse mill, workshop, and miscellaneous articles including a large French walnut cabinet with glass doors, a bureau, couch, featherbed, and stove; tables, chairs, mirrors, and pictures; utensils of pewter, tin, iron, and copper; saws, carts, a plow; and various tools of the carpenter, miller, and cooper.[1]

Obviously it was a profitable day for the Chicago trader. In exchange for furs he supplied the Indian not only with articles commonly used by the white man such as guns, knives, tools, kettles, ammunition, blankets, and mirrors, but also with items produced specifically for the Indian — body paint, clay pipes, glass beads, and trinkets of silver. Indeed, from about 1760 until

45

1820, silver medals, brooches, armbands, crosses, and ear ornaments were so popular among the Indians that silversmiths of Canada, England, and the United States were kept busy supplying traders.

John Kinzie, the first known silversmith in Illinois, was primarily a fur trader. Born in

Silver ornaments made for the Indian trade.
FIELD MUSEUM, CHICAGO

Quebec about 1763, Kinzie left school at about ten years of age, wandering the town's streets in search of his fortune. Finally, intrigued by what he saw in a silversmith's window, he entered the shop and indentured himself to the master craftsman. For hundreds of years indenturing had been the process by which one contracted to learn a trade. A written promise guaranteed that in return for his board, room, and instruction in the intricacies of the master's art, the student would perform menial services for the master for a specified number of years. At the end of his apprenticeship it was customary for the student to produce a "graduation piece," proof of his knowledge and proficiency in his chosen art. Leaving the master's employ, he might then become a journeyman craftsman and go into business for himself.

A number of years passed for young Kinzie in

just such a manner, and eventually he set out on his own. He practiced his new skill in Detroit until about 1797, when he entered the fur trade along the Maumee and St. Joseph rivers. With his silver trinkets he enjoyed a thriving business among the Indians. In the spring of 1804 Kinzie left for Chicago to take over what remained of the buildings of Du Sable. Resuming his trade, he soon became a great favorite with the local Indians, who called him Shawnee-au-kee, the Silverman. By the next year he had established an additional trading house at Milwaukee and is said to have eventually established still another along the Sangamon River in central Illinois.[2]

Only a few of Kinzie's silver pieces have been found. His mark, the initial *K* in a rectangular cartouche, may be seen on a silver wristband at the Chicago Historical Society. The same mark appears on a large silver cross found in Michigan in an Indian grave, and one or two other Kinzie items are in the Yale University Art Gallery in New Haven, Connecticut. This dearth of artifacts is undoubtedly due in part to the fact that little archaeological field research has been conducted on the historic Illinois Indian, and also because within a relatively short time the Illinois Indians were transferred by the U.S. government to reservations west of the Mississippi River. There is, however, the following description by Henry Rowe Schoolcraft (1793-1864), who, journeying up the Illinois River in 1821 to attend an Indian treaty at Chicago, met straggling parties of Indians near the Des Plaines River: "Most commonly they were mounted on horses, and apparelled in their best manner, and decorated with medals, silver bands and feathers. The gaudy and showy dresses of these troops of Indians, with the jingling caused by the striking

The mark of John Kinzie stamped on a silver ornament.
FIELD MUSEUM, CHICAGO

of their ornaments, and their spirited manner of riding, created a scene as novel as it was interesting."[3] Perhaps some of these very ornaments were the work of John Kinzie.

Meanwhile, across the Chicago River from Kinzie's trading post, the erection of Fort Dearborn had involved considerable activity. Construction began in 1804 under the direction of Captain John Whistler (1789-1829). Grandfather of the artist James Abbott McNeill Whistler, he was a former commander of the American fort at Detroit. Like most military officials of his day, Whistler had received considerable training in drawing and map making, enabling him to supply his superiors with necessary records. Upon completion of Fort Dearborn in 1808, Whistler

Aerial view of the reconstructed Fort Dearborn as it appeared at the Chicago World's Fair in 1933.
AFTER A *Chicago Daily News* PHOTOGRAPH

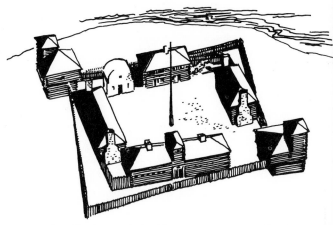

Art, Crafts, and Architecture in Early Illinois

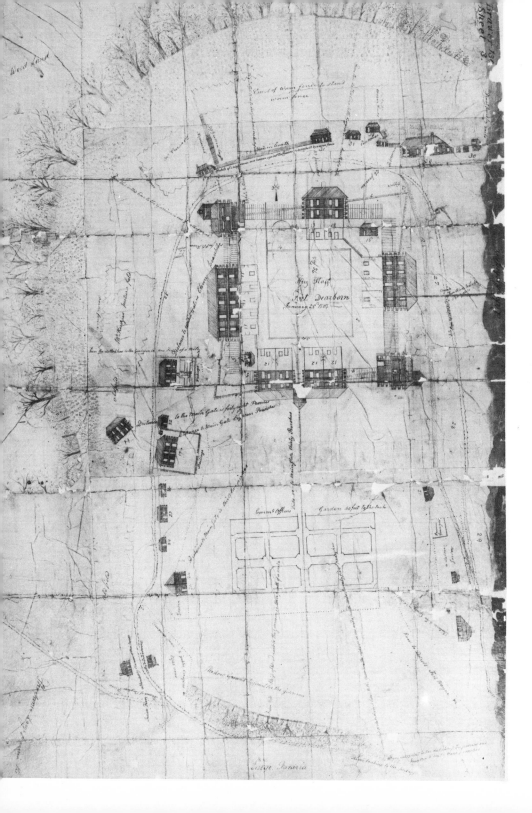

made a pen-and-ink drawing of it and the surrounding area which is the earliest known view of Chicago. The drawing, kept in the National Archives in Washington, D.C., shows not only the buildings and palisade of the fort but also an Indian village and graveyard, a few traders' cabins, the government agency house, and the trading house of John Kinzie on the north side of the Chicago River.

Fort Dearborn was typically Anglo-American in construction. The diamond-shaped bastions at the corners of the palisades constructed by the French in their Illinois forts were replaced by two-story blockhouses at two corners of a double palisade. The second floors overhung the first and were slit with gun openings, allowing a view downward as well as sideways and giving the defender a distinct advantage. The blockhouses and the inner two-story barracks were constructed in the manner of typical American frontier cabins. The barracks had double galleries and shingled gable roofs; the magazine was constructed of brick; and access to the fort was by a main gate on the south with an underground tunnel leading north from the inside parade ground to the Chicago River.[4]

This fort stood intact for only four years; during the War of 1812 Indians burned it to the ground. The life of John Kinzie, friend of the local Indians, was spared, however. After his release from captivity, Kinzie did not return home to Chicago until 1816, after the lands surrounding the head of Lake Michigan, as well as those as far as the Kankakee and Fox rivers, had been ceded

Cartographic plan of Fort Dearborn, drawn by Captain John Whistler in Chicago, 1808.
NATIONAL ARCHIVES, WASHINGTON, D.C.

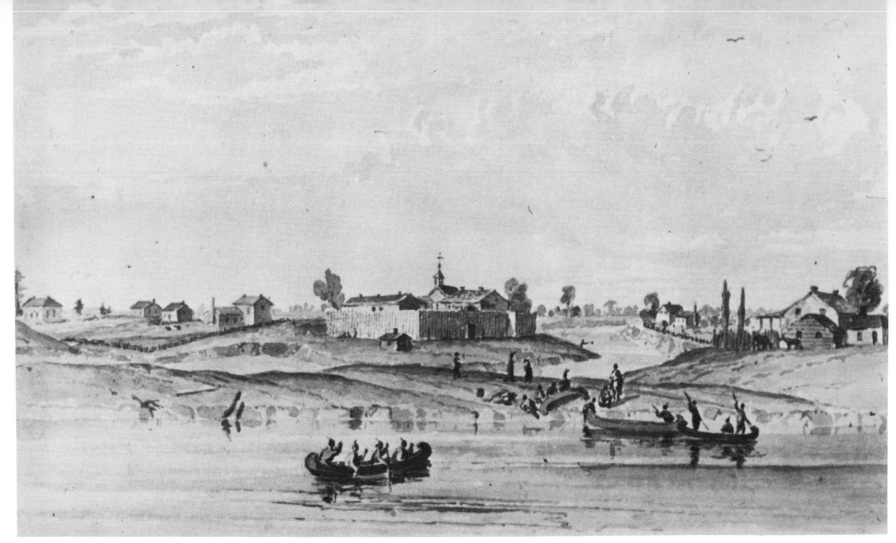

"Chicago in 1820: Old Fort Dearborn." Watercolor made by Seth Eastman from a sketch by Schoolcraft (see p. 221). Kinzie's house is on the right.
JAMES JEROME HILL REFERENCE LIBRARY, ST. PAUL

to the United States. He returned, it is said, to resume his former occupation of silversmith. Also in 1816, Fort Dearborn and Fort Clark, on the western shore of Peoria Lake, were rebuilt. And in northwestern Illinois, where the menace of the Sauk and Fox Indians still remained, two new forts were built: Fort Armstrong at Rock Island and Fort Edwards near Warsaw.

For many years Chicago remained little more than a wilderness post for military men and traders, their families, and the neighboring Indians. Chicago is indebted to Henry Rowe Schoolcraft for a second view of Fort Dearborn and its surroundings. The sketch, made on his visit to the fort in 1820, was later reproduced by Seth Eastman for Schoolcraft's six-volume *Historical and Statistical Information Respecting the History, Condition and Future Prospects of the Indian*

Tribes of the United States. It depicts Fort Dearborn itself, Kinzie's house and outbuildings, the Chicago River, and a few Indians, in an uninviting landscape almost barren of trees. This lack of trees — which had plagued the builders of Fort

Art, Crafts, and Architecture in Early Illinois

Dearborn by forcing them to cut timber at some distance, drag it to the river, and float it to the site — became a formidable obstruction to the choice of this site for future settlement.

Meanwhile, in southern Illinois along the Wabash, Ohio, and Mississippi rivers, settlement was slowly progressing. Here the West had opened a new horizon for more than the explorer, fur trader, soldier, and settler: it was a paradise for the naturalist. According to the twentieth-century naturalist Donald Culross Peattie, nowhere in the temperate zone was there such a vast amount of bird life.[5] The historian William Nelson Moyers describes the wildlife of the region as seen by early explorers, travelers, and settlers:

It is interesting to note the great variety and vast numbers of wild animals that once roamed our forests. There were buffalo-trails, a few of which remain to be seen; bear-wallows; deer-licks; beaver-dams, of which a few remain; otter-slides; raccoon-dens, opossum-flats; fox-dens; panther-bayous; wild-cat-hills, and the habitat of many lesser animals.

Around the edges of the prairies there were paroquets, wood-pheasants, and prairie-chickens by the thousand. There were turkey-flats; swan-ponds where great trumpeters fed, on their spring and autumn flights; eagles' nests on lofty cliffs; and many well-known wild-pigeon-roosts. It will tax the credulity of the present generation to believe what vast numbers of these pigeons frequented our woods. In November, 1700, the entire horizon at the mouth of the Ohio was black with them, according to Father Gravier. That horizon was ten square miles at the tree-tops; and if we reckon but one pigeon to the square yard — Audubon estimated two — at sixty miles per hour, then there were thirty (sixty) million pigeons in that flight. Persons living have seen pigeon-roosts which cov-

ered seven acres, and in which were about five million birds. The last such roost reported anywhere near this territory was seen in 1881, but it contained only a few thousand birds. What became of the wild pigeons is still a question. The last one in captivity died in 1914 at the Cincinnati Zoo.

A thousand migrating grey squirrels have been seen in a single drove. Quails were so numerous as to be a nuisance. All kinds of water-fowls were present in large numbers in their season. Wild bees and bee-trees were to be found literally everywhere.[6]

With wild nature at his door to be tamed, and with the Indian a menace to life and property, the average pioneer took a practical view: nature was there for his use and profit; the Indian was to be conquered and eliminated. However, at the same time there were in the region a few men who held a different point of view. These were inquisitive travelers of romantic or scientific bent who were drawn to the West by curiosity.

Since the earliest days of exploration the French had been fascinated by the Red Man, the beautiful scenery, and the abundant wildlife of the Mississippi valley. George Henri Victor Collot, visiting the French villages of Illinois in the late 1700s, sketched a romanticized version of a Kaskaskia Indian. Late in the 1600s Canada's Father Louis Hennepin published a book containing some highly romanticized engravings of the buffalo and birds of the region. In 1718 the twenty-three-year-old Frenchman Antoine Simon le Page du Pratz, fascinated by the birds of Louisiana Territory, made several journeys west from New Orleans. He traveled several times up the Mississippi River and once to the Illinois country sketching crudely primitive pictures. Included among these is the now-extinct Carolina paroquet (or parakeet), at one time

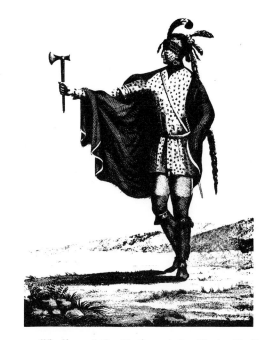

"Indian of the Nation of the Kaskaskia."
An engraving from a sketch by General Collot
when he visited Illinois in 1796.
IN COLLOT

abundant in Illinois as far north as Sangamon County.

The American government came to an awareness of the value of these studies made by Europeans, and around 1805 Thomas Jefferson contemplated sending American scientists to explore the natural wonders of the Mississippi country. Alexander Wilson — weaver, teacher, and painter — offered his services, but the expedition never got started; so in 1810 Wilson set out on his own. He traveled by stagecoach, skiff, and on foot to Lexington, Kentucky, and on to Natchez, Mississippi. By 1813 he had published seven volumes of his *American Ornithology,* which contained paintings and sketches of 278 species of American birds, 56 of which he had personally discovered.

In 1810 Illinois Territory played host purely by chance to a young man in his twenties who was to become one of the most noted artists and ornithologists in all America — John James Audubon (1785-1851). According to the standards of the average industrious American of that day, John James Audubon was a misfit. From childhood in Nantes, France, he had shown little interest in doing anything but playing music or hunting, observing, and drawing birds. In despair, his wealthy father finally sent him to Paris to study with the noted artist David, but drawing from plaster casts was not to Audubon's liking and was soon abandoned. Sent to America, Audubon lived for a time on his father's estate in Pennsylvania. Then, to earn a living so that he might marry and support a wife, he became a clerk in the merchandising house of Ferdinand Rozier in New York. He spent as much time as possible learning taxidermy at Dr. Samuel Mitchill's private museum and continued to observe, draw, and dissect birds he bought in the markets.

Audubon was intensely interested in portraying the characteristic attitudes of the various bird and animal species. He deplored the stiff images of birds as painted by other naturalists of the day, who used mounted skins for their models. As a youth Audubon had tried in vain to pose dead specimens in lifelike attitudes; he had tried to raise their heads and bodies with string and to carve wooden models that would assume lifelike positions. Audubon finally devised his own unique and satisfactory method: he secured the bird upright on a sharp wire fastened to a board, propping the head and tail with more wires and fastening the feet to the board in the position he desired; then he proceeded to paint.

Trumpeter swan (young). Original pastel by John James Audubon, published in 1837 as a hand-colored engraving (pl. 376) for the elephant folio Birds of America *(1827-38).*

NEW-YORK HISTORICAL SOCIETY

In 1807 Rozier, with Audubon and his bride, moved to the Kentucky frontier, where as partners they first established a store at Louisville and then moved on to Henderson. The wilderness enchanted the young Audubon, and he spent less and less of his time tending store. Instead, he spent hours, days, and weeks observing, hunting, and sketching birds, accumulating by 1810 a collection of over 200 life-size drawings. Finally, discouraged by the attitude of his partner and by business prospects in Kentucky, Rozier persuaded

Audubon to leave his wife in Kentucky and move farther westward with him to Ste. Genevieve. A trip down the picturesque Ohio and up the wondrous Mississippi provided a thrilling prospect to Audubon. Anticipating new species of birds along the shores and carrying his pencils, pastel crayons, and watercolors as a precious part of his baggage, he set off with Rozier in a snowstorm in December of 1810. As the keelboat proceeded down the Ohio, however, the travelers found the river increasingly ice-choked and the Mississippi

Art, Crafts, and Architecture in Early Illinois

Trumpeter swan (adult). Original watercolor by Audubon, published in 1838 as a hand-colored engraving (pl. 406) for the elephant folio Birds of America.

NEW-YORK HISTORICAL SOCIETY

completely frozen over. They put in at Cache Creek in present Illinois to await an ice break.

There Audubon discovered that a large hunting party of Shawnee Indians was in the neighborhood tracking animals, shooting birds, and gathering wild pecans. The young naturalist joined in happily with the Indians; Rozier — disgusted — sulked, brooded, and slept. Finding Audubon so interested in animals, the squaws were soon bringing him some of the smaller specimens that had been caught in their traps so

that he might observe them more closely and perhaps sketch them. The second morning, Christmas Day, Audubon accompanied a hunting party across the Ohio River into Kentucky to a lake where hundreds of trumpeter swans gathered each morning to feed. This event probably inspired Audubon's famous depictions of the immature and the mature swan.

A few days later Audubon set off on foot over the southern tip of Illinois with two of the boat's crew to see if the Mississippi ice had broken

enough for them to proceed to Ste. Genevieve. Reaching the river at a point opposite Cape Girardeau, he attracted the attention of some people on the other side and enlisted six men to help pull the keelboat up the Mississippi. When Audubon returned to Cache Creek, the entire party resumed its journey down the Ohio and up the Mississippi toward Ste. Genevieve. Again severe weather forced them to shore, this time on the Tywappity Bottom in Missouri, where the river forms a great oxbow between Cairo and Cape Girardeau. There, with a hunting party of Shawnee and Osage Indians, Audubon again passed his time sketching and observing the turkeys, deer, cougars, raccoons, and other wild birds and animals of the area.

After about six weeks the party was able to proceed toward Ste. Genevieve, going past Grand Tower, a great picturesque rock detached from the Missouri shore, later the subject of many another artist's sketch. Here Audubon saw the immature bald eagle, which he mistook for a new species, calling it "Bird of Washington" or "Sea Eagle."

Established in the partnership at Ste. Genevieve, Audubon soon decided that neither town nor business life was to his liking. Parting with Rozier in 1812, Audubon recrossed the Mississippi. According to the artist, it was on this trip across the Illinois prairies that his life was endangered, for the first and only time, by lawless men. As night came on he sought shelter in a small log cabin occupied by a woman, her two sons, and a wounded Indian. After a meal of venison, jerked buffalo meat, and a (corn?) cake, Audubon innocently drew out his fine watch, which immediately attracted the eye of the woman. Covert warnings from the Indian

Art in the Wilderness

51

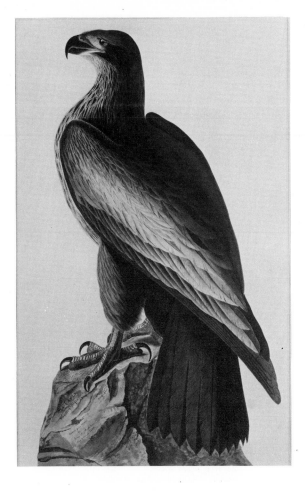

put Audubon on guard, and before lying down for the night on untanned bear hides he loaded his gun and called his dog to his side. While he lay there pretending to sleep, the boys ate and drank themselves into a dangerous state. Then, to his astonishment, he saw the woman take her carving knife, whet it on the grindstone, and order her sons to kill him to obtain the watch. It was at the moment when fear for his life was at its peak that his deliverance came. The door was opened, and to his relief two armed "regulators" (frontier citizen law enforcers) walked in. At daybreak the culprits, arms tied, were led outside. Then, according to Audubon's story, "We marched them into the woods off the road, and having used them as Regulators were wont to use such delinquents, we set fire to the cabin, gave all the skins and implements to the young Indian warrior, and proceeded, well pleased, toward the settlements."[7] On the Ohio River at Shawneetown Audubon took the ferry back to Henderson.

It soon became the custom to send trained pictorialists on government expeditions to make visual records of the excursion, sketching or painting as faithfully and accurately as possible. In 1819, while Audubon was in Cincinnati, Samuel Seymour was sent as staff artist on Stephen Long's expedition to the Yellowstone. Seymour was directed to furnish sketches of those landscapes which were distinguished by beauty or grandeur and to paint Indians, Indian festivals, and any other such subjects of special interest to the government. When the expedition moved down the Ohio River along the shores of Illinois, Seymour made a drawing of impressive Cave-in-Rock, the great orifice in the bluffs that had become famous as a hideout for river pirates. Seymour's paintings have unfortunately disappeared, but some were made into lithographs for Edwin James's *An Account of an Expedition from Pittsburgh to the Rocky Mountains in the Years 1819 and 20* (Philadelphia, 1824).

By this time Audubon was determined to be the first to paint all the birds of America in their natural surroundings, so the following year he set off down the lower Mississippi with his assistant, Joseph Mason, a thirteen-year-old botanist who would paint many of the fruits, flowers, and leaves on Audubon's early drawings. Near the junction of the Ohio and Mississippi Audubon first saw the ivory-billed woodpecker and the Carolina paroquet.

The first journals that Audubon kept were made on this journey; in his own words and faulty rhetoric he wrote an account of his adventures as he proceeded down the Ohio to the mouth of the river:

Tuesday Novemb' 7th 1820
The People of Shawney [Shawneetown] Complaining of Sickness, the place improved but Little
Thursday Novemb' 9th 1820 We Landed at Sun Set at the *Rockin-Cave* [Cave-in-Rock] having Come only about 2 Miles —
The Tell Tales we eat to Day were very fat but very fishy — I eat the purple Grakle it tasted well. . . .
Friday Novemb' 10th 1820 as soon as Day Light permitted me this morning — I took Joseph on Shore and Lighted a good fire — Took also My Drawing Book etc with a Skiff — the Morning pleasant and the Thermometer raised to 50° While I was taking My Sketch of the *Rockin Cave* Cap[e] Cummings took a Good Walk through the Woods — at 9 My Drawing was compleat — This Cave is one of the Curiosities that attract the attention of almost every Traveler on the Ohio and thousands of Names & Dates ornament the sides & Cealing — there is a small upper room dificult of access imediately above & through the Cealing of

Art, Crafts, and Architecture in Early Illinois

"The Legend of the Piasa Bird," an oil painting (1844-45) by an anonymous artist. Probably the earliest known interpretation of one of the romantic legends concerning the ancient pictograph near Alton (see p. 5).
HAYNER PUBLIC LIBRARY, ALTON

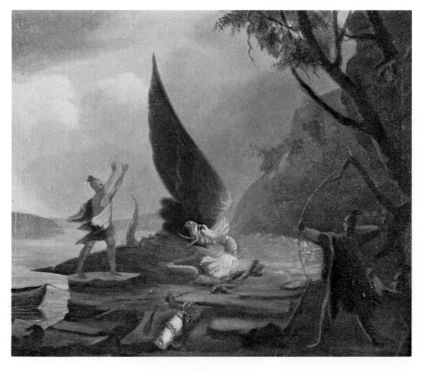

"Dancing Woman," an original prehistoric clay figurine, one of five found in the Knight Mound, Calhoun County (see p. 10).
P. F. TITTERINGTON COLLECTION, MILWAUKEE PUBLIC MUSEUM

Raven effigy pipe from the Rutherford Mound, Hardin County, one of the finest pieces of prehistoric Indian carving ever found.
ILLINOIS STATE MUSEUM

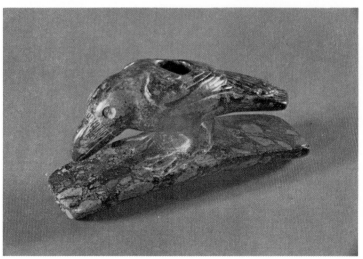

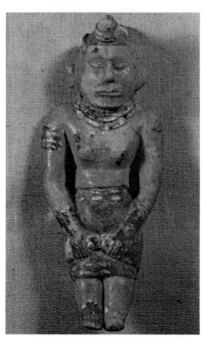

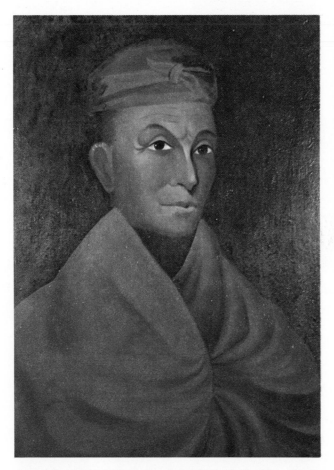

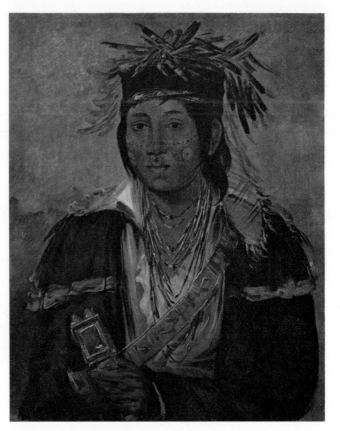

"Kee-mo-rá-nia, No English; a beau; his face
curiously painted and looking-glass in hand."
A Peoria Indian painted in Illinois by George Catlin in
1832-33 as the tribe prepared to move westward
(see p. 121).
SMITHSONIAN INSTITUTION

Portrait of Chief Black Hawk by Samuel Gardiner Drake
(see p. 114), a member of the New Hampshire Historical
Society, who wrote The Book of the Indians of North
America. Details in the Lives of about Five Hundred
Chiefs and Others. . . . *Published in Boston by Josiah*
Drake in 1837. Little is known of the painting's origin.
ILLINOIS STATE HISTORICAL LIBRARY

Ivory-billed woodpecker.
Original watercolor by Audubon,
published in 1829 as a hand-colored engraving
(pl. 66) for the elephant folio Birds of America.

the Ground floord one, Large enough to Contain 4 or 5 persons when sitted on their hams — this place is said to have been for Many Years the *rendez Vous* of a noted Robber of the name of Mason it is about 20 Miles below Shawaney town on the same side; had our Boats spent a Day there, I would have been pleased to take several Diferent Views of it — the Rocks are Blue Lime Stone containing in Many Parts Round Masses of a fine flinty appearance Darker than the Main Body —

Monday Novemb' 13th 1820 Saw a Bear on a Sand Barr, had a great run after it. . . .

Joseph Made a Faux Pas this day — the Whole of our Folks not in the best humour — Killed 7 Partridges — 1 G. Squirel & One Duck

Tuesday Novemb' 14th 1820 Drawing this Morning as soon as the Light would permit me — Started early —

We passed this Day *Fort Massacre* here the Ohio is Magnificent, sunsetts that only belong to America rendered the Scene extremely interesting.

Cap^e C. Brought an Oppossum, Dash [Audubon's dog] after having broke I thought all its bones left it — it was thrown over Board as if dead, yet the moment he toucht the Watter he swam for the Boats — so tenacious of Life are these animals that it tooked a heavy blow of the Axe to finish him —

Thursday November 16th 1820 We floated only about Two Miles & Landed at *America* — to sell some *Articles;* people very sickly, a miserable place altogether —

Friday November 17th 1820 We left early — I took the Skiff and Went to the Mouth of the Ohio, and round the point up the Misisipi —

Eleven Years ago on the 2 of January I ascended that Stream to St. Genevieve Ferdinand Rozier of *Nantes* my partner in a Large Keel Boat Loaded with Sundries to a Large Amount *our* property

The 10th of May 1819 I passed this place in an open Skiff Bound to New Orleans with two of My Slaves —

Now I enter it *poor* in fact *Destitute* of all things and reliing only on that providential Hope the Comforter of this Wearied Mind — in a flat Boat a Passenger —

The meeting of the Two Streams reminds me a little of the Gentle Youth who Comes in the World, spotles he presents himself, he is gradually drawn in to thousands of Dificulties that Makes him wish to keep apart, but at Last he is over done mixed, and lost in the Vortex — [8]

After Alexander Wilson, Audubon was the first great ornithologist to see and make an extensive study of the multitude of birds in the southern Midwest. In New Orleans he rejoined his wife and supported his family and his efforts by tutoring and portrait painting; but as soon as he had assembled 400 bird paintings, he went to New York to find a publisher. He was turned down because the tedious process of having his paintings copied as engravings or aquatints on copper plates was too costly for American publishers of that day. In 1823 Audubon again visited Illinois, this time with his son Victor; and at length, by painting portraits and teaching fencing and dancing, he earned enough money to sail for England. After 1826, 435 of his precious paintings were being engraved life-size, for the most part by Robert Havell of London. As early as 1832 he had become famous even in Illinois. A letter from him to the editor of the *Philadelphia Gazette* was published in the *Sangamo Journal* (Springfield) on March 15, 1832. In 1838 the famous *Birds of America* was finished. In 1845-46 *The Vivaparous Quadrupeds of North America,* containing 150 plates of animals, was published in New York.

It must be realized that the now-familiar engravings of birds are merely copies of Audubon's

original paintings, most of which are now owned by the New-York Historical Society. Though there are modern critics who say that some of the birds' attitudes are scientifically inaccurate, Audubon's paintings and the engravings made from them remain the best and most beautiful pictures of birds and animals of his day. Gazing at the lively attitudes of wildlife now scarce or extinct in Illinois, one can almost imagine the chatter and color they must have once created in the early landscape.

Carolina paroquet.
Original watercolor by Audubon,
published as a hand-colored engraving (pl. 26)
for the elephant folio Birds of America.

Art, Crafts, and Architecture in Early Illinois

6 Early Frontier Craftsmen

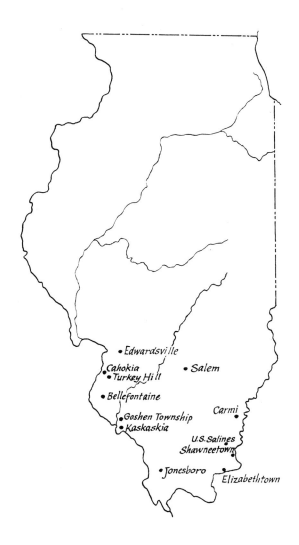

When Audubon first visited the southern tip of Illinois Territory in 1810 the United States was still a nation largely composed of small towns along the waterways, farms scattered in the hinterlands, and vast areas of wilderness. The Industrial Revolution, which had already arrived in England, had not yet reached America, and the craftsman was a greatly needed and respected individual still in his golden age. Although large shops of master craftsmen and apprentices had been established in prosperous cities of the East, the great bulk of industry in the nation still centered in small family shops.

Weaving was the leading industry in that year. In older, more settled areas professional weavers moved from household to household with their looms or operated out of small shops, their customers providing spun linen and wool. But in the hinterlands and on the frontiers this industry remained almost entirely in the home. The family joined in raising and processing raw materials, and the housewife wove the textiles for her family and occasionally for neighbors as well. Illinois Territory in 1810 was typical of such remote areas, having 630 spinning wheels and 460 looms for the weaving of cotton, flax, and wool. The product for the year was 90,039 yards of various types of cloth valued at $54,023.[1]

As early as 1800, when Illinois was a part of Indiana Territory, government-sanctioned indenture provided a way for the poor, the infirm, and the handicapped to earn their keep while learning a useful trade. Some of the French inhabitants who had remained in their old settlements were in dire straits, deprived suddenly of their motherland's support and involved in the chaos of first British and then early American occupation. Indenture provided for them, too. An entry in the court records of 1800 at Cahokia reads: "This indenture witnesseth: That Jean de Hay and Jean Boilieu, overseers of the poor in the township of Cahokia, in St. Clair County, by virtue of a law of this Territory of Indiana, in such cases made and provided, have placed, and by those present do place and bind out a poor child,

Yarn reel made near Salem.
CHARLES LINCOLN MC MACKIN II
COLLECTION

57

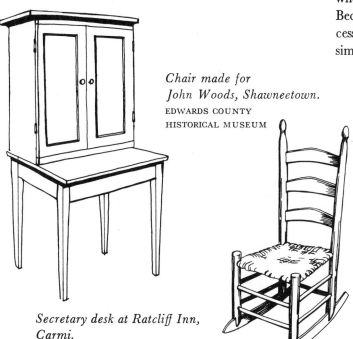

Carved wooden shoe lasts, over which leather shoes were formed.
ROSA MC LAIN COLLECTION

named Philis, aged six years, with Joseph Buelle, for twelve years from this date; to learn the arts, trade and mystery of a spinster, etc., she, the said Philis to receive as compensation for the twelve years one wearing apparel suitable for the Lord's Day and another for working days."[2] Such an entry reveals that in the absence of child labor laws, indenturing of children was a common practice. It indicates as well the origin of the word spinster as one who spins yarn — usually a young girl or unmarried woman.

Chair made for John Woods, Shawneetown.
EDWARDS COUNTY HISTORICAL MUSEUM

Secretary desk at Ratcliff Inn, Carmi.

In some settlements the manual labor of processing raw materials for textiles was lessened early in the century. The cotton gin, invented by Eli Whitney in Georgia in 1793, was such an improvement over the hand picking of cotton from its seeds that as early as 1813 one was built by Thomas Harrison near present Belleville. In 1817 at Cahokia, the manual labor of getting the wool and cotton ready for the spinning wheel was lessened when Judge Jesse B. Thomas decided to build a carding machine moved by ox power, similar to those already in use in Kentucky and Ohio. At that time there was no one in Illinois who knew how to construct such a machine, so Judge Thomas went to Ohio to secure a trained man for the project. The resulting carding mill had an upper structure of wood supported by walls of stone. In the basement a great inclined wheel revolved, powered by the tread of oxen. Because this project at Cahokia was such a success, other towns in Illinois soon constructed similar mills.

Hand-wrought branding irons for cattle, made by a pioneer blacksmith.
ILLINOIS STATE MUSEUM

Andirons made by an early blacksmith.
MR. AND MRS. HOWARD PORTER COLLECTION

Ads in the Illinois Intelligencer (Kaskaskia) of 1819.

Other craftsmen contributed their talents to the textile industry. During the early 1800s wheelwrights manufactured large and small spinning wheels in nearly every neighborhood. Such sley makers as William Roley of Edgar County would construct the sley of the loom — a delicate reed structure which spaced warp threads and beat the woven weft threads to form a tight fabric. Thus the construction of looms was much simplified, as a handy pioneer carpenter could construct the remaining parts.

According to the 1810 census, Illinois Territory had 15 blacksmith shops, 9 tanneries, 7 cooper

Art, Crafts, and Architecture in Early Illinois

shops, 6 cabinetmakers, and a few boat builders. In such larger settlements as Goshen Township (population 1,725), Turkey Hill Township (1,151), Shawneetown (830), and the U.S. Salines (830), American settlers enjoyed some advantages over their predecessors. From a local cabinetmaker they might acquire a few pieces of simple and well-made furniture to add to their possessions. A local blacksmith could make vital repairs on wagons and guns and could supply shoes for oxen and horses, hand-wrought fireplace tools, grease-burning lamps, and branding irons for identifying the free-roaming cattle. Tanners, shoemakers, and saddlers alleviated additional tedious work for the pioneer. In addition, the tanner's abundant use of bark in the preparation of leather was considered a boon to settlers in forested areas. The U.S. Industrial Census of 1810 states: "Bark, abundant every where in America, is redundant [excessive] in new settlements, where the tanning business facilitates the destruction of the forests, which obstruct agriculture. This manufacture has an additional value in producing a market for lime."[3]

The cooper's special aptitude and remarkable skill enabled him to construct various kinds of wooden containers from wooden staves, hoops,

Products of the cooper: a churn and a barrel.

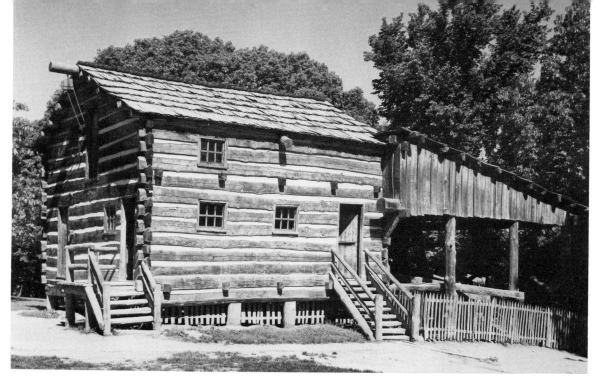

An ox-powered carding mill as seen in the reconstructed frontier village of New Salem.
PHOTOGRAPH BY CHARLES HODGE

and sections of logs. The barrels, kegs, buckets, washtubs, pails, and churns thus produced made life considerably easier. Each container was designed according to its specific application: for dry materials such as cornmeal, tobacco, or salt, the construction was relatively loose; for such liquids as milk, honey, or whiskey, the staves required expert beveling and shaping so as to fit tightly, rendering the container waterproof. The hoops, especially, had to be made of supple woods. This quality was found in hickory, white oak, and ash saplings, which — after a process of splitting, shaving, and soaking — could be shaped into hoops. The cooper's industry was very important in Illinois, to the extent that the town of Hooppole was named for its abundance of appropriate woods.

Sometime before 1820 the first potter appeared in Illinois. A lack of suitable containers was still

The potter at his kick wheel.

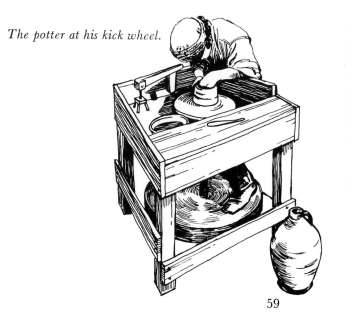

a problem, as even the expertly constructed wooden container was inadequate for certain foods, absorbing odors and fats and resisting thorough cleaning. The arrival of the potter, therefore, was a welcome event for the pioneer housewife. There is no record of the identity of Union County's first potter nor of the exact location of his operation, but according to the U.S. Industrial Census of 1820, $300 worth of pottery was turned out in that county in that year. Since modern Alexander and the greater part of Pulaski counties were attached to Union County in that day, this potter may have worked along the Ohio River or possibly near the present county seat of Jonesboro, where there was an abundance of alluvial clay.

According to the 1820 census a number of other craftsmen had arrived in Illinois, among them wool and felt hatters, saddlers, and millwrights. In St. Clair County there were manufacturers of iron and steel cutlery, guns, and pistols. And in Union County horn combs were available, made by soaking and boiling cow horns, cutting the softened horns, flattening them between heated iron plates, tempering them in cold water, sawing them into rectangular blanks, and cutting teeth in them with a saw and chisel.

The need for expert craftsmen on the frontier was so great that enterprising Illinois settlers often advertised in newspapers in the East inviting more "mechanics" (as craftsmen were called) to come and settle in their towns. Sometimes they even offered land grants as inducements. Necessities that could not be supplied by the artisan were stocked at small village stores set up and operated by ambitious individuals who often had to travel by horse as far as Pittsburgh to purchase their goods. A store in his vicinity allowed

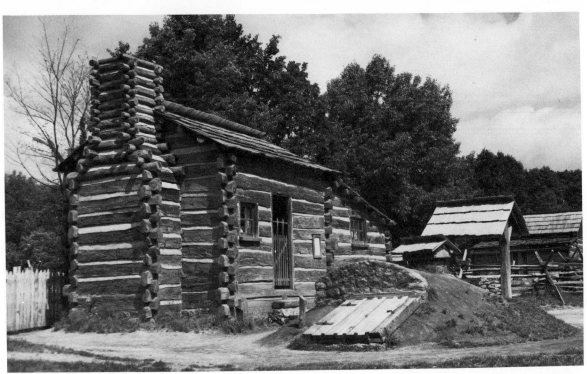

A log "house" as seen in New Salem.
PHOTOGRAPH BY THE
ILLINOIS DEPARTMENT OF CONSERVATION

a settler to trade some of his farm produce, animal hides, beeswax, honey, and even his wife's handwoven textiles for conveniences and necessities such as glass window panes, ammunition, iron and tin utensils, candle molds, and preserving jars. Even English dishes were thus obtainable. Raw materials would be floated downriver to the New Orleans markets, so trade gradually developed and towns grew up around the craftsmen and stores.

Although in 1825 the majority of southern Illinois settlers were still relatively poor hunters, the growth of trade, and especially the advent of the store, had brought a welcome increase in fortune. The more prosperous craftsman, merchant, or farmer usually built a log house — a more com-

fortable, weathertight, and expertly constructed dwelling than the cabin of the typical hunter. More craftsmen and more stores in the area meant his house could be built of logs hewn on two or four sides, notched at the corners, and expertly fitted together so as to shed water and resist rot. The spaces between the logs were daubed with lime mortar, while the fireplace and chimney were often constructed of stone or brick and lime mortar. There were shingles on the roof, floors of closely fitted boards, and windows with glass panes. An occasional settler might cover his log house with hand-rived clapboards, perhaps add-

Art, Crafts, and Architecture in Early Illinois

Typical farm buildings of the more ambitious pioneer. Often a hastily built log cabin became an outbuilding as soon as the owner could build a more substantial house.

PHOTOGRAPH BY THE ILLINOIS DEPARTMENT OF CONSERVATION

trot could be enclosed to make an extra room or a hallway. A pioneer settler of Springfield, Zimri Enos, stated that when Colonel Thomas Cox arrived in 1823,

he immediately engaged in some expensive improvements for that day of limited means, such as his mill, distillery, his hewn log dwelling house with a hall and brick chimneys, one of the finest houses in the county. . . . In addition there were three hewn log houses, viz: the house bought by P. P. Enos, when he came to Springfield, in 1823 . . . a two story double cabin with a porch kitchen; Thos. Cox's double cabin with porch kitchen . . . and John Taylor's. . . . These were the fine residences of the town, and had brick chimneys and were chinked and daubed with lime mortar. . . . These were the days before the introduction of the cooking stove, when the fireplaces, as compared with those of the present day, were huge affairs. Our kitchen fire-

ing laths and plaster to the inner walls. Two families might build a double house with a covered porch between the two structures, or a similar house might be used by one family — one side providing living quarters and the other serving as either a shed or a summer kitchen. The covered area — called a dogtrot — made extra steps for the housewife, but it reduced the number of flies in the main dwelling and created a cool summer shade. When necessary, this dog-

Log structures in New Salem.
At the left is a double log house with a dogtrot, and at the right is the village blacksmith shop with a stone chimney and attached porch. Note the typical rail fence of the southerner and the picket fence of the easterner.

PHOTOGRAPH BY THE
ILLINOIS DEPARTMENT OF CONSERVATION

Early Frontier Craftsmen

place was at least six feet between the jambs and over two ft. deep. The hearth extended past the brick oven and nearly the full width of the kitchen. Attached to the jamb in the fireplace was the iron crane with its hooks to hang the pots and kettles over the fire. In this big fireplace were burned back-logs bigger than two men could carry.... The big kitchen shovel, andirons, crane, and hook were made from bar iron by a pioneer blacksmith for my parents....[4]

At the same time, frontier Illinois offered increasing contrasts in its types of settlers, their origins, occupations, appearance, and relative

The James Leman house-fort with a later addition, near Waterloo. Its style indicates French influence.
AFTER AN EARLY 1900s PHOTOGRAPH BY THE HISTORIC AMERICAN BUILDINGS SURVEY

Characteristic costumes of well-dressed Illinois women of 1804-25 as conceived by Minna Schmitt. Left to right: Sacagawea, or "Bird Woman"; Mrs. John Kinzie; Mrs. Nathaniel Pope; Mrs. George Flower; Mrs. Nathan Heald; Mrs. Seymour Kellogg; Mrs. John Milott Ellis.
ILLINOIS STATE MUSEUM

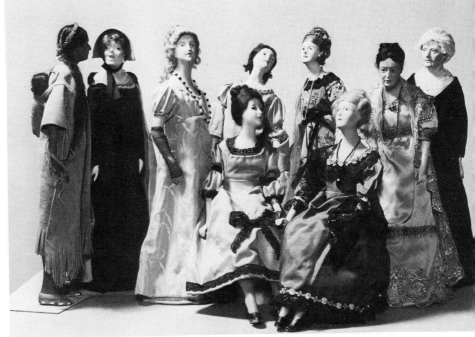

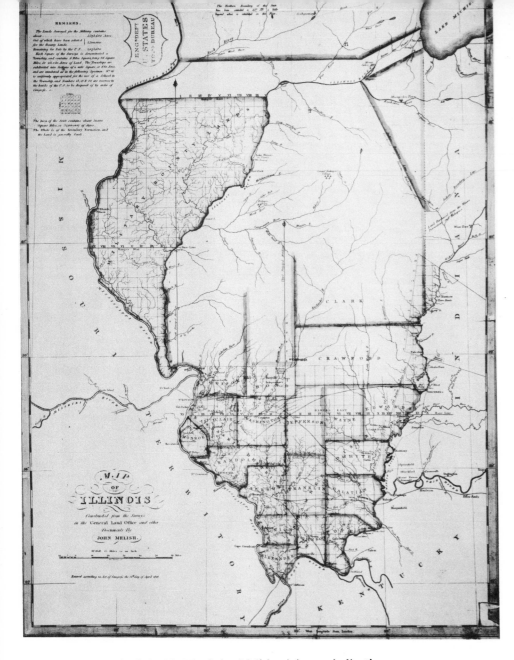

Map of Illinois in 1818 by John Melish, giving an indication of the extent of settlement at that time.
Melish, an engraver from Scotland, had traveled extensively throughout the United States and finally settled in Philadelphia.

62

Art, Crafts, and Architecture in Early Illinois

degrees of prosperity. By 1818 the state's population had reached almost 40,000, but the origin of only about 716 of its citizens can be established. The inconclusive but interesting probability is that about two-thirds of this very small number had come from the South and were largely of non-English stock — the true hunter pioneer of Scotch-Irish, Welsh, or Pennsylvania German ancestry. It may be presumed that only about one-third of the remaining citizens were those more ambitious pioneers: the craftsmen, farmers, merchants, and professional men. These were southerners of English descent from the Atlantic states, Kentucky, and Tennessee, and others from such middle and western states as New York, New Jersey, Delaware, Pennsylvania, Ohio, and Indiana. It is likely that a few were from New England, and probably all had made at least one move before arriving in Illinois. Surprisingly, almost one-tenth of the 716 whose origins are known were of foreign birth — English in the majority, then Irish, German, Canadian, French, and Scotch.

Among these settlers there were wide differences in manners of living and appearance. The hunter pioneer and the more ambitious but poor settler in the forest or small village wore buckskins and simple homespun clothing, while the few who were more affluent, living in towns of thriving commerce such as Kaskaskia, Edwardsville, Shawneetown, and Carmi, were attired much as their counterparts in eastern cities. The

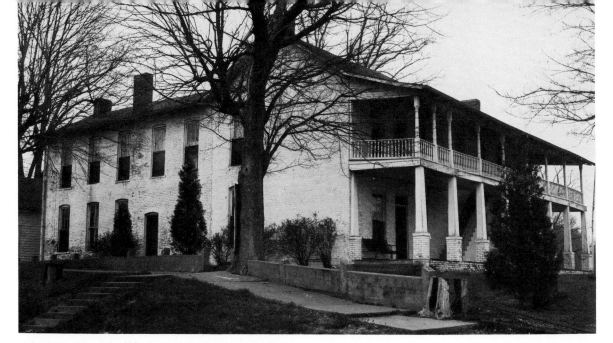

The Rose Hotel in Elizabethtown on the Ohio River. One portion was built by James McFarland ca. 1813.
PHOTOGRAPH BY THE
ILLINOIS DEPARTMENT OF CONSERVATION

fashionable clothing brought with them might be augmented by clothing made of imported and factory-made materials carried by the town merchants: velveteens, cassimeres, broadcloths, linens, printed calicoes, and India muslins. For the fashionable lady who could afford them, the stores also carried worsted and cotton hose, gloves, shawls, silk handkerchiefs, insertion trimmings, and ribbons.

New types of structures arose as more craftsmen arrived. In addition to French upright-timber dwellings, log cabins, log houses, and stone buildings, there were clapboard-covered frame houses with skeletons of hewn timbers morticed and tenoned with wooden pegs (see p. 92). There were also some substantial structures of handmade bricks. Near Bellefontaine James Le-

man built a house-fort, said to be the second oldest brick building in Illinois. About 1813 at Elizabethtown on the Ohio River, Captain James McFarland built a brick inn, now known as the Rose Hotel. A front portion and porch were added to the original structure about 1830, completing the building as it now stands. Both of these brick structures have features reminiscent of old French and southern dwellings.

On the other hand, there were some brick buildings that reflected a new style of architecture brought to Illinois by emigrants from the East. This was the Federal style, which evolved after the Revolution as an assertion by proud eastern patriots of American independence from England. The Colonial building, in the formal, often pompous English Georgian style, seemed inappropriate in a new democracy where men had been proclaimed equal and where the common man had acquired new dignity. What was desired was a simpler, more refined, yet dignified

The Nicholas Jarrot house
in Cahokia, ca. 1800.

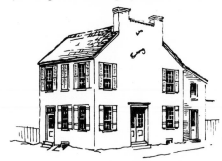

The first capitol building of Illinois in Kaskaskia.

Rawlings House in Shawneetown
where General Lafayette dined in 1825. Razed.

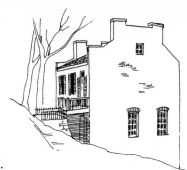

The John Marshall house and bank (ca. 1823).

style that reflected a truer manifestation of the American democratic ideal. Since there were still no architects in America, builders simply eliminated from Georgian plans the heavy stone ornaments and elaborate wooden carvings, moldings, and panelings. Federal structures in New England were often severely plain; those in other portions of the East were frequently given added details: gracefully curved rooms and porches, delicate wood carvings, and moldings.

The plain Federal style as interpreted by middle-class New Englanders was especially suited for the frontier, where expert craftsmen were either scarce or equipped only with simple tools, and builders were limited to materials at hand. The wooden or brick structures were boxlike and devoid of ornament, with the exception of an occasional fanlight or horizontal transom, a small porch, shutters, or delicate, shallow-carved reeds and rosettes in wood members of a doorway or fireplace front. The typically Georgian hip roof was usually replaced with the simple gable roof, each end wall incorporating one or two large chimneys to accommodate necessary fireplaces. The formal arrangement of Georgian dwellings was frequently disregarded by situating the entrance off-center or building a wing at one side.

The oldest surviving brick building in Illinois

is an impressive example of this simple frontier Federal style. It was built about 1800 at Cahokia by Nicholas Jarrot, a wealthy Frenchman who had lived in Baltimore for a time before moving to Illinois. That Jarrot was influenced by the new style he had seen in the East is evident in the two-story mansion he built for his bride. Its walls are sixteen inches thick, of bricks molded and burned on the premises, and Jarrot obtained from his own forest the oak used for the dowels and the walnut used for the framing and millwork. Glass window panes and elaborate interior furnishings are said to have been imported from France to New Orleans, then poled and towed laboriously up the Mississippi River on a keelboat. When Jarrot's home was complete, it had a large ballroom extending across the entire front of the second floor, where the civic-minded Frenchman entertained many of the territorial officials of the day.

On December 3, 1818, when Kaskaskia became the first capital of the new state of Illinois, the new governmental offices were housed in a simple two-story brick structure of the Federal style. Shawneetown, on the eastern edge of Illinois, was the state's southern land office and the chief port of entry into the state, but its population was largely transient. This accounts for the

fact that all of its approximately thirty structures, even the state's first bank (operated by John Marshall), were log buildings. Not until about 1821 did the first Federal brick structures appear in Shawneetown. First was the Rawlings House — an inn — and then two more were erected. These included John Marshall's new combination home and bank, which is the only remaining Federal-style structure and is itself in a ruinous state because of a tornado in recent years. Originally the building had an uninterrupted view of the Ohio River, but years of spring floods made it necessary that a levee be constructed directly in front of it to control the river, costing the house part of its view. A second front entrance was built on the upper level and also a short bridge which extends to the top of the levee.

Federal-style buildings of either wood frame or brick construction were erected in older portions of Illinois into the 1840s. Many survive to this day and can be seen along country roads, on waterfronts, on former stage routes, or on old streets that are perhaps in what are now slum areas of the expanded towns. They may once have been inns, shops, mills, or homes. So severely simple are these old structures that their age is often unsuspected by the average person not acquainted with their history.

Art, Crafts, and Architecture in Early Illinois

7 Early Encounters with the Prairies

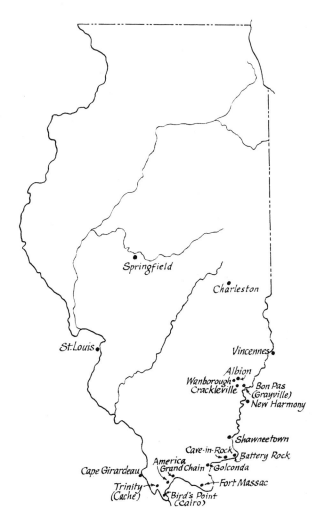

Springfield

Charleston

St. Louis

Vincennes

Albion
Wanborough
Crackleville
Bon Pas
(Grayville)
New Harmony

Shawneetown
Cave-in-Rock
Battery Rock
America
Grand Chain
Golconda
Cape Girardeau
Fort Massac
Trinity
(Cache)
Bird's Point
(Cairo)

The pioneers who had spilled over the mountain barriers into Tennessee, Kentucky, Ohio, and Indiana had become thoroughly accustomed to a forest environment. From wooded regions they had moved westward through seemingly inexhaustible forests, depending always upon wood for building materials and for fuel. Prodigious amounts of timber were used to provide charcoal for the blacksmith; thousands of forested acres were burned to make clearings for farms. Gradually vast forests were destroyed, so that today there remain in the East scarcely a hundred acres of virgin timber. In southern Illinois the early settlers found a familiar environment which called for little change in their mode of living. Having no worry for the future, the pioneers chopped and burned, planted in the forest soil, and built their homes.

Illinois, however, was only about one-quarter forest, the rest being prairie land, and as the pioneers settled beyond the southern regions, they had their first encounter with an unfamiliar and hostile environment. The precious woodlands became increasingly thinned and were interspersed with grassy meadows or prairies. In some places dense forests were to be found only along the rivers and streams, stretching like long fingers through prairies dotted with woodland groves.

In other places prairies stretched without interruption to the horizon — awesome, endless expanses of flowers and grasses in summer as high as a man on horseback. Such expanses of grass waving in the wind evoked an image of the sea; an occasional grove of trees, an island; and the covered wagon that traversed the prairie, a ship (and thus the term prairie schooner).

It is quite understandable that American pioneers avoided the prairies for their settlements and vied with one another for the forests that remained. *The History of Sangamon County* states:

[In 1819] when [Edward] Pirkins . . . and his father-in-law, Mr. [Robert] Pierce, were looking at the country, they were at Island Grove, and Mr. Pierce thought it ought to be called "Lost Grove," because there was not more than enough timber for one family, and, as one family could not live alone, it would be lost. They went to Richland Creek, because there was more timber there. Claims were laid to it all before it came into market, and when it was ready for entry, the timber land was all taken very soon. It had been a source of great anxiety because there were pre-emption laws to protect the settlers, and they felt very much relieved when they had generally secured their homes. This happiness did not last long, for they soon began to worry

Prairies in Illinois about 1820.
The prairies are indicated in black.
ROGER C. ANDERSON,
UNIVERSITY OF WISCONSIN ARBORETUM

horses and cattle to death in a few hours. In the fall, seed stalks became tinder-dry, and lightning or the Indians might ignite a fire which in a matter of moments could sweep the prairie with a solid wall of flames. In the winter the snow blew unchecked into great drifts, bringing death to men and animals. In the spring the snows melted and the rains came; flatlands and valleys became swamps which could bog the traveler's wagon in deep mire and serve as a breeding ground for millions of the mosquitoes which spread the "ague" — malaria. With the arrival of each new summer, the unfamiliar and hostile prairie cycle would begin again.

Pioneers from the South began to make clearings for their farms at the edges of the prairies,

thinking that soil which would not support trees could not support crops. Some chopped holes in the sod with hoes and planted seed, having tried unsuccessfully to plow furrows with a few horses fastened to wooden mold-board plows. To their amazement, those who planted on the prairie realized a crop whose yield far exceeded that of crops planted in forest soil.

In 1817 there arrived in Illinois two well-to-do and cultured Englishmen, typical of the third type of pioneer — the ambitious promoter with money to spend. In England wood had long been scarce, and for hundreds of years the wide open meadows had been cultivated. These two men — George Flower and Morris Birkbeck — knew the scientific methods that were necessary to conserve the soil. Tiring of the excessive taxes and restrictions in England resulting from the Twenty Years' War and the War of 1812, they had come to the United States in hopes of purchasing cheap

Replica of the log house
(ca. 1831) of
Thomas and Sarah Lincoln.
parents of Abraham Lincoln.
On Goosenest Prairie,
nine miles south of
Charleston in Coles County.
PHOTOGRAPH BY
RICHARD PHILLIPS

about how long the timber would last. Mr. Pirkins remembers meeting four or five of his neighbors when the timber question came up. He gave it as his opinion that he would cut the last stick of his timber in twenty years, and he would have to leave the country.[1]

In addition to its lack of timber, the prairie — awesome and beautiful in the summer — could be extremely treacherous; insects could sting

Art, Crafts, and Architecture in Early Illinois

Pen-and-ink sketch of Morris Birkbeck made by an unknown artist.

good land on which to establish a colony of English farmers and artisans.

Like most European travelers, Birkbeck and Flower were critical of the lack of culture among Americans and the inefficiency of their farming methods. They did, however, express great admiration for the freedom possessed by the ordinary man in this country. Arriving at Shawneetown, Birkbeck wrote:

This lamentable deficiency in science and taste, two such abundant sources of enjoyment, must not be attributed to a want of energy in the American character. Witness the spirit and good sense with which men of all ranks are seen to engage in discussions on politics, history or religion, subjects which have attracted, more or less, the attention of everyone. Nature has done much for them and they leave much to Nature; but they have made *themselves* free; this may account for their indifference to science, and their zeal in politics.[2]

For a number of reasons Illinois was enticing to the two Englishmen: there was plenty of good farmland still available; the average man could become an independent landowner, rather than having to remain a renter; Englishmen could vote and hold any political office except the presidency; and with moderate industry a man's for-

tune was bound to grow. Unlike the average early pioneer, the Englishman found the Edwards County prairies both charming and desirable, reminding him of the beautiful parks and meadows back in England. A later English visitor, William Blane, expressed a favorable impression which would also have seemed strange to the Americans: "The prairies form a most agreeable prospect, especially after one has passed through such an interminable wilderness of trees."[3]

Flower and Birkbeck each purchased 1,500 acres of land in Edwards County and laid out the English settlements of Albion (an old term for England) and Wanborough (the name of Birkbeck's English estate) on a high, grassy meadow between Bon Pas Creek and the Little Wabash River. Birkbeck remained to superintend the building of temporary American-style log cabins, while Flower returned to England to round up a colony. At the end of the following year, sixty persons, including Flower, his wife, and his parents, returned to what came to be known as the English Prairie. Ambitious gentlemen, Flower and Birkbeck intended to live no longer than necessary in crude cabins. They planned to build as soon as possible permanent homes of brick and stone, using the log cabins as outbuildings. Neither were they satisfied with the homemade furnishings of their American neighbors; from the abundant cherry and walnut trees of the surrounding forests, local cabinetmakers could provide to order whatever could not be brought from England.

Realizing that if their towns were to grow and prosper they would need more settlers, and in particular more expert craftsmen, the leaders kept journals and industriously wrote letters urging people to emigrate. These letters describe in

Heavy flayed stone lintels, often with projecting keystones

Hip roof very common

Palladian window

Fanlight

Triangular pediment at the cornice line

Projecting horizontal band at second-floor level

Stone quoins at corners

Central entrance with a strict formal balance of elements at the sides

SOME EASILY RECOGNIZABLE FEATURES
OF THE GEORGIAN STYLE.

glowing terms the conditions and advantages of life in Illinois. By 1821 these writings had been published in over eleven editions in Philadelphia, England, Ireland, Germany, and France, helping to accelerate the movement of easterners and Europeans toward Illinois.

After 1819 common American log cabins were no longer erected in Albion. Like other ambitious emigrants to Illinois, the English wanted their permanent homes to look as much as possible like those they had left. Consequently, using available craftsmen, tools, and resources, they began improvements: English Georgian features were added to existing log structures, and the new brick buildings assumed the familiar Georgian forms. The result was a rebirth on the frontier of the old Colonial style of architecture that many patriotic Americans now considered outmoded and ill-suited for a democracy. Nonetheless, Illinois, anxious to promote population growth and new industries, welcomed industrious foreigners. Thus, at the same time that Federal structures were being erected in American settlements, Eng-

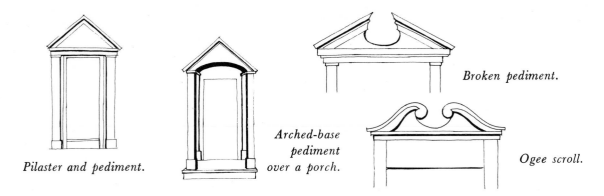

Pilaster and pediment.

Arched-base pediment over a porch.

Broken pediment.

Ogee scroll.

lish Georgian buildings would be erected in this and other English settlements for some years to come.

By 1820 Flower had transformed his parents' 43-by-40-foot hewn-log double cabin into an eleven-room mansion that was the wonder of the prairies around. Park House was built in the center of a thirty-acre woodland area at the edge of the English Prairie (see p. 87). Hampered on the frontier by the shortage of skilled workers who could cut stone — the common material for houses in England — George Flower did what he could with materials at hand; he applied stucco to the front of the log house to give at least an appearance of stone. Grooves at the corners imitated the typically Georgian blocks or quoins. Flanking the hip-roofed main building with two properly balanced wings, he added further Georgian touches: Venetian blinds (or shutters) at the windows, a hipped roof with dormers, and a front door framed by pilasters and topped by a classic pediment. The traditionally formal Georgian arrangement was further carried out in a semicircular drive leading up to the door through a yard planted with imported bluegrass and landscaped with trees and formal flower beds. Flower utilized popular American

features at the back of the house, however, covering the logs with white-painted clapboards and adding a long porch. From French windows that looked out on this porch, Flower and his parents could see their garden with grass plots and flowering shrubs laid out in the English style. Beyond was a peach and apple orchard.

The interior of the house included a hall which divided the rooms equally on each side. Each room had a fireplace and painted or wallpapered plaster walls, and one carpeted room housed a pianoforte from England and a fine assortment of books — luxuries of great scarcity on the frontier.

By 1821 additional English settlers had arrived in Albion and there were thirty habitations, each on a five-acre plot of land. The community had a bricklayer, a wheelwright, a cooper, and a blacksmith. Four miles east on Bon Pas Creek there was a sawmill. Buildings in the town — some of brick — included a well-supplied general store, an inn, a chapel, a post office, and a small library — the first in Illinois. There were the usual crops of grain and vegetables, and also small plantations of tobacco, hemp, and cotton. Flower himself had the finest cattle and a flock of 400 sheep.

Less than two miles to the west of Albion, in Birkbeck's settlement of Wanborough, there were twenty-five cabins, a tavern, and several lodging houses by 1822. There was also a horse or ox mill, a malt house, and at least one brick store. The latter was owned by Frederick Rapp, who also acted as business manager for George Rapp's thriving German town of Harmonie, located about eighteen miles distant across the Wabash River in Indiana. Birkbeck had moved from his first log cabin into a substantial nine-room house, Cauliflower Lodge. Its main construction was half-timber (similar to old houses still seen in England today), with the interstices between the

Portion of a wall showing timber construction with brick-nogging.

timbers filled with bricks or "brick-nogging." However, in outward appearance it was apparently more American than British, as the half-timber skeleton was covered with whipsawed clapboards, a luxury for an Englishman who had been accustomed to a scarcity of wood. Southern features were double porches designed for relaxing in the shade and at least one room — a summer kitchen — separated from the main quarters for protection against the heat from cooking during summer months. The home was described by a traveler named Faux as "very capacious, furnished with winter and summer apartments,

*Sketch by Lesueur that is believed to be of Morris Birkbeck's home
at Wanborough, Cauliflower Lodge.
Dated May 19, 1826.*
AMERICAN ANTIQUARIAN SOCIETY

Rear view of the Flower home sketched in 1826 by Charles Lesueur.
AMERICAN ANTIQUARIAN SOCIETY

*Side view of the above group of buildings — probably a depiction of
the winter and summer quarters of Cauliflower Lodge described by Faux.
Sketch made by Lesueur May 18, 1826.*
AMERICAN ANTIQUARIAN SOCIETY

piazzas and balconies and a fine library to which you ascend by an outward gallery. Every comfort is found in this abode of the Emperor of the Prairies as he is here called."[4] Furnishings included goods from England valued at $4,500, among them the first piano to arrive in Illinois. For $600 Birkbeck hired a cabinetmaker and a wheelwright to make furniture and tools and later purchased $500 worth of articles made of pottery, glass, and iron.

As early as 1817 Flower had advertised the immediate need for a potter in his settlement. The settlers from England, a country long expert in the production of fine pottery, could not be satisfied with crude wooden containers. Potters of English and German descent had already moved from New England and the eastern seaboard into western Pennsylvania, Ohio, and Indiana, but there is no record of a potter in Illinois before 1820. Not until about 1825 were Flower's efforts rewarded in the person of Elias Weaver, a German potter who left then-dissolving Harmonie to work at the new kiln in Albion built by Flower's father. Slate clay in the area, discovered five to thirty feet below the surface of the earth during the process of digging wells, provided him with a fine resource for making stoneware pottery. He was replaced by George Bower, a potter

Unglazed stoneware jug made at Wanborough about 1825-30.
EDWARDS COUNTY HISTORICAL MUSEUM

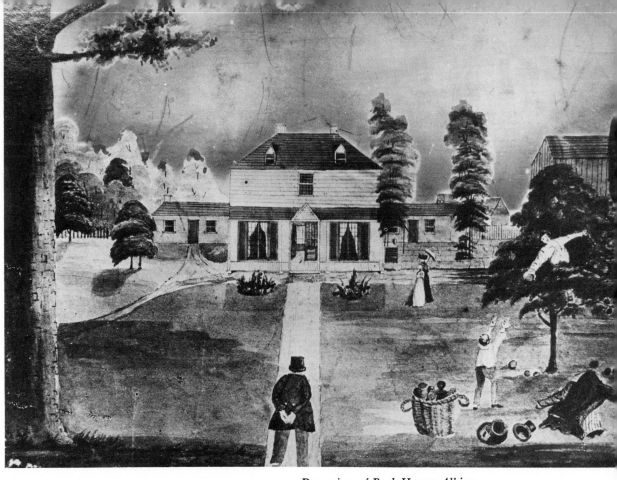

Rear view of Park House, Albion. A watercolor by George Flower, ca. 1820-30.
ILLINOIS STATE HISTORICAL LIBRARY PHOTOGRAPH

from Bavaria who had practiced his art in France, then in New York City, Pittsburgh, Cincinnati, and elsewhere in America before coming to Albion in 1831. Bower worked in Albion and in the neighboring settlement of Wanborough, where he shared the trade with Thomas Cooper, another potter. Today only a few pieces known to be English Prairie pottery remain, including two large stoneware jugs on display in the Edwards County Historical Museum at Albion.

Birkbeck and Flower are well known as early promoters of scientific agriculture and settlement in Illinois, but it is less well known that George

Flower (1787-1862) may also have been the state's first resident artist. He himself wrote: "When a youth, I accompanied my drawing master on his annual sketching tour into the southern counties of Wales and adjoining counties of England. From some three hundred pencil sketches, we selected six for body color, an art I was then learning. Like many first productions of children, my parents put these, my first efforts, into frames and hung them up. By some means

Art, Crafts, and Architecture in Early Illinois

they came in our baggage, and were hung up in my cabins on the prairies."[5] After his arrival in Illinois, Flower sketched in pen and ink and painted in watercolors — a medium that had already become very popular in eastern America as well as in England. Flower made watercolor paintings of both the front (see p. 87) and rear of Park House. These charming examples of "primitive" painting betray the artist's lack of formal training by flatness and naive distortion of perspective, but they display nonetheless his innate talent. Flower's pen-and-ink sketches of plants illustrate his own manual on horticulture, and in the same medium he later made an illustrated map of a portion of the English Prairie. Richard Flower, George's father, seems also to have had artistic talents. He is said to have once had a display of his own paintings at his inn in Albion, although apparently none of these paintings still survive.

Many travelers to Illinois visited the growing prairie towns of Albion and Wanborough. Some — like those who today expect to find the familiar luxuries of home in less affluent foreign lands — were quite critical. Artist traveler Adlard Welby from Lincolnshire, England, published in London (1821) a travel book entitled *A Visit to North America and the English Settlements in Illinois . . .*, illustrating it with a map and a number of engravings probably based on sketches he had made on his 1819-20 trip.

The leaders of Albion and Wanborough were aware of the great desirability of raising the standard of culture on the frontier. In 1824, while on a business trip to England with his son, Richard Flower visited Robert Dale Owen, social reformer and owner of cotton mills in New Lanark, Scotland. Extolling the advantages of life in the

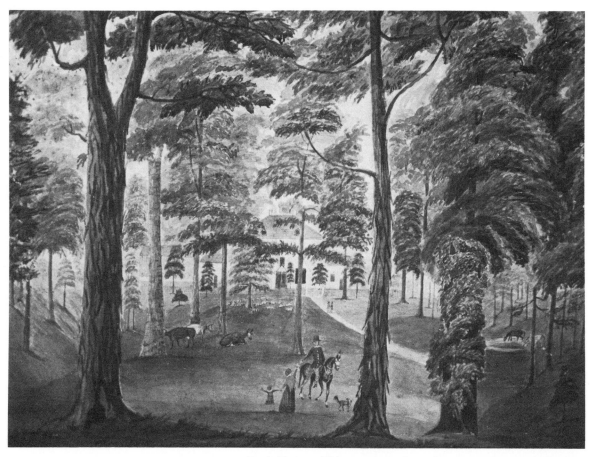

Park House, Albion, as seen through a grove of trees at the rear. Watercolor painting by George Flower, ca. 1820-30.
ILLINOIS STATE HISTORICAL LIBRARY PHOTOGRAPH

Wabash valley, Flower persuaded Owen to come to Indiana to look over the town of Harmonie, then being abandoned by the Rappites. That Christmas season was spent by the Rapps, Robert Owen, and his son William at Richard Flower's home in Illinois.

In spite of Birkbeck's urging that Owen also investigate land in Illinois for his settlement, Robert Owen purchased the town of Harmonie

on January 2, 1825. At this remote spot on the frontier Owen established a remarkable community of distinguished scientists, teachers, artists, and artisans. The community, renamed New Harmony, included geologist William McClure, former librarian of the Academy of Natural Sciences in Philadelphia Thomas Say, and noted artist and naturalist Charles Alexandre Lesueur, whom Flower had known in Philadelphia.

Owen's nearby project undoubtedly promised to be an exciting venture for both Flower and Birkbeck; but before the distinguished intellectuals arrived at New Harmony in 1826, Morris Birkbeck died. He had been a frequent visitor to Harmonie since 1817, but on June 5, 1825, returning from a visit to New Harmony, he drowned while attempting to swim his horse across the Fox River.

Of all the celebrated members of New Harmony, Charles Lesueur is of special interest to Illinois historians. Born in France in 1778, Lesueur had won renown in Europe as a member of the scientific explorations into Australia. In 1816 he came to America and taught art in Philadelphia until he was persuaded to leave for the Indiana frontier. At New Harmony Lesueur kept busy: he taught art and engraving, painted and sketched, wrote, published scientific books, made field trips in the area, and even conducted a number of flatboat trips to New Orleans to sell some of New Harmony's surplus produce. In February 1826 Lesueur set out on a flatboat for a visit to the lead mines of Missouri. Sketching as he went, he recorded such scenes of river life as the interior of a boat's cabin, the preparation of a meal before a fireplace, and the passing of a keelboat with men at the poles and rudder. He also sketched Shawneetown — the port of entry into Illinois from the Ohio River — and Battery Rock, Cave-in-Rock, the nearby islands, and Golconda. At Smithland, Kentucky, Lesueur took a steamboat to Trinity (now Cache), Illinois, where the swift river current carried the boat past the dock. Lesueur and his party were forced to disembark unceremoniously and clamber up a steep river bank to reach the town. After making a sketch of Trinity, Lesueur spent

Sketch made by Lesueur on the night of March 1, 1826, when the artist and his two companions tramped overland from Trinity (now Cache), Illinois, to reach the ferry to Commerce Town, Missouri. The sketch shows Dr. Trost seated on a log, Mr. Cullok lying on the ground, and Lesueur standing by a fire.

a rainy night with his party tramping over the tip of Illinois toward the Mississippi River — a shortcut similar to that taken almost sixteen years earlier by another great artist and naturalist John James Audubon. The following day the party took a ferry to Commerce Town in Missouri, from there proceeding to Cape Girardeau and the inland mines. Lesueur sketched the town of Trinity again on his return trip to New Harmony.

On May 17, 1826, Lesueur set off for another trip into Illinois, this time presumably to visit his friends at the English Prairie settlements. Lesueur sketched some of the first structures at Bon Pas

(which became Grayville in 1837) at the mouth of Bon Pas Creek on the Wabash River. Traveling northward, he seems to have proceeded directly to Wanborough. A sketch marked "From the Piazza of M." shows a rolling prairie and distant hills, very similar to the view seen today from the former site of Morris Birkbeck's home. Lesueur presumably was a house guest for a few days at Cauliflower Lodge, as his sketches include two separate views of an extensive building which answers to Faux's description (see p. 69). Another sketch depicts rolling fields and American- and English-type fences in the foreground similar to Birkbeck's, as described by an English-

Art, Crafts, and Architecture in Early Illinois

Bon Pas (later called Grayville) at the mouth of Bon Pas Creek on the Wabash.
Sketch by Lesueur May 17, 1826.

On the left, a sketch by Lesueur (May 18, 1826) marked with the
inscription "from the Piazza of M." According to Thomson, A Pioneer
Family (1953), one of Birkbeck's daughters wrote in 1819: "I think you
can hardly imagine a more beautiful situation. We are backed to the
north and north west and west by fine woods of our own and a fine
varied landscape of woodland and grass opens before us to the south
and south east bounded by a beautiful outline of wood
at four or five miles distance."

The view above is probably from the same piazza.
Notice the typical English fence in the foreground and the typical
Virginia rail fence of an American settler in the mid-distance.

Early Encounters with the Prairies

Unidentified house, probably in the vicinity of Albion.
Sketch by Lesueur in May, 1826.
AMERICAN ANTIQUARIAN SOCIETY

man named Cobbett who lived in the area for a short time. There is also a sketch showing an unidentified house with fanlighted windows and a Georgian-type pediment centered on and in line with the porch roof.[6]

It is believed that Lesueur then visited Albion. Two previously unidentified views answering the description of its first tavern show a double log structure with a dogtrot in the middle and a common roof and porch uniting the units. The dogtrot evidently provided a pleasant place for dining in warm weather, away from the heat of the fireplace and commanding a lovely view. Lesueur drew a table in this area, covered with a cloth and laden with goblets and dishes. A view of the tavern porch shows a dozen or so patrons in enjoyable conversation.

Strolling about the vicinity on May 22, Lesueur made additional sketches: workers in a field with a man on horseback dressed in an English-

Two views of what is believed to be the Albion tavern, both sketched by Lesueur in May of 1826. Above, a table set for dining in the dogtrot.
AMERICAN ANTIQUARIAN SOCIETY

Art, Crafts, and Architecture in Early Illinois

Sketch titled "Depart de chez M. flower,"
depicting Lesueur's party leaving Flower's home
to return to New Harmony.
AMERICAN ANTIQUARIAN SOCIETY

Lesueur and his friends
enjoying a picnic supper on
May 26, 1826.
AMERICAN ANTIQUARIAN SOCIETY

Sketch by Lesueur
on May 22, 1826,
showing workers
in the field.
AMERICAN
ANTIQUARIAN SOCIETY

type coat; an unidentified house with Georgian features; and another house, now positively identified as the rear view of the Richard Flower residence (see p. 69). A later sketch, entitled "Depart de chez M. flower," pictures Lesueur's mounted party taking leave of Flower's home. They seem to have taken their time returning to New Harmony, dining under the trees on the evening of May 26 and proceeding — probably by flatboat — the following day down Bon Pas Creek to the Wabash River and New Harmony.[7]

During the years 1828 to 1834, Lesueur made a number of leisurely trips on cargo-carrying flatboats down the Wabash, Ohio, and Mississippi rivers, sketching Tower Rock, Golconda, Cave-in-Rock, and Fort Massac. Other of his

drawings show the town of America, the river bank at Grand Chain, and Bird's Point — now part of Point Fort Defiance State Park at Cairo — at the confluence of the Ohio and Mississippi rivers.

Lesueur lived for twelve years at New Harmony, ten years past the time when Owen's utopian experiment failed. In the year 1837 he sailed back to his native city of Le Havre in France to become the first director of the Le Havre Museum of Natural History. He took with him nearly all of his thousands of watercolors and sketches, including 1,200 illustrations of American scenery. Ten years later, in 1846, he died.

Although Lesueur considered himself primarily a scientist, being in fact the first person to study and paint the fishes of the Great Lakes, it is as an artist that he has figured most significantly in the history of the early Midwest. His sketches, engravings, and watercolors of American scenes are extensive contributions to the visual history of this section of growing America. Although most of his art is still in France, photographs of 803 of his sketches are now held at the American Antiquarian Society in Worchester, Massachusetts.

At about the same time that Lesueur was sketching scenes near the Wabash River, another foreign artist, Captain Basil Hall (1788-1844), was traversing the Illinois prairies above Albion. Hall, a British naval officer and artist reporter, had come to America in 1827 and had for two years traveled about the country, through the East and the South, then up the Mississippi and Ohio rivers to Louisville. Hall is probably best known to midwesterners for his sketches of boatmen and various other characters along the Ohio

River. His first contact with Illinois, however, occurred when he took the stagecoach on the road above Louisville to Vincennes, crossing over Illinois toward St. Louis. The opening of the Erie Canal in 1825 had resulted in the passage of a mighty stream of eastern emigrants along this road toward their new homes in the West. Men, women, and children on foot, horseback, and in wagons and carriages of every description often took the northward route toward the new and rapidly growing settlements in central Illinois. Captain Hall wrote: "The Great Prairies of America are familiar, if I mistake not, to the imagination of Europeans, but with what degree of correctness I can hardly say. We certainly were not disappointed and were quite sorry to part with them. We crossed several in the State of Illinois, one of which, the Grand Prairie, was, I think, twenty miles wide where we passed it. Farther to the north, however, it becomes many times wider. . . ."[8]

Hall carried with him on this journey the re-cently invented camera lucida, a device which uses mirrors to project the image of a landscape onto paper so that the outline of the view can be traced. The advantages of this primitive type of camera for the artist reporter were considerable. According to Hall,

it enables a person of ordinary diligence to make correct outlines of many foreign scenes to which he might not have leisure, or adequate skill, to do justice in the common way.

It should be recollected that in most cases, it is not striking or beautiful views that we require, but merely correct representations, as far as form is concerned, of those familiar objects which strike the eye of the traveler every where in his path as characteristic of the country he is visiting.

If his sketches be further relieved by lights and shades, another step is made towards the attainment of this purpose; for even a very few such touches, if strictly true to nature, often serve to place new scenes more distinctly before us than the most elaborate, or the most graphic verbal description can ever hope to accomplish.

Sketch by Basil Hall showing the 1828 costumes of backwoodsmen and a steamboat pilot. From his Forty Etchings.
ILLINOIS STATE
HISTORICAL LIBRARY

Art, Crafts, and Architecture in Early Illinois

Village of Shawneetown on the right bank
of the Ohio, in the State of Illinois.
14th May 1828.

During the late rise of the Ohio most
of these houses had several feet of water
over the floor of the lower storey. At pre-
sent the river is, I should think 15 or 20 ft
below the floor.

*Basil Hall's sketch inscribed "Village of
Shawneetown on the right bank of the Ohio,
in the State of Illinois. 14th May 1828."*
LILLY LIBRARY, INDIANA UNIVERSITY

. . . It adds greatly to the advantageous and agreeable use of the Camera, to have a portable table as part of the apparatus. For this purpose, Mr. Dolland, instrument-maker in St. Paul's Church Yard, London, has recently devised a small brass frame which folds up when not in use, so compactly as to stow away within the legs of a stand not larger than a walking-stick. . . . With his Sketch Book in one pocket, the Camera Lucida in the other, and the sticks above mentioned in his hand, the amateur may rove where he pleases, possessed of a magical secret for recording the features of Nature with ease and fidelity, however complex they may be, while he is happily exempted from the triple misery of Perspective, Proportion and Form, all responsibility respecting these being thus taken off his hands.

In short, if Dr. Wollaston, by this invention, have not actually discovered a Royal Road to Drawing, he has at least succeeded in Macadamising the way already known. . . .[9]

Hall's sketches of pioneers, riverboatmen, and American scenery are not so numerous as Lesueur's sketches and are less highly regarded from an artistic standpoint; nonetheless, they constitute a rare factual record of certain aspects of American expansion westward and are truly

interesting as examples of the earliest form of "photographic" art.

Fascinated by the ways of everyday life in a democracy, Europeans like Hall and Lesueur avidly sketched America's landscape and the people both at work and at play. This must have at first aroused curiosity, suspicion, or even contempt among most Americans, who saw little that was novel in their commonplace surroundings or everyday way of life. To their minds, a man would better profit to spend his time at more practical enterprises; if he had to be an artist, it was better that he paint portraits — an occupation by which one's bread and butter could more easily be earned and which also served a useful purpose. Nevertheless, the European's continuing interest in the American's way of life, coupled with the American's own sense of pride in Jacksonian democracy, eventually influenced some artists in the East. They began to paint what is today known as genre subjects — ordinary people, dressed in everyday clothes, performing their daily tasks. They also began to take an interest in the landscape, as exemplified in the 1820s by the Hudson River School of painters.

Among midwesterners the early influence of such artists was minimal, except in the case of one man — George Caleb Bingham, Missouri's great painter of Mississippi River boatmen. In frontier Illinois, visits by foreign artists seem to have been recorded only in their own writings and sketches, and their influence was felt almost exclusively by the settlers on the English Prairie. The idealistic experiment at New Harmony, with its scholars, authors, scientists, artists, and distinguished visitors, held a fascination, at least for members of the Flower family, who hoped to establish Albion as a cultural center equal to New

Picture mat with knife carving and watercolor decoration. Made by George Flower's sister, Mary Elizabeth, at her art school, Hazel Hill, ca. 1840-48. A detail of the carving is below.
EDWARDS COUNTY HISTORICAL MUSEUM

Harmony. George Flower's sister, Mary Elizabeth (Mrs. Hugh Ronalds), did establish an art school at her home, Hazel Hill, sometime after 1824, but the high hopes for Albion were unfortunately never realized. A great general depression hitting America in 1837 caused federal funds to be cut off, with the result that the state banks of Illinois failed. By 1842 George Flower was near bankruptcy. He had invested perhaps $150,000 in the community for building mills, roads, courthouse, and library and for purchasing supplies from Harmonie and later New Harmony. The finest breeds of livestock and seeds had been expensively imported from England. In 1846 he deeded his house to his son and went to live at

Art, Crafts, and Architecture in Early Illinois

The Perry Huber house (1840), a Georgian structure south of Albion at the former site of the English village of Crackleville.

New Harmony, where he became an innkeeper. Later he moved to Mt. Vernon, and on January 15, 1862, on a visit to Grayville in Illinois, Flower died.

There remain today in the vicinity of Albion few reminders of the English Prairie years. The town of Wanborough has completely disappeared. Having begun to dwindle shortly after Birkbeck's death, it received its death blow when Albion became the county seat. As early as 1835 a traveler named Frederick Julius Gustorf reported that there remained only "eight or ten dilapidated huts, a mill, a workshop and a pottery."[10] Flower's Park House was destroyed by fire in 1870, and many other old structures at Albion have been torn down. One outstanding example of prairie Georgian architecture still remains, however. The Frank B. Thompson home (now the public library), built in 1842, is less elaborate than some English Georgian mansions of the East, but it reveals the basic characteristics of the Georgian style: a strict formal balance of

elements in the entire structure; a classic pediment rising at the cornice line; splayed stone lintels with projecting keystones above the windows; a projecting horizontal band at the second-floor level; fanlights in the gable and above the door (see p. 139). This brick building is painted gray, in imitation of stone. A similar structure, the Perry Huber house (1840), situated south of Albion in what was once the English town of Crackleville, is of a natural brick color. Various old implements and furnishings of English Prairie homes are now displayed in the Edwards County Historical Society Museum, and George Flower's piano — the second in Illinois — is owned by the Chicago Historical Society.

A few English Georgian structures may have been erected early in the century, not by English immigrants but by tradition-bound Americans who had come from the regions of the original English colonies. However, unlike English set-tlers, affluent easterners and southerners had little motivation to move to a raw frontier; hence it is likely that all but the poor or adventurous remained in their familiar and more comfortable surroundings until the frontier had become more civilized and the Federal style was well established.

The tendency to cling to tradition after the advent of a new style resulted in periodic mixtures of architectural elements. Changes were never abrupt, and dates for a particular style period can only be arbitrarily set. The new Federal mode was actually a transitional style, a first step toward a more American architectural expression of democratic ideals. Vestiges of Georgian influence remained in its basic structure and in occasional decorative motifs on the exterior, especially variations of the traditionally popular Venetian or Palladian doorway, window, or porch — as seen on both the Frank B. Thomp-

Origin of the Palladian window.
A portion of an arcade of the Basilica in Venice.

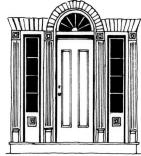

An Illinois adaptation — entrance detail of a former inn near Wenona.

son and Perry Huber houses. The basic design concept for these related features originated in the Italian Renaissance with the great architect Palladio. It had become popular for Renaissance structures in England during the reigns of the Georges, was introduced into the American colonies about 1720, and was carried with its variations to Illinois by both English and American settlers. Palladian motifs reappeared about 1850 with the Renaissance Revival, showed up later on conglomerate types of structures, and in Illinois reached the peak of their popularity with the revival of fully developed Georgian architecture beginning about the end of the nineteenth century.

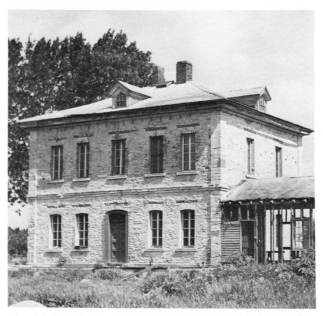

An old stone house near Lomax, Henderson County, with a typical hip roof and other Georgian features.
PHOTOGRAPH BY RICHARD PHILLIPS

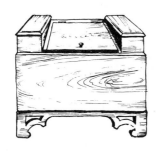

Dough chest made at Albion.
DWAIN O. MASSIE COLLECTION

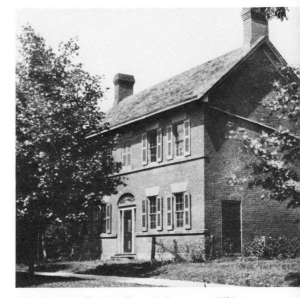

The former George French house at Albion, now razed, was built in 1841. An example of the Georgian style with a gable roof.
EDWARDS COUNTY HISTORICAL SOCIETY PHOTOGRAPH

Art, Crafts, and Architecture in Early Illinois

8 Patriots and Portraits

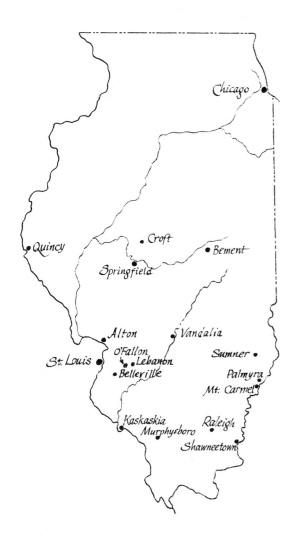

A. *Seal of Illinois Territory.*

B. *First Great Seal, adopted after Illinois' admission to the Union in 1818. Both of the above seals were sketched by the late Brand Whitlock for the* Journal of the Illinois State Historical Society.

C. *Second Great Seal. Though its design differs from the first, it is virtually unchanged in the heraldic sense.*

D. *Illinois Great Seal, designed in 1868.*

SECRETARY OF STATE, STATE OF ILLINOIS

Democracy, lived and felt on the midwestern frontier as perhaps nowhere else in the land, saw rich man and poor, foreigner and new American, craftsman, lawyer, and merchant working together. These people were proud of their freedom, their land, their leaders, and the fruits of their combined labors. Democratic spirit and patriotism were manifest in the patriotic symbols they used and in the names they gave to many of the early Illinois towns: Equality, Liberty, America, Independence, Union, Columbia, and Eagle.

The eagle, symbol of the ancient republic of Rome, was adopted in 1788 as the symbol for the Great Seal of the United States. Eliminating the words "E Pluribus Unum," Illinois Territory also used the eagle on its seal. When Illinois became a state in 1818, the eagle was chosen for the state seal, bearing the motto "State Sovereignty — National Union," and the eagle remains an important part of the seal today.

This symbol of American freedom became popular as a decorative motif. In the East it was stenciled on chairs, molded in glass for whiskey and rum bottles, painted or carved on clocks, printed on cottons, and engraved on silver. On the western frontier, where craftsmen were more scarce, the symbol was used on painted shop and tavern signs and on textiles produced in the home. In 1823 Martha Ann Shaw of Crawford County made an unusual white bedspread using cotton which had been raised on her farm and spun and woven in her home. Around the edges of the spread she worked out a scalloped design by

tracing around a pewter plate. In the center of the spread she traced a large American eagle with outspread wings, and she completed the bedcover by retracing the outlines with candlewicking embroidery. According to her letters other women were making similar spreads — a common evidence of patriotic fervor.

In Illinois after 1830 the eagle symbol was stenciled on counterpanes (see p. 88), appliquéd on quilts (see p. 88), embroidered in wool for pictures, and woven into coverlets. It was carved in wood for firehouses and steamboats and in stone for building ornaments, painted on political signs, drums, and firehouse equipment (see p. 88), punched into the tin doors of pie safes, and cast in iron. Other popular patriotic motifs were turned-wood "cannonballs" for bedposts, arrow shapes for the spindles of chairs and decorative cast-iron fences, and star shapes for quilts

The work of an early stonecutter.
A keystone from an old building near Alton.
ILLINOIS DEPARTMENT OF CONSERVATION

and for the bolts used in tying brick walls of large buildings to their inner wooden frames.

American painting was likewise influenced by the spirit of democracy. The average American home was without pictures on its walls. Engravings, obtainable only in large cities, were expensive, and trained artists were monopolized by the wealthy. In a new republic, where the ordinary

man was expected to assert his new-found dignity and importance, the desire for pictures was one he might fulfill himself.

In the settled East, rather than in the frontier West, the amateur art movement started. A man of ordinary means might learn the rudiments of drawing and painting from instruction books first printed in England and later in America's own eastern cities. He might teach himself simply by copying engravings from books or by watching an artist at work. The more fortunate might take a few lessons from an established artist. Such amateur artists persevered, despite

A slat-back Windsor chair with arrow-shaped spindles. Made near Bement, 1836. It is now in the Francis E. Bryant home, Bement.

Wrought-iron balustrade with star pattern.
On a pre–Civil War home in Knoxville.
PHOTOGRAPH BY RICHARD PHILLIPS

Star punched in tin for a pie safe panel. Vandalia.

Molded iron star used with tie-bolt to strengthen the walls of brick buildings. Common in the middle 1800s.

A "cannonball" bed.
ILLINOIS DEPARTMENT OF CONSERVATION

Art, Crafts, and Architecture in Early Illinois

Oil portrait of James B. Stapp,
state auditor of public accounts in 1831.
The artist is unknown.
ILLINOIS STATE HISTORICAL LIBRARY

The Yankees were uniquely motivated to sketch and paint. Their Puritan background forbade the carving of graven images (excepting symbolic figures on tombstones); its austerity made them feel that the highly embellished art of fashionable painters was frivolous; but because the artist's representation was still the only means of visually recording events or the appearances of men, buildings, and landscapes, these practical men felt that painting provided an ideal way to record facts for the future. The result of this concept of pictorial art was the development in America of a distinctly new style stressing the factual rather than the romantic. Imbued by their historic mission to record America and its people, Yankee artists traveled along the water routes like their "cousins" — the peddlers of tin utensils, clocks, needles, and pins. Ready and able to provide the ordinary American with the kind of pictures he wanted at a reasonable cost, these itinerant painters moved from Atlantic coast to western frontier painting portraits, houses, towns, boats, and buildings.

Most popular was the portrait or "likeness," by means of which a man's heirs might know his appearance. To own such a picture was a symbol of status, and the more affluent might also indulge in a portrait of wife or child, or even a

Oil portraits of an unknown couple, painted about 1850 by an unknown artist.
Found in the Quincy home of the pioneer settler John Wood.
HISTORICAL MUSEUM OF QUINCY AND ADAMS COUNTY

the crudeness of their uneducated talents. Eastern women sketched and painted in watercolors; young girls were given private lessons. House and sign painters, ornamental painters of carriages, furniture, walls, and fire equipment might try their hands at painting portraits and landscapes, encouraged by the success stories of such painters as Benjamin West, who started his career as a tinsmith's apprentice and sign painter in Pennsylvania, and Chester Harding, who had been an itinerant sign painter in New York. Such ordinary men as these had risen to success through diligence and hard work. Opportunity and the dollar sign beckoned the talented and the aspiring.

Patriots and Portraits

family group. Likenesses produced by amateur ("primitive") artists were of several different types, priced within the means of the average man. The least expensive were miniatures — small portraits that were popular among young ladies as personal gifts for favorite beaux. One artist might specialize in small silhouettes cut from black paper and mounted on cardboard;

Watercolor painting of Elizabeth Preston with her niece and nephew, Elizabeth Ann and Frank Crum of Palmyra in Wabash County. Artist unknown, ca. 1840. Settled in 1815, Palmyra failed to prosper after Mt. Carmel, directly south, became the county seat.
MRS. EDNA PIXLEY COLLECTION

Portrait of a little girl by an unknown artist, ca. 1830-40.
ILLINOIS STATE MUSEUM

another might specialize in sketches or paintings smaller than nine inches in pencil, pen and ink, watercolors, or a combination of media on paper. These miniatures contrasted with the far more expensive miniatures made by the more fashionable and talented artist that were delicately painted with oil paints on ivory, copper, or wood. Slightly more expensive than the amateur artist's miniature was the portrait made with "crayons" — pastel chalks. A customer who could afford to pay $15 or $20 (or its equivalent in trade) was likely to want a portrait in oil paints on canvas. Such a picture required more work and ability, as the artist often had to concoct his

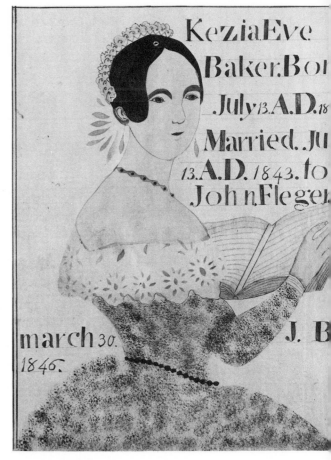

A type of miniature, this birth and marriage certificate was made by John B. Baker on his farm near Croft in Menard County.
ILLINOIS STATE MUSEUM

own oil paints. Various colors of metallic oxides, ground to fine powders in a mortar and mixed with oil, were most easily carried in the tanned bladders of small animals. Prepared canvas from the East was very expensive, so the artist often made his own, using hand-loomed linen, ticking,

Art, Crafts, and Architecture in Early Illinois

or flour sacks tacked to a frame, sized with glue, and covered with at least one layer of paint. Brushes might be made of cat hair, feathers, broom straws, or hog bristles drawn through a quill.

The successful limner or portrait painter was one who could produce a recognizable likeness of the subject's face. This was virtually the only demand of his country customers. Concentrating his attention on the head, he grew fairly proficient in depicting its main features; but lacking formal training in anatomy and perspective, he generally was unable to depict the structure of other parts of the body or to create an illusion of depth on a flat canvas. The features therefore often appeared rather flat, and the rest of the figure was out of proportion and stiff. Feet were tiny appendages; hands, jointless rubber gloves. An artist might avoid painting the hands altogether by hiding them behind objects or showing one tucked inside a vest. Such naive maneuvers are characteristic of "primitive" painting, as opposed to the "academic" painting of the highly trained artist.

The late Wilbur D. Peat asserted that the general belief that itinerant artists spent their winters painting stock bodies for portraits, later to supply the heads when sitters were available, cannot be supported by evidence or practicality. It is much more likely that the head was painted during whatever time the sitter could spare, while the body was supplied later from memory. This would partially account for the typical woodenness of the figure. The occasional similarity of costume might mean only that the artist carried with him a lace collar or a fancy brooch to use as a stage prop, allowing the sitter to pose in finery that he did not own.

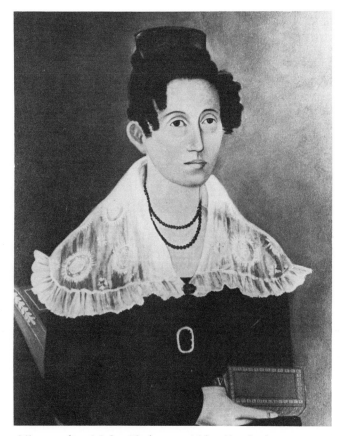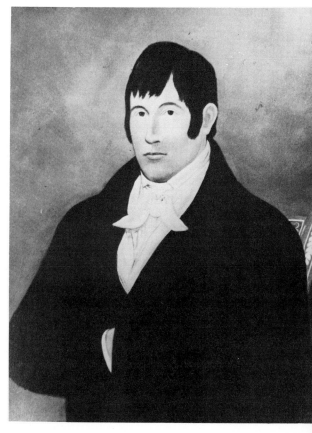

Oil portraits of John Choisser and his wife, the former Nancy Sutton, by an unknown painter (ca. 1820-30). Born in Kaskaskia in 1784, Choisser was a riverboatman and salt merchant near Shawneetown.
JOHN PARISH COLLECTION

Two very early oil portraits painted in Illinois are of John Choisser and his wife, Nancy Sutton Choisser. These were probably painted at Raleigh, in present-day Saline County. The dashing Frenchman, a riverboatman and Illinois salt merchant, is pictured with his hand tucked in his vest, seated on a painted and stenciled chair; his wife, a deeply religious woman, is shown holding her Bible. The painter of Elizabeth Preston with her nephew and niece, Frank and Elizabeth Crum, evidently specialized in watercolor miniatures. About 1840 he seems to have traveled up the Wabash River to Mt. Carmel before scouting in the vicinity for subjects. A crayon artist sketched the portraits of John and Sarah Lindley on Looking Glass Prairie, near Lebanon. Like so many early portraits, these works are all unsigned. The itinerant artist was regarded as sim-

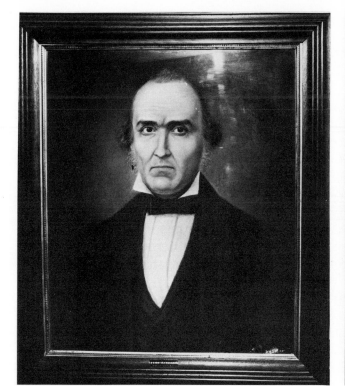

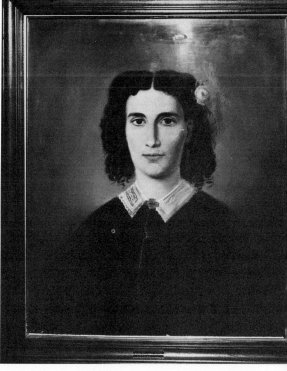

Pastel or "crayon" portraits of John and Sarah Lindley made about 1845 by an unknown artist on Looking Glass Prairie near Lebanon.
DR. AND MRS. FLOYD BARRINGER COLLECTION

ply another skilled craftsman. Like the furniture of the cabinetmaker, the end product, not the identity of the maker, was of importance to the buyer.

One of the first Yankee itinerant portraitists in the new state of Illinois was Horace Harding (1794–ca. 1857). Born in Conway, Massachusetts, Harding was the younger brother of Chester Harding, who eventually achieved considerable fame as a portrait painter. Like his brother, Horace had begun his career as a chair- and cabinetmaker in New York. Chester had become an itinerant sign painter, and the two had gotten together in Paris, Kentucky, apparently deciding at about the same time to become portrait painters. By 1820 Horace was advertising his new profession in Vincennes, while Chester was becoming a proficient painter in St. Louis. The only known record of Horace's activities from 1820 to 1834 is contained in the following entry in the 1821 journal of the House of Representatives of the Second General Assembly of the State of Illinois:

Vandalia February 8th, 1821

The Honorable Speaker of the House of Representatives

I have just completed the portrait of the present chief magistrate of this state, and request the House of Representatives to do me the honor to receive the same as a tribute of my great respect for that honorable body.

I have the honor to be, sir, Your most obt. servt,

HORACE HARDING

A committee of two was appointed to receive the portrait and see that it was placed in Representative Hall. Today there is no evidence that Harding's portrait of Shadrach Bond still exists. Presumably this early portrait of the state's first governor was destroyed in a fire that razed the frame capitol at Vandalia in December of 1823. It is known that Horace Harding worked around Cincinnati from 1834 to 1850, and that he died about 1857 in Mississippi.

In the country the itinerant stayed in the home of his customer, from whom he received room and board. Additional payment might be in the form of a small fee, clothing, a pair of shoes, or perhaps home-woven linen for the artist's canvas. In a town he usually stopped at an office or inn, where he set up samples of his work for display. If he could afford it, he might put an ad in the local newspaper much like one that appeared in the *Sangamo Journal* (Springfield).

A CARD.—WM. HANBACK, Portrait Painter, respectfully informs the Ladies and Gentlemen of Springfield and its vicinity, that he will be found at the room occupied by J. T. STUART, Esq. a few doors north of *Allen & Blankenship's* Store, where he will be happy to accommodate all those who may honor him with their custom. A specimen of his Painting may be seen at his room.
Springfield, Oct. 31st, 1832. 52

Hanback, like so many of his fellows, is known by name, but his work remains unidentified because it is unlikely that he ever signed his name to a canvas.

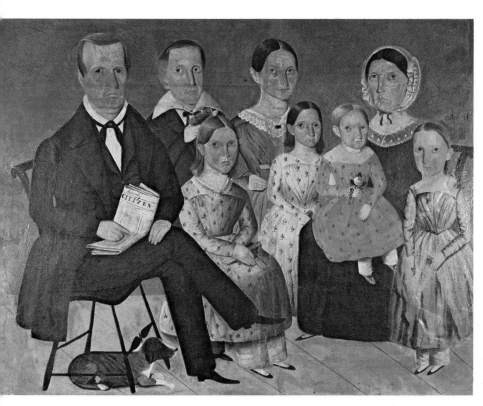

The Wagner family, 1845, painted in Aurora by Sheldon Peck (see p. 163).
AURORA HISTORICAL SOCIETY MUSEUM

"Park House, Albion, Edwards County, Ill.," ca. 1820. George Flower's sketches of his parents' home are thought to be the first made by a resident artist after Illinois became a state (see p. 68). A rear view of the home by Charles Lesueur (1826) is on p. 69.
CHICAGO HISTORICAL SOCIETY

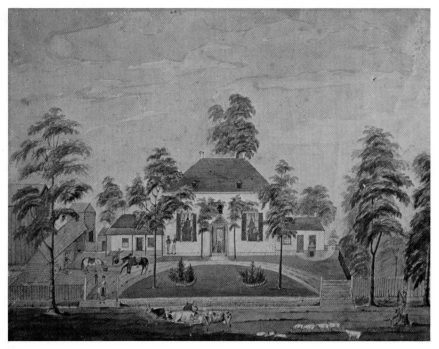

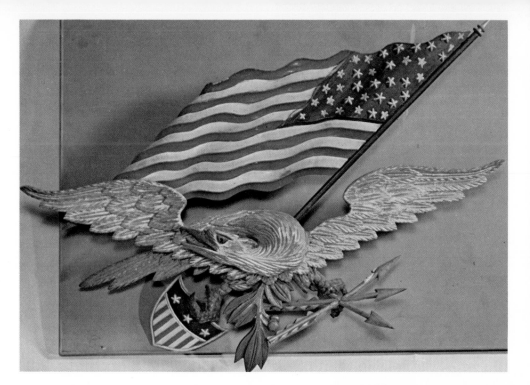

Carved and painted eagle from a firehouse in Galena.
The eagle was but one of the many patriotic symbols
used for decorative motifs during the early
nineteenth century (see p. 82).
GALENA HISTORICAL SOCIETY MUSEUM

Eagles stenciled on a hanging
used to protect the wall
behind a washstand.
Made about 1835 by
a member of the Haskins
family, pioneers in Belvidere,
Boone County.
ILLINOIS STATE MUSEUM

Appliqué counterpane made by Helen Gilcrest
in Hill's Grove, McDonough County, about 1850.
ILLINOIS STATE MUSEUM

Art, Crafts, and Architecture in Early Illinois

At least one early itinerant artist in Illinois is more easily traced since he often signed the backs of his portraits. Patrick Henry Davenport (Richard Davenport was no doubt feeling the patriotic fervor of the times when he named his son) was born in Danville, Kentucky, on November 3, 1803, and lived much of his adult life in Illinois.

Little is known of Davenport's youth, but it is quite possible that he had some kind of artistic training. His father was a man of considerable means, being a tavern owner, a landowner, and a merchant who made frequent business trips to Philadelphia. Patrick may have had art lessons in Philadelphia, but it is more likely that Asa Park, an artist who painted members of the family in Kentucky, provided inspiration and possibly even some actual training. At about the age of seventeen, Patrick was also painting family members; he then set off as an itinerant in Kentucky. In 1827 he married Eliza Bohannon of Mississippi and apparently continued his travels, extending them into Illinois before running a hotel for a time in Crab Orchard Springs, Kentucky. Davenport evidently was persuaded to move to Illinois about 1853. Establishing his family on a farm near Sumner in Lawrence County, he continued to paint, traveling around Illinois, Kentucky, and Indiana in search of subjects. His struggle to earn a living by painting must have been similar to that of many other itinerants, and it may be that he was also plagued by impaired eyesight. For whatever reason, his later subjects are more stern in appearance, and his painting shows less skill than formerly. In 1890 he died at his Sumner home, leaving a wife and eight children. It is indicative of the general attitude of the day that Davenport's immediate family

Self-portrait of Patrick Henry Davenport about 1830-40.
MRS. LYMAN DAVENPORT WHITE COLLECTION

Portrait of Dr. John Logan of Murphysboro by Patrick Henry Davenport.
SALLIE LOGAN PUBLIC LIBRARY, MURPHYSBORO

Portrait of Eliza Bohannon Davenport painted by her husband about 1840-50.
JAMES GORDON WHITE COLLECTION

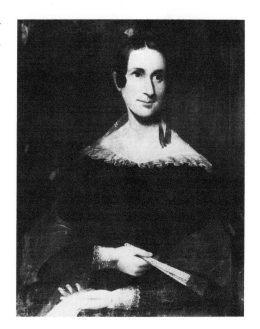

did not leave a record of his career as an artist. Apparently their preference was to consider him a tavern operator and a farmer.

Life was not easy for the itinerant artist. His customers were few and far between on the frontier, and he often had to take a variety of odd jobs to survive: painting window shades and shop signs, carriage ornaments, stage scenery, murals, and doing the popular painting on woodwork and furniture to simulate oak, mahogany, or rosewood. English novelist Charles Dickens remarked on the practice. Visiting St. Louis in 1842, he made a side trip across the Mississippi

into Illinois to see a typical midwestern prairie, riding over morasses of mud to Belleville, Lebanon, and Looking Glass Prairie. After returning to England he wrote in his *American Notes:* "Belleville was a small collection of houses huddled together in the very heart of the bush and swamp. Many of them had singularly bright doors of red and yellow; for the place had been lately visited by a travelling painter 'who got along' as I was told, by 'eating his way.' "[1] Of the Mermaid Inn at Lebanon, where Dickens stayed overnight, he wrote: "In the best room were two oil portraits of the kitcat size[2] representing the landlord and his infant son, both looking as bold as lions, and staring out of the canvas with an intensity that would have been cheap at any price. They were painted, I think, by the artist who had touched up the Belleville doors with red and gold; for I seemed to recognize his style immediately."[3] It was perhaps this same artist who painted the large square sign which hung in front of the inn — "a full-size mermaid standing on her tail on the waves, holding a looking glass before her with one hand and combing her long golden tresses with the other."[4] A portion of the historic Mermaid Inn, built in 1830, still stands, although the sign of the mermaid has long since disappeared.

A letter written by the early fur trader Gurdon S. Hubbard describes another early sign, erected on a tree branch above the first tavern at the site of Chicago. As Hubbard tells the story, Elijah Wentworth, the tavern proprietor, had found and killed a wolf in his meat house. When a sign was later desired for the tavern, Lieutenant James Allen of nearby Fort Dearborn obtained boards, had hinges attached by the Indian agency blacksmith, and painted a picture of a "slethy wolf"

Oil portrait of Shadrach Bond (1773-1832), first governor of Illinois, attributed by the author to James Berry of Vandalia. This and a similarly posed portrait by the eastern artist George Frederick Wright were apparently copied from an earlier family portrait of about 1812.
CHICAGO HISTORICAL SOCIETY

as a memorial to Wentworth's valor. The story has been contested, but the sign with the painted wolf appears in an early sketch, and the area at the fork of the Chicago River for many years was known as Wolf's Point[5] (see p. 126).

In spite of the unsettled life on the Illinois frontier — where craftsmen, farmers, lawyers, doctors, and merchants were the most highly respected citizens — a few cultured amateurs like George Flower at Albion found spare time to engage in painting and sketching (see pp. 66-

71). A spare-time artist of considerable talent was James Berry (1805-77), who had traveled with his father from Kentucky to Kaskaskia and then to Vandalia, the new capital of Illinois. In December of 1824, the nineteen-year-old presented a portrait of Governor Coles to the Senate and another portrait to the House of Representatives. It is presumed that the latter is the unsigned portrait of the first governor of Illinois, Shadrach Bond, which is now owned by the Chicago Historical Society. Oil portraits such as these must indeed have been rare spectacles for the citizens of the young state, many of whom may never have previously seen an oil painting. In recognition of the gift to the House of Representatives, a select committee made the statement: "It is proper to remark that the painting is the work of a young gentleman, by which it is presented; that he has grown up in Illinois and progressed to a high degree of excellence in this fine art, unaided by the instruction of any approved master."[6]

Berry later painted two large and impressive pictures for the state capitol at Springfield (see p. 153). Still, little is known of his life as an artist. Quite characteristically, historians seem to have felt his participation in politics was the more admirable of his accomplishments. It has been recorded that Berry became clerk of the Clinton County Court in 1824, that later he was clerk of the Circuit Court of Fayette County, and that from 1835 to 1839 he was adjutant general for the state of Illinois.[7] There is no certain record of other portraits he may have painted during his lifetime, however. A few others have been attributed to Berry, but the portraits at Springfield apparently are the only ones to which he signed his name.

Art, Crafts, and Architecture in Early Illinois

9 Yankee Influence

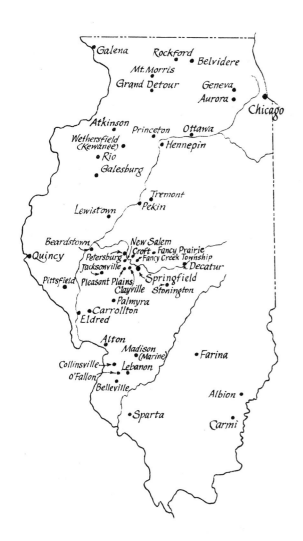

This stone house (1827) near Eldred was once the home of John Russell, who had emigrated from Vermont. One of the fireplaces is pictured below.

The Yankee's presence in Illinois was felt in far more impressive ways than through painting. A busybody, endowed by nature with a zeal for culture, industry, and religion, he found much that needed improving in frontier Illinois. From the beginning of settlement by the French, ambitious easterners had recognized the value of Illinois resources, and during the territory's occupation by the English during the Revolution Yankees had shipped thousands of dollars' worth of household utensils, shoes, dry goods, guns, munitions, and clothing to the American Bottom in exchange for furs. Some easterners later became Illinois merchants; others were among the first settlers of early Illinois towns. Many, like the English settlers at Albion, were instrumental in establishing industries. The five Collins brothers from Litchfield, Connecticut, settled Collinsville, Madison County, in 1817. By 1821 they had built a frame home. Being models of Yankee industry, each a jack-of-all-trades, they followed this building with a store, a blacksmith shop, a shoe shop, a wagon shop, a sawmill, a tannery, a distillery, and a small church. In the same county, not far from Collinsville, a colony of seventy-two easterners settled the village of Madison, renamed Marine when five former shipmasters and their families arrived from the East

in 1819. According to one historian, "Between 1820 and 1830 Marine had a larger proportion of Eastern people within its borders than any other township within the county. They formed an intelligent, educated and religious community, and came to the country possessed of means, prepared to develop their new homes on a broad and intelligent basis."[1]

Easterners arrived in Illinois with distinct advantages over pioneers from the South. Whereas the pioneer hunter family of Scotch-Irish or Pennsylvania German descent might have spent generations in rough living in various forest wildernesses

before settling in Illinois, the early easterner arrived in a relatively short time because his route was easier and more direct. It was possible to float on rafts down the Ohio all the way from Pittsburgh, and improved roads meant that the trip from Maine to western Illinois might be made with a two-horse carriage and a wagon in about sixty days. By 1820 those who were able to afford river passage could take steamboats down the Ohio and up the Mississippi; ten years later steamboats were traveling up the Illinois River into the central portion of the state; and by 1825 the Erie Canal from Albany to Buffalo was enabling easterners and Europeans to travel on to the Midwest by steamboat through the

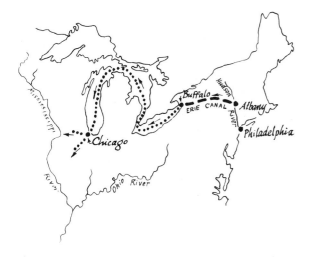

Great Lakes, encouraging settlement of northern Illinois. As a result of these improvements in transportation, the Yankees were separated from culture for a relatively short period. They arrived better educated than earlier settlers, with more money, books, and tools, plus a few pieces of eastern-made furniture to help make their first home in Illinois more comfortable. They also had

more fashionable clothing, and — for a time at least — dressed at meetings and social events much as they had in the East.

As soon as he was able, the eastern pioneer was apt to cover a log home with clapboards or to build a neat and substantial home like the one he had left in the East. Sometimes a new structure was of brick, but more commonly it was of timber frame construction covered with clapboards. Samuel Willard, an early citizen of Carrollton, Greene County, wrote an excellent description of the type of frame construction that was common in many older settlements into the 1850s:

I saw the round logs drawn from the woods and squared into building timber by old John Dee's broadax, queer with its handle set askew. I saw . . . the framing and raising of Joseph Gerrish's house, done in the old style. The timbers of two sides were framed or put together with treenails or pins, while the timbers of the other sides were laid near where they would be wanted, every piece being marked and numbered. Then all the neighbors were invited to the "raising," and these sides were lifted by hands, then by pikes, and lastly by long poles, while Gerrish and Dee guided the tenons of the corner posts into the mortises. . . . While a few guided these erected sides, most went to set up the

Mortise and tenon joint.

Eastern motifs on a Beardstown tombstone (1839). The picket fence may represent the edge of eternity, and the rising sun the resurrection of the soul.

timbers and studs of the other two sides, where many hands but less of strength were required. . . . For the finishing of the house no costly Pine or soft wood was had; a rough shed was built, on which oak boards were stacked on trestles loosely, so that fires built under them might slowly expel the sap and so "season" them; laborious planing took off the smoke and shaped them.[2]

It was not long before easterners and ambitious southerners from the Atlantic states were establishing institutions of higher learning in southern Illinois, beginning in 1827, when Rock Springs Seminary was founded near O'Fallon. This was the achievement of John Mason Peck, born in Connecticut and sent west as a Baptist missionary. Peck, also a writer, induced many more easterners to emigrate by publishing *A Guide for Emigrants* (1831 and 1836) and *A Gazetteer of Illinois* (1834 and 1837). In 1823 William McKendree, a Methodist Episcopal bishop from Virginia, was transferred to the western district.

Art, Crafts, and Architecture in Early Illinois

As a result of his work, McKendree College was erected by settlers in Lebanon.

Although some easterners had settled very early in southern Illinois, it was particularly in the west central portion of the state that southerners for the first time met and mingled with large numbers of Yankees. Sangamon County was the extreme northern county of the state in 1824 when the famous circuit-riding Methodist minister and former Virginian Peter Cartwright finally settled in a double log cabin at Pleasant Plains. About one mile east, on the road to Springfield, lived an ambitious easterner named Moses Broadwell. In 1825 Cartwright mentioned Broadwell's accomplishments at a church meeting in Charleston, Indiana: "Brick houses don't grow on trees in Sangamo Country but there are two fine brick houses within a mile of my home. One is two stories high with verandas on the north and south sides, was built for an inn and is the wonder of Sangamo Country."[3]

Characteristic costumes of average Illinoisans, 1825-35, by Minna Schmitt. Left to right: Mrs. Rachel Hall Munson; Mrs. Thorne H. Carlson; Mrs. John C. Bond; Mrs. John Wanton Casey (a Quaker); Mrs. Peter Cartwright; Mrs. Noah Guyson; Mrs. Joseph Mills (a Quaker); Mrs. Alan Emmerson.
ILLINOIS STATE MUSEUM

THE STRUCTURE OF A TIMBER FRAME BUILDING.

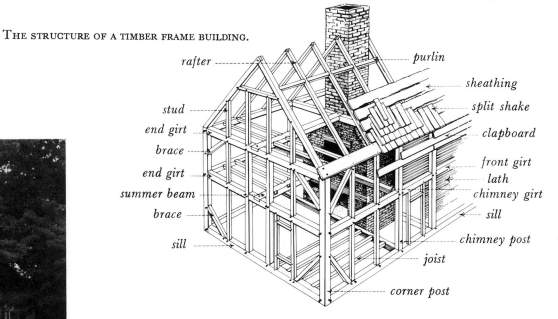

rafter — purlin — sheathing — split shake — stud — clapboard — end girt — brace — front girt — lath — end girt — chimney girt — summer beam — brace — sill — chimney post — sill — joist — corner post

An example of an original log house which was improved through the years. A double log house built by John Crawford in Carmi in 1814 was bought in 1835 by Senator John Robinson. It was then covered with clapboards and two wings were added. Many Illinois houses have had similar transformations.
PHOTOGRAPH BY DIETZ STUDIO

Yankee Influence

93

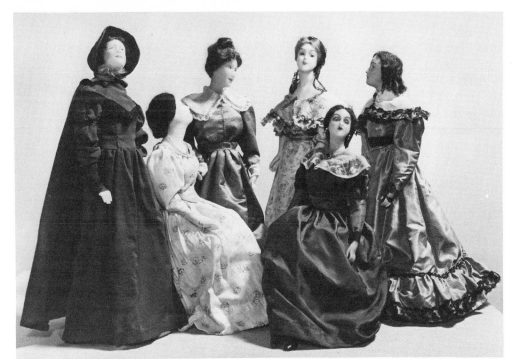

*Characteristic costumes of Illinois settlers, 1830-40,
by Minna Schmitt. Left to right: Mrs. Jeremiah Porter;
Mrs. Silvia H. Horn; Mrs. Theron Baldwin; Mrs. Samuel Adams;
Mrs. David B. Ayers; Mrs. Frances Alsop Post.*
ILLINOIS STATE MUSEUM

Ratcliff Inn, built in Carmi in 1828. A Federal-style structure.
PHOTOGRAPH BY DIETZ STUDIO

*The restored 1838 home of John Deere in Grand Detour, Ogle
County. A blacksmith from Vermont, Deere was a manufacturer of
one of the first self-scouring steel plows.*
PHOTOGRAPH BY RICHARD PHILLIPS

Art, Crafts, and Architecture in Early Illinois

Beecher Hall (1829), Illinois College, Jacksonville. This is the oldest college building in Illinois. Federal style.

PHOTOGRAPH BY RICHARD PHILLIPS

A gable end of Beecher Hall. Notice the double chimney set into the wall, the blind fanlight, the hand-wrought S-ties, the splayed brick lintels over the windows, and the triple window — a late adaptation of the Georgian Palladian window.

PHOTOGRAPH BY THE AUTHOR

Federal-style entrance to the Joseph Duncan home (1834) in Jacksonville.

In 1827 ten students from Yale — a stronghold of classical culture — decided to become missionaries in Morgan County in central Illinois. They organized Illinois College at Jacksonville, one of the first three incorporated college institutions west of the Alleghenies. In 1829 the first building was erected. A sturdy and dignified brick structure in the Federal style, Beecher Hall had for several years a cabinet shop for manual training where furniture for the college and surrounding homes was made. This structure is still on the campus of Illinois College.

John Millot Ellis wrote from Jacksonville: "This is the part of Illinois which now is, and from all appearances, is destined to be the most populous and wealthy. . . . a spirit of industry and enterprise is found in these counties [Morgan, Sangamon, and Greene] not to be found in this state elsewhere nor in Missouri. Many English farmers and many from New England and New York are effecting a happy state of agricultural improvement."[4] Jacksonville also had a number of industrious settlers from the South like the Kentuckian John Henry, who established a cabinetmaking and wood-turning shop. His household, consisting of family and hired hands, numbered thirteen. During the cholera epidemic of 1833 he helped bury fifty-five people in plain raised-lid coffins of cherry wood made in his own establishment.

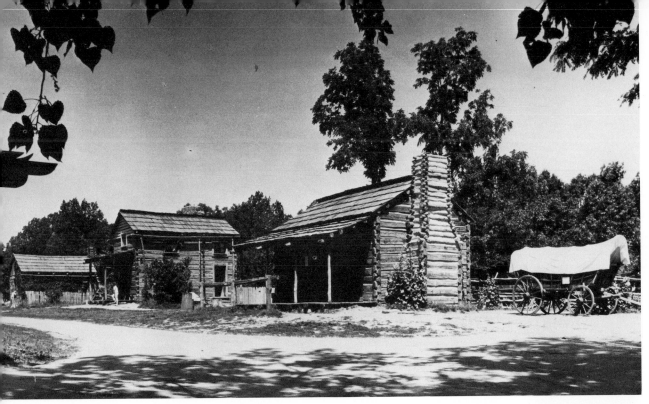

A few of the typical houses of New Salem.
Second from the left is a log structure
that is two stories high.
PHOTOGRAPH BY CHARLES HODGE

The post office in New Salem.
Notice the notching
of the corner logs.
PHOTOGRAPH BY THE
ILLINOIS DEPARTMENT
OF CONSERVATION

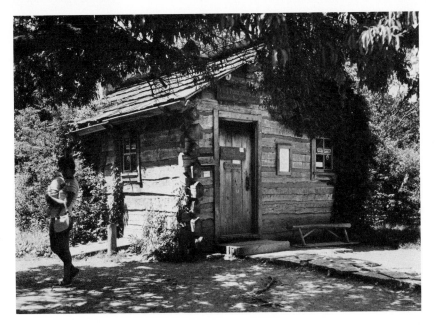

Settlers then penetrated Menard County, north of Sangamon County, and its first village, New Salem, was established in 1829 in the woodlands along the Sangamon River. This frontier village began with a saw- and gristmill to serve scattered settlers and soon had a store and saloon. These resources and the belief that New Salem might become a prosperous steamboat port drew more settlers, some of them easterners.

As was logical on the American frontier, where timber was plentiful and skilled craftsmen were few, early New Salem structures had stick-and-log chimneys, wooden mantels, hinges, latches, probably puncheon floors, tables, and seats —

Art, Crafts, and Architecture in Early Illinois

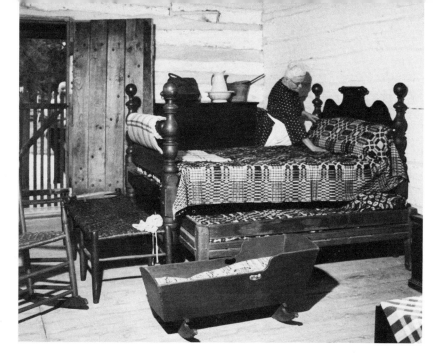

*Typical New Salem bedroom.
Note the trundle bed which
slips under the larger
cannonball bed,
the home-woven coverlets,
and the split-hickory seats
on the chairs.*
PHOTOGRAPH BY
CHARLES HODGE

*Replica of the Berry-Lincoln store, a log structure
covered with sawn clapboards.
In such a building the young Lincoln tended store.*
PHOTOGRAPH BY THE ILLINOIS DEPARTMENT OF CONSERVATION

all made by members of the household. Before long, though, the village acquired the tooled products of a number of skilled craftsmen: Peter Lukins, a shoemaker; Joshua Miller, a blacksmith and wagon maker; Robert Johnson, a wheelwright and cabinetmaker; Martin Waddell, a hatter; Samuel Hill, builder and operator of a carding mill; Henry Onstot, a cooper; and Philemon Morris, a tinner. Necessities not obtainable from these men might be purchased at the New Salem village store or in Springfield, twenty-one miles southeast. Within a short period,

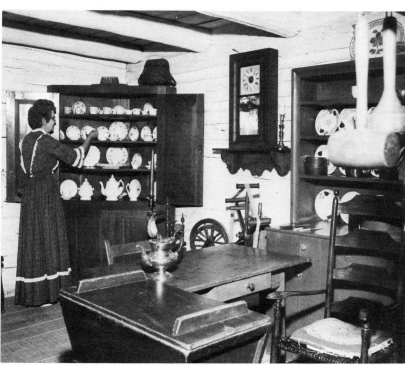

*New Salem homes were snug
and comfortable by pioneer
standards. Dishes of English
manufacture, brass candle-
sticks, and an occasional
piece of silver were usually
precious family possessions
brought from the East.
The shelf clock could have
been purchased from a
Yankee peddler.*
PHOTOGRAPH BY
CHARLES HODGE

a settlement of twenty-five or thirty log structures was thriving. Here the young Abraham Lincoln, born in Kentucky, lived for six years before going to Springfield to practice law.

The later homes of New Salem were log houses rather than log cabins. The easterner, abhorring slovenliness even on a frontier, wanted his home to be the truly well-built structure that the availability of capable craftsmen now permitted. His home was apt to be of hewn logs, expertly fitted at the corners to shed water and avoid rotting, the spaces between tightly chinked and daubed with lime mortar. Some New Salem houses had stone chimneys and fireplaces, whitewashed walls, sawn board floors, iron hinges and locks (see p. 105). A few structures had unpainted weatherboarding over the logs, and one was two stories high. It is likely that nearly all windows had glass panes. This convenience, a rare luxury in earlier Illinois, had become more

Yankee Influence

97

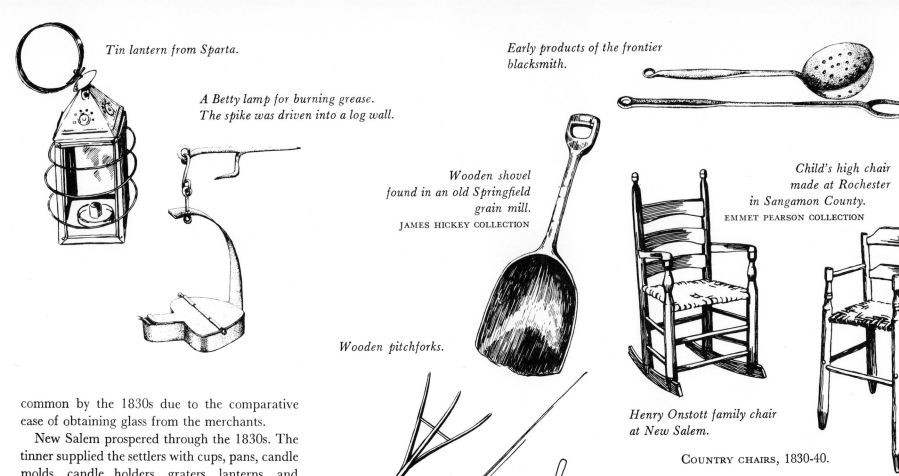

Tin lantern from Sparta.

A Betty lamp for burning grease.
The spike was driven into a log wall.

Early products of the frontier
blacksmith.

Wooden shovel
found in an old Springfield
grain mill.
JAMES HICKEY COLLECTION

Child's high chair
made at Rochester
in Sangamon County.
EMMET PEARSON COLLECTION

Wooden pitchforks.

Henry Onstott family chair
at New Salem.

COUNTRY CHAIRS, 1830-40.

Turkey-wing wheat cradle.
About 1840.
EMMET PEARSON COLLECTION

Child's chair
made in Decatur.
MRS. WILLIAM P. WHITTLE COLLECTION

common by the 1830s due to the comparative ease of obtaining glass from the merchants.

New Salem prospered through the 1830s. The tinner supplied the settlers with cups, pans, candle molds, candle holders, graters, lanterns, and grease lamps. The wheelwright and wagon maker built carts, wagons, and spinning wheels. The blacksmith made nails, hinges, fireplace equipment, ladles, and tools. The cabinetmaker constructed sturdy cupboards and tables, beds, and chairs. In their spare time the eastern farmers fashioned wooden rakes, pitchforks, grain shovels, measures, and the graceful turkey-wing wheat cradle to which was attached a long metal scythe forged by the blacksmith. These were tools more familiar to the easterner, whose accustomed crops were hay and wheat, than to the southerner, who had farmed corn and sweet potatoes.

Art, Crafts, and Architecture in Early Illinois

A carding mill in the village relieved New Salem housewives of some of the tedious labor of preparing wool, while the village store with its cheaply manufactured cotton yard goods from the South made the raising of cotton for summer clothing unnecessary, although in August 1834 easterner C. J. F. Clarke reported that a considerable quantity of cotton was still being raised in the general area for private use. Spinning wheels and looms remained a part of nearly every eastern as well as southern household, and needlework was a necessity — since there were no sewing machines, the women had to assemble every article of clothing by hand. Waste of time was a sin to the Yankee, and the women kept busy at a multitude of tasks. One was the making

of candles for illumination, an improvement over the hunter's crude grease lamps. In her native region the New England housewife had made candles from the sweet-smelling wax of bayberries. These did not grow in Illinois, so she probably had to substitute a less pleasant substance — the tallow from slaughtered farm animals. This was melted, then sometimes poured into a

tin candle mold around wicks that had been fastened inside; more commonly tow-linen wicks were suspended from a rod and dipped repeatedly in a kettle of melted tallow. After each dipping the tallow was allowed to harden, and gradually the accumulation of layers became candle size.

Relieved of some of the labor of the earlier pioneer women, and with a well-constructed and relatively comfortable log house in which she could take a little more pride, the New Salem housewife had more time and energy to make something "pretty" for her home. Hoarded scraps of woolen materials might be braided or woven into a rug; cotton calico scraps left over from cutting out sunbonnets, shirts, and dresses were pieced into blocks for quilts.

Cradle churn, ca. 1842. Made by William Colby, Atkinson, Henry County.
HENRY COUNTY HISTORICAL MUSEUM

Hand-carved butter mold from Farina, Fayette County.
MR. AND MRS. HOWARD PORTER COLLECTION

Grain or vinegar measure made in Jacksonville.
ILLINOIS STATE MUSEUM

Eastern-style eggbeater found in Illinois.
AUTHOR'S COLLECTION

Ohio Star.

Log Cabin.

Prairie Queen.

Mill Wheel.

Jacob's Ladder.

Weather Vane.

QUILT BLOCK PATTERNS FOR PIECED QUILTS.

Quilting — the art of fastening padded materials together with fine running stitches — had long been practiced in Europe and was brought to New England, New Amsterdam, and the Carolinas by early settlers. The pieced quilt, though, was a uniquely American folk product. Colored scraps of cotton material cut into geometric shapes were sewn ("pieced") together to form square patterns. The patterned blocks were then sewn together to blanket size. The quilt top, placed over an interlining of cotton batting, was lined with plain cotton lengths of yard goods sewn together. All three thicknesses were then fastened to a frame to be quilted (see p. 140).

The tedious process of fastening the three thicknesses together with hundreds of rows of fine running stitches was usually accomplished at a quilting bee, a social occasion when a group of women would gather together and work for an entire day on one woman's quilt. While the older women were busy, the little girls would knit, spin, or make samplers.

The sampler (various stitches worked on a plain linen background) demonstrated a child's dexterity at embroidery and also served to teach the letters of the alphabet necessary for the marking of household linens. A sampler might bear the name of the maker, the date, a simple motto, and additional decorative embroidery of borders, flowers, houses, or figures. Completed, the sampler often became the first picture in a frontier home. Eastern settlers particularly encouraged such a sign of culture on the frontier.

Although the making of samplers in Illinois appears not to have continued past mid-century, quilting remained popular far into the late years of the nineteenth century and the early years of the twentieth. Old quilt-block patterns with

fanciful names were often inherited, acquiring new names in new localities, and new patterns were constantly created. Religion, an important part of the woman's life, was reflected in such names as "Jacob's Ladder" or "Job's Tears." Items of everyday life contributed other names: "Rail Fence" or "Log Cabin." Additional patterns featured such ever-popular patriotic symbols as the star.

Of all the products that brightened the frontier home, the woven coverlet was the greatest achievement. This decorative bed covering, woven of dyed wool yarns and cotton or linen threads, featured geometric patterns of two or more colors, easily worked out on a fairly simple home loom. Directions called drafts were used in producing the pattern. These were drawn on long strips of paper and looked somewhat like bars of music with marks or figures instead of

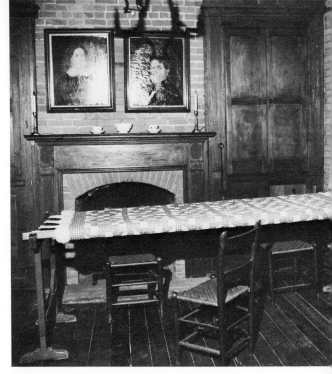

A pieced quilt in the making at Clayville Tavern.
PHOTOGRAPH BY CHARLES HODGE

Sampler made by Eliza Ann Marlett, Aurora, in 1838.
AURORA HISTORICAL SOCIETY MUSEUM

Art, Crafts, and Architecture in Early Illinois

notes. Like quilt patterns, such drafts were usually inherited and brought by the housewife from her former home. As a result, some designs featured items scarce in Illinois, such as the pine tree (see p. 140); and various pattern names, such as "King's Crown," "Snowball," "Gentleman's Fancy," or "Wheel of Fortune," may have originated in other parts of the country.

Most common was the coverlet constructed with "overshot weave," named for its characteristic skips of dark wool weft over a light cotton or linen background. Many coverlets of this type are still to be found in Illinois, but they are rarely in good condition, as their loosely woven structure caused them to become worn rather quickly. A rarer, more complicated, but much more durable weave is "summer and winter," named for its characteristic dark pattern against a light background on one side of the coverlet and reversed colors on the other. This weave, apparently originated by the Germans and carried westward from New York and Pennsylvania, looks very much like the far more complicated "double weave." The latter was actually composed of two layers of woven wool joined together by the pattern and is recognizable when these two layers of background can be separated. Although not impossible, an entire coverlet was very difficult for the average housewife to weave in one piece, so the usual practice was to make two long strips which later were joined together.

The village of New Salem broke up after only about ten years, apparently for two reasons: the town of Petersburg had been settled to the north

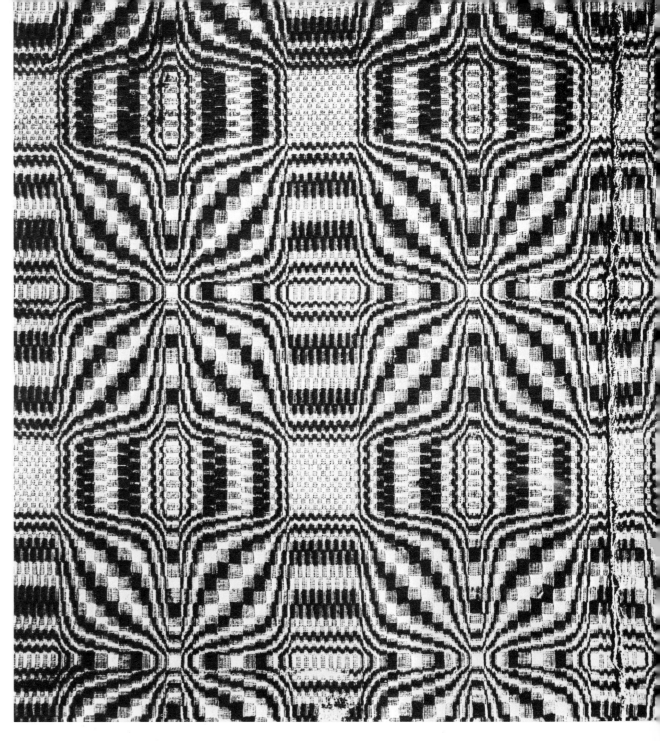

Portion of an overshot weave coverlet made by Elizabeth Davidson Etter, Macoupin County.
ILLINOIS STATE MUSEUM

and had become the county seat; and many of New Salem's inhabitants had finally given up the dream that their town on the Sangamon River might become important as a steamboat port. Settlers moved on, the village rapidly declined, and in time all the buildings of New Salem disappeared except the cooper shop, which was moved to Petersburg in 1840.

During the remaining years of the nineteenth century, writers and local residents kept the memory of New Salem alive because of its associations with Abraham Lincoln. In 1896 William Randolph Hearst bought the entire area, giving it in trust for future development to the Old

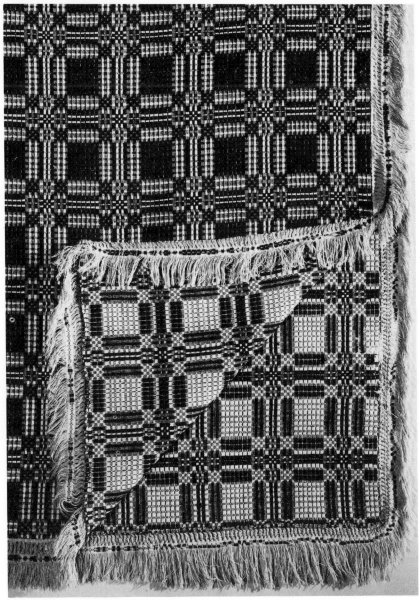

Double-weave coverlet made by Nancy Willcockson Power in Fancy Creek Township, Sangamon County, ca. 1840. Notice the pine tree border.
MRS. JUNE POWER REILLY COLLECTION

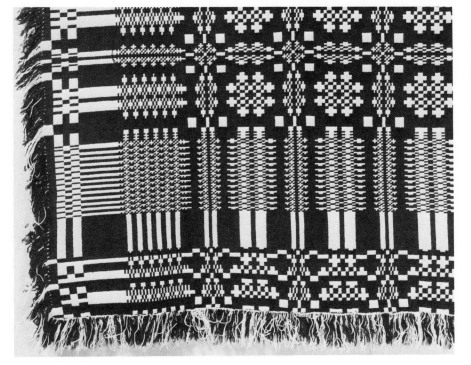

Overshot weave coverlet made about 1840 by Sarah Douglas Smith in Stonington, Christian County.
ART INSTITUTE OF CHICAGO

Art, Crafts, and Architecture in Early Illinois

Salem Chautauqua Association. Later, the state of Illinois, yielding to public request, acquired the site in order to reconstruct the town as it had probably looked in Lincoln's day. Years of intensive research into the backgrounds and occupations of the village inhabitants followed. It was determined what types of log houses they had built, and old house foundations were located and uncovered. By 1932 the village of New Salem had begun to reappear and today probably looks much as it did over 120 years ago.

Many other villages of Illinois vanished as New Salem did, unable to flourish for long when bypassed by newer or more dependable routes of commerce. A more fortunate contemporary village in the area was Clayville, situated only a few miles south of New Salem on an old Indian trail that had become a busy road between the Illinois River landing at Beardstown and the rapidly growing village of Springfield. Here, at least four years before the founding of New Salem, stood the two fine brick buildings owned by Moses Broadwell that had been described by Peter Cartwright in 1825. Broadwell, an ambitious easterner of considerable means, had arrived in the area from New Jersey by way of Cincinnati as early as 1819. He had not only bought and sold land and operated a gristmill at Sangamo Town (also short-lived) on the Sangamon River, but had also built a log trading post on the old Indian trail. This store provided frontier necessities such as flour, sugar, indigo, whiskey, gin, molasses, lead, and salt to the local settlers and a few remaining Indians. It attracted more settlers, and within six years Broadwell had built a house and an inn with bricks made on the premises. By the 1830s and '40s the inn was a popular stop for wagoners, horseback riders,

and stagecoach travelers; it was a center for political rallies and social gatherings. Nearby were a tannery, a school, a blacksmith shop, and a mill.

Today the only remaining building of the original village is Clayville Tavern, a sturdy two-story Federal-style structure deemed worthy of recording by the Historic American Buildings Survey (see p. 106). Its interior framework of great hand-hewn walnut timbers was fastened together with wooden pegs; the brick walls were once lathed and plastered; and the doors were finished with iron locks, keys, and strap-iron hinges. The most unusual feature of Clayville Tavern, however, is the fine cabinetwork, which remains throughout the entire building. The mantelpieces are particularly noteworthy because of their delicately carved reeding (see p. 106). Also interesting is an oven in the kitchen wing, built into the chimney breast beside the great fireplace. After years of neglect, this building was purchased, restored (except for its original front and back porches), and refurnished with articles of the period by Dr. and Mrs. Emmet Pearson of Springfield. Other old buildings of the area were later moved to the site, so that today Clayville is once more, in effect, a small village complex. Here may be seen the tools of the farmer, blacksmith, potter, shoemaker, cabinetmaker, builder, and other individual craftsmen who were once typical of the general area. A festival held each fall under the sponsorship of the Clayville Folk Arts Guild provides demonstrations of more than fifty pioneer activities such as breadbaking, textile weaving, tin- and blacksmithing, pottery making, the preparation of flax, and the boring of gun barrels. In 1973 such activities were augmented with the donation of the land and its buildings

to the Sangamon State University Foundation for use not only as a museum but also as a center for the study and preservation of rural life.

The average housewife in Clayville undoubtedly engaged in much the same activities as the housewife in New Salem, but it is reasonable to assume that, like prosperous women in other Illinois towns, the ladies of Broadwell's household were spared some of the more tedious chores. Being a man of wealth, Broadwell probably had a hired girl for ordinary housework; spinning and weaving were made unnecessary by imported textiles. A woman might have been hired to make clothing for the ladies, while fashionable hand-tailored suits for the men were perhaps made to order in St. Louis. Such advantages left more time to devote to hooking rugs, embroidering, and engaging in the other more genteel arts of the settled East. For example, in addition to making the universally popular pieced quilts for everyday use, the ladies also made elaborate and elegant quilted bedspreads or "counterpanes."

One type of quilted counterpane was made entirely of white materials fastened together with stitched designs of cornucopias filled with fruit or baskets of flowers. The central pattern was surrounded by a decorative border of stitching, the background filled with hundreds of rows of fine stitching. The main patterns were often given emphasis by additional padding ("stuffing") from the back. Cotton cording or wads of cotton were inserted between the woven threads of the lining material; after the surplus was cut off, the holes in the lining were mended by tediously drawing the woven threads back into place. This form of work is called trapunto, but the name was probably unknown to the pioneer women who performed it.

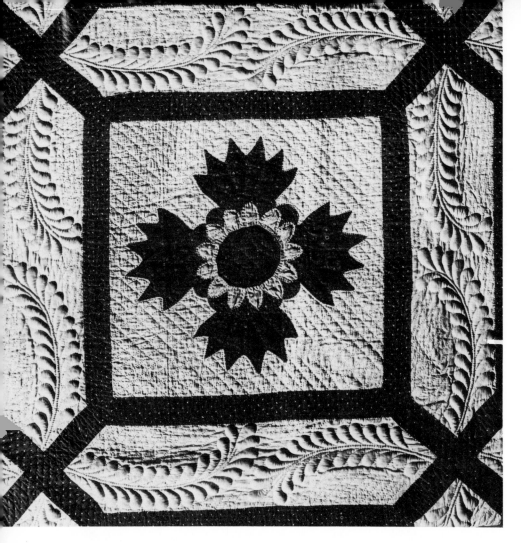

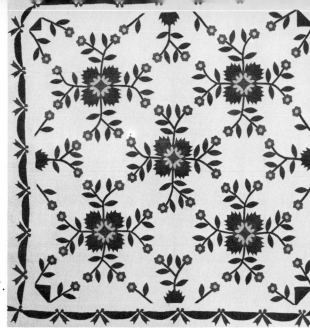

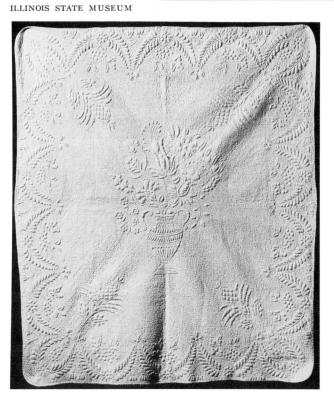

Another elegant type of quilted counterpane had designs made of colorful cotton materials cut out and then patched or appliquéd onto a light background. Often the main designs of this type of cover were also given additional "stuffing." Such quilts sometimes necessitated months of work; they were treasured as works of art and, as such, were often made by friends to be included in a bridal chest or presented to an honored member of the community.

Detail of appliqué quilt showing "stuffing."
ILLINOIS STATE MUSEUM

Art, Crafts, and Architecture in Early Illinois

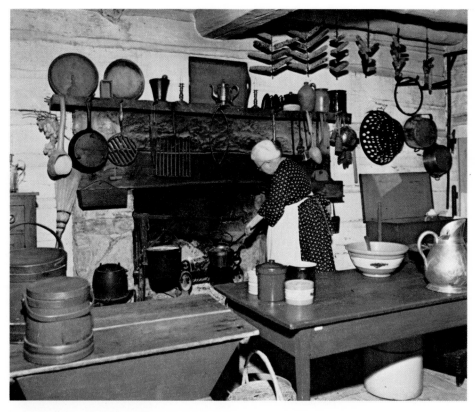

*Restored kitchen of the Rutledge Tavern in New Salem, an example of the
interior of a typical log "house," in contrast to that of the average
log "cabin." Note the stone fireplace, whitewashed walls, and sawn
floor boards. Typically, some of the articles in this room are of
local manufacture, while others were brought to Illinois by the pioneer.*
PHOTOGRAPH BY CHARLES HODGE

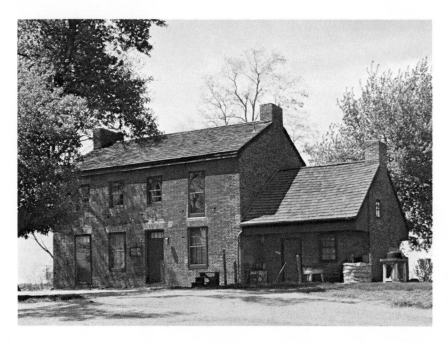

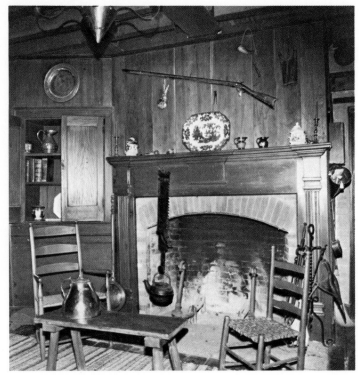

Clayville Tavern on Route 125 near Pleasant Plains. When built before 1825, this brick inn had double porches at the front and back. The wing on the right contains the original kitchen (see opposite page). Today this fine old Federal-style structure is a museum open to the public. An interior view shows some of the excellent original cabinetwork at the tavern. Notice the fine reeding on the mantelpiece characteristic of Federal times.

PHOTOGRAPHS BY CHARLES HODGE

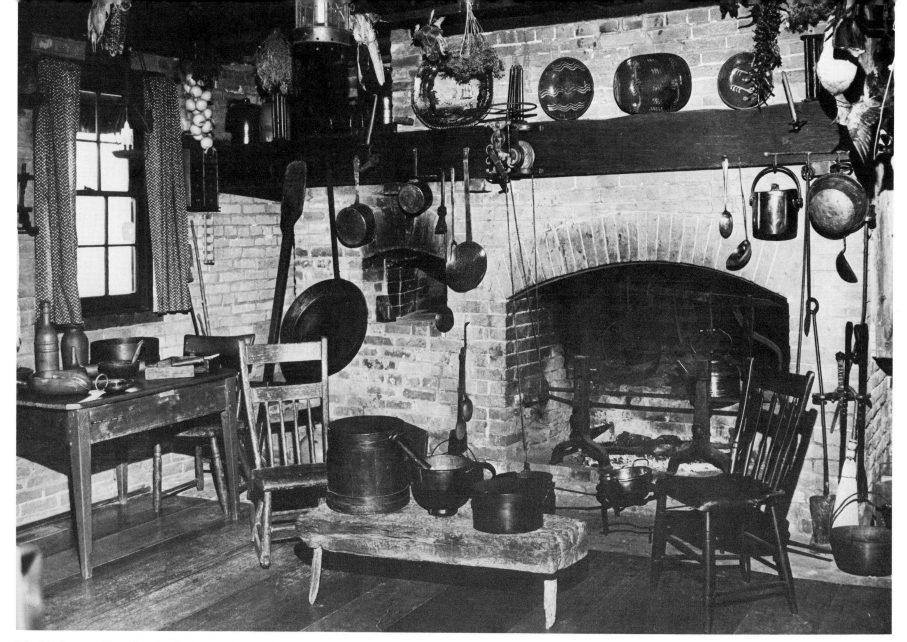

*The kitchen at Clayville. To the left of the fireplace opening is an
oven where bread was baked. To the right is a typical rod-back
Windsor chair with spindles shaped like arrows. The chair on the left is a
slat-back Windsor rocker; beside it stands one of the tavern's original tables.*
PHOTOGRAPH BY CHARLES HODGE

Yankee Influence

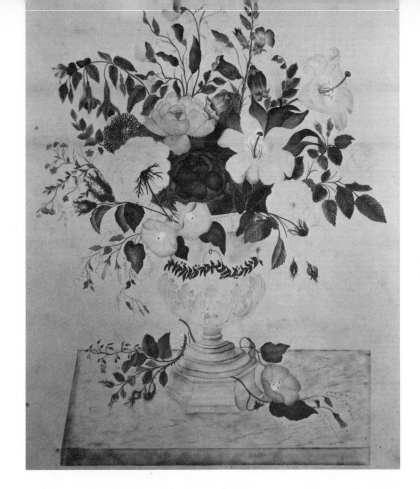

*A page from the sketchbook
of Anne Wakely Jackson,
a student at the Female
Academy in Jacksonville
about 1834.*
EMMET PEARSON COLLECTION

*A theorem painting in watercolors, mid-1800s.
From Rio in Knox County.*
MRS. REYNOLDS EVERETT COLLECTION

*An amateur's landscape painting. Made by
Mrs. Charles Chism of Albion, Edwards County.*
MR. AND MRS. HOWARD PORTER COLLECTION

Art, Crafts, and Architecture in Early Illinois

New cultural opportunities for women were introduced as early as 1833 when Jacksonville established a "female academy" — the first institution in the state (excepting the convents in French settlements) for women exclusively. This was a great advancement for Illinois in a day when average citizens questioned the necessity of continuing education for girls, and even in the East few women received more than an elementary education. Shortly, academies for women began to appear in other prosperous Illinois towns with two general kinds of curricula. There were the "useful" studies, which provided a general background for a young woman or equipped her for teaching, one of the few respectable professions that she might enter; the curriculum included English reading, grammar, composition, mathematics, geography, and occasionally Latin, French, philosophy, chemistry, botany, and mythology. In contrast, the "ornamental" studies were designed to appeal to young ladies of the cultured class, from whom the academies and seminaries received donations as well as tuition. Subjects in this curriculum might include embroidery, Oriental drawing, enamel painting, transfer drawing, and velvet painting. In 1833-34 these were the subjects taught at Miss Catherine Bayne's boarding school in the newly incorporated town of Chicago. Two years later, drawing, needlework, "landscapes," and "fancy painting" were being taught at a female academy in Springfield; and in 1837 a Mrs. Martin informed the young ladies of Springfield that she intended to open a school in which shell work, ebony work, wax work, and theorem painting in oil and watercolors would be taught.

To understand the painting and drawing productions of those academies, it must be understood that the early 1800s neither required nor encouraged originality. Copying was considered the best method of learning, so that instruction books printed both in England and America contained pictures of fruit, romantic English landscapes, animals, and flowers to be copied by the student. Still-life studies were also extremely popular. Bowls of fruit or flowers set on a table were sketched with pencil or pastel chalks or painted in oils or watercolors.

Among the more mechanical arts was theorem painting. Stencils, cut in various shapes from heavy paper, were assembled in various combinations for painting pictures of bowls of fruit, flowers, or other motifs either with watercolors on paper or with oil paints on various textiles. "Ebony work" and "India painting" probably were one and the same thing: a painted folk imitation of the expensive ivory inlay in ebony wood obtainable only by wealthier citizens in the East. One method for this art involved pasting paper cutouts to a surface, covering the entire surface with black paint, and then removing the cutouts to reveal a background with silhouetted shapes that simulated inlay. The reverse of this process was also effective. Stencils were used over a black-painted surface to apply the design in an ivory-colored paint or enamel. Oriental painting was similar to that used on Hitchcock chairs and tinware of New England: patterns were stenciled with metallic powders or colored paints onto a darker painted background. Wax work consisted of the formation of wax into flower or fruit forms for table decorations; shell work was the gluing of various types of shells together to produce floral pieces or designs suitable for pictures or table or mantel ornaments and containers.

A portion of a stenciled counterpane made in Illinois about 1840 by a member of the Haskins family, pioneers of Belvidere, Boone County.
ILLINOIS STATE MUSEUM

Obviously the wealthy man's household furnishings differed greatly from those of his average country neighbors. Not only did he own some furniture brought from the East or bought in St. Louis, but he could have furniture made to order by a local cabinetmaker. As early as December 1831, Moore and Walters of Springfield — the second largest city in Illinois by 1834 — were advertising in the *Sangamo Journal* the wide variety of furniture pieces that they made:

Painted slat-back chair with rush seat. Often called a mule-ear or rabbit-ear chair because of its flattened posts. The narrowed legs are typically midwestern.
EDWARDS COUNTY HISTORICAL MUSEUM

Spinning wheel for flax made by William M. Stewart, a wheelwright at Hennepin, Putnam County, ca. 1831.
WILLIAM CAIN COLLECTION

The following year (June 28, 1832) William G. Doyle of Springfield advertised his Windsor and "fancy" painted chairs — the latter being decorated with the popular stenciled or freehand painted decorations similar to those on chairs of the Hitchcock factory in the East. The stencil type of decoration was also applied to oilcloth, a cheap and durable covering for rough or ill-fitted floors. A *Sangamo Journal* ad of February 23 stated:

Smith and Moffett and E. Tabor placed similar ads in the same paper.

Slat-back chair with split-hickory seat. Made near Ottawa.
LA SALLE COUNTY HISTORICAL MUSEUM

Cherry candle table with drop leaves made in Menard County.
MRS. JUNE POWER REILLY COLLECTION

Walnut cupboard of the Armstrong family at Clary's Grove, Menard County.
DR. AND MRS. FLOYD BARRINGER COLLECTION

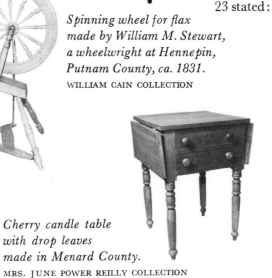

This floor covering consisted of strips of woven flax or hemp covered with thick layers of paint. The lower side was left plain, but the upper side was ornamented with designs in two or more colors. If a customer wanted a patterned border, strips of oilcloth were cut to fit the room, and a border was then added.

Three years later an ornamental artist placed his ad in the same newspaper:

110

Art, Crafts, and Architecture in Early Illinois

Such ads in old newspapers provide the researcher with the most valuable single source of information about the furnishings available for homes and the existing arts and artisans in various portions of the early state. They provide time capsules indicating the relative prosperity of various towns, origins of settlers, their ideals, aptitudes, and customs. The published guidebooks and gazetteers for immigrants provide another rich source of information. The following list compiled from Peck's *Gazetteer* of 1834 gives an idea of the variety of businesses and craftsmen in Jacksonville, the largest town in Illinois, with a population of 1,800:

16 stores	1 house and sign painter
2 taverns or hotels	4 blacksmiths
6 groceries	3 chair makers
several boarding houses	1 coach maker
2 saddlers	1 wagon maker
3 hatters	1 wheelwright
1 silversmith	1 yarn manufactory
1 watchmaker	2 carding machines
2 tinners	1 tannery
3 cabinetmakers	1 brickyard

Quincy, settled in 1822 on the Mississippi River, was settled largely by easterners. It too had a silversmith and had acquired by 1835 the following industries:

3 cooper shops	1 milliner and mantua maker
3 blacksmiths	
1 printing office	1 wheelwright
1 coach maker	1 chair maker
4 tailors	1 wool carding machine
2 wagon makers	1 carriage and orna-
5 carpenter shops	mental painter
1 gunsmith	3 cabinetmakers

Similar craftsmen were situated in other prosperous towns in the state. By 1837 there were new tin and copper "manufactories" in Illinois, and there were silversmiths in Springfield, Belleville, and Beardstown, as well as in Jacksonville and

Early coin silver spoons.
ILLINOIS STATE MUSEUM

Quincy. Their "coin silver" flatware may have occasionally been made from silver coin as in colonial days, but in nineteenth-century Illinois it is more likely that the term meant that a piece was equal in pure silver content to U.S. coins, or 900 parts out of 1,000.

The opening of the Erie Canal in 1825, the removal of the Indian threat in northeastern Illinois, and steamboat traffic along the Great Lakes had combined by 1833 to make the little village of Chicago the main port of entry into Illinois for a great tide of immigration from the East. Activity was great in the village, described by one English visitor, Charles J. Latrobe, as a chaos of mud, rubbish, and confusion. There was immediate need for cheap new houses, as immigrants were sleeping in tents and in the bodies of their wagons. Chicago was faced with

two great problems: the first, a shortage of wood in the area, was solved by shipping pine lumber down Lake Michigan from Wisconsin and Minnesota; the second and even greater problem — that of erecting eastern-type timber frame buildings cheaply and quickly enough to meet the demand — was lessened by the invention in Chicago of the "balloon frame" type of building construction. This ingenious new system later revolutionized the centuries-old method of frame construction in America and became the fastest, easiest, and cheapest way in history for a carpenter to erect a frame house, contributing significantly to rapid expansion of the West. It remains, with only a few added features, the basic system for frame house construction to this day.

Balloon frame construction.

There is some controversy over the identity of the inventor of the balloon frame. Some authors attribute the invention to Augustine Deodat Taylor of Hartford, Connecticut, who in 1833 built St. Mary's Catholic Church, the first authenticated structure using this system. Others (including John Murray Van Osdel, Chicago's first professional architect (1837), the Chicago historian A. T. Andreas, and Rexford Newcomb, former dean of the University of Illinois School of Architecture) have attributed the balloon frame to George Washington Snow, who had come from New Hampshire to Chicago in 1832 as a town surveyor. Whichever man was responsible, the invention was definitely that of a Yankee, and, according to Van Osdel, it completely superseded the old style of framing with posts, girts, beams, and braces in Chicago.

Instead of using heavy timbers fastened together in the usual time-consuming manner, the inventor developed a light framework of standard cut boards fastened together with steel nails and overlaid with sheathing and weatherboarding. Scoffers who said it would blow away with the first strong wind dubbed it the balloon frame, but the structure held up. It was not uncommon to see a frame rise in a single day. The great numbers of immigrants moving into Chicago could be provided with houses, and Chicago grew suddenly from a population of about 350 in the summer of 1833 to 3,265 by 1835.

Easterners emigrating through the port of Chicago were instrumental in the settlement of such central and northern Illinois towns as Lewistown, Pekin, Princeton, Galesburg, Rockford, Tremont, Pittsfield, Wethersfield (now a part of Kewanee), Geneva, and Mt. Morris. They were good businessmen who promoted the building of roads, railroads, stagecoach lines, and the Illinois-Michigan Canal, and among them were excellent silversmiths, carriage builders, and cabinetmakers. In 1832-33 Captain D. S. Harris and his brother built a steamboat named the *Jo Daviess* on the Fever River near Galena, and in 1835 shipbuilding commenced in Chicago.

During the early years of the nineteenth century prejudices and misunderstandings abounded between the Yankees and their southern neighbors. Yankees accused southerners in general of being lazy, shiftless, and uncultured; southerners accused easterners of "putting on airs," of being inhospitable, tight-lipped, and untrustworthy in business deals. The Yankee, it was known, drove a hard bargain, and southerners were particularly suspicious of Yankee peddlers, who were accused of cheating and conniving. In addition, such peddlers, with their bright shiny tinware, ginghams and calicoes, combs, dyes, buttons, and ribbons, were considered a threat to the home industries and merchants. In self-defense, many communities began to require peddlers to buy licenses in an effort to discourage competition. For example, the first clock peddler in Tazewell County, Laman Case, was required to buy a

St. Mary's Catholic Church, the first balloon frame building (1833). Originally without a belfry, it once stood at Lake and State streets in Chicago.
AFTER ANDREAS

three-month lease for $25 in 1831. Nevertheless, the housewife who lived in an area where specialized craftsmen and stores were few was eager for the sight of the peddler's handcart or wagon. She also welcomed the services of other Yankee itinerants: the weavers, tinners, and shoemakers, and the basketmaker, who could also construct new seats for her chairs. Her purchases therefore made the trade profitable, and it continued in spite of license fees.

As the years advanced, prejudices and differences gradually diminished between the southerners and the easterners. Governor Thomas Ford, in his *History of Illinois,* wrote in defense of the poorer southerners: "There is much shrewdness and sagacity in the most ignorant of Southern people; and they are generally accumulating property as fast as any people can do who have had so little to begin with."[5]

Art, Crafts, and Architecture in Early Illinois

10 Painters of the Indian

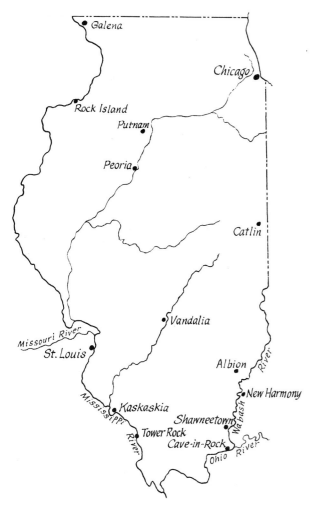

From the earliest days of exploration the American Indian had been of great intellectual interest to the European. The Red Man was the Noble Savage: handsome and brave, an exotic breed unspoiled by the white man's civilization. The Indian was the subject of a multitude of writings and endless discourse; many romanticized sketches of him were engraved for European publications. On the other hand, the average colonist in America had a very different view of the Indian. In his greed for land, the white man was apt to resent the Indian, seeing him as an obstacle in the path of progress, a menace to life and property, a savage without morals, and a perpetrator of bloody massacres. Some men tried to cultivate his friendship, but few saw anything in the Indian's way of life that was worthy of preservation. This general attitude accounts for the scarcity of early American drawings and paintings of Indians. Those that exist depict them either in battle, as enemies of the white man, or in defeat, as signers of treaties.

It was not before the latter part of the 1700s that attitudes in eastern America began to change. With the Indian subdued and being removed from the East, he no longer seemed such a threat. Rousseau's philosophy of the dignity of man was spreading; the Quakers were teaching brotherly love. Eventually the eastern artist began to reflect the new feeling by portraying the Indian sympathetically. Charles Willson Peale (1741-1827) of Philadelphia, trained by John Singleton Copley (1738-1815) in the British tradition of painting fashionable citizens in their silks and satins and powdered wigs, was keenly interested in ethnology. Peale began to paint the Indian chiefs who were negotiating treaties in Philadelphia, and by 1785 he had established a famous museum that probably contained, in addition to a fine gallery of paintings of historic and fashionable citizens, the first American collection of individual portraits of American Indians and their artifacts. Peale portrayed the dignified Indian as a man in his own right — the Noble Savage. Following the new trend, other distinguished eastern artists, including Charles Bird King (1785-1862) and George Cooke (1793-1849), painted Indian chiefs on treaty missions in Washington from 1821 to 1837. These portraits included a number of Sauk, Fox, and Potawatomi Indians from Illinois.

By the early 1800s the U.S. government, deciding that the vanishing Indian's life and customs should be preserved for posterity, made it a practice to send artists along with expeditions to the West to record sites of interest and Indians

113

in their native habitats. Samuel Seymour seems to have been the first American artist sent to paint Indians in the Mississippi River region. Between 1823 and 1833 James Otto Lewis (1799-1858) of Philadelphia was staff artist on several treaty missions in Wisconsin, Indiana, and Michigan. He published two volumes, *The Aboriginal Portfolio* (1835) and *North American Aboriginal Portfolio* (1839), printed in Philadelphia and New York. These were followed by other editions. The original, with seventy-two lithographs made from his sketches by Lehman and Duval of Philadelphia, included more Indians from Illinois: Wa-Baun-See, a Potawatomi chief; Kee-O-Kuck (Watching Fox), chief of the Sauk tribe; and Nabu-Naa-Kee-Shick (One-Half of the Sky), a Chippewa chief. Paintings commissioned by the U.S. War Department for its own collection were made from about eighty-five of Lewis's sketches by Charles Bird King. Later, some pencil sketches of Chippewa chiefs and squaws, made by Lewis in 1826 at Fond du Lac, Wisconsin, and then published as engravings in Thomas L. McKenney's *Sketch of a Tour of the Great Lakes* (Baltimore, 1827), were also copied by King for the government's growing collection of Indian paintings.

While Lewis was at Fond du Lac, a young Swiss artist named Peter Rindisbacher (1806-34) was engaged in painting Indians in the lead-mining area of Wisconsin adjacent to northwestern Illinois. He had spent one disastrous winter in the Red River colony at Hudson Bay before moving to Wisconsin in 1826. For three years Rindisbacher painted Winnebago, Sauk, and Fox Indians, including Keokuk, the Sauk chieftain, who had been friendly with the whites. In 1829 the artist moved to St. Louis, where he

enjoyed some degree of fame for five years before his death at the age of twenty-eight.

By 1830 the Indian was disappearing from Illinois. On May 28 President Andrew Jackson signed the Indian Removal Act requiring all tribes east of the Mississippi River to cede their lands and move to territories in the West. Remnants of the Sauk, Fox, Peoria, Potawatomi, Kickapoo, Shawnee, and Kaskaskia tribes stayed in Illinois for a time, but most of these had been absorbed into the French villages or were living broken and defeated lives, dependent upon the white man for kettles, knives, guns, blankets, trinkets, and whiskey. Two rare and naive paintings of this period are attributed to an untrained artist, Samuel Gardiner Drake, a member of the New Hampshire Historical Society, who in 1837 produced in Boston a crudely illustrated volume, *The Book of the Indians of North America. Details in the Lives of about Five Hundred Chiefs and Others. . . .* One painting attributed to Drake is of Se-na-ge-woin (Senachwine), a Potawatomi chief buried at Putnam, Illinois; the other is of Black Hawk, the famous Sauk warrior (see p. 54). The latter portrait is now owned by the Illinois State Historical Library.

During the winter of 1832-33, a young Swiss painter named Karl (Charles) Bodmer (1809-93) stayed at New Harmony, Indiana, with the German prince Maximilian of Wied-Neuwied. Maximilian, an amateur scientist fascinated by accounts of the American Indian tribes, had chosen the talented Bodmer to accompany him to the American West to make accurate sketches for a book he intended to write, hoping to help perpetuate what remained of the Indian and his way of life. Bodmer sketched and painted in watercolors views around New Harmony and the

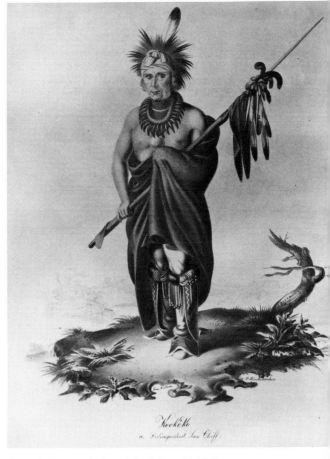

"Keoköke, a Distinguished Sax Chiff,"
by Peter Rindisbacher.
WEST POINT MUSEUM COLLECTIONS,
U.S. MILITARY ACADEMY

lush vegetation of the Wabash River. In addition, he sketched the town of Albion, Illinois, and the mouth of the Fox River near the site of Morris Birkbeck's drowning.

In the spring the visitors traveled by steamboat down the Ohio, where Bodmer sketched Cave-in-Rock and the confluence of the Ohio and Missis-

114

"View of a farm on the prairies of Illinois." Watercolor painting
by Karl Bodmer in 1833.

NATURAL GAS COMPANY COLLECTION, JOSLYN ART MUSEUM, OMAHA

Painters of the Indian

sippi. The two men then proceeded northward; when they made stops to pick up wood, Bodmer sketched the cabins of Illinois settlers and the old town of Kaskaskia, while Maximilian made notes. In his *Travels in the Interior of North America, 1832-34,* published in London in 1843-44 after earlier German and French editions, Maximilian wrote: "The Tribe of Kaskaskia Indians dwelt in these parts, and some remains of them still live near the settlement. We were told that there was at present only one man amongst them of the pure race."[1] The two men traveled to the Missouri River, then turned westward. They had not yet found their ideal Noble Savage, so Bodmer's Illinois paintings were not of Indians but of landscapes. These pictures are unequaled in their artistic quality, depicting with great charm

The luxuriant vegetation along the Wabash River in Illinois as seen by Karl Bodmer, 1832-33. This is an engraving by Lucas Weber after Bodmer's "New Harmony on the Wabash."
IN MAXIMILIAN

"Tower-Rock." Lithograph made by John Outhwaite after a sketch by Karl Bodmer.
NEWBERRY LIBRARY, CHICAGO

Art, Crafts, and Architecture in Early Illinois

"Mouth of Fox River [Indiana]."
Aquatint after Karl Bodmer's painting of 1832-33.
IN MAXIMILIAN

by Stanley in Galena in 1838 is in a private collection in Omaha. Stanley was more interested in painting Indians, however, and made occasional trips to Minnesota to do so. In 1846-53 he went to the far West and Southwest to paint, returning with a collection of 151 paintings of Indians, buffalo, and western scenery which he deposited in the Smithsonian Institution's Indian Gallery, established in 1852. The gallery also contained the War Department's collection, with its sketches by J. O. Lewis, paintings by Charles King and George Cooke, and a few other works by such artists as A. Ford and S. M. Charles.

Concurrent with the increasing interest of easterners in the West, James Hall (1793-1868),

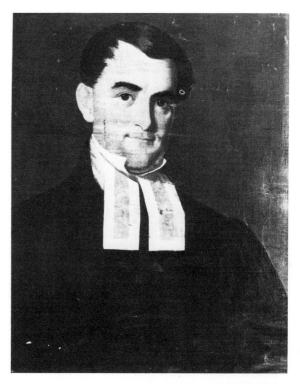

Portrait of an unknown man.
Signed: "John M. Stanley Galena 1838."
MRS. RALPH REDFIELD COLLECTION

yet without romantic exaggeration some rare early Illinois scenes. A few of these sketches, along with many of his more famous sketches of western Indians, were reproduced as engravings for Maximilian's book, but over 400 of the original sketches, owned by the Northern Natural Gas Company, are preserved in the Joslyn Art Museum of Omaha.

An itinerant painter named John Mix Stanley (1814-72), best known for his western scenes and Indian portraits, also painted in Illinois. During 1838-39 he was in Chicago and Galena painting portraits of local citizens. A fine full-length portrait of H. H. Gear in the Galena Historical Society Museum has been attributed to this artist. Gear, a pioneer settler, lead miner, and industrialist, is shown standing beside a mine shaft, with lead miners working in the rolling hills of the background. A signed portrait made

from a literary family of Pennsylvania, moved first to Shawneetown (1820-27) and then to Vandalia, where he became editor of the *Illinois Intelligencer* and state treasurer. He wrote many articles and books about the West and its people, and his *Letters from the West, Containing Sketches of Scenery, Manners and Customs; and Anecdotes Connected with the First Settlements of the Western Sections of the United States* was

"Portrait of H. H. Gear, Galena," 1839. Attributed to John Mix Stanley.
GALENA HISTORICAL SOCIETY MUSEUM

published in London in 1828. By 1829 he had begun to publish, with his partner Robert Blackwell, the *Illinois Monthly Magazine,* the first literary periodical in Illinois. However, because of a lack of laborers and materials he moved to Cincinnati in 1833, continuing to publish his magazine under a new title, *Western Monthly Magazine.* Today Hall is more noted for his collaboration with Thomas L. McKenney, superintendent of the U.S. Bureau of Indian Affairs, in the publication of a folio edition of *The Indian Tribes of America* in Philadelphia in 1836. The printing of this fine book, beautifully illustrated with hand-colored lithographic copies of some of the paintings in the Indian Gallery, proved to be most fortunate. Today many of its pictures are the only remaining records of some of the early nineteenth-century Indians, because in 1865 a fire in the gallery destroyed nearly all of the precious drawings, paintings, and artifacts that had been collected. Luckily, some of the early Stanley portraits, including an early portrait of Black Hawk, had been copied by King and bequeathed to the Redwood Library at Newport, Rhode Island. As a result of the fire, however, only one great collection of early Indian paintings executed by a single man remains — the work of the master Indian painter George Catlin (1796-1872).

Catlin, like Audubon, was consumed by a desire to record what he saw with the utmost fidelity. Sometime during the period 1821-25, when he was in Philadelphia working as a miniaturist, he was inspired, perhaps because of his association with Charles Willson Peale, to establish a natural history museum and Indian collection of his own. His mind made up, he spent the years 1830-38 traveling on foot, by canoe, and on horseback through the West, sketching, painting, and describing in his journal members of the tribes of American Indians he visited. Some of these Indians were still living in Illinois; others had been transferred to reservations west of the Mississippi River. Catlin, feeling that the wilderness was the true school of the arts, spurned the refinements of civilization. Fascinated by the wild beauty and colors of the West and by the trappings and natural grace of the Indian, he developed a great sympathy for the tribes who were then being divested of their forests and prairies. He recognized their plight, realizing with regret that their crafts were disappearing and that their morals were being corrupted by the white man's whiskey. His great desire was to preserve on canvas the unspoiled looks and unique customs of the American Indians. For eight years Catlin lived with various Indian tribes, western hunters, and fur traders. Each fall he made his way downstream to spend the winter in St. Louis, New Orleans, or in the East, where he painted portraits to finance further trips to the Indian country or completed his sketches and paintings of the Indians.

In the summer of 1830 he was at Prairie du Chien and Fort Crawford, where treaties were being made with Iowa, Missouri, Omaha, Sioux, Fox, and Sauk tribes, and that fall he was on the Missouri River at Leavenworth, painting Iowas, Delawares, and Shawnees. He visited villages on the Kansas River to paint portraits of the Kansa tribe, and the next spring he traveled up the Platte River from village to village, painting Grand Pawnee, Oto, Omaha, and Missouri tribes.

Although he tried to be as accurate as possible in his descriptions of the tribes and the particular

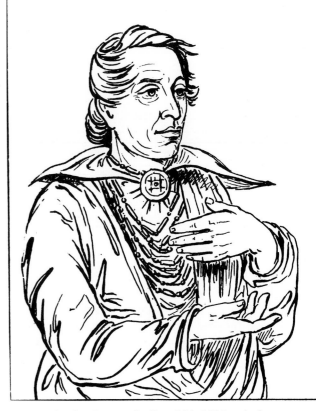

Engraving by George Catlin of his 1831 painting of Kee-án-ne-kuk, the Prophet, chief of the Kickapoos.
IN CATLIN (1845 ED.)

subjects he painted, Catlin was careless in his chronological assemblage. His *Manners, Customs and Condition of the North American Indians* (London, 1841) has caused much contention among his biographers as to where and when certain pictures were painted and what tran-

Art, Crafts, and Architecture in Early Illinois

spired during the gaps in his notes. Thomas Donaldson, an early biographer who accepted the Catlin collection for the Smithsonian Institution in 1879, based his interpretation of Catlin's travels and portraits entirely on the published volumes and catalogs. Later biographers contend that this interpretation is erroneous.

Except for his Rock Island paintings, Catlin's paintings of Illinois Indians are generally considered to have been done on reservations west of the Mississippi; John Ewers's map of Catlin's travels shows no painting sites within the state at all. It should be realized, however, that some members of Illinois tribes still remained in the area, although their lands had been ceded. The final treaty of the United Nation of Chippewa, Ottawa, and Potawatomi Indians was not signed at Chicago until September 26, 1833, and the final treaty which ceded lands of the Sauk and Fox was not signed until 1836. It is therefore quite probable that in his travels back and forth from the East, Catlin not only passed through Chicago but also visited Illinois tribes remaining in their natural habitats. According to Donaldson, Catlin visited Chicago every year from 1832 to 1836. During this period a small investment might have made Catlin rich, but, says Donaldson, he "did not invest, but was in search for Indians and their life and habits. He sketched and resketched Chicago and was in daily association with men who were there for investment and who eventually became enormously rich from land purchases made at that time. Yet it never seems to have occurred to Mr. Catlin that he could become rich as *well* as his friends.... Indians and their habits were his objective point, not lands or wealth."[2]

In 1831 Catlin painted six members of the Kickapoo tribe then residing, according to the artist, "within the State of Illinois, near the south end of Lake Michigan, and living in a poor and miserable condition, although they have one of the finest countries in the world." They were "reduced in numbers by whiskey and smallpox," their game was being destroyed, and their tract was becoming surrounded by civilization. Those who remained, he wrote, "will soon be obliged to sell out their country for a trifle and move to the West."[3] One of his portraits was of Kee-án-ne-kuk (Foremost Man), called the Prophet. Chief of the Kickapoo tribe, he was painted in an attitude of prayer, for he was a very devout Christian who held regular Sunday meetings for his followers. Ah-ton-we-tuck (Cock Turkey) was depicted holding a maple prayer stick engraved with the characters of a prayer taught by a Methodist missionary. Every member of the tribe was required to have one of these sticks, which were manufactured and sold at a good profit by the chief himself. Catlin also painted Ma-shee-na (Elk's Horns), a sub-chief, in the act of prayer; Ke-chim-qua (Big Bear), wearing wampum around his neck and holding a red flag, symbol of war or "blood"; A'h-tee-wot-o-mee, a woman wearing wampum and a profusion of silver brooches at her neck; and Shee-nah-wee, another woman of the tribe.

It was with some difficulty that Catlin obtained portraits of women. Indian chiefs and braves wondered at Catlin's condescending to paint a woman, conferring on her the same honor that had been given them. Catlin explained to them that he "wanted the portraits of the women to hang under those of their husbands merely to show how their women looked and how they dressed."[4] It was perhaps in this way that Catlin

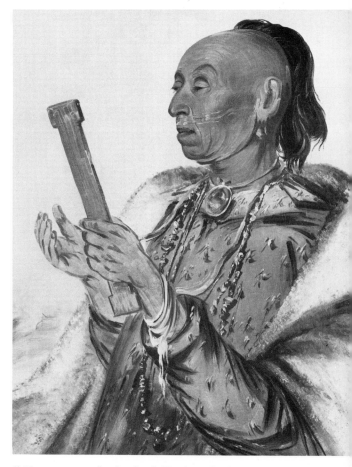

"*Ah-ton-we-tuck, the Cock Turkey, disciple of Kee-án-ne-kuk, in the attitude of prayer.*" *Oil painting by George Catlin, 1831.*
SMITHSONIAN INSTITUTION

obtained permission to paint these two women, as well as an old woman of the Illinois Kaskaskia tribe and a Potawatomi woman in Michigan.

Early in 1832 Catlin, leaving his wife in the East, set off for St. Louis. He intended to travel up the Missouri River to the mouth of the Yellowstone on a pioneering voyage aboard the

steamboat *Yellow Stone* in order to paint members of the Assiniboin, Blackfoot, Crow, Plains Cree, and Plains Ojibwa tribes. Many of these Indians considered Catlin to be a great medicine man. They believed that when he painted a portrait he created a twin endowed with a certain amount of life, so the Indian whose portrait had been painted would guard it night and day, believing that harm to it meant harm to himself.

For some time trouble had been brewing in northwestern Illinois. Near Fort Armstrong on Rock Island, a rebellious and influential warrior named Black Hawk proudly led a group of Sauks in their refusal to leave their village of Saukenuk, situated on a beautiful point of land between the Rock and the Mississippi rivers. These Sauks had not accepted the validity of treaties by which the principal Sauk war chief, Keokuk, had ceded their lands. Black Hawk, advised to give up the resistance and move away, had refused, and for

several years he had defied settlers who had encroached upon his lands. He and his followers had stolen the settlers' horses and pigs and had destroyed their wheat and corn. The Sauks had spent the winter of 1829 at their hunting grounds, and in the meantime new American settlers had invaded Black Hawk's land, settled in his village, and even moved into his lodge. Black Hawk's powerful rival, Keokuk, had acquiesced to the demands, moving his own band of Sauks into Iowa, but Black Hawk remained stubborn.

While Catlin was busy painting American Indians in the far West, the trouble brewing around Fort Armstrong came to a climax. General Gaines, sent with troops and authorized to remove Black Hawk and the remaining Sauks forcibly, found that the Sauks had slipped to safety across the Mississippi. Black Hawk was compelled to sign an agreement never again to cross the Mississippi without permission, to cease

contact with his British friends, and to submit to the authority of Keokuk. Lacking further excitement, the undisciplined American volunteers burned Black Hawk's village and plundered the old Indian graveyard.

Black Hawk's followers were indignant. Their town had been destroyed and their dead were left uncovered and in defilement. Moreover, they had been forced to leave their community before crops could be harvested, with the result that they were starving before the end of winter. Desperate and faced with loss of prestige among his followers, Black Hawk returned to Illinois in the spring of 1832 with 500 men, women, and children in the hope that his people might at least be allowed to grow a crop of corn and beans at a village of his former friends, the Winnebagos. Turned away by them, Black Hawk entreated the Potawatomis and was again refused.

The government was by now thoroughly

The Colonel Davenport house near Fort Armstrong as it looked when it was built in 1833. Federal style. Davenport was a wealthy and cultured trader who laid out the town of Davenport, Iowa. Peter Britt's portrait of the colonel is on p. 257.
AFTER A MEASURED DRAWING BY THE
HISTORIC AMERICAN BUILDINGS SURVEY

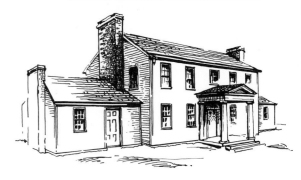

Art, Crafts, and Architecture in Early Illinois

aroused, and the militia moved in hot pursuit. Black Hawk sent out bearers with a white flag of surrender, but the militia, filled with a blind hatred of the Indian, fired on the flag bearers and pursued the others. From May 14 until June 6 fierce battles raged, the Sauks gradually retreating toward Canada. In a final battle, fought below the mouth of the Bad Axe River in Wisconsin, the starving Sauks were practically annihilated.

Catlin returned to St. Louis in 1832 to learn that the once-proud Black Hawk, his sons, and some of the leading warriors of his band were imprisoned at nearby Jefferson Barracks, and he was granted permission to paint their portraits. The following year Black Hawk, taken on a tour by the government, was sketched by James Otto Lewis in Detroit and painted by R. M. Sully in the East, while tens of thousands thronged for a glimpse of the famous leader who had fought so hard for his home and his people.

Apparently during the late fall and winter of 1832-33 Catlin visited some of the remaining Illinois Indians. Before returning to Cincinnati he wrote: "I start in a day or two, with a tough little pony and pack horse, to trudge through the snow drifts from this place to New Madrid and perhaps further; a distance of three hundred miles to the South. . . . I close my book for further time and further entries."[5] What transpired that winter is not recorded in the journal. The gap has puzzled historians, but Harold Mc-Cracken has determined that from May until December of 1833 Catlin lived with his wife in Cincinnati, working on his portraits. However, in Catlin's notes and catalogs there are descriptions of Kaskaskia, Peoria, and Piankashaw Indians painted in Illinois in 1832-33.

By this time the once-powerful and warlike Kaskaskia Indians had been reduced almost to annihilation by whiskey and smallpox, the cruelty of neighboring tribes, and the avarice of settlers who had taken over their lands. Perhaps a dozen still lived, merged into the Illinois tribe of Peorias. Catlin said of the Kaskaskias, "With the very few remnants of this tribe will die in a few years a beautiful language, entirely distinct from all others about it, unless some enthusiastic person may preserve it from the lips of those few who are yet able to speak it."[6] Catlin painted Kee-món-saw (Little Chief) and his aged mother Wah-pe-séh-see (painted earlier in 1831).

Remnants of the Peoria tribe in Illinois, numbering only about 200, were then under contract to move to the west of the Missouri River. Catlin wrote: "Of this tribe I painted the portrait of Pah-me-ców-ee-tah (the Man who Tracks), and Kee-mo-rá-nia (No English) [see p. 54]. These are said to be the most influential men in the tribe and both are very curiously and well dressed in articles of civilized manufacture."[7] An additional painting was that of Wap-sha-ka-náh, a brave.

That same winter (1832-33) Catlin visited remnants of the Piankashaw tribe, then living in Illinois and Indiana but reduced to about 170 persons and under contract to move west. His paintings included those of Ni-a-có-mo (Fix with the Foot), "a brave of distinction," and Men-són-se-ah (Left Hand), "a fierce and very distinguished warrior, with a stone hatchet in his hand."[8]

In 1834 Catlin painted Indians of the southern plains — displaced Cherokee, Creek, and Choctaw Indians and Osages, Comanches, Kiowas, Wacos, and Wichitas. The following year he went

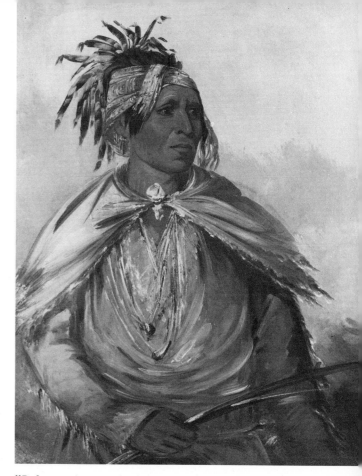

"Pah-me-ców-ee-tah, the Man who Tracks," a Peoria chief. Oil painting by George Catlin, 1832-33.
SMITHSONIAN INSTITUTION

north on the upper Mississippi to the Falls of St. Anthony; paddling downriver on the return trip, Catlin paused to paint Galena and Rock Island in areas of rapidly expanding population. He wrote:

On the upper Mississippi and Missouri, for the distance of seven or eight hundred miles above St. Louis, is one of the most beautiful champaigne countries in the world, continually alternating into timber and fields of the softest green, calculated, from its latitude, for the people of the northern and

eastern states, and "Jonathan" is already here — and almost everybody else from "down East" — with fences of white, drawn and drawing, like chalk lines, over the green prairie. "By gosh, this ere is the biggest clearin I ever see." "I expect we hadn't ought to raise nothin but wheat and rye here." — "I guess you've come arter land, ha'nt you?"

Such is the character of this vast country, and such the manner in which it is filled up, with people from all parts, tracing their own latitudes, and carrying with them their local peculiarities and prejudices. The mighty Mississippi, however, the great and ever-lasting highway on which these people are for ever to intermingle their interests and manners, will effectually result in an amalgamation of feelings and customs, from which this huge mass of population will take one new and general appellation.

It is here that the true character of the *American* is to be formed — here where the peculiarities and incongruities which detract from his true character are surrendered for the free, yet lofty principle that strikes between . . . low cunning and self-engendered ingeniousness. Such will be found to be the true character of the Americans when jostled awhile together, until their local angles are worn off. . . . And yet, many people of the East object to the Mississippi, "that it is too far off — is out of the world." But how strange and insufficient is such an objection to the traveller who has seen and enjoyed its hospitality, and reluctantly retreats from it with feelings of regret; pronouncing it a "world of itself, equal in luxuries and amusements to any other." How weak is such an objection to him who has ascended the Upper Mississippi to the Fall of St. Anthony, traversed the States of Missouri, Illinois and Michigan, and territory of Ouisconsin; over all of which nature has spread her green fields, smiling and tempting man to ornament with painted house and fence, with prancing steed and tasselled carriage — with countless villages, silvered spires and

"Sailing Canoes." An engraving by George Catlin from his 1836 painting of Sauk and Fox Indians at Rock Island.
IN CATLIN (1845 ED.)

domes, denoting march of intellect and wealth's refinement. The sun is such to look upon these scenes, and we, perhaps, "may hear the tinkling from our graves." Adieu.[9]

Catlin made at least one more stop before returning to St. Louis to paint Keokuk, who by 1834 had become high chief of the Sauk tribe, with a new village on the Des Moines River. Catlin's painting shows him in his native costume holding in his hand the staff of high office.

In 1836, again moving down the Mississippi, Catlin heard that the entire Sauk and Fox nation was meeting Governor Dodge at Rock Island for a final treaty to exchange their lands in Illinois for a reservation near Leavenworth, Kansas. He arrived just in time to witness the conclusion of the meeting, with Keokuk as the honored speaker and the dejected Black Hawk broken and silent. The following day was one of amusements, parades, and dances. Catlin made hurried sketches of the Indians "sailing" in their light dugout canoes, the women steering with paddles while the men contrived sails by standing on two corners of blankets or fastening them to their legs, holding the other corners up in the air so the blankets could catch the wind. Here he also painted "Begging Dance," "Dance to the Berdashe," "Discovery Dance," and "Smoking Horses."

For two more years Catlin continued to paint the American Indian, returning to the East in

Art, Crafts, and Architecture in Early Illinois

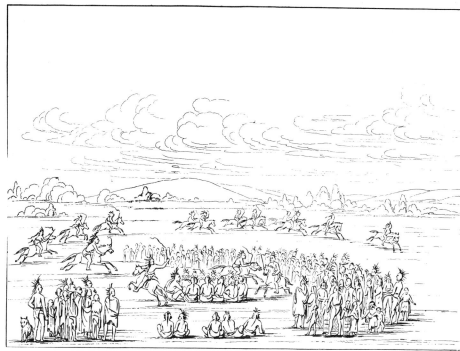

1838 to exhibit his collection. His eight years of travel in the West had resulted in a collection which contained 507 Indian portraits, pictures of Indian costumes, crafts and curios, landscapes, scenes of sports and amusements, and depictions of customs and ceremonies. The collection, enthusiastically received in the East, was then taken by Catlin to Europe for exhibition in London and Paris. King Louis Philippe was especially enthusiastic about the collection. In 1796, while in temporary exile from France, he had come to America, hiking over the mountains and boating down the Ohio and Mississippi rivers. He too had been fascinated by the Indian. At the king's order, Catlin's Indian collection was transferred to the royal palace, and the artist was asked to copy fifteen of his paintings for the royal collec-

tion. In addition, Catlin made twenty-four paintings depicting events of the French voyages of exploration which are now in the National Gallery of Art, Washington, D.C. The Illinois area scenes which Catlin painted included the arrival of La Salle at Peoria, an Indian feast at Peoria, Father Hennepin being attacked by the Sioux, and La Salle and his men crossing the frozen tip of Lake Michigan on sleds.

Catlin had just completed these paintings when revolution again flared up in France. The king was forced to flee, and in 1848 Catlin also

had to take hurried leave of the country. In Europe in 1852, bankrupt on account of some bad investments, Catlin was obliged to borrow money in Philadelphia with his Indian collection as security. In spite of his success in the East and in Europe and in spite of a petition sent by a number of American artists in Paris — notably John Vanderlyn, Thomas Hicks, and J. F. Kensette — the Smithsonian Institution remained uninterested in his collection. The result was that Catlin, unlike J. O. Lewis and Charles King, never received money from the government for his ser-

vices. Not until 1870 did he recover his paintings of French exploration and return to America with them. He had offered his collection to the Smithsonian as early as 1849, but only after his death in 1879 was the collection finally transferred to the institution. Since the collections of Lewis, King, and Stanley were destroyed by fire in 1865, Catlin's work alone remains the one great collection of Indian paintings made before the Civil War.

Catlin's fame, however, has been as historian rather than as artist. As Catlin himself explained his art: "...the world will surely be kind and indulgent enough to receive and estimate them, as they have been intended, *as true and facsimile traces of individual life and historical facts,* and forgive me for their present unfinished and unstudied condition as works of art."[10]

Forced to sketch rapidly, often under most unfavorable circumstances, Catlin did not conform to a "painterly" style while in the West. (An examination of some of his thirty or more early portraits in the East leaves little doubt that he was capable of sophisticated painting.) Because he rendered every detail of custom and costume precisely, Catlin's paintings are particularly valuable to the historian and ethnologist.

Catlin, presenting the image of the American Indian and the West to both America and Europe, had an influence on such artists as Arthur Fitzwilliam Tait (1819-1905) and Louis Maurer (1832-1932), who depicted scenes of western buffalo hunts, and his paintings have furnished illustrations and research material for thousands of works on Indians in America. "They have been modified, cut, altered, changed, but they remain Catlin's work. Authors in all lands have used them. Menageries, 'Wild West' exhibitions and theatres to this day use his 'war dance,' 'scalp dance,' and other views for advertisements, both in Europe and America.... It can be said with justice that no other painter or writer has had so broad and wide an influence in the diffusion of knowledge of the North American Indian as he has."[11]

11 Melting Pot Culture

Typically southern styles.

After the end of the first quarter of the nineteenth century the settled areas of Illinois were appearing more prosperous as a result of the arrival of more and more skilled craftsmen. New courthouses had sprung up, patterned as a general rule after the typical New England meetinghouse — a boxy structure with a fanlight over the door and perhaps a cupola; larger and more substantial Federal-style houses had been built, many with dormer windows in the upper half-story to allow more light in the rooms. Such signs of progress in the central and southern parts of the state were in great contrast to Chicago, which was still a struggling village in the swamps with relatively few inhabitants.

The appearance of dwellings in the southern rural areas varied according to the origins of the settlers. Southerners, accustomed to a warm climate and a rural life, were apt to live in houses with long verandas for shelter from the sun, set away from the road in the manner of southern plantation homes. Chimneys and fireplaces often were additions to outside walls; outbuildings were at a distance from the house; cellars were dugouts in the yard near the houses, reinforced and given doors. The easterner, on the other hand, acclimated to the deep winter snows which would sometimes force him to rely on his own resources for many days, preferred buildings close to the road and outbuildings nearby. A cellar underneath his house meant steps saved in inclement weather. As frugal as he was practical, the easterner conserved heat by building his chimneys inside the walls of his house, and he perhaps added shutters to his windows. The neat and tidy appearance he desired might be achieved by painting the clapboard house white and the shutters green. Paint, he had learned, helped to conserve wood in a rigorous climate. Rather than copy the southerner's Virginia-style zigzag split-rail or worm fences, he made straight fences of sawn planks or pickets and painted them white. This "painting about the house" was a constant wonder to the upland southerner, who was apt to consider it the eastern settler's way of "putting on airs."

Typically eastern styles.

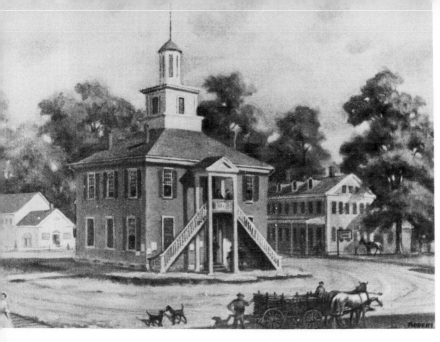

The public square and courthouse of Shelbyville as it probably appeared about 1832. Painted by Robert Marshall Root (1863-1937).

"Wolf's Point in 1833." Eastern Chicago as it appeared just before its period of enormous growth. A lithograph by Charles Shober (working in Chicago 1858-83) after an original drawing by George Davis (1808-55). On the left is Elijah Wentworth's tavern with its sign of the wolf, which gave the point its name.

The New Englander, like the Englishman, was a lover of colorful flowers, fruit trees, and gardens. He probably mounted a weathervane on his barn which he could watch from his house. Favorite weathervane subjects were the Indian with bow and arrow, the rooster, and the horse. Usually these were cut from sheet iron by the blacksmith and then painted black.

Throughout the state travelers in the early part of the century would have seen even greater variations in customs and life-styles — those derived from European cultures. The quaint French structures in Cahokia, Kaskaskia, and Prairie du Rocher were only one example of European influence. Illinois had been widely publicized in foreign lands by such writers as Birkbeck and Flower and such artist reporters as Audubon,

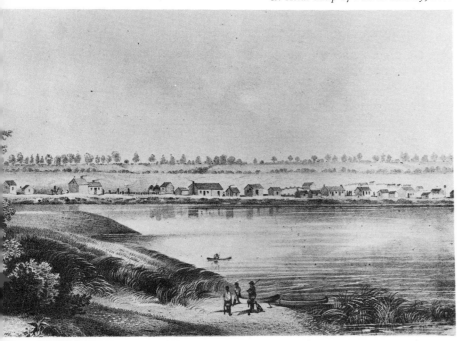

"Peoria Aug. 29th 1831." A lithograph of the Peoria County seat made from a watercolor by John M. Roberts.
IN *Atlas Map of Peoria County*, 1873

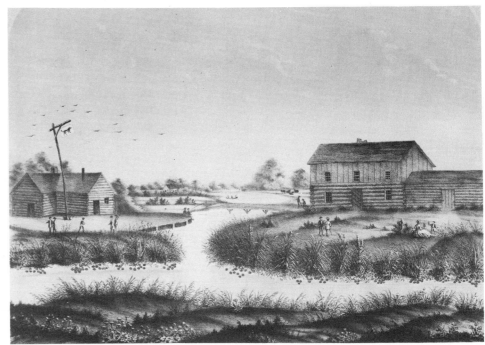

Art, Crafts, and Architecture in Early Illinois

Basil Hall, and Bodmer. The ambitious or oppressed European saw Illinois as a land of freedom and new opportunity — a wonderful land indeed. English, German, Scotch, Welsh, Dutch, Irish, Swiss, and Norwegian settlers had already left distinctive marks of their residence, and Swedish and Portuguese immigrants would soon add their own variations. For instance, roofs thatched with prairie grass appeared on some homes of English, Irish, and Scotch settlers; sod houses covered with thatch would soon be seen on the prairies and in the Irish settlement at La Salle.

Perhaps nowhere in the state was there such a mixture of cultures as in Galena, in the far northwestern corner of Illinois. This area had begun to attract the attention of settlers as early as 1819 because of its abundant lead, necessary for the making of ammunition. By 1827 the population had so increased that a village was laid out. According to the early state geologist A. H. Worthen, "Galena became the mining metropolis of the Northwest. Thousands of rough miners swarmed through her streets. All sorts of moving vehicles were in her thoroughfares, and every language was spoken, every costume worn."[1]

Living in Galena about 1830-35 were rough Irish farmers and English lead miners from Cornwall, French immigrants from St. Louis, and Swiss, German, and Scottish settlers. In addition, there were numbers of native-born Americans from New England, New York, Pennsylvania, other parts of the Midwest, and the South. The latter arrivals came to be given various imaginative nicknames. *The History of Jo Daviess County, Illinois* (1878) reports:

Miners and others came in such large numbers from Missouri as to suggest to the fertile imagination that the State of Missouri had taken an emetic, and

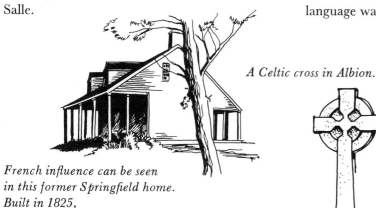

A Celtic cross in Albion.

French influence can be seen in this former Springfield home. Built in 1825, it was the residence of George Forquer.

Wrought-iron grave marker in the St. Pancratius Church cemetery, Fayetteville. Similar markers can be found on French graves in Ste. Genevieve, Missouri.

The seventeenth-century English shaped gable was adapted by some early Illinois stonecutters for gravestones.

Today this Galena house is called a "miner's cottage." It accommodated two families under one roof. The present home of Katherine Delihant, it was built sometime before 1840. Federal style.

PHOTOGRAPH BY THE ILLINOIS DEPARTMENT OF CONSERVATION

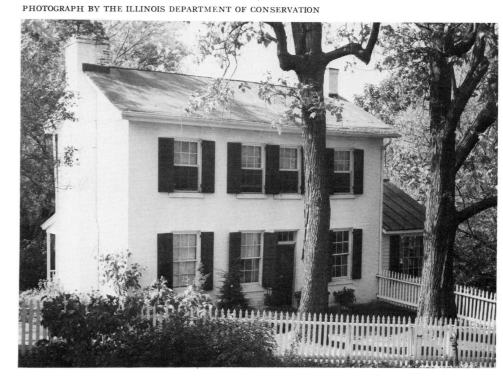

forthwith all Missourians were dubbed "Pukes." The people of Southern Illinois had the habit of coming up here with their teams in the Spring to haul mineral and work in the mines, but regularly returned to their homes in the Fall. This suggested that they were like the fish called "suckers," which run up the small streams in the Spring, and run down to deeper water at the approach of cold weather. All Illinoisans were called "Suckers," therefore, and here, in the lead mines of the Upper Mississippi, originated the term which is now applied to all residents of the "Sucker State." Kentuckians were called "Corn-crackers," Indianians, "Hoosiers," Ohioans, "Buckeyes," etc.[2]

Galena lay along the Fever (now Galena) River about two miles from the Mississippi. In those days the river port was broad and deep, accommodating as many as sixteen steamboats at one time at its piers. Along the waterfront and up the steep hillsides that bordered the river there had formed a conglomeration of log, stone, and brick buildings. Once again, the building — its size, type, and materials — reflected the origin and economic status of the builder. Most of the early structures in the area were log cabins, some with thatch roofs "covered with sods," like the first dwelling of H. H. Gear, a pioneer settler and later industrialist of the town. A few log cabins survive today — under modern weatherboard covering and more substantial roofing. The wealthier merchant or speculator was apt to have a dwelling of stone. Galena's oldest remaining structure of this type was built by John Dowling and his son Nicholas about 1826-28. A two-story stone structure with a double porch, the building served both as a trading post and as a home. Today, restored and furnished with objects typical of its period of occupancy, it is a museum

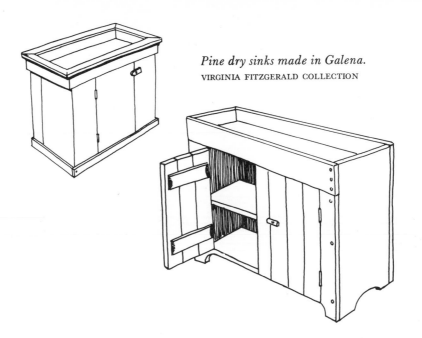

Pine dry sinks made in Galena.
VIRGINIA FITZGERALD COLLECTION

Pine cupboard made in Galena.
VIRGINIA FITZGERALD COLLECTION

open to the public. Later houses of this early period are typically wood frame or brick, and a number like the Dowling house are in the Federal style of architecture.

Among the remnants of old Galena are some pieces of early furniture made in the town. The early furniture of central Illinois was made largely of local walnut, cherry, ash, and sycamore woods, while in the northwest part of the state early furniture was made largely of maple, oak, birch, or pine — woods indigenous to that area. When sources were exhausted in the Galena area, great rafts of pine logs were floated down the Mississippi River from Wisconsin.

Economic opportunity drew settlers to the Galena region, but many European immigrants in other portions of the state had been drawn to Illinois for other reasons. The freedom in America to worship openly and without fear of perse-

cution seemed an especially rare and precious thing to thousands of Europeans who rebelled against nationalization of religion in their own countries. As a result, the United States became a haven for many colonies of religious dissenters.

A boxlike New England–type house as seen in Galena today. Notice the compact shape, inside chimneys, painted shutters, and picket fence.

Art, Crafts, and Architecture in Early Illinois

The Midwest, with its abundant and fertile farming land, was especially attractive to these immigrants, and many added their cultures and beliefs to those of other foreigners who had settled in the region. The *Sangamo Journal* (September 1, 1838) stated, "We welcome them. Our country is now the asylum for the oppressed of all nations," and the immigrants were allowed, to a large extent, to govern their own affairs, required only to refrain from disturbing the public peace.

As early as 1825, dissenters from the established Lutheran Church of Norway had sailed to America in a small sloop with their leader Cleng Peerson. After a short period in Kendall, New York, Peerson found a more fertile region for his farmers in the rolling prairies near the Fox River in northeastern Illinois. There they laid out the town of Norway, the first permanent Norwegian settlement in America. New settlers arrived the following year; in 1836 emigration from Norway increased; and eventually the Fox River area became a prosperous "mother-settlement" for new settlements in La Salle County at Marseilles, Miller Township, Rutland, Leland, and Ottawa; in Grundy County at Morris; and in Lee, De Kalb, and Livingston counties. Later immigrants settled in Missouri, Iowa, northern Illinois, and Wisconsin.

The early settlers erected log houses like their American neighbors. One La Salle County settler wrote in 1839:

...when we came to the place where the earlier settlers were supposed to be located, we saw only a few huts which, lacking a better comparison, resembled the cattle sheds in Bergen, and we could see both sky and earth through the walls.... Here we had a start to build a few houses of the same

The stone trading post and home of John Dowling built in Galena about 1826-28. A Federal structure, it shows French or perhaps Dutch Colonial (New York) influence in its overshot roof.
PHOTOGRAPH BY THE AUTHOR

kind, and thereafter every man had to set out to earn enough for food for himself and his family....[3]

In 1842 another settler wrote of the advantages of such log structures:

I note...that our houses are described as shocking, but the houses are so constructed here that they can be occupied as soon as completed, and they can be improved as one's resources permit. In Norway, many build their houses in such a way that they cannot be occupied until every part is completed. Both I and most of my neighbors have now just as good houses as we had in Norway.[4]

The earliest Norwegian settlers had come from the western fjord and central mountain region where colorful folk arts had thrived for hundreds

of years. They undoubtedly carried with them a few of their woven and embroidered textiles, gaily painted chests, boxes, bowls, carved utensils, and musical instruments, as well as the knowledge of how to produce such articles in their new homes. Many of their original folk arts are on view in the Norwegian-American Museum at Decorah, Iowa, and at Little Norway west of Madison, Wisconsin — a replica of a Norwegian village established by Norwegian-American businessman Isak Dahle of Chicago. In the vicinity of today's sleepy, deteriorating village of Norway, however, little remains to remind the traveler of its Norwegian background except a small church. Near Marseilles, one descendant has proudly revived such old crafts as "poker painting," the art of burning linear designs on wood objects, and "rosemaaling," the painting of bright floral patterns on wooden objects.

In 1822 a colony of thirty or forty people from Switzerland settled in the southeastern section of St. Clair County. With their homeland in mind, they named their town Helvetia (later changed to Highland). By 1835 Jacob Eggen and M. Zabbart had started a pottery and were soon furnishing "pots to the white lead factory of St. Louis, salve jars for doctors and druggists, and tile stoves made to order and installed in St. Louis, Belleville, and Mascoutah."[5]

Political revolutions in their homelands brought still more immigrants to Illinois in the 1830s. The Poles, under the domination of the despot Prince Constantine of Russia, had been sadly oppressed, and with the failure of a ten-month revolution in 1830-31, thousands of Poles were exiled, of whom most sent to America were soldiers and members of the lower nobility. The state of Illinois addressed the Polish-American Committee with "Come to us, heroes and martyrs of liberty. We extend to you our fraternal arms. Come and share the luxuriant fruit of our land and the freedom which your ancestors helped us to secure."[6] Waiting in vain for land in Illinois promised by Congress, the first 235 exiles

A twentieth-century example of rosemaaling by Johny Johnson, a descendant of Norwegian settlers in La Salle County near Marseilles.
AUTHOR'S COLLECTION

scattered all over America. A few settled in Illinois at El Paso, Jacksonville, Cahokia; at Catlin in Vermilion County; and in Shelby and Effingham counties. Nearly all these exiles were highly educated and knew little about physical labor: George Suprunowski learned the hatter's trade, settled near Cahokia, and died a poor man; Alexander Bielaski, who arrived in 1837, became a civil engineer for the state before his appointment in 1844 as principal draftsman in the patent office; Edward Wilkoszewski, inclined to be artistic, had learned the picture-frame business in Paris and after settling in Illinois in 1860 established the first picture-frame factory in Chicago.

Among Italian settlers was a Belleville immigrant, Count Murrazelli di Monto Pescali, whose daughter Marca Arelia (d. 1919) married the Connecticut artist George Frederick Wright in 1866.

By far the largest foreign group to settle in Illinois were the Germans, who had been settling in America since colonial times. United in their determination not to be ruled by kings and princes, Germans had been some of the bravest soldiers in the American Revolution. Many were expert wagon makers, millers, coopers, blacksmiths, and gunsmiths. Some had even manufactured silk from silkworms they had cultivated in Georgia.

During the early nineteenth century, American democracy had increasing appeal for Germans; the educated classes rebelled against the rule of petty princes, and the poor and half-starving saw little chance of improving their status by remaining where they were in Europe. As early as 1818 Conrad Bornman, a blacksmith, settled in Belleville. Soon he was making brick

and erecting some of the earliest brick structures of the town. In 1820-21 a small colony of Germans from Hanover settled Vandalia, under the leadership of the affluent and cultured Ferdinand Ernst. Unfortunately Ernst died in 1822, and the colony was virtually annihilated by sickness. Gottfried Duden, who lived in Missouri for three years before returning to Germany in 1827, began to publish such romantic and exaggerated accounts of the Garden of Eden in the American Midwest that there was even talk among some Germans of a mass exodus to America, where they might establish a state of their own to preserve German culture. About 1832 Germans began immigrating in greater numbers. Some settled in Missouri, while others, objecting to the practice of slavery in that state, decided to settle across the Mississippi River in Illinois. A number of wealthy and cultured Germans from the Rhineland and Palatinate regions began to settle in Shiloh Valley and Turkey Hill near Belleville — a region with rich prairie and timberland that probably reminded them of their homeland.

Like early English settlers at Albion, the early German immigrants first occupied homes built by Americans. Theodore and Edward Hilgard, graduates of the agricultural institute at Hohenheim in Württemberg, bought a 400-acre farm near present-day Shiloh with a relatively luxurious house, weatherboarded and painted white with green shutters. In 1833 a number of wealthy political refugees arrived in the general area, some having been forced to flee Germany as a result of their part in an unsuccessful revolution. Among a group of sixteen arrivals was Theodore Frederick Engelmann, his family, and some friends, including Gustave Koerner, a lover of fine books, art, and architecture and a law graduate of Heidel-

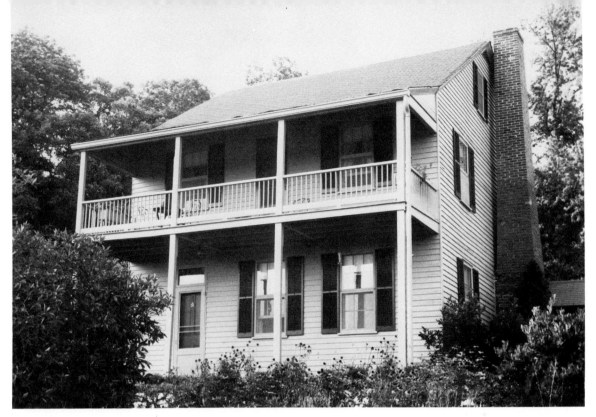

Theodore Frederick Engelmann's home in Shiloh Valley, built ca. 1835-40 on the site of the log cabin on the upper farm. Note the unusual chimney, built away from the house to accommodate stovepipes rather than fireplaces. An example of southern Federal style.
PHOTOGRAPH BY RICHARD PHILLIPS

berg who later became lieutenant governor of Illinois and ambassador to Spain under President Lincoln. Koerner's father had been a publisher and an art- and bookseller with a gallery collection of nearly 100 fine paintings.

Once arrived, Frederick acquired two dwellings for the group. Frederick's nephew, George Engelmann, a physician and later botanist for Henry Shaw's Garden in St. Louis, shared a 2½-room log cabin, built on the side of a hill by Irishman Ben Watts, with Koerner and four other bachelors. The cabin was filled with three large

bedsteads, tables, chairs, and bookshelves. Engelmann had his medicine chest and articles relating to scientific studies such as "snake skins, birds ready for stuffing, and piles of gray blotting paper for drying his plants." The light in the cabin came mainly from the door, as the sole window of one room had panes mainly of boards and cardboard. A "miserable cellar" was underneath, near one of the large chimneys. Three times each day the bachelors walked for their meals to a nearby farm, where the rest of their group lived in a more substantial four-room frame house with

painted clapboards and good chimneys which had been erected by Ben Watts's carpenter son.

The *Memoirs of Gustave Koerner, 1809-1896* includes a description of a folk custom undoubtedly introduced into Illinois by the Germans. Koerner wrote:

What a contrast between our present life and the one we enjoyed in the Fatherland! . . . The Americans celebrate Christmas in their own way. Young and old fired muskets, pistols, and Chinese firecrackers which, with a very liberal consumption of egg-nog and tom-and-jerry, was the usual, and in fact, the only mode of hailing the arrival of the Christ-Child (Christ-Kindchen, corrupted into Christ-kinkle) On Christmas day, 1833, we had a Christmas tree, of course. In our immediate neighborhood we had no evergreen trees or bushes. But Mr. Engelmann had taken the top of a young sassafras tree, which still had some leaves on it, had fixed it into a kind of pedestal, and the girls had dressed the tree with ribbons and bits of colored paper and the like, had put wax candles on the branches, and had hung it with little red apples and nuts and all sorts of confectionery, in the making of which Aunt Caroline was most proficient. Perhaps this was the first Christmas tree that was ever lighted on the banks of the Mississippi.[7]

Although a number of the settlers had attempted to learn a trade before emigrating, few of these cultured Germans had any knowledge of agriculture, and because they knew more of Latin than farming, they later became known as the Latin Farmers. Frederick Engelmann, however, had brought grape roots from the Rhineland and had experimented with their culture. When this failed, he planted Catawba and Virginia grapes instead, and his grapes and wine soon gained him a great reputation in the country.

It was not long before the German settlement in Shiloh Valley "received some very excellent accessions." One was Dr. Adolph Reuss and his wife, of a highly respected family of Frankfurt. Having already examined places in Pennsylvania, Ohio, and Missouri, Reuss bought a "beautiful large farm with good buildings adjoining Ledergerber's." By 1844 Reuss had a large new home built of "fachwerk" in the manner of many homes back in Germany. Similar to the "brick-nogging" of the English, this consisted of a sturdy white oak frame skeleton, mortised and pegged together and braced at strategic points. The interstices were then filled with sun-dried clay bricks, and the ceilings were insulated with batts formed by rolling wooden sticks over a mixture of clay and prairie grass. The inside walls were completely covered over with mud mixed with shredded straw, but on the outside only the bricks were covered, leaving the timber frame exposed. A finish coat over the rough plaster, inside and out, was of lime whitewash; floors, window frames, and a winding staircase to the second floor were constructed of walnut. At some later time, a similarly constructed addition was made to the

Rolled clay and straw batts used for insulation in the ceilings of the Reuss house. Similar batts were used in the Rappite houses in New Harmony.
PHOTOGRAPH BY RICHARD PHILLIPS

back of the house, with the substitution of kiln-baked bricks, which by that time had become readily available. Such fachwerk construction was impractical in regions where winters were more severe than in Germany, and only a few notable examples of American fachwerk still exist in Wisconsin, Pennsylvania, and in some of the original German Rappite buildings at New Harmony, Indiana. The Reuss home was preserved by later weatherboarding, but its interior structure was not revealed until a fire in the 1970s destroyed the upper portion, and rapid deterioration of the remaining structure uncovered its unusual inner construction. By 1973 the building was in ruins, and the land around it was being cleared for a new highway. A similarly constructed home built by Jacob Stizelberger, a

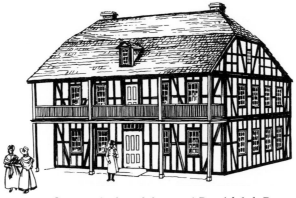

German fachwerk house of Dr. Adolph Reuss as it probably appeared about 1845-50.

132

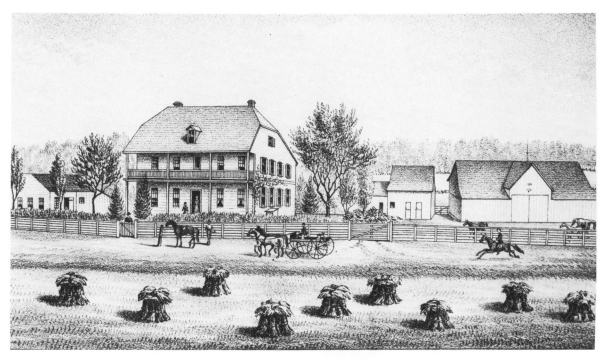

Residence of Dr. Reuss in Shiloh Valley
as it appeared in the 1870s
after it was covered with weatherboarding.
IN WILDERMAN

and articles of silver. In 1836 they established in a Shiloh Valley home one of the earliest libraries in Illinois. The personal property of Vandalia's Ferdinand Ernst, listed at his death in 1832, included such items as German carriages, looking glasses, hydrometers, clocks and watches, and fine table linens and glassware. Also listed were an "elegant wing pianoforte," a steel "musical instrument," clarinets, flutes, French horns, violins, and a large assortment of sheet music — indications of the Germans' love of music. In Alton, Highland, and other Illinois towns, later German and Swiss immigrants established organ factories; at Belleville one of the first philharmonic orchestras west of the Appalachians was formed in 1867; and at about the same time, Hans Balatka, a former choral conductor in Vienna, was encouraging the development of chamber music in Chicago.

Belleville potter, was demolished in 1939; a Belleville-area log cabin with a fachwerk addition has now been moved by the Sangamon State University Foundation to its rural life studies center at Clayville, near Pleasant Plains.

When kiln-baked brick became available, some of the Latin Farmers of Shiloh Valley moved into substantial brick homes. Others moved to Belleville, discouraged over the rigors of farm living. Accustomed to luxury and leisure, they had brought to their American homes precious mementos of their former way of life — beautiful European engravings and paintings, rare books,

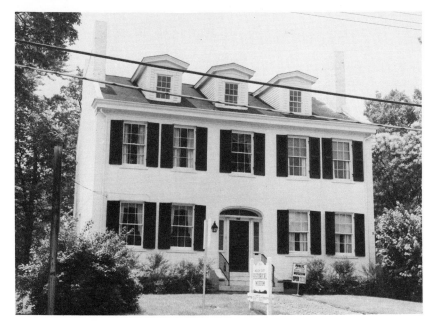

The Dr. Weir House,
built in Edwardsville in 1836.
Presently the Madison County
Historical Museum.
PHOTOGRAPH BY
RICHARD PHILLIPS

Melting Pot Culture

German houses on Main Street, Columbia, Monroe County.
PHOTOGRAPH BY EDWARD MOORE FOR THE HISTORIC AMERICAN BUILDINGS SURVEY

disastrous potato famine in western Europe. As artisans multiplied, the town began to acquire an even more Germanic character. Small brick homes decorated with ornamental brick motifs under the eaves were built close to the street in the manner of old German towns; some were built as row houses with common walls and yards in back containing flower beds, smoke- and wash houses, and wells, surrounded by neatly painted fences.

As the Germans became established in the area, their tradesmen became increasingly important. The cooper made barrels for both beer and wine.

Belleville — a town originally laid out in 1814 as the new county seat of St. Clair County — was thriving by the early 1830s. Former territorial governor Ninian Edwards had purchased many lots and had advertised the town far and near, offering such inducements to craftsmen as building lots at a nominal price and on their own terms. As a result, the town had already acquired some handsome public buildings. As reported in *Illinois in 1837; a Sketch,* "There are two large steam flouring mills, with six pairs of stones, a brewery, a steam distillery, a wool carding machine, eight carpenters, one cabinet maker, five blacksmith's shops, one tinner's shop, two silversmiths, three wagon makers, one turner and wheelwright, two shoemaker's shops, one millwright, two coopers, two saddlers, two tailors, one bakery, one high school, one common school, a Presbyterian, a Baptist, and a Methodist congregation, and about 700 inhabitants, of whom about one hundred are Germans, twenty French, and the residue Americans."[8]

During the 1840s the proportion of Germans in Belleville increased rapidly, due largely to a

Brick row houses built by Germans in Belleville. Note the common walls between dwellings and the lack of front yards. In their homeland, these Germans had undoubtedly been town dwellers.

The well-dressed gentleman of 1835-45 as depicted in an 1843 ad in the St. Louis Deutsche Tribune.

Tin candle mold and oil lamps made by Balthasar Lengfelder in Belleville about 1860. Trained in Paris as a silversmith, he worked with copper and tin in Illinois, finding them more lucrative.
PHOTOGRAPHS BY RICHARD KERN, *Belleville News Democrat*

Art, Crafts, and Architecture in Early Illinois

134

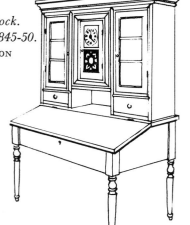

Two-piece desk with a built-in clock. Made in the Belleville area, ca. 1845-50.
MR. AND MRS. J. E. TRABUE COLLECTION

Walnut pie safe with punched tin panels, 1840-50. Vandalia area, Fayette County. Stars and hearts were favorite German design motifs.
AUTHOR'S COLLECTION

A sheet-iron weathervane, five feet tall, which once marked an old Illinois inn. It represents St. Stanislaus, the patron saint of German innkeepers.
MR. AND MRS. ROLAND JESTER COLLECTION

Hand-carved wooden shoes were worn by many German farmers in Illinois throughout the nineteenth century.
ILLINOIS STATE MUSEUM

The tinner fashioned fancy cake pans and cutters for Christmas cookies and manufactured shiny wall sconces, candle molds, and oil lamps. Cobblers carved wooden shoes for the farmer's use in wet weather. Blacksmiths, cabinetmakers, wagon makers, boot and shoe and saddle and harness makers — all plied their respective trades, and later watchmakers, clockmakers, and weavers joined the growing communities. In 1849 the Germans in Belleville were still fabricating "jeans" — the twilled, undressed cotton material which they produced in a number of colors. The town had its own spinning mill and "made the loveliest kinds of materials." A potter by the name of Gruenig on D Street was only one of the area's many craftsmen.

Although Belleville was the greatest center of German population in Illinois, other German immigrants had settled very early in surrounding areas and counties and in such towns as Peoria, Alton, Quincy, Nauvoo, and Chicago. Germans also emigrated from other states to Teutopolis, Perry, Havana, and into Effingham, Woodford, and La Salle counties. Quincy had been founded by Americans in 1822, but in 1829 Michael

Mast, a German tailor, settled in the town, followed by a number of German carpenters and farmers. The river town began to bloom about 1834 with the arrival of more German and American craftsmen:[9]

1834

Adam Schmitt, furniture maker
John Frederick Steinbeck, cooper

1835

John Holbrecker, engraver, marble cutter, and later manufacturer of iron railings and fences
Frederick William Jansen, cabinetmaker
Henry Grimm, carpenter
John Schell, blacksmith
George P. Heller, carpenter and builder

1836

John Bernhard Schwindeler, carpenter
Andrew Keller, tailor
John Roth, cabinetmaker
Ulrich Lugenbuehl, tailor
Charles A. Maertz, tinner

1837

John Bernhard Koch, saddler and harness maker
Daniel Ertel, carpenter
Henry Schuchmann, stonecutter
John Henry Lock, blacksmith
Jacob Ruff, carpenter

1838

Matthias Ohnemus, saddler and harness maker
Matthias Obert, shoemaker
Philip Schwebel, blacksmith
George Liebig, shoemaker
John Paul Eppel, blacksmith who later manufactured the first carriage in Quincy

1839

Xavier Flaiz, shoemaker
Pantaleon Sohm, cooper

In 1840 a German hat maker, George Joseph Laage, began making felt and silk hats, caps, and articles of fur for the citizens. In 1843 Joseph Brockschmitt, who had learned the clockmaking trade in his native country, exhibited in the window of his shop his masterpiece, a clock whose complete works were contained in the pendulum.

Foreign immigrants as a whole contributed much to the backbone and sinew of the young state. Some who arrived as craftsmen later achieved renown in other pursuits. For example, Scotsman Allan Pinkerton was a cooper when in 1843 he settled in Dundee, a little village of Scots on the Fox River. A short while later he became famous as a detective and the founder of the detective agency which still bears his name. Immigrants arrived with talents and characteristics peculiar to their native lands; separated by language barriers and customs foreign to their American neighbors, they often clustered into villages which were picturesque foreign islands on the Illinois prairies. Some of their ways shocked their prim Anglo-Saxon neighbors, but time was to erase many of the differences as nationalities intermixed and leaders emerged to influence and in turn be influenced by Illinois neighbors. As a result of this great melting pot of cultures in the Midwest, Americans by 1850 would be classed into three general types — the Yankee, the Southerner, and a new, homogenous breed called the Western Man.

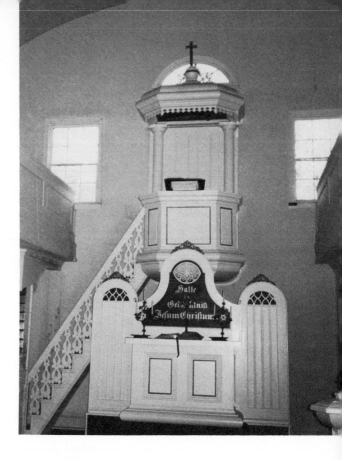

Interior of the Kornthal ("Valley of Grain") church near Jonesboro, erected in 1861 by Austrian immigrants. Its altar, balconies, and the high pulpit with carved canopy are similar to those of Georgian churches built in colonial Virginia.
One of the settlers, Charles Fettinger, is credited with having designed and executed the carved woodwork, including the baptismal font on the right and the ornate guard rail of the pulpit steps.
PHOTOGRAPH BY JOAN HUNTER

Art, Crafts, and Architecture in Early Illinois

12 Greek Temples and Gothic Spires

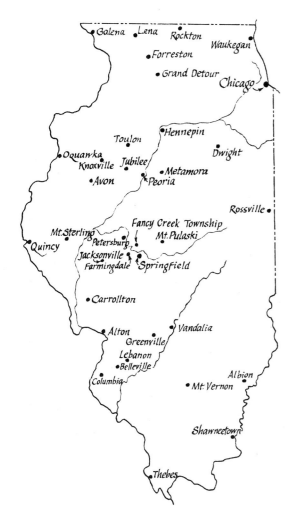

The increasing number of skilled craftsmen in Illinois and the arrival of many new, relatively prosperous settlers helped to bring some changes in the appearance of buildings which would previously have been difficult to accomplish. Plain Federal-style buildings would be erected into the 1850s, but as early as the 1830s new styles were being introduced by emigrants from the East. One of these styles — the Classic Revival — had been created as a new symbol for American democracy; the other — the Gothic Revival — reflected the spirit of Christianity in this new country.

The Classic Revival began in Virginia in the late 1700s with Thomas Jefferson, who dreamed of a building style for the new republic which would be free from all ties with England. He desired buildings that would symbolize the simple dignity that was the strength and virtue of American democracy, rather than the stiff pomposity of the Georgian kingdom. He wanted buildings that would be not only beautiful but also an inspiration to freedom-loving people of all lands.

Like many other cultured men of his day, Jefferson was intrigued by classic literature, popular in America after the uncovering in the 1770s of the ancient cities of Herculaneum and Pom-

peii. Struck by the many similarities between the government of republican Rome and that of his own republic of America, Jefferson saw the United States as a kind of reincarnation of the ancient democracy. In his large library he pored over new engravings made from measured drawings of Roman temples. Then, while minister to France, he went to see the Maison Carrée at Nîmes — a Roman temple erected in the first century. The dignity, strength, and beauty of proportion of this building symbolized for him all the vital qualities of the American republic. His search was at an end; the Roman temple offered him a style symbolic of the ideals of American democracy.

Jefferson's idealism resulted in the world's first Classic Revival building — the state capitol at Richmond. Planned by him after a model of the

The Virginia State Capitol.

Maison Carrée and completed in 1788, it was nonetheless not a slavish copy of the Roman temple. He simplified features of the ancient structure and adapted it for American use. He substituted Ionic for Corinthian columns on the portico and used simple pilasters for the elaborate engaged columns at the sides; he used brick instead of stone for the main structure and added windows, chimneys, and doors to the design. Later Jefferson remodeled his famous home, Monticello, borrowing features from the Pan-

theon in Rome. Other builders in the South and East quickly adopted the Neo-Classic style.

For at least two important reasons Jefferson's Roman temple style did not become universally popular. First, in the 1820s the attention of liberty-loving Americans was drawn to Greece as that country became embroiled in a struggle for independence from the Turks. A more intense study of Greece resulted, revealing that actually Greece, not Rome, had been the Cradle of Democracy; the Romans had in fact borrowed their basic temple style from the Greeks and had then elaborated upon it. The second reason for the Roman temple's lack of extensive popularity

was the general fussiness of its appearance. The Puritan easterner was more attracted by the relative simplicity of the Greek temple style, and the ordinary builder found it easier to construct.

Since trained architects were practically non-existent in the early United States, it was an architect from England — Benjamin Henry Latrobe — who first used Greek forms in American buildings. He designed structures in Philadelphia, Virginia, and Baltimore; later he trained other architects in this mode of building. During the

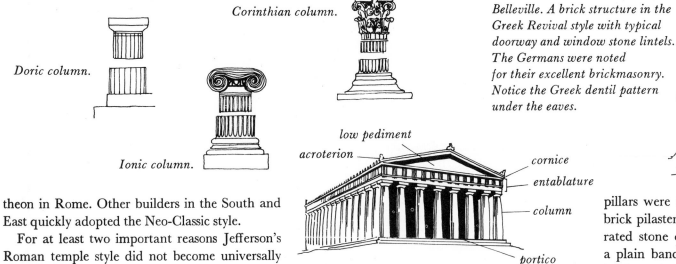

Corinthian column.

Doric column.

Ionic column.

The Emma Kunz home (1830) in Belleville. A brick structure in the Greek Revival style with typical doorway and window stone lintels. The Germans were noted for their excellent brickmasonry. Notice the Greek dentil pattern under the eaves.

low pediment

acroterion

cornice

entablature

column

portico

The Parthenon in Athens, 447-432 B.C.

1820s Greek Revival buildings mushroomed in the East, and guidebooks for the ordinary carpenter and builder were authored by such architects as John Haviland, Asher Benjamin, and Minard Lafever. Armed with such books of instruction, builders, carpenters, and even a small number of architects moved with the tide of emigration toward the Midwest, prepared to

erect fashionable adaptations of classic temples or small buildings with a few Greek motifs, or to simply add stylish new details to existing structures.

The fully developed temple portico seldom was a feature on the early Greek Revival homes in Illinois. The average builder, limited both by his ability and by his client's purse, simply adapted or applied to a basic structure some of the general Greek motifs. Originally of stone, these motifs were constructed of brick or wood. Round fluted

pillars were replaced by square wooden piers or brick pilasters. Instead of a typically Greek decorated stone entablature, the builder constructed a plain band of boards or horizontal courses of brick, and small windows occasionally replaced the Greek ornaments.

In predominately German communities, such as Belleville, the masons were especially adept at brick ornament, so brick entablatures often were laid with dentil patterns which simulated a common ornament of Greek temples. Such details are seen on the Emma Kunz home, built about 1830 and apparently the earliest Greek Revival building still existing in Illinois. Even the simplest

Art, Crafts, and Architecture in Early Illinois

The Frank B. Thompson house (1842),
typical of prairie Georgian architecture
and one of the few remaining structures
of its type in Illinois. It is now the
Albion Public Library (see p. 79).

PHOTOGRAPH BY THE AUTHOR

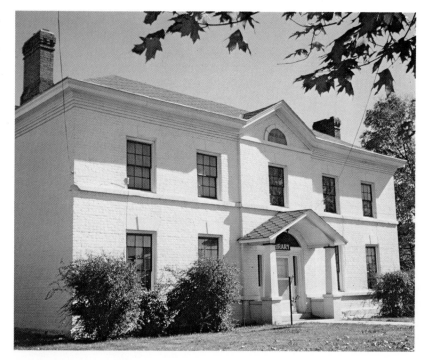

The First National Bank of Old Shawneetown,
built in 1836, is one of the finest old
Greek Revival structures in the state.
An unusual feature is the odd number of columns
on the portico, which provided a clear view
of two front doors instead of the usual one.

PHOTOGRAPH BY RICHARD PHILLIPS

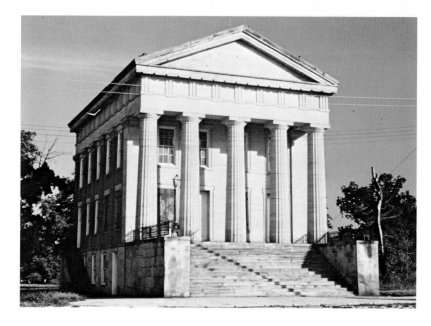

Greek Temples and Gothic Spires

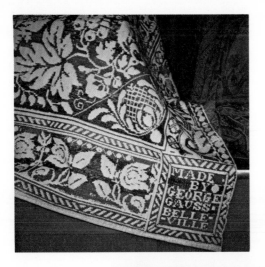

Jacquard coverlets woven by George Gauss
of Belleville (left) and John Philip Seewald
of St. Clair County. The "signature" of Seewald's
1849 coverlet can be seen in the lower right corner.
He was able to produce three coverlets a week
at a price of $10 to $12 each (see p. 171).
ST. CLAIR COUNTY HISTORICAL MUSEUM
AND THE ILLINOIS STATE MUSEUM

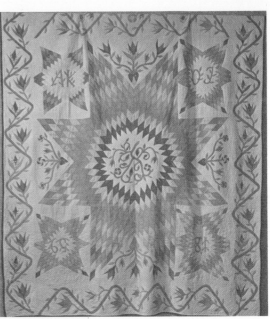

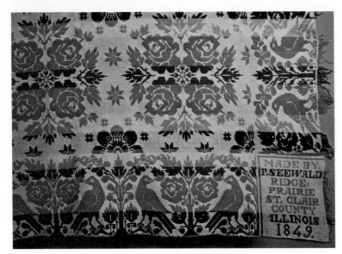

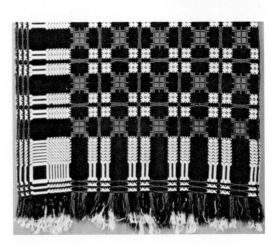

Pieced and appliquéd quilt
with a "sunburst" center.
Made by Ann Koenig
(Mrs. John Bernhard) Koch
in Quincy, Adams County,
1859.
HISTORICAL MUSEUM
OF QUINCY AND ADAMS COUNTY

Double-woven coverlet with stylized pine
tree border made ca. 1860 by Mrs. William
N. Bock, Logan County. Pine trees were
rare in Illinois, and the motif probably
originated in another part of the country
(see p. 101).
ILLINOIS STATE HISTORICAL LIBRARY

Art, Crafts, and Architecture in Early Illinois

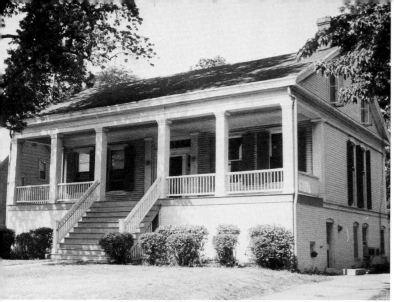

The Elijah Iles house in Springfield, built in 1832.
The weatherboarding is of black walnut, the floors are of ash,
and the frame is joined with wooden pins. The main living
quarters over a ground floor were probably inspired by French
Colonial homes in Kaskaskia. Other features
are typically Greek Revival.

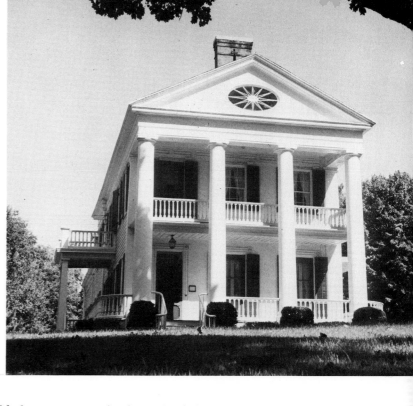

The John Wood mansion
in Quincy, built in 1835.
Greek Revival style with
a Federal elliptical window
in the pediment. Its double
porches are reminiscent
of those on plantation homes
in the South. Today the
house is the museum of the
Historical Society of Quincy
and Adams County.

houses retained the solid horizontality typical of the Greek column-and-lintel system of construction. Heavy stone lintels were placed over squat windows on brick or stone buildings; and a small, squarish porch and an entrance featuring sidelights and a horizontal light over the door were common on brick, stone, and frame houses. With such modifications and simplifications, the Greek temple was adapted in America for use as a home.

As was usual in Illinois, early signs of new trends appeared first along the commerce routes, where some new buildings might be a mixture of old and new styles. In 1832 a wealthy Springfield merchant named Elijah Iles built a new house that was just such a combination. Iles had

earlier lived in Kaskaskia and had probably been impressed by the imposing home of fellow merchant Pierre Menard. Aware as well of the national trend toward Greek Revival architecture, Iles had his house built with a combination of French Colonial and Greek Revival motifs. The main floor, which had walnut weatherboarding, was reached by a long staircase; it was set over a ground story of brick in the manner of the Menard building and the French plantation houses around New Orleans. The general details of the main floor exterior, on the other hand, showed those adaptations which American builders often utilized in constructing the Greek Revival style of house: a porch with sturdy, square pillars, a squarish entrance framed on the top and sides by small windowpanes, a wide band of wood beneath the eaves, and triangular pedi-

ments in the ends of the structure. Although not in its original location, the Iles house is the oldest remaining house in Springfield.

The Iles home, relatively modest in proportions and only generally characteristic of the new style, contrasts sharply with the more elegant mansion built in 1835 at Quincy on the Mississippi River by John Wood. An early settler from the East, Wood — who eventually became governor of Illinois — wanted a stately building truly classic in its proportions and with a fully developed temple portico. Since a man more expert than the ordinary builder was needed for such a project, Wood probably hired a St. Louis architect to plan and supervise the building of his home, now the Historical Museum of Quincy and Adams County and an elegant example of the prosperity attainable by a few in the busy

Chicago's first courthouse, built in 1835. This one-story and basement structure once stood on the northeast corner of Clark and Randolph streets. Greek Revival style.

AFTER ANDREAS

low-pitched roof
triangular pediment
entablature under the cornice
column
portico

BASIC CHARACTERISTICS OF THE GREEK TEMPLE AND GREEK REVIVAL VARIATIONS.

Broken pediment and corner pilasters.

Small windows in the entablature.

Double porches.

Wings with porticos.

Portico on the side of the building.

steamboat ports of the 1830s. Like many buildings in the South, the Wood mansion has a two-story portico incorporating a second-floor balcony. Basically of Greek inspiration, it has some features — delicate carvings and an oval window in the pediment — reminiscent of the earlier Federal style. Thus, like the Iles home in Springfield, the Wood mansion incorporates features from two systems, marking the transitional stage between two architectural periods.

Also in 1835, a one-story temple-style brick courthouse was built in rapidly growing Chicago, and the following year an elaborate Greek Revival residence was erected for the city's future mayor, William Butler Ogden, by John M. Van Osdel of New York. Chicago's first architect, Van Osdel later designed many outstanding buildings in Illinois, including the present governor's mansion in Springfield. Both Ogden's home and the courthouse were destroyed in the 1871 Chicago fire, but a contemporaneous building which did survive is the elaborate frame building erected for Henry B. Clarke in 1836. Now the oldest remaining house in Chicago, this structure originally had a roof balustrade and a two-story Greek Revival portico attached to the broad side facing the street. Such a placement of the portico was a common American variation of the Greek style, but this feature was lost when the house was moved from its original Michigan Avenue site in 1872; the balustrade and portico were removed, and a cupola — then in fashion — replaced the old elements.

The Greek Revival style could not have come to Illinois at a more opportune time. Thousands of new houses were about to be erected by citizens old and new, foreign and American, who were enjoying the fruits of democracy. The temple style was considered especially appropriate

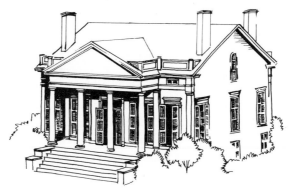

The Henry B. Clarke house as it appeared in 1836, the year it was built. It now stands (altered) at 4526 South Wabash.

AFTER A PHOTOGRAPH AT THE CHICAGO HISTORICAL SOCIETY

Art, Crafts, and Architecture in Early Illinois

The column and beam.

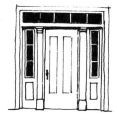

At the entrance.

On doors and casings.

On a fireplace.

*Sturdy pillars (round or square)
on porches.*

*Entablature and
pilasters.*

*Typical Greek Revival
store front.*

Heavy lintels over the windows.

for such public structures as banks and courthouses. An outstanding early example is the First National Bank of Old Shawneetown, erected in 1836 and one of the town's few structures to survive the devastating floods of the Ohio River (see p. 139). The building's portico with five sturdy Doric columns, its lack of ornate decoration, and its eminence on a high podium (a Roman feature) combine to give it an aspect of great dignity and monumental simplicity. Today the building is a state memorial.

Centrally located in the state, Springfield had also grown rapidly in importance. Peck's *Gazetteer* of 1834 stated: "Situated not far from the geographical center of the state, and surrounded with one of the richest tracts of country in the great western valley, it is thought by many, that should the seat of government be moved from Vandalia, it will find a location at this place." The growing feeling that the state capital should more appropriately be at a central location was indeed a worry to the citizens of Vandalia, and they attempted to make their town an attractive capital by raising $16,000 for a new capitol building. Instead of a more up-to-date Greek Revival structure, they invested in 1836 in the construction of a new two-story brick capitol in

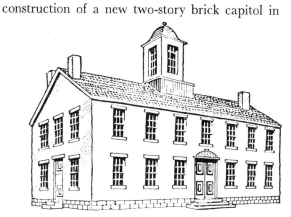

The third statehouse in Vandalia (1836). Federal style.
IN *Documentary History of Vandalia*

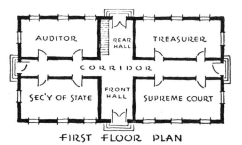

FIRST FLOOR PLAN

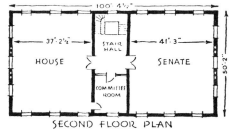

SECOND FLOOR PLAN

143

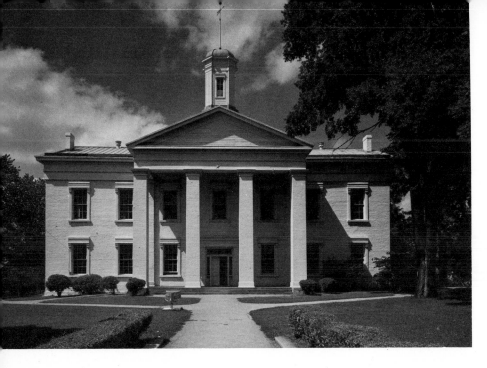

*The old statehouse
in Vandalia
as it looked after
remodeling in 1858-59.
It has been restored as
a state memorial.*
PHOTOGRAPH BY THE
ILLINOIS DEPARTMENT
OF CONSERVATION

the older and more familiar Federal style. It had scarcely been built when their fears were realized. The combined efforts of a group of lawmakers, including Abraham Lincoln, resulted in a vote of the 1836-37 legislature that moved the state capital to Springfield.

On April 8, 1837, an advertisement was placed in Springfield's *Sangamo Journal* offering a premium of $300 for the best plans submitted for a new capitol building; similar ads appeared in St. Louis, Louisville, Cincinnati, Pittsburgh, and Harrisburg publications. As fashionable an eastern firm as Town and Davis of New York, which had designed the state capitols of North Carolina, Ohio, and Indiana, entered plans; but the prize-winning designs were those of two midwesterners: a Mr. Singleton of St. Louis, who received a $100 award, and John Francis Rague, a Springfield architect who received $200 for the entry which was the final choice.

Rague, the son of a surgeon in the French army under Lafayette, had been born at Scotch Plains, New Jersey, in 1799. His early life had been spent in New York City, where he had eventually worked in the office of Minard Lafever, the prominent architect and author of architectural manuals. In 1831, nine years after his marriage, Rague moved with his wife to

Springfield. In this small town, however, there was little demand for an architect, and he was forced to work for a time as a baker. Nevertheless, he became the first president of the Mechanics' Institute and in 1836 was elected one of the town trustees. It seems that Rague then returned to New York for a short time and on his return in 1837 placed the following ad in the *Sangamo Journal*:

ARCHITECTURAL DRAWING

The subscriber recently returned from New York, and having had ten years experience as a builder in the city, now offers his services to the citizens of this country. He will execute plans and elevations for buildings in any of the orders of architecture — write specifications, receive estimates (and superintend any work of sufficient importance to require it), and construct foundations in such a manner that the building will neither settle or crack.

He is also prepared to execute Rough Casting in imitation of granite, or any other stone, warranted to stand firm — also Stucco work with enriched cornices, centre pieces, etc.

As wood carving for buildings has in a great degree been superseded in the Eastern Cities, the subscriber will furnish to order, and send to any part

*The Peter Wilding home in Belleville (1851).
Greek Revival style with lingering features
of the Federal style.*

144

The Lincoln-Herndon building, erected in Springfield in 1840.

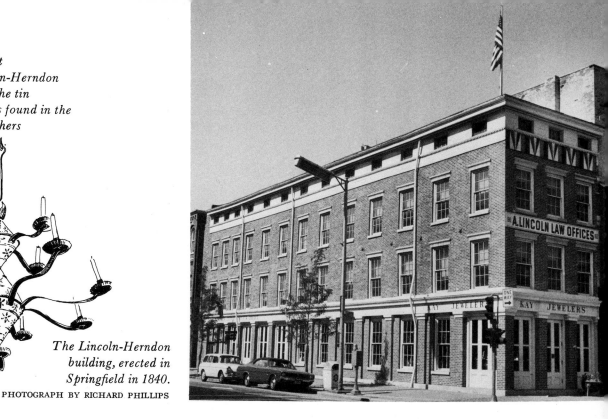

of the State composition egg and dart mouldings, stair bracketts, etc. etc. warranted to resist the influence of all weather for less than half of the cost of carving.

J. F. RAGUE

Springfield, March 27, 1837.

The Greek Revival house of Abraham Lincoln in Springfield as it probably looked when he purchased it in 1844. In 1856 another half-story was added. It then assumed its present-day appearance.

On January 4, 1837, the cornerstone of the new state capitol was laid in Springfield. Since there were no stonecutters in the town, William Harrower of New York was invited to superintend the cutting of the sandy dolomite. The great stones, quarried about seven miles south of Springfield on Sugar Creek, were hauled over rough and often muddy country roads in wagons drawn by ten or twelve oxen. Black walnut from the woods of Sangamon County furnished much of the building's interior woodwork. William Helmle carved beautiful Corinthian capitals for the pillars, which support a half-dome in the House of Representatives.

During the many years of this grand building's construction, Rague designed another Greek Revival capitol building in Iowa City. Erected in 1840-42, this building today is a part of the University of Iowa. Rague also designed a number of other Iowa and Wisconsin buildings. He died in Dubuque in 1877.

From 1837 to 1847 Abraham Lincoln watched the Illinois capitol's construction from the windows of the law office which he shared first with Stephen T. Logan and later with William Herndon. The office was located in a Greek Revival business building (ca. 1840) that is still standing on the south side of the square across the street from the capitol. This old office building has been restored by a group of Springfield citizens, and it is now a museum with a post office, courtroom, and the law offices of Lincoln, Logan, and Herndon exhibiting typical furnishings of its early period.

The Captain William Post home in Alton, ca. 1837,
another example of Greek Revival architecture.
Originally from Connecticut, Post was a steamboat
captain and several times mayor of Alton.
A later owner, James Patterson, owned an iron
foundry and probably added the iron railing.
PHOTOGRAPH BY RICHARD PHILLIPS

A Greek Revival farmhouse on Route 108, east of
Carrollton. It is the present home of Clarence Scott.
About 1840.

PHOTOGRAPH BY RICHARD PHILLIPS

The Greek Revival office of Dr. Thomas Hall was
built in 1847 in Toulon, Stark County. It is
a unique wooden structure ornamented with
hand-carved walnut. Hall came from England
in 1837 to become the first physician in the district
between Rock Island and Peoria. The building is
now owned by the Stark County Historical Society.
PHOTOGRAPH BY RICHARD PHILLIPS

The John H. Swartout house in Waukegan, 1847.
Fretwork similar to that seen on the pilasters
of this portico might also appear on the pilasters
of contemporary mantelpieces.
PHOTOGRAPH BY CHESTER HART FOR THE
HISTORIC AMERICAN BUILDINGS SURVEY

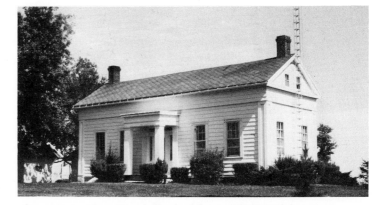

An unpretentious Greek Revival home (1845-50) between
Springfield and Pleasant Plains. Basic characteristics of the style
may be seen in its entrance and porch, the wide entablature under
the eaves, the corner pilasters, and the triangular pediment in the
gable end. The present home of Elmer McMillan.
PHOTOGRAPH BY THE AUTHOR

Art, Crafts, and Architecture in Early Illinois

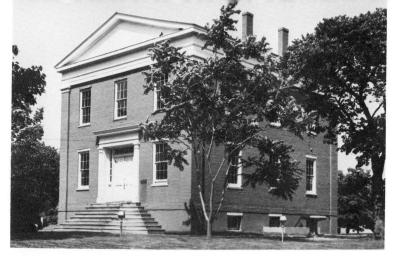

The Logan County courthouse, Greek Revival, was built in Mt. Pulaski in 1847.

PHOTOGRAPH BY RICHARD PHILLIPS

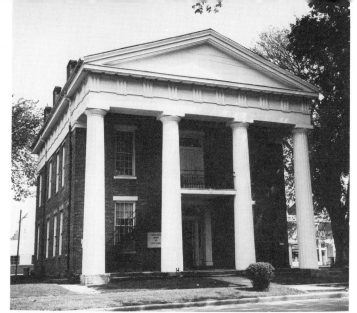

Knox County courthouse in Knoxville (1839). The architect was John Mandeville.

PHOTOGRAPH BY RICHARD PHILLIPS

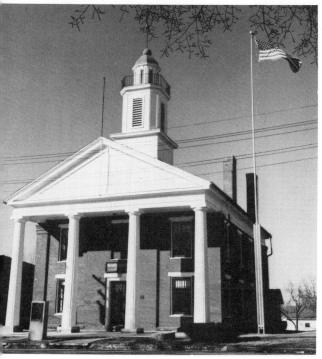

The Woodford County courthouse (1845) in Metamora.

PHOTOGRAPH BY RICHARD PHILLIPS

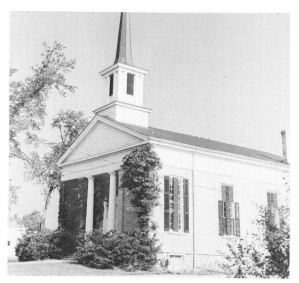

The First Congregational Church, Rockton, built 1847-50. John Peterson's design is similar to that of the 1835 Carmine Street Church in New York City, planned by the noted eastern architect Alexander Jackson Davis. Here a Christian belfry and steeple have been added to the Greek temple form.

PHOTOGRAPH BY RICHARD PHILLIPS

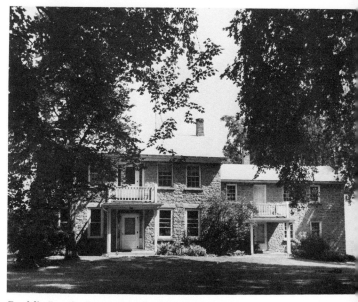

Dodd's Inn in Lena, Stephenson County. Built in 1848 as a stagecoach stop on the Chicago-Galena line. Greek Revival.

PHOTOGRAPH BY RICHARD PHILLIPS

Greek Temples and Gothic Spires

147

Cast-iron cresting over a lintel of the Gross house (1850s) in Columbia. An example of a mass-produced ornament that simulated hand-carved stone or wood.

A window casing in the Old State Capitol, Springfield.

Lyre and honeysuckle motifs on the peak of an ancient Greek temple.

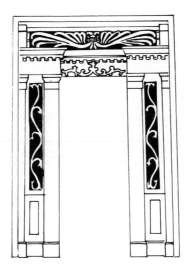

Entrance of the Talcott-Olson house in Rockton. Built in 1843.

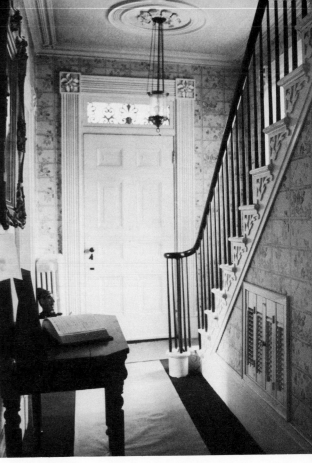

Hallway and staircase of the John Wood mansion in Quincy. Notice the plaster medallion in the ceiling, the cornice, and the beautifully carved decorations of the woodwork. The staircase spindles are exaggerated adaptations of the Greek vase, a favorite motif as well for cabinetmakers, chair makers, and silversmiths of the day.

PHOTOGRAPH BY CHARLES HODGE

Ornamentation of Greek Revival buildings was confined mainly to the doorway, cornices, mantel-pieces, and window frames. Interior walls were usually painted in pastel colors; in a more elaborate structure, a classic medallion of plaster might be centered on the ceiling. Fireplace openings were flanked by columns or pilasters; chests as well as mantel shelves were occasionally topped by shallow pediments.

Typical furniture for the wealthy included pieces in the French Empire style, introduced to America after the conquests of Napoleon Bonaparte. Classic Greek or Roman motifs were often evident on such pieces. Like the furniture makers of the East, Illinois craftsmen during the mid-1800s turned out chairs with saber legs based on the *klismos*, a chair style of ancient Greece. American imitations of Greek vases decorated bedposts, the spindles of staircases, furniture legs, and the back splats of chairs. Columns and scrolls supported the upper drawers of chests, and the stylized Greek lyre was a popular ornamental

A walnut bootjack made for Jacob Blatter of Greenville about 1850-60. The needlework in the panel was made in 1874 in Highland, Madison County.

MRS. BONNIE E. BOLL COLLECTION

Art, Crafts, and Architecture in Early Illinois

The Greek chair or klismos as pictured in Greek paintings of 500-600 B.C.

Walnut chest or linen press attributed to the Petersburg area. About 1840. Notice especially its pediment and slightly overhanging top drawers.
DR. AND MRS. FLOYD BARRINGER COLLECTION

The back of this "balloon-back" chair is actually an inverted lyre with a vase splat. The chair is painted in imitation of rosewood, striped with yellow, and stenciled with gold powder. Attributed to the Galena area, 1845-50.
AUTHOR'S COLLECTION

Variation of the saber-leg chair of the Greek Revival period. Notice the carved lyre motifs on the horizontal back slat.
ILLINOIS STATE
HISTORICAL LIBRARY

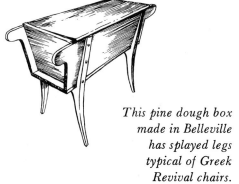

This pine dough box made in Belleville has splayed legs typical of Greek Revival chairs.
MR. AND MRS. J. E. TRABUE COLLECTION

motif for many objects. Elaborately carved or veneered mahogany and rosewood furniture had at first to be imported to Illinois from the East by way of New Orleans and St. Louis, but less ornate pieces made of native walnut, maple, and cherry were constructed within the state by the thousands. Cabinetmakers in Springfield built French bedsteads for $8 to $10 and cherry tables with turned legs for $7 and could not keep up with the demand for their services. As was common when several types of local woods were used in one chair, decorators often painted them with artificial graining in imitation of the more fashionable mahogany and rosewood. Classic motifs were evident on many other objects in this period — for instance the so-called fiddle-back handles (actually vase-shaped) on coin-silver spoons. Even the Illinois stonecutter adopted Greek motifs.

Greek Revival–type tombstones with draped vase and broken pillar motifs.

Georgian- and Federal-type tombstones.

An interesting progression of styles is evident in old graveyards. Georgian- and Federal-style tombstones sometimes had the general outlines of a Palladian window or were multicurved like old English gables. Decorative motifs of Federal days included winged heads, rosettes, fan shapes, or sun rays carved in low relief, while quaint lettering conformed to the style of the day. Greek Revival tombstones were much more severe. Generally square-topped slabs, they were occasionally topped by a pediment, and sometimes they were decorated with an urn, a broken column, a willow tree, the hand of God, or a dove. The main inscription was usually in solid block lettering.

Some historians insist that classic symbols lost their democratic significance in time and continued in use only because people considered them stylish. Even so, the spirit of democracy was an especially powerful sentiment in Illinois, and it continued to be expressed in many ways other than in architecture. New towns were given such names as Athens, Augusta, Aurora, Carthage, Crete, Elgin, Eureka, Rome, Sparta, Troy, Utica, and Xenia. Politically oriented citizens engaged in debates, held rallies, and conducted parades, especially on the Fourth of July — a special occasion for celebration because the days of the Revolution lived on in the minds of many veterans who had settled in Illinois.

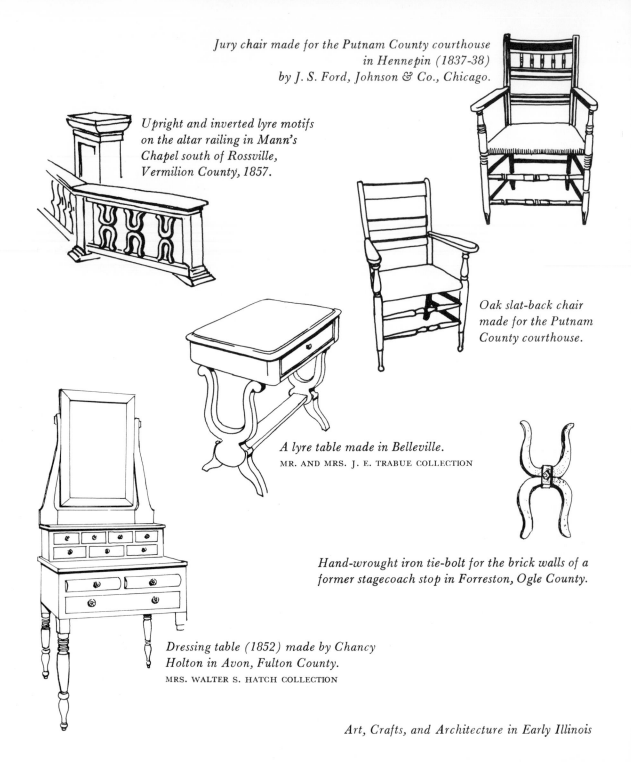

Jury chair made for the Putnam County courthouse in Hennepin (1837-38) by J. S. Ford, Johnson & Co., Chicago.

Upright and inverted lyre motifs on the altar railing in Mann's Chapel south of Rossville, Vermilion County, 1857.

Oak slat-back chair made for the Putnam County courthouse.

A lyre table made in Belleville.
MR. AND MRS. J. E. TRABUE COLLECTION

Hand-wrought iron tie-bolt for the brick walls of a former stagecoach stop in Forreston, Ogle County.

Dressing table (1852) made by Chancy Holton in Avon, Fulton County.
MRS. WALTER S. HATCH COLLECTION

Art, Crafts, and Architecture in Early Illinois

Greek vase motif on the posts of a fruitwood bed
made in Fancy Creek Township about 1840.
MRS. JUNE POWER REILLY COLLECTION

Adaptation of the Greek vase on a
newel post at Bishop Hill, about 1840.

The column-and-beam motif can be
seen in the doors of this walnut
"Jackson" chest. Made by Charles
Watts in Farmingdale, Sangamon
County, about 1840.
EMMET PEARSON COLLECTION

A daybed made for Jacob Blatter of Greenville.
This is a small country version of the "French"
or sleigh bed that was popular during the Greek
Revival period.

MRS. BONNIE E. BOLL COLLECTION

Vase shapes for the turned legs of a walnut
drop-leaf table and lamp stand.
Attributed to Mt. Sterling, Brown County,
about 1840.
MRS. SIBLEY GADDIS COLLECTION

The column-and-beam motif
is apparent in this doll chest
made in Jacksonville.
This miniature piece of furniture
is only twenty-six inches high.
ANNA DOAN COLLECTION

There was also great general pride in the nation's heroes, in particular George Washington and the French general Lafayette. For a grand party at Fort Dearborn about 1830, the whitewashed walls of one room were decorated with flags, and on the wooden floor a young soldier drew a large figure of the revered Washington. In 1835 the German traveler Frederick Gustorf recorded in his journal: "Here in the West one frequently sees the great Washington on tavern signs. In the evening we stopped at Washington Hall."[1] Charles Dickens described his overnight stop at Lebanon in 1842: "I took a survey of the inn's two parlours, which were decorated with coloured prints of Washington, and President Madison."[2]

Following closely behind Washington in general popularity was the Marquis de Lafayette. As a nineteen-year-old fighting at Washington's side, he had so impressed the Continental Congress that he was made a major general. Lafayette's death in 1834 was an event of national mourning. On his last visit to the United States in 1825, he included Illinois in his grand tour of the enthusiastically grateful nation. Arriving at Kaskaskia on April 30, Lafayette was greeted by old veterans who had fought under him at the battles of Brandywine and Yorktown, and he was entertained at a dinner and grand ball at Colonel Sweet's Tavern in the evening. On May 7 Lafayette visited Shawneetown, where he was given a twenty-one-gun salute and escorted from the river's edge over a path laid with calico cloth strewn with roses. That evening Lafayette was again feted at a grand feast, this time at the Rawlings House, a new brick inn on the waterfront.

Paintings of national heroes were popular hangings for the state capitols of America, and it became a common practice among famous artists of the East to copy and recopy existing portraits. Whereas the copy of another artist's painting is not today highly regarded, a very different attitude prevailed before color reproduction processes were invented. Only through an artist's copy could the true-to-life features of a dead hero — in full color and approximately life-size — be viewed by the average American. Following the established custom, Rembrandt Peale, a celebrated eastern artist, offered a copy of his own painting of George Washington to the state of Illinois:

To the Senate & House of Representatives
of the State of Illinois

———————

The undersigned, one of the last surviving artists who enjoyed the privilege of painting the Portrait of Washington from the life, having succeeded in producing a likeness of that illustrious man which has united in one expression of distinguished preference the voices of his most intimate friends & contemporaries — feels it his duty to offer his service to the State.

If it be true that this portrait is justly distinguished for its fidelity & expression of character it must be ascribed to the personal knowledge which the Artist had of the living model. Copies of this Picture made by the artist himself will be entitled to greater confidence, and will be of greater value than any which may be executed after his death or by other hands — he therefore offers to the State of Illinois an opportunity of possessing for a moderate compensation as directed in a letter to the Governor, an accurate Copy of this work.

Rembrandt Peale[3]

New York Feb 2 1826

It would seem that Peale's offer was not ac-cepted, as no trace of such a painting has been found in the state collections.

In 1839 the Illinois state legislators commissioned native son James Berry of Vandalia (see p. 90) to make copies for the new statehouse of two large paintings hanging in the House of Representatives in Washington, D.C. One was of George Washington, painted 1832-34 by a New Yorker, John Vanderlyn; the other was of Lafayette, painted by the Dutch-French artist Ary Scheffer.

It might at first seem that Berry, as adjutant general for the state, wielded considerable political influence in obtaining acceptance of his own paintings for the statehouse over those by a nationally known artist, but this is not necessarily the case. The proud democratic spirit of the time encouraged support of local artists, and it is quite possible that the refusal of Peale's portrait was considered a commendable demonstration of Illinois' loyalty to its own artists. As a matter of economic fact, the choice of Berry's paintings provided a substantial saving for the state. Copies by fashionable eastern artists were generally more expensive than the originals; Congress had paid Vanderlyn $2,500 for his painting of Washington, "the head to be a copy of Stuart's Washington, and the accessories to be left to the judgment of the artist."[4] Berry was paid only $750 each for his copies of the Washington and Lafayette portraits.

After finishing and delivering his paintings, Berry evidently returned to Vandalia. He had been painting portraits since the age of nineteen, so he probably continued to paint; but little is actually known about the rest of his life. In 1843 William D. Ewing wrote him a letter asking if he would be willing to spend the next winter

A copy of John Vanderlyn's portrait of Washington by James Berry of Vandalia. Commissioned in 1839 by the state legislature for the Illinois House of Representatives in Springfield. The original painting by Vanderlyn hangs in the U.S. House of Representatives in Washington, D.C.

PHOTOGRAPH BY CHARLES HODGE

A copy of Ary Scheffer's portrait of Lafayette by James Berry, the second of two paintings commissioned by the state legislature for permanent exhibition in the Illinois state capitol. This portrait was placed in the senate chambers (see p. 157). Scheffer's original painting was executed at the time of Lafayette's visit to the United States in 1826 and hangs in the U.S. House of Representatives.

PHOTOGRAPH BY CHARLES HODGE

Greek Temples and Gothic Spires

in Springfield if he could be guaranteed at least twenty commissions. It is not known whether Berry did follow up on the proposal. He died in January of 1877 and was buried in the cemetery at Vandalia. His modest two-story brick home has been converted into a small museum.

The new capital city, with its growing accumulation of people of stature, education, and wealth, provided encouragement for even the amateur resident artist. Dr. Ethan T. Cabanis (newspaper spellings vary: Cabinis, Cabiness, Cabiniss, Cabaniss), a former physician of Monmouth in Warren County, came to Springfield in 1833, and four years later he was exhibiting his pencil portraits of various citizens of the town. The *Sangamo Journal* of July 1, 1837, felt "justified in commending those who desire the species of immortality which can be conferred by the pencil, to visit the rooms of Dr. Cabiness. It seems to us that he is worthy of encouragement." By 1839 Dr. Cabanis had become a "portrait painter." Like other artists he apparently traveled, periodically returning to Springfield. On one occasion he brought with him a portrait of his former commanding officer, the president-elect, General William H. Harrison, and by 1845 he had also painted J. Y. Scammon and John Buford. In 1847 Cabanis settled in Springfield, working as both daguerreotype artist and portrait painter. In 1848, fired by the discovery of gold in California, he joined a band of twenty emigrants and did not return to Springfield until 1852. Nothing further is known about this early doctor-turned-painter. The only one of his signed paintings found depicts an unknown gentleman and is presently in the Sheldon Swope Art Gallery of Terre Haute, Indiana.

The Greek Revival was the most universally

Portrait of an unknown man (1845) by Ethan T. Cabanis of Springfield.
SHELDON SWOPE ART GALLERY,
TERRE HAUTE, IND.

popular style ever to appear in America. In Illinois it remained popular until almost 1860; perhaps nowhere in the United States were there more courthouses in this mode. Examples still stand at Hennepin (1837-38), Knoxville (1839), Oquawka (1842), Metamora (1845), Thebes (1845), Mt. Pulaski (1847), and Toulon (1856). Most of these buildings have typical temple porticos, but they also show features which never appeared on Greek temples — windows, cupolas with vertical sides, and outside stairways to the second floor.

In the East, however, the style lasted only

until about 1840. A few architects had for some time openly questioned the advisability of using the Greek temple style for all American building and for every person. They felt that such a structure was ill-suited to family living. More important, they felt that a structure symbolic of democracy — one which was quite appropriate for public buildings — was hardly fitting as a symbol of the Christian home and church. After all, their argument continued, the original Greek or Roman temple had been a place for the worship of pagan gods. This attitude was expressed as early as 1805 by the noted architect Benjamin Latrobe when he made plans for a Roman Catholic cathedral in Baltimore in the Gothic style of the Middle Ages, a style evolved during the great flowering of the Christian faith. Latrobe's designs were not accepted; the bishop in Baltimore decided that a classic Roman edifice would be a more suitable symbol for a Catholic church, as it would recall the seat of its faith in Rome.

A Connecticut builder named Ithiel Town had in 1814 broken with tradition in constructing Trinity Episcopal Church in New Haven. This church was based not on the familiar English Georgian, Federal, or Classic styles, but followed certain aspects of the medieval Gothic cathedral. Town, drawing his inspiration from engravings of old cathedrals, had especially noted the tall windows, doors, arches, and finials that symbolically pointed upward toward heaven. He added these features to a plain, boxy structure with additional Gothic motifs — crockets, mullions, and tracery — and thereby set a precedent for other Christian churches in America.

In the 1830s a few such Gothic Revival churches were built by Episcopalian New Eng-

landers in Illinois. Town had not advocated strict imitation of old Gothic buildings but had suggested merely that certain motifs of the medieval style be used as Christian symbols ornamenting a basic structure. Consequently early frontier churches like Trinity Church in Jacksonville (1834) sometimes retained a few characteristics of the Greek Revival period, such as flat pilasters, and at the same time featured Gothic symbols — tall, pointed windows, high doorways, and a spire. (This church, apparently the earliest Gothic structure in Illinois, no longer exists.)

In 1836 the Episcopalian bishop Philander Chase came to Illinois. Bishop Chase, a graduate of Dartmouth, one-time rector of Christ Church in Hartford, and founder of Kenyon College in Ohio, visited Chicago, Peoria, Springfield, Jacksonville, and Danville and decided to build a seminary in the heart of the Illinois wilderness for training Episcopalian ministers. Chase needed

York Minster, England.

Salisbury Cathedral, England.

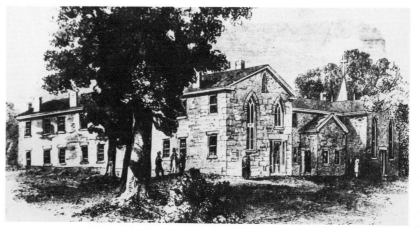

Jubilee College, erected in 1840 by Bishop Philander Chase as a training school for Episcopalian ministers. Northwest of Peoria, this structure can still be seen.
ILLINOIS STATE
HISTORICAL LIBRARY
PHOTOGRAPH

money for his project, and, returning to England, he succeeded in raising about $10,000. Additional funds were collected in the East during his absence, and Chase returned to Illinois with a substantial sum. About fourteen miles northwest of Peoria, he built a log house which he called the Robin's Nest, since it was "built of mud and sticks and filled with young ones."[5] The timbered land adjacent to the farm contained good limestone and freestone and suitable clay for brick, so he began there to erect Jubilee College, which was completed in 1840.

A two-story stone building in the form of a cross, Jubilee College had some pointed Gothic windows and a slender spire surmounted by a wooden cross. Mrs. Chase wrote to a friend in 1840: "It would do your heart good to look into Jubilee Chapel; the pulpit, desks, and folding-doors of black walnut, the pews painted in imitation oak, everything plain but neat and in very good taste."[6]

Bishop Chase died in 1852, but Jubilee College continued to function, and additional buildings — residences for the teachers, boarding houses for scholars and workmen — were built.

Industries in and around the little town of Jubilee included a sawmill, a flour mill with both steam and water power, a store, a blacksmith shop, a shoemaker's shop, and a small hand printing press. By 1859, however, the college was in a state of deterioration, and by 1868 it had closed its doors. For over sixty years the buildings stood in neglect. About 1931 the two remaining buildings were bought by Dr. George A. Zeller of Peoria and presented first to the Boy Scouts of America and later to the state of Illinois. Jubilee Chapel still stands, and in the small cemetery on the state park grounds Bishop Chase's grave is marked by a stone pulpit carved with Gothic motifs.

The grave marker of Bishop Chase at Jubilee College State Memorial.

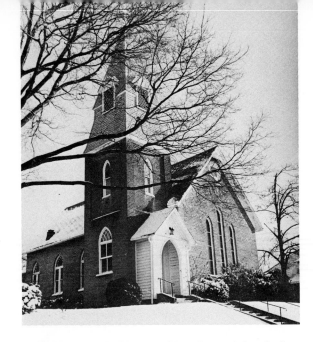

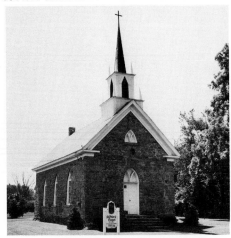
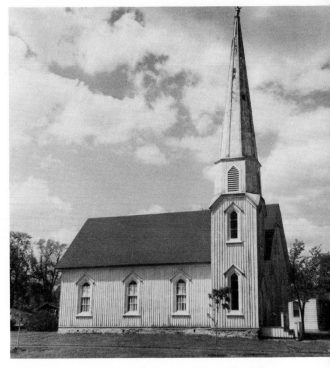

Evidence of Bishop Chase's activity before 1850 may be found at other widely scattered points in Illinois: St. John's Episcopal Church at Albion (1842), believed to be the oldest surviving Episcopal church in Illinois; Christ Episcopal Church (1845), a stone parish church built for a settlement of English immigrants seven miles west of Peoria and one-half mile north of Farmington Road; St. Peter's Chapel (1849), a quaint stone building at Grand Detour on the Rock River; and Grace Episcopal Church at Galena (1848-50). Perhaps the most beautiful old American Gothic church in Illinois, Grace Church is built of native stone with typical Gothic buttresses and pointed windows. A square tower originally surmounted by a steeple is pierced by narrow, pointed openings, and the original altar and reredos, carved by R. Geissler of New York, are still in place. Near them is a beautifully carved lectern in the shape of an eagle with outspread wings, the work of Frank Grunner of Galena.

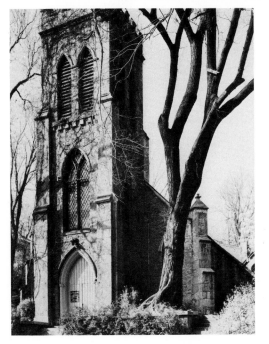

This pioneer Gothic church was built in Dwight, Livingston County, in 1857, only four years after the founding of the town. Boards applied vertically on the outsides of buildings became popular about this time, emphasizing the sense of upward movement characteristic of Gothic structures.
PHOTOGRAPH BY RICHARD PHILLIPS

Grace Episcopal Church in Galena. In contrast to most of the earlier Gothic Revival churches in Illinois, this structure was designed by an architect, C. W. Otis, from Buffalo, New York. In addition to the usual features of Gothic Revival, this church has buttresses to support the stone walls, indicating a trend toward truer representation of the medieval Gothic style. A wooden spire was removed in 1894.
ILLINOIS STATE HISTORICAL LIBRARY PHOTOGRAPH

Art, Crafts, and Architecture in Early Illinois

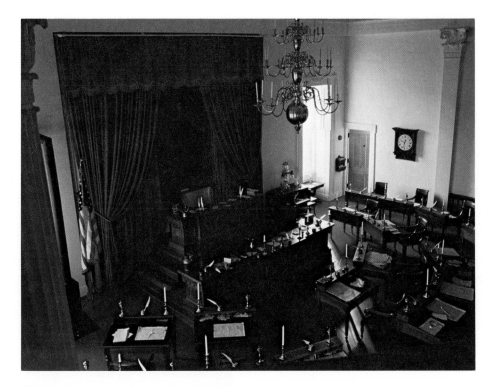

Senate chamber of the restored Old State Capitol in Springfield.
The painting in the background is by James Berry (see p. 153). The desks are
patterned after the original design of the architect, John Francis Rague
(see pp. 247 and 253).

A Tuscan villa in Galena, with jigsawed "wedding cake"
ornament and bay windows, which began to appear in
Illinois about 1850. This home, Belvedere, was once
the residence of J. Russell Jones, who became
U.S. marshal of the northern district of Illinois
under President Lincoln.
GALENA HISTORICAL SOCIETY PHOTOGRAPH

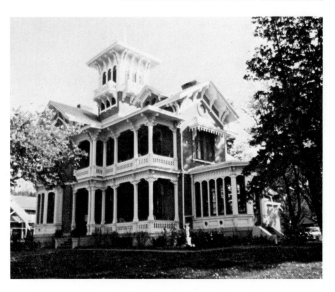

*"The Knitting Lesson" by Junius R. Sloan.
An example (ca. 1853-57) of genre painting,
the portrayal of everyday scenes or events.*
SLOAN GALLERIES OF AMERICAN PAINTINGS,
VALPARAISO UNIVERSITY, VALPARAISO, IND.

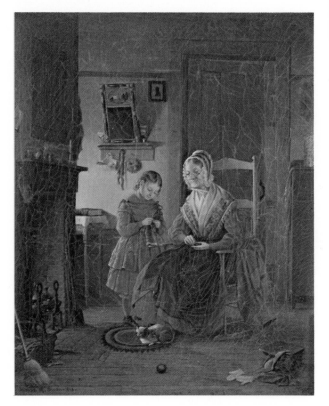

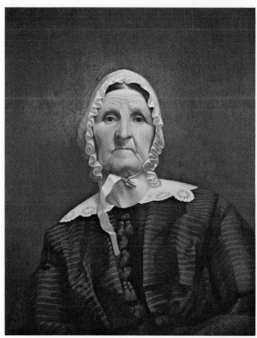

*Mary "Polly" Greene Watkins of Clary's Grove
near Petersburg, Menard County.
Oil portrait (1850-60) by an unknown artist.
The realism of the portrait is notable,
and shows the growing influence of the camera
on the art of the time (see p. 258).*
MR. AND MRS. C. RUSSELL DAVIS COLLECTION

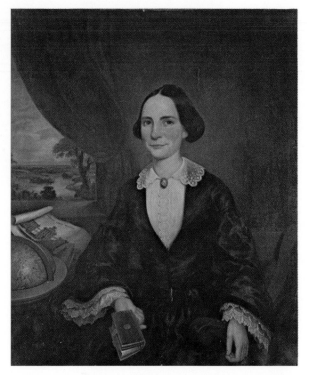

*Oil portrait of Anna P. Sill (ca. 1860),
founder of Rockford Seminary, which later
became Rockford College. Painted by
George J. Robertson, teacher of painting,
drawing, and graphics from 1860 to 1885,
and later a professor at the college.*
ROCKFORD COLLEGE

Art, Crafts, and Architecture in Early Illinois

13 The Plight of the Artist

Chicago Daily American, *1841.*

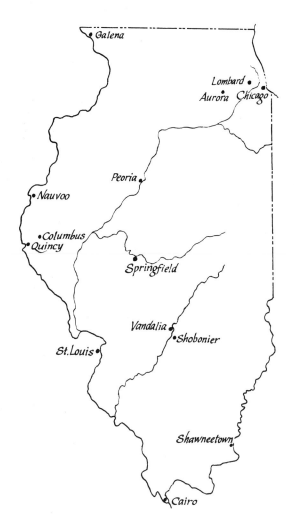

Publication in America and Europe of various books and emigration guides was making the world aware of new opportunities in the American Midwest. The publicity resulted in a somewhat ludicrous frenzy of speculation in real estate and paper money that in 1837 would finally bring about a depression and the closing of banks all over America.

In Chicago the veritable mania in real estate speculation contradicted the 1833 assessment that the settlement was too distant from Shawneetown to amount to much. Chicago, the western debarkation point of immigration by steamboats on the Great Lakes, was beginning to assume importance as a center of industry and commerce. In spite of the mud during the wet season, stagecoaches, light Yankee wagons, heavy German Conestogas, carriages, and droves of cattle crowded its streets. In 1835 the first foundry, the Chicago Furnace, was in operation, and two years later Charles Morgan established a large business for the manufacture of furniture. Ships were being built, wagons and carriages were being manufactured, and hundreds of balloon-frame houses, shops, and public buildings were being erected.

The 1839 city directory lists five house, sign, and ornamental painters: J. M. Attwood, A.

Cole, Cleveland & Co., John A. Oliver, and Alexander White. No doubt it was these men who produced the signs in front of the many shops, taverns, and offices of professional men. Such signs were usually painted symbols: a large watch for the shop of F. T. Heyman, the watchmaker, or a padlock for the shop of L. W. Holmes, manufacturer of tin, copper, and sheet-iron wares. Eyeglasses, teeth, a mortar and pestle, or a hat were other symbols that helped the passerby identify at a glance the service provided within a building.

159

A woodcut engraving in an early issue of the Chicago Democrat.

In addition to the ordinary wares of local craftsmen and merchants, Chicago newspapers advertised imported luxuries: gilt, alabaster, and ebony clocks; glassware; music boxes; silver-plated castors, tea sets, candlesticks, and tableware; cooking stoves; ingrain carpets; musical instruments; and many kinds of imported silks, linens, cassimeres, laces, plush cravats, velvet ribbons, silk ribbons, and French trimmings.

A merchant's ad looked quite different from the modern newspaper ad. Rarely over a column wide and a few inches long, it often had no picture at all or only a tiny print made from a woodblock. The creation of a woodcut was the work of an engraver, a combined artist and craftsman. This specialized workman drew a picture on the end of a type-high piece of wood and then cut away the background with engraving tools. This woodcut would be locked together with the type during the printing process. The inked surface would be covered with a paper, and heavy pressure would cause an impression of the type and picture to be transferred to the paper.

It is not known when the earliest engraver came to Illinois. Some early newspapers had a few tiny illustrations, but these were probably made in the East, along with the type, and brought to Illinois by the printer. Since merchants had to limit themselves to whatever pictures the printer might have in his office as long as there were no trained engravers in the state, here at last was a type of artist whose services were in demand.

With the arrival of the engraver Shubael (or Shuball) Davis Childs (1799-1870), the enterprising Chicago merchant no longer had to limit himself to whatever the printer could provide; a new, made-to-order woodcut might be ordered for his ad, or even a large picture cut on a wooden plank for printing posters. Childs had been trained in Boston and had worked in New York. In addition to all kinds of engraving, he advertised a willingness to perform a multitude of other services, as advertised in the *Daily American:*

ENGRAVING & PAINTING

Sign & Ornamental Painting, Perspective Drawings, &c., Engraving on Wood and Metals, **Seals for Corporations or Individuals,** Name Punches, Marking of all kinds, etc. etc. S. D. CHILDS, Clark st. between Lake & Water-sts. Chicago, March 30, 1839.—37w3.

Line engraving on metals had been carried on for many years. Silverware, brass name plates, and gold, silver, and pewter buttons had long been decorated with engravings, while engraved copper plates had been used for printing bank-notes, fine landscapes, and portraits. A picture or ornament printed from a metal plate required skill and patience on the part of the engraver, who inscribed the lines of the design into the metal with special tools. When the finished plate was mounted on wood, the surface was inked and then wiped off, so that ink remained only in the grooves. This ink was transferred to a sheet of damp paper pressed firmly down on top of the plate. The process produced a finer product than the woodcut method, but it was also a slower and costlier procedure. Metal engraving for this reason never gained the wide popularity of wood engraving and was used mainly for printing maps, paper currency, documents, certificates, trade cards, seals, and insignias.

The early wood engravings were often quite crude, but engravings for newspapers were not meant to be fine art. In 1836 the *Chicago American* introduced into its heading an eagle with a scroll in its beak and the motto "E Pluribus Unum." According to the historian A. T. Andreas, "The skill of the artist was not displayed for the love of the art, but to render just so much work with the graver as would be adequate to the recompense he was to receive from his employer."[1]

A scene painter, Henry (or Harry) Isherwood, also arrived in Chicago in 1837. Being a producer as well as a theater artist, Isherwood that summer organized with Alexander McKenzie the first theatrical productions to appear in the city. Isherwood found Chicago a discouraging sight; it lay, according to one comment, between "Lake Michigan roaring on one side and the bloody prairie wolves on the other."[2] The theater, first located outside town in the Sauganash Hotel dining room, was enlivened somewhat by several scenes Isherwood had painted to serve for such melodramas as were typical of that time. That spring and summer he and his troupe worked at the hotel; fall and winter they spent in the prairie towns. In 1838 McKenzie and Joseph Jefferson contracted to build the Rialto, to be used specifically for theater in Chicago.

Art, Crafts, and Architecture in Early Illinois

The Sauganash Hotel in Chicago as it looked in 1837. The first dramatic
performances in Chicago were held in this Greek Revival frame structure.
IN ANDREAS

Jefferson, also an actor and painter of scenery,
had arrived in Chicago only that year. Later,
describing the interior of the theater in his auto-
biography, he wrote:

Now for the theatre. Newly painted canvas, tack
hammer at work on stuffed seats in the dress circle,
planing boards in the pit, new drop curtain let
down for inspection — "beautiful." A medallion of
Shakespeare suffering from a severe pain in the
stomach over the center, with "One touch of nature
makes the whole world kin" written under him, and
a large painted, brick-red drapery looped up by
Justice with swords and scales showing an arena
with a large number of gladiators hacking away at
one another in the distance to a delighted Roman
public. There were two private boxes with little
white and gold balustrades and turkey-red curtains,
over one box a portrait of Beethoven and over the
other a portrait of Handel — upon unfriendly
terms, glaring at each other. The dome was pale
blue with pink and white clouds on which reposed
four ungraceful ballet girls representing the seasons
and apparently dropping flowers, snow and grapes
into the pit. Over each season there floated four
flat little cherubim in various stages of spinal curva-
ture.... The green room was a perfect gem, with
a three-foot mirror and cushioned seats around the
wall — traps under the stage so convenient that
Ophelia could walk from her grave to her dressing
room with perfect ease.[3]

In their efforts to bring theater to Chicago,
the producers were not completely successful.
Prim, morality-minded Yankee ladies of the city
evidently had a somewhat low opinion of the
salty versions of the contemporary plays. Still, a
newspaper editorial in the *Chicago American* of
September 5, 1839, stated:

If the ladies are waiting for fashionable precedents,
we will inform them that at Springfield in this state,
the theatre was attended generally by the beauty
and fashions of the fair sex, and by the gentlemen
of the place, of all official positions from Judge of
the Supreme Court down. This has been the case,
we believe, at St. Louis and in the East. The theatre
at Springfield presented not a tithe of the induce-
ments for attendance of the Chicago Theatre.
There the seats were of rough boards, without backs
to them, and there were no divisions into boxes, etc.
but still the theatre was almost nightly crowded.
Here is an example set by the capital of the State.

Nevertheless, after the theatrical company de-
parted from Chicago in 1840, the city had no
dramatic company of repute for seven years.

News of the rich land in the state enticed
even writers and artists to buy land in Illinois.
In 1835 the noted American writer Washington
Irving bought two lots in Quincy for $52. Illus-
trating the speculative mania of the day in all
areas of trade in Illinois, Milo M. Quaife wrote:
"Numerous tales of individual experiences have
been handed down to us by contemporaries, but
the underlying spirit of the time is perhaps best
illustrated by the story, reported in the first issue
of Milwaukee's first newspaper of this conversa-
tion between two Chicagoans: 'I say,' inquired
one of the gentlemen, 'what did you give for your
portrait?' 'Twenty-five dollars,' was the reply,
'and I have been offered fifty for it.' "[4]

An artist in New York who was intrigued with the idea of making his fortune from Illinois property was portrait painter John Quidor (1801-81). For a short time Quidor had been an apprentice to the noted eastern painter John Wesley Jarvis, and as a young man he was supporting himself in New York by painting portraits, banners, and fire engines. His most satisfying work was painting imaginative genre scenes after passages in the works of Washington Irving. While occupied as a painter, Quidor bought Illinois land as an investment. As early as 1823 he made his first acquisition at Columbus, a town existing only on paper but intended as the future seat of Marquette County. Other transactions followed, and in 1834 he was in Quincy purchasing land for himself and his family. Opening a studio in the town, Quidor continued painting portraits and apparently also resumed the more pleasurable work on genre subjects. According to researcher David M. Sokol, those Quidor paintings which were exhibited at the National Academy and the Apollo Association from 1834 to 1839 were probably sent from Illinois by the artist.

In 1844 Quidor bought another, larger farm, agreeing to pay for it by painting huge canvases at $1,000 apiece of such popular subjects as "Christ Healing the Sick," "Death on a Pale Horse," and "The Raising of Lazarus." Some of the 11-by-17-foot paintings were exhibited at the Quincy courthouse, in Springfield, and perhaps in other Illinois towns, and in 1847 they were sent to New York. There is no further record of these paintings and no evidence at all of their survival.

It was difficult to earn a living in the West by painting, and there are indications that the

"Rip Van Winkle: At Nicholas Vedder's Tavern." Painted by John Quidor in 1839. This imaginative genre painting inspired by the writings of Washington Irving may have been painted in Quincy.
M. & M. KAROLIK COLLECTION, MUSEUM OF FINE ARTS, BOSTON

labors of farming and a drinking problem combined to force John Quidor to return to New York City in 1851. There for the most part he continued to produce imaginative genre works inspired by literary sources.

During Quidor's residence in Quincy, other artists arrived in Illinois, some of whom were

quickly disillusioned with life in the West. J. S. Porter, a painter of miniatures, had come to Chicago in 1835 but left shortly after, and artist J. Jackson apparently stayed only a little longer. About 1840 Jackson made a sketch of the Mormon temple in Nauvoo. Later the following ad appeared in the *Shawneetown Republican:*

EXIHBITION.

J. JACKSON,

RETURNS his sincere thanks to the citizens of Shawneetown, for the liberal patronage he has hitherto received. And begs leave to inform the public, that he will give an EXHIBITION on Saturday night in each week, (commencing this evening until the first of April. Room 2 doors below W. A. Docker's, Feb. 26, 1842.

There is no further evidence of Jackson's work in Illinois.

The earliest known view of the city of Chicago was sketched in 1838 by a Frenchman, Francis de Castelnau, while on a two-year tour of the United States. This drawing was made into a lithograph for his book, *Vues de l'Amérique du Nord,* published in Paris in 1842.

A few of the aspiring artists remained for longer periods in Illinois. In 1837 Sheldon Peck (1797-1868), a portrait painter, moved to Chicago with his wife and family from Jordan, New York, where he had worked from 1828 to 1836. Of his early life the little that is known is that this talented amateur was born in Cornwall, Vermont. At least three of his early oil portraits of family members still survive in the home of a descendant. These charming paintings, depicting the subjects in the typically prim, stiff style of the Yankee amateur, were done on wooden

panels which have since warped. Peck is said to have bought property on the present site of Marshall Field and Company in Chicago. Deciding that Chicago was a mud hole and no place to raise a family, he exchanged his purchase for a wagon and a team of horses and moved with his family to Babcock's Grove, about twenty miles west, where he became one of the first settlers of what is now Lombard. A government survey had not yet been made, and it is said that Peck plowed a strip around his plot to mark it, and used his wagon for shelter until a modest house of hewn logs could be completed. Peck farmed his land in the summer and in the winter traveled about the area, staying in the homes of his subjects. For a double portrait his fee was $50 plus board and keep for himself and his horse.

Around 1839 Peck painted a double portrait of Mr. and Mrs. William Vaughan of Aurora, seated on either side of a small table upon which there is a Bible and a vase of flowers. While boarding at the same home he is believed to have painted a single portrait of a brother, Mr. S. Vaughan, that is now owned by the Illinois State Museum. The Aurora Historical Society houses two later paintings attributed to the same itinerant painter: one of Mr. and Mrs. Bloss of Aurora, the other of the John Wagner family, who lived in the vicinity (see p. 87).[5]

Portrait commissions were at times scarce in the immediate area, so Peck traveled by stagecoach to St. Louis, where he made drawings of operations and anatomy for medical students. From 1853 to 1854 he worked as an ornamental artist in Chicago. With his purse filled again, he returned to his home and family. Peck died of pneumonia on March 19, 1868, and was buried

Sheldon Peck, about 1850.
MRS. WILLIAM ALEXANDER COLLECTION

in a Lombard cemetery, where an obelisk marks his grave.

The house in which Sheldon Peck lived still stands in Lombard; however, the hewn timbers of the outer walls have been covered with stucco, and alterations and additions have been made; consequently, the house at the corner of Grove and Parkside bears little resemblance to Peck's original cabin.

The Past and Present of Woodford County gives the first account of a painter from England who apparently had come to stay:

In 1836 there came to Woodford County [north of Peoria] an English portrait painter, the first in the county, by the name of James Wilkins, and an

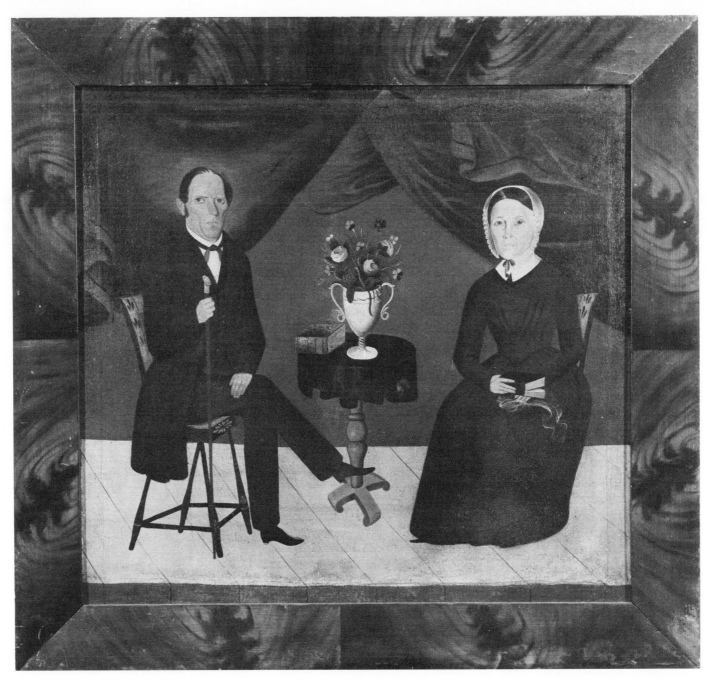

*Mr. and Mrs. William Vaughan
of Aurora. Painted 1839-40
by Sheldon Peck.*
EDITH BARENHOLTZ COLLECTION

Art, Crafts, and Architecture in Early Illinois

*Portrait of Mr. S. Vaughan by Sheldon Peck,
about 1839, the frame of which is painted on the
canvas. This was intended to simulate rosewood,
which was fashionable during the Greek Revival period.*
ILLINOIS STATE MUSEUM

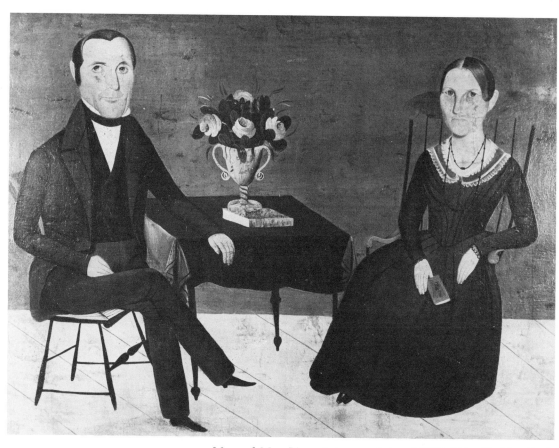

Mr. and Mrs. Bloss of Aurora, painted 1840-45 by Sheldon Peck.
AURORA HISTORICAL SOCIETY MUSEUM

Irishman named Canaday. The latter, apparently, was of a good family and seemed to have plenty of money. He bought considerable land and accumulated other property around him. Quite an intimacy seemed to exist between him and the Englishman, and for a time they worked and lived together in a kind of rude, easy way; but after a while they broke up, and Canaday went to board with Reverend Mr. Davenport. . . .[6]

In 1837 Wilkins (1808-88) seems to have set up housekeeping in Peoria. An experienced artist, he had exhibited his miniatures at the Royal Academy in London a short time before leaving England. Life in Illinois, though, proved strenuous. Wilkins established his home and family in the state and lived there for nearly the rest of his life, but he was forced to leave his family periodically and become an itinerant in order to survive as an artist. Chicago's business directory for 1839-40 indicates that Wilkins spent some time in the city during that year.

Another English miniature painter, also an exhibitor at the Royal Academy, was in St. Louis during the same period, and in 1840 he too decided to try his luck in Illinois. He placed the following ad in Springfield's *Sangamo Journal:*

In February of the following year Wilkins joined Stevenson (Stephenson) in Springfield,

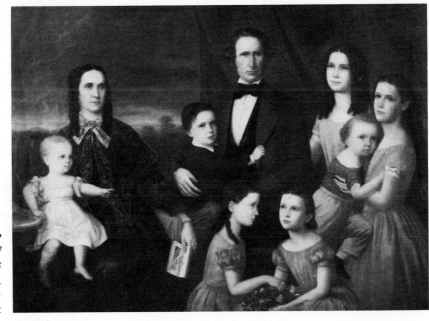

The Charles Ballance family, painted 1853-55 by James Wilkins in Peoria.
PEORIA HISTORICAL SOCIETY MUSEUM

and later that year they organized Chicago's first art exhibition, including 200 of their own paintings, drawings, and sketches. The two also gave lessons in painting in Chicago, but in spite of their efforts, business was poor and their partnership ended within a year. Stevenson left for Cleveland, and it is known that he later worked in Madison and Milwaukee. Wilkins went to New Orleans in 1842, returning to Chicago to work from 1843 until 1845 and then spending some time in St. Louis.

The discovery of gold in California drew Wilkins to the far West. He rode his horse ahead of the emigrant train and sketched the trail as preliminary work for a panorama production, the "Immense Moving Mirror of the Land Route to California by the South Pass of the Rocky Mountains." This panorama was completed in 1850 in Peoria, and Wilkins exhibited it in Peoria, St. Louis, Milwaukee, Cincinnati, Louisville, and Franklin in 1850-51.

After enjoying moderate success with his panorama, Wilkins's return from California was dismal: cholera had hit the area of his home and his possessions had been sold to pay debts. During 1852 and 1853 he needed to supplement his portraiture income by becoming a partner in a store. Later selling his interest in the little enterprise, Wilkins settled in St. Louis, then returned to Peoria in 1855. Little more is known of the remainder of Wilkins's life other than that in 1866 he was in Vandalia and in 1872 bought land at nearby Shobonier, Fayette County, where he died in 1888.

Although Wilkins lived in Illinois for many years, only a few of his paintings are known to exist. Two painted about 1853, depicting the family groups of Charles Ballance and John Rey-

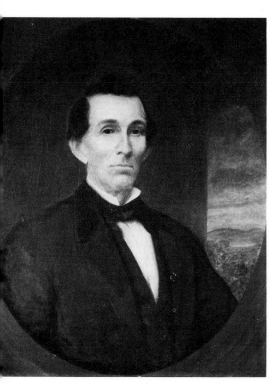
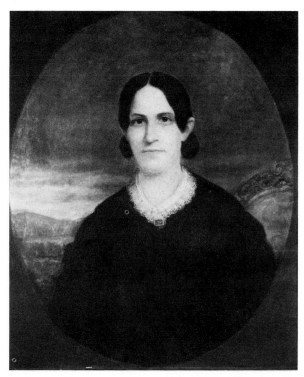

Portraits of Judge Daniel Gregory and his wife, Julia A. M. Gregory,
by James Wilkins, 1866.
ILLINOIS STATE MUSEUM

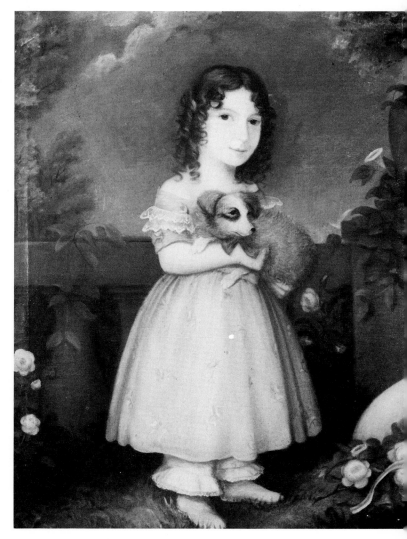

nolds, are presently housed in the buildings
owned by the Peoria Historical Society. Two
more portraits painted in 1866 and presently
owned by the Illinois State Museum show Judge
and Mrs. Daniel Gregory of Vandalia.

Meanwhile, a Chicago citizen, Samuel Mars-
den Brookes (1816-92), on the basis of some
three months' instruction by portraitists Wilkins
and Stevenson, had set up a portrait studio in
Chicago in 1841. From this period may have
come his winsome portrait of Corinne Gale, now
owned by the Chicago Historical Society. In
mid-1843 Brookes spent three months in Galena,
painting miniatures on ivory and advertising
private lessons in painting and drawing. His

Portrait of Corinne Gale (1837-?)
by Samuel Marsden Brookes, 1842.
CHICAGO HISTORICAL SOCIETY

accomplishments evidently also included portrait mementos of the dead, since his ad in the *North Western Gazette & Galena Advertiser* concluded:

Blest is the art that keeps the absent near,
The beautiful unchanged from time's rude theft,
Guards the first tint of childhood's polished brow,
And when love yields its idol to the tomb
Doth snatch a copy.

That same year Brookes was joined in Chicago by Edward M. Clifford, an itinerant portrait painter who remained with him only five months. The next year Brookes left for Milwaukee, Chicago's sole rival for the western commerce on the Great Lakes. He returned to Chicago the following year but remained only long enough to sell his paintings by lottery and earn sufficient money to spend a year studying and copying famous old paintings in England. Back in Chicago in 1846, he was greeted by the *Democrat* as "one of the very best painters of portraits and landscapes in the country." He held another lottery, this time including his copies from the European paintings. There was enthusiastic comment on his products in the *Daily Journal*, far more enthusiastic than those awarded to Miss N. E. Hadley, Theodore Lund, and E. C. Stowe, contemporaneous ornamental and miniature painters in Chicago.

His reputation well established, Brookes, the first resident artist of Chicago, left the young city in 1847 for the last time, going to Milwaukee. There he continued to paint portraits and with Thomas H. Stevenson executed a series of Wisconsin battlefield landscapes for the Wisconsin Historical Society. With the advent of the Civil War, Brookes yielded to the lure of the far West and is known to have died in San Francisco.

Unusual examples of life and death portraits, presumably of the same child, Charlotta Richardson (1838-42). The artist, Edward Richardson, Jr. (1824-58), was an English immigrant who died in Springfield. The first (below) is painted in oils on a wood panel and the second in watercolors.
JOHN PAUL AND THE
ILLINOIS STATE MUSEUM

Stories of the wanderings of such artists as Peck, Wilkins, Stevenson, and Brookes provide a depth of insight into the discouraging prospects of portrait artists in midwestern cities of the 1840s. George Winter, a competent landscape and Indian painter of that day, wrote from Logansport, Indiana: "Had I been told before I ventured into the wilderness that the same hand that wielded the pencil to perpetuate beauty and transcribe upon canvas the associated river nook or scene, should have to lug wood indoors, occasionally saw too, to keep the pot aboiling, make trades, swaps, and twist and turn after the fashion of a new country, I would not, could not have believed it."[7]

Art, Crafts, and Architecture in Early Illinois

14 Signs of a Vanished Frontier

Andrew Cunningham's adobe house.

In the twenty-two years following the admittance of Illinois to statehood, vast changes had taken place in the area. By 1840 nearly every portion had been settled except for the vast, almost treeless Grand Prairie, the bulk of which stretched down for about 200 miles through northeastern Illinois. Even the appearance of the less fortunate settlers had changed: moccasins had been discarded for boots, shoes, and slippers; buckskin and crude homespun clothing had largely been replaced by more modern materials such as calicoes manufactured in the South. Farmers were experimenting with new crops: mulberry trees for growing silkworms, Osage orange trees for fencing the prairies, and hemp for the commercial production of coarse twine and rope. In fact, some hemp from central Illinois was considered so excellent that for a time it was purchased by the U.S. government for naval use.

The growing of flax and raising of sheep had become increasingly important enterprises. Around the countryside women still wove woolens and linens for family use, but in towns the raw wool and flax were usually taken to mills to be processed; homespun thread and yarn might be taken to a professional weaver; and it was no longer necessary for the woman to concoct her own dyestuffs. A complete range of dyes — including logwood, oil vitriol, madder, indigo, alum, blue vitriol, nutgalls, and copperas — could be purchased in the larger towns.

A variety of guidebooks made life easier for fledgling settlers. Some guides included directions for home industries — pickling, soap making, weaving and dyeing, candle making, fruit and vegetable raising, and the cultivation of dyer's madder. *The Farmer's and Emigrant's Handbook* published in 1845 advised the newcomer concerning the purchase of tools, implements, and furniture available at reasonable prices in the West; it informed him that even in the sparsely settled areas he might build a comfortable first home of hewn timber with thirty glass panes for windows and a second floor reached by ladder. The total expenditure for such a dwelling, he was told, should be about twenty days' work and $25, which included the price of butts and metal screws, twenty pounds of nails, and some 400 split clapboards for the roof. For those settling on the almost treeless prairies, there were even directions for making adobe bricks of sundried clay. Many adobe and sod houses were built during this period, though nearly all have disappeared because of their general unsuitability in a damp climate. One adobe house that remains was built in 1852 near Virginia, Illinois,

by a Scotchman. Being a tanner, Andrew Cunningham was able to use more durable material as a binding for his adobe bricks than the average settler, who usually used straw. To a mixture of dry clay and water he added animal hair and some of the ground oak tanbark used for curing the animal hides. This mixture was pressed into wooden molds, the molds were lifted off, and the resultant bricks were allowed to dry in the sun. Cunningham used these bricks for all the walls of his house, adding wide eaves at the first-floor ceiling level in order to protect the mud bricks from the rain. The half-story above was similarly protected by the wide eaves of the roof. These precautions, along with a covering of stucco on the bricks, have allowed Cunningham's house to survive to this day.

The homemade woolen coverlet might still be the housewife's proudest production, but professional weavers were now able to provide coverlets with more intricate designs and more varied colors, thanks to the new Jacquard loom. Named for its developer, Frenchman Joseph Marie Jacquard, the loom first appeared in Europe in 1804 and was introduced into the United States about 1820 in Philadelphia. It was the final stage in weaving technology before the power loom and employed a sophisticated sequence of cards punched with various combinations of holes through which needles passed. An immense variety of intricate patterns could thus be woven — multicolored birds, flowers, animals, and ornamental scrolls. Many designs originated on

Portion of a linen tablecloth (ca. 1850)
spun and woven by Lucebra Ellis
of Morgan County, near Franklin.
ILLINOIS STATE MUSEUM

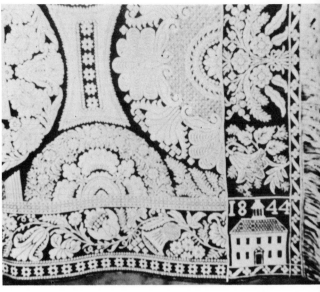

Jacquard coverlet
with the Carmi courthouse on its corner.
Made by Mary Ann Kelly Foster,
Carmi, 1844.
WHITE COUNTY HISTORICAL MUSEUM

European tapestries; others — especially those incorporating eagles, stars, streets, buildings, or even portraits of George Washington — were distinctly American.

After 1835 German, English, Scotch, and French immigrants and their descendants were weaving Jacquard coverlets in Illinois. Many were never recorded by name and, like thousands of other craftsmen, will never be known. Signatures woven into many coverlets serve to identify some, while the names of others have been obtained from descendants, county histories, and city directories. The following compilation represents some of Illinois' professional weavers who worked before the advent of the factory:

Art, Crafts, and Architecture in Early Illinois

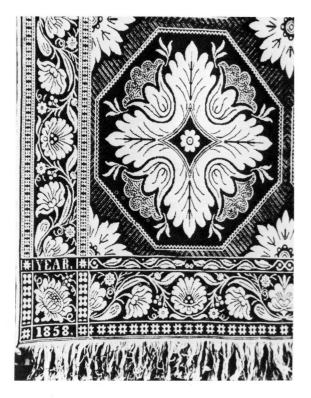

Portion of a double-woven Jacquard coverlet made by Sarah LaTourette, Vermilion County. The pattern, "Frenchman's Fancy," is taken from traditional textile designs.
PHOTOGRAPH BY EDITH JORDAN

A Jacquard loom of the 1840s which was acquired and probably used in Lyons, France.
SMITHSONIAN INSTITUTION

Eliza Jane Baker, New City (now a part of Chicago)
Augustus Beck, Quincy
——— Berry, Bluff Springs (Watseka)
Elihu Bone, Menard Co.
Joseph Chenne, Nauvoo
W. Fasig, Clark Co.
Samuel Fernberg, Mendota City
Mary Ann Kelly Foster, Carmi
J. Frazie, Casey
George Gauss, Belleville
John Hamilton, Lanark
Charles G. Hartmann, Shelbyville and Effingham
Charles A. Herrmann, Champaign Co.
Gottlieb Huhulin, Goodfield
James Jessup, Fairfield
A. D. Knirim, Dixon

Sarah LaTourette, Vermilion Co.
George McCann, Aurora
Emanuel Meilly, Lebanon
——— Michaels, Albion
D. L. Myers, Bethel Township, Madison Co.
Uriah Netzley (Aitzley?), Naperville
Joseph Oertle, Peoria
Jacob Schipper, Quincy
John Philip Seewald, Ridge Prairie, St. Clair Co.
Henry Walhaus, Belleville and Quincy
W. C. Worley, Lewistown

Of these, the histories of two German immigrants, John Seewald and George Gauss, are best known. Both lived in the Belleville area. Seewald, who was born in Kelheim, Germany, had come to Philadelphia about 1828 and there

learned the weaver's trade. Drawn westward, he settled in 1834 at Ridge Prairie, near the present-day town of O'Fallon. His wool, at first carded, dyed, and spun in his own home, was interwoven with linen thread on the great loom that stood beside his fireplace. He quickly developed a fine business providing household linens for area residents, in addition to coverlets woven from the thread and yarn which his customers supplied (see p. 140). Probably Seewald was able to produce about three double-woven coverlets a week, each priced from $10 to $12. He frequently wove into the corner of a coverlet his name, the date, and sometimes the customer's name. One coverlet identified as Seewald's contains a border of "distelfink" birds (a contraction

of thistle finch), a favorite motif among Pennsylvania German settlers for the decoration of textiles, furniture, and hand-painted documents.

George Gauss settled in Belleville in 1847 and worked until 1868 as a "teppichwebber" (tapestry weaver) in his small house (see p. 140). When the Civil War brought a shortage of wool and the factory system brought changes in taste, Gauss, like many other weavers, stopped making coverlets and became a carpet weaver instead.

Although census taking in the early 1800s was incomplete and far from accurate, statistics listed in the U.S. Industrial Census of 1840 indicate the growth of some Illinois industries other than weaving (see chart on p. 173).

The Industrial Revolution was felt in many Illinois towns, and the fact that cast-iron furnaces were operating in Fulton, Hardin, and Wabash counties and in Chicago indicates that iron steps, railings, street lamps, fences, and decorative urns would soon be produced in Illinois foundries. There has been little research in this area of Illinois arts, but it is reasonable to assume that many such fixtures contained the typical decorative devices — crossed spears, arrows, and acanthus leaves.

The blacksmith was strongly affected by the new system. He was accustomed to toiling over individual handmade articles of his own design, but as an independent worker he could no longer compete with foundry production in pattern, variety of articles, or speed of manufacture. The result was that many blacksmiths began doing piecework in foundries, while those who kept their own trade were forced to reduce the variety of their products.

In the foundry, a pattern maker, rather than the blacksmith, was responsible for the design of an iron product. He carved a pattern for the object in walnut or mahogany wood from which a mold of sand was made to receive the molten iron. From the 1830s sheet-iron cook stoves were imported for use in Illinois, but in that same decade iron foundries in the state were making possible the home manufacture of both round "cannon" and cast-iron plate stoves, as well as pots and kettles. In 1838 George Heberling of Quincy was making patterns for all kinds of castings, and within two years William R. Hopkins of Peoria started manufacturing hollow ware and stoves for both cooking and heating. Many other producers of cast-iron products were established in Illinois by mid-century, including C. R. Vandercook and Company, whose first cooking stove, "Queen of the Prairies," was produced in Chicago in 1846.

Furniture factories sprang up wherever there was a supply of running water to turn a lathe or convert to steam. Germans in particular were fine woodworkers; one — Frederick William Jansen — arrived in Quincy in 1835, having labored

Painted chair with a cane seat made by the Jansen Furniture Company, Quincy, about 1840.
HISTORICAL MUSEUM OF QUINCY AND ADAMS COUNTY

for about six years to learn the cabinetmaking trade during his teens in Germany. In 1838 he established his own furniture factory in Quincy. At this factory — one of the first large concerns in the state to be run by waterpower — Jansen turned out superior Empire-style furniture, including carved sofas and cane-seated "Grecian" chairs, which were painted with wood graining and embellished with gold stripings. Another Quincy cabinetmaker, J. S. Funk, advertised in

Empire couch made by the Jansen Furniture Company about 1840.
HISTORICAL MUSEUM OF QUINCY AND ADAMS COUNTY

Art, Crafts, and Architecture in Early Illinois

U.S. INDUSTRIAL CENSUS IN ILLINOIS, 1840

No.	Place	No. Employees	Value	No.	Place	No. Employees	Value	No.	Place	No. Employees	Value
Potteries				*Carriages and Wagons*				*Furniture*			
2	Brown Co.	12	$ 4,000		Quincy	4	$ 8,800		Quincy	10	
1	Hancock Co.		200		Chicago	13	9,250		Brown Co.	7	
1	Iroquois Co.		120		Fulton Co.	21	10,510		Calhoun Co. (Hamburg)	45	
1	Jersey Co.		300		Jersey Co.	8	4,200		Christian Co.	5	
1	La Salle Co.		600		Madison Co. (including Alton,				Clark Co.	1	
1	Lawrence Co.		1,000		Edwardsville, and Upper				Clinton Co.	5	
1	Madison Co. (Highland)	2	550		Alton)	62	31,490		Coles Co.	2	
2	Madison Co. (Upper Alton)	7	6,250		Morgan Co.	10	11,500		Chicago	4	
1	Rock Island Co.	6	500		Sangamon Co. (including				Greene Co.	8	
4	Sangamon Co.	8	3,900		Springfield)	32	16,475		Jefferson Co.	11	
1	Scott Co. (Winchester)	6	5,000		St. Clair Co.	9	4,865		Galena	6	$ 7,000
1	Scott Co. (outside Winchester)	3	2,000		Will Co. (including Joliet and				Alton	17	15,650
2	Tazewell Co.		400		and Lockport)	13	13,200		Peoria	5	
1	Union Co.	1	20	*Hardware, Cutlery*					Putnam Co.	9	
3	Vermilion Co.	3	1,900		Brown Co.	5	$ 2,250		Rock Island Co.	10	
Small Arms					Edwards Co.	5	1,500		Randolph Co.	1	
	Hamilton Co.	2		*Iron (cast-iron furnaces)*					Schuyler Co.	5	
	Jefferson Co.	1		1	Chicago	20	$20,000		Scott Co. (including Winchester)	12	
	Chicago	1		1	Fulton Co.	2	2,800		St. Clair Co.	8	
	Peoria	1		1	Hardin Co.	50			Vermilion Co. (including		
	Perry Co.	1		1	Wabash Co.	50			Danville)	5	
	Putnam Co.	1						*Ships*			
	Union Co.	1							Quincy		$ 2,000
									Calhoun Co. (Hamburg)		30,000
									Rock Island Co.		4,000
									Randolph Co.		4,000

Mahogany veneer secretary with a writing flap, from Bloomington, McLean County, 1840-50.
ILLINOIS STATE HISTORICAL SOCIETY

Chicago American gives an indication of the great variety of pieces available at that early time in Chicago:

Furniture Warehouse.

J. ROCKWELL continues to manufacture Cabinet Furniture at the stand on South Water street formerly occupied by Clark, Filer & Co., where he intends keeping constantly for sale a complete assortment of Cabinet Furniture, consisting of Sideboards, Secretaries, Bureaus, Commodes, Wardrobes, Lockers, Dressing, Card, Pier, Centre and Common Tables, Ottomans, Divans, Crickets, and Foot Stools. Also, a variety of Chairs and Bedsteads, which, with all other articles in his line, will be made after the latest French and New York fashions.

A few thousand feet of seasoned lumber of different kinds, wanted immediately, for which Cash will be paid on delivery.

Chicago, June 8, 1835. tf

"Angel-wing" country chairs, ca. 1840-50.
MR. AND MRS. J. E. TRABUE
COLLECTION

Cherry and walnut chairs attributed to Jacob Knoebel of Belleville, 1840-50.
MR. AND MRS. CLARENCE BLAIR
COLLECTION

A parlor chair made by Silas Tuthill in Liberty (now Rockwood) about 1845. This was a painted "fancy chair," obtainable in black with gold trim or green with gold stenciling.
TERESA YOUNG COLLECTION

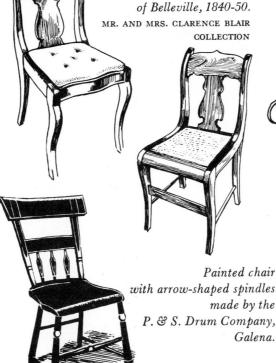

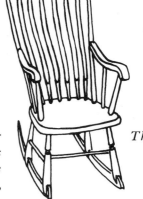

Silas P. Tuthill made these bent-spindle chairs in Rockwood about 1845-55. Most early chair makers used a variety of woods. The framework here is of hickory, the head rests, arms, and seats are of poplar, and the rockers are of oak.
TERESA YOUNG COLLECTION

1840 that his stock included fine-quality curled maple and black walnut, from which he made such pieces as sideboards, dining tables, washstands, bookcases, and bedsteads. German artisans in Belleville were turning out exceptional Empire chairs of cherry and a variety of other fine furniture. In 1845 the Peoria firm of Fridley and Lincoln employed fifty hands and produced furniture valued at $40,000. An 1835 ad in the

Painted chair with arrow-shaped spindles made by the P. & S. Drum Company, Galena.

Art, Crafts, and Architecture in Early Illinois

By 1847 Chicago was no longer importing furniture. The city's furniture businesses included the large concern of Charles Morgan and those of Claus and Tetard, Caleb Morgan and Andrew McClure, A. S. Bates, and the chair manufacturer John Phillips. In Springfield some twenty-eight cabinetmakers placed ads in the local newspapers between 1842 and 1855.

In spite of the fact that this was the rising age of the factory, the great majority of U.S. cabinetmakers were still small operations working on horsepower or footpower. The craftsman frequently was a coffin maker who doubled as an undertaker. Cabinetmakers ran ads in local newspapers, often including such messages as the postscript to A. S. Bates's ad in the *Chicago Express* of October 24, 1842:

And S. Conant of Springfield ran this ad in the *Sangamo Journal* in November 1846:

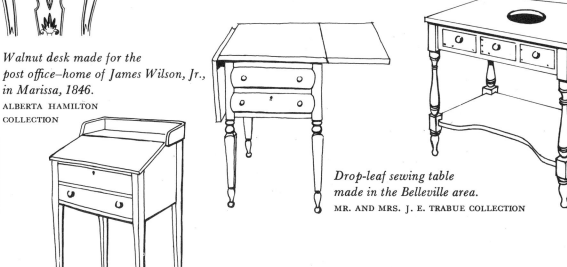

A typical corner cupboard of about 1840, attributed to Brown County.
MRS. SIBLEY GADDIS COLLECTION

Detail of a "bootjack balloon-back" chair made in Galena.
VIRGINIA FITZGERALD COLLECTION

Walnut desk made for the post office–home of James Wilson, Jr., in Marissa, 1846.
ALBERTA HAMILTON COLLECTION

Drop-leaf sewing table made in the Belleville area.
MR. AND MRS. J. E. TRABUE COLLECTION

Silversmiths were still manufacturing on an individual basis. As late as 1854 the following Ives and Curran ad appeared in the Springfield *Illinois State Journal:*

Washstand from the Hovy Boarding House, Galena, about 1840.
VIRGINIA FITZGERALD COLLECTION

The same newspaper carried an ad for the Eagle Rifle Factory. Although called a factory, the operation made rifles and pistols to order. Illinois contained quantities of fine silica sand suitable for making glass, but the earliest written mention of a glassblower in the area is in the 1883 publication *History of Effingham County*, which notes the career of Samuel Little. On his trading boat, Little traveled down the Ohio River in 1841-43, at first manufacturing tinware at various stops from Pittsburgh to New Orleans. Having learned the art of glassblowing in Pennsylvania, Little and a man he employed at Cairo later gave daily and nightly demonstrations of lamp work and fancy glassblowing.

An October 10, 1840, *Chicago Tribune* ad announced the receipt of a shipment of Peru glass, referring perhaps to window glass made at Peru, Illinois (on the Illinois River near Ottawa and La Salle), where glass is being made to this day.

Ads of the day also indicate that the number and type of machine-made articles were rapidly increasing. Rosewood and mahogany were being imported by some furniture manufacturers. India matting, chenille, and ingrain carpeting were replacing handmade rugs. Fashionable ladies of Springfield purchased for their homes velvet carpets, damask and lace curtains, rosewood and mahogany furniture covered with silk brocatelle, and gold-banded china and solid silver for their tables.

The rise of prosperity in many Illinois towns is most evident in the town of Galena, by 1845 the richest town in Illinois and the most important commercial point north of St. Louis on the Mississippi River (see p. 192). In that year steamers towed keelboats carrying 54,000,000

The Thomas A. Melville house in Galena, built about 1836.
PHOTOGRAPH BY THE AUTHOR

Tisdell Inn (1851) in Warren, Jo Daviess County, on the former stagecoach route between Chicago and Galena. Built of native stone and walnut by Welsh and Cornish workmen for Freeman Tisdell, the second settler in the area. A ballroom extended the length of the third floor. The east wing contained sixteen sleeping rooms. In the main building were common rooms, a dining room, and the owner's apartment. Restored by the Women's Club of Warren, it is now the Warren Community Building.
PHOTOGRAPH BY RICHARD PHILLIPS

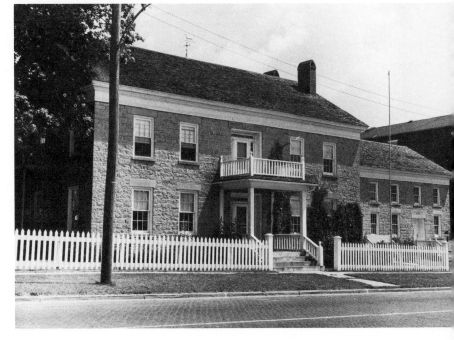

Art, Crafts, and Architecture in Early Illinois

The Parnell House was built in Galena in 1843. Greek Revival style,
it is a good example of the manner in which builders sometimes substituted
horizontal courses of brick for the usual wooden entablature. It also
illustrates the typical substitution of small windows for the traditional
decorations on ancient Greek entablatures. The entrance at the center
is part of a passageway that leads to a garden at the rear of the house.
PHOTOGRAPH BY RICHARD PHILLIPS

pounds of lead downriver to St. Louis and New Orleans. Wheat was another important export, with Frink and Walker stagecoaches making biweekly trips to Galena from Chicago. The town had become a metropolis for its day — an El Dorado of the Midwest and a focal point for thousands of travelers, settlers, and emigrants. Only a few of the original rude log cabins, Irish shanties, and simple cottages remained, having been largely replaced by substantial business buildings, homes, and churches. These structures were largely Federal in style, but already some of the wealthier citizens had erected buildings in the newer, more distinguished and fashionable Classic Revival mode.

Today the majority of surviving early Galena buildings are Greek Revival in character. Typically, the earliest structures are simple in construction and show only the general characteristics of the style. One such house, built before 1840, was the home of Major Thomas Melville — uncle of the famous author of *Moby Dick*. Its Greek Revival features include a dominance of horizontal lines, a columned porch, and an entrance lighted at the top and sides. Others houses of the era are of mixed styles. For instance, the Parnell House (1843), with heavy stone lintels above the main windows and smaller windows set in the entablature, is at first glance a typical Greek Revival structure, yet a covered walkway extending from the street through the house to a terraced garden in the back is more English in character.

Buildings such as these were easily constructed by the ordinary builder, but some of the later Greek Revival structures with fully developed temple porticos certainly required the services of an expert. The St. Louis architect-builder

Henry J. Stouffer built the house of jeweler John E. Smith in 1845. He also built the very similar Bastian House and the home of Joseph Hoge, a lawyer from Baltimore. In 1846 Stouffer worked on the Market House, a public building which today is a state memorial. The two-story central section with heavy stone lintels over the windows is flanked by one-story wings with front and back columned porches. Atop the central building is a square cupola decorated with small Greek-inspired pediments with corner acroteria. Similar motifs may be found on a tombstone in the old Galena cemetery. The Market House was for many years a center of activity for the town, with farm families selling produce directly from wagons in the square in front of the building. On festive occasions, modern town residents and farmers reenact earlier days by donning old costumes and bringing wagons filled with produce to the square.

Pediment with acroteria on an 1835 grave marker in Galena.
PHOTOGRAPH BY RICHARD PHILLIPS

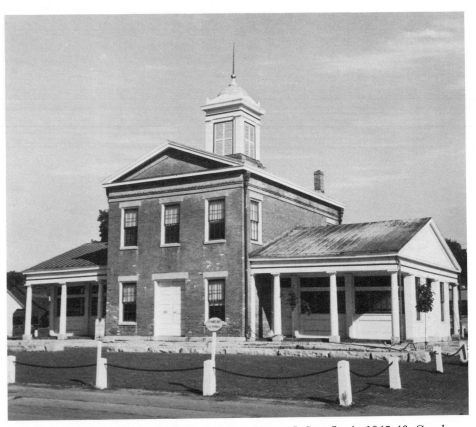

The Galena Market House, built by architect Henry J. Stouffer in 1845-46. Greek Revival style. It is now a state memorial.
PHOTOGRAPH BY RICHARD PHILLIPS

Art, Crafts, and Architecture in Early Illinois

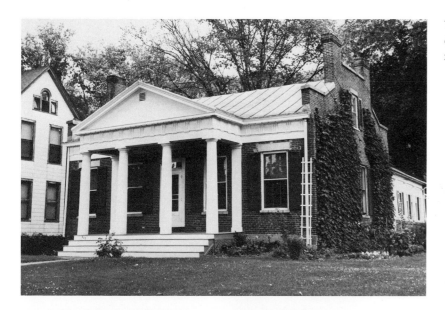

*The Joseph Hoge house, built in Galena in 1845 by Henry Stouffer.
Greek Revival style.*
PHOTOGRAPH BY RICHARD PHILLIPS

*The Bastian House in Galena. Built in 1845 by Henry Stouffer, who may
have lived in this Greek Revival structure.*
PHOTOGRAPH BY THE ILLINOIS DEPARTMENT OF CONSERVATION

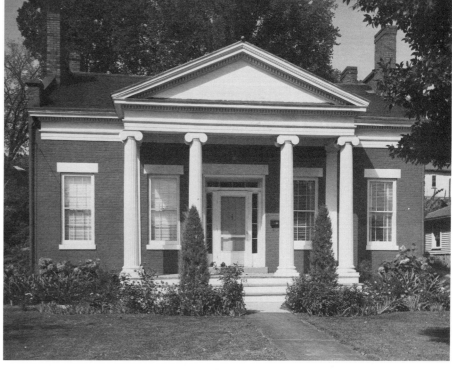

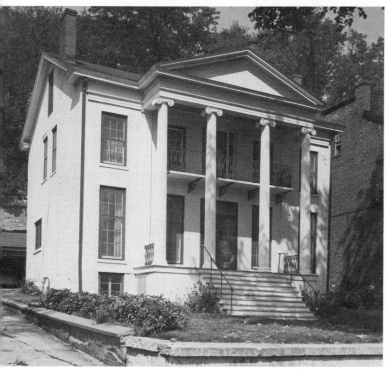

*The Nicholas Dowling house in Galena, built in the
early 1850s with an imposing Ionic two-story
portico and a balcony. Much of the beautiful
cast-iron ornament in Galena was made in the town.*
PHOTOGRAPH BY THE ILLINOIS DEPARTMENT OF CONSERVATION

The interiors of such homes as Nicholas Dowling's were furnished with a mixture of heirlooms from former homes, mahogany and rosewood articles from St. Louis or New Orleans, and some furniture and coin-silver flatware of local manufacture. The wealthy citizens of Galena attracted cabinetmakers who imported various hardwoods for the making of fine mid-century furniture, and expert ornamental artists painted and decorated some of the most beautiful and elaborate "fancy chairs" in the state.

The Galena Directory and Miners' Register for 1848-49 lists the following numbers of resident master craftsmen and manufactories:

4 jewelers and watchmakers	4 gunsmiths
4 saddlers and harness dealers	2 iron foundries
15 boot and shoe manufactories	10 wagon makers
8 carpenter shops	1 plough maker
2 chair manufactories	10 tailors
3 cabinetmakers	1 pottery
2 upholsterers	1 cooper
1 bookbinder	1 chandler
12 blacksmiths	

Sterling silver spoons and forks made by John E. Smith of Galena before the Civil War. The shape of the handles is often likened to that of a fiddle, though they might more properly be considered vase-shaped. The simplified vase shapes on the left are earlier than those on the right.
COLLECTIONS OF
MRS. LOUIS NACK AND
MRS. A. J. MILLHOUSE

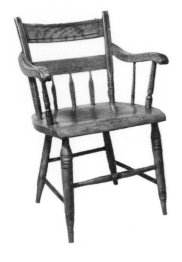

Arrow-back chair with simulated oak graining made for the Jo Daviess County courthouse about 1840-50 by the P. & S. Drum Company.
BOARD OF SUPERVISORS, JO DAVIESS COUNTY

During the era of Galena's glory, many exceptional Greek Revival, Italianate, and French-inspired mansions were built (see p. 157). By 1854 the *Galena City Directory* listed among its craftsmen 29 cabinetmakers, 36 blacksmiths, and 8 chair makers. After 1860, though, the Galena mines began to give out, and steamboat transportation was being supplanted by railroads. By the end of the century, the town's population had dwindled, and Galena began to merit its present title, "The Town That Time Forgot." Architects, artists, and historians have rediscovered the old town, and together with the local citizens are energetically restoring and preserving its charm.

Despite such instances of affluence in the larger towns, it was some time before the average settler in outlying areas was able to experience prosperity. His life had been made much easier by the presence of specialized craftsmen in increasing numbers, but it was still one of toil. His home was a simply furnished dwelling; his entertainments were few. Nevertheless, he was beginning to see the rewards of toil, diligence, and ingenuity and had reason to believe that an ordinary man like himself could eventually prosper through application and effort.

Art, Crafts, and Architecture in Early Illinois

15 Jug Towns

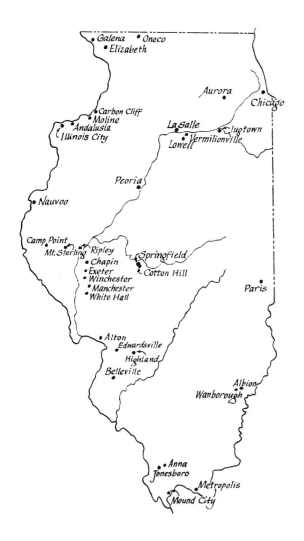

According to the U.S. Industrial Census of 1840, it was in the pottery industry that the most significant development had occurred. The exact locations of the twenty-three listed potteries are still unknown; all were undoubtedly small operations, usually limited to members of one family. At least two or three potters had worked in the state during the 1820s, but John Ebey was apparently the first to advertise his wares in an Illinois newspaper (*Sangamo Journal*, November 10, 1831):

> ## POTTER'S WARE.
>
> THE subscriber has established in Springfield, near the Public Square, a **Potter's Ware Manufactory**; and will be able to supply all orders in his line of business on good terms.
>
> ☞WANTED---In exchange for Ware, Clean Cotton and Linen **RAGS**; for which two and a half cents per pound will be allowed. Most kinds of Country produce will also be received in exchange for Ware. **JOHN N. EBEY.**
> Springfield, Nov. 10, 1831· 1tf

Born in Huntington County, Pennsylvania, John Neff Ebey had been raised in Ohio, and there

he learned the potter's trade. About 1826 he moved with members of the Brunk family to Cotton Hill, south of Springfield. The following year he made his first Illinois pottery — common redware.

Meanwhile, the production of stoneware, a finer grade of pottery, had become a leading industry in New Jersey, New York, Ohio, and Indiana. This type of pottery had been produced for centuries in Germany and England, but the large amounts of fine, light buff or gray clays needed for its manufacture had not been found by the early potters of eastern America. Nonetheless, stoneware was much desired. It requires a relatively high temperature for proper baking, but it is much more durable than ordinary redware and has a density that requires no glaze in order to be waterproof. Consequently, early American potters, especially those of German and English descent, maintained a constant search for veins of stoneware clays. It was not until the late 1700s, as settlers began to move across the mountains into the Midwest, that large amounts of the required clay were discovered, first in Ohio, then in Indiana, and later in Illinois. In Illinois, the clays were found in certain areas surprisingly near the surface, having been shoved upward during periods of the earth's

181

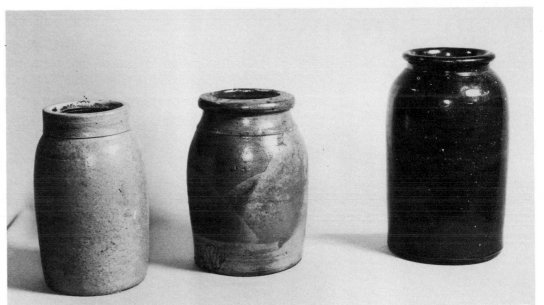

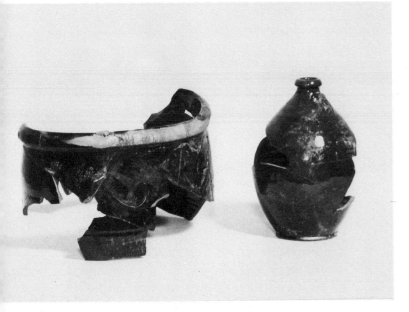

Stoneware by John Ebey or David Brunk, Cotton Hill, Sangamon County, 1830-50.
JAMES HICKEY COLLECTION

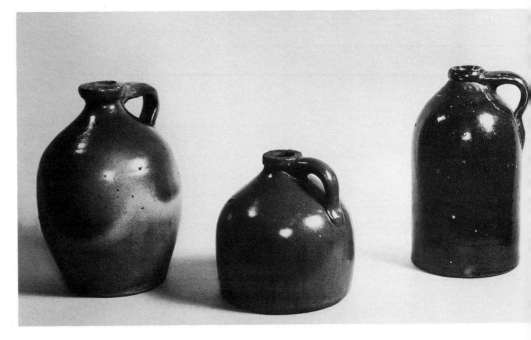

turbulence from their usual resting place near
veins of coal.

Despite the availability of the ordinary brick
clays used for his redware productions, John
Ebey scoured the area for the finer stoneware
clays. He probably found them among the veins
of coal that outcropped along the Sangamon
River and its tributaries, and before long he
was producing stoneware.

Potters in west central Illinois, meanwhile,
were making redware. As early as 1824, William
Heath (and later, Michael Baker) was working

Art, Crafts, and Architecture in Early Illinois

near White Hall in Greene County. In 1828 John Ebey's brother George discovered stoneware clay in this area and took a sample back to Ohio for testing. It appears that this was the earliest discovery of one of the most extensive and accessible sources of fine stoneware clay in the United States. The outcropping formed a belt extending from Rock Island to Alton, about one-half the length of the state.

In 1833 John Ebey sold his inventory to a fellow Springfield potter, David Brunk, and moved to White Hall. There he introduced the making of stoneware by adapting Heath and Baker's redware kiln. This turned out to be the initial step toward the subsequent development

Vase attributed to the George Ebey pottery, Winchester.
ILLINOIS STATE MUSEUM

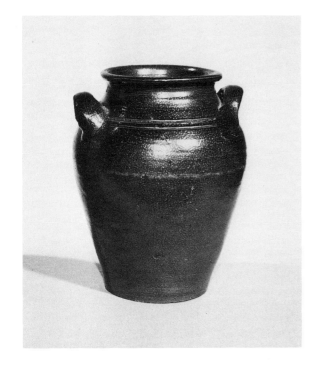

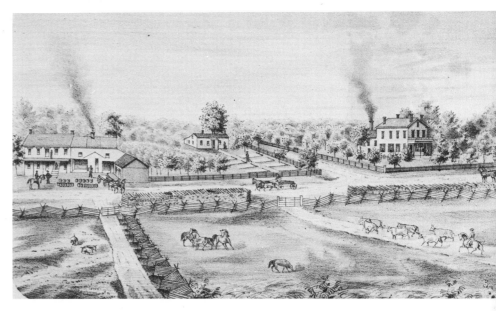

The George Ebey farm and pottery near Winchester. From a Scott County atlas, 1870s.

Stoneware oil lamp (miniature) made at the George Ebey pottery, Winchester.
GEORGE VASEY AND MRS. EUGENE WAHL COLLECTION

of a large stoneware industry in that area (see pp. 189-94). It was not to be fully developed, however, for another thirty years.

Sometime before 1834, the Ebey brothers, always alert to the discovery of newer and perhaps even richer veins of clay, moved to Manchester in Scott County. Then, in 1834, George Ebey struck such a vein at Winchester, a small village in the woods and hazel brush about fourteen miles from White Hall. He bought out the pottery establishment of Robert Harrison, and by 1870 he and his sons operated the most extensive pottery, firebrick, and drain-tile factory in the

county. During these years George Ebey made a major contribution to the future development of the Illinois prairies. In 1855, experimenting on his own farm, he demonstrated that, with the use of drainage tile, he could convert wet and swampy regions into productive farmland and keep roads passable even during the wet seasons. The drainage of low prairie lands also led to the virtual elimination of the "ague" (malaria), which had been the great scourge of early settlers.

John Ebey, meanwhile, continued to search for richer veins of clay. One evening in 1836, while hauling pottery to Rushville, he stayed with Willis O'Neal, a Brown County pioneer. During the course of a conversation about pottery making and the clay essential for stoneware, Willis told Ebey about the light blue shale clay he had seen near the roots of an upturned tree in his neighborhood. Upon investigating, Ebey found the clay ideal for his purposes and be-

Molded and glazed stoneware pipe bowls attributed to Cornwall Kirkpatrick while working in Point Pleasant, Ohio, 1849-56.

B. B. THOMAS, JR., COLLECTION

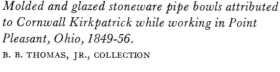

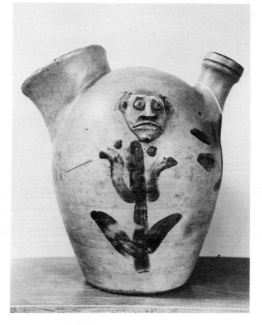

Sugar crock or sweetmeat jar made by a Ripley potter as a gift. Brown slip-glazed stoneware with modeled, stamped, and inscribed decoration.

Two views of a salt-glazed stoneware syrup jug attributed to Cornwall Kirkpatrick, Vermilionville, La Salle County. Grotesque heads on pottery were popular about 1850 in other parts of the country as well. Note also the incised and cobalt-painted decorations.

LA SALLE COUNTY MUSEUM

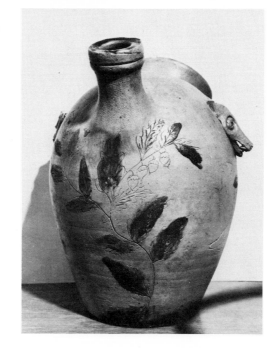
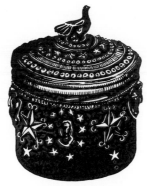

gan almost immediately to manufacture Brown County's first stoneware at Centerville (later Ripley). More than fifteen other manufacturers of pottery followed him to the area. In 1843 John Ebey moved to Iowa, only to return to Chapin (Morgan County, west of Jacksonville) and then to Ripley. In 1863 he settled once more in White Hall, where he died.

Even a short history of early Illinois potters must include mention of one of the most unusual families of potters in the state, that of Andrew Kirkpatrick. Born in Pennsylvania, with ancestors from New Jersey, Kirkpatrick was making pottery by the age of fourteen. For a time he worked in Champaign County, Ohio, and in 1837 he emigrated with his family to Vermilionville (near Lowell) in Illinois. There, below a coal vein that outcropped in the bluffs of the Big Vermilion River, Kirkpatrick found

good stoneware clay. From it he and seven of his ten sons produced stoneware for the neighboring countryside. Twenty years later some of the young Kirkpatricks had potteries of their own at Mound City and Metropolis on the Ohio River. Cornwall, the most talented of the sons, produced some of the most unusual pieces of pottery of the nineteenth century.

In 1859 Wallace and Cornwall Kirkpatrick went to Anna, where there were some of the best stoneware clays in the state, sedimentary clays similar to kaolin, the fine white clay used in porcelain. Both men were artists and expert craftsmen, and their production in Anna included many fine off-hand pieces, as well as such utilitarian articles as clay pipes for southern plantations. The brothers created dolls' heads, frog inkwells and mugs, dog doorstops, planters, cemetery urns, and fanciful chimney pots. The

Art, Crafts, and Architecture in Early Illinois

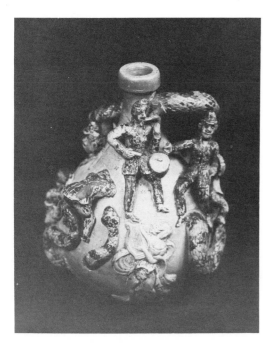

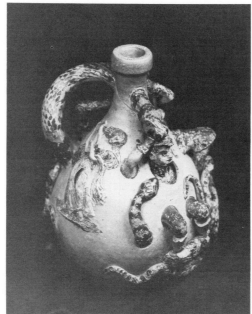

most fantastic of their productions were their one-of-a-kind jugs wound with writhing serpents to illustrate the evils of strong drink and commemorative pitchers molded with caricatures of contemporary political figures. One of the most unusual was a twenty-five-foot-square model of a pioneer farm that was exhibited at Coney Island and the Philadelphia Centennial of 1876. This model, complete with pioneer cabins, cabbages, oxen, farm implements, arrows, and even lurking Indians, was last seen in Forest Park, St. Louis, but its present location is not known.

Unusual creations like these appeared, for the most part, after 1850 in Illinois and were hardly typical of early products. Early ware consisted largely of plain jugs, crocks, churns, pitchers, inkwells, oil lamps, and other utilitarian articles intended for everyday use. Some pieces were left unglazed, having a stonelike mat surface of light buff, cream, or gray. The majority were at least partially glazed to make cleaning easier. The inside of the container, in contact with food, was most often glazed with a common brown slip, a mixture of liquid stoneware clay containing iron oxides, which provide color, and sand, which forms a glassy surface as it melts during the firing. The slip was poured into the container and then poured out, so that only a thin layer remained. An unglazed outer surface usually was left plain, but an occasional potter might decorate it with a brushed-on script number, a swirl, or a design adapted from nature (see p. 191). Cobalt, which produces a blue color that will not fade in the intense heat required for firing stoneware, was used for this sort of ornamentation. Most of the utility pieces also received a glaze on the outer surface. The article was either dipped into the slip, or the slip was brushed on. The bottom was left unglazed or wiped clean so the article would not stick to the shelf of the kiln. If covered with the usual brown slip, the finished article was called brownware. A light, shiny, and transparent surface is the mark of a salt glaze, achieved by simply throwing salt into the loaded kiln when the heat is most intense. As the salt vaporizes, it deposits itself on the surface of the ware as a glaze. This type of glaze is also recognizable by its pebbled surface, which resembles an orange peel.

Occasionally an early potter stamped or scratched his name on the ware or painted it with a distinctive design considered to be his mark. However, of the many thousands of articles produced in the more than seventy-four potteries known to exist in Illinois before 1860, relatively few were given such marks of identification. This fact and the scarcity of scientific research on early Illinois pottery have prevented identification of the products of most of these early potteries.

In this day of slick pottery products from the factory production line, the study of even simple old pieces is an intriguing aesthetic experience. The hand-formed pieces are unique, and it seems that the potters instinctively gave them pleasing

Stamped with the potter's name and salt-glazed, this crock was made by H. H. Yates, Chicago.
JAMES HICKEY COLLECTION

ters were forced by their location to peddle their wares during most of the year in the neighboring countryside. They had to wait for spring, when the nearby streams would rise, to float their goods to the Illinois River and on to more distant points. The peak of the Ripley potters' production was reached in the 1880s, but eventually a lack of efficient means of transportation spelled their doom, as they could not compete with those more fortunate potteries that were located near railroads or close to the large rivers.

The earliest pottery on the Mississippi River above Nauvoo was probably at Carbon Cliff, where extensive coal operations were conducted by W. S. Thomas, who also manufactured pot-

tery and firebrick during the 1840s. Ironically, it was the rising use of coal for industry and heating that destroyed some of the richest veins of stoneware clays in the state. Today most of the valuable clay deposits near White Hall have been destroyed by the extensive strip mining of coal. This would have seemed a shocking waste of natural resources to the early English settler, who would have used both.

According to available records, before 1844 Samuel B. King was making many kinds of stoneware and earthenware, including plain and fancy flower pots, in his establishment in Peoria, and by 1846 J. M. Labhart was operating a pottery in Chicago. To the southwest, at a cut-

shapes. Training and considerable skill in the use of the potter's wheel were required in producing these pieces. But despite the smooth outer finish — achieved with wooden scrapers known as "potter's ribs" — the potter's fingermarks can still be felt on inner surfaces and seen on spouts and added handles.

At and around Ripley, Brown County, the number of potteries steadily increased after 1840. After John Ebey came L. D. Stofer, in 1847, from Summit, Ohio; the following year Francis Marion Stout arrived from New Jersey; and in 1849 Charles W. Keith came from Indiana. Eventually the number of pottery operations that had worked in the area would exceed twenty-five (see pp. 189-94). The Ripley pot-

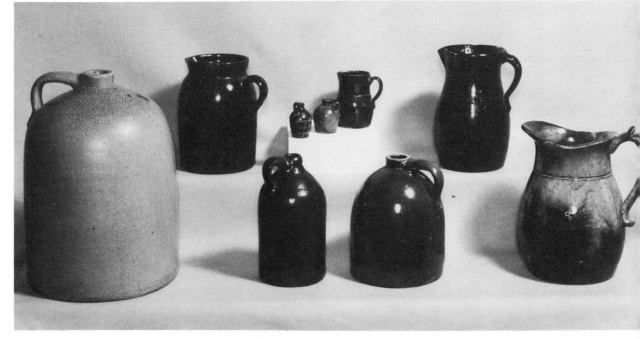

Assorted types of stoneware pottery from the Ripley area, Brown County.
ILLINOIS STATE MUSEUM

Art, Crafts, and Architecture in Early Illinois

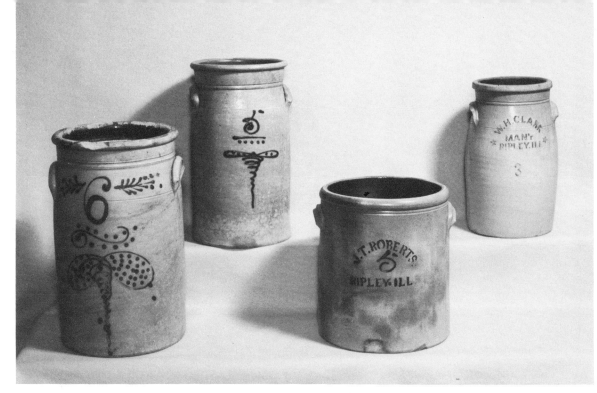

Stoneware butter churns and a five-gallon crock from the Ripley area.
ILLINOIS STATE MUSEUM

a few potatoes, we should like him to come, as we will undertake to find him plenty of beef and pork to [for] them; although, perhaps, when he comes here, we shall find him something else to do. For ewers we pay 4s. per dozen; for chambers, 4s. 6d.; for cover-dishes, 3s. 3d.; for 4's jugs, plain 3s. 3d. per dozen; and 12's French, 2s. 11d.; for round nappies, 12's 5d. per dozen; 11's 4½d.; 10's, 4d.; 9's, 3½d.; 8's, 7's, 6's, 2½d. per dozen; and for plates, twifflers, and muffins, 4s. 2d. per score. Such are our prices![1]

While most Illinois potters turned from redware to stoneware as soon as the more desirable clays could be found, redware was made exclusively in one part of Illinois until almost 1900. The northwestern tip of the state, around Galena and Elizabeth, had been bypassed by the glaciers

Salt-glazed stoneware crock with cobalt decoration. Peoria Pottery Company.
ILLINOIS STATE MUSEUM

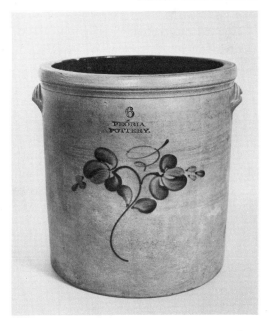

off meander of the Illinois River called Goose Lake, the community of Jugtown developed around its pottery industry, which would serve a part of Chicago during and after the 1850s.

News of the wealth of stoneware clays in the Midwest traveled across the Atlantic. In the early 1840s a potter's society newspaper in England circulated information to the pottery towns of Staffordshire. Advertisement of the great advantages of immigration to the Midwest attracted additional potters to the stoneware clay districts of Illinois. The great need for pottery in the young state afforded unlimited opportunity to such men as Benjamin Berrisford and a number of other Englishmen who settled at Alton, one of whom explained in a letter what sort of articles

were made by Illinois potters from England and what prices they commanded:

We have built our new kiln, and a very pretty one it is, too; and, as the Americans say, "I guess it will shine when it is filled full of glost ware": which circumstances will not be long before it takes place; and then I should like for the whole of you to be here, that you may see the reward of persevering industry. Our old slip kiln, not being large enough for our present purposes, we have built another this week, which is 21 feet long by 5 feet wide. We have engaged a sagger-maker, a dish-maker, a hollow-ware presser, a man to throw coarse ware, and now we are going to send to St. Lewis for a slip maker. I will now tell my brother B. a few of our prices, so that if he thinks he can earn at those prices sufficient to purchase a little bread and

Jug Towns

187

which had scraped away surface soil in other regions. Here remained a thick mantle of ordinary brick clays, which accounts for the many brick houses in Galena. In addition, the deposits of galena (lead sulfide) resulted in an abundant source of the common glaze ingredient for redware pottery (see p. 191). From 1843 to 1863 D. A. Sackett and then Alfred M. Sackett made pottery in Galena; during the 1850s David Sackett was working in Elizabeth. These potters were followed by a number of others who worked in the area during the remainder of the century.

Like other early Illinois redware, the Galena products were largely plain and utilitarian. Capacity figures were occasionally stamped or inscribed on jugs and crocks, and lines were sometimes inscribed around the necks of various containers, but little in the way of ornamentation seems to have been added. If the piece was decorated, it was usually in the form of an occasional large dot of clay slip in a contrasting color, a crimped piecrust edge, ruffles, or a border of cogglewheel impressions.

The common glaze for Galena redware consisted of a mixture of lead, for flux; alumina, for viscosity; and silica, for a glassy surface. The uneven heat of the early wood-fired kilns and mineral impurities in the clay produced various colors upon firing: iron oxides produced oranges and yellows; copper oxides, the greens; and manganese, the browns. Despite redware's tendency to break or chip due to its relatively soft and fragile body, and despite its unsuitability for containing certain foods (acid contents cause a toxic reaction with the lead glaze), it was made in great quantities in the Galena-Elizabeth area until late in the nineteenth century. Today this ware is avidly sought by collectors on ac-

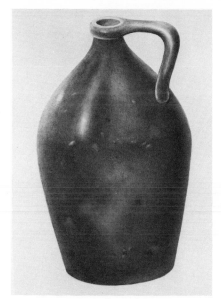

Green and yellow redware jug attributed to A. M. Sackett, Galena, about 1849.
INDEX OF AMERICAN DESIGN

count of its pleasing forms, charming colors, and varieties of shape, which include milk pans and pitchers, whiskey and water jugs, jars for meat preservation, flower pots, door stops, and containers for grease, soap, and honey.

Production of redware was not, of course, restricted to Galena, but apparently no other kiln sites except that of Ebey's, near Springfield, have been determined. For this reason Illinois redware in general might appropriately be termed "Galena pottery," especially since, in all likelihood, the galena that most Illinois potters used for their glaze came from that area.

Had it not been for the advent of the Civil War and an unfortunate stroke of fate, the city of Peoria might have become a center for the largest plant in the history of early American pottery. In 1858 the famous United States Pot-

tery at Bennington, Vermont, was forced to close due to the rising costs of fuel and distribution. In 1859 Christopher Webber Fenton, son of a pioneer potter, and his partner, Decius W. Clark, began work on an ambitious new enterprise in Peoria. They projected an immense "departmental pottery" which was to have employed more than 1,000 workers. An elaborate diagram was prepared, showing a series of buildings arranged in the shape of a large wheel, the hub being the office and each spoke being devoted to a separate branch of the industry. In one unit Rockingham ware would be produced; in another, whiteware; in a third, stoneware, etc. Their greatest hopes were founded upon an entirely new branch of the industry, the manufacture of enameled bricks, blocks, and ornamental architectural pieces.

A letter written by the partners after their arrival in Illinois explained the reason for their transfer:

. . . we are influenced only by the superior advantages that the locality presents over the Atlantic States, in the abundance and quality of Pottery material — its unrivaled facilities for cheap freights — the extent and rapid growth of its markets, and the superior advantages it possesses for a more successful competition with foreign manufactures — a consideration not to be overlooked in this early stage of the enterprise in this country. With these advantages in our favor, and the practical foreign skill that a more liberal international sentiment has opened to our reach, we doubt not we shall meet the full reward our efforts may deserve.[2]

In December 1859 one wing of the American Pottery Company was complete except for the final installation of machinery by a Bennington firm. Designs and molds were supplied by Daniel

Art, Crafts, and Architecture in Early Illinois

Greatbach, former chief designer and modeler at the United States Pottery in Bennington. In 1860 he moved to Peoria and began production of mottled Rockingham ware articles such as pitchers and mugs. By 1861 stoneware was in production; apparently yellow ware and white- and cream-colored earthenwares were also produced. Unfortunately the new enterprise was doomed to early failure. According to historian John Spargo, Decius Clark wrote in 1861 of hardships caused by the Civil War and the enlistment of many of the factory employees in the army and home guard. By 1865 the pottery had ceased operation, and two years later the fifty-nine-year-old Fenton, president of the company, was killed in an accident.

The hopes of the Bennington partners had not

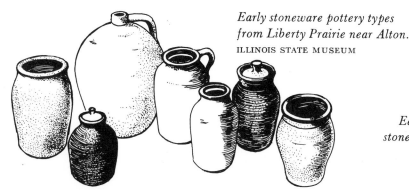

Early stoneware pottery types from Liberty Prairie near Alton.
ILLINOIS STATE MUSEUM

Early brownware (glazed stoneware) attributed to the Stizelberger Pottery, Belleville.

been realized, but this did not deter the growth of the pottery industry in Illinois. In 1873 the old American Pottery at North Adams above Caroline Street was reopened under new management as the Peoria Pottery Company. By 1880 it was the largest manufacturer of fine glazed stoneware in the United States. It could produce 30,000 gallons of jugs, milk pans, and other containers, and 300,000 flower pots a week. Its products were sold in every state except the New England area. This was but one of the many late nineteenth-century manufacturers that by 1900 made Illinois second only to Ohio in the production of pottery.

A CHECKLIST OF ILLINOIS POTTERS

Date	Potter	Site	Potter's Origin	Type and Volume of Production
Before 1820[a]		Union Co.		
ca. 1820[b]	Nathaniel Pinckard and William Heath	Upper Alton, Madison Co.		Earthenware
ca. 1820–25	Robert Harrison	Cahokia Creek, near Edwardsville		Probably redware
ca. 1824–35	William Heath	Vicinity of White Hall, Greene Co.		Redware
ca. 1824–30	Robert Harrison	Upper Alton, Madison Co.		Probably redware
ca. 1825–ca. 1831	Elias Weaver	Albion, Edwards Co.	Germany	
ca. 1826–31	John Neff Ebey	Cotton Hill, Sangamon Co.	Ohio	Redware and stoneware

Date	Potter	Site	Potter's Origin	Type and Volume of Production
ca. 1828–29	George Ebey	Cotton Hill, Sangamon Co.	Ohio	Redware and stoneware
ca. 1830–34	Robert Harrison	Winchester, Scott Co.		Redware
ca. 1831	George Bower	Albion, Edwards Co.	Bavaria	
ca. 1831	Thomas Cooper	Wanborough, Edwards Co.		Stoneware
1831–33	John Neff Ebey	Springfield, Sangamon Co.	Ohio	Redware and salt-glaze stoneware
ca. 1831–33	William Ramsey	White Hall, Greene Co.		
ca. 1831–55	David Brunk	Cotton Hill, Sangamon Co.	Ohio	Redware, brownware, salt-glaze stoneware

Date	Potter	Site	Potter's Origin	Type and Volume of Production
Before 1834[c]		Upper Alton, Madison Co.		
ca. 1833–34	George Ebey	Manchester, Scott Co.	Ohio	Stoneware
ca. 1833–34	John Neff Ebey	White Hall, Greene Co.	Ohio	Stoneware
1834–36	John Neff Ebey	Manchester, Scott Co.	Ohio	Stoneware
1834–ca. 1860	George Ebey	Winchester, Scott Co.	Ohio	Stoneware with occasional inscriptions
ca. 1835–60+	Michael Baker	Vicinity of White Hall, Greene Co.		(9,000 gals. in 1860)
1835[b]	Jacob Eggen and M. Zabbart	Highland, Madison Co.	Switzerland	Probably redware: pots, salve jars, tile stoves
1836–43	John Neff Ebey	Ripley, Brown Co.	Ohio	Stoneware
1836–60+	Ulrich and Whitfield	Upper Alton, Madison Co.	Westphalia, Prussia	Redware and stoneware (stoneware in 1860: $500)
1836–ca. 1850	John L. Martin	Exeter, Scott Co.	Ohio	Stoneware (50,000 gals.)
1837–59	Andrew Kirkpatrick	Vermilionville (near Lowell), La Salle Co.	Pennsylvania and Ohio	Stoneware
ca. 1840	H. H. Yates	Chicago, Cook Co.		Stoneware, stamped mark
ca. 1840–ca. 1850	Murray Kirkpatrick	Vermilionville (near Lowell), La Salle Co.	Ohio	
1840[a]	W. S. Thomas?	Carbon Cliff, Rock Island Co.		
		Tazewell Co. (2 potteries) Jersey Co. Vermilion Co. (3 potteries) Iroquois Co. Lawrence Co.		
ca. 1842	John Carlin	Nauvoo, Hancock Co.		Stoneware(?), some yellow-glazed
ca. 1842	Samuel B. King	Peoria, Peoria Co., and Elizabeth, Jo Daviess Co.		Redware and stoneware
1843	Thomas J. Filcher	Nauvoo, Hancock Co.	England	
1843–48	D. A. Sackett & Co.	Galena, Jo Daviess Co.		Redware
1843	Benjamin Berresford	Alton, Madison Co.	England	Stoneware
1843	J. Grocott	Nauvoo, Hancock Co.	Iowa	Earthenware
1844	John B. Convay	Peoria, Peoria Co.		
ca. 1844	Mathew Moore and Moses Martin	Nauvoo, Hancock Co.		Redware and brownware
1844–84+	Charles Reay (Belleville Clay Mining and Pottery Co.)	Belleville, St. Clair Co.		Stoneware
ca. 1844	Harvey Irwin	Ripley, Brown Co.	Ohio	
ca. 1846	J. M. Labhart	Chicago, Cook Co.		
1846	Elijah K. Fuller	Nauvoo, Hancock Co.		Queensware
1847–60+	L. D. Stofer	Ripley, Brown Co.	Summit, Ohio	Stoneware (62,000 gals. in 1860)

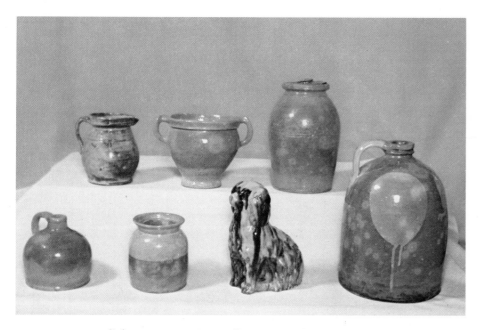

*Galena pottery. A sampling of some of the many sizes and shapes of
lead-glazed redware made in the area from 1843 until almost 1900.*

COLLECTIONS OF VIRGINIA FITZGERALD AND EDWARD KELLY

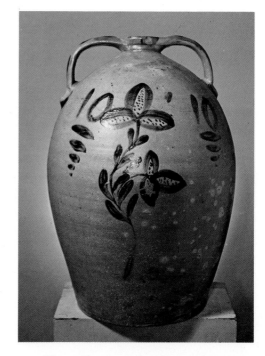

*Ten-gallon strap-handle stoneware jug
made at White Hall.
Decorated with cobalt and salt-glazed.*

ILLINOIS STATE MUSEUM

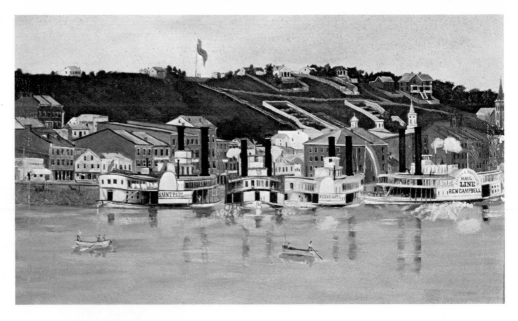

"Galena Harbor, 1852."
Painted by Bayard Taylor
(1825-78), a traveling
newspaper correspondent
who worked at the time
for the Galena Gazette.
Later he wrote several books
and articles on his travels
in America and Europe
which he sometimes illustrated
with his own sketches.
MRS. H. F. MC COY COLLECTION

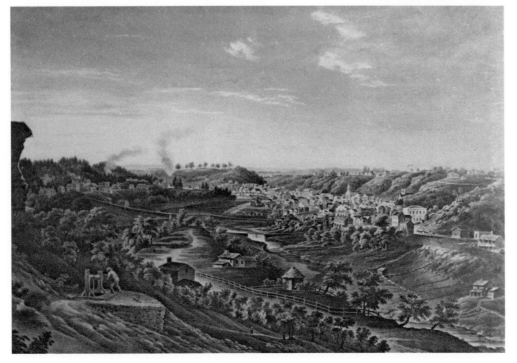

"View of Galena," 1845. A large lithograph by John
Caspar Wild depicting the city, which at that time
was the wealthiest in Illinois (see p. 214).
GALENA HISTORICAL SOCIETY MUSEUM

Art, Crafts, and Architecture in Early Illinois

Date	Potter	Site	Potter's Origin	Type and Volume of Production
1848–78	Francis Marion Stout	Ripley, Brown Co.	Kentucky	Stoneware (74,000 gals. in 1860)
1848–63	Alfred M. Sackett	Galena, Jo Daviess Co.		Redware, including dog figures (1,000,000 gals. in 1860)
1849	Gruenig	Belleville, St. Clair Co.		Stoneware
1849–ca. 1869	Charles W. Keith	Ripley, Brown Co.	Indiana	Stoneware
ca. 1850s	Barnett Ramsey	Athens, Menard Co.		
1850[a]	Walter Croxton (4 employees)	Barnbridge Township (east of Ripley), Schuyler Co.		Misc. ware (8,000 pieces)
	Murray Kirkpatrick (2 employees)	Deer Park Township, Vermilion Co.		Stoneware (12,000 gals.)
	Alfred Slater	Deer Park Township, Vermilion Co.		Stoneware (12,000 gals.)
	Fielding T. Harrison (6 employees)	Upper Alton, Madison Co.		Stoneware (40,000 gals.)
	George Smithingham (7 employees)	Upper Alton, Madison Co.		Stoneware
	Charles Olevett (2 employees)	Upper Alton, Madison Co.		Stoneware
	Ulrich Smithfield	Upper Alton, Madison Co.		Stoneware (35,000 gals.)
	Christian Heitzie (2 employees)	Jersey Co.		Salt-glaze earthenware
	D. C. Woodruff (1 employee)	Elizabeth, Jo Daviess Co.		Jugware (5,000 gals.), 10,000 crocks, 5,000 misc. pieces
	David Sackett (3 employees)	Elizabeth, Jo Daviess Co.		Crockware (10,000 gals.), 6,000 jugs, 2,500 misc. pieces
	F. M. Nash (4 employees)	Scott Co.		Stoneware (25,000 gals.)
	Seth Davidson (2 employees)	Scott Co.		
	Theodore Sickman	Alexander Co.		(48,000 gals.)
	John Martin (3 employees)	Winchester, Scott Co.		
1850	Jeremiah and Andrew Simmons	Andalusia, Rock Island Co.	Vermont	
ca. 1850	P. H. Smith	Aurora, Kane Co.		Stoneware with occasional inscriptions
ca. 1850–ca. 1860	Augustus Pierce	Ripley, Brown Co., and later Winchester and White Hall		Stoneware
ca. 1850	Isadore Couloy	Nauvoo, Hancock Co.	France	
ca. 1850	W. W. Hubbs	Ripley, Brown Co., Frederick, Schuyler Co., White Hall, Greene Co.		Stoneware
ca. 1851	E. G. Martin	Camp Point, Adams Co.		Stoneware
1852–64	Adam E. Martin	Ripley, Brown Co.	Stark Co., Ohio	Stoneware
1852–70	Joshua Gorham	Illinois City, Rock Island Co.		

Date	Potter	Site	Potter's Origin	Type and Volume of Production
1853–ca. 1935	Jacob Stizelberger, Sr., followed by son William	Belleville, St. Clair Co.	Germany	Redware, later stoneware
1853–60+	William White	Jugtown (now Goose Lake), Grundy Co.		Stoneware (75 tons in 1860)
1854–75	William Shank	Paris area, Edgar Co.	Ohio	Stoneware
1854	Daniel Sanders	Oneco, Stephenson Co.		
1855	Isadore Couloy	Nauvoo, Hancock Co.		
1856	Ludon & Long	Peoria, Peoria Co.		Stoneware
1856–ca. 1866	C. R. Harrison	Upper Alton, Madison Co.		Stoneware
1857–59	Alexander, Cornwall, Murray, and Wallace Kirkpatrick	Mound City, Pulaski Co.	Pennsylvania	Stoneware
1857–82	Joseph Jäger	Peoria, Peoria Co.		Stoneware
ca. 1858	Sawyer & Brothers	Upper Alton, Madison Co.		Stoneware
ca. 1858	C. R. Harrison	Upper Alton, Madison Co.		Stoneware
1859–ca. 1900	Cornwall and Wallace Kirkpatrick	Anna, Union Co.	Pennsylvania	Stoneware, inscribed and stamped
1859–65	Christopher W. Fenton and Decius W. Clark	Peoria, Peoria Co.	Bennington, Vermont	Yellow ware, white- and creamware, Rockingham ware
ca. 1860	Grommes & Ulrich	Chicago, Cook Co.		Stoneware
1860[a]	James S. Wilson	Mt. Sterling, Brown Co.		(20,000 gals.)
	William Glenn	Ripley, Brown Co.		Stoneware (74,000 gals.)
	W. W. Haukins	Ripley, Brown Co.		(50,000 gals.)
	Michael Donnahower (5 employees)	Cooperstown, Brown Co.		Stoneware (48,000 gals.)
	William Shank (2 employees)	Paris, Edgar Co.		Jars and crocks (800 gals.), jugs (200 gals.),1,000 fruit jars
	Goose Lake Stoneware Manufacturing Co. (6 employees)	Grundy Co.		Stoneware (75 tons)
	A. Jennings Pottery	Dunleith, Jo Daviess Co.		Potteryware (54,500 gals.)
	Martin Schultz (2 employees)	Elgin, Kane Co.		All kinds of pottery (15,000 gals.)
	James Cornell	Decatur, Macon Co.		Earthenware (9,000 gals.)
	H. Sawyer (Salamander Pottery)	Alton, Madison Co.		Earthenware (12,000 gals.)
	Isaac Warwack (5 employees)	Alton, Madison Co.		Stoneware
	John Pierson & Co. (4 employees)	Athens, Menard Co.		Crockery
	H. (or W.) Warner	Marina City, Pulaski Co.		
	Hugh Fullerton	Moline, Rock Island Co.		Assorted stoneware
	Henry Steinbach (1 employee)	Chicago, Cook Co.		Brown earthenware
	John Glassen (1 employee)	Chicago, Cook Co.		Brown earthenware
	Glenn & Hughes	Ripley, Brown Co.		Stoneware (67,500 gals.)

[a] U.S. Industrial Census.
[b] Norton, *Centennial History of Madison County*.
[c] Peck's *Gazetteer*.

16 Nauvoo, the Utopia

• Galesburg

• Nauvoo
• Carthage

• Quincy

South of Mendon, New York, a carpenter and glazier named Brigham Young had been producing chairs and spinning wheels on his large wooden lathe, while nearby Heber C. Kimball, a blacksmith and potter, had developed a product with wavy, trailed-slip decoration called mucker-pucker ware. In 1832 both craftsmen converted to the newly organized religion called Mormonism.

Mormon belief held that the group's leader, Joseph Smith, had experienced from the age of fourteen a number of heavenly visions and revelations. In one revelation the angel Moroni had directed Smith to a hill near Palmyra, New York, where he found a set of gold tablets. When translated, the characters on these tablets revealed the true Gospel of Jesus Christ, or what came to be called the Book of Mormon. The Mormon congregation increased rapidly; by 1830 they had organized the Church of Jesus Christ of Latter-Day Saints in New York and had branches in Pennsylvania. By 1831 the church, with over 1,000 members, had moved to Kirtland, Ohio, where they built a first temple during the years 1833-36. After 1836 Mormon missionaries were making new converts in England.

The Mormons met intolerance wherever they settled. A new center had grown in Missouri after 1831, so the main church was moved there in 1838. Victims of mob violence and bloodshed, the Mormons lived in misery until a majority of the congregation fled across the Mississippi River to Quincy, Illinois, where the local citizens were more friendly. The Mormons purchased land at Commerce, a small settlement in the middle of a wide horseshoe bend of the river about fifty miles north of Quincy. Joseph Smith moved into a log house (later called the Homestead) which had been built in 1803 as an Indian trading post, and then set to work with his 2,000 followers to transform the swampy bottomland and the hill behind it into the city to be called Nauvoo, from a Hebrew word meaning "beautiful place."

Most of Nauvoo's citizens were not wealthy; moreover, they had embarked on their project during a statewide depression. They were, however, not lacking in energy or fine craftsmanship. Every able person worked, including Brigham Young as carpenter and glazier and Heber Kimball as blacksmith and potter. Those without money for material bartered for it; those who could afford to do so purchased tools and machinery, dividing what remained of their money among the poor. The Mormons drained

the bogs and laid out orderly streets with large lots so that each farmer lived within the town complex and at the same time farmed an adjacent area. Industriously they erected hundreds of buildings: shops for industries, stores, and houses constructed of lumber rafted from Wisconsin, using brick and lime made in their own kilns. The architectural style of these buildings once again tended to reflect the owners' origins. Former New Englanders favored neat Federal houses, while most New Yorkers preferred the Greek Revival style for their homes. Some of the brick houses — Brigham Young's, for exam-

The Wilford Woodruff home in Nauvoo, built in 1843. Woodruff spent only ninety-two days in this Federal-style house due to his absence as a missionary for the Mormon Church. It was sold in 1846 to secure wagons and teams for the trek to Utah. Notice the unusually large bricks splayed over the windows.
PHOTOGRAPH BY
RICHARD PHILLIPS

Reconstructed blacksmith and wainwright shop in Nauvoo.
PHOTOGRAPH BY RICHARD PHILLIPS

Greek Revival home of the Mormon Apostle Orson Hyde. Built in 1843, this frame house has unusually large corner pilasters. It was occupied by the Hyde family until 1846.
PHOTOGRAPH BY RICHARD PHILLIPS

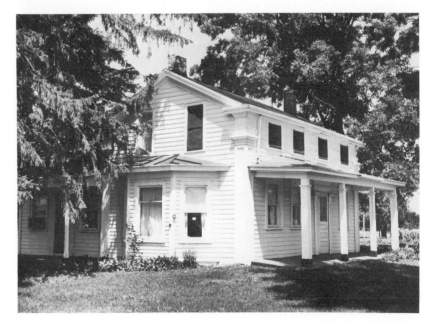

Art, Crafts, and Architecture in Early Illinois

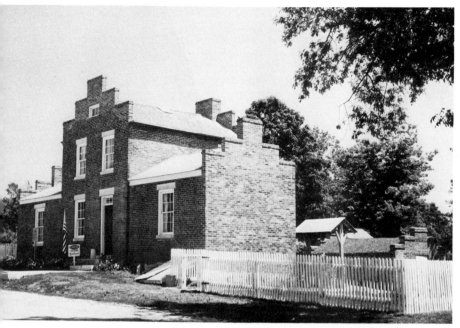

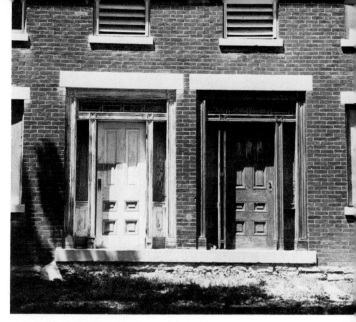

Nauvoo home of Brigham Young, second president of the Mormon Church. Erected in 1843 with wings added later, its crow-step gables reflect the influence of old Dutch houses of New York.
PHOTOGRAPH BY
RICHARD PHILLIPS

Greek Revival doors of a duplex built in 1843-44 by the Erastus Snow and Nathaniel Ashby families in Nauvoo. Snow, an Apostle of the Mormon Church, and Ashby, a shoe merchant, lived in the building with their families for two years before leaving for Utah.
PHOTOGRAPH BY RICHARD PHILLIPS

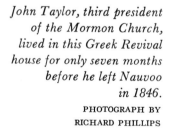

John Taylor, third president of the Mormon Church, lived in this Greek Revival house for only seven months before he left Nauvoo in 1846.
PHOTOGRAPH BY
RICHARD PHILLIPS

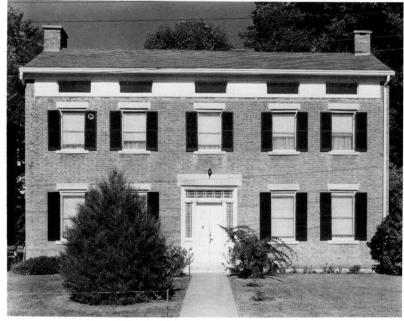

ple — had crow-step gables typical of old Dutch houses in New York, while others had plainer stepped gables like the Federalist buildings of Virginia. Nearly all Mormon buildings were practical, boxlike structures with gable roofs and single or double brick chimneys built into the end walls, revealing knowledge from experience of the value of heat saved in a cool climate by a compact shape and an enclosed chimney.

In spite of terrible epidemics of malaria from the mosquito-infested lowlands, Nauvoo grew rapidly. By 1845, with a population of 11,052, it was the largest city in Illinois. Among its new citizens were additional craftsmen: masons and carpenters from the eastern United States, Can-

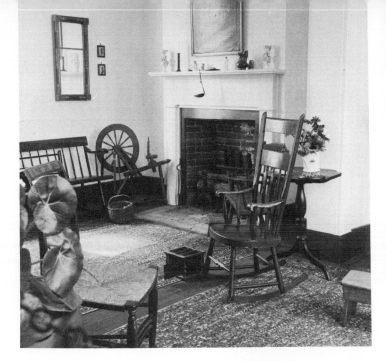

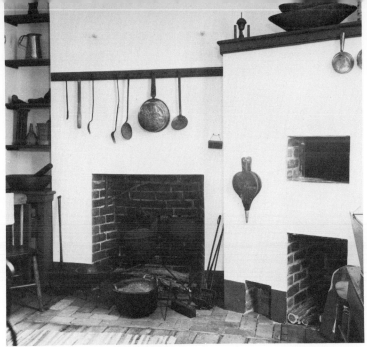

The living room of the restored Wilford Woodruff home. Notice the footwarmer beside the central chair. Although this furniture was purchased in the East for the restoration, the only piece not typical of Illinois furniture is the chair at the lower left.

PHOTOGRAPH BY RICHARD PHILLIPS

Kitchen of the Woodruff home. Notice the wall oven (right) for baking bread. This was accomplished by preheating the oven with hot coals. A removable door was used to conserve heat while the bread was baking.

PHOTOGRAPH BY
RICHARD PHILLIPS

Restored dining room of the Brigham Young home. Young was by trade a carpenter, wood turner, and chair maker, and some of the doors of this house still bear traces of his painted artificial wood graining.

PHOTOGRAPH BY RICHARD PHILLIPS

Art, Crafts, and Architecture in Early Illinois

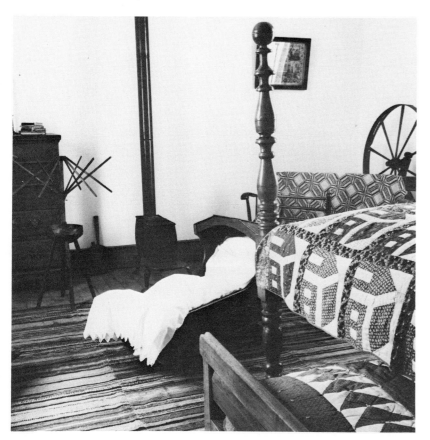

A "Boston" rocker
made at Nauvoo
by Phineas Young,
Brigham's brother.
It is dark brown
with gold stencil decorations
that include an eagle,
a sailing ship,
and a beehive — symbol
of the Mormon Church.
PHOTOGRAPH BY
RICHARD PHILLIPS

Restored bedroom
in the Brigham Young home.
PHOTOGRAPH BY
RICHARD PHILLIPS

Redware pitcher with a straw-yellow glaze.
Made at Nauvoo and inscribed "Mr. Carlin 1842."
EVERHART MUSEUM, SCRANTON, PA.

ada, and Great Britain, and potters from Staffordshire, England. One potter, J. Grocott, arrived in 1843 by way of Iowa. Later arrivals Mathew Moore and Moses Morton built the Old Connecticut Pottery, where they produced bright-colored and mottled redware. Queensware (cream-colored earthenware) pitchers, bowls, and plates were being manufactured by 1846 by Elijah K. Fuller.

The wagon and carriage shops were turning out spinning wheels as well as vehicles, and the town had at least two commercial weavers: George Thorpe and a man from Paisley, Eng-

land, who specialized in making paisley shawls. At least two hatters made summer hats of braided straw, some of which the Mormon children sold along with walking sticks to travelers on the steamboats at the busy wharf. There were tailors, dressmakers, candle makers, soap makers, tanners, cobblers, a watchmaker, and a man who fashioned ladies' combs from cattle horns. Gustavus Hill — a combination jeweler, goldsmith, and silversmith — was also an engraver; he published a map of the growing city of Nauvoo as it appeared during the winter of 1842-43.

The city had many carpenters, cabinetmakers,

The Heber C. Kimball home, with both Federal and Greek Revival features. The main two-story structure was erected in 1845, while the story-and-a-half addition dates from 1867. Kimball was a missionary, statesman, and a counselor to Brigham Young during his church presidency, 1847-68. The building was occupied for only four months before the exodus to Utah.

PHOTOGRAPH BY RICHARD PHILLIPS

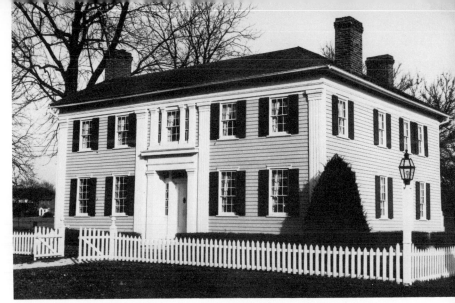

Joseph Smith's Mansion House (1842-43) was built of white pine. It originally had twenty-two rooms. Its hip roof, broad pilasters, and triple window are typical of late Federal houses of New England, yet some of the details are Greek Revival. Today it is a museum maintained by the Reorganized Church of Jesus Christ of Latter-Day Saints.

PHOTOGRAPH BY RICHARD PHILLIPS

Tin downspout head from the Mansion House.

INDEX OF AMERICAN DESIGN

Desk said to have been made for the Mormon temple about 1845. Now in the Mansion House in Nauvoo.

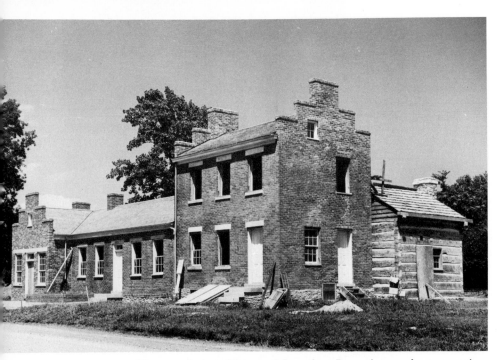

Nauvoo shop and home of Jonathan Browning, under restoration.

PHOTOGRAPH BY RICHARD PHILLIPS

Wrought-iron seat, Nauvoo.

Art, Crafts, and Architecture in Early Illinois

and joiners. One citizen, Joseph W. Coolidge, in addition to building his own house, built the Mansion House, which served as headquarters for the church and Prophet Joseph Smith. Hiram Kimball's iron foundry manufactured castings for a good many of the community's locks, keys, and ornamental stars for capping the tie bolts of brick walls. At least seventeen blacksmiths serviced the town, and three gunsmiths — including Jonathan Browning, father of the famous gun designer John Moses Browning.

Jonathan Browning, an inventor and maker of specialized firearms, turned out made-to-order guns using only a foot lathe and simple hand tools. He had earlier lived and worked in Quincy, producing single-action revolving rifles and hand-

"Joseph Smith, President of the Church of Jesus Christ of Latter Day Saints Addressing the Chief & Braves of several tribes of Indians in the City of Nauvoo, Illinois, North America, June 1843." Lithograph by John M'Gahey.
ILLINOIS STATE HISTORICAL LIBRARY PHOTOGRAPH

Lithograph of Joseph Smith in his lieutenant general's uniform, 1842, after Sutcliff Maudsley.
NAUVOO RESTORATION, INC.

guns. Sometime between 1834 and 1842 he invented one of the first repeating rifles — an excellent weapon, simple in mechanism and quite inexpensive. This rifle, capable of firing twenty-five shots, was ideal for the frontier hunter. A Mormon convert, Browning moved to Nauvoo in 1840 and plied his trade there for six years. He went west with the final Mormon migration, maintaining an interest in firearms until his death at Ogden, Utah, in 1879. In the manner of most frontier craftsmen, Jonathan Browning seldom put a distinctive mark on his work, so it is now difficult to identify his products. His son, John Moses, was later to invent the automatic pistol and the machine gun and to found the Browning Arms Company.

To the outsider, the city of Nauvoo was the object of much curiosity and wonder. In addition to considerable verbal discussion, travelers and newspapermen wrote numerous accounts of Joseph Smith and his city. Landscape artists found Nauvoo fascinating as a subject for sketches and paintings; portraitists sought out its leading citizens for sittings. Sutcliff Maudsley, an English member of the church, sketched portraits of several residents. Profile portraits of Joseph Smith and his brother Hyrum, said to have been painted in 1842 by D. Rogers, were copied for engravings by W. Edwards, and in 1844 John M'Gahey was exhibiting his lithograph showing Joseph Smith addressing the Indians at Nauvoo.

A lithograph of Nauvoo published in 1843 by Hermann J. Meyer, New York. The original oil painting from which it was made is in the Knox College Library, Galesburg. The scene shows the uncompleted Mormon temple.
ILLINOIS STATE HISTORICAL LIBRARY PHOTOGRAPH

lumber rafted down the Mississippi from Wisconsin, glazing windows, mixing mortar, painting, or carving.

The architect William Weeks had made at least two preliminary plans for the temple, each with architectural features of the popular Greek Revival style of the day. These were summarily rejected by Joseph Smith, who stated that the design of the building must be in accord with its appearance in the vision he had experienced ordering its erection. Five years of labor and the equivalent in cash and labor of at least $750,000 were expended in erecting the structure, which

Original conception of the Mormon temple by architect William Weeks.
NAUVOO RESTORATION, INC.

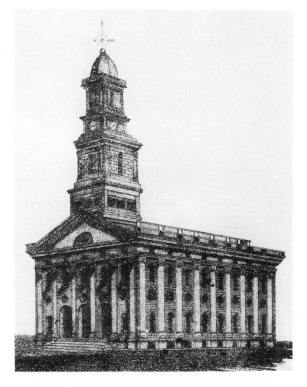

Most intriguing and impressive to the outsider was a huge structure which began to rise in 1841 on top of the river bluff at Nauvoo. This great Temple of the Lord was intended to stand in view of every traveler for miles up and down the Mississippi and far out onto the prairie east of Nauvoo. Erection of this temple was a labor of love, religious zeal, and personal sacrifice which provided as well a needed boost to the city's economy. Each Mormon was ordered to contribute at least one-tenth of his income or was required to support full-time workers. Produce prepared by Nauvoo women was allotted for the workers' food. Other women knitted socks and mittens or sewed veils and garments for the future temple ceremonies. Everyone was occupied, with men cutting and hauling light gray limestone from two nearby quarries, sawing pine

Art, Crafts, and Architecture in Early Illinois

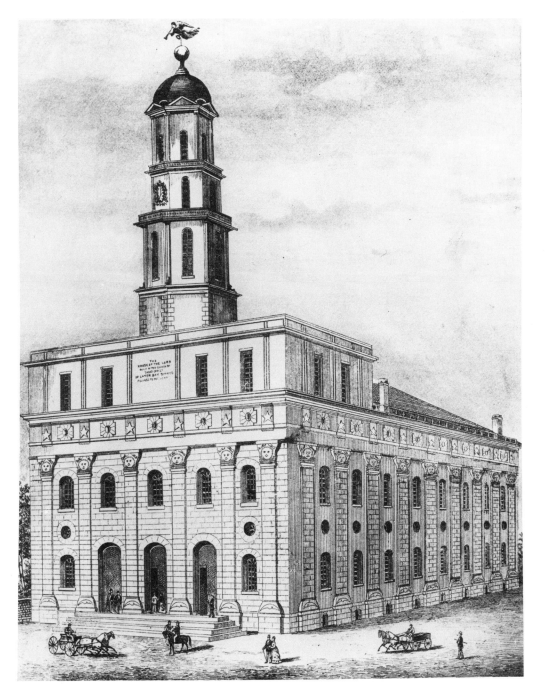

was finished in April 1846, two years after the Prophet's death. Externally, it was an odd combination of architectural motifs from both antique and contemporary styles.

The building was indeed massive for its day: 128 feet long, 88 feet wide, 60 feet to the top of the cornice. A terraced octagonal belfry and clock tower extending above the front facade, topped by a tower dome with a gilded figure of the angel Moroni, reached a total height above ground level of 158½ feet. Along the four sides of the building were thirty pilasters, the base of each carved with an inverted crescent moon and the capital carved with a sun with strange human features and two trumpets held by hands presumed to be those of God. On the frieze above each pilaster there was a five-pointed star.

A sunstone from the Nauvoo temple, now at the Historical Museum of Quincy and Adams County.
PHOTOGRAPH BY CHARLES HODGE

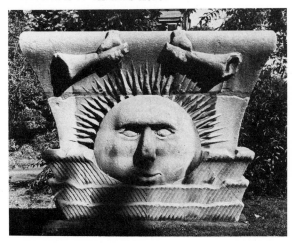

These carved suns, moons, and stars symbolized the three grand divisions of Glory — celestial, terrestial, and telestial — into which, according to Mormon belief, people will be separated in the hereafter according to their earthly works. In the middle of the attic face was the gilt inscription "The House of the Lord. Built by the Church of Jesus Christ of Latter Day Saints. Commenced April 6, 1841. Holiness to the Lord."

The second and third floors of the temple contained large auditoriums which received light through tall round-headed windows. Between these two rooms there was a mezzanine composed of rows of small offices lit by circular windows. The attic above the three floors contained a large hall flanked by twelve smaller rooms for the Apostles. The most impressive feature of the interior of the building, however, was a great wooden baptismal font, which from 1841 to 1845 stood in the basement. This font was a large oval bowl, 16 feet long, 12 feet wide, and 7 feet high, ornamented with antique moldings, which rested on the backs of twelve carved wooden oxen symbolizing the twelve tribes of Israel. The font resembled the "brazen sea" — a large bowl of water supported on the backs of twelve oxen placed by King Solomon in his temple at Jerusalem. (A similar font may be seen today in a stained-glass window of the Church of St. Etienne-du-Mont in Paris, France.) In 1845 this temporary wooden font was replaced by one of stone, the work of ten or fifteen stonecutters and carvers. The completed font had eighteen stone steps leading into the basin and out the other side, and there were twelve carved stone oxen with horns and ears of tin.

Joseph Smith was enormously influential

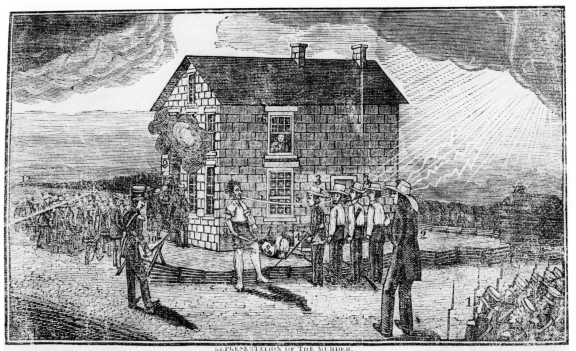

REPRESENTATION OF THE MURDER.

EXPLANATION—Fig. 1, the Carthage Greys. Fig. 2, Col. Williams. Fig. 3, the four ruffians who shot Gen. Joseph Smith. Fig. 4, the well-curb. Fig. 5, the flash of light. Fig. 6, Elder Richards at the window of the jail from which Gen. Smith fell. Fig. 7, Gen. Smith, after he was shot. Fig. 8, the ruffian who was about to sever his head from his body. Fig. 9, the door leading into the entry, through which the murderers entered. Fig. 10, Capt. Smith. Fig. 11, the mob. Fig. 12, the point of wood which the mob entered when going to the jail.

"Representation of the Murder." A wood engraving from a pamphlet published in 1845 entitled A Correct Account of the Murder of Generals Joseph and Hyrum Smith at Carthage, on the 27th of June, 1844: by Wm. M. Daniels, an eye-witness.
ILLINOIS STATE HISTORICAL LIBRARY PHOTOGRAPH

among the Saints and even aspired to the presidency of the United States. But non-Mormon neighbors and state officials had become increasingly incensed over lawless acts by some of the Mormons and fearful of their powerful militia, and in 1844 Joseph and his brother Hyrum, in jail at Carthage awaiting a hearing on a charge of treason, were assassinated by an angry anti-Mormon mob. The stricken Mormons bore the bodies back to their city for secret burial. Death masks were made of the faces of the Prophet

and his brother, from which L. A. Ramsey, a Lawrence County native, later in the century painted two portraits which now hang in the great Mormon temple in Salt Lake City.

The following year a Nauvoo Mormon, Major William Warner, painted a picture of the assassination to appear as one of a series illustrating the tribulations of the Mormons. The picture was copied as a wood engraving for a published pamphlet describing the murder.

Expelled from Illinois as they had been from

Art, Crafts, and Architecture in Early Illinois

the East and from Missouri, the Mormons began preparations to move on to the far West. While every shop and building was alive with feverish preparations for their removal and hundreds of wagons were being built for the long trek, the people of Nauvoo were still concerned that their temple be finished before their departure. About 2,000 members of the community left during the winter of 1845-46, but the remaining Mormons labored on. The great edifice was officially dedicated on May 1, 1846. The following day the temple was stripped of everything that could be removed, the wagons were loaded, the oxen hitched, and the greatest wagon trek in history set off toward Utah to begin a new home for the Saints. Their new leader and the second president of the Mormon Church was Brigham Young, with Heber C. Kimball serving as his special counselor. Young, who planned and directed the exodus, is today honored in the Rotunda at the nation's capital as "America's greatest colonizer."

Sketch of Joseph Smith made in the courtroom by Benjamin West of Rochester, Illinois, during Smith's trial.
ILLINOIS STATE HISTORICAL LIBRARY

The former school building erected in Nauvoo by the Icarians with stones from the Mormon temple. Demolished.
PHOTOGRAPH BY
RICHARD PHILLIPS

Death masks of Joseph (left) and Hyrum Smith made by Philo Dibble, Joseph Smith's bodyguard. The original masks are in the Mormon Church library in Salt Lake City.
ILLINOIS STATE
HISTORICAL LIBRARY
PHOTOGRAPH

Back in Nauvoo, the Mormon temple, standing in lonely majesty over the almost deserted city of Nauvoo, continued for two years to inspire writers and artists to record the most magnificent edifice in the entire Midwest. On the night of October 8, 1848, the temple that had stood completed for so short a time was set on fire by an arsonist. The wooden interior burned rapidly, and soon just the smoking walls of the gutted structure remained. The following spring a colony of French Icarians moved into some of the deserted houses of the Mormons, and their leader, Etienne Cabet, fascinated by the ruins of the temple, tried to rebuild it with help from his followers. They were at work on it in 1850 when a violent windstorm struck the area and destroyed most of the remaining walls. Reconstruction was then abandoned, and the Icarians, using stones from the temple ruins, built a new

"Nauvoo as it was."
Painted by
David H. Smith, son of the
Prophet. This view shows
the unfinished hotel,
Nauvoo House, as it looked
at the time of Joseph Smith's
death in 1844.
ILLINOIS STATE
HISTORICAL LIBRARY
PHOTOGRAPH

structure to serve as a schoolhouse. Nearby they erected a large community dining hall and four two-story frame apartment houses.

Unlike the Mormons, the Icarians had no established church of their own. Cabet, once attorney general and later deputy of France, had authored *A Voyage to Icaria, True Christianity,* and other pieces advocating a Christian type of communism. In exile for his sympathies toward the common people, he had succeeded in gaining many devoted followers. Some of these preceded Cabet to Texas and remained there when about 300 decided to move on with him to Nauvoo, where empty houses were available at low cost.

The first group of Icarians at Nauvoo, mainly artisans and professional men with little knowledge of agriculture, were on the verge of starvation when Cabet set them to rebuilding the temple. Grumbling about the impracticality of this project, they nonetheless continued at their assigned duties. They had at last attained some

small prosperity when another group of gentleman recruits arrived from France who were even more unused to any physical labor. A 1905 *Harper's Monthly* article describes some of these men of brilliant talent: "There were several musicians, two painters of wide reputation, a famous civil engineer; a physician who had stood at the head of his profession in Vienna; Dadant, the authority on bee-culture; Piquenard, afterward architect of the Capitol buildings of Illinois and Iowa, famous on two continents; Vallet, the sociologist; von Gauvain, nobleman, officer and teacher, one of the gentlest as well as one of the ablest of men. Icaria's prospects were surely bright."[1]

According to one writer, "The dining hall was a work of beauty and exquisite taste. Around the walls were pictures by one [Jasmine Pierre] Bergeron, an artist of no mean merit, with here and there motifs of the creed of the Icarians, chief of which was 'Everybody according to his capacity.' "[2]

Another community artist, Emile Vallet (1834-1907), was also a poet and writer. Duties were assigned him as a working member of the colony, but he managed, in addition, to paint at least two pictures while at Nauvoo, both of which remain in Illinois. One, a view of the town, hangs in the Nauvoo Historical Society Museum; the other, which depicts the Nauvoo temple as it appeared in 1846-47, is owned by the Chicago Historical Society.

For a time the Icarians worked in their earthly utopia with a will, building, teaching, cultivating their fields, and manufacturing flour and whiskey. They found themselves among the other communal societies that sprang up in the mid-1800s — including the Shakers at Pleasant Hill, Kentucky; the Oneida colony in New York; and the original Amana colonies near Cedar Rapids, Iowa — who learned from experience that such a venture was necessarily short-lived. Doling out money on the basis of need and assigning such

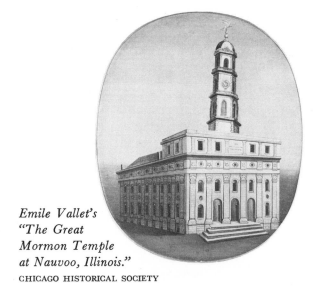

Emile Vallet's
"The Great
Mormon Temple
at Nauvoo, Illinois."
CHICAGO HISTORICAL SOCIETY

Art, Crafts, and Architecture in Early Illinois

A view of Nauvoo painted by Emile Vallet.
NAUVOO HISTORICAL SOCIETY MUSEUM

duties as planting, plowing, harvesting, wood chopping, coal digging, and flour milling to professionally trained artists, sculptors, and architects, the society failed in the long run to satisfy individual ambition and to provide personal fulfillment.

The Illinois census of 1855 lists the following among the Icarian artists and craftsmen:

Claude Antoine Grubert, master of music
Alfred H. Piquenard, architect
François Nazet, architect
Louis Jacquin, whitster [linen bleacher]
Louis Marcoff, chamois draper
Jean Mazarin, sculptor
Pierre Blanc, painter
Pierre Grillar, ebonist
Jean Flachcot, tapestry maker
Martin Mahay, lithographer
Jean Lafaix and Frederick Gmunder, engravers

Charles Ianglois, foundryman
Jean Delever, clockmaker
Isadore Couloy, potter
Joseph Chenne, weaver
Manon Chevant, rope maker
Etienne Dorey, tanner
4 jewelers
14 tailors
10 shoemakers
1 last maker
carpenters
coopers
joiners
cartwrights
masons, etc.

It is certain that few of these men were allowed to work to their satisfaction in these fields, and the ideals of the society obstructed the accumulation of personal fortune. With community members grumbling and dissatisfied, production failed and debts mounted. In 1856 Cabet left Nauvoo in discouragement, considering the experiment a failure, to settle in St. Louis. Some of the dissenters transferred to another French colony established three years earlier at Corning, Iowa.

During the early years of Icarian occupation, even the ruined walls of the Mormon temple continued to excite the wonder of visitors. English portrait and landscape artist Frederick Piercy was one of those whose work can still be seen. The temple was sketched and painted from memory, from descriptions, and from existing engravings. The ruined building was even photographed with the new invention, the daguerreotype. Local residents, such as J. A. Field, Elsie Fleury, Amelia Stevens, Charles DeBault, and David H. Smith (son of the Mormon leader), painted and sketched views of the town or the temple. Some of these resident artists had been members of the Mormon community; others were French, English, or German immigrants who arrived in Nauvoo after the Mormons had emigrated.

German and Swiss settlers at Nauvoo proved far more sturdy and permanent citizens than the French. Evidence indicates that it was a German from Belleville, rather than the Icarians, who introduced a flourishing wine industry in the town. These Germans also left behind more examples of their native artistic talents. They were natural wood carvers of unbounded ingenuity, especially in the making of toys for Christmas. Some of their homemade wicker baskets, furniture, candle molds, and a doughbox remain in the reconstructed German kitchen at the Nauvoo Historical Society Museum. German

artists who painted views of Nauvoo and its temple included Christian Breugger, Joseph Reinberger, and John Schroeder.

Joseph Kirschbaum, Sr., and his brother Werner came with their families from Berlin, becoming carriage builders in Nauvoo. Twenty-one-year-old Joseph, Jr. (1829-1926), was an artist. His portfolio was filled with raven's-quill drawings of cathedrals in Germany, Switzerland, and France that he had made as a boy in Cologne and while a student at Düsseldorf. When he drew flowers, they were botanically as well as artistically correct. He continued his art studies in St. Louis, afterward working as a fresco painter on some of the Mississippi River steamboats. While traveling by steamboat with an opera company, he made sketches of the Nauvoo temple before and after its destruction. Then, prior to 1860, he finally settled in Nauvoo, having purchased a house built during the Mormon period by a fellow German, Jacob Weiler. Six generations of the Kirschbaum family have lived in the home, which now is owned by Nauvoo Restoration, Incorporated.

Many of the unoccupied frame buildings erected by the Mormons had been torn down by 1918, and a number of deserted brick dwellings had fallen into advanced disrepair. The Reorganized Church of the Mormons, based at Independence, Missouri, about that time acquired for restoration the old log Homestead, frame portions of which had been added by Joseph Smith during his first year at Nauvoo. The group also restored the front portion of the Mansion House (1842-43), Smith's official residence at the time of his death, which was originally an L-shaped building with twenty-two rooms. In addition, they renovated a portion of the Nauvoo House — a brick hotel planned by architect Lucien Woodworth, begun in 1841 and left incomplete at Smith's death in 1844. One corner was completed some time in the 1870s.

Nauvoo Restoration, Incorporated, organized in 1962 by the Mormons headquartered at Salt Lake City, declared as its purpose "to acquire, restore, protect, and preserve . . . all or part of the city of Nauvoo." Grants were received and nationally renowned experts hired: historians to research; archaeologists to dig; craftsmen to reconstruct and renovate buildings. A new information center was erected to bring to the American people the story of the Mormons' significant role in the settlement of the West.

Despite the excellent restoration of many old buildings and the reconstruction of others, the magnificent Mormon temple may never be rebuilt. Only the outlines of its foundations may be marked; to this date the rest of the edifice is visible only in the paintings and drawings of artists and the words of writers. In such form it remains a great symbol of the faith, determination, and religious zeal of men who for a time lived in Illinois.

Only three sunstones and three moonstones remain from the original building. One moonstone stands in the yard of the Nauvoo Hotel (1841), once a Mormon residence in the town of Nauvoo. One sunstone was taken to Springfield in 1870 as a sample of stone from the Sonora quarries in the bluffs of the Mississippi four miles south of Nauvoo. (Some of this Sonora stone was used in the Illinois capitol [1868-88], built under the supervision of architect Alfred H. Piquenard, former French Icarian at Nauvoo.) Later this sunstone was returned to Nauvoo. A second sunstone is on the grounds of the Historical Society Museum of Quincy and Adams County; and the third is in the Smith family burial plot near the Homestead residence of Joseph Smith.

A moonstone from the Mormon temple.

Art, Crafts, and Architecture in Early Illinois

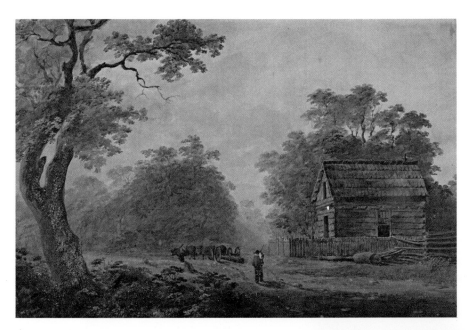

"Old Man Grey — 1½ miles South of Plainfield on road to Alton." Watercolor painted about 1852 by artist John Williams O'Brien while he was working as a civil engineer (see p. 217).
(see p. 217)
DOROTHY DRENNAN COLLECTION

"View of Alton, Illinois" (ca. 1856). An oil painting attributed to J. B. Blair, a resident of Milwaukee, Wisconsin, who also painted a panorama of geological and biblical history (see p. 263).
(see p. 263)
HAYNER PUBLIC LIBRARY, ALTON

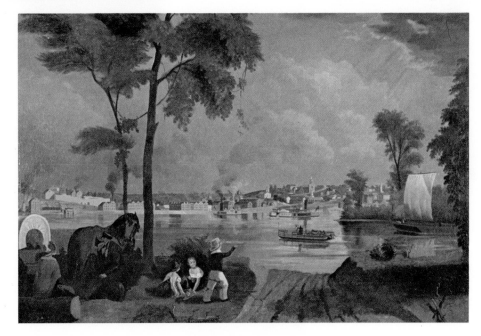

Art, Crafts, and Architecture in Early Illinois

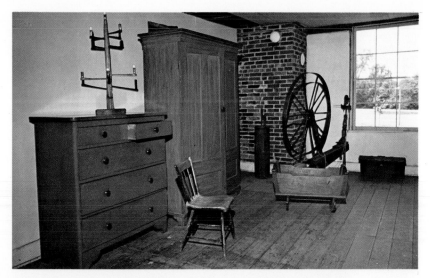

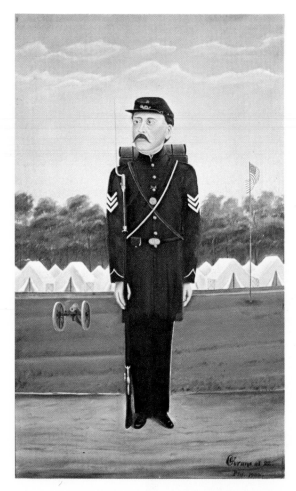

"Olof in his Union Suit," painted in 1908 by Olof Krans, and "Butcher Boys on a Bender," painted in 1900. Many of Krans's paintings were done from memory and deal with the first days of the Bishop Hill colony in Henry County.
MR. AND MRS. REYNOLDS EVERETT COLLECTION AND THE ILLINOIS DEPARTMENT OF CONSERVATION

Art, Crafts, and Architecture in Early Illinois

17 Discovering the Landscape

The English, long lovers of the outdoors, had been romanticizing for more than a century over their medieval castle ruins, half hidden by clinging vines and leafy bowers. One result had been a revival in England of Gothic architecture, believed by English taste makers to be closest to nature because it unobtrusively blended in color and rustic materials. Another result was the abandonment of the centuries-old concept of landscape design — one that had featured formal gardens shaped into geometric patterns, trees planted in rows, and shrubs clipped into unnatural shapes. The new, romantic ideal more nearly resembled nature itself, with "gently controlled" informal gardens shaped by rambling curvilinear outlines and with alternating grassy meadows and wooded retreats. Homes in these settings were half hidden by trees, luxuriant shrubbery, and climbing vines. This new concept of landscape design had already traveled westward to America and would reach Illinois about 1850.

The Romantic Movement in England eventually inspired American writers to romanticize over the beauties of their own landscape. Sir Walter Scott's novels were widely read; his tales of castles, knights, and ladies and, in particular, his preoccupation with nature had enormous

suggestive power in America for such writers as James Fenimore Cooper, Washington Irving, and Ralph Waldo Emerson. Some writers and poets traveled westward, drawn by curiosity or by the accounts of other travelers who had visited the area. Massachusetts critic and reformer Margaret Fuller (1810-50) traveled over the Illinois prairies by stagecoach and down the Illinois River by steamboat. She compared the beautiful Rock River region with the artfully contrived flower gardens and parks of England. The poet William Cullen Bryant (1794-1878) compared the scenery along the Illinois with the combined beauty of the Hudson and Connecticut rivers. (His enthusiasm may have been the inspiration for a later painting of Starved Rock by his nephew Julian.) In her *Summer Journey in the West,* easterner Eliza R. Steele, telling of a trip made in 1830, described in glowing terms the stately trees, steep bluffs, and flowering prairies along the Illinois River and tributaries like the Spoon and the Sangamon, which meandered through some of the most fertile land in North America.

On the other hand, American artists were influenced not so much by the Romantic Movement in England as by similar, older movements in Italy, France, and Germany — countries

Oil painting of Starved Rock in La Salle County by Julian Edwards Bryant of Princeton, Bureau County. About 1855.
PRINCETON HISTORICAL SOCIETY

nature uncorrupted by man: its soft mists, its changing lights and shadows, its craggy rocks and rushing streams. Their works, particularly abundant after 1820, are exemplified by the paintings of Thomas Cole and other artists of the Hudson River school. Many such paintings were copied as lithographs for eastern homes.

Lithography, introduced into America in 1819, allowed a quantity of prints to be produced directly from a drawing made with a grease pencil on a smooth stone surface. Far simpler and cheaper than either wood or metal engraving, the lithograph provided the average American with pictures at a moderate cost. Lithographic views therefore became quite popular, and whoever could produce them was assured of a better living than the average artist who painted single-copy watercolors or oil paintings.

There were few artists in the West who were encouraged to paint romantic landscapes like their fellow painters in the East. There was no demand for such paintings; as long as wild and often hostile nature lay at one's very doorstep there was no desire to bring it indoors. This general attitude on the part of westerners was no different from that prevalent in the East during the days of early settlement. Thus, following precedent, western artists confined their efforts to factual reporting of town views, portraits, and historical events, with natural scenery appearing only as a background. With the one exception of Missouri's George Caleb Bingham

where artists went to study in increasing numbers. At home they had seen imported engravings of romantic works by old masters and the more recent European artists; in Europe they viewed the original paintings of Nicolas Poussin (1594-1665), Claude Lorrain (1600-1682), and Salvator Rosa (1615-73) that emphasized the beautiful, picturesque, emotional, and sublime aspects of nature. They studied in the schools of landscape painting in Rome, Paris, and after about 1850 in Düsseldorf; they saw firsthand the beau-

tiful scenery that had inspired European works. Upon their return to America, eastern artists had a new appreciation of their land's natural beauties that were already fast disappearing in the East as towns grew and remaining lands were cleared of trees and bisected into roads and farm plots. A nostalgic search resulted for what remained of the natural scenery, and for the first time landscape artists left the confines of their studios to execute paintings in the wild areas that remained. They reveled in the majesty of

Art, Crafts, and Architecture in Early Illinois

(1811-79), who painted the everyday life of the people around him and the boatmen on the Mississippi River, nearly all early scenes in the Midwest were productions of artists from the East, New Orleans, or Europe. One early view, titled "Mt Joliet, Ill. 1834," was made into a lithograph by a Peter Maverick after a sketch by H. Inman. This probably was the Henry Inman (1801-46) who was a competent landscape artist in the East.

The Mississippi River, flowing past towns along the western border of the state, proved to be a greater attraction for the artist than the hinterlands of Illinois. St. Louis, situated at the natural crossroads of America, had been since its founding in 1674 the hub of commerce to and from the North and South on the Mississippi, the East by way of the Ohio and the Mississippi, and the far West by way of the Missouri and its tributaries. By 1840, with a population of 16,649, it was four times the size of Chicago and one of the country's most colorful towns. Adventurers, river men, foreign and American immigrants, and wealthy ladies and gentlemen of French ancestry toured its streets. The waterfront teemed with the life of the river: boatmen steered hundreds of pirogues, barges, and flatboats along the docks, while tinsmiths, potters, blacksmiths, and glassblowers operated on their various trade boats. Most exciting, however, were the marvelous steamboats. Some were floating palaces, fitted with carpeting, crystal chandeliers, and fashionable oil paintings. Elegant furniture and wood carvings for some of their opulent parlors had been made by German cabinetmakers in Alton.

St. Louis also provided an ideal base from which the artist could travel by boat for hun-

Lithograph of a view of Belleville in 1859 by N. Roesler.
Printed in colors by A. McLean, St. Louis.
ST. CLAIR COUNTY HISTORICAL MUSEUM

dreds of miles in comparative ease. He could sketch or paint luxuriant vegetation, towering limestone bluffs, prehistoric mounds, famous sites of Indian legends, riverboats, and hundreds of villages and towns on both sides of the Mississippi River. A few sketches and paintings were later copied as engravings, but more were copied as lithographs.

The most prolific agency of the lithographic art was the noted house of Currier and Ives in New York. This publishing firm (active 1857-1907) sent artists far and wide to capture in

sketches the life of nineteenth-century America. Some of their dramatized scenes included steamboats tied to the river landing in the process of taking on wood, passengers, and cargo or racing down the river with steam billowing and sparks flying. A collection of the numerous lithographs of the period vividly illustrating Mississippi River life can be seen in the library of Knox College in Galesburg.

A young Swiss artist, John Caspar Wild (1806-46), in addition to painting, produced a number of fine lithographs of Mississippi valley

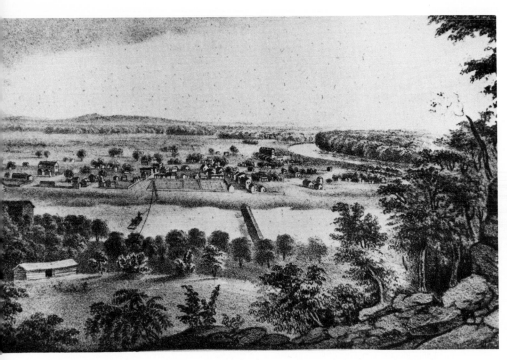

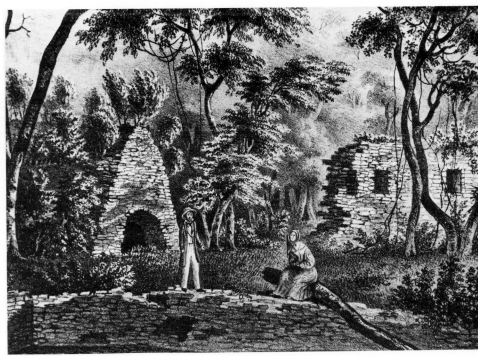

scenes. From St. Louis in 1839, Wild traveled up and down the Mississippi making sketches and paintings, some of which he copied himself to produce lithograph prints. Wild's views, published monthly in a series of four, were titled *The Valley of the Mississippi Illustrated in a Series of Views* (St. Louis, 1841-42). Among thirty-five prints in a portfolio dated 1841 are a number of Illinois scenes. Wild depicted the Illinois shore with St. Louis in the background, Illinois Town (now East St. Louis), Alton, and Cairo — at that time no more than a small village at the junction of the Ohio and Mississippi rivers — and also the unusual rock formations in the river called Grand Tower and the Devil's Bake Oven (the southern end of the high cliffs which outline the American Bottom). "Cahokia,

Illinois," "Falling Spring Near Cahokia, Illinois," "Ruins of Fort Chartres, Illinois," and "Prairie DuRocher, Illinois" were all scenes in or near the old French settlements along the American Bottom — a region that charmed a number of river artists by its luxuriant verdure and quaint eighteenth-century atmosphere. "Monk's Mound, St. Clair County, Ill." and "Piasau Rock, Alton, Illinois" (see p. 53) were included because of their unusual and mysterious prehistoric Indian origins.

After five years Wild went from St. Louis to Davenport, Iowa, and later to Fort Snelling, Minnesota. Settling in Davenport in 1845, he made paintings and later lithographs of towns in Iowa and Illinois, including Moline, Galena, and one view of Davenport and Rock Island. The lithograph of Galena is especially fine and is of considerable historic interest, showing a lead miner standing near a mine shaft in the foreground and an assortment of contemporary building types, including one with a thatched roof (see p. 192). Only a year after the publication of this work the forty-year-old Wild died. Among the oil paintings listed in his will is one of Fort Armstrong.

Art, Crafts, and Architecture in Early Illinois

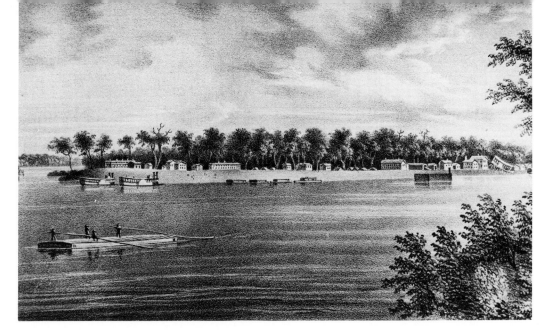

Co. of New York and published in 1856 by the artist.

Advance subscriptions for prints provided the artist with funds to cover the expense of lithography. The following correspondence indicates the unfortunate outcome of Whitefield's own business dealings with the city fathers of Galena. Concerning the print he had made, the artist wrote:

To the Mayor and Common Council
of the City of Galena

Gentlemen

Last fall I made an effort to obtain sufficient subscriptions to enable me to get up a View of

Wild was one of the minority of artists whose published lithograph prints were produced from their own grease-pencil drawings on stone. Most artists had their works reproduced by one of the many commercial lithographers who had establishments in most of the larger cities. This was the procedure followed by the English-born artist Edwin Whitefield (1816-92).

Whitefield, who came to America in his early youth, spent most of his time between 1845 and 1856 making drawings as he traveled from one to another of the more important cities and towns of the United States and Canada. A number of these drawings were subsequently taken to commercial lithographers, including a sketch of Galena — the thirty-seventh in a series of large prints — which was lithographed by Endicott &

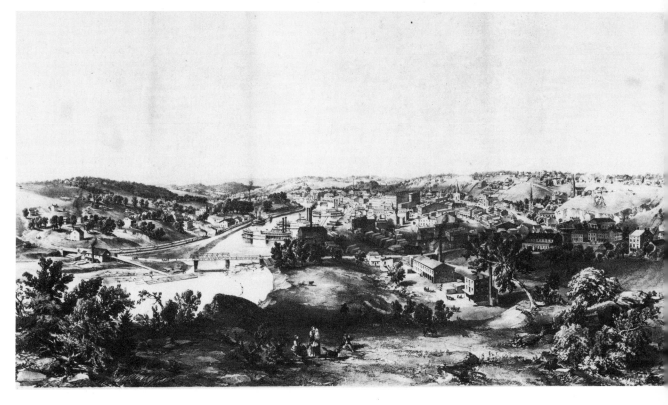

"View of Galena Ill." (1855-56).
Lithograph by Endicott & Co., New York, after a drawing from nature by Edwin Whitefield.
ILLINOIS STATE MUSEUM

Discovering the Landscape

your City which should be a faithful and at the same time a favorable representation of Galena, so that you might send it abroad, and thus let strangers see what you really look like. It was only after lengthened and strenuous efforts that I succeeded in obtaining a number barely sufficient to pay all the expences necessarily attendant upon such a work. I have at length completed the undertaking, and can honestly say have not spared a single dollar in getting up a work of which you might be proud; and I believe I might say without fear of contradiction that a better specimen of the Fine Arts of a similar character has not been produced in this country.

Your former Council subscribed to the amount of Eighty Dollars, and of course I supposed I should receive that amount when I had fulfilled my part of the contract; but I find that owing to what I think must have been an oversight I am only to be paid in scrip on which I can realize only about two-thirds of the above sum. If I were sure of losing five or even ten percent I should not have referred to the matter, or if I were a resident here it would not perhaps signify, but I can only make use of this scrip by selling it for whatever it will fetch in the market.

This, gentlemen I feel satisfied you will arrange differently, and there are two ways in which the affair can be satisfactorily adjusted; the first is to pay me in current funds the sum of $80, and the second is to increase your subscription sufficiently to enable me to realize the original amount, say five or six copies extra. In this way you will have a greater number to circulate abroad, and I shall receive as much as I calculated upon.

Trusting that you will consider this request in a favorable light I beg to subscribe myself

Gentlemen

Your obt servt.

E. Whitefield.[1]

The reply is brief, and doubtless Whitefield found it unsatisfactory.

Galena Dec. 16/56

The committee to whom was refered the written communication touching the views of the city with ten copies of said views for the sum of $80 — which sum is now drawn in his favor but in consequence of the discount the amt. has not been accepted or the views delivered. They find further that the price of these views from the stores vary from 4 to 5 — they would therefore report that the 80 — already appropriated is a sufficient sum which he can receive or retain his views.

J. P. Dezoya Chairman.[2]

After that, Whitefield lived in Minnesota for three years before moving to Chicago in 1861. There he published (1861-63) seven views of the city, lithographed and printed by Charles Shober. The scenes included the Illinois and Michigan Central Depot, the Clark and Wells Street bridges, Rush Street Bridge, Michigan Avenue, the Tremont House, the Sherman House, and Michigan Terrace. By 1866 he had moved his family to Boston, then traveled about New England and into Canada painting watercolors of cities, old houses, and scenery. Today, notable collections of his published works are in the New York Public Library and the Mariner's Museum in Newport News, Virginia.

A small combination journal and sketchbook kept by Edwin Whitefield (now in the manuscript collection of the Henry Francis du Pont Winterthur Museum at Winterthur, Delaware) briefly describes an 1859 trip through Illinois from Chicago to Cairo. Upon reaching Mattoon, Whitefield took the Terre Haute and Alton Railroad west to Alton with a side trip north to Decatur, where he sketched the depot and the

Central Hotel. Typical of the foreigner's interest in American scenery, he described the prairie wheat fields, the apple trees bursting into blossom, the handsome bright pink flower clusters of the "Wild Pear," alternating timber and prairie lands of central Illinois, and the forests of the south. At Pana he sketched a hotel called the Beckwith House and a general scene of the town showing an Illinois Central Railroad train and twenty-five or so buildings. Bunker Hill, he wrote, was a "pretty place, settled mostly by Bostonians." Alton, by then a city of from 12,000 to 15,000 inhabitants, was sketched looking both north and south along the Mississippi River. On the way to Cairo the scenery became increasingly wooded, with smaller towns and with "here and there a clearing and a southern shanty," a clay or gravel pit, or a steam sawmill. He found Cairo much more prosperous than had Wild in 1841; already it had several large three-story brick stores and "a new hotel nearly finished ... a large and handsome brick edifice 4 stories high." A sketch of this hotel appears to have been his last made in Illinois. Apparently Whitefield returned shortly to the East, where he spent his later years making drawings for three books concerned with buildings of New England. In 1892 he died in Dedham, Massachusetts.

The artist who did not provide for commercial reproduction of his work found earning a livelihood in the West far more difficult. For instance, John Williams O'Brien from the Royal Dublin Society's Drawing and Painting Academy made every attempt to remain an artist. He was listed as an artist in the Chicago business directories from about 1845 until October of 1850, when he advertised that he was in Springfield, prepared to paint portraits and give lessons in

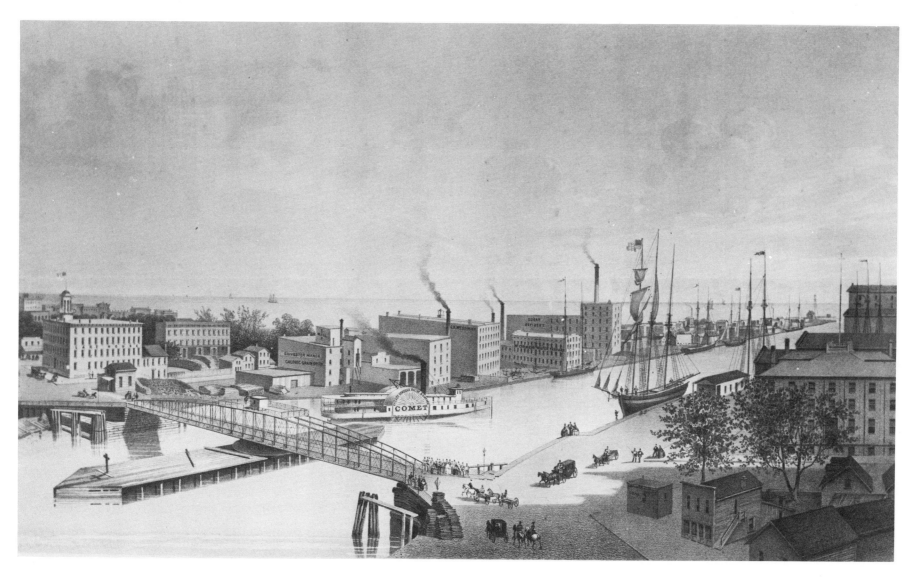

"View of Rush Street Bridge & c...." (Chicago).
An 1861 lithograph made by Charles Shober of
Chicago after an original drawing by
Edwin Whitefield.
CHICAGO HISTORICAL SOCIETY

architectural drawing and landscape painting. The railroad was apparently able to offer O'Brien, who was also a civil engineer, more lucrative employment, and he was shortly at work on the building of the Chicago and Alton Railroad. He continued painting, however, and from the Wabash shops at Springfield he made a watercolor sketch of the city; a later painting shows a rural scene on the road to Alton (see p. 209). Back in Chicago in 1855, he won a prize at the Illinois State Fair for an animal and landscape painting.

Conrad Roeder (d. 1877) was another landscape artist in Illinois who did other work in order to earn a living. Little is known about his life before 1858, when the following ad appeared in the Alton city directory:

Conrad Roeder

<small>ARTIST</small>

Respectfully informs the citizens of Alton and Vicinity that he is now prepared to execute in the very best style of art, orders for:

Portraits in Oil, Crayon or Water Colors

Especial attention will be given to Portraits of deceased persons taken from Drawings, Engravings, Daguerreotypes &c.

Landscapes

Taken from nature in every style of Painting and Drawing faithfully finished. Signs of any desired description made at the shortest notice. Ornamental Painting, Guilding, Transparencies, Fancy Painting on Glass, Canvas or Paper done in superior style. Private drawing and Painting lessons will be given to Ladies and Gentlemen at their residences, at moderate terms and at any hour desired. Studio over Holton & Co's Drug Store, corner Third and Belle Streets, Alton, Illinois.

While living in Alton, Roeder painted at least two known landscapes: a panorama of the Alton area, recently found in Los Angeles, and a view of the home and grounds of A. E. Mills of Alton, painted in 1860 and now in the Illinois State Museum. From 1864 to 1877 Roeder was listed in the St. Louis directories as an artist or portrait painter.

The scenery of the American Bottom drew the attention of a Swiss artist of the romantic school of painting. Rudolph Kurz made a number of trips in 1847 from St. Louis to spots across the Mississippi River. An idealist, he was enchanted by the old French village of Cahokia, replete with quaint houses of vertical timbers and adjoining gardens — "so different from American homes" — and he made watercolor sketches of the heavy growth of twining vines and creepers suspended from boughs of the primitive forest along the nearby Cahokia River. He visited Nauvoo and ascended the Mississippi, enraptured by the beautiful bluffs, wild glens, and ravines which extended the entire distance to Warsaw, Illinois. He was sketching Rock Island when overheated boilers on the steamboat exploded, stranding the passengers and giving Kurz ample opportunity to complete his work. Another boat carried them all to Galena, where Kurz spent two days making sketches of that busy lead-mining town.

Kurz's journal entries for the winter of 1848 tell of the artist's unrealized dream of painting Indians and wild animals. He expresses satisfaction at having been able to depict the primeval woods, prairies, and rivers at every season. Still, he adds:

I leave out prosaic accounts of my activities in the way of earning a livelihood, with the exception of this observation: in the United States, just now, a painter in the fine arts has no prospect whatsoever. He is looked upon as a "windbag," an intriguer, a "humbug." A house painter, on the contrary, makes a good income. In saying this I bring no reproach against the Americans; they are republicans — that means the political life of the nation absorbs, to a great degree, their energy of mind and their interest. Furthermore, the nation is young; the ambition of the people is to become a great country, to get the mastery, so that they can dictate to European powers. And lastly, the inhabitants outside the cities are a farming class, who have no taste for works of art. They regard such things as extravagance.[3]

Kurz spent the next four years painting Indians in the far West, where he encountered Mormons and California gold seekers traveling westward. On April 19, 1852, he arrived back in St. Louis in possession of a large collection of sketches and Indian relics and determined to spend the rest of his life painting. Needing money, he applied for the position of drawing master at St. Louis University. The position went instead to his friend, a German architect. Kurz then recorded his new plans:

As I am offered no better outlook for earning my bread as artist in St. Louis than in any of the other States, owing to the prevailing lack of interest in painting, I must, though with heavy heart, dispose of a large part of my Indian collection in order to get money enough to travel to New York or to Paris, where I hope to find more encouraging prospects.

To force myself to abandon art merely for the sake of making a longer stay in this region possible by painting houses, ships and mural decorations, or by undertaking once more the duties of merchant's clerk, is an outlook I cannot contemplate.[4]

The average American of the 1840s, especially the midwesterner, was not ready for the romantic landscape paintings of Rudolph Kurz; nor could the American appreciate the idealistic philosophy behind his art: "No true artist regards as his highest purpose mere reproduction of nature; beauties of nature are daily pleasures from which only the blind are debarred. The artist's task is to improve nature's forms, make perfect her imperfections, strive not only to emulate but to excell her in the creation of beauty. . . . To inspire their fellow beings is the artist's most lofty aim; to that end they should bend their efforts, each according to his ability."[5] Disillusioned and

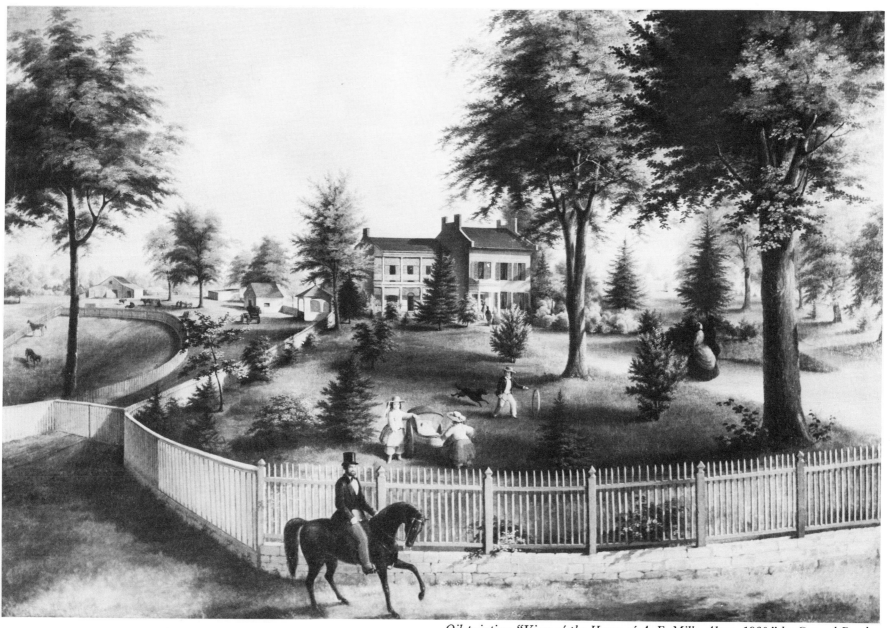

Oil painting, "View of the Home of A. E. Mills, Alton, 1860," by Conrad Roeder.
Today the house is nearly lost among later buildings of Upper Alton.
ILLINOIS STATE MUSEUM

Three pages from a Seth Eastman sketchbook. Clockwise:
"Kaskaskia — 1 mile below Kaskaskia River — looking North. Oct.
1848"; "Devil's Bake Oven looking S.E. Oct. 1848";
"Miss. Flat Boats at Cairo — Mouth of the Ohio — Oct. 1848."
MARION KOOGLER MC NAY ART INSTITUTE, SAN ANTONIO

discouraged, Kurz took a stagecoach from Ca-
hokia to Vincennes, then proceeded to his home
in Switzerland. Exciting as art was in the West
during that period in America, few found it a
lucrative venture.

One artist who successfully combined his art
with another profession was Seth Eastman (1808-
75). While attending West Point, Eastman had
received instruction in drawing from Captain
John Whistler, the builder of Chicago's Fort
Dearborn. While stationed in Wisconsin and at
Fort Snelling, Minnesota, the young officer be-
came interested in the Indian as a subject for

Art, Crafts, and Architecture in Early Illinois

"Sunset on the Mississippi." Oil painting by Seth Eastman.

his art. After 1831 he spent a number of years as a topographer and an assistant instructor of drawing at the military academy. During this period Eastman exhibited at the National Academy of Design and developed a reputation as the foremost Indian painter of his day.

In 1848, after two years at Fort Snelling, Eastman was ordered to Texas. Taking fullest advantage of his trip down the Mississippi, he sketched and painted in the minutest detail views of the placid river, its beautiful shoreline, old towns, and river craft. Some of the views of the upper river area are today in the Peabody Museum of Salem, Massachusetts, and the Minneapolis Public Library; scenes from the mouth of the Kaskaskia River to New Orleans are at the Marion McNay Koogler Art Institute in San Antonio. The Illinois scenes include the mouth of the Kaskaskia (with a wrecked ship below the river), the town of Kaskaskia, the Devil's Bake Oven, Grand Tower, and four views of Cairo. Recently discovered in a private collection is a portfolio of miniature watercolor landscapes depicting realistically and in the minutest detail seventy-nine more scenes of the river from the Falls of St. Anthony to a point near the mouth of the Ohio. These have been edited by historian John Francis McDermott and published with the observation: "So small that they might have been painted with the aid of a jeweler's glass, so sharply distinct that the artist might have been viewing the scenes through a telescope, so sensitive in the use of atmosphere, so delicate in their tints, these pictures are a glowing triumph" for Eastman.[6]

Eastman retired from the army at the age of forty-one, remaining in Washington, however, to make illustrations for Schoolcraft's *Historical and Statistical Information Respecting...the Indian Tribes of the United States.* He made a watercolor version of Schoolcraft's 1820 sketch of the settlement at Chicago (see p. 48) which became the second earliest view of Fort Dearborn and the surrounding area after the cartographic view made by Whistler in 1808.

Realistic though they were, it is doubtful that Eastman's landscapes were much appreciated by the average westerner. The pioneer was little impressed by aesthetic beauty; his preference was for something more entertaining, more awe-inspiring in its size, more theatrical. For example, the puritanical easterner approved highly of large religious scenes presented dramatically and in a lifelike manner. Benjamin West's huge painting "Christ Healing the Sick" and William Dunlap's copy of West's "Death on a Pale Horse" — which had forty figures painted on 200 feet of canvas — were exhibited all over the country to enthusiastic audiences who paid admission to see them.

Large paintings called cosmoramic views brought exotic scenes of the outside world to an

Three 1857 panoramic views made by Karl Wimar from the cupola of the Old State Capitol in Springfield. From left to right, the views are south, east, and north. Note the Greek Revival structures (east). Lincoln's law office was located in the prominent corner building in the southern view.

audience of whom most might never travel more than fifty miles away from home. Chicago's first museum (1845) contained a superior collection of these views.

The panorama — a scene with a large vista — was also popular with American audiences. Such a painting often required that the artist paint from the highest spot in the midst of a city — usually the courthouse — separate views of that city — north, south, east, and west. One such panorama, made into lithographs by John Caspar Wild, showed four views from the state capitol building in Philadelphia.

Another painter of panoramas was Karl (Charles) Wimar (1828-62), who had come at the age of fifteen to St. Louis from Germany. Wimar (or Weimar), who had been an ornamental sign painter before taking painting lessons in St. Louis from the French artist Leon D. Pomarède (ca. 1807-92), accompanied his

teacher on sketching expeditions to the upper Mississippi. Wimar painted Indians in the regions of the Mississippi and Missouri rivers before leaving the United States in 1852 to study in Düsseldorf. Returning to St. Louis four years later, Wimar evidently spent some time as an itinerant painter, because in 1857 he painted four panoramic views of the town of Springfield from the dome of the state capitol. These originally were made for the lobby of the St. Nicholas Hotel but now are owned by the Illinois State Historical Library in Springfield.

For Wimar, as for many contemporary painters, photography proved to be a competitor, having by mid-century become a more perfected and popular art. For a time Wimar himself worked as a photographer, making portraits of Indians in the West. In 1861, when the Victorian vogue for mural painting in the Romantic mode finally arrived in the Midwest, Wimar was com-

missioned to paint four murals and four classical allegories for the courthouse at St. Louis, and he was at work on this project until his death in 1862.

A further development of the panorama was a semicircular version, the cyclorama, which added size and the illusion of reality to a scene. Invented as early as 1797 by Robert Barker of England, this innovation intrigued American inventor Robert Fulton (1765-1815), who painted a cycloramic view of Paris later exhibited in that city by James Thayer. Circular buildings, designed with seating space in the center, were built for the display of such pieces. One such building, erected in Chicago to accommodate a cyclorama of the 1871 fire, was 50 feet high and 400 feet in circumference. The work of Cephas Henry Collins (1844-1942), a Chicago landscape and portrait painter, the cyclorama was so lifelike that "spectators seemed

Art, Crafts, and Architecture in Early Illinois

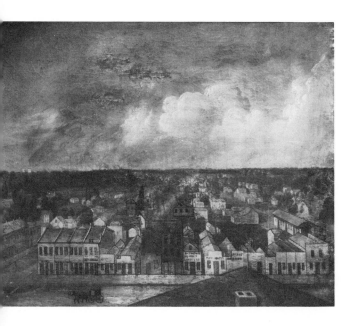

accompaniment on a pianoforte. Such theatrical panoramas as "The Conflagration of Moscow," "The Funeral of Napoleon," and "The City of London" were among the most popular of such displays in Chicago.

The most impressive of all were the great panoramas of the Mississippi River, which brought the landscape and life of the great river and its tributaries to Americans in the East as well as to Europeans. Realistic presentations of the dramatic beauty of the frontier, these productions no doubt tempted many a young easterner to go west. The romantic landscape paintings of the Hudson River painters, with their moral or purely aesthetic overtones, had never appealed to the ordinary citizen as did these vivid theatrical displays. There was nothing in them to scandalize the Victorian moralist in the audience, and the works could be further praised for their educational value. Even allowing for the exaggeration of comtemporaneous advertis-

ing — commonly overstated and high-flown — there is every reason to believe these Mississippi River panoramas were indeed impressive.

The earliest known panorama to include the southern Mississippi region was one done by John Banvard (1815-91), a native New Yorker whose great desire from early childhood was to paint the world's largest picture. When he was only sixteen, Banvard and some companions made a number of panoramic paintings at New Harmony, Indiana. The plan had been to exhibit the paintings on a flatboat on the Ohio River, but at Shawneetown this type of transportation proved more than awkward: the raft became caught on rocks, and the producers were unable to get to shore to entertain their assembled audience. That night, while the frustrated artists were sleeping, the swells of a passing steamer freed the raft. When they awoke, they found themselves stuck on a sandbar downstream.

From Henry Lewis (1819-1904), then a stage

to be in the midst of the great fire, with flames soaring, roofs falling and people fleeing."[7] His fame as the creator of this work won Collins a commission to paint similar historic works for a number of other large cities — Sydney, Melbourne, San Francisco, Denver, Philadelphia, New York, London, and Glasgow. For several years after 1890 Collins served as a penmanship instructor at Iowa State College. In 1918 he and his family moved first to Bement, Illinois, and later to Decatur.

More amazing even than the cyclorama was the mammoth moving panorama. This dramatic production — the first moving-picture newscast or travelog — consisted of a series of scenes painted on an extremely long stretch of canvas unwound from one roll at one side of the stage and onto another roll at the other side. As the canvas passed in front of the audience, a narrator described the events, usually with musical

"The Machinery for Banvard's Moving Panorama." Diagram in Scientific American, *Dec. 16, 1848.*

carpenter and scene painter at the St. Louis Opera House, Banvard acquired the idea of painting the great midwestern rivers in panoramic form. By 1846 he was busy working on one in his Louisville studio, and the following year was ready to exhibit it for the first time. The Boston edition of his descriptive pamphlet (1847) advertised the panorama as a three-mile-long canvas depicting 3,000 miles of the Missouri, Mississippi, and Ohio rivers. Extending from the mouth of the Yellowstone on the Missouri and from the Little Miami on the Ohio south on the Mississippi to New Orleans, the work was billed as the "largest picture ever executed by man!" Following a triumphant tour in the United States, the panorama was taken to Europe and presented in Windsor Castle to Queen Victoria.

In 1833-34 John Rowson Smith (1810-64) was sketching in the Mississippi region, though not until 1848 was his "Leviathan Panorama of the Mississippi River" ready to be shown in Philadelphia. For the first time a panorama depicted the far reaches of the upper river and the Gulf of Mexico. Smith's descriptive pamphlet (Philadelphia, 1848) lists thirty-two views of the corn region, including Galena and the country to the east, the Rock River, Rock Island and Fort Armstrong, Nauvoo, the islands near Hamburg, the mouth of the Illinois River, the town of Grafton, the bluffs above Alton, the American Bottom, and Grand Tower. Smith's sketches of Nauvoo were made while the temple was still standing, and the engravings made from his sketches and three others which appeared in *Graham's Magazine* in 1849 are the only surviving pictorial records of Smith's panorama. In his engraving of the temple the basement bap-

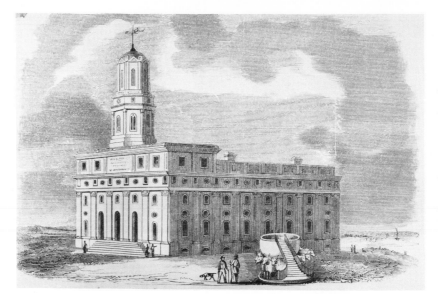

"Mormon Temple, Nauvoo" which appeared in Graham's Magazine *in 1849. This is one of four engraved views made from John Rowson Smith's panorama of the Mississippi River. Smith showed the baptismal font outside the building in order to illustrate its construction.*
ILLINOIS STATE
HISTORICAL LIBRARY

tismal font stood outside the temple — where it showed to better advantage.

In 1847 Samuel A. Hudson's (1813-?) "Gigantic Panorama of the Ohio and Mississippi Rivers" appeared with four separate reels, a combined length of 1,300 yards. It showed views along both sides of the rivers, although from the mouth of the Ohio up to Pittsburgh scenes were mostly of the south bank. Those in Illinois included the mouth of the Wabash, Shawneetown, Cave-in-Rock, Battery Rock, Devil's Portico, Castle Rock, Golconda Islands, the villages of Metropolis and America, and two views of Cairo. After a year-long tour through the Midwest and the East, Hudson's panorama was destroyed by fire in Troy, New York. Fortunately, however, a somewhat shorter copy of it had been made, and this one, taken to Europe by George W. Cassidy, is known to have toured Germany, although today there is no further record of it.

Meanwhile in St. Louis, the originator of the idea of the Mississippi panorama, Henry Lewis, had by 1845 set up a studio with English artist James F. Wilkins (see pp. 163-66). As the mammoth panoramas usually required some assistance, Lewis arranged for a number of other artists and at least one writer to help him. In 1848 he made his way to Fort Snelling, Minnesota, where he built a river craft, the *Minnehaha*, consisting of two canoes bridged with a platform holding a small cabin. Lewis and his companions traveled down the river on this craft, the artist sketching from a vantage point on top of the cabin. The party camped near the Fever River at Galena, where they were joined by an artist named Rogers, who had been making sketches of the lower Mississippi. The party proceeded southward, stopped at Rock Island and Oquawka to sketch the prairie, then proceeded to Burlington and Fort Madison, Iowa. On June 29, 1848, the party paused while Lewis made detailed draw-

Art, Crafts, and Architecture in Early Illinois

ings of the temple at Nauvoo. Sketches made beyond this point include views of Quincy, Hamburg, the area around Grafton, and Alton.

With his sketchbook of the upper river and Rogers's sketches of the lower, Lewis went to Cincinnati, where in 1848-49 he worked on the panorama. Having exhibited it in St. Louis, Peoria, Chicago, in the East, and then in Europe, Lewis married and settled in Europe. He remained in Düsseldorf for the rest of his life and there published *Das Illustrirte Mississippithal* (1854), illustrated with seventy-eight lithographs made from his own sketches and some by Eastman. The river sketches also provided models from which he made some oil paintings. The huge Mississippi panorama itself was said to have been sold to an East Indies planter, but it, like nearly all others, has since disappeared.

There was immense rivalry among the panorama painters, each endeavoring to outdo his competitors in the length, scope, or theatrical effect of his product. Leon D. Pomarède's por-

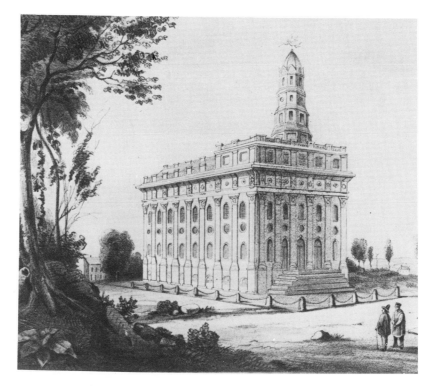

On June 29, 1848, the artist Henry Lewis made a sketch of the Mormon temple for his Mississippi panorama. Later this lithograph was made from it for the Illustrirte Mississippithal.
ILLINOIS STATE
HISTORICAL LIBRARY

View of Quincy, Illinois, from a sketchbook by Henry Lewis, 1848.
MISSOURI HISTORICAL SOCIETY, ST. LOUIS

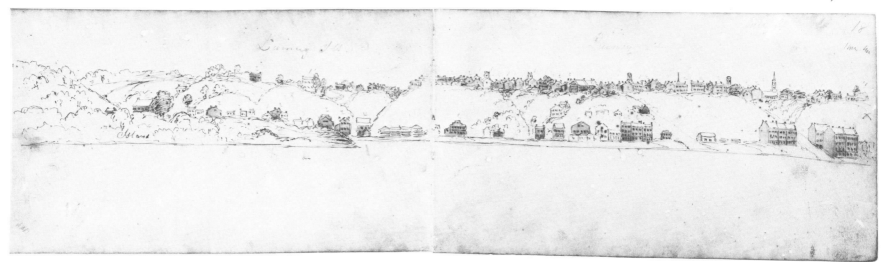

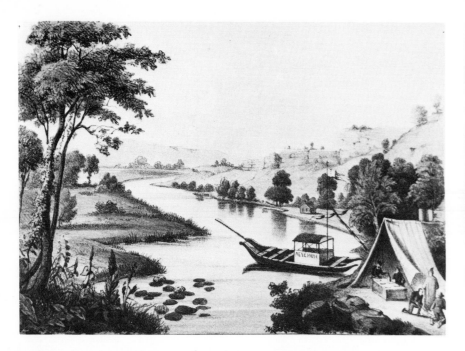

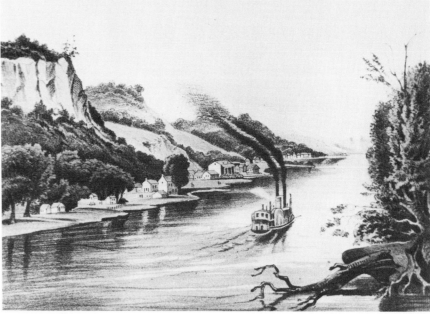

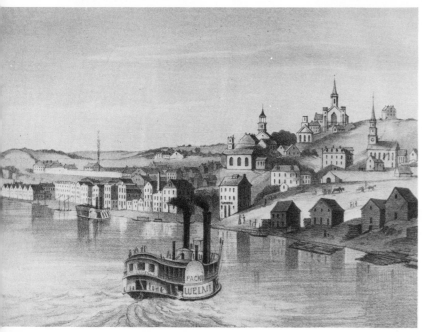

Three lithographs from Henry Lewis's Das Illustrirte Mississippithal. *Clockwise: "Alton, Illinois," "View on Fever River," depicting the artist and companions in camp, and "Savannah, Illinois," showing the rock formations that are part of the Mississippi Palisades.*
ILLINOIS STATE
HISTORICAL LIBRARY

trayal of 1,500 miles of the Mississippi River provided the ultimate in dramatic ingenuity. Arriving in St. Louis in 1832 with the advantages of a formal European art training, Pomarède (ca. 1807-92) gained experience in St. Louis painting window transparencies and murals for St. Louis churches. His father-in-law, Antonio Mendelli, an experienced theatrical painter, apparently gave the young artist additional training.

Starting in 1844, Pomarède spent four years making sketches of the upper Mississippi, accompanied for at least a part of the time by his pupil Karl Wimar. He worked to heighten the effects of his panorama by including dramatic contrasts: the quiet beauty of a lazy river hung over with verdure against the vivid excitement of a prairie fire, or a romantic moonlight scene

Art, Crafts, and Architecture in Early Illinois

Antonio Mendelli's "View of Cairo, Illinois" (1848). Oil painting on paper laid down on canvas.

CITY ART MUSEUM OF ST. LOUIS

against the holocaust of a burning St. Louis. Most impressive of all was the effect derived from the use of special machinery to move painted steamboats separately in front of the main canvas. The boats appeared to be pushing against the current, and simulated steam and smoke gushed from their chimneys. Flatboats floated downriver with the current or were propelled upstream by poles. Another of Pomarède's innovations was the "dissolving view," a scene which passed from moonlight to sunrise, or before-and-after views of the St. Louis fire. The panorama, finished by the summer of 1849 at a cost of $6,000, opened in St. Louis on September 19 accompanied by a lecturer and the combined music of piano and violin. Pomarède's

masterpiece toured until November 1850, when it too was destroyed by fire. Only the printed guide that accompanied it remains to testify to the magnificence of the display.

The only known Mississippi panorama still in existence is owned by the City Art Museum of St. Louis. It was shown with appropriate musical accompaniment and stage effects at the museum's exhibition, "Mississippi Panorama," in 1950. The work was painted by John J. Egan about 1850 from the sketches of Montroville W. Dickeson of Philadelphia, who had originated a new concept in subject matter. Primarily interested in natural sciences, Dr. Dickeson approached the Mississippi and Ohio rivers intent on portraying their archaeological, botanical, and geo-

Discovering the Landscape

"The Tornado of 1844. . . ." Painted by John J. Egan from drawings by Dr. M. W. Dickeson.
CITY ART MUSEUM OF ST. LOUIS

logical aspects. According to his handbill, Dickeson had opened more than 1,000 Indian mounds while in the region, collecting some 40,000 Indian objects, many of which were displayed as part of the panoramic entertainment.

The first reel introduced the audience to Cave-in-Rock, the great cavern on the Illinois bank of the Ohio River that had once been a shelter for Indians and a secluded hiding place for river pirates. Egan's painting described an imagined view of the area's exploration by torchlight. Strange crystalline formations actually glittered where the artist had applied mica and tinsel onto the painted surface. Skeletons, mummified bodies,

and mysterious petroglyphs on the rock walls heightened the effect of eeriness and no doubt thrilled the viewers. Following such imaginative scenes of the past were depictions of contemporary events. One showed a family caught in the savage fury of the tornado of 1844 — a storm especially destructive to a twelve-mile stretch of Jackson County in Illinois. Primarily an educational show, the panorama was designed by Egan to hold its audience in moods of delight, fear, and awe through artful dramatics. Romantic moon-

light, mysterious shadows, and exaggerated action intensified the theatrical effect.

Although fire was always a source of danger to the seven known Mississippi River panoramas, most of the bulky, hard-to-handle productions were probably destroyed or cut up when they had outlived their usefulness. A large painting in the Madison County Historical Society

The above is a faithful representation of the Artist—Mons. Andrieu.

The only known panorama including a trip through central Illinois. Illinois Journal, *Feb. 24, 1854.*

Art, Crafts, and Architecture in Early Illinois

Museum, Edwardsville, showing the Cahokia Mounds on the American Bottom, may be a fragment of one of them.

There were painters who aspired to yet more vast portrayals of the American scene. In 1854 a Monsieur M. A. Andrieu was exhibiting in Springfield a portion of his panorama of the United States. A large ad in the *Illinois Journal* of February 27 contains a woodcut portrait of the artist and a description of a completed portion of the panorama, depicting a trip from Chicago to St. Louis. It would appear that, having worked his way southward, the artist was at that time sketching Springfield. An ad appearing in the *Springfield Daily Register* on February 27

indicates some lack of enthusiasm in the reception of the exhibition:

Springfield not completed..

Mons. Andrieu, not yet having finished his sketchings of Springfield, will remain in our city this day and to-morrow, for which period, his beautiful panorama will continue on exhibition during afternoons and evenings. That all may be enabled form a correct opinion of what his panorama of Springfield will be, by an inspection of what he has done in the way of sketching other scenery, he has concluded to reduce his admission fee to the low price of 25 cents for a gentleman; 50 cents for a gentleman and two ladies, and 10 cents for children. All should profit by this accommodating offer, and fill the court room to overflowing.

"The American Bottom and the Cahokia Mounds." Unknown artist, 1840-50. Dimensions: 3 by 8 feet.
MADISON COUNTY HISTORICAL MUSEUM

According to A. T. Andreas, "Monsieur Andreau [*sic*], an excellent artist in landscape work, resided here in 1854-55. In the latter year he painted and exhibited a representation of the Garden City, in four sections. His views were taken from the observatory of the Tremont House."[8]

A more exciting subject for panoramas in this day was the Gold Rush of 1848-49, of interest to citizens throughout the entire nation. Not only fortune hunters were drawn to California. Painters, among them at least two artists from Illinois, succumbed to the irresistible lure of the distant West. One of the Illinoisans was James Wilkins, who traveled with the gold seekers and upon his return to Peoria in 1850 painted his "Immense Moving Mirror of the Land Route to California by the South Pass of the Rocky Mountains" (see p. 166). The other was Sheldon Peck's (see p. 163) son Charles (1827-1900). Born in Burlington, Vermont, on May 10, 1827, the younger Peck moved with his family to Illinois at the age of ten. He taught school in his father's house and became interested in landscape painting. The Gold Rush offered exciting opportunities for a young artist, and in 1849 Peck, his brother John, and a friend set out for California. They walked nearly the entire distance, and Peck made many sketches along the way. Once in the West, however, he had little luck finding gold. Consequently, he obtained passage on a clipper ship sailing around the tip of South America to New Orleans, where he painted a panorama from sketches he had made on his travels. According to the *Chicago Democratic Press* in 1853, "It contains 2460 yards of canvas, nine feet in width and shows scenes eighteen feet long and eight feet six inches wide. There are represented 38 cities and towns in California, 5000 miles of country, 40 scenes on the Pacific, Isthmus, Gulf of Mexico and San Francisco and more than 1000 figures of men and animals, many of them life size."[9] Peck toured with his panorama from New Orleans to California, then through the East and Midwest. In Chattanooga a theater fire destroyed the work, and the penniless young artist was forced to apprentice himself to a doctor in order to finance his return to Illinois. Later a lithograph copy of a painting Peck made of Peoria was published in 1858 by Reen & Shober of Chicago.

Peck served during the Civil War as a photographer for the Union Army. He had a photography studio in St. Louis for about a year, and in 1866 he married Harriet Shotwell, who was at that time an art teacher at Rockford Academy. Moving to Chicago, he became a charter member of the Chicago Academy of Design in 1866, and for many years his western sketches provided him with models for landscape paintings of "mountains, gorges, ponderosa pines, big and bold, wild and grand" and also "views of farms with barns and chickens and sheep."[10] Before his death in 1900, Peck painted murals of western scenery for the Great Northern Hotel of Chicago.

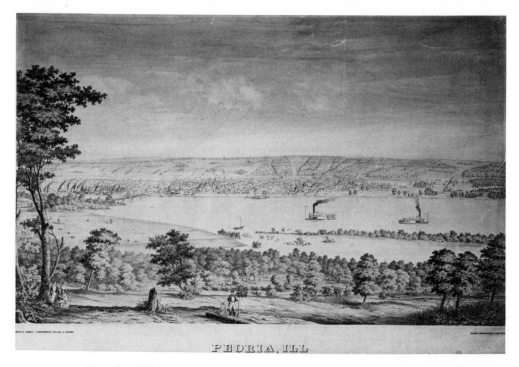

"Peoria, Ill." Drawn from nature by Charles Peck and lithographed by Reen & Shober, Chicago (1858). View of the city from the bluffs across the Illinois River.

18 Swedes on the Prairies

One of the most significant and best-preserved foreign settlements in the United States is the small town of Bishop Hill in northwestern Illinois. Here lies practically unadulterated a rich display of the heritage left by Swedes — immigrants who fled their native land to escape religious persecution. On the other hand, here is a vivid example of the eagerness of most foreigners to become Americans, to adopt the customs of their American neighbors, and even to Americanize the spelling of their names. The changing of names is graphically illustrated on the tombstones of the old settlers.

The leader of the Bishop Hill settlers, Eric Janson (Erik Jansson), had attempted to reform the established church in Sweden. Feeling the need for a return to the simplicity of early Christianity, he had succeeded in attracting a large following. The growing strength of the Jansonists and the fanatic zeal of their leader were not tolerated by the Lutheran authorities in Sweden, and finally about 1,100 of the persecuted Jansonists organized to leave their native land for America. Olof Olson (Olsson) traveled as an advance scout through Wisconsin, Minnesota, and Iowa before locating a suitable site in Illinois for the colony. In Sweden, meanwhile, the Jansonists were selling their farms and depositing the money in a common fund so that, like the early Christians, they might provide for the poor. They followed Janson in sailing ships to Albany, New York, where they transferred to canal boats for passage to Buffalo, and then continued by steamboat to Chicago. There the earliest arrivals purchased wagons and oxen and, with their belongings and infirm in the wagons, walked the entire distance to their new homes on the grove-dotted rolling prairies of Henry County.

By the last of October in 1846 about 400 colonists had arrived at Red Oak Grove and nearby Bishop Hill — named from Biskopskulla, the parish in Uppland, Sweden, where Eric Janson was born. Lacking time and materials to build permanent buildings before winter set in, they erected several log structures. These included a large church in the form of a cross with a canvas roof and some twelve dugouts built into the side of a ravine which ran through the center of the site. Each dugout was constructed with a log front into which a door and two windows were cut. Lined with wooden planks and covered with planks, earth, and sod, these dwellings contained double beds in three tiers along the inner side walls and a large fireplace at the far end of each interior. About 18 feet wide and 25 to 30 feet deep, each dugout accommodated from twenty

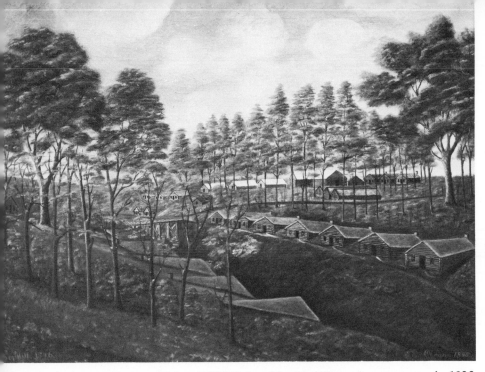

"*First Winter at Bishop Hill.*" *Painted by Olof Krans from memory in 1896.*

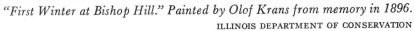

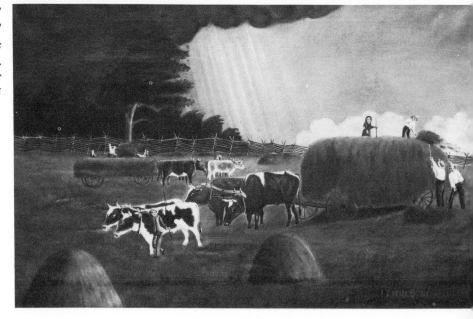

*"Breaking the Sod"
and "It Will Soon Be Here,"
painted by Olof Krans
from memory about 1900.*

to thirty persons. That first winter, the crude, cramped quarters — cold, damp, and unhealthy — combined with the food shortage led to the deaths of ninety-six colonists.

When spring arrived, the Jansonists broke 350 acres of virgin prairie. Eight yokes of oxen drew the thirty-six-inch plows, and the colonists planted their first food crops and flax — a staple crop in their home region in Sweden. Once harvested with scythes, the flax was prepared for spinning into linen thread for the looms. These looms were kept running night and day because the colonists had so few, and the women wove over 12,000 yards of linen material and rag carpeting from that first harvest. As the settlers had sufficient clothing for their own use, they sold the material. That year saw the con-

Art, Crafts, and Architecture in Early Illinois

struction of the community's first frame house, a grist mill, and five new dugouts. Under the direction of a neighbor, Philip Mauk, they learned how to make mortar from chalkstone (found in the sides of the ravine) and adobe bricks mixed with straw. With these materials they constructed several more temporary houses.

Despite discouragement and sickness, each Swedish colonist worked doggedly at the task assigned him for the public welfare. The women were cooks, spinners, and weavers, while the men were butchers, carpenters, and blacksmiths; young "ox boys" hauled supplies by wagon, and girls served as dairymaids. During the busy farm seasons the able-bodied all worked in the fields.

The housing situation continued to be critical, largely because of the constant stream of new arrivals, and Janson ordered celibacy in the colony. In 1848 some of the log houses and the church were destroyed by fire, so the group decided to build a new church of sufficient size to house a part of the congregation. The first fired brick from a new kiln was used in the church foundation. Because of the shortage of men, young women participated in brick making, and on occasion they pressed their scissors into an unbaked brick to leave an imprint, or incised their initials, a complete alphabet, or even a sketch of a spinning wheel in the soft clay.

Upon this brick foundation the Jansonists erected a plain two-story structure of wood with a gambrel roof. The building bore little resemblance to those the group had known in Sweden, having necessarily been designed to accommodate interior apartments. The large timbers of oak and walnut were obtained from nearby Red Oak Grove, but much of the finishing lumber had to be hauled from Peru, Illinois. Adobe

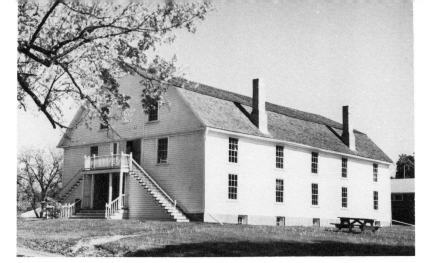

The Bishop Hill church, erected in 1848, and its sanctuary, viewed from the balcony. Because of a shortage of housing, the first floor was divided into apartments (see p. 210).

PHOTOGRAPHS BY
RICHARD PHILLIPS
AND CHARLES HODGE

bricks between the timbers provided additional insulation. Neither the church sanctuary on the second floor nor its anterooms had a fireplace. Reached by an outside double stairway, the sanctuary contained a high pine pulpit and walnut pews with hand-turned maple spindles at the backs and sides. Up to 1,000 persons — men on one side, women and children on the other — could assemble for the services held twice on weekdays and three times on Sunday. The first artificial lighting for the church consisted of hollowed-out sticks filled with lard with a string wick. In time these were replaced by beautiful candelabra made with wrought-iron arms radiating out from a central wooden spindle.

The basement and first floor of the church building were divided into living apartments which allowed one or two rooms to a family (see p. 210). Furniture, regardless of how sparse and plain, was beautifully made. Gracefully turned legs, spindles, and posts or an occasional color contrast obtained by the use of more than one type of wood relieved the severity of such pieces. An occasional bit of gay Swedish folk

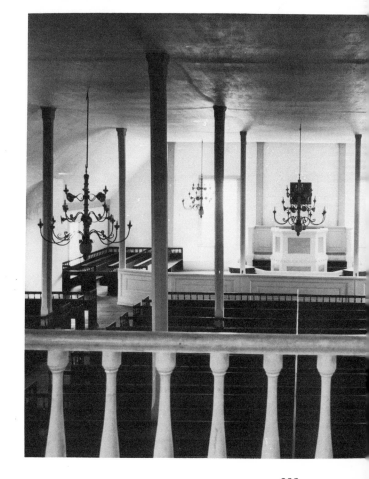

Swedes on the Prairies

233

art might also be seen in a brightly painted baby cradle, a decorated chest, or a precious piece brought from the homeland.

In 1849 the sixth party of Jansonists arrived, swelling the population of Bishop Hill so much that a four-story building was erected to provide additional family rooms. The original building was 45 by 100 feet, but an addition soon increased the size, so that by 1851 it was 200 feet long and had ninety-six rooms. Each of the six front entrances had double staircases leading up to the doors. On the ground floor of this building, called Big Brick, were two large community dining halls (one for children, the other for adults). Table linens, changed three times a week, were the colony's own products. Family apartments on the three upper floors consisted of one or two rooms, and for some time a few rooms were reserved for guests. This building, which burned in 1928, was the largest brick structure west of Chicago and perhaps the first apartment building in the United States outside New Orleans.

In four years Bishop Hill had acquired a total population of about 1,000 residents. Zealously industrious, the Jansonists erected storehouses, barns, shops, and a brick brewery, acquired 13,000 acres of land, and began the manufacture of brooms from their first crop of broomcorn. In 1850 Eric Janson, the iron-handed ruler of the community, on trial for what were considered to be criminal acts, was murdered during a court recess by the irate husband of a Jansonist woman. The town was temporarily stunned, but the return to glorious labor brought relief and an increased productivity. During the winter months of 1850-51 the women wove 28,322 yards of linen and 13,237 yards of rag carpeting. There

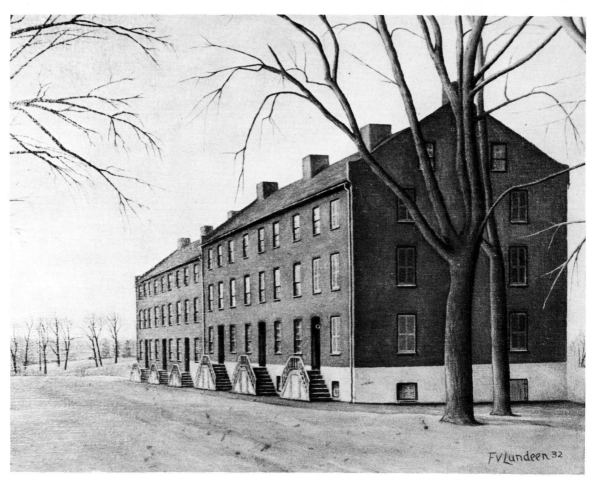

"Big Brick," painted by F. V. Lundeen in 1932.
ILLINOIS DEPARTMENT OF CONSERVATION

were 140 spinning wheels located throughout the colony apartments, and more were situated in the special spinning and weaving establishment. Material for all the clothing, bedding, carpeting, tablecloths, towels, and undergarments for the entire colony was produced on these looms. Some of the linen was quite fine, but it was the coarser variety that was in real demand. This, along with carpeting, was peddled around the country for cash, or it was traded for items not produced in the colony. Originally, woolen

materials, like the linen, were left in their natural colors or bleached white in the sun. A member of the colony was eventually sent to the Shakers at Pleasant Hill, Kentucky, to learn the art of dyeing with fast colors, thereby permitting the introduction of bright colors into materials. Twice yearly a dressmaker visited the colony to teach the women to cut and sew clothing for

Art, Crafts, and Architecture in Early Illinois

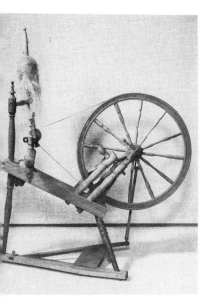

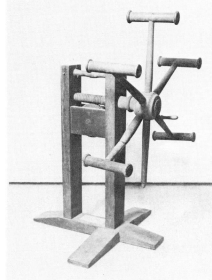

A flax wheel and a yarn winder made at Bishop Hill about 1850.
ILLINOIS DEPARTMENT
OF CONSERVATION

Pine desk from Bishop Hill grained to resemble oak.
HENRY COUNTY HISTORICAL MUSEUM

themselves and their children, and once a year the colony tailor turned out two suits of home-spun wool for each man plus a pair of jeans for everyday wear. From hides processed at the colony tannery, a shoemaker was able to supply each colonist with two pairs of shoes a year.

With commerce increasing, Bishop Hill became the largest business and industrial center on the busy route between Peoria and Rock

A settee which converts to a bed when part of the seat portion is pulled forward; a banjo clock with iron works made by Sven Bjorklund, 1855, of pine grained to simulate mahogany; a rocking chair originally painted black and decorated with Swedish designs painted in white.
PHOTOGRAPH BY CHARLES HODGE

Bishop Hill cradle.
ILLINOIS DEPARTMENT
OF CONSERVATION

Bishop Hill table now at the Henry County Museum.

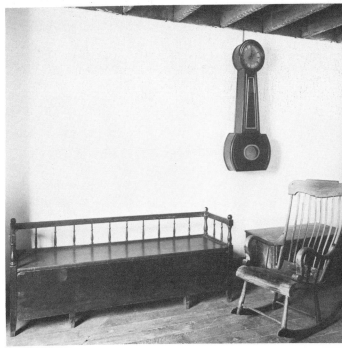

Imprint of scissors on a brick. Found in the ruins of Big Brick after it was destroyed by fire in 1928.

Bishop Hill common chair of hickory and pine, originally painted black.
MR. AND MRS. REYNOLDS EVERETT
COLLECTION

One of a pair of communion tables made for the Bishop Hill church.
ILLINOIS DEPARTMENT
OF CONSERVATION

Swedes on the Prairies

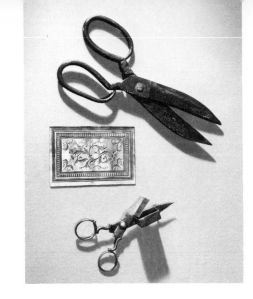

"Plowing and Sowing." Painted from memory by Olof Krans.
ILLINOIS DEPARTMENT OF CONSERVATION

Island. Horse-drawn steel plows had been sub-
stituted for crude ox-drawn plows, and the
turkey-wing cradle which had replaced the scythe
was itself replaced by modern machinery. A
hotel, built in 1850 to house visitors at Bishop
Hill, was a far more sophisticated structure than
the earlier unornamented ones. The building had
a stylish two-stage cupola, later surmounted by
a painted tin eagle. Inside, black walnut stair-
cases with graceful, slender spindles rose to a
large upper-level ballroom.

In 1853 the Bishop Hill colony became a legal
corporation under the laws of the state of Illinois.
No longer under the rule of a single individual,
it retained nonetheless many of its communal
ways. A board of seven trustees administered to
the needs of the colony from a fund that included

*Clockwise: a copper teakettle made at Bishop Hill; metal
products of the colony, about 1849-50, including iron shears,
a copper die used to stamp the leather cover of
Eric Janson's hymnbook, and a brass wick trimmer; and a
Bishop Hill Hotel lantern.*
PHOTOGRAPHS BY RICHARD PHILLIPS; CHARLES HODGE; INDEX OF AMERICAN DESIGN

Official stamp of the Bishop Hill colony.
INDEX OF AMERICAN DESIGN

Art, Crafts, and Architecture in Early Illinois

*Painted tin eagle
made about 1860 by a tinner named Neumann
for the Bishop Hill Hotel.*
MRS. GUNNAR BORG COLLECTION

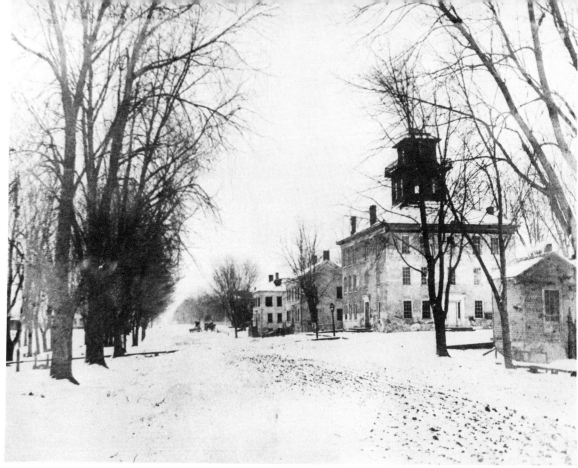

A street in Bishop Hill, 1865. The large building with the cupola is the hotel, erected in 1850.

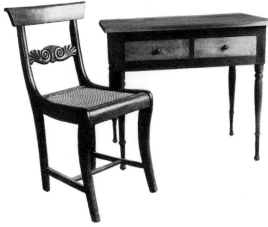

A cherry Empire-style chair made for the hotel dining room, and a common table.
ILLINOIS DEPARTMENT OF CONSERVATION

all property and whatever money was acquired from community industry.

The ravine in the center of town was filled in and a park was planted. Brick buildings included a meat storage building and a colony store erected in 1853, plus a dairy and a hospital built in 1855. The town had a harness maker and a tinsmith, a coppersmith, and a silversmith. The directors, well aware of the importance of impressing possible customers, made the hotel a showplace with fashionable Empire-style furniture made in Bishop Hill. There was even gold wallpaper in some of the

rooms. The hotel guests were provided with music and dancing facilities, and, although such frivolous activities were strictly forbidden to the colonists themselves, it is said that some of the younger men carved fiddles for themselves and sneaked off to the grove to enjoy their own music.

The most impressive building exterior in Bishop Hill was that of the Tornbygen (Steeple Building). Erected in 1854, the building was intended to be a second hotel but came to be used instead for additional apartments, offices, and schoolrooms. Far more elegant than any of the town's previous structures, the Steeple Building was equal in splendor to many an edifice in larger Illinois cities. The architectural trend of the building was Italianate rather than Greek Revival, resembling some of the plans of the noted Italian Renaissance architect Palladio. Pilastered and pedimented with finely turned wooden balustrades, beautiful wrought-iron railings, and an imitation stone wall up to the second-floor level, it constituted the epitome of elegance for a small town. An octagonal tower held a great clock constructed by three colonists — Lars Soderquist, Swan (Sven) Bjorklund, and Peter Blomberg. Its four faces and hour hands were made of wood; the works — of brass and iron — were patterned after the works of a grandfather clock made by Soderquist in Sweden and later set in a Bishop Hill case. Constructed in 1857, the tower clock had a pendulum fourteen feet long, and the two iron weights suspended from the tower reached ground level when at their greatest length. Once a week this great clock was wound by means of a large crank. Its four wooden dials, each of which was four feet across, held only hour hands (min-

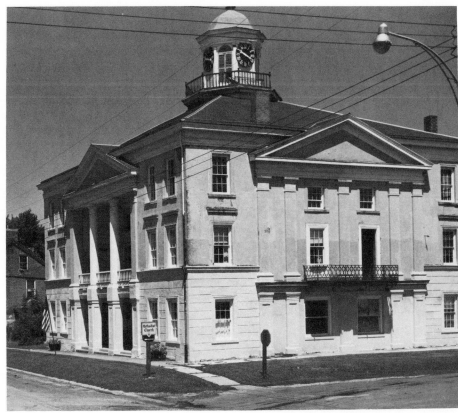

The Tornbygen or Steeple Building, erected in 1854.
PHOTOGRAPH BY THE ILLINOIS DEPARTMENT OF CONSERVATION

utes meant little to the Bishop Hill colonists), and a bell tolled the hours for workers in the fields.

In 1854-55 one of the first Illinois railroads in the area was laid a few miles southeast of Bishop Hill. The advantages of a relatively close and efficient means of transportation for colony products — such as broomcorn, which was later shipped as far as New York — was quickly realized by the colony trustees. In the minds of these exploiters of manpower, the distance of seven miles from the community was considered a distinct advantage: the marvel of the railroad,

Town house designed by Palladio, the Italian Renaissance architect, and constructed at Friuli, Italy, in the 1500s. Compare it with the Steeple Building.

Art, Crafts, and Architecture in Early Illinois

A wrought-iron bracket on the Steeple Building.

Cupola of the Steeple Building showing the clock, a weather vane, and a bell which rang the hour.
PHOTOGRAPH BY EARL REED FOR THE
HISTORIC AMERICAN BUILDINGS SURVEY

Lars Soderquist made the works of this grandfather clock in Sweden. Later the works served as a model for the huge works of the steeple clock.
BISHOP HILL
HERITAGE ASSOCIATION

A cradle made at Bishop Hill.
HENRY COUNTY HISTORICAL MUSEUM

A convertible pine and walnut couch, or utdraggssoffa.
ILLINOIS DEPARTMENT
OF CONSERVATION

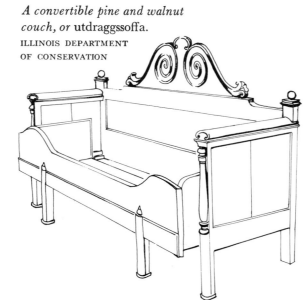

with its easy access to the outside world, was not so apt to lure the isolated Bishop Hill colonists from their labors. The trustees then bought fifty lots on either side of the railroad tracks and began to construct a warehouse for the storage of material to be shipped, plus a store and another hotel for outsiders who might wish to buy merchandise or visit the community. The station was called Gefle — from a Swedish seaport of the same name — but was soon corrupted to Galva by the American settlers; it is by this Americanized name that the town is still known. Meanwhile, in 1857 a seven-forge blacksmith shop was erected in Bishop Hill. The upper level of this brick structure became a carpenter shop for the manufacture of small pieces of furniture and spinning wheels. A brick carriage and wagon shop with a second-floor paint shop was constructed close by.

Despite the feverish industry of the colonists, prosperity did not remain long in Bishop Hill. The new railroad, advantageous insofar as it transported colony products to other widespread points, also worked to the disadvantage of the town, bringing cheap new goods into the area to compete with the colony products. The colony soon found itself in debt, not only because one trustee had squandered large amounts of town funds, but also because of the widespread bank failure during the 1857 depression. Upon the demand of the colonists, the corporation was dissolved, and in 1861-62 the communal property of the Bishop Hill colony was divided among its members. Many residents moved away, and by the late 1800s once-prosperous Bishop Hill was reduced to a tiny village of some 200 inhabitants, its houses in neglect and its shops empty.

Despite the eventual failure of the colony,

some of its former members retained fond memories of the simple life and customs of early days. One such colonist provided a unique collection of memoirs depicting life in Bishop Hill: Olof Krans (1838-1916), born Olof Olson, had traveled from Sweden with his parents to Bishop Hill in 1850. At first he worked as an ox boy; later he did various chores in the paint shop and the blacksmith shop. Enlisting during the Civil War (see p. 210), he changed his name to Krans, and upon returning to Bishop Hill the following year he found that many other things had changed as well. His sweetheart had married someone else, and the corporation had been dissolved. Ill and discouraged, he remained for a time in Bishop Hill, working as a clerk and then as a daguerreotypist.

Krans's natural talent for painting and drawing had revealed itself when he was a boy in Sweden. He had refused an offer of formal training, as it would have required his family to go to America without him, but Krans was at last able to utilize his native skill upon leaving Bishop Hill for Galesburg, where he became a house, sign, and ornamental painter. His services were quite popular, and he was able to indulge his fancy freely in painting on walls and furniture the then-fashionable ornamental motifs: trailing vines, simulated inlay, artificial woodgraining, marbleizing, and an occasional eagle. In 1867 Krans and his wife moved to Galva, where he painted the ceiling of the Swedish Lutheran church to resemble a blue sky sprinkled with gold stars. He also painted road signs, scenery for the Galva Opera House, and a drop curtain for its stage.

Toward the end of the century Krans, having injured his leg in a fall, started painting pictures

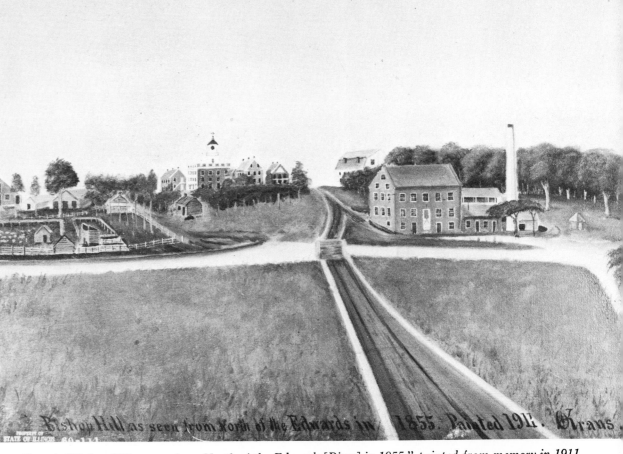

Krans's "Bishop Hill as seen from North of the Edwards [River] in 1855," painted from memory in 1911.
<small>ILLINOIS DEPARTMENT OF CONSERVATION</small>

of Bishop Hill as he remembered it or scenes of early settlement as they had been described to him by others. One scene depicted the horrible first winter when the colonists had lived in log cabins in the ravine. Another showed the men breaking the tough prairie sod and broadcasting the grain. Still another represented a line of twenty-four women planting corn, digging holes, and dropping the kernels at the spots indicated by knots on a long rope held in front of them

by two men. His paintings of the harvest customs include one of seven reapers with cradles followed by twelve women who are gathering the stalks and tying them into sheaves. The shortage of manpower was dramatized in Krans's painting of women operating a pile driver to construct a bridge over the Edwards River. All was not drudgery in the colony, though, and one jolly scene — titled by Krans "Butcher Boys on a Bender" (see p. 210) — shows a group of boys

Art, Crafts, and Architecture in Early Illinois

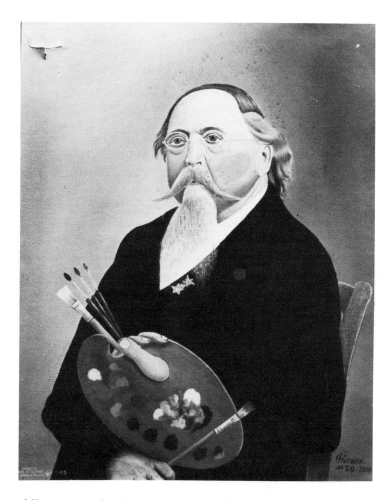

*Self-portrait by Olof Krans
painted in 1908 at the age of seventy.*
ILLINOIS DEPARTMENT OF CONSERVATION

*Bishop Hill women driving piles
for a bridge over the Edwards River,
painted by Olof Krans.*
ILLINOIS DEPARTMENT OF CONSERVATION

Krans — copying pictures, calendars, advertisements, even Christmas cards — produced an amazing quantity of work. Whether copying or producing original scenes from memory or imagination, he betrayed his lack of formal training in canvases which are naive, at times grotesque, frequently amusing, and yet most often delightful. Beyond any aesthetic appeal, the paintings are valuable as historical records of the life and customs in an unusual Illinois prairie colony. Many of these — which comprise one of the largest groups of primitive paintings by any one man of nineteenth-century America — are still housed at Bishop Hill. Together with

riding on a sleigh behind two gaily galloping oxen.

In addition, Krans painted a series of portraits of the colonists undoubtedly copied from daguerreotypes, some of which he may have taken himself during his years as a daguerreotypist. Those portraits which are characterized by their singular stiffness and lack of color would appear to be such copies, while portraits of himself or his mother — more colorful and pleasant in appearance — are probably from sittings.

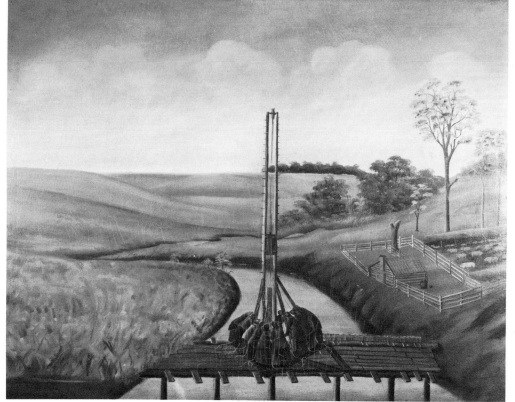

the colony church and the Bjorkland hotel, they are the property of the state of Illinois. The old church has been restored to its original appearance; newly exposed in the second-floor sanctuary pulpit is some of the artificial marbleizing executed about 1849, and on the lower floor is a theater screen Olof Krans painted for the town auditorium.

After the Bishop Hill colony was dissolved, the town slept quietly for more than three-quarters of a century. Following the fire in 1928 which destroyed Big Brick, the roofs of other buildings were in danger of caving in, and residents of the old apartment buildings struggled to keep them in repair. In 1946 the church was acquired by the state of Illinois, and a later group of local citizens — in an effort to save the town's remaining structures — acquired the Steeple Building for use as the Henry County Historical Museum, and the Bishop Hill Heritage Association purchased the blacksmith shop.

The example of Bishop Hill encouraged further migration of Swedes to Illinois; they settled in great numbers at Andover, Galesburg, Rock Island, Elgin, and Rockford. The Erlanger Museum in Rockford exhibits a number of examples of Swedish folk arts, in addition to later products from the famous furniture factories of Rockford. In the former watch factory at Elgin there were many Swedes among the most expert of its

The Jenny Lind Chapel at Andover, Henry County. A plaque at the door reads: "The first house of worship of the Swedish Evangelical Lutheran Congregation of Andover, Illinois . . . dedicated on Advent Sunday, December 3, 1854, and named after the noted Swedish singer whose generous interest helped to make this structure possible."
PHOTOGRAPH BY
RICHARD PHILLIPS

craftsmen. However, the most extensive example of the unique heritage left by Swedes in Illinois is still in the little town of Bishop Hill with its thirteen remaining colony buildings, its collection of paintings by Olof Krans, and many of the original farm tools and furniture of the Jansonists. Some of this furniture still bears the durable red ocher and buttermilk paint which preceded modern casein paints; others are of natural wood polished to a soft patina with alcohol and linseed oil. There are sturdy pieces in the old Swedish tradition and also frank imitations of popular American styles — painted Windsor-type chairs, cannonball beds, Empire-style chairs with carved backs and cane seats, and cupboards and chests painted with the popular artificial woodgraining. Such articles and hundreds of others produced in the busy shops and apartments of Bishop Hill provide a priceless insight into the fine craftsmanship and amazing productivity of the Swedish settlers in the Midwest. They reveal to modern Americans a stage in the evolution of this nation and show in fascinating detail the environment of the "common" people, who comprise one aspect of this country's history.

19 End of an Era

By 1850 Illinois was moving toward wealth and greatness with ten incorporated cities: Chicago (29,963), Quincy (6,902), Galena (6,004), Peoria (5,095), Springfield (4,533), Alton (3,585), Pekin (1,678), Bloomington (1,594), Beardstown (1,583), and Rock Island (1,711). The state's total population was 851,470, of which about 92,600 were foreign-born. Thirty-eight thousand were Germans, who were now living in practically all sections of the state, especially Belleville, Quincy, Nauvoo, Havana, Bath, Peoria, Chicago, and in Mason, Pike, Woodford, and La Salle counties. In addition there were 28,000 Irish, 18,600 English, 4,500 Scotch, and 3,500 Scandinavian settlers. More than half of Chicago's population was foreign-born.

Throughout the state sheep were raised for wool, and nearly every county produced flax. In the production of pottery, Illinois followed only Pennsylvania, Ohio, New York, and New Jersey; it was sixth in the nation in the number of tin and sheet-iron works and twelfth in the value of homemade articles. The chart on p. 244 from the U.S. Industrial Census gives an indication of the various types of industrial establishments in the state in 1850.

Illinois' chief city, Chicago, was already the greatest primary wheat depot in the world, and would in the next decade replace St. Louis as the main marketplace of the West. The city had become an especially important center for the manufacture of farm implements of every description: Cyrus McCormick's reaper factory alone employed several hundred men. Blacksmiths and coach makers were hard pressed to meet the demand for their services. Brickmakers were manufacturing millions of bricks for new buildings; some structures were even being built of Athens Marble — a fine building stone that had been discovered in 1846 near Lemont, on the banks of the projected Illinois-Michigan Canal (completed in 1849). In September of 1850, Chicago was lighted with gas for the first time, and almost ten miles of plank streets had been completed. In three years Chicago would have its first omnibus service (Franklin Parmelee). In five years 300 melodeons would be manufactured (R. G. Green), and the city would have its first piano factories (Knaub & Sons, H. Stone, and John Preston). In addition, it would have the only woodware manufactory in the West and the largest in the United States. According to the historian Bessie Louise Pierce:

Chicago was not a beautiful city. There could be few fine buildings, wide promenades, and well-laid streets while Chicagoans were so hurried. The city had sprung up in less than a generation and city beautification takes longer than that. To be sure, some attention had been paid these matters, and where improvements had been made gratification and pride followed. When plate glass windows were put in store fronts in the early 'fifties, the press remarked on the significance of the change and in doing so noted not only the commercial value of better displays but the improved appearance of the buildings.[1]

Nevertheless, the city had at least one fine hotel for its day. At five stories, the Tremont House was the highest brick building in Chicago.

Furnishings alleged to have cost $30,000, mantles of Egyptian marble, stucco "elegantly done" by Chicago artists, transoms over the doors to improve ventilation, and both lower and upper sashes of the windows "hung on pullies" to be opened or closed at will seemed the quintessence of comfort and elegance. Damask curtains lined with silk, rosewood and mahogany chairs in the parlors, drinking fountains in the halls, steam counters in the kitchen, bedrooms so well furnished that a bachelor would "never miss the comforts of home," not to mention a Jackson Annunciator and speaking tube in each room, commended the Tremont to the well-to-do.[2]

MANUFACTORIES IN ILLINOIS IN 1850[a]

No.	Type of Establishment	Male	Female	Cost of Labor	Value of Product
84	Agricultural tool makers	646	..	$216,060	$ 761,970
2	Asheries (producing ashes for pot-ash)	5	..	1,164	4,400
31	Bakers	85	..	21,216	148,807
2	Basket makers	3	..	960	2,400
387	Blacksmiths	807	1	207,180	248,256
4	Bookbinders and blank book-binders	12	..	3,336	12,000
182	Boot- and shoemakers	638	10	193,220	478,925
1	Box maker	2	..	252	1,000
1	Brass foundry	6	..	1,800	9,000
28	Breweries	85	3	18,936	162,411
59	Brick makers	399	3	93,936	135,160
20	Broom makers	50	4	12,756	40,620
1	Brush maker	650
140	Cabinetmakers	550	..	173,352	357,203
49	Carpenters and builders	109	..	29,096	75,097
18	Carriage and coach builders	100	..	30,288	71,285
1	Cement factory	3	..	360	3,000
14	Chandlers (candle and soap man-ufacturers)	66	..	19,200	184,739
12	Charcoal makers	21	..	3,120	10,765
8	Coal mines	76	..	30,984	71,135
241	Coopers	879	..	263,940	435,483
8	Confectioners	22	1	7,920	46,720
1	Daguerreotypist	2	..	384	2,000
31	Distilleries	188	3	30,052	822,659
316	Flour and meal mills	848	3	242,976	5,781,483
2	Glove makers	6	65	6,720	26,500
1	Gunpowder mill	4	..	1,200	8,000
14	Gunsmiths	23	..	8,484	18,398
1	Hardware factory	2	..	480	2,000
18	Hat and cap makers	34	53	20,988	78,257
27	Iron foundries	279	..	94,908	347,180
2	Iron furnaces (ore smelters)	150	..	39,600	93,600
2	Iron mines	20	..	6,000	10,000
93	Lead mines	113	7	33,072	634,725
19	Lime kilns	82	..	19,752	48,366

No.	Type of Establishment	Male	Female	Cost of Labor	Value of Product
1,306	Lumber, saw, and planing mills	468	..	$432,995	$1,324,484
22	Machinists and millwrights	218	..	80,772	247,595
2	Match makers	10	..	1,300	3,040
2	Medicine, drug, dyestuff pro-ducers	8	..	1,200	50,600
7	Milliners	...	26	4,632	32,500
1	Mirror and picture framer	18	..	6,480	15,000
10	Castor oil refineries	33	..	8,820	62,050
1	Linseed oil refinery	1	..	360	4,600
1	Paper mill	13	5	5,400	39,600
25	Potteries	77	..	19,080	48,376
11	Produce (beef and pork) packers	245	..	103,380	496,302
7	Printers and publishers	27	..	6,300	18,475
3	Rope, bagging, cordage makers	10	..	2,832	9,500
135	Saddle and harness makers	473	2	127,344	444,482
1	Salt boilers and refineries	3	..	720	6,000
14	Sash and blind makers	80	..	24,144	68,550
27	Shingle makers	76	..	22,560	50,314
1	Shipwright and boat builder	4	..	1,920	2,500
14	Silversmiths, jewelers, watchmakers	23	..	7,140	26,985
24	Stone carvers, marble quarries	19	..	6,000	14,200
61	Tailors and clothiers	351	..	132,432	441,897
89	Tanners and curriers	243	..	54,924	337,384
82	Tin and sheet-iron factories	224	..	70,944	261,400
17	Tobacconists	57	..	17,208	69,780
1	Trunk and carpetbag maker	4	..	960	5,400
2	Upholsterers	6	..	1,560	12,000
9	Wood turners	20	..	6,144	13,535
206	Wheelwrights and wagon makers	701	..	206,892	472,155
1	Whip and cane maker	1	..	240	500
1	Woodware maker	2	..	600	1,625
60	Wool carders	107	..	23,700	170,025
19	Woolens: carders and fullers	118	55	40,872	200,845
1	Woven wire maker	1	..	300	3,000

[a] The figures given are for shop and factory products only and therefore do not include products made in the home. They are not to be taken too literally because of the inaccuracy of early census taking.

Art, Crafts, and Architecture in Early Illinois

At mid-century, music and penmanship were generally accepted in the Illinois public school curriculum. The Western Museum, erected in 1845 a few doors east of the Tremont House, was advertised in the local newspapers as containing "the best collection of specimens in the West, including an extensive variety in geology, mineralogy, chronology, and ornithology." The museum aspired as well to exhibit "the beauties of art"; there were, therefore, "several groups of wax figures and a superior collection of cosmoramic views." In 1849 the museum passed into the possession of Thomas Buckley, who established Saturday afternoon matinees so that families and school children could view the collection, which at that time included a group of wax figures representing the Judgment of Solomon. One figure was said to represent Queen Victoria.

West's large painting entitled "Christ Healing the Sick" — exhibited in Chicago in 1850 — attracted little attention, but a piece of sculpture displayed the same year aroused a good deal of interest and discussion. Entitled "Greek Slave," it portrayed a nude woman in chains. The sculptor was Hiram Powers of Cincinnati, who had worked in Florence, Italy. Although statues of nude figures in the classic style of Greece and Rome had now become more or less accepted in the East, the reaction of many Chicagoans was one of shock.

Exhibits in Chicago of such sensational art failed, however, to draw the public in the numbers that other entertainments did. Drama became a permanent feature of Chicago life when, on June 28, 1847, John B. Rice of Buffalo opened a new theater. It boasted a stock company which performed *Hamlet, Romeo and*

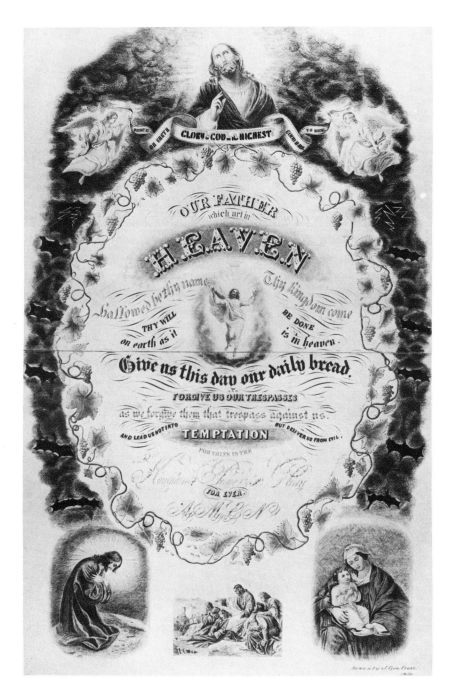

"The Lord's Prayer" (1859), a decorative pen-and-ink drawing by Professor J. George Cross of Aurora, an expert in the art of Spencerian script being taught in the schools at mid-century.

Juliet, Othello, and *Macbeth,* interspersed with comedies, performances of Christy's Minstrels, and evenings with dancers and musicians. During its second year Rice's theater imported such theatrical celebrities as James H. McVicker, Dan Marble, Edwin Forrest, and Junius Brutus Booth. The theater burned in 1850, but two years later a dramatized version of *Uncle Tom's Cabin* was performed in the new house. Popular amusements in Chicago included Winter's Chemical Dioramas, exhibitions at the museum, and the appearance of General Tom Thumb, the nationally celebrated midget and main attraction of P. T. Barnum's circus.

The smaller cities in the state were also provided with amusement. Rice's company toured Aurora, Naperville, St. Charles, and other communities. As early as January 1845, Springfield citizens were treated to such imported attractions as "Messrs. Sauvinet & Co.'s Prominade Concert; Mr. Munson's Juvenile Concert; the concerts of the Congo Serenaders; the Exhibitions of West's Painting of 'Death on a Pale Horse,' the exhibition of the Painting of 'Christ Healing the Sick,' a splendid copy of West's Painting by a citizen of Adams County [probably that of John Quidor]; the Exhibition by Mr. Higby of his Gallery of Paintings. . . ."[3]

The quality of the state's culture was improving. Comments on contemporary American art and artists occasionally appeared in city newspapers, and literary figures of national fame were encouraged to visit Illinois: such noted authors as William Cullen Bryant, Washington Irving, Charles Dickens, Horace Greeley, Oliver Wendell Holmes, Sr., Bayard Taylor, and Horace Mann made appearances. Ralph Waldo Emerson first came in 1850, and three years later he

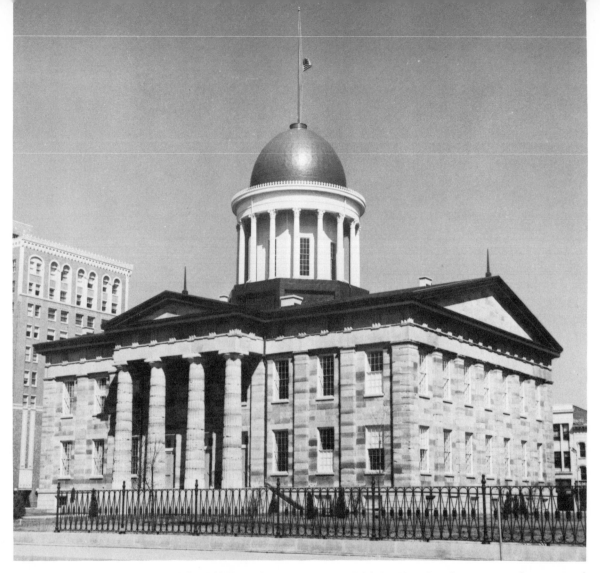

The Old State Capitol in Springfield (1837-53) as it appears today, restored.
PHOTOGRAPH BY RICHARD PHILLIPS

spoke in Springfield on three evenings, on the last of which he discussed the topic "Culture." In 1854 he spoke again on the same topic in Chicago. He later lectured on "Beauty" in Chicago, Rock Island, Freeport, Galena, and Belvidere.

The most distinguished architectural accomplishment of the period was the state capitol at Springfield. The structure had been under construction since 1837, and work was not finished until 1853. The cost for land, construction, and some of the furnishings was about $260,000.

Art, Crafts, and Architecture in Early Illinois

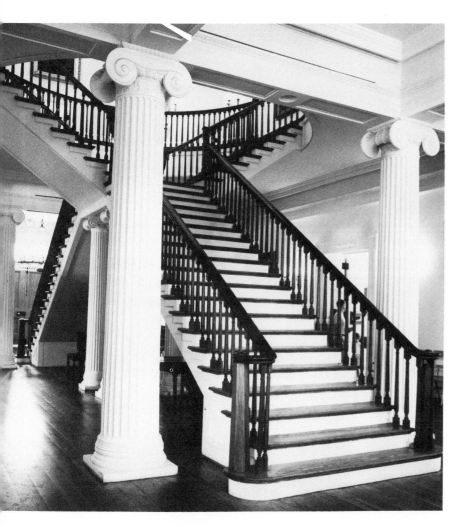

First-floor hall and staircase in the restored Old State Capitol.
PHOTOGRAPH BY
CHARLES HODGE

The House of Representatives in the Old State Capitol.
PHOTOGRAPH BY
CHARLES HODGE

fence around the square. A perfect example of Greek Revival architecture, the structure was an impressive symbol of the democratic fervor of the era, as well as of the cultural achievements, ideals, and aspirations of the growing state. Solid and simple on the exterior, it housed a wealth of beautifully designed details in its main staircase, pristine pillars, and classic moldings and ornamentation.

During the years of its glory, many historic personages moved in the shadow of this building. Stephen A. Douglas and Ulysses S. Grant worked in Springfield during this time, and Abraham Lincoln delivered the memorable "House Divided" speech there in June 1858 upon his

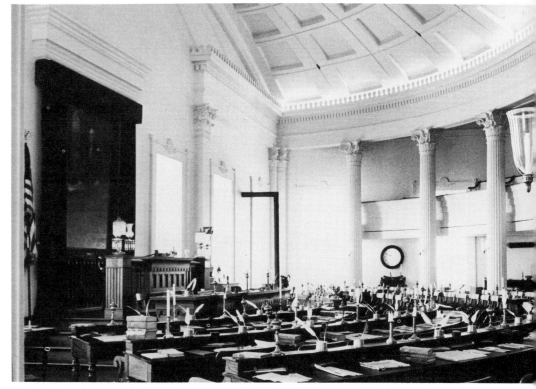

Although the building was far from complete in 1844, both the Senate and House chambers were in use (see p. 157). By 1848 the original copper-sheathed roof and dome had already developed cracks from the prairie wind, and final completion of the building required a new covering of sheet iron. The statehouse, as completed in 1855, was surrounded by plank streets, and there were gaslights in the gateposts of the

End of an Era

Sitting room (left)
and front parlor (below)
of the Abraham Lincoln
home, described as
typical of that
of the average American.
From Frank Leslie's
Illustrated Newspaper,
March 9, 1861.

nomination to the state senate. Lincoln remained in Springfield until February 11, 1861, when he moved to Washington to serve as president. Four years later he lay in state in the House chamber beneath Berry's painting of George Washington. It was, ironically, the same room in which he had so eloquently pleaded in 1858 for the unity of the country and the brotherhood of man.

A survey of Illinois culture of the early 1850s indicates the many changes brought about by the state's rapid population growth, the increasing prosperity of the Machine Age, and the departure from ideals exalting hand labor. Simple handmade products could not compete with the manufactured goods of the cities. Even hand-molded pottery was eventually replaced by work produced in factory molds. The railroads also

Art, Crafts, and Architecture in Early Illinois

America of the 1850s, and the average citizen wanted a dwelling which reflected his personal taste and sense of comfort. The most outstanding proponent of this concept was Ithiel Town, who in 1814 had introduced Christian symbology with the American Gothic design. Twenty years later, in New York, Town formed a partnership with designer Alexander Jackson Davis. Together they encouraged a number of new styles patterned after various foreign precepts. As architect, Town would consult with a client, showing him drawings of such alternatives as the Greek Revival house, the Italian villa, or the picturesque English rural Gothic manor or cottage. He would then advise the client as to which was most suited to his station in life and representative of his ideals. When a type of structure had been agreed upon,

created a situation disadvantageous to many craftsmen. New industries tended to locate near the railroads so as to gain the benefit of efficient transportation of their wares to distant points, while craftsmen who still had to rely on wagons for transportation were gradually forced out of business, drifting eventually into factory jobs.

Changing ideals also brought to an end the popularity of Greek Revival architecture. A new kind of individualism was developing in the

Greek Revival home (1850) of Captain Wells at Geneva. Because early brick tended to disintegrate in time, this house was given a coat of plaster cement.
PHOTOGRAPH BY
RICHARD PHILLIPS

The Gross House in Columbia, built in 1856 by John Gundlach. Features of the house include cast-iron lintels, a decorative entablature of brick, and a recessed doorway.
PHOTOGRAPH BY
RICHARD PHILLIPS

The Greek Revival home of John Hassock, a wealthy Scottish-born grain dealer in Ottawa, La Salle County. Designed by Sylvanus Grow of Chicago, it was completed in 1855.
PHOTOGRAPH BY
THE AUTHOR

working plans would be drawn up by Davis tailored to the client's specific needs and financial resources. The partnership proved to be extremely successful, and through it Town contributed much to the rise in importance of the American architect. By the same token, the status of the builder was lowered, as he was required to work from an architect's plans and specifications. In 1857 the creation of the American Institute of Architects elevated the designer-supervisor still further, although it was not until the latter part of the century that special schools for the training of architects came into existence. The first college-trained architect in America was Nathan Clifford Ricker, who graduated from the University of Illinois in 1873.[4]

Town's influence extended as well into the field of cabinetmaking. He designed Gothic,

Art, Crafts, and Architecture in Early Illinois

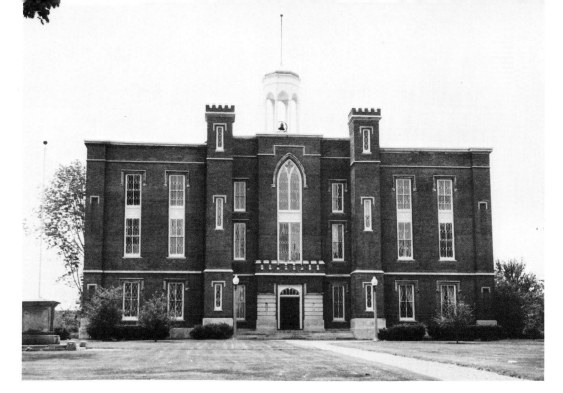

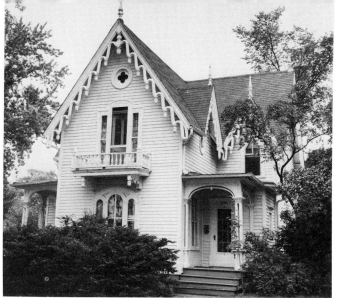

Left: Old Main, Knox College, Galesburg. This Gothic Revival structure was the 1858 site of the fifth Lincoln-Douglas debate. Above: a Gothic Revival house in Marengo features carved festoons, pointed pinnacles and pendants, and a quatrefoil-shaped window.

PHOTOGRAPHS BY RICHARD PHILLIPS

The Daniel Smith Harris house in Galena (left) is typical of English-influenced Gothic Revival. The A. Y. Trogden house in Paris, Edgar County, has an unusually large number of lancet windows, considering its size.

PHOTOGRAPHS BY RICHARD PHILLIPS AND THE AUTHOR

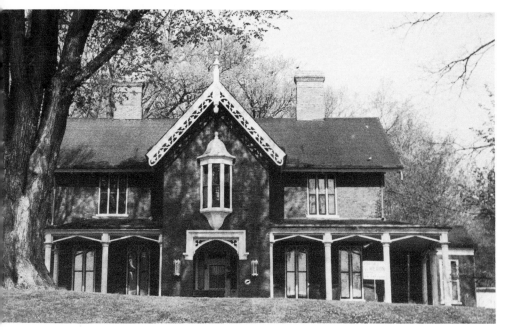

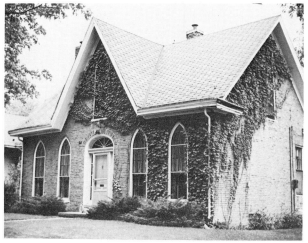

A "fancy" chair, about 1860. The
arched back shows the influence
of Italianate design at the time.
MR. AND MRS. REYNOLDS EVERETT
COLLECTION

Painted loop-back chair, 1850-60,
made in Dixon.
STEVEN MARTIN COLLECTION

"Firehouse" Windsor chair
from Liberty Prairie.
MR. AND MRS. J. E. TRABUE
COLLECTION

Original auditor's desk
at the Old State Capitol.
PHOTOGRAPH BY CHARLES HODGE

Late Empire cherry chest (left)
and sideboard (below)
made in the Belleville area
about 1850.
MR. AND MRS. CLARENCE BLAIR
COLLECTION AND THE ST. CLAIR
COUNTY HISTORICAL MUSEUM

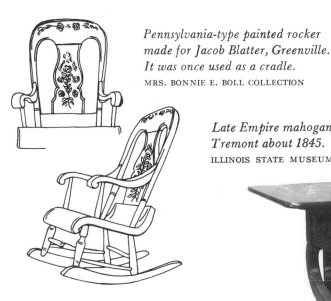

Pennsylvania-type painted rocker
made for Jacob Blatter, Greenville.
It was once used as a cradle.
MRS. BONNIE E. BOLL COLLECTION

Late Empire mahogany veneer sewing table made in
Tremont about 1845.
ILLINOIS STATE MUSEUM

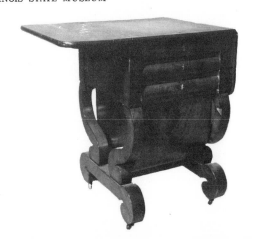

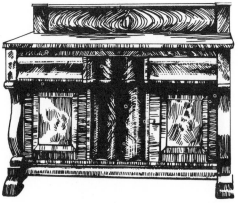

A spool-turned cherry table
made by Benjamin Darneille, Loami, Sangamon County.
IRENE AND MILDRED GARVEY COLLECTION

Art, Crafts, and Architecture in Early Illinois

*Trends in cupboard design, 1840-50.
Note the rounded corners of the
walnut country cupboard (left),
and the trefoil motifs
of Gothic Revival design (below).
Made by Benjamin Cowell in Staunton.*

COLLECTIONS OF ALBERT AKER
AND THE AUTHOR

*Original senate desk designed
by the architect John Francis Rague.*

PHOTOGRAPH BY CHARLES HODGE

*Pedestal-base drop-leaf table
made by George Blackman, Hillsboro,
about 1853.*

IDABEL EVANS COLLECTION

*This walnut spool bed shows Gothic influence in its tall, turned posts.
Notice also the rope springs, the home-woven coverlet, the star-patterned
and "log cabin" quilts. The bed is a furniture factory product, 1850-60.*

HISTORICAL MUSEUM OF QUINCY AND ADAMS COUNTY

*The sturdy legs of this
sewing table combine
turnings with square
central sections. Made by
Benjamin Cowell in
Staunton, Macoupin County,
about 1850.*

ALBERT AKERS COLLECTION

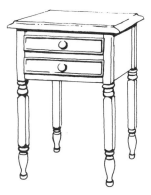

*One end of a three-part walnut
dining table, Pittsfield, Pike County.*

MRS. PAUL GROTE, SR., COLLECTION

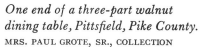

End of an Era

253

Grecian, Egyptian, and Italian furniture to harmonize with his buildings or to serve the particular requirements of various rooms. He thereby contributed to a fall in esteem for the furniture maker, who now merely implemented the architect's designs. Town and later designers eventually published furniture-design books, which lessened the creative aspect of the craftsman's labor. For those workmen who did piecework in the factories, there was an inevitable decrease in pride in the finished product.

Since the 1830s the Gothic Revival style had been used in Illinois for Christian churches, but it is doubtful that many homes of that design were erected in the state before 1850. The Gothic image gradually acquired more cultural and romantic symbolism, especially for the intellectual. It came to be associated with the widely read poetry of Byron and the novels of Scott, which fired the imagination with visions of medieval houses and castles in a setting of chivalry and romance. Eastern architects and designers began to write books advocating acceptance of the style for homes. Some Illinois residents followed their fashion decrees, but because of its association with English wealth and snobbery, the completely Gothic house never gained great popularity with Americans. Nevertheless, certain decorative Gothic motifs were adapted by carpenters and applied to homes so imaginatively that the style is often called "Steamboat" or "Carpenters'" Gothic.

In contrast to the Greek Revival structure — characteristically rectangular and solid with squarish windows and doors, low gables, and heavy horizontal accents — the American Gothic was basically vertical in its accents, with tall, narrow windows and doors, high ceilings, slim

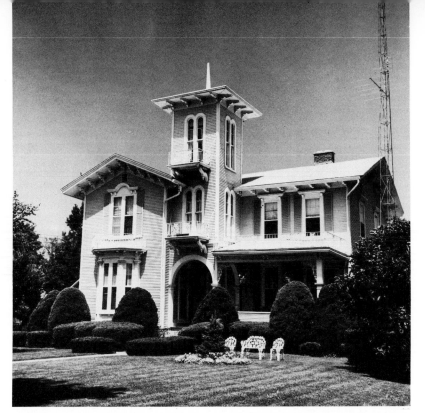

porch posts, steeply pitched gables, and perhaps vertical board-and-batten siding. The Gothic house often included pinnacles on the roof, pointed or lancet-shaped windows, and carved or sawed tracery along gable eaves and between the posts of the porch. This ornamentation in wood was an American adaptation of the stone fretwork on medieval churches and of the decorative but functional wooden trusses in the gables of medieval homes.

Probably the most influential book in architecture affecting the public's taste was Andrew Jackson Downing's *Architecture of Country Houses*, first published in 1850 and in its fifteenth edition before 1880. Despite his awareness of the varying budgets and personalities of his readers, Downing advocated the principles of

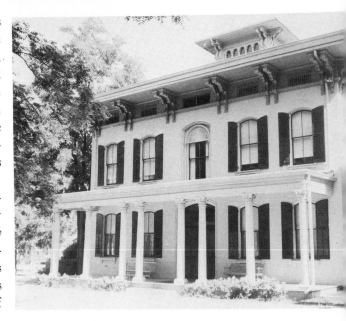

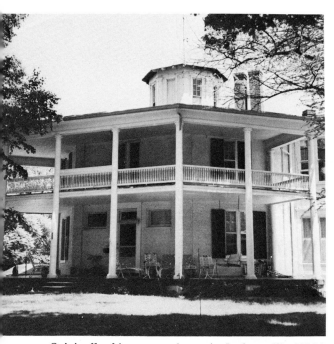

Originally this octagon house in Jacksonville (1854-56) had pie-shaped rooms around a central hall.
PHOTOGRAPH BY RICHARD PHILLIPS

the Gothic in popularity. Remaining houses of this type are easily recognized: the Tuscan villa features a square tower centered at the front of the house or at the corner of an L-shaped structure (see p. 157); the Italianate as a whole is characterized by arched or round-headed windows, porches with lacy arcades, bay windows, fretwork made with the newly invented jigsaw, and wide eaves supported by elaborate brackets which cast interesting shadows onto the building walls.

During the 1850s several other interesting architectural variations appeared in the state. On top of some roofs of Italianate buildings there was a cupola — a feature which had originally been useful as a lookout for ship and riverboat owners, but which also provided a practical means of ventilation for a house on the hot prairie. A rather rare architectural variation in Illinois is the Swiss chalet. But the rarest and most unusual construction is the octagon house, an eight-sided structure advocated by Orsen Squire Fowler of New York. Fowler defended it as being more economical of space than conventional designs and better adapted to receive light and ventilation. Although only a daring man would build a home so radically different from those of his neighbors, twenty or more octagons still survive in the state. They were solidly built of wood, stone, or brick, or of cement poured into molds filled with rubble. The most elaborate Illinois octagon was probably the residence of John Wood of Quincy, designed by Chicago architect Van Osdel and not completed until after the Civil War at a cost of over $200,000.

good design in even the simplest home. He specialized in Gothic, Norman, Swiss, and Italian styles and proposed that rooms be planned according to the convenience of the individual householder, rather than in the set pattern of former periods. He praised the English manner of setting homes unobtrusively among climbing vines and leafy shrubbery. Probably as a result of Downing's *Treatise on Landscape Gardening* (1841) and his journal *The Horticulturist* (1846-52), Chicago became known in the 1850s as the "Garden City," and homes in nearby Riverside were later planned by landscape designer Frederick Law Olmsted to stand amid "gently controlled nature."

In Illinois, the elegant Italian styles surpassed

This octagonal residence of John Wood in Quincy was designed by the famous Chicago architect John Murray Van Osdel. Begun in the 1850s, it was completed after the Civil War at a cost of over $200,000. Fireworks were shot from the roof to signal the fall of Richmond and the victories of Grant and Sherman. The building is no longer standing. From an Adams County Atlas, 1870s.

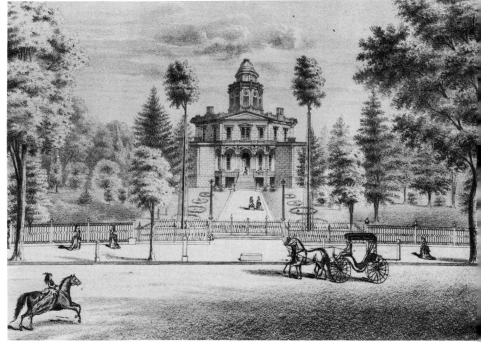

The Machine Age created serious competition for the average artist, whose work could not compete in accuracy with the modern photograph. The daguerreotype camera had been invented in 1839 by a Frenchman, Louis Jacques Mandé Daguerre, and was brought to America by Samuel F. B. Morse, at that time president of the National Academy of Design and himself a distinguished portrait painter. Morse, who was in Paris to secure a French patent for his telegraph, immediately recognized the advantages of the camera as a tool for obtaining an accurate "sketch" that could later be copied as a painting, engraving, or lithograph. He made the first photograph of an American building, the Unitarian church in New York City, with the camera he purchased in Paris. One of the first pupils in his photography school, Mathew Brady, was by 1845 working on a project to preserve the likenesses of all the distinguished men in America. With a camera strapped on his back as he traveled, Brady was soon supplying most of the photographs (to be copied as woodcut engravings) for *Harper's* and *Frank Leslie's Illustrated Newspaper*.

A great deal of controversy arose among artists over the advantages and disadvantages of the invention. Morse himself said that he considered the daguerreotype mainly as a convenience to the artist. Many others, however, regarded the medium as a serious competitor, a challenge to their ability to create lifelike appearances. Moreover, many felt that the new mechanical device, despite its accuracy, lacked the artist's capacity to capture the true character — the "soul" — of the subject, the subtler moods, the changes of light and its reflections. Lacking human inspiration and feeling, it could not be considered

a valid art form. Nevertheless, work in the medium continued, and an important step in the progress of photography, the invention of the wet plate, was announced in 1851 by an English sculptor, Frederick Scott Archer. By this process an image could be fixed on a glass plate from which innumerable reproductions could be made, and transparencies as large as 25 by 50 inches.

In 1853 the first magazine photograph appeared. The tintype and the life-size portrait photograph, which was often tinted with color by the photographer, also became commonplace. By October 27, 1859, it was declared by *Harper's Weekly:* "The vocation of the portrait painter is not gone but modified. Portrait painting by the old methods is now as completely defunct as is navigation by the stars." The photographer was even beginning to refer to himself as an "artist," and his rooms of photographs were now called an "art gallery."

Many photographers worked in Illinois during the 1850s. One of the most noted was Alexander Hesler, who, while living in Galena in 1853, won several medals at the Crystal Palace Exhibition in New York. Hesler moved to Chicago in 1855, already a photographer of some repute. In 1857 he took a photograph of the beardless Abraham Lincoln, who was in Chicago to attend to one of his law cases and to campaign for the new Republican party. Later, as president, Lincoln commented: "This course, rough hair of mine was in a particularly bad tousle at the time and the picture presented me in all its fright. After my nomination, this being about the only picture of me there was, copies were struck to show those who had never seen me how I looked. One newsboy carried them around to sell, and had for his cry: 'Here's your likeness of Old Abe!'

Alexander Hesler's advertisement in a Chicago newspaper of 1855, his first year of business there.
GEORGE EASTMAN HOUSE, ROCHESTER, N.Y.

256

Art, Crafts, and Architecture in Early Illinois

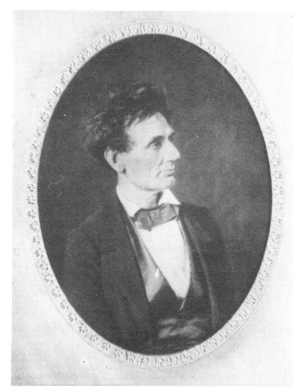

A rare colored camera portrait on glass of Lincoln, made by Hesler in Chicago in 1857.

LLOYD OSTENDORF COLLECTION

Will look a good deal better when he gets his hair combed!' " Nevertheless, he considered the photograph to be "a very true one; though my wife and many others do not. My impression is that their objection arises from the disordered condition of the hair."[5]

Further illustrating the influence of the daguerreotype upon the artist is the career of Peter Britt (1819-1905). Already an accomplished portrait painter in Switzerland, Britt brought his family in 1845 to Helvetia (now Highland) in Madison County. Britt actively sought out portrait subjects, and within a short time he had

painted several Illinois citizens. One of these portraits was of Colonel George Davenport, early settler of Rock Island and founder of Davenport, Iowa. Britt is believed to have painted Davenport only a few weeks before he was murdered by river pirates.

According to researcher Alan Clark Miller, Britt left his Madison County farm in 1847 to train at the daguerreotype studio of J. H. Fitzgibbon in St. Louis, and in the same year he established his own studio at Highland. Britt spent six years daguerreotyping in southern Illinois and in June 1852 left for Oregon, where he set up a studio in the mining community of Jacksonville. There he experimented with new developments in the art and eventually became the best known and most popular photographer in southwestern and northern Oregon. Occasionally Britt painted an oil portrait in a meticulously accurate style reflecting the influence of photography.

Another artist whose work shows such an influence is Olof Krans of Bishop Hill (see p. 210). Although his most noted and charming works are of posed subjects or scenes done from memory, Krans painted dozens of portraits from daguerreotypes. Each portrait reflects the stiffness and dour expression characteristic of photographic subjects of that time, when a metal clamp was used to hold the subject's head motionless long enough to expose the plate. Krans's subjects were painted in somber grays, causing them to resemble further the colorless daguerreotype.

Both the daguerreotype and the later tintype were tremendously popular. The camera produced a recognizable likeness quickly and inexpensively. Consequently, the amateur limner was

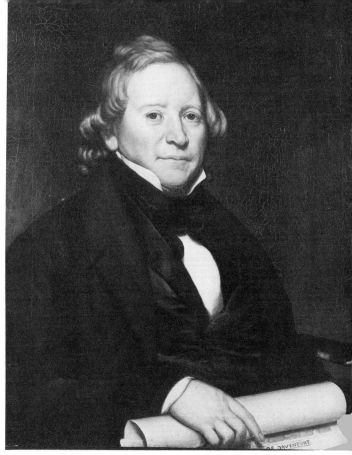

"Col. George Davenport" by Peter Britt, 1845.

DAVENPORT MUNICIPAL ART GALLERY

forced to earn his living in fields other than portraiture. Such an aspiring artist might turn to ornamental painting or to commercial art. Quite frequently he gave up his artistic career entirely, or painted in his spare time.

Even the competent painter experienced difficulties arising from the competition of the camera. When, for example, miniaturists like Wilkins or Stevenson found their featured product outmoded, they were forced to make large portraits with a finish and accuracy never before expected by the public. The *Chicago Daily Tribune* of May 7, 1849, editorially quipped,

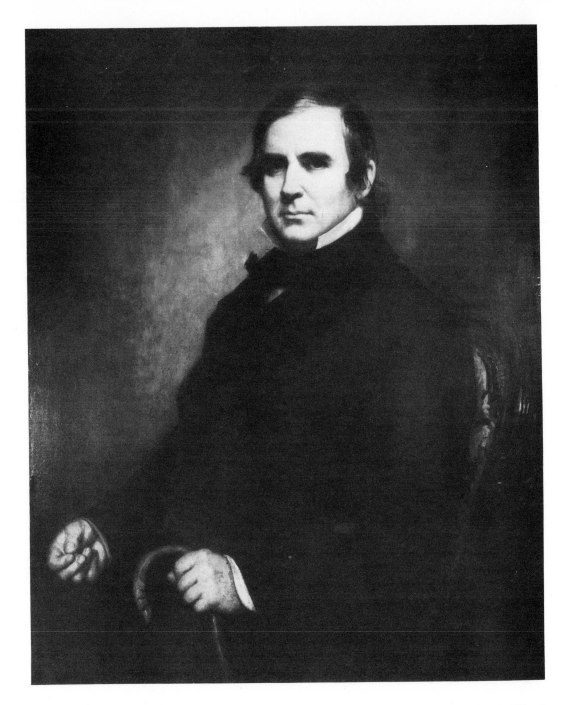

"We heard the other day a funny story of an artist of this city who painted a cow and cabbage so natural that he was obliged to separate them before they were finished; because the cow commenced eating the cabbage! His name was Smith." Another example of such realism is the portrait of Mary (Polly) Greene Watkins of Clary's Grove near Petersburg. Unfortunately it was not signed by the artist (see p. 158).

Somewhat helpful to the artist was the inauguration of the Illinois State Fair, held first in Springfield in October 1853 and then in Chicago in 1855. The Chicago event allowed exhibit space for the work of Illinois artists, thereby allowing them a larger audience than they had previously enjoyed.

An artist arrived in Chicago late in 1855 who was to contribute greatly toward the furtherance of art in that city. George Peter Alexander Healy, born in Boston in 1813, had been encouraged by Thomas Sully, a well-known eastern artist, to make painting his career. Financial aid from the wealthy Bostonian Mrs. Harrison Gray Otis enabled him to study art in Europe from 1834 to 1838. He worked from life and copied the old masters in the museums of France and England, eventually painting the portraits of numerous citizens and receiving the patronage of a few royal European families. Healy was already internationally known when William B. Ogden, the former mayor of Chicago, sat for his portrait in Paris and persuaded him to visit the burgeoning city in the Midwest. Of the city as he saw it in 1855, Healy later wrote that it

was then in a somewhat rough stage. Like an over-grown youth whose legs and arms are too long for his clothes, and who scarcely knows how to dispose of his lank, awkward body, the city stretched along the lake shore and out on the prairie, unfinished, ragged and somewhat uncouth as yet. The streets were abominably paved; the sidewalks raised high above the level of the streets, were composed of rough planks, often out of repair, so that one had to pick one's way carefully for fear of accidents. . . .

And with it all, Chicago in those rough, far away days was delightful. The wooden North side especially, where resided Mr. William B. Ogden and most of my other kind friends, well justified the name of "Garden City" which Chicago bore. Land had not then risen so much in price as to make a big space about each house an impossible luxury; the trees were magnificent, and in summer almost hid the houses one from the other. Mr. Ogden's house, kept by his sister and brother-in-law Mr. and Mrs. Edwin Sheldon, stood in the midst of a whole "block," — a large, roomy, comfortable, old fashioned frame house, spreading broadly in the midst of the enormous garden, or "yard," as people modestly called their gardens — the trees were superb, the flower-beds of the brightest hues, the lawn stretched before the house; it was a delightful residence, — a town house with the pleasant aspect of a country place.

And this may be taken as a typical house among the rich citizens of that day.[6]

One of the commissions he received during his stay in Chicago called for a series of portraits of presidents of the United States, to be hung in the White House. Painting furiously, he also took the time to encourage other young artists and to arouse civic pride in the city's future as a cultural center.

In November 1856, Healy and his family moved into a tall frame house on Ontario Street.

"Col. Wood's Museum." A lithograph by Louis Kurz from Chicago Illustrated, published in 1866-67 by Jevne and Almini, Chicago. After the destruction of Barnum's Museum in New York and before the 1871 Chicago fire, this building, completed in 1862, held the largest collection of curiosities in North America.
ILLINOIS STATE HISTORICAL LIBRARY

Painting portraits in other major cities in addition to his Chicago work became so strenuous for Healy that the household was moved after a year to nearby Cottage Hill (now Elmhurst). The Healy family resided there for six years before returning to live in the city. In the few years after his arrival in Illinois, Healy painted nearly all of the wealthier citizens of Chicago,

as well as portraits of Stephen Douglas and of President-elect Lincoln, whom he would paint again twice in later years. Healy left for Europe in 1867 to regain his health, having painted, it is said, some 577 portraits during his residency in Illinois. While he was in Madrid, the October 1871 Chicago fire destroyed his home, which was filled with paintings and personal treasures. Not

The first Chicago buildings with cast-iron fronts were begun in 1857-58. This view, "Corner Lake Street and Wabash Avenue," a lithograph by Louis Kurz from Chicago Illustrated, *1866-67, shows the buildings of Burch's Iron Block. Similar buildings were on the opposite side of the street. In the distance is the cupola of the Tremont House.*

ILLINOIS STATE HISTORICAL LIBRARY

until 1892 did Healy return to Chicago, where he lived for two years before his death. He had painted more portraits of presidents than any other artist.

Maps, views of Illinois towns, commerce, industry, and historic events remained popular with the more practical-minded citizenry. A. T. Andreas says of Chicago during that era:

The year 1858 found Chicago too deeply engaged in commercial enterprises of every description to bestow more than a passing thought upon Art. The struggle for wealth engrossed alike the mental and physical activities of the citizens. Few were found at this period who were not contented to leave the entire subject of Art for future consideration. We can not bestow too much praise upon those earnest, hopeful artists who, with firm faith

in the city's future, looked forward to a day when Chicago should become one of the leading Art centers of America, and were content to offer to the public, however unappreciative, the best productions of their genius. Among the artists of that time were L. W. Volk, G. P. A. Healy, S. P. Tracy, Howard Strong, George S. Collis and Daniel F. Bigelow.[7]

In 1859 Chicago's first major public art exhibition was sponsored by the Chicago Historical Society with the express purpose of giving Chicagoans "an opportunity to gratify and improve their taste in Art matters." The exhibition, consisting of 369 works, included statuary, paintings in oil and watercolors, and crayon drawings. The more than 12,000 visitors proved the success of the venture, and local artists and art patrons were so encouraged that they formed the Chicago Art Union the same year. For the further "encouragement of Fine Art in the West" the group held its initial exhibition on December 5 in the photographic gallery of Alexander Hesler. Featured were the works of Leonard W. Volk, G. P. A. Healy, Howard Strong, and Simon P. Tracy.[8]

Leonard W. Volk (1828-95) was the only sculptor in the group, and he was the first sculptor of note in Illinois. Many "stonecutters" had been listed in early Illinois business directories, but there had been no listing at all of "sculptors." One may conjecture that the deep-seated Puritan aversion to "graven images" had endured longer in Illinois than in the East, and that the ordinary carver of tombstones could meet the needs of the accepted stone ornamentation of buildings in the early days. Volk himself had been a simple stonecutter in St. Louis before deciding to sculpt the human figure.

260

Art, Crafts, and Architecture in Early Illinois

Bust of Abraham Lincoln by Leonard W. Volk made in his Chicago studio in 1860.

Born in New York, at the age of sixteen Volk began training under his father to be a marble cutter. Beckoned westward by an ambition to be a sculptor, he settled only a few years later in St. Louis. It was there that he executed the first piece of marble sculpture made west of the Mississippi — a bust of Henry Clay. Its success brought new commissions, and in 1852 he felt sufficiently secure in his career to marry. The couple moved to Galena, then back to St. Louis, and finally to Rock Island, where Mrs. Volk's cousin, Senator Stephen A. Douglas, offered to pay the sculptor's expenses while he studied in Rome. From 1855 to 1857 Volk toured the gal-leries of England and France and studied in Rome and Florence. Upon his return to Chicago, he executed a life-size bust of Senator Douglas which insured his future success in the Midwest. In 1860 he made a life mask and a bust of President-elect Lincoln which eventually brought him international fame.

Another sculptor in Chicago during the 1850s was John Rogers (1829-1904), who had worked as a draftsman and mechanic in Massachusetts, New York, and Hannibal, Missouri, before de-ciding to become a sculptor. Studying in Europe in 1858, he discovered that the neoclassic style being taught there was of no interest to him, and he returned to take a drafting job in the office of the surveyor of the city of Chicago. In the meantime, Rogers had modeled a group of figures playing checkers — a popular game in that day. Cast in plaster, the group was exhibited at the 1859 Cosmopolitan Bazaar in Chicago, and it brought a $75 bid at the auction. Con-temporary statuary consisted usually of promi-nent men or of classic figures modeled in striking or dignified poses. Rogers, however, had de-picted ordinary American people engaged in ordinary activity. The work was one of the first pieces of "genre" sculpture in America, and its reception encouraged Rogers to resign his job. With an Italian craftsman as his teacher, he began to study full-time the making of molds and casts. Rogers's next piece, "Slave Auction," received much attention when it was exhibited in Chicago. Rogers then took the work to New York, where in the fall of 1859 he opened a studio. "Rogers Groups," eventually to be copied by new methods and priced from $15 to $40 apiece, would make him the most successful sculptor America ever produced.

Changing times, changing tastes and ideals, and a new prosperity were at last bringing recog-nition to the competent artist. Chicago was fast becoming the great art center of the Midwest, encouraged mostly by culture-minded patrons who had grown rich from burgeoning industry.

On the other hand, the camera and increasing factory production were now bringing to an end

"Checkers up at the Farm" by John Rogers.

the era of the amateur artist, the builder, and the hand craftsman, an era that had lasted for at least 14,000 years, ever since the first human in Illinois had fashioned a simple tool. Those untold thousands of people who had helped to shape and record history with their hands were largely to be forgotten in the ensuing years, overshadowed by a relatively few individuals whose acts or works were more spectacular in the development of the state and the nation. To those unsung heroes the following epitaph is therefore dedicated:

Let us now praise famous men,
Even the artificer and workmaster,
That passeth his time by night and by day;
They that cut gravings of signets,
And his diligence is to make great variety;
He setteth his heart to preserve likeness in his portraiture,
And is wakeful to finish his work.

So is the smith sitting by the anvil,
And considering the unwrought iron;
The vapor of the fire wasteth his flesh,
And in the heat of the furnace doth he wrestle with his work;
The noise of the hammer is ever in his ear,
And his eyes are upon the pattern of the vessel;
He setteth his heart upon perfecting his works,
And is wakeful to adorn them perfectly.

So is the potter sitting at his work,
And turning his wheel about with his feet,
Who is always anxiously set at his work,

And all his handiwork is by measure;
He fashioneth the clay with his arm,
And bendeth its strength in front of his feet,
He applieth his heart to finish the glazing,
And is wakeful to make clean the furnaces.

All these put their trust in their hands,
And each becometh wise in his own work.
Yea, though they be not sought for in the council of the people,
Nor be exalted in the assembly;
Though they sit not on the seat of the judge,
Nor understand the covenant of judgment,
Though they declare not instruction and judgment,
And be not found among them that utter dark sayings;
Yet without these shall not a city be inhabited,
Nor shall men sojourn or walk up and down therein.
For these maintain the fabric of the world,
And in the handiwork of their craft is their prayer.

— *Ecclesiasticus of the Apocrypha*

A copper finial made by Balthasar Lengfelder in Belleville about 1860.
PHOTOGRAPH BY RICHARD KERN, *Belleville News Democrat*

Art, Crafts, and Architecture in Early Illinois

Appendix: Additional Artists Known to Have Been in Illinois

ABBREVIATIONS: *BD* — *Business Directory; CD* — *City Directory; DAA* — George C. Groce and David H. Wallace, comps., *Dictionary of Artists in America 1564-1860* (New Haven: Yale University Press, 1957); *JISHS* — *Journal of the Illinois State Historical Society.*

Abston, U. C. Portrait painter in Springfield, 1850. Ref.: *Sangamo Journal,* Sept. 2, 1850.

Acheson, Henry. Engraver and lithographer in Chicago, 1853-56. Ref.: *Chicago BD.*

Ackerman & Bros. (John and Jacob). Fresco painters in Aurora, 1859-60. Ref.: *Aurora CD.*

Ainslee, Col. Henry Francis. British army officer who traveled in Illinois in 1842. Painted "Dixon's Ferry," "Dresden, Illinois" (present Channahon), and "Winnebago Swamp — a Prairie on Fire" in watercolors. Ref.: Chicago Historical Society.

Allen, Marie W. Exhibitor of monochromatic painting and crayon drawing at the Illinois State Fair in Chicago, 1855. Ref.: *Chicago Daily Press,* Oct. 15, 1855.

Almini, Peter M. Swedish artist who settled in Chicago in 1852. As an ornamental and fresco painter he decorated several churches and the Crosby Opera House. Worked with Otto Jevne. Ref.: Adolph B. Benson and Naboth Hedon, *Swedes in America* (New Haven: Yale University Press, 1938), pp. 493-94.

Andruss, Mrs. W. B. Artist in Amboy township, ca. 1855. Ref.: *History of Lee County* (Chicago: H. H. Hill, 1881), p. 319.

Bacon & Ellis. Wood engravers in Chicago, 1856. Ref.: *Chicago BD.*

Baker, John B. Amateur artist who lived near Croft, Menard County. Painted a birth and marriage certificate of Kezia Eve Baker in 1846. Ref.: Illinois State Museum.

Baker, William D. Wood engraver from Philadelphia in Chicago, 1859-60. Ref.: *Chicago BD;* A. T. Andreas, *History of Chicago* (Chicago: A. T. Andreas, 1884), 1:489; *DAA.*

Barber, John W. (1798-1885). Made a pen-and-ink drawing, "South Eastern View Galena, Illinois, from the Draw Bridge," ca. 1856-60. Ref.: I. N. Phelps Stokes and Daniel C. Haskell, *American Historical Prints, Early Views of American Cities, etc.* (New York: New York Public Library, 1933), p. 89.

Barth, Otto. Amateur artist in Galena, ca. 1840. Painted "Old Town, Galena." Ref.: Galena Historical Museum.

Becker, A. H. Fresco, house, sign, and ornamental painter in Quincy, 1859. Ref.: *Quincy CD.*

Beckert, L. Fresco painter in Chicago, 1858. Ref.: *Chicago BD.*

Beman (or Beaman), Allen C. Engraver in Chicago, 1856-58. Ref.: *Chicago BD, CD.*

Bender, Major A. S. Engineer in the office of the U.S. superintendent of mining lands in Galena. Painted the oldest extant view of the Galena levee in 1844. Ref.: *JISHS,* Apr.-July, 1932, p. 113.

Blair, J. B. Resident of Milwaukee in 1845 who painted a view of Alton in 1856. Ref.: Hayner Public Library, Alton; *DAA.* (See p. 209.)

Blood, M. I. Pastel artist in Galesburg, ca. 1840-50. Made an oval portrait of Benjamin Lundy. Ref.: Illinois State Historical Library.

Bodstein, Herman. Engraver in Chicago, 1856. Ref.: *Chicago BD.*

Bond, Charles V. Exhibitor of portraits and landscapes at the Illinois State Fair in Chicago, 1855. Had a studio in the Exchange Building. Ref.: *Chicago Daily Press,* Oct. 15, 1855; Andreas, *History of Chicago,* 1:506; *Chicago BD,* 1855-57.

Bosse, Herman. Engraver in Chicago, 1849. Ref.: Andreas, *History of Chicago,* 1:414.

Brooks, Noah (1830-1903). Landscape painter from Boston who came to Dixon in 1854. Painted a view of John Dixon's home in 1859 (as it appeared in 1839), while he was a newspaper editor in Dixon. Left for the West that same year. Ref.: Dixon Public Library; *DAA;* Wayne Temple, Illinois State Archives; *Lincoln Herald,* Winter 1970, p. 173, n. 64.

Bryant, Julian (1836-65). Born in Princeton, Illinois. Nephew of William Cullen Bryant. After studying art in New York he became an art teacher at Illinois State University, Bloomington (1860). Was drowned during the Civil War. Ref.: painting of Starved Rock and sketchbook at Bureau County Historical Museum, Princeton. (See p. 212.)

Burns, Miss N. J. Teacher of drawing and portrait and landscape painting by the "Polychromatic & Monochromatic" method. Ref.: *Sangamo Journal* (Springfield), Aug. 12, 1850.

Bush, John A. (1836-65). Ornamental painter in Peoria. Ref.: *Peoria Daily Transcript,* Mar. 22, 1859; *JISHS,* Summer 1963, pp. 257-91; *Chicago Inter-Ocean,* Mar. 1883.

Bynum, B. Portrait artist in Belleville, 1846. Ref.: *The Advocate* (Belleville), Jan. 3, 1846; *DAA.*

Carpenter, R. R. Engraver in Chicago, 1854. Ref.: *Chicago CD.*

Case, H. Engraver in Chicago, 1849. Ref.: Andreas, *History of Chicago,* 1:414.

Castelnau, Francis de. French lithographer who traveled in America ca. 1838-40. His *Vues de l'Amérique du Nord* (Paris, 1842) contains the earliest known view of the city of Chicago — "View of the Mouth of the Chicago River." Ref.: *DAA;* Chicago Historical Society.

Chambers, Joseph T. Artist in Chicago, 1858. Ref.: *Chicago CD.*

Chandler, R. W. Drew and published a map of Galena, 1829.

Cherrill, Adolphus. Amateur watercolor painter and cartographer who came to Jacksonville (1838) and later lived in Augusta (1842) and Carthage (1847). Published a map of Hancock County with sketches of local scenes (Chicago, 1859). Ref.: *DAA.*

Childs, Shubael (Shuball) Davis (1799-1870). Wood and metal engraver in Chicago. Ref.: Andreas, *History of Chicago,* 1:488. (See p. 160.)

Childs, Shubael Davis, Jr. Engraver in Chicago, 1850-60 and 1869. Joined father's business. Ref.: Andreas, *History of Chicago,* 1:414; *Chicago BD,* 1855, 1859-60, 1869; ads for the business in Chicago in *Sketches of the Early Settlement and Advantages of Princeton* (Princeton, Ill.: I. B. Smith, 1857); *Alton CD,* 1858.

Chism, Mrs. Charles. Amateur painter in oils. Member of an early family of Albion. Ref.: Mrs. Howard Porter; Edwards County Historical Society.

Clapperton, William R. Ornamental painter at the American Car Co. works in Chicago. Painted landscapes in his spare time. Ref.: *Chicago CD,* 1853-55; *DAA.*

Clark, G. W. Portrait painter in Chicago. Ref.: *Chicago Almanac,* 1855.

Clark, Harry A. Exhibitor of crayon drawings at the Illinois State Fair in Chicago, 1855. Ref.: *Chicago Daily Press,* Oct. 15, 1855.

Clark, Mason. Amateur artist in pen, watercolor, and oils in Princeton, 1850s. Ref.: *JISHS,* Spring 1956, p. 100.

Collis, George S. Artist in Chicago. Ref.: Andreas, *History of Chicago,* 2:556; *Chicago BD,* 1868.

Connor & Hussey. Wood and copper-plate engravers in Alton. Ref.: *Alton CD,* 1858.

Cook, G. W. E. Exhibitor of pencil drawings from Lacon at the Illinois State Fair in Chicago, 1855. Ref.: *Chicago Daily Press,* Oct. 15, 1855.

Cridland, Charles E. Landscape painter from Cincinnati who established a studio in Chicago in 1855. A landscape which he exhibited at the Illinois State Fair in Chicago that same year received the award as the best landscape work on exhibition. Ref.: *Chicago Daily Press,* Oct. 15, 1855; Andreas, *History of Chicago,* 1:506; *DAA.*

Cross, J. George. Calligraphic and pen-and-ink artist; high school teacher in Aurora. Ref.: Aurora Historical Society Museum. (See p. 245.)

Daniel, Holy. Primitive landscape painter in watercolors, in Illinois in 1850s. Ref.: Jean Lipman and Alice Winchester, *Primitive Painters in America, 1750-1950* (New York: Dodd, Mead, 1950), p. 171.

Davis, James. Portrait painter in Peoria, 1844. Ref.: *Peoria Directory for 1844* (Peoria: S. DeWitt Drown, 1844), p. 64.

Dawson, R. W. Artist in Batavia, 1859-60. Ref.: *Batavia CD.*

Daye, Thomas J. Engraver in Chicago with William C. Ellis, 1858-59. Ref.: *Chicago CD.*

DeBault, Charles. In Nauvoo, 1853. Copied a portrait of Joseph Smith in crayons. Ref.: *DAA.* (See p. 207.)

Dillingham, John E. Exhibitor of pencil drawings at the Illinois State Fair in Chicago, 1855. Ref.: *Chicago Daily Press,* Oct. 15, 1855.

Drown, Simeon DeWitt. Publisher and engraver in Peoria, 1840s and 1850s. Ref.: *Peoria Directory for 1844; Drown's Annual Record* (Peoria, 1849); *Drown's Record and Historical View of Peoria* (Peoria, 1850); *Peoria City Record or Drown's Statistics for 1853; Peoria City and County Record or Drown's Statistics for 1855.*

Ellis, William C. Engraver in Chicago with Bacon & Ellis, 1856; Daye & Ellis, 1858. Ref.: *Chicago CD,* 1856, 1858.

Fairthorne, William C. English engraver who moved to Springfield from New York City. Ref.: *Springfield CD,* 1857-58; *DAA.*

Field, J. A. Amateur artist in Nauvoo, 1851. Ref.: *DAA.* (See p. 207.)

Finger, Henry. German doctor and amateur artist near Marissa, St. Clair County, 1841-63. Ref.: *Marissa: "From Wagon to Jet"* (n.p., 1967), p. 26.

Fleury, Elsie. A pupil in the Icarian school in Nauvoo, 1855. Made a drawing of the Mormon temple, 1855. Ref.: *DAA.* (See p. 207.)

Frank, James. Engraver in Chicago, 1855. Ref.: *Chicago Almanac.*

Frune, George W. Artist in Chicago, 1858. Ref.: *Chicago CD.*

Gemmell, John. Lithographer in Chicago. Published a view of Chicago (ca. 1816-20) about 1857. Ref.: *Chicago CD,* 1858-59; Stokes and Haskell, *American Historical Prints,* pp. 57-58, pl. 44b; *DAA.*

Goodman, J. Reginald. Painter in watercolors of "View in Randolph Street, 1856" and "Western Market" (both in Chicago). Ref.: Chicago Historical Society.

Goodwin, Russell F. Artist in Dundee, 1859-60. Ref.: *Dundee CD*.

Greene, William C. Engraver in Chicago. Ref.: *Chicago BD*, 1856; *Chicago CD*, 1859.

Hawkins, D. W. Artist in Geneva, 1859-60. Ref.: *Geneva CD*.

Heade, Martin Johnson (1819-1904). Noted eastern landscape, portrait, and still-life painter who worked in Chicago, 1853-54. Ref.: *DAA*.

Helmle, Leopold. Partner with Conrad Roeder in Roeder and Helmle Drawing School, Alton, 1858. Ref.: *Alton BD*.

Hillman, Richard S. House, sign, and decorative painter in Springfield, 1855. Painted "Lady Suffolk Trotting in Her 19th Year" in 1851. Ref.: *DAA; American Collector*, Mar. 1937; *Springfield CD*, 1855.

Hubban, E. A. Exhibitor of flower painting at the Illinois State Fair in Chicago, 1855. Ref.: *Chicago Daily Press*, Oct. 15, 1855.

Hunt, Elisha. Portrait painter in Bloomington, 1855. Ref.: *Bloomington BD;* Illinois State Historical Library.

Ingalls, Walter (1805-74). Portrait, still-life, and scene painter born in New Hampshire. In Chicago, 1855. Ref.: *Chicago Almanac,* 1855; *DAA*.

Jevne, Otto, and Peter M. Almini. Fresco and ornamental painters in Chicago. Published (1860s) a noted set of scenes of Chicago lithographed by Louis Kurz of the Chicago Lithographing Co. Ref.: *Chicago BD*, 1858; *Chicago History,* Spring 1948, pp. 313-16; *Antiques,* Feb. 1943, pp. 66-69.

Jones, E. A. Painting and writing master in Bloomington, 1855. Ref.: *Bloomington CD*.

Kellogg, E. B. and E. C. Made a lithograph, "Old Fort Dearborn," ca. 1857. Published by Rufus Blanchard, Chicago. Ref.: New York Public Library.

Kelter, William J. Engraver in Rock Island, 1858. Ref.: *Davenport, Moline, and Rock Island BD*.

Kennicott, Mrs. Marie Antoinette. Teacher of drawing and painting at Chicago Female Seminary, 1851-54. Ref.: Andreas, *History of Chicago,* 2:560.

Kimball, H. C., & Co. Landscape painters in Chicago with Nils Rasmussen, 1858-60. Ref.: *Chicago BD*.

Kinzie, Juliette M. Daughter-in-law of John Kinzie, early settler of Chicago. Made a sketch of the village as it appeared in 1831 that was lithographed by Sarong & Co., New York, for her history of the northwest, *Waubun* (1856). Ref.: Kinzie, *Wau-bun, the Early Days in the Northwest* (Philadelphia: J. B. Lippincott, 1873).

Kleinhofen, Henry. Landscape painter in Chicago. Partner with Nils Rasmussen in Kleinhofen & Rasmussen, 1859. Ref.: *Chicago CD*.

Köllner, August (1813-?). German artist who came to America about 1839. Drew a sketch of Chicago about 1849 that was later lithographed by J. H. Camp (Philadelphia) under the title "View of Chicago as Seen from the Top of St. Mary's College." Ref.: Stokes and Haskell, *American Historical Prints,* pp. 87, 104; original print in New York Public Library.

Kurz, Louis. Scene painter and lithographer who was in Chicago 1852-71, 1878- ? . Made many fine lithographs for the Chicago Lithographic Co., which he had helped to form. Ref.: *DAA; Antiques,* Feb. 1943, pp. 66-69; Andreas, *History of Chicago,* 2:489; *Chicago History,* Spring 1948, pp. 314-16. (See pp. 259-60.)

Lenox, E. S. Artist in Chicago. Ref.: Andreas, *History of Chicago,* 1:506.

Lester, John W. Artist in Quincy, 1859. Ref.: *Quincy BD*.

McMaster, William E. Exhibitor of portraits at the Illinois State Fair in Chicago, 1855. Ref.: *Chicago Daily Press,* Oct. 15, 1855.

Mehrle, W. Ornamental and sign painter in Chicago, 1854-55. Ref.: *Chicago CD*, 1854-55.

Mendel, Edward. Engraver and lithographer in Chicago, 1854-58. Made illustrations of maps, town and city views. Ref.: *Chicago BD*, 1854-56, 1858; "Bird's Eye View of Chicago" (publ. Rufus Blanchard, n.d.), Chicago Historical Society; map of Logan County with local scenes (at Logan County Historical Society Museum, Lincoln); *DAA*; Harry Twyford Peters, *America on Stone* (Garden City, N.Y.: Doubleday, 1931), p. 279.

Merck, C. Painter of oil portraits in Alexander Hesler's photographic studio, Chicago, 1855. Later painted a portrait of Abraham Lincoln, 1860. Ref.: George Eastman Co.; Southern Illinois University Library, Alton. (See p. 256.)

Miller, William M. Copper-plate printer and engraver in Chicago. Moved to Boston in 1857. Ref.: "View of Princeton, Ill. as Seen from the Northwest" in *Princeton CD,* 1857; *DAA*.

Moffet, Thomas. Engraver in Chicago, 1859-60. Ref.: *Chicago BD*.

Möllhausen, Heinrich Balduin (1825-1905). Explorer and topographical artist in Belleville, 1849-52. Ref.: *DAA*.

Montel, E. Monochromatic and chromatic painter in Chicago, 1854-55. Ref.: *Chicago CD;* Andreas, *History of Chicago,* 1:506.

Mundson, Sarah H. Exhibitor of monochromatic painting at the Illinois State Fair in Chicago, 1855. Ref.: *Chicago Daily Press,* Oct. 15, 1855.

Murphy, William. Architect in Nauvoo, before 1848 to 1860s. Ref.: *DAA*.

North, L. Made a drawing of Fort Crèvecoeur in 1849. Ref.: *Sangamo Journal* (Springfield), Nov. 25, 1847.

O'Brien, John Williams. Portrait, landscape, and animal painter from the Royal Dublin Society's

Drawing and Painting Academy. In Springfield in 1850. Won a prize at the Illinois State Fair, Chicago, 1855. Ref.: *Sangamo Journal* (Springfield), Oct. 5, 1850; *DAA; Chicago Daily Press,* Oct. 15, 1855. (See pp. 209, 216-17.)

O'Shannessy, J. J. Banknote and general engraver in Chicago, 1856-59. Ref.: *Chicago BD,* 1856; *Chicago CD,* 1858-59.

Padelford, R. W. Artist in Elgin, 1859-60. Ref.: *Elgin CD.*

Page, S. P. Exhibitor of pencil drawings at the Illinois State Fair in Chicago, 1855. Ref.: *Chicago Daily Press,* Oct. 15, 1855.

Parker, George. Engraver in Springfield. Ref.: *Springfield CD,* 1859. (Possibly the same George Parker who had come to the United States from England about 1834 to work on the National Portrait Gallery plates and then worked for the most part in Boston. Ref.: *DAA.*)

Parker, Matthew. Engraver in Chicago, 1858. Ref.: *Chicago CD.*

Pearce, Hart L. Engraver in Chicago, 1859-60. Ref.: *Chicago BD.*

Pendergast, W. W. artist in Chicago, 1850s. Ref.: Andreas, *History of Chicago,* 1:506.

Piercy, Frederick (1830- ?). Portrait and landscape painter from England who traveled in the Midwest in 1853-54. Steel engravings made from his sketches and paintings, which appear in his portfolio, *The Route from Liverpool to Great Salt Lake Valley, Illustrated* (Liverpool, 1855), include views of Nauvoo and of the ruins of the Nauvoo temple. Ref.: *Chicago History,* Summer 1846, pp. 109-12; *DAA;* Boston Museum of Fine Arts. (See p. 207.)

Pilkington, Adam (?-1856). Amateur artist in Nauvoo. Ref.: *DAA.*

Platt, James C. Portrait, landscape, and still-life painter of New York City who was in Chicago in 1859. Ref.: *Chicago BD,* 1859; *DAA.*

Potter, Edith. Teacher of painting at Clark Seminary, Aurora, 1859-60. Ref.: *Aurora CD.*

Powers, Asahel (1813-43). Itinerant portrait painter from Vermont. Painted in northern New England until 1840, when he worked in New York. Came to Illinois ca. 1841 and died at Olney, Richland County, in 1843. Ref.: Correspondence with Nina Fletcher Little; *Asahel Powers, Painter of Vermont Faces,* Abby Aldrich Rockefeller Folk Art Collection catalog, Colonial Williamsburg, Va., Oct. 14–Dec. 2, 1973.

Pratt, D. C. Artist in St. Charles and Aurora, 1859-60. Ref.: *St. Charles CD; Aurora CD.*

Pratt, F. F. Artist in Aurora, 1859-60. Ref.: *Aurora CD.*

Radfore, P. M. Original artist of "East Joliet from West Joliet School," a view that was issued as a lithograph by Edward Mendel of Chicago. Ref.: Illinois State Historical Library.

Rasmussen, Nils. Chicago landscape painter. Partner of Henry Kleinhofen, 1859-61. Ref.: *Chicago BD.*

Reed, W. A. Artist in Quincy, 1855-56. Ref.: *Quincy CD.*

Reen, Charles. Artist and lithographer from Philadelphia who was a Chicago partner of Charles Shober in Reen & Shober, 1857-58. Ref.: *Chicago CD; DAA;* lithograph, "Peoria, Ill." (after a painting by Charles Peck) at Chicago Historical Society.

Richardson, Edward, Jr. (1824-58). English decorative artist, copyist, and primitive portrait painter who lived in Springfield for eight years before his death. Ref.: Bible records courtesy of the Grunendike family; surviving paintings in collections of the family, John Paul, and Illinois State Museum.

Roesler, N. Drew from nature and made lithographs of eleven views of Belleville in the 1850s. Printed in colors by A. McLean, St. Louis. Ref.: St. Clair County Historical Society.

St. Alary, E. Exhibitor of pastel portraits at the Illinois State Fair in Chicago, 1855. Apparently stayed in Chicago for several years afterward. Among his pieces which attracted much attention were "Contemplation," "Calypso," "Canadian Belle," "Spanish Belle," and "Child at the Brook." Ref.: *Chicago Daily Press,* Oct. 15, 1855; Andreas, *History of Chicago,* 1:506.

Sellers, George Escol (1808-99). Amateur artist and inventor; grandson of Charles Willson Peale. Pioneer at Seller's Landing, Hardin County. Ref.: *DAA;* Charles C. Sellers, *Charles Willson Peale* (Philadelphia: American Philosophical Society, 1947), 2:354, 420.

Shober, Charles. Lithographer from Philadelphia. In Chicago ca. 1858-83. Associated with Charles Reen as Reen & Shober in 1858. Examples of work: "Peoria, Ill.," 1858, after a painting by Charles Peck; "View of Rush St. Bridge & c. . . ." after a drawing by Edwin Whitefield, 1861. In the 1860s Shober & Carqueville formed the Chicago Lithographic Co., which turned out some of the finest views of Chicago in the era before the fire of 1871. Ref.: *Chicago CD,* 1858; Peters, *America on Stone,* pp. 366-67; Chicago Historical Society. (See p. 230.)

Sloan, Junius (or John) R. (1827-1900). Had been an itinerant portrait painter in Ohio, Pennsylvania, and the East before working in Kewanee, 1853-54. Moved to Princeton, where he had a studio and painted both portraits and landscapes, 1855-57. (Ref.: *Sketches of Princeton,* 1857.) After visits to the East he settled in Chicago in 1864 and became a prominent member of the Chicago art world. Ref.: *Art in America,* Summer 1952, pp. 103-52. (See p. 158.)

Smithmeyer & Co. Fresco painters in Chicago, 1859. Ref.: *Chicago BD.*

Starkweather, J. M. Exhibitor of landscapes at the Illinois State Fair in Chicago, 1855. Ref.: *Chicago Daily Press,* Oct. 15, 1855.

Starr, Eliza Allen (1824-1901). Art teacher, lecturer, and painter in Chicago, 1856-71. Ref.: *Chicago BD,* 1862-63; *Dictionary of American Biography; DAA.*

Strong, Howard. Artist in Chicago, 1858-63. Member of Chicago Art Union. Ref.: Andreas, *History of Chicago,* 2:556-57.

Sutterly, Clement. Artist in Chicago, 1859-60. Ref.: *Chicago BD.*

Swift, S. W. Fresco painter in Galena. Ref.: *Weekly Northern Gazette* (Galena), Mar. 25, 1856.

Thielke, Henry D. Portrait painter in Chicago, 1855-66, 1878. Ref.: *Chicago BD* and *CD; DAA;* Andreas, *History of Chicago,* 1:506.

Thomas, Frank E. Engraver in Chicago in partnership with S. D. Childs, Sr., 1850. Ref.: Andreas, *History of Chicago,* 1:414.

Timme, E. A. Engraver in Chicago, 1859-60. Ref.: *Chicago BD.*

Towne, Abigail. Art teacher and painter. Taught at Batavia Institute, Batavia, 1853-67. Ref.: Mary Williams and Elaine Cannon.

Townsend, Charles (1836-94). Accountant and amateur artist from New York in Neponset, Bureau County, 1858-59. Ref.: *Bureau County Directory; DAA.*

Tracy, G. P. Landscape painter who exhibited "Landscape with Cows" at Chicago's first fine arts exhibition, May 1859. Ref.: *Chicago History,* Spring 1971, pp. 322-23, 325.

Tracy, Simon P. Landscape painter in Chicago, 1859-61. Died in 1863 in the Civil War. Ref.:

Andreas, *History of Chicago,* 2:556-57; *Chicago CD,* 1860-61.

Wakeman, Thomas (1812-78). English artist in the United States, 1840-60. Painted "Elijah P. Lovejoy Printing Office, Alton, Ill." Ref.: Chicago Historical Society.

Wallis, Frederick I. (or J.). Artist in Chicago, 1859-60. Ref.: Andreas, *History of Chicago,* 1:414.

Ware, Joseph E. Engraver in Chicago, 1840. Ref.: Andreas, *History of Chicago,* 1:414.

Warren, S. K. Artist in Dundee, 1859-60. Ref.: *Dundee CD.*

Waugh, Henry W. Itinerant artist. Was a landscape and scene painter and actor in a traveling theatrical group in Indiana. Helped paint a panorama in Indianapolis in 1853. Later joined a traveling circus and became a clown. Made pen, pencil, and wash drawings in Illinois, 1856-60. His painting of San Antonio was exhibited at Rock Island in the late 1850s and then in Chicago. Ref.: Wilbur D. Peat, *Pioneer Painters of Indiana* (Chicago: R. R. Donnelley, 1954), pp. 156-57; Rock Island Public Library; *DAA;* University of Illinois. (See p. 288.)

Wellman, Edward. Engraver of "Galena in 1855." Ref.: *JISHS,* Spring 1963, cover and p. 102.

West, Horace B. Portrait and decorative artist in Belleville, 1848-49. Ref.: *The Advocate* (Belleville), Sept. 28, 1848, Apr. 5, 1849.

West, Washington J. Portrait and ornamental painter in Belleville, 1848. Ref.: *The Advocate* (Belleville), Apr. 20, 1848.

Whitaker, E. M. Drew "A Prairie Scene in Illinois" in 1857. Ref.: Chicago Historical Society.

White, Roswell N. Wood engraver from New York who was associated with Shubael D. Childs in Chicago, 1845-53. Ref.: Andreas, *History of Chicago,* 1:414; *DAA;* Sinclair Hamilton, *Early American Book Illustrators and Wood Engravers, 1670-1870* (Princeton: Princeton University Press, 1968), 1:45, 49, 65, 87, 90, 139.

White, W. J. Engraver in Chicago. Ref.: *Chicago BD,* 1855-56.

Wilkins, Benjamin. Artist with R. W. Padelford, Elgin. Ref.: *Elgin CD,* 1859-60.

Willoughby, Edward C. Landscape painter in Chicago. Ref.: *Chicago CD,* 1859-60.

Wilson, Henry. Exhibited animal painting in oils at the Illinois State Fair in Chicago, 1855. Wilson listed himself as a stonecutter in 1851. Ref.: *Chicago Daily Press,* Oct. 15, 1855; *Chicago CD,* 1849-60.

Wilson, Oliver. Exhibitor with Henry Wilson of an animal painting in oils at the Illinois State Fair in Chicago, 1855. Ref.: *Chicago Daily Press,* Oct. 15, 1855.

Winter, [William?]. Miniature painter in photography studio of Alexander Hesler, Chicago, 1855. Ref.: Hesler ad in George Eastman House Collection, Rochester, N.Y. (See p. 256.)

Wolfe, John C. Landscape painter in Chicago. Ref.: *Chicago BD,* 1859-60.

Woodbury, M. A. Engraver in Chicago. Ref.: *Chicago BD,* 1859.

"Sunburst" pieced quilt made by Susannah Tweed Arganbright and her aunt, Eliza Eagleston, near Wyoming, Stark County, about 1850.
ILLINOIS STATE MUSEUM

Art, Crafts, and Architecture in Early Illinois

Notes and Sources

ABBREVIATIONS: *JISHS* and *TISHS* — *Journal* and *Transactions of the Illinois State Historical Society.*

Chapter 1: Art before Written History
(pp. 3-14)

NOTES

1. Thwaites, 59:139-41.
2. Russell, "The Bird That Devours Men."
3. McAdams, p. 5.
4. Wild, pp. 71-73; "L," "The Manitou of the Piasa."
5. Hewitt, pp. 15-16.
6. Russell, "The Piasa Bird."
7. Quoted in English, pp. 152-53.
8. McAdams, pp. 11-12.
9. Temple, pp. 326-27.
10. Fundaburk and Foreman, pls. 21, 24.
11. Eifert, "The Piasa Bird in Pottery?," pp. 411-12.

SOURCES

Bayliss, Clara Kern. "The Significance of the Piasa." *TISHS*, 1908, pp. 114-21.

Bluhm, Elaine, ed. *Chicago Area Archaeology.* Illinois Archaeological Survey Bulletin 3. Urbana: University of Illinois, 1961.

——, ed. *Hopewell and Woodland Site Archaeology in Illinois.* Illinois Archaeological Survey Bulletin 6. Urbana: University of Illinois, 1968.

——, ed. *Illinois Archaeology.* Illinois Archaeological Survey Bulletin 1. Urbana: University of Illinois, 1964.

——, ed. *Illinois Prehistory.* Illinois Archaeological Survey Bulletin 4. Urbana: University of Illinois, 1963.

Caldwell, Joseph. "New Discoveries at Dickson Mound." *The Living Museum,* Oct. 1967, pp. 139-42.

——. "The House That X Built." *The Living Museum,* Apr. 1967, pp. 92-93.

Deuel, Thorne. "Hopewellian Dress in Illinois." In *The Archaeology of Eastern United States.* Ed. James B. Griffin. Chicago: University of Chicago Press, 1952.

Eifert, Virginia S. "A Forgotten People Come to Life." *The Living Museum,* Mar. 1949, p. 372.

——. "Once There Was an Indian Artist." *The Living Museum,* June 1947, pp. 10, 15.

——. "The Piasa Bird in Pottery?" *The Living Museum,* Sept. 1953, pp. 411-12.

——. "The Raven Pipe." *The Living Museum,* July 1959, pp. 402-3.

English, Tom. "The Piasa Petroglyph: The Devourer from the Bluffs." *Art and Archaeology,* Sept. 1922, p. 152.

Fowler, Melvin L., ed. *Explorations into Cahokia Archaeology.* Illinois Archaeological Survey Bulletin 7. Urbana: University of Illinois, 1969.

——. *Summary Report of Modoc Rock Shelter.* Illinois State Museum Report of Investigations 8. Springfield: Illinois State Museum, 1959.

Fundaburk, Emma Lila, and Mary Douglas Foreman. *Sun Circles and Human Hands: The Southeastern Indians — Art and Industry.* Luverne, Ala.: Emma Lila Fundaburk, 1957.

Grimm, R. H., ed. *Cahokia Brought to Life: An Artifactual Story of America's Greatest Monument.* St. Louis: Greater St. Louis Archaeological Society, 1949.

Hewitt, J. N. B., ed. *Journal of Rudolph Friederich Kurz.* Smithsonian Institution Bulletin 115. Washington: Bureau of American Ethnology, 1937.

L. "The Manitou of the Piasa: An Indian Tradition." *Alton Telegraph & Democrat Review,* Apr. 20-27, 1844.

Lewis, Henry. *The Valley of the Mississippi Illustrated.* Tr. A. Hermina Poatgieter, ed. Bertha L. Heilbron. St. Paul: Minnesota Historical Society, 1967.

McAdams, William. *Records of the Ancient Races in the Mississippi Valley.* St. Louis: C. R. Barnes, 1887.

Phillips, Richard, ed. "Prehistoric People of Illinois." *Iliniwek,* Jan.-Feb. 1968.

Russell, John. "The Bird That Devours Men." Reprinted in *Sangamo Journal* (Springfield), Oct. 15, 1836.

——. "The Piasa Bird — an Illinois Legend." *Illinois Journal* (Springfield), Oct. 28, 1847.

Schoolcraft, Henry Rowe. *Travels in the Central Portions of the Mississippi Valley: Comprising Observations on Its Mineral Geography, Internal Resources, and Aboriginal Population.* New York: Collins and Hannay, 1825.

Temple, Wayne. "The Piasa Bird: Fact or Fiction?" *JISHS,* Fall 1956, pp. 308-27.

Thwaites, Reuben Gold, ed. *The Jesuit Relations and Allied Documents: Travels and Explorations of the Jesuit Missionaries in New France, 1610-1791.* 73 vols. Cleveland: Burrows Brothers, 1896-1901.

Walton, Clyde, ed. *John Francis Snyder: Selected Writings.* Springfield: Illinois State Historical Society, 1962.

Wild, John Caspar. *The Valley of the Mississippi Illustrated in a Series of Views.* Ed. Lewis F. Thomas. St. Louis: Chambers and Knapp, 1841-42.

Chapter 2: Map Makers and Fort Builders
(pp. 15-22)

NOTES

1. Dr. Temple, then on the staff of the Illinois State Museum, is presently acting administrator of the Illinois State Archives, Springfield.

2. Quoted in Hennepin, p. 153.
3. Pease and Werner, pp. ix-x, 302-96.
4. *Ibid.*, p. 358.
5. *Illustrated Encyclopedia of Madison County*, p. 62.
6. Tucker.

SOURCES

Anderson, Melville B., ed. *Relation of Henri de Tonty Concerning the Exploration of La Salle from 1678 to 1683*. Chicago: Caxton Club, 1898.

———, ed. *Relation of the Discoveries and Voyages of Cavelier de La Salle from 1679 to 1681*. Chicago: Caxton Club, 1901.

Babson, Jane F. "The Architecture of Early Illinois Forts." *JISHS*, Spring 1968, pp. 9-40.

Brown, Lloyd A. *The Story of Maps*. New York: Bonanza Books, 1949.

Delanglez, Jean. "Franquelin, Mapmaker." *Mid-America, an Historical Review*, Jan. 1943, pp. 29-53.

———. *Life and Voyages of Louis Jolliet (1645-1700)*. Chicago: Institute of Jesuit History, 1900.

Donnelly, Joseph P. *Jacques Marquette*. Chicago: Loyola University Press, 1968.

Hale, Richard R., and the editors of Time-Life Books. *Age of Exploration*. New York: Time, Inc., 1966.

Hamilton, Raphael N. *Father Marquette*. Grand Rapids, Mich.: William B. Eerdman's, 1970.

Hennepin, Louis. *A Description of Louisiana*. Tr. John G. Shea from the Paris, 1683, ed. New York: John G. Shea, 1880.

———. *A New Discovery of a Vast Country in America*. 2 vols. Ed. Reuben Gold Thwaites from the London, 1698, ed. Chicago: A. C. McClurg, 1903.

Illustrated Encyclopedia of Madison County, Illinois. St. Louis: Brink, McCormick, 1873.

Pease, Theodore Calvin, and Raymond C. Werner, eds. "Memoir of De Gannes Concerning the Illinois Country." In *The French Foundations, 1680-1693*. Illinois State Historical Library Collections, French Ser., vol. 1. Springfield: Illinois State Historical Library, 1934. The original manuscript, *Mémoire Concernant le Pays Illinois* (Montreal, 1721), is in the Ayer Collection, Newberry Library, Chicago.

Phillips, Richard, ed. "The Prelude and Voyage of Discovery by Louis Jolliet and Father Jacques Marquette, S.J." *Iliniwek,* Mar.-Apr. 1973.

Temple, Wayne C. *Indian Villages of the Illinois Country: Historic Tribes*. Springfield: Illinois State Museum, 1958.

Thwaites, Reuben Gold, ed. *The Jesuit Relations and Allied Documents: Travels and Explorations of the Jesuit Missionaries in New France, 1610-1791.* 73 vols. Cleveland: Burrows Brothers, 1896-1901.

Tucker, Sara Jones, ed. *Indian Villages of the Illinois Country: Part I, Atlas.* Springfield: Illinois State Museum, 1942.

Chapter 3: The French Settlers
(pp. 23-36)

NOTES

1. Belting, *Kaskaskia under the French,* p. 25, citing Margry, *Découvertes et Établissements.*
2. Babson, pp. 17-20.
3. Flagg, pt. 2, pp. 177-78.
4. Peterson, "Notes on Old Cahokia," p. 336.
5. Peterson, "French Houses of the Illinois Country," pp. 4-7.
6. Belting, *Kaskaskia under the French,* p. 30, citing Rowland and Sanders, *Mississippi Provincial Archives.*
7. Belting, *Kaskaskia under the French,* pp. 30-31, citing Pittman, *Present State of the European Settlements.*
8. Peterson, "Notes on Old Cahokia," p. 342.
9. During the ensuing years Clarence Alvord wrote *The Illinois Country,* based on his studies of the manuscripts which he had discovered. Some of the records, involving the years after 1763, were published in the *Illinois Historical Collections.*
10. Ford, pp. 36-37.
11. Schlarman, p. 304.
12. Ford, pp. 36-37.
13. Smith, p. 70.

SOURCES

Alvord, Clarence. *Cahokia Records 1778-1790.* Illinois State Historical Library Collections, Virginia Ser., vol. 1. Springfield: Illinois State Historical Library, 1907.

———. *The Illinois Country — 1673-1818.* Springfield: Illinois Centennial Commission, 1920.

Angle, Paul, ed. "The French Regime in Illinois." *Chicago History,* Winter 1961-62, pp. 161-83.

Babson, Jane F. "The Architecture of Early Illinois Forts." *JISHS,* Spring 1968, pp. 17-20.

Belting, Natalia M. *Kaskaskia under the French Regime.* Urbana: University of Illinois Press, 1948.

———. "Vanished Kaskaskia." *Antiques,* Nov. 1941, p. 282.

Breese, Sidney. *The Early History of Illinois from Its Discovery by the French in 1673, until Its Cession to Great Britain in 1763, Including the Narrative of Marquette's Discovery of the Mississippi.* Chicago: E. B. Myers, 1884.

Brooks, George R. "History in Houses — the Bolduc House in Ste. Genevieve, Missouri." *Antiques,* July 1967, pp. 96-99.

Collot, Victor. "A Journey in North America" (excerpts from *Voyage dans l'Amérique du Nord,* Paris, 1826). *TISHS,* 1908, pp. 269-98.

Flagg, Edmund. *The Far West: or, A Tour beyond the Mountains. Embracing Outlines of Western Life and Scenery; Sketches of the Prairies, Rivers, Ancient Mounds, Early Settlements of the French.* 2 vols. New York: Harper & Brothers, 1838.

Ford, Thomas. *A History of Illinois from Its Commencement as a State in 1818 to 1847.* Reprint of the 1854 ed. Ann Arbor, Mich.: University Microfilms, 1968.

Franzwa, Gregory M. *The Story of Old Ste. Genevieve.* St. Louis: Patrice Press, 1967.

Howe, Henry. *Historical Collections of the Great West.* Cincinnati: H. Howe, 1851.

McDermott, John Francis. *Old Cahokia: A Narrative and Documents Illustrating the First Century of Its History.* St. Louis: St. Louis Historical Documents Foundation, 1949.

Margry, Pierre, ed. *Découvertes et Établissements des Français dans l'Ouest et dans le Sud de l'Amérique Septentrionale, 1614-1754.* 6 vols. Paris: Maisonneuve, 1879-88.

Maynard, Paul. "Report of Archaeological Excavation of Cahokia Court House." Unpublished letters and report of research undertaken under the Federal Works Agency Work Projects Administration, 1938-39.

———. "Report of Archaeological Excavation of Fort Massac." Unpublished letters and report of research undertaken under the Federal Works Agency Work Projects Administration and Illinois State Museum, 1939.

Newcomb, Rexford. *Architecture of the Old Northwest Territory.* Chicago: University of Chicago Press, 1950.

Peterson, Charles E. "French Houses of the Illinois Country." *Missouriana,* Sept. 1938.

———. "Notes on Old Cahokia." *JISHS,* Mar. 1949, pp. 7-29; June 1949, pp. 193-208; Sept. 1949, pp. 313-43.

Pittman, Philip. *The Present State of the European Settlements on the Mississippi, with a Geographical Description of That River Illustrated by Plans and Draughts.* Ed. Frank Heywood Hodder from the London, 1770, ed. Cleveland: Arthur H. Clark, 1906.

Rowland, Dunbar, and A. G. Sanders, eds. *The Mississippi Provincial Archives, French Dominion.* 3 vols. Jackson: Press of the Mississippi Department of Archives and History, 1927-32.

Russell, Nelson Vance. "The French and British at Play in the Old Northwest, 1760-1796." *JISHS,* Mar. 1938, pp. 22-53.

Schlarman, Joseph H. *From Quebec to New Orleans.* Belleville, Ill.: Buechler Publishing, 1929.

Smith, George Washington. *A History of Southern Illinois.* Chicago: Lewis Publishing, 1912.

Thwaites, Reuben Gold, ed. *Early Western Travels.* 32 vols. Cleveland: Arthur H. Clark, 1904-6.

Wallace, Joseph. "Fort de Chartres, Its Origin, Growth and Decline." *TISHS,* 1903, pp. 105-17.

Chapter 4: Pioneer Hunters and Spinners
(pp. 37-44)

NOTES

1. Parrish, "Pioneer Preacher's Autobiography," p. 427.
2. Reynolds, "Pioneer Times," p. 170.
3. Perrin, p. 76.
4. A detailed description of the loom mechanism and the weaving process is found in Tunis, pp. 50-52.
5. *History of Edgar County,* p. 395.
6. *History of Sangamon County,* pp. 539-40.
7. For this and many other frontier customs see Tillson.

SOURCES

Adrosko, Rita J. *Natural Dyes and Home Dyeing.* New York: Dover, 1968.

Allen, John W. *Legends and Lore of Southern Illinois.* Carbondale: Southern Illinois University Press, 1963.

Brown, Harriette J. *Hand Weaving for Pleasure and Profit.* New York: Harper Brothers, 1952.

Buley, R. Carlyle. *The Old Northwest.* Bloomington: Indiana University Press, 1950.

Cox, Charles E. "Pioneer Days of Major Richard Rue Cox." *TISHS,* 1918, pp. 139-83, 585-87.

Davenport, Elsie G. *Your Handspinning.* Pacific Groves, Calif.: Craft and Hobby Book Service, 1968.

Flagg, Gershom. "Pioneer Letters." Ed. Solon J. Buck. *TISHS,* 1910, pp. 139-83.

Ford, Thomas. *A History of Illinois from Its Commencement as a State in 1818 to 1847.* Reprint of the 1854 ed. Ann Arbor, Mich.: University Microfilms, 1968.

Gould, Mary Earle. *Early American Wooden Ware.* Rutland, Vt.: Charles E. Tuttle, 1962.

Haines, James. "Social Life and Scenes in the Early Settlement of Central Illinois." *TISHS,* 1905, pp. 35-57.

History of Edgar County, Illinois. Chicago: William Le Baron, Jr., 1879.

History of Sangamon County, Illinois. Chicago: Interstate, 1881.

History of Schuyler and Brown Counties, Illinois. Philadelphia: W. R. Brink, 1882.

Ingals, Ephraim. "Autobiography of Dr. Ephraim Ingals" (excerpts). *JISHS,* Jan. 1936, pp. 279-308.

Kluger, Marion. *The Joy of Spinning.* New York: Simon and Schuster, 1971.

McFarland, Amelia G. Excerpt from *Recollections of the Pioneers of Lee County* (1893). *JISHS,* June 1949, pp. 219-20.

McGoorty, John P. "The Early Irish of Illinois." *TISHS,* 1927, pp. 54-64.

Moyers, William Nelson. "A Story of Southern Illinois, the Soldiers' Reservation, Including the Indians, French Traders and Some Early Americans." *JISHS,* Apr. 1931, pp. 26-104.

Parrish, Braxton. "Pioneer Preacher's Autobiography" (address at Benton, Ill., Aug. 3, 1874). *JISHS,* Winter 1956, pp. 424-31.

Patterson, Robert Wilson. *Early Society in Southern Illinois.* Chicago: Fergus Printing, 1881.

Perrin, William Henry, ed. *History of Alexander, Union and Pulaski Counties, Illinois.* Chicago: O. L. Baskin, 1883.

————, ed. *History of Cass County, Illinois.* Chicago: O. L. Baskin, 1882.

Reynolds, John. *My Own Times.* Reprint of the 1879 ed. Ann Arbor, Mich.: University Microfilms, 1968.

————. *Pioneer History of Illinois, Containing the Discovery, in 1763 and the History of the Country to the Year Eighteen Hundred and Eighteen, When the State Government Was Organized.* Reprint of the 1887 ed. Ann Arbor, Mich.: University Microfilms, 1968.

————. "Pioneer Times." Reprinted from *Illinois State Journal* (Springfield), 1857, in *History of Sangamon County, Illinois.* Chicago: Interstate, 1881.

Thompson, Scerial. "A Century Ago in Saline County." *JISHS,* June 1947, pp. 200-208.

Tillson, Christiana Holmes. *A Woman's Story of Pioneer Illinois.* Ed. Milo Milton Quaife. Chicago: R. R. Donnelley, 1919.

Tunis, Edwin. *Colonial Living.* Cleveland: World, 1957.

————. *Frontier Living.* Cleveland: World, 1961.

Chapter 5: Art in the Wilderness
(pp. 45-56)

NOTES

1. Quaife, "Property of Jean Baptiste Point du Sable," pp. 90-91.
2. Andreas, 1:72-74.
3. Quaife, *Pictures of Illinois,* pt. 3, p. 121, citing Schoolcraft, *Travels.*
4. Babson, pp. 35-37.
5. Peattie, p. 14.
6. Moyers, pp. 36-37.
7. Quoted in Peattie, p. 99.
8. Quoted in *ibid.,* pp. 139-40.

SOURCES

Andreas, A. T. *History of Chicago.* 3 vols. Chicago: A. T. Andreas, 1884.

Audubon, John James. *The Birds of America.* Orig. ed., London, 1827-38; new ed., New York: Macmillan, 1937.

Audubon, Marie R. *Audubon and His Journals.* New York: Charles Scribner's Sons, 1897.

Babson, Jane F. "The Architecture of Early American Forts." *JISHS,* Spring 1968, pp. 9-40.

Dwight, Edward H. "Audubon: Naturalist into Artist." *Art News,* May 1965, p. 37.

Eifert, Virginia S. *Men, Birds, and Adventure.* New York: Dodd, Mead, 1962.

————. "The Naturalists Discover Illinois." *The Living Museum,* Nov. 1959, pp. 329-40.

————. "Three Men and a Bird." *The Living Museum,* Feb. 1965, pp. 362-68.

Henson, Clyde E. "A Note on the Early Travels of John James Audubon in Southern Illinois." *JISHS,* Sept. 1947, pp. 336-39.

McDermott, John Francis. "Audubon's Journey up the Mississippi" (excerpts from Audubon's "Winter's Wreath"). *JISHS,* June 1943, pp. 148-73.

Meehan, Thomas A. "Jean Baptiste Point du Sable, the First Chicagoan." *JISHS,* Fall 1963, pp. 439-53.

Moyers, William Nelson. "A Story of Southern Illinois, the Soldiers' Reservation, Including the Indians, French Traders and Some Early Americans." *JISHS,* Apr. 1931, pp. 26-104.

Peattie, Donald Culross, ed. *Audubon's America.* Boston: Houghton Mifflin, 1930.

Quaife, Milo Milton, ed. *Pictures of Illinois One Hundred Years Ago.* Chicago: R. R. Donnelley, 1918.

———, ed. "Property of Jean Baptiste Point du Sable." *Mississippi Valley Historical Review,* June 1928, pp. 90-91.

Quimby, George Irving. *Indian Culture and European Trade Goods.* Madison: University of Wisconsin Press, 1966.

Salisbury, Albert and Jane. *Two Captains West.* New York: Bramhall House, 1950.

Schoolcraft, Henry Rowe. *Travels in the Central Portions of the Mississippi Valley: Comprising Observations on Its Mineral Geography, Internal Resources, and Aboriginal Population.* New York: Collins and Hannay, 1825.

Wilson, Alexander. *American Ornithology,* vol. 1, preface. Ed. George Ord. Philadelphia: Collins and Hall, 1828.

Woodward, Arthur. "Highlights on Indian Trade Silver." *Antiques,* June 1945, pp. 328-31.

Chapter 6: Early Frontier Craftsmen
(pp. 57-64)

NOTES

1. Coxe, p. 15.
2. Wilderman and Wilderman, 2:699.
3. Coxe, p. 15.
4. Enos, pp. 197-98, 201, 206-7.

SOURCES

Beck, Lewis C. *A Gazetteer of the States of Illinois and Missouri.* Albany, N.Y.: C. R. and G. Webster, 1823.

Buck, Solon J. *Illinois in 1818.* 2nd ed. Urbana: University of Illinois Press, 1967.

Coxe, Tench. *A Statement of the Arts and Manufactures of the United States for the Year 1810.* Prepared for the Secretary of the Treasury for the U.S. Census of 1810. Philadelphia, 1814.

Digest of the Accounts of Manufacturing Establishments in the United States, and of their Manufactures. Made under the direction of the Secretary of State in pursuance of a resolution of Congress of Mar. 30, 1822. Washington, 1823.

Enos, Zimri. "Description of Springfield." *TISHS,* 1909, pp. 190-208.

History of Edgar County, Illinois. Chicago: William Le Baron, Jr., 1879.

History of Randolph, Monroe and Perry Counties, Illinois. Philadelphia: J. L. McDonough, 1883.

Newcomb, Rexford. "Beginnings of Architecture in Illinois." *JISHS,* Sept. 1946, pp. 303-22.

Peat, Wilbur D. *Indiana Houses of the Nineteenth Century.* Chicago: R. R. Donnelley for the Indiana Historical Society, 1962.

Power, Richard Lyle. *Planting Corn Belt Culture.* Indianapolis: Indiana Historical Society, 1953.

Snyder, John Francis. *Adam W. Snyder and His Period in Illinois History, 1817-1842.* Reprint of the 1906 ed. Ann Arbor, Mich.: University Microfilms, 1968.

Study, Guy. "Oliver Parks Restores the Jarrot Mansion at Cahokia." *JISHS,* Sept. 1945, pp. 351-53.

Thompson, Scerial. "A Century Ago in Saline County." *JISHS,* June 1947, pp. 200-208.

Tunis, Edwin. *Colonial Craftsmen and the Beginning of American Industry.* Cleveland: World, 1965.

———. *Frontier Living.* Cleveland: World, 1961.

Van Wagenen, Jared, Jr. *The Golden Age of Homespun.* New York: Hill and Wang, 1953.

Wells, E. F. "Old Times in Illinois." *JISHS,* July 1912, pp. 179-96.

Wigginton, Eliot, ed. *The Foxfire Book.* Garden City, N.Y.: Doubleday, 1972.

———, ed. *Foxfire 2.* Garden City, N.Y.: Doubleday, 1973.

Wilderman, A. S. and A. A., eds. *History of St. Clair County, Illinois.* 2 vols. Chicago: Munsell Publishing, 1907.

Chapter 7: Early Encounters with the Prairies
(pp. 65-80)

NOTES

1. *History of Sangamon County,* p. 814.
2. Quaife, pt. 1, p. 19.
3. *Ibid.,* p. 46.
4. Boewe, p. 130.
5. *Ibid.,* p. 151, citing Birkbeck and Flower, *History of the English Settlements.*
6. Additional evidence to support the belief that these views were sketched at Birkbeck's home is found in a description of the view from its piazza in Thomson, p. 57, and in the fact that Morris Birkbeck was in the habit of signing his name simply M. Birkbeck.
7. Vail, pp. 41-42, 54-55, 57. The Illinois sketches in the catalog are often incorrectly titled by the editor, due in part to difficulty in reading the artist's handwriting and also to the fact that other Illinois scholars have conducted little research into the works of Lesueur.
8. Hall, pl. 39, with its description.
9. *Ibid.,* Introduction.
10. Gustorf, p. 145.

SOURCES

The author is indebted to George Bassett, curator, and various members of the Edwards County Historical Society, Albion, for their helpful information.

Birkbeck, Morris. *Letters from Illinois.* Illinois Sesquicentennial ed., reprint of the 1818 ed. Ann Arbor, Mich.: University Microfilms, 1968.

———. *Notes on a Journey in America, from the Coast of Virginia to the Territory of Illinois.* Reprint of the 1818 ed. London: A. M. Kelley, 1971.

———, and George Flower. *History of the English Settlements in Edwards County, Illinois, Founded in 1817 and 1818.* Reprint of the 1882 ed. Ann Arbor, Mich.: University Microfilms, 1968.

Boewe, Charles. *Prairie Albion.* Carbondale: Southern Illinois University Press, 1962.

Boggess, Arthur C. *The Settlement of Illinois, 1778-1830.* Reprint of the 1908 ed. Ann Arbor, Mich.: University Microfilms, 1968.

Buley, R. Carlyle. *The Old Northwest.* 2 vols. Bloomington: Indiana University Press, 1963.

Drury, John. *Old Illinois Houses.* Springfield: Illinois State Historical Society, 1948.

Dukes, E. L. *Yesteryears in Edwards County, Illinois.* Privately printed, 1948.

Foreman, Grant. "English Settlers in Illinois." *JISHS,* Sept. 1941, pp. 303-33.

Gustorf, Fred. "Frontier Perils Told by an Early Illinois Visitor" (excerpts from the journal of Frederick Julius Gustorf). *JISHS,* Summer 1962, pp. 136-56.

Hall, Basil. *Forty Etchings from Sketches Made with the Camera Lucida in North America in 1827 and 1828.* Edinburgh: Cadell, 1829.

History of Edwards, Lawrence and Wabash Counties, Illinois. Philadelphia: J. L. McDonough, 1883.

History of Sangamon County, Illinois. Chicago: Interstate, 1881.

Peat, Wilbur D. *Pioneer Painters of Indiana.* Chicago: R. R. Donnelley for the Art Association of Indianapolis, 1954.

Quaife, Milo Milton, ed. *Pictures of Illinois One Hundred Years Ago.* Chicago: R. R. Donnelley, 1918.

Thomson, Gladys Scott. *A Pioneer Family: The Birkbecks in Illinois 1818-1827.* London: Cape, 1953.

Thwaites, Reuben Gold, ed. "Flower's Letters from Lexington and the Illinois, 1819," "Flower's Letters from the Illinois, 1820-21," and "Wood's Two Years' Residence, 1820-21." In *Early Western Travels,* vol. 10. Cleveland: Arthur H. Clark, 1904.

Tunis, Edwin. *Colonial Craftsmen and the Beginning of American Industry.* Cleveland: World, 1965.

Vail, R. W. G. *The American Sketchbooks of Charles Alexandre Lesueur, 1816-1837.* Worcester, Mass.: American Antiquarian Society, 1938.

Chapter 8: Patriots and Portraits
(pp. 81-90)

NOTES

1. Dickens, pp. 222-23.
2. A bust portrait, about 28 by 36 inches, similar to those in London's Kitkat Club in the reign of Queen Anne.
3. Dickens, p. 227.
4. Snyder, p. 16.
5. From an 1880 letter by Gurdon S. Hubbard to Rufus Blanchard in Andreas, 1:630.
6. Letter in the Illinois State Archives, Springfield.
7. *History of Fayette County,* p. 30.

SOURCES

Andreas, A. T. *History of Chicago.* 3 vols. Chicago: A. T. Andreas, 1884.

Black, Mary. "American Primitive Watercolors." *Art in America,* Aug. 1963, pp. 64-82.

———, and Jean Lipman. *American Folk Painting.* New York: Clarkson N. Potter, 1966.

Butts, Porter. *Art in Wisconsin.* Madison: Democrat Printing for the Madison Art Association, 1936.

Christensen, Erwin O. "Symbols of a Nation." In *Index of American Design.* New York: Macmillan, 1950.

Dickens, Charles. *American Notes for General Circulation.* Reprint of the 1842 ed. Ed. John S. Whitley

and Arnold Goldman. Baltimore: Penguin Books, 1972.

Dolan, J. R. *The Yankee Peddlers of Early America.* New York: Bramhall House, 1964.

Dreppard, Carl W. "American Amateur Art." *The Spinning Wheel,* Oct. 1953, pp. 12, 14-16.

———. *American Pioneer Arts and Artists.* Springfield, Mass.: Pond-Ekberg, 1942.

———. "Silhouettes...Personable Portraits for the People at Penurious Prices." *The Spinning Wheel,* July 1950, pp. 20-24, 50.

———. "What Is Primitive and What Is Not?" *Antiques,* May 1942, pp. 308-10.

Freeman, G. L. "Primitive Painting and Portraits." *Heirlooms,* Sept. 1940, pp. 25-27.

Harbeson, Georgiana Brown. *American Needlework.* New York: Bonanza Books, 1938.

History of Fayette County, Illinois. Philadelphia: Brink, McDonough, 1878.

Lipman, Jean. *American Primitive Painting.* London: Oxford University Press, 1942.

McLanathan, Richard. *The American Tradition in the Arts.* New York: Harcourt, Brace & World, 1968.

Peat, Wilbur D. *Pioneer Painters of Indiana.* Chicago: R. R. Donnelley for the Art Association of Indianapolis, 1954.

Sanderson, Ruth, comp. *Amos Williams and Early Danville, Illinois, as Told to Miss Ruth Sanderson by His Woodbury Grandchildren.* Danville: privately printed, ca. 1934.

Snyder, John Francis. "Charles Dickens in Illinois." *JISHS,* Oct. 1910, pp. 7-22.

White, Judson. "Patrick Henry Davenport, Pioneer Portrait Painter." *JISHS,* Fall 1958, pp. 245-67.

Whitlock, Brand. "Great Seal of Illinois." *JISHS,* Jan. 1913, pp. 435-50.

Woolf, Doris. "Silhouettes: The Poor Man's Portrait." *Antiques Journal,* Jan. 1956, pp. 16-17.

Yates, Marguerite W. and Raymond F. *Early American Crafts and Hobbies.* New York: Wilfred Funk, 1954.

Chapter 9: Yankee Influence
(pp. 91-112)

NOTES

1. Norton, 1:564.
2. Willard, pp. 77-78.
3. Pearson, p. 7.
4. Kofoid, p. 276.
5. Ford, p. 281.

The author is indebted for the critical reading of this chapter to Richard Hagen, historian and restoration expert, formerly with the Illinois State Department of Conservation, Division of Parks and Memorials.

Allen, John W. *Legends and Lore of Southern Illinois.* Carbondale: Southern Illinois University Press, 1963.

Andreas, A. T. *History of Chicago.* 3 vols. Chicago: A. T. Andreas, 1884.

Atwater, Mary Meigs. *The Shuttle-craft Book of American Hand-weaving.* New York: Macmillan, 1947.

Bateman, Newton, and Paul Selby, eds. *Historical Encyclopedia of Illinois and History of Sangamon County.* 2 vols. Chicago: Munsell Publishing, 1912.

Blankmeyer, Helen Van Cleave. *The Sangamon Country.* 2nd ed. Springfield: Phillips Brothers for the Sangamon County Historical Society, 1965.

Burnham, Harold B. and Dorothy K. *"Keep me warm one night": Early Handweaving in Eastern Canada.* Toronto: University of Toronto Press in cooperation with the Royal Ontario Museum, 1972.

Carriel, Mary Turner. *The Life of Jonathan Baldwin Turner.* Centennial ed. Urbana: University of Illinois Press, 1961.

Collins, William H., and Cicero F. Perry. *Past and Present of the City of Quincy and Adams County.* Chicago: S. J. Clarke, 1905.

Dolan, J. R. *The Yankee Peddlers of Early America.* New York: Bramhall House, 1964.

Ford, Thomas. *A History of Illinois from Its Commencement as a State in 1818 to 1847.* Reprint of the 1854 ed. Ann Arbor, Mich.: University Microfilms, 1968.

Hall, Carrie A., and Rose G. Kretsinger. *The Romance of the Patchwork Quilt in America.* New York: Bonanza Books, 1935.

Hall, Eliza Calvert. *A Book of Hand-woven Coverlets.* Rutland, Vt.: Charles E. Tuttle, 1966.

Harbeson, Georgiana Brown. *American Needlework.* New York: Bonanza Books, 1938.

History of Jo Daviess County, Illinois. Chicago: H. F. Kett, 1878.

History of Sangamon County, Illinois. Chicago: Interstate, 1881.

History of Tazewell County, Illinois. Chicago: Charles C. Chapman, 1879.

Illinois: A Descriptive and Historical Guide. Originally compiled and written by the Federal Writers' Project

for the State of Illinois. Rev. ed. Chicago: A. C. McClurg, 1947.

Jenkins, J. Geraint. *Traditional Country Craftsmen.* New York: Frederick A. Praeger, 1967.

Kofoid, Carrie Prudence. "Puritan Influences in the Formative Years of Illinois History." *TISHS,* 1905, pp. 264-338.

Koval, Ralph and Terry. *American Country Furniture, 1788-1875.* New York: Crown, 1965.

Lane, Rose Wilder. *Women's Day Book of American Needlework.* New York: Simon and Schuster, 1963.

Lewis, Alfred Allan. *The Mountain Artisans Quilting Book.* New York: Macmillan, 1973.

Lord, Priscilla Sawyer, and Daniel S. Foley. *Folk Arts and Crafts of New England.* Philadelphia: Chilton, 1965.

McClelland, Clarence P. "The Education of Females in Early Illinois." *JISHS,* Dec. 1943, pp. 378-407.

McGrath, Robert L. *Early Vermont Wall Paintings 1790-1850.* Hanover, N.H.: University Press of New England, 1972.

Newcomb, Rexford. "Beginnings of Architecture in Illinois." *JISHS,* Sept. 1946, pp. 303-22.

Norton, W. T., ed. *Centennial History of Madison County, Illinois, and Its People, 1812-1912.* 2 vols. Chicago: Lewis Publishing, 1912.

Osborne, Georgia L. "Pioneer Women of Morgan County." *JISHS,* Apr. 1925, pp. 228-56.

Pearson, Emmet F. *Pioneer Crafts and Folk Life as Demonstrated at Clayville Stagecoach Stop.* Springfield: Phillips Brothers, n.d.

Peck, John Mason. *A Gazetteer of Illinois.* Jacksonville: Robert Goudy, 1834.

Power, Richard Lyle. *Planting Corn Belt Culture.* Indianapolis: Indiana Historical Society, 1953.

Rammelkamp, C. H., ed. "The Memoirs of John Henry." *JISHS,* Apr. 1925, pp. 39-75.

Strickland, W. P., ed. *Autobiography of Peter Cartwright.* New York: Methodist Book Concern, n.d.

Taylor, Marjorie Caroline. "Domestic Arts and Crafts in Illinois." *JISHS,* Sept. 1940, pp. 278-303.

Thomas, Benjamin P. "Lincoln and New Salem: A Study in Environment." *TISHS,* 1934, pp. 61-75.

———. *Lincoln's New Salem.* Rev. ed. Chicago: Abraham Lincoln Book Shop, 1966.

Tillson, Christiana Holmes. *A Woman's Story of Pioneer Illinois.* Ed. Milo Milton Quaife. Chicago: R. R. Donnelley, 1919.

Tyler, Alice Felt. *A New England Family on the Illinois Frontier.* Papers in Illinois History, 1942. Springfield: Illinois State Historical Society, 1944.

Van Osdel, John M. "The History of Chicago Architecture." *Inland Architect and News Record,* vol. 1, no. 3 (1883), pp. 36 ff.

Van Wagenen, Jared, Jr. *The Golden Age of Homespun.* New York: Hill and Wang, 1963.

Willard, Samuel. "Personal Reminiscences of Life in Illinois, 1830 to 1850." *TISHS,* 1906, pp. 73-87.

Yates, Raymond F. and Marguerite W. *Early American Crafts and Hobbies.* New York: Wilfred Funk, 1954.

Chapter 10: Painters of the Indian
(pp. 113-24)

NOTES

1. Thwaites, p. 210.
2. Donaldson, p. 711.
3. *Ibid.,* p. 138.
4. *Ibid.,* p. 723.
5. McCracken, p. 130.
6. Donaldson, p. 139.
7. *Ibid.,* p. 141.
8. *Ibid.*
9. Catlin, 2:158-59.
10. Donaldson, p. 11.
11. *Ibid.,* pp. 745-46.

SOURCES

Andreas, A. T. *History of Chicago.* 3 vols. Chicago: A. T. Andreas, 1884.

Beckwith, Hiram W. *The Illinois and Indiana Indians.* Chicago: Fergus Printing, 1884.

Butts, Porter. *Art in Wisconsin.* Madison: Democrat Printing for the Madison Art Association, 1936.

Catlin, George. *Letters and Notes on the Manners, Customs and Conditions of the North American Indians.* 2 vols. Reprint of the London, 1844, ed. New York: Dover, 1973.

Cumming, John. "John Mix Stanley: Artist of the West." *Antiques Journal,* May 1964, pp. 8-15.

Custer, Milo. "Kannekuk or Keeanakuk — the Kickapoo Prophet." *JISHS,* Apr. 1918, pp. 48-49.

Davidson, Marshall B. "Carl Bodmer's Unspoiled West." *American Heritage,* Apr. 1963, pp. 43-48.

Donaldson, Thomas, ed. "The George Catlin Indian Gallery in the U.S. National Museum." *Smithsonian Institution Report, 1885,* vol. 2, pt. 5. Washington: U.S. Government Printing Office, 1885.

Ewers, John. "George Catlin, Painter of Indians and the West." *Smithsonian Institution Report, 1955,* pp. 507-28. Washington: U.S. Government Printing Office, 1956.

Haberly, Lloyd. *Pursuit of the Horizon — a Life of George Catlin, Painter and Recorder of the American Indian.* New York: Macmillan, 1948.

Hauberg, John H. "The Black Hawk War, 1831-1832." *TISHS,* 1932, pp. 91-134.

Josephy, Alvin M., Jr. "The Boy Artist of Red River." *American Heritage,* Feb. 1970, pp. 30-49.

McCracken, Harold. *George Catlin and the Old Frontier.* New York: Dial Press, 1959.

McDermott, John Francis. "Another Coriolanus — Portraits of Keokuk, Chief of the Sac and Fox." *Antiques,* Aug. 1948, pp. 99-101.

McKenney, Thomas L., and James Hall. *The Indian Tribes of North America.* New ed. by Frederick Webb Hodge. Edinburgh: John Grant, 1933.

Past and Present of Rock Island County. Chicago: H. F. Kett, 1887.

Peat, Wilbur D. *Pioneer Painters of Indiana.* Chicago: R. R. Donnelley for the Art Association of Indianapolis, 1954.

Smith, Robert C. "The Noble Savage in Paintings and Prints." *Antiques,* July 1958, pp. 57-59.

Thomas, Stephen. "George Catlin, Portrait Painter." *Antiques,* Aug. 1948, pp. 96-101.

Thwaites, Reuben Gold, ed. "Maximilian, Prince of Wied's Travels in the Interior of North America, 1832-1834." In *Early Western Travels,* vols. 22 and 25 (Atlas). Cleveland: Arthur H. Clark, 1906.

U.S. Department of the Interior, National Park Service. *Voyages of Discovery.* Catalog of twenty-six paintings by George Catlin from the Paul Mellon Collection, National Gallery of Art, Washington, D.C.

Chapter 11: Melting Pot Culture
(pp. 125-36)

NOTES

1. Worthen, p. 42.
2. *History of Jo Daviess County,* p. 294.
3. Quailey, p. 167.
4. *Ibid.,* pp. 164-65.
5. Norton, 1:532.
6. Rawlings, p. 86.

7. McCormack, 1:330-31.
8. Trabue, p. 22.
9. Wilcox, 1:299-309.

SOURCES

The author is greatly indebted to many members of the Madison and St. Clair county historical societies for helpful information.

Beinlich, B. A. "The Latin Emigration in Illinois." *TISHS,* 1909, pp. 209-14.

Blair, Mrs. C. D. "Artisans with Loom, Metal, among Belleville Pioneers." *Belleville News Democrat,* Oct. 15, 1968.

Blum, Ida. *Nauvoo, an American Heritage.* Carthage: Journal Printing, 1969.

Busch, Moritz. *Travels between the Hudson and the Mississippi 1851-1852.* Tr. and ed. Norman H. Binger. Lexington: University Press of Kentucky, 1971.

Faust, Albert B. *The German Element in the United States with Special Reference to Its Political, Moral, Social, and Educational Influence.* Boston: Houghton Mifflin, 1909.

Foreman, Grant. "English Settlers in Illinois." *JISHS,* Sept. 1941, pp. 303-33.

Gustorf, Fred and Gisela. *The Uncorrupted Heart — Journal and Letters of Frederick Julius Gustorf.* Columbia: University of Missouri Press, 1969.

Harvey, G. *Historical Review of Belleville, Illinois.* Belleville: G. A. Harvey, 1870.

Hinchcliff, John. *Historical Review of the City of Belleville from Early Times to the Present.* Belleville: G. A. Harvey, 1870.

History of Jo Daviess County, Illinois. Chicago: H. F. Kett, 1878.

Lincoln Lore. Fort Wayne, Ind.: Lincoln National Life Foundation, 1960.

McCormack, Thomas J., ed. *Memoirs of Gustave Koerner, 1809-1896.* 2 vols. Cedar Rapids, Iowa: Torch Press, 1909.

MacMillan, Thomas C. "The Scots and Their Descendants in Illinois." *TISHS,* 1919, pp. 31-85.

"Native Clay, Straw and White Oak Used in Early Homes Here." *Belleville Daily Advocate,* Aug. 3, 1939.

Newbauer, Ella C. "The Swiss Settlements of Madison County, Illinois." *TISHS,* 1906, pp. 232-37.

McGoorty, John P. "The Early Irish of Illinois." *TISHS,* 1927, pp. 54-64.

Norton, W. T., ed. *Centennial History of Madison County, Illinois, and Its People, 1812-1912.* 2 vols. Chicago: Lewis Publishing, 1912.

O'Connor, Richard. *The German-Americans: An Informal History.* Boston: Little, Brown, 1968.

Paulding, James Kirk. "The Illinois and the Prairies." *Graham's Magazine,* Jan. 1849, pp. 16-25. Reprinted as "A Tour of Illinois in 1842," ed. Mentor Williams, *JISHS,* Sept. 1949, pp. 295-312.

Perrin, Richard W. E. *The Architecture of Wisconsin.* Madison: State Historical Society of Wisconsin, 1967.

Phillips, Richard, ed. "Shiloh Valley." *Iliniwek,* Sept.-Oct. 1973.

Pooley, William V. *The Settlement of Illinois, 1830-1850.* Reprint of the 1908 ed. Ann Arbor, Mich.: University Microfilms, 1968.

Power, Richard Lyle. *Planting Corn Belt Culture.* Indianapolis: Indiana Historical Society, 1953.

Quailey, Carlton C. "The Fox River Norwegian Settlement." *JISHS,* July 1934, pp. 133-77.

Rawlings, Mrs. Isaac D. "Polish Exiles in Illinois." *TISHS,* 1927, pp. 83-103.

Reynolds, John. *My Own Times.* Reprint of the 1879 ed. Ann Arbor, Mich.: University Microfilms, 1968.

Sabine, David P. "The Barrelmaker Turned Detective." *Outdoor Illinois,* Nov. 1966, pp. 16-20.

Trabue, J. D. "Our Towns in 1837." In *1970 Journal of the St. Clair County Historical Society.* Belleville: St. Clair County Historical Society, 1970.

Villard, Oswald Garrison. "The 'Latin Peasants' of Belleville, Illinois." *JISHS,* Mar. 1942, pp. 7-20.

Weisberger, Bernard A. *The American Heritage History of the American People.* New York: American Heritage, 1971.

Wilcox, David F., ed. *Quincy and Adams County History and Representative Men.* 2 vols. Chicago: Lewis Publishing, 1919.

Wilderman, A. S. and A. A., eds. *History of St. Clair County, Illinois.* 2 vols. Chicago: Munsell Publishing, 1907.

Worthen, A. H. *Geological Survey of Illinois,* vol. 5. Springfield: Illinois State Journal Printing, 1873.

Chapter 12: Greek Temples and Gothic Spires
(*pp. 137-57*)

NOTES

1. Gustorf, p. 156.
2. Dickens, p. 226.
3. Letter courtesy of James Hickey, Illinois State Historical Library, Springfield.
4. Information courtesy of Wayne Temple, Illinois State Archives, Springfield.
5. Martin, p. 131.
6. Leffingwell, p. 92.

SOURCES

The author is indebted to the following individuals for information contained in this chapter: Lowell Anderson, Mary Burtschi, Richard Hagen, and Howard E. Wooden.

Andreas, A. T. *History of Chicago.* 3 vols. Chicago: A. T. Andreas, 1884.

Angle, Paul, ed. *Prairie State: Impressions of Illinois, 1673-1967, by Travelers and Other Observers.* Chicago: University of Chicago Press, 1968.

Benjamin, Asher. *The American Builder's Companion.* Reprint of the 1827 ed. New York: Dover, 1969.

Burtschi, Mary. *Vandalia — Wilderness Capital of Lincoln's Land.* Decatur: Huston Patterson, 1963.

"Chicago Pioneer, Mrs. Emily Beaubien Le Beau." *JISHS,* Jan. 1920, pp. 641-42.

Converse, Henry A. *The House of the House Divided.* Springfield: Sangamon County Bar Association, 1958.

Dickens, Charles. *American Notes for General Circulation.* Reprint of the 1842 ed. Ed. John S. Whitley and Arnold Goldman. Baltimore: Penguin Books, 1942.

Documentary History of Vandalia, Illinois. Vandalia: Vandalia Historical Society, 1954.

Drury, John. *Old Illinois Houses.* Springfield: Chicago Daily News, 1941.

Early, James. *Romanticism and American Architecture.* New York: A. S. Barnes, 1965.

Gillon, Edmund Vincent, Jr. *Early New England Gravestone Rubbings.* New York: Dover, 1966.

Gloag, John. *Guide to Western Architecture.* Rev. ed. London: Hamlyn, 1969.

Gowans, Alan. *Images of American Living.* Philadelphia: J. B. Lippincott, 1964.

Grandjean, Serge. *Empire Furniture.* New York: Taplinger, 1966.

Gustorf, Fred. "Frontier Perils Told by an Early Illinois Visitor" (excerpts from the journal of Frederick Julius Gustorf). *JISHS,* Summer 1962, pp. 136-56.

Hamlin, Talbot. *Greek Revival Architecture in America.* New York: Dover, 1964.

History of Fayette County, Illinois. Philadelphia: Brink, McDonough, 1878.

Kimball, Fiske. *Domestic Architecture of the American Colonies and of the Early Republic*. New York: Dover, 1966.

Koeper, Frederick. *Illinois Architecture*. Chicago: University of Chicago Press, 1968.

Kovel, Ralph and Terry. *American Country Furniture, 1780-1875*. New York: Crown, 1965.

Larkin, Oliver W. *Art and Life in America*. New York: Rinehart, 1949.

Leffingwell, C. W. "Bishop Chase and Jubilee College." *TISHS,* 1905, pp. 82-100.

McLanathan, Richard. *The American Tradition in the Arts*. New York: Harcourt, Brace & World, 1968.

Mansbridge, John. *Graphic History of Architecture*. New York: Viking, 1967.

Martin, Lorene. "Old Jubilee College and Its Founder Bishop Chase." *TISHS,* 1934, pp. 121-52.

Newcomb, Rexford. "Beginnings of Architecture in Illinois." *JISHS,* Sept. 1946, pp. 303-22.

Peck, John Mason. *A Gazetteer of Illinois*. Jacksonville: Roubert Goudy, 1834.

Study, Guy. *History of St. Paul's Church, Alton, Illinois*. St. Louis: Mound City Press, 1943.

Swain, Joseph Ward. "La Fayette — on the Centenary of His Visit to Illinois." *TISHS,* 1925, pp. 70-82.

Tallmadge, Thomas E. *Architecture in Old Chicago*. Chicago: University of Chicago Press, 1941.

"Whatever Happened to Patriotism?" *Time,* Nov. 10, 1967, pp. 30-31.

Chapter 13: The Plight of the Artist
(pp. 159-68)

NOTES

1. Andreas, 1:415.
2. *Ibid.,* p. 475.
3. Still, p. 85, quoting Jefferson, *Autobiography.*
4. Quaife, p. 25.
5. The assumption in *Antiques,* June 1957, p. 541, that these paintings are by Peck's son Charles is erroneous.
6. *The Past and Present of Woodford County,* pp. 260-61.
7. *The Journal and Indian Paintings of George Winter,* p. 62.

SOURCES

The author is indebted to George Irwin for a copy of a deed showing lots bought in Quincy by Washington Irving; to Louella Harlan, curator, Peoria Historical Society, and Henry Capps for information about James Wilkins; and to John Bereman, collector and researcher, and Sanford S. Witherell, Mrs. William H. Alexander, and Mrs. Robert Mertz, descendants of Sheldon Peck, for information about Peck.

Andreas, A. T. *History of Chicago*. 3 vols. Chicago: A. T. Andreas, 1884.

Butts, Porter. *Art in Wisconsin*. Madison: Democrat Printing for the Madison Art Association, 1936.

Drown's Record and Historical View of Peoria. Peoria: S. DeWitt Drown, 1850.

Great Industries of the United States. Hartford, Conn.: J. B. Burr, 1874.

Hornung, Clarence P. *Handbook of Early Advertising Art*. 3rd ed. New York: Dover, 1956.

Jefferson, Joseph. *The Autobiography of Joseph Jefferson*. Reprint of the 1890 ed. Ed. Alan S. Downer. Cambridge, Mass.: Harvard University Press, 1964.

The Journal and Indian Paintings of George Winter, 1837-1839. Indianapolis: Indiana Historical Society, 1948.

McDermott, John Francis, ed. *An Artist on the Overland Trail — the 1849 Diary and Sketches of James F. Wilkins*. San Marino, Calif.: Huntington Library, 1968.

McVicker, J. H. *The Theatre, Its Early Days in Chicago*. Chicago: Knight & Leonard, 1884.

Newman, Ernest. "Wood Engravings." *Spinning Wheel,* Mar. 1951, pp. 26-28.

New-York Historical Society. *Dictionary of Artists in America*. New Haven: Yale University Press, 1957.

The Past and Present of Woodford County, Illinois. Chicago: William Le Baron, Jr., 1878.

Pierce, Bessie Louise. *History of Chicago*. 3 vols. New York: Alfred A. Knopf, 1937-57.

Quaife, Milo Milton. *Chicago's Highways Old and New*. Chicago: D. F. Keller, 1923.

Snyder, John Francis. "Charles Dickens in Illinois." *JISHS,* Oct. 1910, pp. 7-22.

Sokol, David M. "John Quidor, Literary Painter." *American Art Journal,* Spring 1970, pp. 60-73.

Still, Bayard. "Evidences of the 'Higher Life' on the Frontier as Illustrated in the History of Cultural Matters in Chicago, 1830-1850." *JISHS,* July 1935, pp. 81-99.

Weitenkampf, F. *American Graphic Art*. New York: Macmillan, 1924.

Chapter 14: Signs of a Vanished Frontier
(pp. 169-80)

SOURCES

Andreas, A. T. *History of Chicago*. 3 vols. Chicago: A. T. Andreas, 1884.

Bateman, Newton, and David McCulloch, eds. *Historical Encyclopedia of Illinois and History of Peoria County*. 2 vols. Chicago: Munsell Publishing, 1902.

Brown, Caroline Owsley. "Springfield Society before the Civil War." *JISHS,* Apr.-July 1922, pp. 477-500.

Bryan, John Albury. "Molded Iron in the Midwest." *Antiques,* Feb. 1943, pp. 79-81.

Burnham, Harold B. and Dorothy K. *"Keep me warm one night": Early Handweaving in Eastern Canada*. Toronto: University of Toronto Press in cooperation with the Royal Ontario Museum, 1972.

Chetlain, Augustus Louis. *Recollections of Seventy Years*. Galena: Gazette Publishing, 1899.

Dale, Edward Everett. "From Log Cabin to Sod House." *JISHS,* Dec. 1945, pp. 401-13.

Drury, John. *Old Illinois Houses*. Chicago: Chicago Daily News, 1941.

Eby, Esther E. "Once Glorious Galena." *JISHS,* July 1937, pp. 171-79.

History of Jo Daviess County, Illinois. Chicago: H. F. Kett, 1878.

Koeper, Frederick. *Illinois Architecture*. Chicago: University of Chicago Press, 1968.

Marshall, Josiah T. *The Farmer's and Emigrant's Handbook*. New York: D. Appleton, 1845.

Martin, Lorene. "An Old Adobe House." *JISHS,* July 1945, pp. 110-14.

Owens, Kenneth N. *Galena, Grant, and the Fortunes of War*. Northern Illinois University Research Ser. DeKalb: Northern Illinois University, 1963.

Paulding, James Kirk. "The Illinois and the Prairies." *Graham's Magazine,* Jan. 1849, pp. 16-25. Reprinted as "A Tour of Illinois in 1842," ed. Mentor Williams, *JISHS,* Sept. 1949, pp. 295-312.

Perrin, William Henry, ed. *History of Effingham County, Illinois*. Chicago: O. L. Baskin, 1883.

Phillips, Richard, ed. "Galena." *Iliniwek,* Nov.-Dec. 1969.

Pierce, Bessie Louise, ed. *As Others See Chicago*. Chicago: University of Chicago Press, 1933.

Pratt, Harry E., ed. "Illinois as Lincoln Knew It" (excerpts from letters by J. H. Buckingham to the *Boston Courier*). *TISHS,* 1937, pp. 109-87.

Rally Once Again. Galena: Galena Civil War Centennial Commission, n.d.

Safford, Carleton L., and Robert Bishop. *America's Quilts and Coverlets.* New York: E. P. Dutton, 1972.

Savage, James P., Jr. "Do-It-Yourself Books for Illinois Immigrants." *JISHS,* Spring 1964, pp. 42-46.

Snow, Barbara. "Preservation, 1962: Old and New Frontiers." *Antiques,* Apr. 1962, pp. 416-20.

Tour Guide; Paths of History: Galena, Illinois. Springfield: State of Illinois Department of Business and Economic Development, n.d.

Wilkey, Harry L. "Infant Industries in Illinois as Illustrated in Quincy." *JISHS,* Dec. 1939, pp. 474-97.

Chapter 15: Jug Towns
(pp. 181-94)

NOTES

1. Foreman, pp. 309-10.
2. Spargo, pp. 150-51.

SOURCES

The author is indebted to the following individuals for their contributions to this chapter: Sibley B. Gaddis, Margaret Kirkpatrick, Robert Mauk, Vera Millhouse, Kathy Oestreich, John Paul, Robert Sherman, Mrs. Eugene Wahl, William Walter, and Gary Whitbeck.

Atlas Map of Scott County, Illinois. Davenport, Iowa: Andreas, Lyter, 1873.

Ayers, Esther Mary. "Art in Southern Illinois." *JISHS,* June 1943, pp. 164-89.

Bateman, Newton, and David McCulloch, eds. *Historical Encyclopedia of Illinois and History of Peoria County.* 2 vols. Chicago: Munsell Publishing, 1902.

———, and Paul Selby, eds. *Historical Encyclopedia of Illinois and History of Rock Island County.* 2 vols. Chicago: Munsell Publishing, 1914.

Foreman, Grant. "English Settlers in Illinois." *JISHS,* Sept. 1941, pp. 303-33.

History of Jo Daviess County, Illinois. Chicago: H. F. Kett, 1878.

History of La Salle County, Illinois. 2 vols. Chicago: Interstate, 1886.

History of Peoria County, Illinois. Chicago: Johnson, 1880.

History of Sangamon County, Illinois. Chicago: Interstate, 1881.

History of Schuyler and Brown Counties, Illinois. Philadelphia: W. R. Brink, 1882.

Horney, Wayne B. *Pottery of the Galena Area.* East Dubuque, Ill.: Telegraph-Herald, 1965.

Norton, W. T., ed. *Centennial History of Madison County, Illinois, and Its People, 1812-1912.* 2 vols. Chicago: Lewis Publishing, 1912.

Peck, John Mason. *A Gazetteer of Illinois.* Jacksonville: Robert Goudy, 1834.

Perrin, William Henry, ed. *History of Alexander, Union and Pulaski Counties, Illinois.* Chicago: O. L. Baskin, 1883.

Portrait and Biographical Album of Morgan and Scott Counties, Illinois. Chicago: Chapman Brothers, 1889.

Power, John Carroll. *Early Settlers of Sangamon County, Illinois.* Springfield: Edwin A. Wilson, 1876.

Rosenow, Jane. "Peoria Pottery and How It Grew." *Antiques Journal,* Dec. 1969, pp. 30-31.

Spargo, John. *The Potters and Potteries of Bennington.* Boston: Houghton Mifflin, 1926.

Summerfeld, Evan. "A History of Nineteenth-Century Pottery in Illinois." Unpublished manuscript, n.d.

Taylor, Marjorie. "Stoneware of Ripley, Illinois." *Antiques,* Nov. 1949, pp. 370-71.

Worthen, A. H. *Economic Geology of Illinois,* vol 2. Reprint of original reports. Springfield: H. W. Rokker, 1882.

———. *Geological Survey of Illinois,* vol. 4. Springfield: State Journal Steam Press, 1870.

Chapter 16: Nauvoo, the Utopia
(pp. 195-208)

NOTES

1. Brown, p. 145.
2. Miller, p. 104.

SOURCES

The author is indebted to Ida Blum, historian at Nauvoo, and to Dr. T. Edgar Lyon, head of historical research, Nauvoo Restoration, Inc., for valuable new information and for the correction of misinformation in existing publications.

Berry, Orville F. "The Mormon Settlement in Illinois." *TISHS,* 1906, pp. 88-102.

Blum, Ida. *Nauvoo: An American Heritage.* Carthage: Journal Printing, 1969.

Brown, Katharine Holland. "The Icarian Community." *Harper's Monthly Magazine,* Dec. 1904, pp. 141-46.

Chandler, Josephine Craven. "Nauvoo: Twice Tried Utopia among Illinois Towns." *Welfare,* Dec. 1928, pp. 1350-57.

Clark, Nancy Duffy. "An Old Mormon Town, Nauvoo, Illinois." *JISHS,* Apr. 1918, pp. 38-42.

Cummings, J. C. "The Icarians at Nauvoo." *Keokuk (Iowa) Citizen,* Jan. 18, 24, Feb. 1, 8, 1924.

Flanders, Robert Bruce. *Nauvoo, Kingdom on the Mississippi.* Urbana: University of Illinois Press, 1965.

Green, Nelson Winch, ed. *Fifteen Years among the Mormons; the Narrative of Mary Ettie V. Smith.* New York: Charles Scribner, 1858.

Griffith, Will and Katharine, eds. *Historic Nauvoo.* Peoria: Quest Publishing, 1941.

Kimball, Stanley B., comp. *Sources of Mormon History in Illinois, 1839-49: An Annotated Catalogue of the Microfilm Collection at Southern Illinois University.* Carbondale: Southern Illinois University Library, 1964.

McGavin, Cecil. *The Nauvoo Temple.* Salt Lake City: Deseret Book Company, 1962.

Marsh, Eodocia Baldwin. "Mormons in Hancock County: A Reminiscence." Ed. Douglas L. Wilson and Rodney O. Davis. *JISHS,* Spring 1971, pp. 22-65.

Miller, Mrs. I. G. "The Icarian Community of Nauvoo, Illinois." *TISHS,* 1906, pp. 103-7.

Pratt, Harry E., ed. "Illinois as Lincoln Knew It" (excerpts from letters by J. H. Buckingham to the *Boston Courier*). *TISHS,* 1937, pp. 109-87.

"Recollections of the Nauvoo Temple" (excerpt from *Illinois Journal,* Dec. 9, 1853). *JISHS,* Dec. 1945, pp. 481-85.

Reynolds, John. *My Own Times.* Reprint of the 1879 ed. Ann Arbor, Mich.: University Microfilms, 1968.

Roberts, B. H. *The Rise and Fall of Nauvoo.* Salt Lake City: Desert News, 1900.

Rude, Fernand. *Voyage en Icarie.* Paris: Presses Universitaires, 1952.

Sanford, Mabel Adelina. *Joseph's City Beautiful.* Independence, Mo.: Herald Publishing, 1939.

Wadsworth, Nelson. "The Guns of Jonathan Browning...." *Guns,* Aug. 1967, pp. 43-45, 64-65.

Chapter 17: Discovering the Landscape
(pp. 211-30)

NOTES

1. Letter courtesy of Galena Public Library.
2. *Ibid.*
3. Hewitt, pp. 15-16.
4. *Ibid.,* pp. 25-26.
5. *Ibid.,* p. 189.
6. McDermott, *Seth Eastman's Mississippi,* pp. 32-33.

7. Obituary, *Decatur Review,* Mar. 12, 1942.

8. Andreas, 1:506.

9. *Lombard Spectator,* Dec. 27, 1945.

10. Letter from Mrs. Basil Misovsoroff, courtesy of Mrs. William Alexander.

SOURCES

Andreas, A. T. *History of Chicago.* 3 vols. Chicago: A. T. Andreas, 1884.

Angle, Paul, ed. *Prairie State: Impressions of Illinois, 1673-1967, by Travelers and Other Observers.* Chicago: University of Chicago Press, 1968.

Arrington, Joseph Earl. "Destruction of the Mormon Temple at Nauvoo." *JISHS,* Dec. 1947, pp. 414-25.

——. "Leon D. Pomarède's Original Panorama of the Mississippi River." *Missouri Historical Society Bulletin,* Apr. 1953, pp. 261-73.

——. "Samuel A. Hudson's Panorama of the Ohio and Mississippi Rivers." *Ohio Historical Quarterly,* Oct. 1957, pp. 355-74.

"Banvard's Panorama." *Scientific American,* Dec. 16, 1848.

"Banvard, the Artist." *Scientific American,* June 3, 1848.

Butts, Porter. *Art in Wisconsin.* Madison: Democrat Printing for the Madison Art Association, 1936.

Eifert, Virginia S. *Mississippi Calling.* New York: Dodd, Mead, 1961.

Elder, Lucius W. "The Mississippi River as an Artistic Subject." *TISHS,* 1937, pp. 34-42.

Heilbron, Bertha, ed. "Making a Motion Picture in 1848" (Henry Lewis's journal of a canoe voyage down the Mississippi). *Minnesota History Quarterly Magazine,* 17 (1936): 131-58, 288-301, 421-36.

Hewitt, J. N. B., ed. *Journal of Rudolph Friederich Kurz.* Smithsonian Institution Bulletin 115. Washington: Bureau of American Ethnology, 1937.

Larkin, Oliver W. *Art and Life in America.* New York: Rinehart, 1949.

Lewis, Henry. *The Valley of the Mississippi Illustrated.* Tr. A. Hermina Poatgieter, ed. Bertha L. Heilbron. St. Paul: Minnesota Historical Society, 1967.

McDermott, John Francis, ed. *An Artist on the Overland Trail — the 1849 Diary and Sketches of James F. Wilkins.* San Marino, Calif.: Huntington Library, 1968.

——. "J. C. Wild, Western Painter and Lithographer." *Ohio State Archaeological and Historical Quarterly,* Apr. 1951, pp. 111-25.

——. *The Lost Panoramas of the Mississippi.* Chicago: University of Chicago Press, 1958.

——. *Seth Eastman's Mississippi: A Lost Portfolio Recovered.* Urbana: University of Illinois Press, 1973.

Pierce, Bessie Louise. *History of Chicago.* 3 vols. New York: Alfred A. Knopf, 1937-57.

Rathbone, Perry T., ed. *Mississippi Panorama.* Rev. ed. St. Louis: Von Hoffmann Press for the City Art Museum of St. Louis, 1950.

Richardson, E. P. *Painting in America.* New York: Thomas Y. Crowell, 1965.

Smith, John Rowson. *Leviathan Panorama of the Mississippi River.* Philadelphia, 1848 (pamphlet).

Steele, Eliza R. *A Summer Journey in the West.* New York: J. S. Taylor, 1841.

Stokes, I. N. Phelps, and Daniel C. Haskell. *American Historical Prints, Early Views of American Cities, etc.* New York: New York Public Library, 1933.

Sturges, Walter Knight. "American Romantic Landscapes." *Antiques,* Nov. 1965, pp. 689-700, 702-8, 712.

Wild, John Caspar. *The Valley of the Mississippi Illustrated in a Series of Views.* Ed. Lewis F. Thomas. St. Louis: Chambers and Knapp, 1841-42.

Wittman, Otto. "The Attraction of Italy for American Painters." *Antiques,* May 1964, pp. 552-56.

Chapter 18: Swedes on the Prairies
(pp. 231-42)

The author is indebted to Ronald E. Nelson for the critical reading of this chapter, and to Merrill Nystrom, George Swank, and Mrs. Reynolds M. Everett for their generous help in supplying information.

SOURCES

Anderson, Theo J., comp. *History of Bishop Hill, 1846-1946.* Chicago: Theo J. Anderson, 1946.

Bergendoff, Conrad. "The Beginning of Swedish Immigration into Illinois a Century Ago." *JISHS,* Mar. 1948, pp. 16-27.

Bigelow, Hiram. "The Bishop Hill Colony." *TISHS,* 1902, pp. 101-8.

Hedstrom, Mrs. Walter T. Series of weekly articles in the *Kewanee* (Ill.) *Star Courier* starting Mar. 28, 1946.

Isaksson, Olov. "Discover Bishop Hill." *Swedish Pioneer Historical Quarterly,* Oct. 1968, pp. 221-33.

——, and Sören Hallgren. *Bishop Hill: A Utopia on the Prairie.* Stockholm: LT Publishing, 1969.

Jacobson, Margaret E. "The Painted Record of a Community Experiment." *JISHS,* June 1941, pp. 164-76.

Lowe, David G. "A Prairie Dream Recaptured." *American Heritage,* Oct. 1969, pp. 14-25.

Morton, Stratford Lee. "Bishop Hill, an Experiment in Communal Living." *Antiques,* Feb. 1943, pp. 74-77.

Nelson, Ronald E. "Bishop Hill, Illinois . . . Prairie Utopia." In *Catalogue of Lake Forest Antiques Show.* Lake Forest Academy, Ill., 1968.

Phillips, Richard. "Bishop Hill Colony." *Iliniwek,* Mar.-Apr. 1969.

Rosenau, Jane. "Olaf Krans — American Primitive Artist." *Antique News,* Aug.-Sept. 1965, pp. 1-2.

Swank, George. *Bishop Hill: A Pictorial History and Guide.* Galva, Ill.: Galvaland Press, 1965.

Chapter 19: End of an Era
(pp. 243-62)

NOTES

1. Pierce, *History of Chicago,* 2:475-76.

2. *Ibid.,* p. 465.

3. Angle, pp. 173-74, quoting the *Sangamo Journal,* 1845.

4. Maas, p. 10.

5. Hamilton and Ostendorf, p. 7.

6. Healy, pp. 61-62.

7. Andreas, 2:556.

8. *Ibid.,* p. 557.

SOURCES

The author is indebted to James Hickey, Alan Clark Miller, and Mrs. Lawrence Oestreich for certain information in this chapter.

Andreas, A. T. *History of Chicago.* 3 vols. Chicago: A. T. Andreas, 1884.

Angle, Paul. "Nathaniel Pope, 1784-1850 — a Memoir." *TISHS,* 1936, pp. 173-74.

Bardwell, A. C., ed. *History of Lee County.* Chicago: Munsell Publishing, 1904.

Bateman, Newton, and Paul Selby, eds. *Historical Encyclopedia of Illinois and History of Sangamon County.* 2 vols. Chicago: Munsell Publishing, 1912.

Coles, Arthur Charles. "The Passing of the Frontier." In *The Era of the Civil War 1848-1870.* Centennial History of Illinois, vol. 3. Springfield: Illinois Centennial Commission, 1919.

Debow, J. D. B. *Statistical View of the United States — a Compendium of the Seventh U.S. Census.* Washington, 1854.

De Mare, Marie. *G. P. A. Healy, American Artist.* New York: David McKay, 1954.

Downing, A. J. *The Architecture of Country Houses.* Orig. printed 1850. Ed. Adolph K. Placzek. New York: Da Capo Press, 1968.

Drury, John. " 'The City in a Garden': Chicago before the Fire of 1811." *Antiques,* Feb. 1943, pp. 66-69.

Early, James. *Romanticism and American Architecture.* New York: A. S. Barnes, 1965.

Gardner, Albert Ten Eyck. *Yankee Stonecutters.* New York: Columbia University Press for the Metropolitan Museum of Art, 1945.

Gowans, Alan. *Images of American Living.* Philadelphia: J. B. Lippincott, 1964.

Hamilton, Charles, and Lloyd Ostendorf. *Lincoln in Photographs: An Album of Every Known Pose.* Norman: University of Oklahoma Press, 1963.

Healy, George P. A. *Reminiscences of a Portrait Painter.* Chicago: A. C. McClurg, 1894.

Horan, James D. *Mathew Brady, Historian with a Camera.* New York: Crown, 1955.

Huback, Robert R. "Illinois: Host to Well-Known Nineteenth Century Authors." *JISHS,* Dec. 1945, pp. 446-67.

Johnson, Charles Beneulyn. *Illinois in the Fifties, or A Decade of Development.* Centennial ed. Champaign: Flanigan Pearson, 1918.

Larkin, Oliver W. *Art and Life in America.* New York: Rinehart, 1949.

Maas, John. *Gingerbread Age.* New York: Bramhall House, 1957.

McLanathan, Richard. *The American Tradition in the Arts.* New York: Harcourt, Brace & World, 1968.

Miller, Lillian B. *Patrons and Patriotism: The Encouragement of the Fine Arts in the United States 1790-1860.* Chicago: University of Chicago Press, 1966.

Newhall, Beaumont. *The History of Photography.* New York: Museum of Modern Art, 1964.

The Old Capitol, 1840-1876: Springfield, Illinois. Springfield: Illinois State Historical Society for the Abraham Lincoln Association, n.d.

Pease, Theodore Calvin. *The Frontier State.* Springfield: Illinois Centennial Commission, 1918.

Peat, Wilbur D. *Indiana Houses of the Nineteenth Century.* Chicago: R. R. Donnelley for the Indiana Historical Society, 1962.

Pierce, Bessie Louise. *As Others See Chicago.* Chicago: University of Chicago Press, 1933.

——. *History of Chicago.* 3 vols. New York: Alfred A. Knopf, 1937-57.

Sandham, Mrs. William R. "George Peter Alexander Healy." *JISHS,* Oct. 1915, pp. 469-88.

Taft, Lorado. *The History of American Sculpture.* Rev. ed. New York: Macmillan, 1924.

Warren, Louis. *He Belongs to the Ages.* Ann Arbor, Mich.: Edwards Brothers, 1912.

Engraving detail from a double-barrel percussion shotgun made by George T. Abbey of Chicago about 1860.

CHICAGO HISTORICAL SOCIETY

"*N. C. Thompson Reaper Works, Rockford*," 1855-
60. *Painted by an unknown artist.*
ROCKFORD COLLEGE

Art, Crafts, and Architecture in Early Illinois

Index of Names

Abbey, George T. (gunsmith): engraving on shotgun, *279*

Abston, U. C. (portrait painter), 263

Acheson, Henry (engraver, lithographer), 263

Ackerman, John and Jacob (fresco painters), 263

Ainslee, Henry Francis (artist traveler): "Dixon's Ferry," "A Prairie on Fire," "Dresden," 263

Allen, James (sign painter), 90

Allen, Marie W. (amateur artist), 263

Almini, Peter M. (ornamental and fresco painter, publisher), 263

Andrieu, M. A. (panorama painter), 229-30; ad, *228*

Andruss, Mrs. W. B. (artist), 263

Arganbright, Susannah Tweed: pieced quilt, *268*

Ashby, Nathaniel: Nauvoo home, *197*

Attwood, J. M. (house, sign, ornamental painter), 159

Audubon, John James (nature artist), 50-52, 55-56; trumpeter swan (young), *50;* trumpeter swan (adult), *51;* bald eagle (immature), *52;* ivory-billed woodpecker, *55;* Carolina paroquet, *56*

Bacon & Ellis (wood engravers), 263

Baker, Eliza Jane (weaver), 171

Baker, John B. (amateur artist), *84c*

Baker, Michael (potter), 182, 190

Baker, William D. (wood engraver), 263

Balatka, Hans (music conductor), 133

Banvard, John (panorama painter), 223-24; machinery for panorama, *223*

Barber, John W. (artist), 263

Barker, Robert (inventor of cyclorama), 222

Barnum, P. T. (circus owner), 246

Barth, Otto (amateur artist), 263

Bates, A. S. (cabinetmaker), 175, *175*

Bayne, Catherine: boarding school, 109

Beck, Augustus (weaver), 171

Becker, A. H. (fresco, house, sign, ornamental painter), 263

Beckert, L. (fresco painter), 263

Beman (or Beaman), Allen C. (engraver), 263

Bender, A. S. (artist, engineer), 263

Bergeron, Jasmine Pierre (artist), 206

Berrisford, Benjamin (potter), 187, 190

Berry, James (portrait painter), 90, 152-54; portrait of Governor Coles, 90; portrait of Shadrach Bond, 90, *90;* copy of Vanderlyn's portrait of Washington, *153;* copy of Scheffer's portrait of Lafayette, *153*

Bielaski, Alexander, 130

Bigelow, Daniel F. (artist), 260

Bingham, George Caleb (Missouri artist), 78, 212-13

Birkbeck, Morris (English colony leader), 66-72, *67;* Cauliflower Lodge (home), 68-70, *69, 72, 73;* approximate site of death, *117*

Bjorklund, Sven (Swan) (clockmaker), 235; hotel, 242

Black Hawk (Sauk Indian leader), 120-22; portrait by Drake, *54,* 114; portrait by King, 118; portraits by Lewis and Sully, 121; portrait by Catlin (at Jefferson Barracks), 121

Blackman, George (furniture maker): pedestal drop-leaf table, *252*

Blair, J. B. (landscape painter), 217, 263; "View of Alton," *209*

Blanc, Pierre (painter), 207

Blatter, Jacob: furniture made for, *148, 151, 252*

Blomberg, Peter (clockmaker), 238

Blood, M. I. (pastel artist), 263

Bloss, Mr. and Mrs.: portrait, 163, *165*

Bock, Mrs. William N. (weaver): coverlet, *140*

Bodmer, Karl (Indian and landscape painter), 114-17; view of Albion, 114; "View of a farm on the prairies of Illinois," *115;* "New Harmony on the Wabash," engraving after, *116;* "Cave-in-Rock," mezzotint after, *116;* view of Kaskaskia, 116; "Tower-Rock," lithograph after, *116;* "Mouth of Fox River [Indiana]," aquatint after, *117*

Bodstein, Herman (engraver), 263

Bond, Charles V. (portrait and landscape painter), 263

Bone, Elihu (weaver), 171

Booth, Junius Brutus (actor), 246

Bornman, Conrad (blacksmith), 130

Bosse, Herman (engraver), 263

Bower, George (potter), 70, 189

Brady, Mathew (photographer), 256

Britt, Peter (portrait painter, photographer), 257; "Col. George Davenport," *257*

Broadwell, Moses, 103; brick buildings, 93, 103, *106-7*

Brockschmitt, Joseph (clockmaker), 136

Brookes, Samuel Marsden (miniature, portrait, landscape painter), 167-68; portrait of Corinne Gail, *167*

Brooks, Noah (landscape painter, editor), 263

Browning, Jonathan (gunsmith), 201; home and workshop, *200*

Brunk, David (potter), *182, 183,* 189

Bryant, Julian (artist), 211, 263; painting of Starved Rock, *212*

Bryant, William Cullen (poet), 246; describes scenery along Illinois River, 211

Buckley, Thomas (museum owner), 245

Burns, Miss N. J. (art teacher), 264

Bush, John A. (ornamental painter), 264

Bynum, B. (portrait painter), 264

Cabanis, Ethan T. (portrait painter, photographer): portrait of an unknown man, *154;* portraits of Harrison, Scammon, and Buford, 154

Cabet, Etienne (author, French colonizer), 205-6, 207

Carlin, John (potter), 190

Carpenter, R. R. (engraver), 264
Cartwright, Peter, 93, 103
Case, H. (engraver), 264
Castelnau, Francis de (artist traveler), 163, 264; "View of the Mouth of the Chicago River," 264
Catlin, George (Indian painter), 118-23; in Illinois, 119, 120, 121, 122; concerning the character of the upper Mississippi region and its settlers, 121-22; paints French voyages of exploration, 123; "Kee-mo-rá-nia, No English," *54,* 121; "Kee-án-ne-kuk, or Shawnee Prophet," *118,* 119; "Ah-ton-we-tuck, the Cock Turkey," 119, *119;* "Ma-shee-na (Elk's Horns)," 119; "Ke-chim-qua (Big Bear)," 119; "A'h-tee-wot-o-mee, a woman," 119; "Shee-nah-wee," 119; "Pah-me-ców-ee-tah, the Man who Tracks," *121;* "Wap-sha-ka-náh, a brave," 121; "Ni-a-có-mo (Fix with the Foot)," 121; "Men-són-se-ah (Left Hand)," 121; "Sailing Canoes," 122, *122;* "Begging Dance," 122; "Dance to the Berdashe," 122; "Discovery Dance," 122, *123;* "Smoking Horses," 122, *123*
Chambers, Joseph T. (artist), 264
Chandler, R. W. (map maker), 264
Charles, S. M. (eastern artist), 117
Chase, Philander: log house, Jubilee College, and tombstone, 155, *155;* sponsors Gothic churches, 156, *156*
Chatterton, George W. (silversmith), *111*
Chenne, Joseph (weaver), 171, 207
Cherrill, Adolphus (amateur painter, map maker), 264
Chevant, Manon (rope maker), 207
Childs, Shubael (Shuball) Davis (engraver, painter), 160, 264
Childs, Shubael Davis, Jr. (engraver), 264
Chism, Mrs. Charles (amateur painter): landscape, *108,* 264
Choisser, John (Jean) Baptiste, Jr.: portrait, 85, *85*
Choisser, Nancy Sutton: portrait, 85, *85*
Clapperton, William R. (ornamental painter), 264
Clark, Decius W. (pottery manufacturer): "departmental factory" in Peoria, 188-89, 194
Clark, G. W. (portrait painter), 264
Clark, George Rogers, 31, 38
Clark, Harry A. (crayon artist), 264
Clark, Mason (amateur artist), 264
Clark, William, 22, 45
Clarke, Henry B.: house, 142, *142*
Claus and Tetard (furniture manufacturers), 175
Cleveland & Co. (house, sign, ornamental painters), 159
Colby, William: cradle-type churn, *99*
Cole, A. (house, sign, ornamental painter), 159

Collins, Cephas Henry (landscape, portrait, cyclorama painter), 222-23
Collis, George S. (artist), 260, 264
Collot, George Henri Victor (soldier, amateur artist, map maker), 21-22; "Map of the Country of the Illinois" after, *21;* engraving of a French house in Illinois after, *26,* 27; "Indian of the Nation of the Kaskaskia," engraving after, *49*
Conant, S. (cabinetmaker): ad, *175*
Connor & Hussey (engravers), 264
Convay, John B. (potter), 190
Cook, G. W. E. (artist), 264
Cooke, George (artist): paints Illinois Indians in Washington, 113, 117
Coolidge, Joseph W. (builder), 201; former Nauvoo home, *208*
Cooper, Thomas (potter), 70, 189
Cornell, James (potter), 194
Couloy, Isadore (potter), 193, 194, 207
Cowell, Benjamin (cabinetmaker): sewing table, *252;* cupboard, *253*
Cox, Thomas: home, 61
Cridland, Charles E. (landscape painter), 264
Cross, J. George (Spencerian script expert), 264; "The Lord's Prayer," *245*
Croxton, Walter (potter), 193
Crum, Elizabeth Ann and Frank: watercolor painting, *84,* 85
Cunningham, Andrew (tanner, builder), 170; adobe house, *169*
Currier and Ives (lithographers): Mississippi River scenes, 213

Daguerre, Louis Jacques Mandé (daguerreotype inventor), 256
Daniel, Holy (primitive landscape painter), 264
Darneille, Benjamin (cabinetmaker): spool-turned cherry table, *252*
Davenport, Patrick Henry (portrait painter), 89; self-portrait, *89;* portrait of John Logan, *89;* portrait of Eliza Bohannon Davenport, *89*
Davidson, Seth (potter), 193
Davis, Alexander Jackson (architect, draftsman, lithographer), 249
Davis, George (artist): lithograph of Wolf's Point after, *126*
Davis, James (portrait painter), 264
Dawson, R. W. (artist), 264
Daye, Thomas J. (engraver), 264

DeBault, Charles (crayon artist), 207, 264
Deere, John (blacksmith): Grand Detour home, *94*
Degge, John Robert and Mary Frances: cradle quilt, *104*
de Granville, Charles Bécard, 18; drawing of Illinois Indian chief, *18*
Delever, Jean (clockmaker), 207
Dennis, S. A. (amateur artist), 6; "The Piasa," *6*
Dennis, William (amateur artist), 3; "Flying Dragon," *3*
Dickens, Charles: in Illinois, 89-90, 246
Dickeson, Montroville W. (panorama innovator, natural scientist), 227-28; handbill for Mississippi panorama, *227*
Dillingham, John E. (artist), 264
Dixon, John: artist Brooks's view of home, 263
Donnahower, Michael (potter), 194
Dorey, Etienne (tanner), 207
Douglas, Stephen A.: in Springfield, 247
Dowling, John and Nicholas: home and trading post, 128, *129;* Nicholas Dowling home, *179,* 180
Downing, Andrew Jackson (architect, landscape gardener): advocate of individualism in architecture and of English landscape design, 254-55
Doyle, William G. (chair maker), 110
Drake, Samuel Gardiner (writer, Indian painter): portrait of Senachwine (Potawatomi), 114; portrait of Black Hawk (Sauk), *54,* 114
Drown, Simeon DeWitt (publisher, engraver), 264
Drum, P. & S. (chair makers), *174,* 180
Duncan, Joseph: entrance to home, *95*
du Pratz, Antoine Simon le Page (nature artist), 49
du Sable, Jean Baptiste Point (Indian trader, craftsman), 45, 46

Eagleston, Eliza: pieced quilt, *268*
Eastman, Seth (landscape and Indian artist), 220-21; "Chicago in 1820: Old Fort Dearborn," *48;* "Kaskaskia," *220;* "Devil's Bake Oven," *220;* "Miss. Flat Boats at Cairo," *220;* "Sunset on the Mississippi," *221*
Ebey, George (potter), 183, 189-90; drain tile, *183;* miniature oil lamp and vase, *183*
Ebey, John Neff (potter), 181, 182, 183-84, 189-90; pottery, *182*
Edwards, Benjamin S.: Springfield house, *254*
Edwards, W. (engraver), 201
Egan, John J. (panorama painter), 227-28; "The Tornado of 1844," *228,* 228
Eggen, Jacob (potter), 130, 190

Ellis, John Millot: central Illinois description, 95
Ellis, Lucebra: woven linen, *170*
Ellis, William C. (engraver), 264
Emerson, Ralph Waldo (writer): lectures on "Culture" and "Beauty," 246
Engelmann, George: occupies log cabin, 131
Engelmann, Theodore Frederick, 131-32; home, *131*
Enos, Zimri: description of Springfield homes (1823), 61-62
Eppel, John Paul (blacksmith, carriage maker), 135
Ernst, Ferdinand (German pioneer), 131
Ertel, Daniel (carpenter), 135
Etter, Elizabeth Davidson: coverlet, *101*
Ewing, William D.: invites artist Berry to Springfield, 152, 154

Fairthorne, William C. (engraver), 264
Fasig, W. (weaver), 171
Featherstonhaugh, G. W. (artist): engraving of Monk's Mound after, *12*
Fenton, Christopher Webber (pottery manufacturer): in Peoria, 188-89, 194
Fernberg, Samuel (weaver), 171
Fettinger, Charles (wood carver), *136*
Field, J. A. (amateur artist), 207, 264
Filcher, Thomas J. (potter), 190
Finger, Henry (amateur artist, doctor), 264
Flachcot, Jean (tapestry maker), 207
Flager, John: family quilt, *104*
Flaiz, Xavier (shoemaker), 135
Fleury, Elsie (amateur artist), 207, 264
Flower, George (English colonizer, amateur artist), 66-67, 70-71, 78-79; builds Park House, 68; artist Lesueur visits home, *69, 75, 75;* illustrates manual on horticulture, 71; rear view of Park House, *70;* Park House from the grove, *71;* "Park House, Albion," *87*
Flower, Richard (English pioneer, artist), 71; influences establishment of cultural center at New Harmony (Ind.), 71
Ford, A. (Indian portrait copyist), 117
Forquet, George: Springfield house, 127
Forrest, Edwin (actor), 246
Foster, Mary Ann Kelly (weaver), *170, 171*
Fowler, Orsen Squire: advocate of octagon house, 255
Frank, James (engraver), 264
Frazie, J. (weaver), 171
French, George: Albion house, *80*
Frune, George W. (artist), 264
Fuller, Elijah K. (potter), 190, 199

Fuller, Margaret (author traveler): describes Illinois and Rock River regions, 211
Fullerton, Hugh (potter), 194
Funk, J. S. (cabinetmaker), 172-73

Gauss, George (weaver), 171-72; Jacquard coverlet, *140*
Gear, H. H.: portrait, *117;* thatched log cabin, 128
Gemmell, John (lithographer), 264
Gilcrist, Helen: appliqué counterpane, *88*
Glassen, John (potter), 194
Glenn, William (potter), 194
Glenn & Hughes (potters), 194
Gmunder, Frederick (engraver), 207
Goodman, J. Reginald (watercolorist), 265
Goodwin, Russell F. (artist), 265
Gorham, Joshua (potter), 193
Grant, Ulysses S.: in Springfield, 247
Greatbach, Daniel (pottery designer, modeler): in Peoria, 188-89
Greeley, Horace (author traveler), 246
Green, R. G. (melodeon manufacturer), 243
Greene, William C. (engraver), 265
Grillar, Pierre (ebonist), 207
Grimm, Henry (carpenter), 135
Grocott, J. (potter), 190, 199
Grommes & Ulrich (potters), 194
Grow, Sylvanus (architect), *250*
Grubert, Claude Antoine (music master), 207
Gruenig, ———— (potter), 135, 193
Grunner, Frank (wood carver), 156

Hadley, Miss N. E. (ornamental and miniature painter), 168
Hall, Basil (artist traveler): describes Illinois prairies, 76; uses and describes camera lucida, 76-77; sketch of backwoodsman and river pilot, *76;* "Village of Shawneetown," *77*
Hall, James (writer, publisher), 117-18; *Indian Tribes of North America,* 118
Hall, Thomas: Toulon office, *146*
Hamilton, John (weaver), 171
Hanback, William (portrait painter): ad, *86*
Harding, Horace (itinerant painter): portrait of Shadrach Bond, 86
Harris, Daniel Smith (steamboat builder), 112; Galena house, *251*
Harrison, C. R. (potter), 194
Harrison, Fielding T. (potter), 193
Harrison, Robert (potter), 183, 189

Harrison, Thomas (builder of cotton gin), 58
Harrower, William (stonecutter), 145
Hartmann, Charles G. (weaver), 171
Haskins, ————: stenciled hanging, *88*
Hassock, John: Ottawa home, *250*
Haukins, W. W. (potter), 194
Hawkins, D. W. (artist), 265
Heade, Martin Johnson (landscape, portrait, still-life artist), 265
Healy, George Peter Alexander (portrait painter), 258-60; portrait of William B. Ogden, *258;* portraits of presidents, Chicago citizens, Douglas, and President-elect Lincoln, 259-60
Heath, William (potter), 182, 189
Heberling, George (foundry pattern maker), 172
Heitze, Christian (potter), 193
Heller, George P. (carpenter, builder), 135
Helmle, Leopold (art instructor), 265
Helmle, William (wood carver), 145
Hennepin, Louis (French explorer): description of Kaskaskia Indian lodges, 18; depiction of regional fauna, 49; depiction of Sioux attack, 123
Henry, John (cabinetmaker, wood turner), 95
Herndon, William: law offices, 145, *145*
Herrmann, Charles A. (weaver), 171
Hesler, Alexander (photographer), 256-57, 260; ad, *256;* camera portrait of Lincoln, *257*
Heyman, F. T. (watchmaker), 159
Hilgard, Edward and Theodore: Shiloh Valley home, 131
Hill, Gustavus (jeweler, goldsmith, silversmith, engraver): map of Nauvoo (1842-43), 199
Hill, Samuel (carding-mill builder), 97
Hillman, Richard S. (house, sign, decorative painter), 265
Hoge, Joseph: Galena home, 178, *179*
Holbrecker, John (engraver, marble cutter, ornamental iron manufacturer), 135
Holmes, L. W. (tin, copper, sheet-iron manufacturer), 159
Holmes, Oliver Wendell: in Illinois, 246
Holton, Chancy (cabinetmaker): dressing table, *150*
Hopkins, William R. (hollow ware and stove manufacturer), 172
Hubban, E. A. (artist), 265
Hubbs, W. W. (potter), 193
Hudson, Samuel A. (panorama painter), 224
Huhulin, Gottlieb (weaver), 171
Hunt, Elisha (portrait painter), 265

Index of Names

Hutchins, Thomas (map maker), 20-21, 22; "A Plan of the several Villages in the Illinois Country...," 21
Hyde, Orson: Nauvoo home, 196

Ianglois, Charles (foundryman), 207
Iles, Elijah: Springfield home, 141, *141*
Ingalls, Walter (portrait, still-life, scene painter), 265
Inman, H. (Henry?): sketch of Mt. Joliet, 213
Irving, Washington, 246; buys land in Illinois, 161
Irwin, Harvey (potter), 190
Isherwood, Henry (scene painter, theatrical producer), 160
Ives and Curran (silversmiths), 175

Jackson, J. (artist), 163, *163*
Jacquard, Joseph Marie (loom inventor), 170
Jacquin, Louis (linen bleacher), 207
Jäger, Joseph (potter), 194
Jansen, Frederick William (furniture manufacturer), 135, 172, *172*
Janson, Eric (Swedish colonizer), 231, 234
Jarrot, Nicholas: Cahokia home, 64, *64*
Jefferson, Joseph (actor and scene painter), 160-61
Jefferson, Thomas: advocate of westward exploration and expansion, 45, 49; advocate of Classic Revival architecture, 137-38
Jennings, A. (potter), 194
Jessup, James (weaver), 171
Jevne, Otto (fresco and ornamental painter, publisher), 265
Jevne and Almini (publishers): lithographs from *Chicago Illustrated, 259, 260,* 265
Johnson, Johny (artist, craftsman), *130*
Johnson, Robert (wheelwright and cabinetmaker), 97
"Joliet," Louis (map maker), 16-17, *17,* 22
Jolliet, Louis (explorer, map maker): life and explorations, 3, 7, 16, 17; 1674 map, *19,* 22
Jones, E. A. (painting and writing teacher), 265
Jones, J. Russell: Galena home, *157*

Kaufmann, Johann Georg: inscription on house, *208*
Keith, Charles W. (potter), 186, 193
Keller, Andrew (tailor), 135
Kellogg, E. B. and E. C. (lithographers), 265
Kelter, William J. (engraver), 265
Kennicott, Mrs. Marie Antoinette (art teacher), 265
Keokuk (Sauk Indian chief), 120, 122; portrait by Rindisbacher, 114, *114;* portrait by Catlin (in Missouri), 122

Kimball, H. C., & Co. (landscape painters), 265
Kimball, Heber C. (Mormon leader, foundry owner, blacksmith, potter), 195, 205; Nauvoo home, *200*
King, Charles Bird (Indian painter), 117; paints Illinois Indians in Washington, 113; copies Illinois Indian sketches by James Otto Lewis, 114; copies Stanley portraits (including Black Hawk), 118
King, Samuel B. (potter), 186, 190
Kinzie, John (silversmith), 46, *46,* 47, 48
Kinzie, Juliette M. (amateur artist), 265
Kirkpatrick, Alexander (potter), 194
Kirkpatrick, Andrew (potter), 184, 190, 194
Kirkpatrick, Cornwall and Wallace (potters), 184-85, 194; unusual creations, *184-85*
Kirkpatrick, Murray (potter), 190, 193
Kirschbaum, Joseph, Jr. (landscape, botanical, fresco artist), 208
Kirschbaum, Joseph, Sr., and Werner (carriage makers), 208
Kleinhofen, Henry (landscape painter), 265
Knaub & Sons (piano manufacturers), 243
Knirim, A. D. (weaver), 171
Knoebel, Jacob (furniture maker), *174*
Koch, Ann Koenig (Mrs. John Bernhard): pieced and appliquéd quilt, *140*
Koch, John Bernhard (saddler and harness maker), 135
Koerner, Gustave, 121-22; description of first Mississippi valley Christmas tree, 122
Köllner, August (artist), 265
Krans, Olof (amateur artist, ornamental painter, daguerreotypist), 240-42, 257; "Olof in his Union Suit," *210;* "Butcher Boys on a Bender," *210;* "First Winter at Bishop Hill," *232;* "Breaking the Sod," *232;* "It Will Soon Be Here," *232;* "Plowing and Sowing," *236;* "Bishop Hill...from North of the Edwards," *240;* self-portrait, *241;* women driving piles, *241*
Kurz, Louis (scene painter, lithographer), 265; "Col. Wood's Museum," *259;* "Corner Lake Street and Wabash Avenue," *260*
Kurz, Rudolph Friederich (landscape and Indian painter), 218, 220; description of Piasa Bird, 5

"L": version of Piasa legend, 4
Laage, George Joseph (hat maker), 136
Labhart, J. M. (potter), 186, 190
Lafaix, Jean (engraver), 207
Lafayette, Marquis de: in Illinois, 152; portrait copied by Berry, 152, *153*
Lafever, Minard (architect), 138, 144

La Salle, Robert Cavelier, Sieur de (explorer, map maker), 3, 123; builder of Forts Crèvecoeur and St. Louis, 17-18; map copied by Minet, 18
LaTourette, Sarah (weaver), 171, *171*
Latrobe, Charles J.: description of Chicago in 1830s, 111
Leman, James: house-fort, 63, *63*
Lengfelder, Balthasar (tinsmith): candle mold and oil lamps, *134;* copper finial, *262*
Lenox, E. S. (artist), 265
Lester, John W. (artist), 265
Lesueur, Charles Alexandre (artist, naturalist), 71-76; rear view of Flower home, *69;* sketch made on Illinois trek, *72;* sketches of Shawneetown, Battery Rock, Cave-in-Rock, nearby islands, Golconda, Trinity, etc., 72, 75; Bon Pas, *73;* "from the Piazza of M.," *73;* landscape, *73;* unidentified house, *74;* Albion tavern (?), *74;* workers in a field, *75;* "Depart de chez M. flower," *75;* picnic supper, *75;* drawings of America, river bank at Grand Chain, Bird's Point (Cairo), 76
Lewis, Henry (landscape and panorama artist), 223, 224-25; lithograph of Piasa Bird after, 4-5, *5;* "Fort Armstrong on Rock Island," *120;* lithograph of Mormon temple after, *225;* "Quincy," *225;* "Alton," *226;* "View on Fever River," *226;* "Savannah," *226*
Lewis, James Otto (Indian artist), 114, 117
Lewis, Meriwether, 22, 45
Liebig, George (shoemaker), 135
Lincoln, Abraham: at New Salem, 96, 97; Springfield home (1844), *145;* Springfield law office, 145, *145;* sitting room and front parlor (1861), *248;* campaign banner, *248;* "Lincoln the Railsplitter," *249;* Hesler photograph, 256-57, *257*
Lincoln, Thomas and Sarah: log house, *66*
Lindley, John and Sarah: pastel portraits, 85, *86*
Little, Samuel (tinsmith and glassblower), 176
Lock, John Henry (blacksmith), 135
Logan, Stephen T., 145
Long, Stephen H. (artist), 22
Ludon & Long (potters), 194
Lugenbuehl, Ulrich (tailor), 135
Lukins, Peter (shoemaker), 97
Lund, Theodore (ornamental and miniature painter), 168
Lundeen, F. V. (artist): "Big Brick," *234*
Lundy, Benjamin: portrait by Blood, 263

McAdams, William (early anthropologist), 6, 14
McCann, George (weaver), 171

McClure, Andrew (furniture manufacturer), 175

McCormick, Cyrus (reaper manufacturer), 243

McFarland, James: Rose Hotel once owned by, 63, *63*

M'Gahey, John (lithographer): "Joseph Smith . . . Addressing the Chief & Braves," 201, *201*

McKendree, William: founds McKendree College, 92-93

McKenney, Thomas L.: engravings of Illinois Indians in *Sketch of a Tour of the Great Lakes,* 114

McKenzie, Alexander (theatrical producer), 160

McMaster, William E. (art exhibitor), 265

McMillan, Elmer: Springfield area home, *146*

McVicker, James H. (actor), 246

Maertz, Charles A. (tinner), 135

Mahay, Martin (lithographer), 207

Mandeville, John (architect): Knox County courthouse, *147*

Mann, Horace (writer), 246

Marble, Dan (actor), 246

Marcoff, Louis (chamois draper), 207

Marlett, Eliza Ann: sampler, *100*

Marquette, Jacques (map maker): exploration, 3, 4, 16-17; description of Piasa Bird, 3; map of 1673-74, 16, *18,* 22

Marshall, John: Shawneetown house and bank, 64, *64*

Martin, Mrs. ———: Springfield academy, 109

Martin, Adam E. (potter), 193

Martin, E. G. (potter), 193

Martin, John L. (potter), 190, 193

Martin, Moses (potter), 190

Mast, Michael (tailor), 135

Mathews & Co. (ornamental painters), *111*

Maudsley, Sutcliff (portrait painter, lithographer): lithograph of Joseph Smith, 201, *201*

Mauk, Philip (mason), 233

Maximilian, Prince of Wied-Neuwied (scientist, traveler), 114, 117; *Travels in the Interior of North America, 115-17*

Mazarin, Louis (sculptor), 207

Mehrle, W. (sign and ornamental painter), 265

Meilly, Emanuel (weaver), 171

Melish, John (map maker): 1818 map of Illinois, *62*

Melville, Thomas A., 177; house, *176*

Menard, Pierre (trader, military officer, lieutenant governor), 34; fireplace, *34;* Kaskaskia home and kitchen, *35*

Mendel, Edward (engraver, lithographer), 265

Mendelli, Antonio (theatrical and landscape painter), 226; "View of Cairo," *227*

Merck, C. (portrait painter), 256, 265

Michaels, ——— (weaver), 171

Miller, Joshua (blacksmith, wagon maker), 97

Miller, William M. (engraver, printer), 265

Moffet, Thomas (engraver), 265

Möllhausen, Heinrich Balduin (topographical artist), 265

Montel, E. (painter), 265

Moore, Mathew (potter), 190, 199

Moore and Walters (cabinetmakers), 110, *110*

Morgan, Caleb (furniture manufacturer), 175

Morgan, Charles (furniture manufacturer), 159, 175

Morris, Philemon (tinner), 97

Morse, Samuel F. B. (painter): introduces daguerreotype to America, 256

Morton, Moses (potter), 190, 199

Mundson, Sarah H. (artist), 265

Murphy, W. (lithographer): Nauvoo temple, 203

Murphy, William (architect), 265

Murrazelli di Monto Pescali, Count, 130

Murrazelli, Marca Arelia, 130

Myers, D. L. (weaver), 171

Nash, F. M. (potter), 193

Nazet, François (architect), 207

Netzley, Uriah (weaver), 171

Neumann, ——— (tinner): tin eagle, *237*

North, L. (artist): drawing of Fort Crèvecoeur, 265

Obert, Matthias (shoemaker), 135

O'Brien, John Williams (portrait and landscape artist), 216-17, 265; "Old Man Grey," *209*

Oertle, Joseph (weaver), 171

Ogden, William Butler: Chicago home, 142, 259; portrait, *258*

Ohnemus, Matthias (saddler and harness maker), 135

Olevett, Charles (potter), 193

Oliver, John A. (house, sign, ornamental painter), 159

Olmsted, Frederick Law (landscape designer), 255

Olson, Olof, 231

O'Neal, Willis (pioneer), 183

Onstott, Henry (cooper), 97; family chair, *98*

O'Shannessy, J. J. (engraver), 266

Otis, C. W. (architect): Grace Episcopal Church, *156*

Padelford, R. W. (artist), 266

Page, S. P. (art exhibitor), 266

Palladio, Andrea (Renaissance architect), 238, *238*

Parker, George (engraver), 266

Parker, Matthew (engraver), 266

Parmelee, Franklin (omnibus service), 243

Parnell, Edmund: Galena house, 177, *177*

Parrish, Braxton (pioneer): log cabin, 40

Peale, Charles Willson (artist, naturalist): introduces painting of American Indians, 113

Peale, Rembrandt (artist), 152

Pearce, Hart L. (engraver), 266

Peck, Charles (landscape, mural, panorama painter), 230; "Peoria," lithograph after, *230*

Peck, Harriet Shotwell (art teacher), 230

Peck, John Mason (writer, missionary): founds Rock Springs Seminary, 92

Peck, Sheldon (primitive portrait painter), 163; portrait of the Wagner family, *87;* photograph, *163;* portrait of Mr. and Mrs. William Vaughan, *164;* portrait of Mr. S. Vaughan, *165;* portrait of Mr. and Mrs. Bloss, *166*

Peerson, Cleng, 129

Pendergast, W. W. (artist), 266

Peterson, John (architect): Rockton church, *147*

Phillips, John (chair manufacturer), 175

Pierce, Augustus (potter), 193

Piercy, Frederick (traveler, portrait and landscape painter), 207, 266

Pierson, John (potter), 194

Pike, Zebulon, 22

Pilkington, Adam (amateur artist), 266

Pinckard, Nathaniel (potter), 189

Pinkerton, Allan (cooper), 136

Piquenard, Alfred H. (architect), 206-8

Platt, James C. (portrait, landscape, still-life painter), 266

Pomarède, Leon D. (panorama, mural, transparency painter), 225-27

Porter, J. S. (miniature painter), 163

Post, William: Alton home, *146*

Potter, Edith (painting teacher), 266

Power, Nancy Willcockson: coverlet, *102*

Powers, Asahel (amateur portrait painter), 266

Pratt, D. C. (artist), 266

Pratt, F. F. (artist), 266

Preston, Elizabeth: watercolor painting, *84,* 85

Preston, John (piano manufacturer), 243

Quidor, John (portrait and genre painter), 162-63; "Rip Van Winkle," *162;* "Christ Healing the Sick" (copy of West painting), 162, 246; "Death on a Pale Horse" and "The Raising of Lazarus," 162

Index of Names

Radfore, P. M. (artist), 266
Rague, John Francis (architect): Old State Capitol, 144-45; senate desk, *253*
Ramsey, Barnett (potter), 193
Ramsey, L. A. (portrait painter): portraits of Joseph and Hyrum Smith, 204
Ramsey, William (potter), 189
Rasmussen, Nils (landscape painter), 266
Reay, Charles (pottery manufacturer), 190
Reed, W. A. (artist), 266
Reen, Charles (artist, lithographer), *230*, 266
Reen & Shober (lithographers): "Peoria," lithograph after Peck drawing, *230*
Renault, Phillipe, 26
Reuss, Adolph: fachwerk home, 132, *132*; appearance of home in 1870s, *133*
Reynolds, John, 40
Rice, John B. (theater manager), 245-46
Richardson, Edward, Jr. (amateur artist), 266; life and death portraits of Charlotta Richardson, *168*
Rindisbacher, Peter (Indian painter): paints Winnebago, Sauk, and Fox Indians, 114; "Keoköke," *114*
Roberts, John M. (artist): "Peoria Aug. 29th 1831," lithograph after, *126*
Robertson, George J. (artist, teacher): portrait of Anna P. Sill, *158*
Robinson, David C.: map of Kaskaskia, *24*
Robinson, John: Carmi home, *93*
Rockwell, J. (furniture maker), 174, *174*
Roeder, Conrad (portrait and landscape painter), 218, 265; "View of the Home of A. E. Mills," *219*
Roesler, N. (artist and lithographer), 266; view of Belleville, *213*
Rogers, ——— (panorama artist), 224
Rogers, D. (portrait painter): portraits of Joseph and Hyrum Smith, 201
Rogers, John (sculptor); 261; "Checkers up at the Farm," *261*; "Slave Auction," 261
Roley, William (sley maker), 58
Ronalds, Mary Elizabeth Flower (Mrs. Hugh), 78; knife carving, *78*; still-life, *108*
Root, Robert Marshall (artist): the public square at Shelbyville, *126*
Roth, John (cabinetmaker), 135
Ruff, Jacob (carpenter), 135
Russell, John: versions of Piasa legend, 4, 5
Russell, Spencer G.: description of Piaza Bird, 5-6

Sackett, Alfred M. (potter), 188, 193

Sackett, D. (David?) A. (potter), 188, *188,* 190, 193
St. Alary, E. (pastel portrait artist), 266
Sanders, Daniel (potter), 194
Sawyer, H. (pottery manufacturer), 194
Sawyer & Brothers (potters), 194
Schell, John (blacksmith), 135
Schipper, Jacob (weaver), 171
Schmitt, Adam (furniture maker), 135
Schoolcraft, Henry Rowe (map maker): version of Piasa Bird, 6, *7;* description of Illinois Indian, 46; sketch of Fort Dearborn, 48
Schuchmann, Henry (stonecutter), 135
Schultz, Martin (potter), 194
Schwebel, Philip (blacksmith), 135
Schwindeler, John Bernard (carpenter), 135
Scott, Clarence: Carrollton area home, *146*
Seewald, John Philip (weaver), 171-72; coverlet, *140*
Sellers, George Escol (amateur artist), 266
Seymour, Samuel (government artist): drawing of Cave-in-Rock, 52; first to depict Indians in Midwest, 114
Shank, William (potter), 194
Sheldon, Edwin: Chicago home, 259
Shober, Charles (lithographer), 216, 266; "Wolf's Point in 1833," lithograph after George Davis drawing, *126*; "View of Rush Street Bridge & c. . .," lithograph after Whitefield drawing, *217*
Sickman, Theodore (potter), 193
Sill, Anna P. (founder of Rockford College): portrait, *158*
Simmons, Andrew and Jeremiah (potters), 193
Slater, Alfred (potter), 193
Sloan, Junius R. (artist), 266; "The Knitting Lesson," *158*
Smith, ——— (artist), 258
Smith, David H. (amateur artist), 207; "Nauvoo as it was," *206*
Smith, Hyrum (brother of Joseph): depictions, 201; death mask, 204, *205*
Smith, John E. (jeweler, silversmith): house, 178; silver, *180*
Smith, John Rowson (panorama painter), 224; engraving of Mormon temple after, *224*
Smith, Joseph, 195, 201-2, 204; log homestead, 195, 208; mansion house, *200,* 201; depictions, 201, *201,* 204, *205;* "Representation of the Murder," *204;* death mask, 204, *205*
Smith, P. H. (potter), 193
Smith, Sarah Douglas: coverlet, *102*

Smith and Moffett (cabinetmakers), 110
Smithfield, Ulrich (potter), 193
Smithingham, George (potter), 193
Smithmeyer & Co. (fresco painters), 266
Snow, Erastus: Nauvoo home, *197*
Snow, George Washington (inventor (?) of balloon frame), 112
Snyder, John Francis (writer, amateur archaeologist), 7
Soderquist, Lars (clockmaker): clock works, 238, *239*
Sohm, Pantaleon (cooper), 135
Stanley, John Mix (portrait, Indian, western painter), 117; "Portrait of H. H. Gear" (attrib.), *117;* portrait of an unknown man, *117*
Stapp, James B.: portrait, *83*
Starkweather, J. M. (landscape painter), 266
Starr, Eliza Allen (art teacher, painter), 267
Steele, Eliza R.: description of Illinois scenery, 211
Steinbach, Henry (potter), 194
Steinbeck, John Frederick (cooper), 135
Stevens, Amelia (amateur artist), 207
Stevenson, Thomas H. (miniature, portrait, landscape artist), 66-67, 257
Stewart, William T. (wheelwright): flax spinning wheel, *110*
Stizelberger, Jacob (potter), 194
Stizelberger, William (potter), 194
Stofer, L. D. (potter), 186, 190
Stone, H. (piano manufacturer), 243
Stouffer, Henry J. (architect, builder), 177
Stout, Francis Marion (potter), 186, 193
Stowe, E. C. (ornamental, miniature painter), 168
Strong, Howard (artist), 260, 267
Suprunowski, George (hatter), 130
Sutterly, Clement (artist), 267
Swartout, John H.: house, *146*
Swift, S. W. (fresco painter), 267

Taylor, Augustine Deodat (builder): inventor (?) of balloon frame, 112
Taylor, Bayard (artist, writer), 246; "Galena Harbor, 1852," *192*
Thielke, Henry D. (portrait painter), 267
Thomas, Frank E. (engraver), 267
Thomas, Jesse B. (carding machine builder), 58
Thomas, W. S. (potter), 186, 190
Thompson, Frank B.: Albion house, 79, *139*
Thorpe, George (weaver), 199
Thumb, Tom (with P. T. Barnum circus), 246
Timme, E. A. (engraver), 267

Tisdell, Freeman: inn, *176*
Town, Ithiel (architect): introduces Gothic features for American churches, 154, 249; advocate of individualism in architecture and furniture, 249-50; raises status of architect, 250
Towne, Abigail (painter, art teacher), 267
Townsend, Charles (amateur artist), 267
Tracy, G. P. (landscape painter), 267
Tracy, Simon P. (landscape painter), 260, 267
Trogden, A. Y.: Paris (Edgar County) home, *251*
Tuthill, Silas P. (chair maker), *174*

Ulrich and Whitfield (potters), 190

Vallet, Emile (poet, writer, artist), 206-7; "The Great Mormon Temple," *206;* view of Nauvoo, 206, *207*
Vandercook, C. R., and Company (stove manufactory), 172
Van Osdel, John Murray (architect): designs Chicago homes, 142; octagon house, *255*
Vaughan, S.: portrait, 163, *165*
Vaughan, Mr. and Mrs. William: portrait, 163, *164*
Volk, Leonard W. (sculptor), 260-61; busts of Clay and Douglas, 261; bust of Lincoln, 261, *261;* life mask of Lincoln, 261

Waddell, Martin (hatter), 97
Wakeman, Thomas (artist traveler): "Elijah P. Lovejoy Printing Office," 267
Walhaus, Henry (weaver), 171
Wallis, Frederick I. (or J.) (artist), 267
Ware, Joseph E. (engraver), 267
Warner, H. or W. (potter), 194
Warner, William (artist): depicts assassination of Joseph Smith, 204
Warren, S. K. (artist), 267

Warwack, Isaac (potter), 194
Watkins, Mary "Polly" Greene: portrait, *158*
Watts, Ben: pioneer cabin, 131
Watts, ———— (son of Ben) (carpenter), 132
Watts, Charles (cabinetmaker), *151*
Waugh, Henry C. (artist), 267; pencil and wash drawings, *288*
Weaver, Elias (potter), 70, 189
Weeks, William (architect), 202; original conception of Mormon temple, *202*
Welby, Adlard (artist traveler), 71
Wellman, Edward (engraver): "Galena in 1855," 267
Wentworth, Elijah, 126; tavern, *126*
West, Benjamin: "Joseph Smith in the Courtroom," 205
West, Horace B. (portrait and ornamental artist), 267
West, Washington J. (portrait and ornamental artist), 267
Whistler, John (soldier, fort builder, map maker), 45, 46; cartographic plan of Fort Dearborn, *47*
Whitaker, E. M. (artist): "A Prairie Scene in Illinois," 267
White, Alexander (house, sign, ornamental painter): ad, *159*
White, Roswell N. (wood engraver), 267
White, W. J. (engraver), 267
White, William (potter), 194
Whitefield, Edwin (artist traveler), 215-16; "View of Galena," lithograph after, *215;* "View of Rush Street Bridge," lithograph after, *217*
Whitney, Eli (inventor of cotton gin), 58
Wild, John Caspar (artist traveler, lithographer), 213-15, 222; description and depiction of Piasa Bird, 4, *4;* "View of Galena," *192; The Valley of the Mississippi Illustrated in a Series of Views,* 214; "View of Kaskaskia," *214;* "Ruins of Fort Chartres," *214;*

"Cairo," *215*
Wilkins, Benjamin (artist), 267
Wilkins, James (miniature, portrait, panorama artist), 163, 166-67, 224, 257; portrait of Charles Ballance family, *166;* panorama of land route to California, 166; portraits of Judge and Mrs. Daniel Gregory, *167;* panorama of Gold Rush, 230
Wilkoszewski, Edward (picture-frame maker), 130
Willoughby, Edward C. (landscape painter), 267
Wilson, Alexander (nature artist), 49
Wilson, Henry (stonecutter, animal painter), 267
Wilson, James S. (potter), 194
Wilson, Oliver (animal painter), 267
Wimar, Karl (mural and panorama painter), 222, 226; three panoramic views of Springfield, *222-23*
Winter, George (landscape, portrait, Indian painter), 168
Winter, [William?] (miniature painter), 256, 267
Wolfe, John C. (landscape painter), 267
Wood, John: Quincy mansion, 141-42, *141, 148;* octagonal residence, 255
Woodbury, M. A. (engraver), 267
Woodruff, D. C. (potter), 193
Woodruff, Wilford: Nauvoo home, *196, 198*
Woodworth, Lucien (architect), 208
Worley, W. C. (weaver), 171
Wright, George Frederick (portrait painter), 90, 130

Yates, H. H. (potter), *186,* 190
Young, Brigham (Mormon leader, carpenter, chair maker, wheelwright), 195-96, 205; Nauvoo home, *197-98*
Young, Phineas (chair maker), *199*

Zabbart, M. (potter), 130, 190

Near Aurora, Ills.

St. Charles, Ills.

Scrub Oak. Chrystal Lake, Ills.

Near Oswego, Ills.

Pencil and wash drawings made by Henry C. Waugh,
an itinerant artist who was also a clown in a traveling circus.
UNIVERSITY OF ILLINOIS DEPARTMENT OF ART

Art, Crafts, and Architecture in Early Illinois

General Index

Adams County. *See* Camp Point; Quincy

Adobe. *See* Construction, adobe

Advertisements: value to researcher, 111, 176; illustrations in, *see* Engraving

Albion (Edwards Co.): English settlement, 66-68; Park House, 68, *69, 70, 79, 87b;* craftsmen, 68, 70, 171, 189; artist Lesueur, *69,* 74-75, *74-75;* art school, 78, *78;* Thompson home, 79, *139;* French home, *80;* landscape by settler, *108,* 264; artist Bodmer, 114; St. John's Episcopal Church, 156, *156*

Alexander County, 193. *See also* Audubon; Cache; Cairo; Thebes

Alton and Upper Alton (Madison Co.): Germans, 135; Post home, *146;* craftsmen, 173, 187, 189-90, 193-94; artists' views, *209,* 214, 216, 218, 224, 225, *226,* 263, 267; engravers, 264; drawing school (Helmle & Roeder), 265. *See also* Piasa Bird

Amateur ("primitive") artists: painting style, 71, *71,* 83, *83,* 85, *87, 236, 241;* inspiration, training, 82-83; customs, types of work, 83-86, 89-90, 163

Amboy Township (Lee Co.), 263

America (Pulaski Co.), 55, 76, 224

American Bottom, 38, 224, *229*

American Pottery Company, Peoria, 188-89

Andalusia (Rock Island Co.), 193

Andover (Henry Co.), 242, *242*

Anna (Union Co.), 184-85, *184-85,* 194

Apartments, 233, 234, *234*

Apprentice, apprenticeship, 46, 57

Architect: need for, 141-42, 177-78; of State Capitol, Springfield, 144-45, 206; first college-trained, 250; as furniture designer, 250, *253, 254*

Architectural drawing lessons, 216-17

Architecture:

— French Colonial. *See* Construction, French Colonial

— Federal: history, features, 63-64, 103, 125, 131; ex-amples, *64, 94-95, 120, 125-26, 127-29, 131, 143, 196;* motifs applied to tombstones, *92, 150;* decline, 137

— Georgian: introduction by English, 67-68; general features, examples, *67-68,* 74, 79-80, *79-80,* 87, *136, 139;* motifs applied to tombstones, *150*

— Greek Revival: inspiration for, symbolism of, 137-38, *137-38;* guidebooks, 138; features, 138, *138-39, 142-43, 176;* ornament, *138,* 144-45, 148, *148;* miscellaneous public buildings, *139, 144, 147,* 176, *178;* transitions to, *141,* 141-42, *144, 176;* home, office buildings, 142, 145, *145-46, 177, 179, 196-97,* 250; State Capitol, Springfield, 145, *157, 246-47,* 247; motifs applied to objects, 148-50, *148-51, 178, 247;* decline, 154, 249

— Gothic Revival: origin, Christian symbolism of, 154-56, *155,* 211; introduction to Illinois, 155-56; as intellectual symbol, *251, 254;* homes, *251, 254-55, 262*

— Italianate: Tuscan villa, *157, 254,* 255; general features, 238, *238,* 255; cupola as feature, *254, 255*

— Octagon, 255, *255*

— *See also* Construction

Artificial graining. *See* Wood graining

Art instruction, 78, *78,* 82-83, 109, 166, 265 (Helmle)

Artist naturalists, 49-56

Art union, 260

Athens (Menard Co.), 193-94

Athens Marble, 243

Augusta (Hancock Co.), 264 (Cherrill)

Aurora (Kane Co.): effigy mound near, *14;* citizen portraits, *87,* 163, *164-65;* sampler made in, *100;* craftsmen, 171, 193; theatre, 246; artists, 263 (Ackerman), 266 (Potter); view near, *288*

Avon (Fulton Co.): dressing table made in, *150*

Barnbridge Township (Schuyler Co.), 193

Baskets and basket makers, 9, 43, *43,* 112, 244

Batavia (Kane Co.), 264 (Dawson), 267 (Towne)

Battery Rock (Hardin Co.), 72, 224

Beardstown (Cass Co.), 40

Bellefontaine. *See* Waterloo

Belleville (St. Clair Co.): cotton gin near, 58; Dickens's description, 90; German center, 130, 133-35; Italian immigrants, 130; philharmonic orchestra, 133; crafts and craftsmen, 134-35, *134-35, 140a, 149, 150,* 171, *174, 175,* 189, 190, 193, 194, *252;* row houses, *134;* Kunz home, 138, *138;* Wilding home, *144;* view, *213,* 266 (Roesler); artists, 264 (Bynum), 267 (West); map maker, 265 (Möllhausen)

Belvidere (Boone Co.), *88, 109,* 246

Bement (Piatt Co.): armchair made in, *82*

Bethalto, formerly Bethel Township (Madison Co.), 171

Bethel Township. *See* Bethalto

Bird's Point. *See* Cairo

Bishop Hill (Henry Co.): crafts and craftsmen, *82, 151,* 233, 234-35, *235-37;* church, *210,* 231, 233, *233,* 242; artist Krans's depiction of customs, *210, 232, 236,* 240-42, *240-41;* Swedish settlement, 231-32, *232;* commerce, 232, 235, 237, 238; "Big Brick," 234, *234,* 242; hotel, 236, 237-38, *237,* 242; corporation, 236-39, *236* (seal); Steeple Building, 238, *238-39,* 242

Blacksmiths: French Colonial, 23, 24, 29, 33; products, *33, 58,* 62, 98, *98, 135, 236,* 238, *239;* in pioneer settlements, 38, 58, 59, 68, 111, 135; timber used, 65; Industrial Revolution affects, 172; in Galena, Nauvoo, Bishop Hill, 180, *196,* 201, 239; in 1850, 244

Bloomington (McLean Co.), *174,* 265 (Jones)

Bond County. *See* Greenville

Bon Pas. *See* Grayville

Bookbinders, 180, 244

Boone County. *See* Belvidere

Boots. *See* Shoes and shoemakers

Box maker, 244

General Index

Brass, *236*, 238, 244 (foundry)
Broomcorn, 238
Brooms and broom making, 43, *43*, 234, 244
Brown County, 173, *175. See also* Cooperstown; Mt. Sterling; Ripley
Brownware, 185
Brush maker, 244
Builder: guidebooks for, 138; status lowered by architects, 250
Bunker Hill (Lawrence Co.): description, 216
Bureau County. *See* Princeton; Townsend, Charles

Cabinetmakers: in 1810, 58-59; woods used, 67, 128, 149, 174; patriotic motifs used, 82, *82;* as coffin makers, 95, 175; in 1830s, 111, 135, *199;* in 1850, 244; design books, factory system affects, 254. *See also* Furniture
Cache, formerly Trinity (Alexander Co.), 72
Cache Creek: Audubon at, 51
Cahokia (prehistoric Indian center, Madison Co.): Monk's Mound, *12,* 13, 214; view of mounds, *229*
Cahokia (St. Clair Co.): French settlement, 23; courthouse, 32, *32;* Church of the Holy Family, 32-33, *36;* indenture, 57-58; carding mill, 58; Jarrot house, 64, *64;* Polish settlers, 130; artists' depictions in or near, 214
Cairo, formerly Bird's Point (Alexander Co.): artists' depictions, 76, 114, 116, 214, *215,* 216, *220,* 224; glassblower from, 176
Calhoun County: prehistoric figurines from, *10, 53. See also* Hamburg
Camera lucida, 76-78
Camp Point (Adams Co.), 193
Candle making, 99, *134,* 199. *See also* Chandlers
Candlewicking, 82
Canvas (painter's), 84-85
Carbon Cliff (Rock Island Co.), 186
Carding machine (mill), 58, *59,* 97, 99, 111, 134, 169, 244
Carmi (White Co.), *58,* 63, *93, 94,* 171
Carpenters, 33, 45, 111, 134, 135, 180, 199, 207, 239, 244; guidebooks for, 138
Carpeting (rag), 232
Carriage and coach builders, 111, 135, 173, 199, 239, 244
Carroll County. *See* Lanark
Carrollton (Greene Co.): home near, *146*
Carthage (Hancock Co.), 204, *204,* 264 (Cherrill)
Cartography. *See* Maps and map making
Cartwrights, 207

Casey (Clark Co.), 171
Cass County. *See* Beardstown; Virginia
Catlin (Vermilion Co.), 130
Chair makers, 110, 111, 180, *199*
Chamois draper, 207
Champaign County, 171. *See also* University of Illinois
Chandlers, 180, 244. *See also* Candle making
Channahon, formerly Dresden (Will Co.), 263 (Ainslee)
Chapin (Morgan Co.), 184
Chemical dioramas, 246
Chicago (Cook Co.):
—1696-1830: map makers, fort, craftsmen, 22, 45, *46,* 46-48, *46-47;* mission, 24; depiction, 48, *48;* in 1825, 125
—1830-40: art instruction, 109; balloon frame invented, 111-12, *112;* craftsmen, industry, 112, 159, 174; artists, 117, 119, 163, 166, 264 (Castelnau); 1833 view, *126;* architecture, 142, *142;* port of eastern immigration, 159; newspapers, engraving, 159-60; theater, 160-61; Sauganash Hotel, *161*
—1840-50: artists, 166-68, *167,* 216, 257-58, 265, 266; craftsmen, industry, 171, 172, 173, 174, 175, 186, *186,* 190; compared to St. Louis, 213; first museum, 222, 245; panoramas shown, 223, 225; engravers, 263, 264, 267
—1850-60: chamber music, 133; artists, artisans, 167, 216, *217,* 230, 263, 264, 265, 266, 267; craftsmen, industry, 194, 243; art exhibitions and exhibitors, 217, 245, 246, 258, 260; Academy of Design, 230; brick and stone structures, 243; theater and authors, 245-46; as "Garden City," 255, 259; photography, 256-57, *257,* 267; artist Healy and works, 258-60, *258;* architecture, *259-60;* sculptors, Art Union, 260-61, *261*
Chicago River, 16, 24, 217
Christian County, 173. *See also* Pana; Stonington
Christmas tree, 122
Churches, 23-24, 32-33, *36,* 112, *112, 136, 147,* 154-56, *155-56,* 233, *233*
Clark County, 171, 173. *See also* Casey
Clary's Grove, *110, 158* (Mrs. Watkins)
Classic Revival. *See* Architecture, Greek Revival; Furniture
Clayville (Sangamon Co.), *100,* 103, *106-7*
Clinton County, 173
Clockmakers. *See* Watch- and clockmakers
Cobblers. *See* Shoes and shoemakers
Coffin maker, 95, *175*
Coin silver, 111, *111, 149*
Coles County, 173. *See also* Charleston

Colleges and seminaries, 92-93, 95, *95,* 155, *155, 251*
Collinsville (Madison/St. Clair Co.), 91
Columbia (Monroe Co.), *134, 250*
Commerce (town). *See* Nauvoo
Communal settlements, 205-7, 231-42
Confectioners, 244
Construction:
—Indian: prehistoric, 9, 12; historic, 18, 20
—French Colonial: fort, 17-18, 24, 28-29, *28-29; poteaux en terre,* 26, *26,* 27; *poteaux sur sole,* 26, 32, *32, 36;* stone, 26, 31; plantation style, 34, *35*
—American fort, *46,* 46-48, *48*
—early pioneer: log cabin, 38-40, *39;* "half-faced camp," 39; thatched-roof cabin, 127; sod house, 127, 169; dugout, 231-32, *232*
—advanced pioneer: log house, 60-62, *60-62, 66, 96,* 97-98, *105,* 129, 169; timber frame with clapboards, 63, 92, *93, 196,* 233, *233;* brick, 63-64, *64,* 103, *106,* 134, *134,* 234, *234,* 243; improved log house, 68, *87,* 92, *93;* stone, *80, 91,* 129
—English: brick-nogging, 68, *68;* half-timber, 68
—balloon frame, 111, *111,* 112, *112,* 159
—southern compared with eastern, 125, *125,* 128, 131, 196-97, *196-97*
—German: fachwerk, *132,* 132-33; brick, 134, *134,* 138, *138*
—adobe, 132, 169-70, *169,* 233
—Swedish, 233-34, *233-34,* 238
—mid-century: brick, frame, stone, 243, 250-51, 254-55, *254-55, 259-60*
Cook County. *See* Chicago; Chicago River; Riverside
Coopers: French, 45; products, 58-59, *59,* 134; early settlement, 97, 111, 135, 136; mid-nineteenth century, 180, 207, 244
Cooperstown (near Mt. Sterling, Brown Co.), 194
Copper and coppersmiths: prehistoric, 9-10, *10, 13;* 1830-60, 111, 159, *236,* 237, *262*
Corn-husk uses, 43
Cornish and Welsh, 127
Cosmoramic views, 221-22, 245
Costume:
—Indian: prehistoric, 9-10, *10-11,* 13; historic, 18, 20, 45-46, *46, 49, 54, 114, 118-19, 121-22*
—French, 29-31, *29-30*
—pioneer, 40, 42-43, *62,* 63
—1825-35 period, 67-72, 75-76, *83a,* 85, *89c,* 90, 92, 93
—1835-45 period, *84b, c, 87a, 94,* 117, 134, 164-65, *167c, 169,* 201, 204-5
—1845-55 period, *84c, 166,* 168, 228, *257b*

— 1855-65 period, *158, 219, 249, 261*

Cotton: raising, processing, spinning and weaving, 40-42, 57, 58, 68, 99; for bedspreads and candlewicking, 82; yard goods, 99. *See also* Dyes

Cotton Hill. *See* Springfield

Counterpanes (bedspreads): candlewicked, 81-82; stenciled, 82, *109;* appliquéd, *88. See also* Coverlets; Quilts

Courthouses, 32, *32, 126,* 142, *142,* 147, 154

Coverlets: patriotic motifs, 82, 170; drafts, patterns, 100-101; "overshot weave," 101, *101, 102;* "summer and winter weave," 101; "double weave," 101, *102, 140;* professional weaver, *140,* 170-72, *170-71*

Crackleville (Edwards Co.): Huber house, *79*

Craftsmen: indenture process, 46, 57-58; in 1810, 58, 59; called "mechanics," 60; effect on growth of towns, 67; effect of Machine Age, 172, 248-49, *253,* 254, 261-62; in 1850, 244. *See also* under individual types

"Crayons" (pastel chalks), 50, 84, *86*

Croft (near Athens, Menard Co.), *84, 104*

Crow-step gable, 197, *197*

Crystal Lake (McHenry Co.): view near, *288*

Cupola, 226, *227*

Cutlery, 60, 173

Cyclorama painting, 222-23

Decatur (Macon Co.), *98,* 194, 216

Democracy and patriotism: in architecture, 63-64, 137-38, 142-43; in genre and landscape painting, 78; in names of towns, 81, 150; in decorative motifs, 81-82, *81-82, 88,* 170, *199;* in amateur art movement, 82-83; in portrait painting, 152, *153*

Devil's Bake Oven (Jackson Co.), 214, *220*

Dickson Mounds (Fulton Co.), 14

Dixon (Lee Co.), 171, *252,* 263 (Ainslee, Brooks)

Dogtrot, 61, *61,* 74, *74*

Dolls, *43,* 184

Drainage tile, 183

Dressmakers, 199, 234

Dubois Hills (Lawrence Co.), 45

Dugouts, 231-32, *232*

Dundee (Kane Co.), 136, 265 (Goodwin), 267 (Warren)

Dunleith (Jo Daviess Co.), 194

Du Page County. *See* Aurora; Elgin; Elmhurst, Lombard; Naperville

Dupo, formerly Prairie du Pont (St. Clair Co.), 38

Dutch, 126

Dwight (Livingston Co.): Gothic church, *156*

Dyes, 42, 169, 234

Easterners. *See* Settlers, easterners

East St. Louis, formerly Illinois Town (St. Clair Co.), 214

Ebonist, 207

"Ebony work," 109

Edgar County, 58. *See also* Paris

Edwards County, 173. *See also* Albion; Crackleville; Grayville; Wanborough

Edwardsville (Madison Co.), 63, 189. *See also* Harrison, Robert

Effingham (Effingham Co.), 171

Effingham County, 130, 135. *See also* Effingham; Teutopolis

Elgin (Cook/Kane Co.), 194, 242, 266 (Padelford), 267 (Wilkins)

Elizabeth (Jo Daviess Co.), 188, 190, 193. *See also* King, Samuel B.

Elizabethtown (Hardin Co.), 63, *63*

Elmhurst, formerly Cottage Hill (Du Page Co.), 259

El Paso (Woodford Co.), 130

Embroidery, 82, 100, *100*

Empire-style furniture, 148, *149,* 172, *172,* 174, *174*

Engraving: woodcut, 15, *29,* 160, *160, 204,* 256; metal, 15, 21-22, *27,* 82, 160, 199; for making copies, 55-56, *203;* compared with lithography, 212

English: occupation of Illinois, 20, 31; settlement, 63, 66-75, *69-71, 73-75,* 78-80, 127; attitude toward Americans, 67; Georgian structures, *67,* 67-68, 79-80, *79-80, 87;* influence, 67, 73; craftsmen, 170, 187, 190, 199; population in 1850, 243

Erie Canal, 76, 111

Exeter (Scott Co.), 190

Exhibitions for artists, 245-46, 258, 260

Fachwerk, 132-33, *132*

Fairfield (Wayne Co.), 171

"Fancy" chair, 110. *See also* "Fancy painting"

Fancy Creek Township (Sangamon Co.), *43, 102,* 151

"Fancy painting": in female academies, 109; on chairs, *149, 174, 175, 180, 252*

Farina (Fayette Co.), *99*

Farmingdale (Sangamon Co.), *151*

Fayette County. *See* Farina; Shobonier; Vandalia

Fayetteville, formerly Horse Prairie (St. Clair Co.), 38

Female academies, *108,* 109

Fences, *73,* 126

Fever River (Jo Daviess Co.), 224, *226*

Fine art: frontier attitudes, 212-13, 218, 221, 223; 1858 attitude, 260; encouraged, 258, 259, 260-61

Flax. *See* Linen

Forreston (Ogle Co.), 150

Fort: Crèvecoeur, 17, 265; St. Louis, 17-18, 23; Massac, 22, *28, 28,* 32, 55, 75; de Chartres, 24, 28-29, *28-29,* 31, 32, 33, *214;* Gage, 31, *31;* Kaskaskia, 34; Dearborn, 45, *46,* 46-49, *48,* 90, 265; Clark, 48; Armstrong, 48, *120,* 214; Edwards, 48

Fox River, 47, 72, 129

Franklin County: cabin, 40

Frederick (Schuyler Co.), 193

Freeport (Stephenson Co.), 246

French: exploration, 3-4, 7, 15-19; maps, 17-21, *17-21;* forts, 17-18, 22-23, 24, 28-29, *28-29,* 31-33; settlements, *21,* 23-26, *24-25, 31,* 33-34, 45; miscellaneous structures, 23-24, *26,* 26-27, 31-34, *31-33, 35-36,* 127; household furnishings, 27, 27-28, *34-35,* 45; costumes, 29-30, *30;* festivities, *29,* 31; under English, 31; under Americans, 31-32, 57. *See also* Icarians

French Colonial architecture. *See* Construction, French Colonial

Fulton County, 173. *See also* Avon; Dickson Mounds; Lewistown

Furniture and furnishings: French, 27-28, *27, 34-35,* 45; log cabin, 40, *40;* by pioneer craftsmen, *58, 98,* 103, 110, *110, 128,* 135; prairie Georgian, 68, *80;* log house, *97, 98, 105;* of easterners, *106-7, 198-200;* Greek Revival period, *145,* 148-49, *148-51,* 172-75, *172, 174-75,* 176, 180, *180;* of Swedes, *210,* 233-34, *235, 237, 239,* 242; mid-nineteenth century, 243, *248;* Gothic, Grecian, Italian, 250, *253,* 254. *See also* Cabinetmakers; Oilcloth; Wallpaper

Galena (Jo Daviess Co.): mound near, *14;* craftsmen, *88,* 180, *180,* 187-88, *188,* 190, *191,* 193; steamboat built in, 112; artists Stanley, Catlin, 117, *117,* 121; early cultures, structures, 127-28, *127-29;* early furniture, 128, *128;* Greek Revival furniture, *149,* 173, *174, 175,* 180, *180;* Gothic church, 156, *156;* Tuscan villa, *157;* wealthiest Illinois town, 176-77; Greek Revival structures, 176-79, *177-79;* depictions, 192, 214, *215,* 215-16, 224, 263 (Barth, Bender), 267 (Wellman); Emerson, 246; 1829 map, 264 (Chandler); fresco painter, 266 (Swift)

"Galena pottery," 188. *See also* Pottery, redware

Galesburg (Knox Co.), 112, 240, 242, *251,* 263 (Blood)

Gallatin County. *See* Shawneetown; U.S. Salines

Galva (Henry Co.), 239, 240
"Garden City" (Chicago), 255, 259
Geneva (Kane Co.), 112, *250,* 265 (Hawkins)
"Genre" works: by European artist settlers, *70, 87, 232, 236,* 240-41, *241;* by European artist travelers, *74-76;* defined, 78; by Illinois artists, sculptors, *158,* 162, *162,* 261, *261*
Georgian architecture. *See* Architecture, Georgian
German: population (1818), 37-38; craftsmen, 70, 134-36, *134-35, 140,* 170-72, 189-90; settlements, 130-36, 207-8, *208;* cultural contributions, 131-35; fachwerk houses, 132-33, *132;* brick and row houses, *133-34;* population (1850), 243
Glass and glassblowers, 176, 213
Glove makers, 244
Golconda (Pope Co.), 72, 75, 224
Goldsmith, 199
Goodfield (Woodford Co.), 171
Goose Lake, formerly Jugtown (Grundy Co.), 187, 194
Goshen Township (Randolph Co.), 59
Gothic Revival. *See* Architecture, Gothic Revival; Landscape design
Grafton (Jersey Co.), 224, 225
Grand Chain (Pulaski Co.), 76
Grand Detour (Ogle Co.), *94,* 156, *156*
Grand Tower (Jackson Co.), 214, 221, 224
Grayville, formerly Bon Pas (Edwards/White Co.), 72, 79
"Grecian" chairs, 148, *149,* 172, *172,* 174
Greek Revival. *See* Architecture, Greek Revival; Furniture
Greene County, 173. *See also* Carrollton; White Hall
Greenville (Bond Co.), *148, 151, 252*
Grundy County. *See* Goose Lake; Morris
Guidebooks: for emigrants, 92, 111, 159, 169; for builders and carpenters, 138; for furniture makers, 254
Gunsmiths, 29, 60, 111, 180, *200,* 201; in 1840 census, 173; Eagle Rifle Factory, 176; in 1850 census, 244

"Half-faced" camps, 39
Half-timber. *See* Construction, English
Hamburg (Calhoun Co.), 173, 224, 225
Hamilton County, 173
Hancock County, 173. *See also* Cherrill, Adolphus; Nauvoo; Warsaw
Hardin County, 173. *See also* Battery Rock; Cave-in-Rock; Elizabethtown; Sellers, George Escol
Hardware factory, 244
Harmonie (Ind.), 68. *See also* New Harmony

Hatters, cap makers, milliners, 60, 97, 111, 136, 199, 244
Havana (Mason Co.), 135
Helvetia. *See* Highland
Hemp, 43, 68, 110, 169
Henderson County. *See* Lomax; Oquawka
Hennepin (Putnam Co.), *110, 150,* 154
Henry County: Swedes in, 231-42. *See also* Hooppole; Kewanee
Highland, formerly Helvetia (Madison Co.), 130, 257
Hill's Grove (McDonough Co.), *88*
Hooppole (Henry Co.), 59
Horn combs, 60, 199
Horse Prairie. *See* Fayetteville
Hudson River school, 212

Icarians, 205-7, *205, 206*
Illinois: prehistoric, *see* Indians, prehistoric; exploration, 3, 16, 17-18; natives, *see* Indians, historic; first white settlement, *see* French; wildlife, 19-20, 49; clays, 60, 181-82, 183, 184; population character, 63 (1818), 122 (1834), 243 (1850); land character, 65-66, *66,* 76; scenery, 121-22, 211, 214, 216; incorporated cities (1850), 243
Illinois City (Rock Island Co.), 193
Illinois River, 16, 17, 22, 24, 211, *212*
Illinois State Fair: art exhibitors, 217, 263, 264, 265, 266, 267; art exhibition, 258
Illinois state seal, 81, *81*
Illinois Town. *See* East St. Louis
Indenture, 46, 57-58
Indians, historic: Iliniwek confederation, 16, 26; depictions, *8, 18, 54,* 113-14, *114,* 118-24, *118-19,* 121-23, *121-23;* lodges and dwellings, 18, 20, *121-23;* clothing and ornaments, 20, 46, *62;* arts, 20; trade goods, 45-46; village at Chicago, 47; European and American attitudes toward, 112-13; Removal Act affecting, 114, 118-22
Indians, prehistoric:
— Paleo (nomadic hunters): origin and tools, 7-8, *8*
— Archaic (hunters and gatherers): tools and ornaments, 8-9, *8*
— Early Woodland (land cultivators): arts, 9, *9*
— Middle Woodland (settlers): houses, 9; arts, 9-10, *9-11, 53;* mounds, 10-11
— Late Woodland, 11
— Middle Mississippian (village and city dwellers): pictographs, 7, *7;* center at Cahokia, 12-13; mounds, 12, *12,* 13, 14, *14;* arts, *12-13,* 13-14; crops, 13. *See also* Piasa Bird

Indian tribes: Winnebago, *7,* 114, 120; Kaskaskia, 18, 23, *49,* 116, 121; Tamaroa, 23; Peoria, *54,* 121-22, *121-22;* Sauk and Fox, *54,* 113, 114, *114,* 119, 120-21, 122, *122-23;* Fox, 113, 114, 118, 119; Potawatomi, 113, 114, 119, 120; Chippewa, 114, 119; Kickapoo, 118-19, *118-19;* Ottawa, 119; Piankeshaw, 121
"India painting," 109
Individualism: in amateur art movement, 82-86; in architecture and furniture design, 249-50, 254-55
Industrial Revolution: in England, 57; effect on crafts and craftsmen, 172, 248-49, *253,* 254, 261-62; effect on art and artists, 256-58, 261-62
Industry: (1810), 57, 58-59; (1820), 60; (1840), 173; (1850), 254
Inns, taverns, hotels: French style, 33; log, 74, *74,* 105, 126; Federal, 90, *94,* 103, *106-7;* Greek Revival, *147,* 160-61, *161, 176;* Italianate, 243
Irish, 127, 243
Iron: wrought, 9, *58, 127, 200,* 233, *233,* 238; foundry, *82,* 159, 172, 180, 201, 243, 244, *250, 260;* furnaces, 172, 173
Iroquois County, 173. *See also* Onarga; Watseka
Island Grove (Sangamon Co.), 65
Italianate architecture. *See* Architecture, Italianate
Itinerant artists, 83-87, 89-90, 166; Dickens comments on, 90

Jackson County, *13,* 228, *228. See also* Devil's Bake Oven; Grand Tower; Tower Rock
Jacksonville (Morgan Co.): Illinois College, 95, *95;* craftsmen, 95, 111, *151;* Duncan home entrance, *95;* grain measure made in, *99;* female academy (1833), *108,* 109; largest Illinois town (1834), 111; Polish settlers, 130; Trinity Church, 155; octagon house, *255;* painter-cartographer Cherrill, 264
Jacquard loom weavers, *140,* 170-72, *170-71*
Jansonists. *See* Bishop Hill
"Jeans," 135
Jefferson County, 173
Jersey County, 173, 190, 193. *See also* Grafton
Jewelers, 207, 244
Jo Daviess County. *See* Dunleith; Elizabeth; Fever River; Galena; Warren
Joiner, 33, 201, 207
Joliet (Will Co.), 266 (Radfore)
Jonesboro (Union Co.), 60; Kornthal church near, *136*
Journeyman craftsman, 46
Jubilee (Peoria Co.): Jubilee College and Chase tombstone, 155, *155*
Jugtown. *See* Goose Lake

Kane County. *See* Aurora; Batavia; Dundee; Elgin; Geneva; St. Charles

Kankakee River, 47

Kaskaskia (Randolph Co.): French settlement, 23, 28, 33; early structures, 23-24, 26, *31;* map, *24;* English garrison, 31, *31;* Sweet Tavern, *33,* 152; Edgar home, *33;* "Liberty Bell of the West," 34; Menard house, 34, *34-35;* disappearance, 34; American settlements in and near, 38, 63; 1819 craftsmen, 58; first Illinois capitol (1818), *64;* views, 116, *214, 220;* Lafayette (1825), 152

Kaskaskia River, 34

Kendall County. *See* Oswego

Kewanee, formerly Wethersfield (Henry Co.), 112

Knife carving on cardboard, *78*

Knox County. *See* Galesburg; Knoxville; Rio

Knoxville (Knox Co.), *82;* Knox County courthouse, *147,* 154

Koster site (Greene Co.), 14

Lacon (Marshall Co.), 264 (Cook)

Lake County. *See* Waukegan

Lake Michigan, 16, 45, 47

Lanark (Carroll Co.), 171

Landscape design: formal, 68, *87;* affected by Gothic Revival, 211; advocated by Downing, 255; in Chicago and Riverside, 255, 259

Landscape painting, *212;* European influence, 78, 211-12; in female academies, *108,* 109; pioneer attitude, 212-13, 218. *See also* Panoramas

La Salle (La Salle Co.), 127

La Salle County, 136, 173. *See also* La Salle; Leland; Marseilles; Mendota; Miller Township; Norway; Ottawa; Peru; Rutland; Starved Rock; Utica; Vermilionville

Last maker, 207

Lawrence County, 173, 190. *See also* Dubois Hills; Sumner

Lebanon (St. Clair Co.): portraits made near, 85, *86;* Dickens and Mermaid Inn, 90; McKendree College, 93; weaver, 171

Lee County. *See* Amboy Township; Dixon

Leland (La Salle Co.), 129

Lena (Stephenson Co.): Dodd's Inn, *147*

Lewistown (Fulton Co.), 14, 112, 171

Liberty. *See* Rockwood

Liberty Prairie (Madison Co.), *189, 252*

Lighting devices: oil, 43, *134, 183;* lanterns, *98; 236;* chandeliers, *145, 233, 233. See also* Candle making

Linen: production from flax, *41,* 41-42, 57, 169; for making artists' canvas, 84-85; for making oilcloth, 110; weavers, *170,* 171, 232, 234

Linsey-woolsey, 41

Livingston County. *See* Dwight

Lithography and lithographs: Illinois scenes, *201-3,* 213-16, *213-15, 217, 259-60;* introduction and advantages, 212; Currier and Ives, 213

Logan County, *140,* 265. *See also* Mt. Pulaski

Lomax (Henderson Co.), 80

Lombard, formerly Babcock's Grove (Du Page Co.), 163

Looms: early types, 42, *44;* in 1810, 57; Jacquard, 170, *171*

McDonough County. *See* Hill's Grove

McHenry County. *See* Crystal Lake; Marengo

McLean County. *See* Bloomington

Macon County. *See* Decatur

Macoupin County, *101. See also* Bunker Hill

Madison County, 173. *See also* Alton; Bethalto; Cahokia (prehistoric); Collinsville; Edwardsville; Highland; Liberty Prairie; Marine; Monk's Mound; Wood River

Maison Carrée (Nîmes, France), 137-38, *137*

Manchester (Scott Co.), 183, 190. *See also* Eby, George

Manual training, 95

Manufactories (1850), 243, 244. *See also* Industry

Maps and map making: history and purpose, 15-16, 20, *20;* Jolliet, "Joliet," Marquette, 16-17, *17, 18-19;* La Salle and Minet, 18; U.S. engineers, 20, *21,* 22; Collot, 21, *21;* Whistler, 46-47, *47;* Melish and Hill, *62,* 199

Marengo (McHenry Co.), *251*

Marina City, probably present Mound City (Pulaski Co.), 194

Marine (Madison Co.), 91

Marissa (St. Clair Co.), *175,* 264 (Finger)

Marseilles (La Salle Co.), 129-30

Marshall County. *See* Lacon; Wenona

Mascoutah (St. Clair Co.), 130

Mason County. *See* Havana

Masons, 207

Massac County, *13. See also* Fort Massac; Metropolis

Match maker, 244

"Mechanics" (craftsmen), 60

Menard County, *110,* 171. *See also* Athens; Clary's Grove; Croft; New Salem; Petersburg

Mendota (La Salle Co.), 171

Metamora (Woodford Co.), *147,* 154

Metropolis (Massac Co.), 184, 224

Miller Township (La Salle Co.), 129

Millwright, 60, 244

Miniatures and miniature painters, 84, *84,* 163, 166, 167

Mississippi River: exploration, mapping, 16, 17, 22; fertile land along, 23, 27; Cahokia oldest permanent settlement, 23; Audubon and Catlin, 51, 55, 121-22; attraction for artists, 213-16, 218, 220-21; prints, sketches, paintings, 213-14, *215,* 220-21; panoramas, 223-29

Modoc (Randolph Co.), 9, *9*

Moline (Rock Island Co.), 194, 214

Monk's Mound (St. Clair Co.), *12,* 13, 214

Monroe County. *See* Columbia; New Design; Piggott's Fort; St. Philippe; Waterloo

Morgan County, 173. *See also* Chapin; Jacksonville

Mormons. *See* Nauvoo

Mormon temple. *See* Nauvoo

Morris (Grundy Co.), 129

Mound City (Pulaski Co.), 184. *See also* Marina City

Mt. Joliet (Will Co.), 213

Mt. Morris (Ogle Co.), 112

Mt. Pulaski (Logan Co.), *147,* 154

Mt. Sterling (Brown Co.), *151,* 194. *See also* Cooperstown

Musical instruments: fiddles, 31, 34, 238; organs, 133; melodeons, 243; pianos, 243

Music taught in schools, 245

Nauvoo, formerly Commerce (Hancock Co.): craftsmen, 171, 190, 193-94, 195-96, *196,* 197, *198-200,* 199-201; Mormon settlement, 195; architectural styles, 196-97; homes, *196-200,* 201, 208; Mormon temple, *202-3,* 202-4, 205-6, *206,* 207, 208, *208, 224-25,* 266; depictions, *202, 206-7,* 266 (Piercy); French Icarians, 205-7, *205-7;* resident artists, 207; Germans, 207-8, *208;* restoration, 208; Nauvoo House, 208. *See also* Smith, Hyrum; Smith, Joseph

Naperville (Du Page Co.), 171, 246

New Design (Monroe Co.), 38

New Harmony, formerly Harmonie (Ind.): artists and artisans, 71; influence on Albion settlers, 78; views, *116, 223. See also* Harmonie

New Salem (Menard Co.): structures, *59-61,* 96, *96-97,* 97-98, *105;* Lincoln, *96,* 97; typical crafts and craftsmen, 97, 98-103, *98-99, 101-2,* restoration, 103

Norway (La Salle Co.): first permanent Norwegian settlement in U.S., 129-30

Norwegians, 127, 129-30; folk arts, 130, *130*

General
Index

Octagon. *See* Architecture, octagon
O'Fallon (St. Clair Co.), 92, 171
Ogle County. *See* Forreston; Grand Detour; Mt. Morris
Ohio River: Fort Massac, 22, *28*, 32; route of emigration, 38, *38*; Audubon, 50-51, 52, 55; depiction of sites, 52, 72, 75-76, *77*, 114; panoramas including, 224, 228
Oilcloth, 110, *110*
Oil paints: early preparation, 84-85
Old Shawneetown. *See* Shawneetown, Old
Olney (Richland Co.), 266 (Powers)
Onarga (Iroquois Co.), *254*
Oquawka (Henderson Co.), 154, 224
Oriental painting, 109
Ornamental painting, 111, 159; patriotic motifs, 81-82, *81, 82,* 240; types, 82, *85,* 89, 109, 111, 160, 240, 242
Ornaments (personal), 9-10, 13, 45
Oswego (Kendall Co.): view near, *288*
Ottawa (La Salle Co.), *110,* 129

Paisley shawl maker, 199
Palmyra (Wabash Co.), settlers, *84*
Pana (Christian Co.), 216
Panoramas, 166, 222-30, *222-23;* theatrical appeal, 223, 226-28; Gold Rush, 230
Paris (Edgar Co.), 194, *251*
Patriotism. *See* Democracy and patriotism
Peddlers, 112, 183, 234
Pekin (Tazewell Co.), 112
Penmanship, 245, *245*
Pennsylvania Germans, 37-38
Peoria, formerly Ville de Maillet (Peoria Co.): French village, 45; La Salle and Indians, 65; Catlin paintings of La Salle, 123; 1831 view, *126;* Germans, 135; Christ Episcopal Church near, 156; artist Wilkins, 166-67, *166;* craftsmen (1840-45), 171, 173-74, 186, *187,* 190; Bennington pottery factory, 188-90, 194; panorama exhibited, 225; artist Davis, 264; ornamental painter, 264; view, 266
Peoria County. *See* Jubilee; Peoria
Peoria Pottery Company, 189
Perry (Pike Co.), 136
Perry County, 173
Peru (La Salle Co.), 176, 233
Petersburg (Menard Co.), *104, 149*
Photography: invention, development, 256-57, *256-57;* considered "art," 256; influence on painters, 222, 241, 256-58

Piasa Bird: descriptions, 3, 4, 5, 5-6, 6; depictions, 3, *3, 4, 4,* 4-5, *5,* 6, *6,* 7 (?), 7 (?), *53, 297;* legends, 4, 5
Piatt County. *See* Bement
Pictographs, 7, *7. See also* Piasa Bird
Picture- and mirror-frame maker, 130, 244
Piggott's Fort, or fort of the Grand Ruisseau (Monroe Co.), 38
Pike County. *See* Perry; Pittsfield
Pioneer types, 37. *See also* Settlers
Pipes: prehistoric Indian, 10, *10, 53;* corn-cob, 44; Indian trade, 45; pottery, 184, *184*
Pittsfield (Pike Co.), 112, *253*
Plainfield (Will Co.), *209*
Pleasant Plains (Sangamon Co.), 93
"Poker painting," 130
Pope County. *See* Golconda
Portraits: Indian, *54,* 113-14, 118-24, *118-19, 121;* early types, *67,* 83-86, *83-86;* as expressions of patriotism, 152; copies, 152, *153;* influence of camera, *158,* 256
Potter's wheel, *59,* 186
Pottery:
— prehistoric Indian, 9, *9,* 10, *10-13,* 13
— makers (1820-60), *59,* 59-60, 70, 130, 135, 173, 181-87, 188; from England, 187, 199; from Bennington, Vt., 188-89; checklist, 189-90, 193-94; in 1850, 243-44; effect of machine age, 248
— redware, 181, *182,* 182-83; at Galena, 187-88, *191;* glazes and markings, 188; disadvantages, 188
— stoneware: production centers, 60, 183-84, 186-87, 188-89; articles, *70,* 184-85, *182-87, 191;* advantages, clays, 181; discovery of clays, 183; glazes and markings, 185-86
Prairie du Pont. *See* Dupo
Prairie du Rocher (Randolph Co.), 24, *25, 33, 33,* 214
Prehistoric Indians. *See* Indians, prehistoric
"Primitive" artists. *See* Amateur artists
Princeton (Bureau Co.), 112, 265
Printers and publishers, 92, 118, 244, 259
Pulaski County. *See* America; Grand Chain; Marina City; Mound City
Putnam County, 173. *See also* Hennepin

Queensware, 199
Quilts and quilting, 99-100, *99-100,* 103-4, *104, 140,* 268
Quincy (Adams Co.): early craftsmen, 111, 135; Germans, 135; quilt made in, *140;* John Wood mansion, 141-42, *141, 148;* Washington Irving buys lots, 161;

artist Quidor, 162, *162;* craftsmen (1840s), 172-74, *172;* Mormons, 195; Lewis depiction, *225;* John Wood octagon house, *255;* miscellaneous artists, 263 (Becker), 265 (Lester), 266 (Reed)

Railroads affect craftsmen, 238-39, 248-49
Raleigh (Saline Co.), 85, *85*
Randolph County, 173. *See also* Goshen Township; Kaskaskia; Modoc; Prairie du Rocher; Rockwood; Ste. Anne of Fort de Chartres
Red Oak Grove (Henry Co.), 231, 233
Redware. *See* Pottery, redware
Reel. *See* Yarn winder
Religious paintings, 221, 245-46
Richland County. *See* Olney
Richland Creek (Sangamon Co.), 65
Ridge Prairie (St. Clair Co.), *140,* 171
Rifles. *See* Gunsmiths
Rio (Knox Co.): theorem painting from, *108*
Ripley, formerly Centerville (Brown Co.): pottery center, 184, *184,* 186, *186-87,* 190, 193-94
Riverside (Cook Co.), 255
Rochester (Knox Co.?), *205*
Rochester (Sangamon Co.), 98
Rockford (Winnebago Co.): effigy mound, *14;* easterners, 112; artist Robertson, *158;* Swedes, 242; Erlanger Museum, 242; reaper factory depiction, *280*
Rockingham ware, 188
Rock Island (Rock Island Co.): Fort Armstrong, 48, *120;* Indian village near, 120; Davenport house, *120;* Catlin, 121, 122, *122-23;* miscellaneous artists' depictions, 214, 224; Swedes, 242; Emerson, 246; Waugh painting exhibited, 267
Rock Island County, 173. *See also* Andalusia; Carbon Cliff; Illinois City; Moline; Rock Island
Rock River, 211, 224
Rockton (Winnebago Co.), *147;* entrance of home, *148*
Rockwood, formerly Liberty (Randolph Co.): chairs made in, *174*
Romantic Movement: reflected by Europeans, 4-5, 5, *53a,* 113, 114, *114,* 213-22, *214-15, 219-23;* effect on Americans, 211-12
Roofs: thatch, 12, 23, 127, 214; hip, *26,* 27, *67, 80;* gable, 27, 64, *64, 80*
Rope, bagging, cordage makers, 9, *10,* 169, 244
"Rosemaaling," 30, *30*
Rossville (Vermilion Co.), *150*
Rugs, braided and woven, 99

Rutland (La Salle Co.), 129

Saddle and harness makers, 59, 60, 111, 134, 135, 180, 244

St. Charles (Kane Co.), 246, 266 (Pratt); view, *288*

St. Clair County, *13,* 60, 173. *See also* Cahokia (town); Belleville; Dupo; Fayetteville; Lebanon; Marissa; Mascoutah; Monk's Mound; O'Fallon; Prairie du Pont; Ridge Prairie; Shiloh Valley; Turkey Hill

Ste. Anne of Fort de Chartres (Randolph Co.), 24, 33

Ste. Genevieve (Mo.), 28, 31; Bolduc House, 33; Audubon trip, 50-51, 55

St. Louis: called Mound City, 13; settlement, 31; midwestern art and commerce center (1840), 213

St. Philippe (Monroe Co.), 24, 26

Saline County. *See* Raleigh

Sampler, 100, *100*

Sangamon County, 42, 65-66, 173. *See also* Clayville; Cotton Hill; Fancy Creek Township; Farmingdale; Pleasant Plains; Springfield; State capitol, Springfield

Sangamon River, 46, 96, 102

Sash and blind makers, 244

Scandinavian settlers (1850), 243. *See also* Norwegians; Swedes

Schuyler County, 173. *See also* Barnbridge Township; Frederick

Scotch, 127, 136, 170, 243

Scott County, 173, 193. *See also* Exeter; Manchester; Winchester

Sculpture: prehistoric, 10, *10, 11, 53;* Puritan attitude, 83, 245, 260; Volk and Rogers, 260-61, *261*

Settlers:
— French. *See* French
— southern pioneer hunters: origins and aptitudes, 37-38; routes and settlements, 38, *38;* miscellaneous crafts, 38, 42-43, *43;* log cabins and furnishings, 39-40, *39-40;* handmade textiles, 41-42; clothing, 42-43; dependence upon wood, 65-66; nicknames, 127-28
— in 1818, 63
— pioneer craftsmen, farmers, merchants, professional men, 58-60; typical houses, fences, tools, 60-63, *60-61, 63, 96-97, 97, 98,* 125, *125,* 126, *126. See also* Coverlets; Quilts
— easterners (Yankees): typical structures, fences, *64, 91,* 92, *93-95,* 97, *97, 106, 196-200;* character, 91, 95; advantages and routes, 91-92, *92;* compared to southerners, 98, 103, 112, 125, *125;* typical crafts, 99-104, *100-102, 104, 108-10, 109-12*

— Europeans, 63. *See also* English, Germans, Norwegians, Swedes, etc.

Shakers: relations with Jansonists, 234

Shawneetown, Old (Gallatin Co.): in 1810, 52, 59; chair from, *58;* early clothing, 63; Rawlings House, Marshall bank, 64, *64,* 152; Birkbeck, 67; Lesueur and Hall, 72, *77;* First National Bank, *139,* 143; Lafayette, 152; artist Jackson, 163, *163;* panorama artists, 223, 224

Shelby County, 130. *See also* Shelbyville

Shelbyville (Shelby Co.), *126,* 171

Shell work: prehistoric, 8, 9, *10, 13, 13;* in academies, 109

Shiloh Valley (St. Clair Co.): German settlement, early homes, 131-33, *131;* fachwerk houses, 132-33, *132*

Shingle makers, 244

Ship and boat building, 59, 112, 159, 173, 213, 244

Ship furnishing, 213

Shobonier (Fayette Co.), 166

Shoes and shoemakers: French, 30; pioneer, 42-43, 59, 97, 135; wooden last, *58;* German, *135;* boots and, 180, 199, 207, 235, 244

Signs and sign painters, 90, *135, 159,* 159-60

Silhouettes, 84

Silver and silversmiths: for Indian trade, 45-46, *46;* coin, 111, *111;* vase motif, 149; article types, 175; sterling, 180, *180;* in religious colonies, 199, 237; in 1850, 244

Sley maker, 58

Soap makers, 199

Sod houses, 127, 169

Southerners. *See* Settlers, southern pioneer hunters, pioneer craftsmen

Spinners and spinning, 37, 41, 135, 232, 244. *See also* Spinster

Spinning wheels, 40-41, *41,* 57, 99, 234, *235;* wheelwrights make, 58, *110,* 199

Spinster, 58. *See also* Spinners and spinning

Springfield (Sangamon Co.):
— 1820-30: pioneer homes, 61-62
— 1830-40: artist Hanback, 86, *86;* art school, 109; furniture, oilcloth made in, 110, *110;* second largest Illinois town, 110; ornamental artist, 110-11; French-type house, *127;* Iles home, 141, *141;* theater, 161; potter's shop, 181, 182, *182,* 183, 189; capitol building, *see* State capitol, Springfield
— 1840-50: silversmiths and cabinetmakers, 111, *111,*

149, 175; Lincoln-Herndon office building, 145, *145;* Lincoln home (1844), *145;* miniature artists, 166; entertainment, 246
— 1850-60: artists, *168, 209,* 216-17, 264, 265 (Hillman), 266 (Richardson); panoramas, 222, *222-23,* 228, 229; Emerson lectures, 246; addition to Edwards house, *254;* engravers, 264 (Parker), 266 (Fairthorne)
— 1860–: interior of Lincoln home, *248*

Stark County. *See* Toulon; Wyoming

Starved Rock (La Salle Co.), 18, *212*

State capitol:
— Kaskaskia, 64, *64*
— Vandalia, 86, 90, 143, *143-44*
— Springfield: competition for, architect, construction, 144-45; Berry paintings, 152, *153,* 248; restored interior, *157, 247;* restored exterior, *246;* completion, 246-47; historic persons, 247-48; auditor's desk, *252;* architect-designed desk, *253*

"Steamboat" or "Carpenters'" Gothic, 254

Stencil painting: on paper and cloth, 82, *108,* 109, *109;* on chairs, 85; on oilcloth, 110

Stephenson County. *See* Freeport; Lena

Still-life painting, *108,* 109

Stone carving and carvers: prehistoric, 10, *10, 53;* architectural, *82, 203,* 203-4, 208, *208;* of tombstones, 83, *92, 127,* 149-50, *149-50,* 155, *155, 178;* in 1850 census, 244

Stone chipping, 7-8, *8, 11*

Stone cutting: as inspiration for sculpture, 260

Stoneware. *See* Pottery, stoneware

Stonington (Christian Co.): coverlet made in, *102*

Stores, trading posts, 96, 97, 103, *129, 143;* home products traded, 60

Straw: insulation bats, *132;* braided for hats, 199

Sumner (Lawrence Co.), 89

Swedes, 127. *See also* Bishop Hill

Swiss: settlement, 130; potters, 130, 190; organ factories, 133; at Nauvoo, 207

Symbolism: in Federal architecture, 63-64; in Classic Revival architecture, 137-38, 142-43; in Gothic Revival architecture, 154-56, 254; in Gothic Revival churches, 154, 249; in signs, 159; in beehive design, *199*

Tailors, 111, 135, 180, 199, 207, 235, 244

Tanners, tanneries, and tanning: pioneer, 38, 42-43, 58, 111; later, 170, 199, 207, 235, 244

Tapestry maker, 207

Tazewell County, 173, 190; spearpoint from, *11. See also* Pekin; Tremont

Teutopolis (Effingham Co.), 135

Theater: production in Illinois, 160-61, 245-46; painting, 160-61, 240, 242; "moving picture" productions, 166, 222-30, *227*

Thebes (Alexander Co.), 154

Theorem painting, *108,* 109

Timber frame construction, 63, 92; with brick-nogging, 68, *68*

Tinners, 97, 111, 134, 159, 243-44; products, *98,* 135, *145, 200, 236-37*

Tombstones. *See* Stone carving

Tools: prehistoric Indian, *8,* 8-9, 10; early pioneer, 40, *43;* manufacturers, *94,* 180, 244; of easterners and southerners, 98, *98;* scythes, cradles, plows, 232, *232,* 236, *236*

Toulon (Stark Co.), *146,* 154

Tower Rock (Jackson Co.), 75, *116*

Toys, 43, *43,* 184, 207

Trade boats, 213

Tremont (Tazewell Co.), 112, *253*

Trinity. *See* Cache

Trunk and carpetbag maker, 244

Turkey Hill (St. Clair Co.), 38, 59

Turner, 134

Union County, *13,* 60, 173, 189. *See also* Anna; Jonesboro

U.S. Salines (Gallatin Co.), 59

University of Illinois (Champaign Co.), 250

Upholsterers, 180, 244

Upper Alton. *See* Alton

Utica (La Salle Co.), 17

Vandalia (Fayette Co.): National Road, 22; pie safe from, *82, 135;* German settlers, 131; statehouse, 143-44, *143-44;* artist Wilkins, *167*

Vermilion County, 171, 173, 190, 193. *See also* Catlin; Kirkpatrick, Murray; Rossville

Vermilionville (La Salle Co.), 184, 190

Ville de Maillet. *See* Peoria

Virginia (Cass Co.): adobe house near, 169-70, *169*

Wabash County, 173. *See also* Palmyra (Wabash Co.)

Wabash River, 72, *116,* 224

Wagon makers, 97, 111, 173, 180, 199, 239, 244. *See also* Wainwright

Wainwright, *196. See also* Wagon makers

Walking sticks, 199

Wallpaper, 68, 237

Wanborough (Edwards Co.): English settlement, 67-70, *73,* 79; Cauliflower Lodge, 68-70, *69,* 72, *73;* artist Lesueur, *69,* 72, *72, 73;* pottery, *70,* 189

Warren (Jo Daviess Co.): Tisdell Inn, *176*

Warsaw (Hancock Co.), 48

Watch- and clockmakers, 111, 135-36, 180, 199, 207, *235, 238, 239;* sign of, 159; in 1850, 244

Watercolor: as convenient medium, 50, *51, 115;* as newly popular medium, 71, *71, 87b;* used for miniatures, 84, *84b, c*

Waterloo, formerly Bellefontaine (Monroe Co.), 22, 38; Leman house-fort near, 63, *63*

Watseka, formerly Bluff Springs (Iroquois Co.), 171

Waukegan (Lake Co.): Swartout house, *146*

Wax figures, 245

Wax work, 109

Wayne County. *See* Fairfield

Weathervanes, 126, *135*

Weaving: prehistoric Indian, 10; historic Indian, 20;

pioneer, 42, 57, 100-101, *101-2, 170,* 234; professional, *140,* 169, 170-71, *170-71,* 199

Wenona (Marshall Co.), *79*

Western Man (midwesterner), 136

Wheelwrights, 58, 97, *110,* 111, 134, 244

Whip and cane maker, 244

White County. *See* Carmi; Grayville

White Hall (Greene Co.): potteries in or near, 182-84, 189-90, 193, *see also* Ebey, John Neff; stoneware jug made in, *191*

Whiteware, 188

Whitster (linen bleacher), 207

Wigmaker, 30

Will County, 173. *See also* Channahon; Joliet; Mt. Joliet

Winchester (Scott Co.): potteries, 183, *184,* 190, 193. *See also* Ebey, George; Martin, John L.

Winnebago County. *See* Rockford; Rockton

Winter's Chemical Dioramas, 246

Wire maker, 244

Wood carving: utilitarian, 43, *43,* 98, *98-99,* 135; decorative, *88, 130, 136,* 204, 213, *237, 239;* architectural, 145; of toys, 207; of fiddles, 238

Woodenware manufactory, 243-44

Woodford County, 135, 165. *See also* El Paso; Goodfield; Metamora

Wood graining (artificial), 149, *149,* 172, *172, 180*

"Woodhenges," 12

Wood River, later Upper Alton (Madison Co.), 45

Wool: raising of sheep, 41, 243; processing, 41, 42, 169, 234, 244; weaving, 41, 42, 57, 234. *See also* Carding machine; Looms

Writers in Illinois, 117-18, 246

Wyoming (Stark Co.): quilt made near, *268*

Yankees. *See* Settlers, easterners

Yarn winder (reel), 41, *57, 235;* manufactory, 111

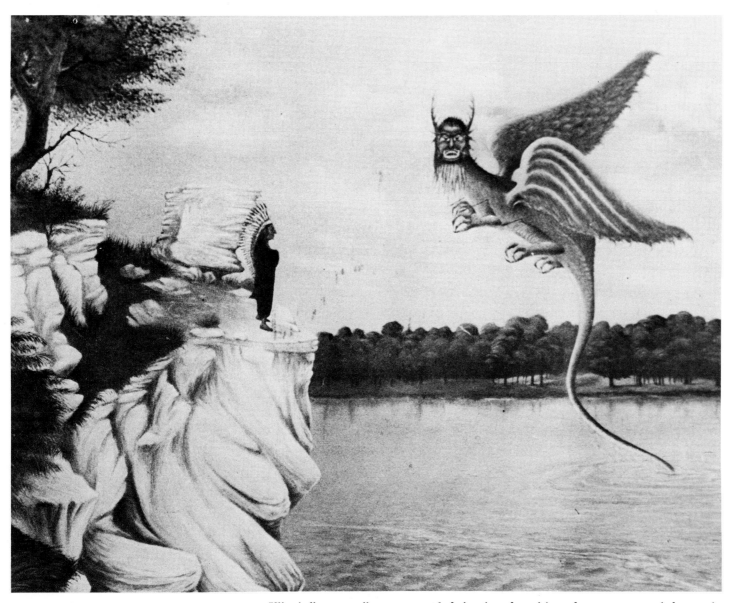

Illinois "treasures" are constantly being found as citizens become aware of the state's heritage. "Ouatogá and the Piasa Bird," painted by an unknown artist, was discovered by the author as this book was going to press. May it be one of many such "treasures" to come to light in the future.

HENRY MC ADAMS COLLECTION